Art of Mesopotamia

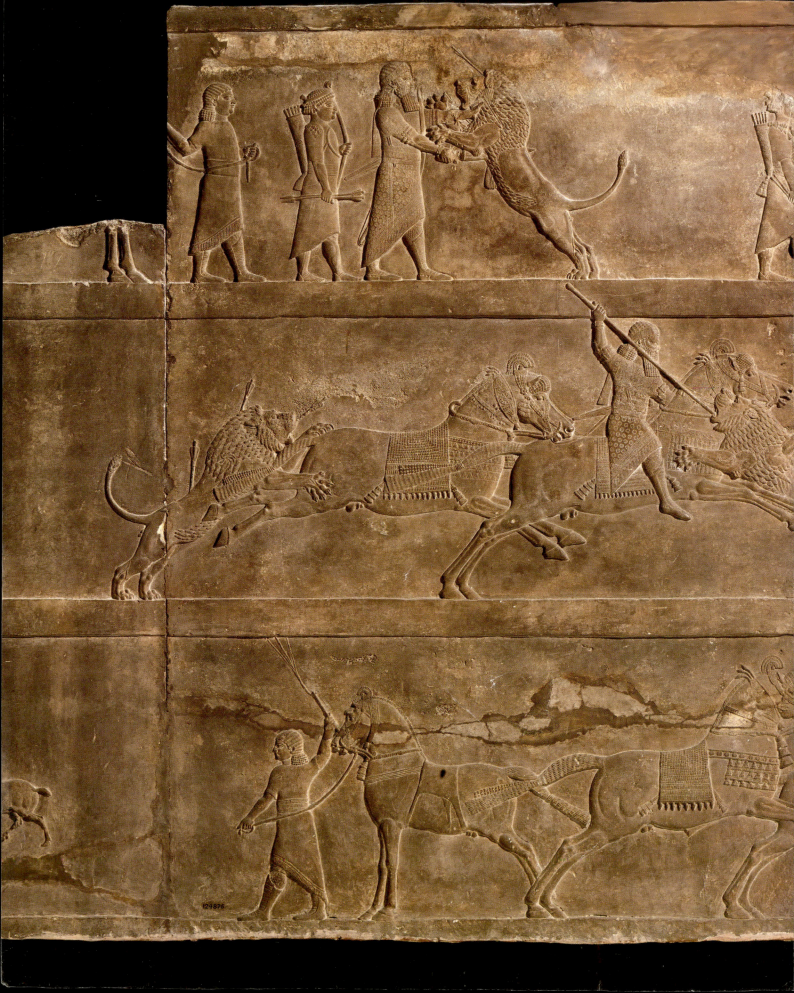

ZAINAB BAHRANI

Art of Mesopotamia

Thames & Hudson

On the cover Middle Assyrian seal with winged
horse, see p. 215; female ivory head, Babylon, Iraq:
see p. 296

Title page Lion hunt in three registers, Nineveh, Iraq:
see pp. 244–45

Page 7 Lion procession and stylized palm trees,
detail from throne room wall, Palace of
Nebuchadnezzar II, Babylon, Iraq: see p. 270

Art of Mesopotamia © 2017 Thames & Hudson Inc.
Text © 2017 Zainab Bahrani

First published in the United States of America in
2017 by Thames & Hudson Inc., 500 Fifth Avenue,
New York, New York 10110

www.thamesandhudsonusa.com

Library of Congress Control Number 2016943976

ISBN 978-0-500-29275-4

Printed and bound in China by Everbest Printing

CONTENTS

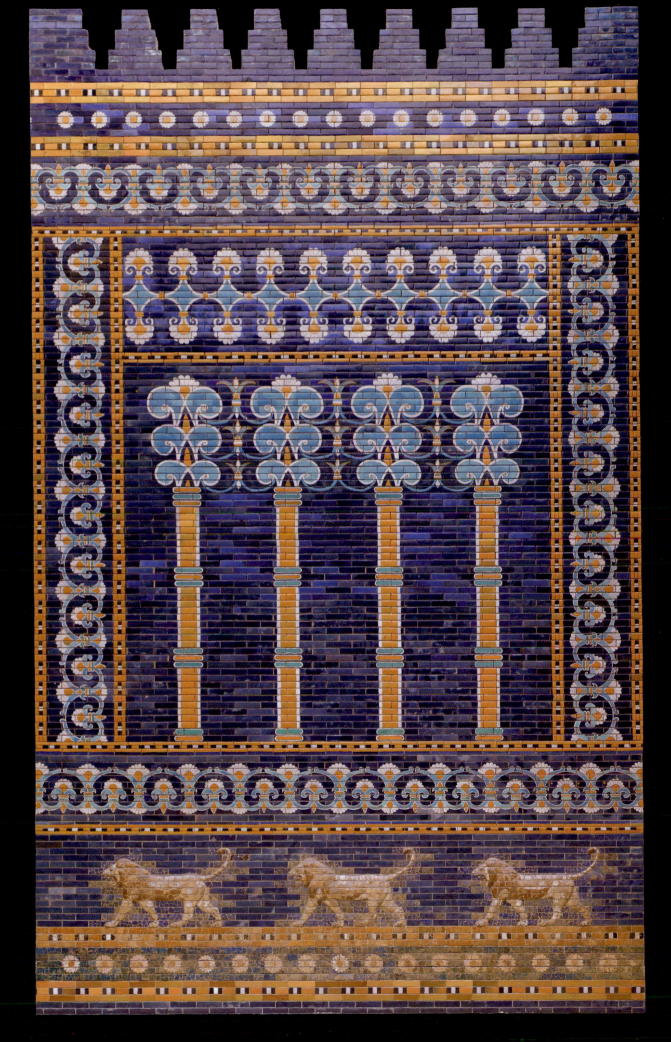

INTRODUCTION

Becoming Art

Art, like myth and the narratives of history, gives meaning to our existence and orders our world. Images of all kinds have a powerful influence on us, perhaps increasingly so today. That is why we create them, love them, and hate them—as all people have done throughout history. Images and their production, monuments, and artworks make us human; they set us apart and bring us together. According to physical anthropologists, one activity that distinguishes modern *homo sapiens* from Neanderthals is this ability to think symbolically; to create symbols and representations of the physical world and the world of the imagination, the sacred and the divine. Architecture, the urge to order and organize the lived environment, is also a fundamental aspect of what it is to be a human being. Art and architecture thus fix things in the world, and allow us to visualize the invisible and the intangible, such as the gods or abstract thoughts.

This book presents a history of Mesopotamian art: one of the most fascinating and earliest developments of art and architecture, and one that forms the basis of many later traditions. The term "Mesopotamia" is a modern one, based on a late **Hellenistic**-era Greek word that refers to the "land between the two rivers," the Tigris and the Euphrates. The region encompassed an area well beyond those rivers, including all of the contemporary nation state of Iraq as well as northeastern Syria, southwestern Anatolia (Turkey), and, at times, the westernmost part of Iran. The "ancient Near East" covered a wider area; archaeologists use it to describe the region spanning the eastern Mediterranean to Iran.

This book begins with the premise that ancient Mesopotamian art is an important enough topic to merit attention in its own right, even while the arts are undoubtedly always part of their greater context. Yet since the mid-twentieth century,

books on Mesopotamian art have fallen out of favor. Some scholars of antiquity do not feel that the ancient Near East produced any "art" at all: that visual representations and architecture from antiquity are not examples of fine art, because they had religious or political functions, and were never considered art for art's sake. Taking this view, art is a modern and Western idea that cannot be shared by other cultures. Other scholars disagree with this view, and have shown through their writing and research that visual art is a historically limited concept that cannot be used as a measure by which to include or exclude the aesthetic forms produced across the world and throughout history. Be that as it may, the European and North-American academic discipline of Art History had long ago taken the art of Mesopotamia as a place of origin, since the earliest days of its scholarship, and while this construction of a narrative of artistic origin and progress requires some discussion, Mesopotamian art continues to be widely described as the beginning of the cultural heritage of the entire world, both in the popular press and in academic writing, with its influence persisting in the works of leading artists today.

Mesopotamia in Art History

The idea that the origin of art was to be sought in Mesopotamia and Egypt is not a new one. The Italian **Renaissance** writer Giorgio Vasari, who is sometimes credited with being the first art historian, ascribed the beginnings of art to the ancient Egyptians and the **Chaladaean** Babylonians of Mesopotamia. In his treatise *The Lives of the Artists* (1550), he traced the earliest forms of art to the ancient Near Eastern past. Later, during the era of the European Enlightenment, Johann Joachim Winckelmann wrote the *History of the Art of Antiquity* (1764), often

referred to as the earliest work of art historical scholarship and aesthetic thought. He presented the study as a comparative history of art of the Near East and the Classical world, and had already included in his discussion some of the works that we shall see in the later chapters of this book.

In architectural history, Johann Bernhard Fischer Von Erlach's *A Plan of Civil and Historical Architecture*, published in 1721 in Vienna, included imaginative reconstructions of architecture from such cities as Babylon and Nineveh. These cities had not at the time been excavated, nor were they known from scientific archaeological research, so the images he presented could not have been accurate studies—even though he included them as examples of the origins of architecture.

At the start of the nineteenth century, the great German philosopher G. W. F. Hegel incorporated the arts of the ancient Near East in his lectures on aesthetics (published in 1835, a few years after his death). In Hegel's writings, art was seen as a tangible material manifestation of its greater historical context, and as part of a unilinear development across world history. Thus, since the early days of the European aesthetic discourse, Mesopotamia has been part of the story of the origins of art and architecture.

Influence on Artists

As for the tangible remains of the Mesopotamian arts, the rise of the public museum in the eighteenth and nineteenth centuries coincided exactly with the rediscovery of the Assyrian and Babylonian past, when antiquities began to be excavated and taken to museum collections in the West (see chapter 1). The arrival of these works had a great impact on the museum-going public in Europe and North America, in the mid-nineteenth century especially, as well as on the artists of this time. After the arrival of a number of Assyrian works in London in 1847, the British painter Dante Gabriel Rossetti produced a series of paintings of women representing historical and literary subjects. His painting titled *Bocca Bacciata* (1859), an image of a fallen woman, seems to have been influenced by the newly found Assyrian ivories.

In the painting, a sensuous and exotic woman is represented frontally, her head and shoulders confined within a framed window. Her thick hair and jewelry, as well as her constrained appearance in the window, reference a Nimrud ivory **relief** of the same theme that Rossetti was able to see in London.

A less well-known era in the history of **reception** of the arts of ancient Mesopotamia, however, is the early twentieth century. At that time, European **avant-garde** artists became interested in the early non-Western arts, and they paid close attention to those of the Near East. The works of art of Sumer in southern Mesopotamia of the third millennium BCE were of especial interest. The British sculptor Henry Moore (1898–1986), for example, was deeply inspired by ancient Near Eastern art, and he considered **Sumerian** sculpture to be among the best achievements of art in the world's history. He devoted an essay to it published in *The Listener* magazine in 1935, and was also inspired by it in some of his own sculptures, such as *Girl with Clasped Hands* (1930) [**0.1**].

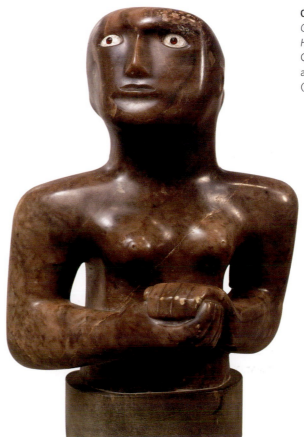

0.1 Henry Moore, *Girl with Clasped Hands*, 1930. Cumberland alabaster, h. 16¾ in. (42.5 cm)

Moore's Swiss contemporary Alberto Giacometti made a series of sketches of ancient artworks, many of them studies of Sumerian sculpture, as these were among the arts that inspired his own work. Although today we do not often acknowledge this remarkable impact, the Museum of Modern Art in New York's opening exhibition in 1936, "Cubism and Abstract Art," put ancient Near Eastern art on the chart of **Modernism** and the influences behind it [**0.2**]. The chart was reproduced on the cover of the exhibition catalogue, and was fundamental to the organization and the vision of this newly established museum. After the era of Modern art, and into the contemporary period—beginning around 1960—artists in the West continued

0.2 Alfred Hamilton Barr Jr., cover for the MoMA exhibition catalogue "Cubism and Abstract Art," 1936

to be influenced by the arts of Mesopotamia, albeit less prominently. In 1987, for example, the American artist Cy Twombly (1928–2011), whose work is much inspired by antiquity, made the sculpture *Ctesiphon* [**0.4**], named after the great Mesopotamian arch of the Roman era [**0.3**].

Not only Europeans and Americans, but also, unsurprisingly, artists from the Middle East were significantly influenced by the art of ancient Sumer and Mesopotamia throughout the twentieth century. At the start of the century, Zabelle Boyajian, an Armenian artist from Diyarbekir in eastern Anatolia, painted wonderful fantasies of the ancient Near Eastern past in works that are now mostly lost, surviving only in book illustrations that she produced based on her paintings. In twentieth-century Iraq, the celebrated Modernist Pioneers group of artists looked to the past in order to form a new Modernist art that was their own yet international at the same time. Jawad Salim's famous *Tahrir* or *Liberty* monument takes the forms of Assyrian relief sculptures and **cylinder seal** narratives and transforms them into a Modernist statement for the new nation state at its independence in 1958. Even before this monument, the sculptor Khalid al Rahal had made extensive use of Sumerian art in his work, such as the sculpture *Sharqawiya* (1950), which represents **Ishtar** and the Bull of Heaven. The works of contemporary Iraqi artist Dia Azzawi include the Gilgamesh and Enkidu series of paintings from the 1960s, and *Majnun Laila* (1995), which echoes the fourth millennium **Uruk** head (see p. 49, fig. 2.6). Among the powerful works that Iraqi artists have produced in response to the wars of the last decades, the Mesopotamian past emerges repeatedly as a place of mourning and identity. Hanaa Malallah's (b. 1958) installation *Mesopotamian Rhythm* (2011) is not only a visual reference to antiquity but also participates in the ancient Sumerian dirge, the poetic form of the lament over the destruction of cities, known from the third millennium BCE. In *The God Marduk*, Malallah conjures up the Babylonian god and the splendid sculpted wall reliefs of Babylon, revealing to the viewer their echoes across time [**0.5**, see p. 12].

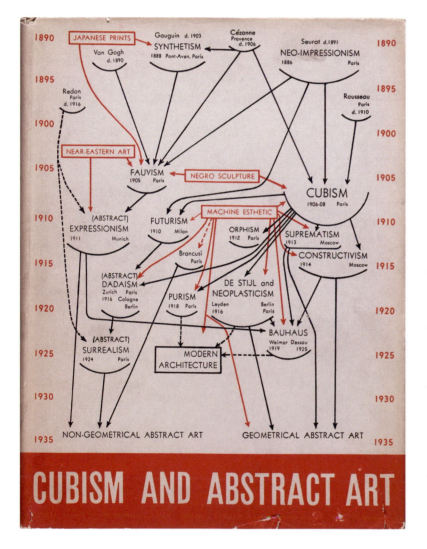

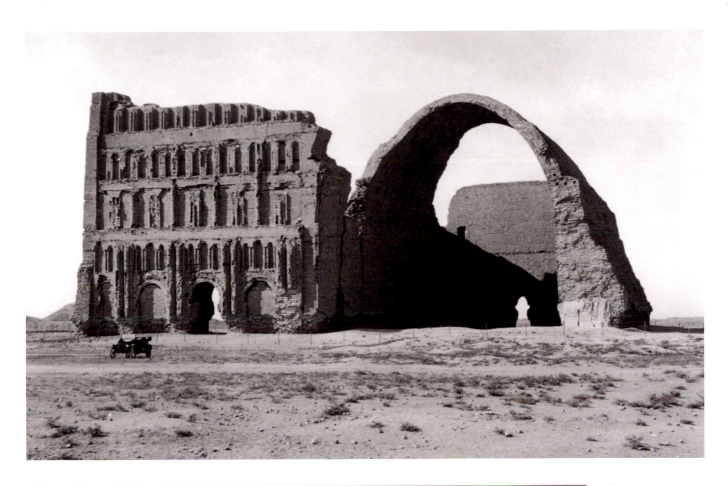

Above
0.3 Arch of
Ctesiphon, at ancient
al Mada'in, Iraq,
3rd century CE,
photograph *c.* 1916.
Brick, h. 121 ft.
(37 m)

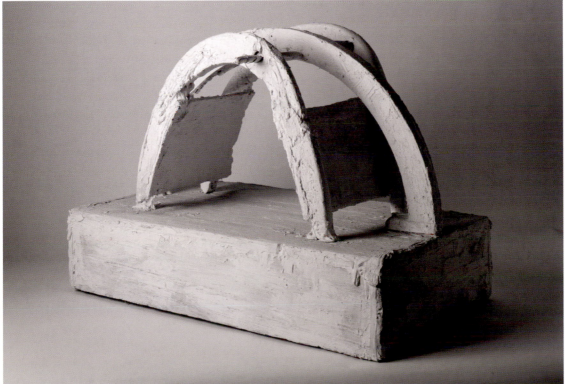

Left
0.4 Cy Twombly,
Ctesiphon, 1987.
Wood, plaster, metal
strips, nails, paint,
and wire, h. 25¾ in.
(65.4 cm)

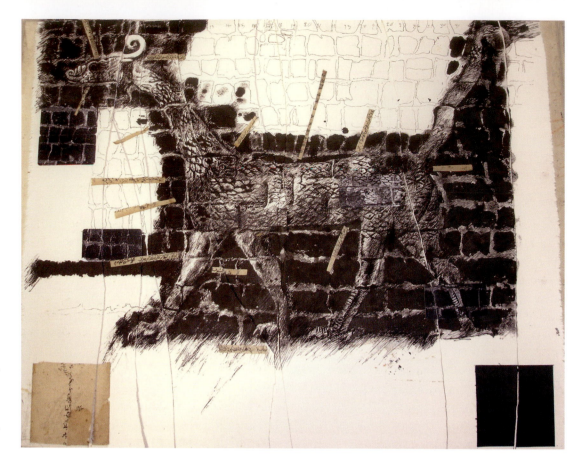

0.5 Hanaa Malallah, *The God Marduk*, 2008. Artist's book, mixed media on paper, 23⅝ × 18½ in. (60 × 46 cm)

Innovation and Creativity in Mesopotamian Art

Ancient Mesopotamia has sparked the imagination of historians and artists for a very long time. We can observe that many of the **genres** and techniques that we associate with art and the study of art today were developed in Mesopotamian antiquity. For example, just as we can say that the Italian Renaissance invented modes of representation and technologies that we now consider to be turning points in art history—for example, the rendition of perspectival space, easel painting, or the print—many techniques and technologies of art production first emerged and developed in the ancient Near East. These include hollow casting of copper and bronze with the **lost-wax method**; the creation of open molds, which allowed images to be mass-produced for the common people; and complex forms of architectural sculpture. In terms of genres, we can include such major contributions as the first appearance of commemorative or historical public monuments; the depiction of the act of artistic creation itself, including the use of **hypericons**, or self-referential images; the creation of **epiphanic** images, which allowed one to encounter the divine; and dream images. The works that were produced reveal an exuberant creativity and imagination, combined with remarkable technological skills. Artists were often intellectuals who were also able to write; indeed, they developed **calligraphic** forms of written script for public display. They were also concerned with abstract ideas (such as how images can have an agency of their own that impacts the world around them), the nature of the gods, and how to represent the gods as aspects of a visual theology. They constantly negotiated the boundaries between images and reality, and the place of art and representation in the world.

From ancient Mesopotamia, we also have the first recorded fine-tuning of aesthetic definitions and terms, and the first use of **ekphrasis** (literary description and commentary on a work of visual art; see chapter 8, p. 194) in the description of works of art, accompanied by the first literary admiration of sculpture and architecture. Collecting, preservation, and conservation techniques that we usually associate with far later eras already existed and are extensively recorded in the ancient texts. For all these reasons, this book

takes the view that ancient Mesopotamian art can indeed be studied as an early form of art, not simply as an archaeological artifact that documents or opens a window upon historical or political epochs of the past.

The Approach of this Book

This book is unusual in its approach for two reasons. The first is that it covers Mesopotamian antiquity up to the developments into the late antique world, while most other surveys end when the Greeks conquered the Near East. Secondly, the book insists on taking works of art and of architecture as the focus of study, unlike other textbooks on ancient Mesopotamia. Archaeology, especially in the US, has been more allied to the sciences rather than the humanities, and visual representations and **iconographies** have been given far less attention in general introductory books on Mesopotamia than the social structures and political formations of early states.

I survey Mesopotamian art and architecture from the fourth millennium BCE until the third century CE, covering a time span that is longer than the period between Homer and the present day. After discussing the historiography of the discipline and ideas of origins, I introduce the era of the establishment of the first cities in the fourth millennium BCE, an event that led to vast developments in monumental art and architecture. Following a chronological framework, I continue beyond the Greek conquest of the Near East in the fourth century BCE, when new **Graeco-Babylonian** styles and techniques emerged, to conclude with the remarkable art and architecture produced in the era of the Parthian-Arsacid dynasty, such as the magnificent stone temples and sculptures of Hatra. Obviously such a great expanse of time forces me to be highly selective in the choice of works and genres discussed, and to omit many others for the sake of coherence.

Within this broad historical framework (c. 3500 BCE to 300 CE), each chapter of the book focuses on the Mesopotamian forms and concepts of artworks, as well as aesthetics and the ancient reception of, and response to, images. Each chapter presents such topics as the development of the first narrative representations; the earliest known public historical monuments; the use of architectural sculpture; and of small-scale arts of a personal character, including those of commoners and others who are often ignored in ancient art history. Additionally, some of the main topics that emerge in the study of Mesopotamian art practices in a wider context are fascinating rites of making and animating images, later disparaged as idols in the biblical traditions; architectural forms and architectural rituals; **iconoclasm** and the removal of images in wars; and the import and exchange of exotic luxury arts. Yet, although the historical and cultural context will be carefully explained in each case in order to allow the reader to place the works in a clear historical frame, it is the works of art themselves that will be emphasized. Each chapter uses specific works of art as the point of departure for the discussion.

While Mesopotamia is widely acknowledged as the place that gave the world the first cities and urban societies, the invention of writing, law, government and institutionalized religion, and so many other aspects of early complex societies, Mesopotamia's contribution to the visual arts and architecture has thus far been given far less attention. This book shows how some of the main conceptual issues and themes that are central to the history of art emerge in the Mesopotamian record, among them: collecting practices; space as an abstract concept; historical consciousness and antiquarian concerns; aesthetic choices and decisions; as well as the power of images and visual ideologies.

When the great scholar of Mesopotamian literature, Samuel Noah Kramer, wrote in 1956 that "history begins at Sumer," he based this declaration on the invention of writing, the wheel, law, and other "firsts of civilization." Here we will see that works of art, monuments, and architecture are not just tools or illustrations of social structures and political epochs that are historically significant, but they are also worthy of study in their own right. Here too, in the world of artistic creativity, Mesopotamia can be seen as a land of many firsts.

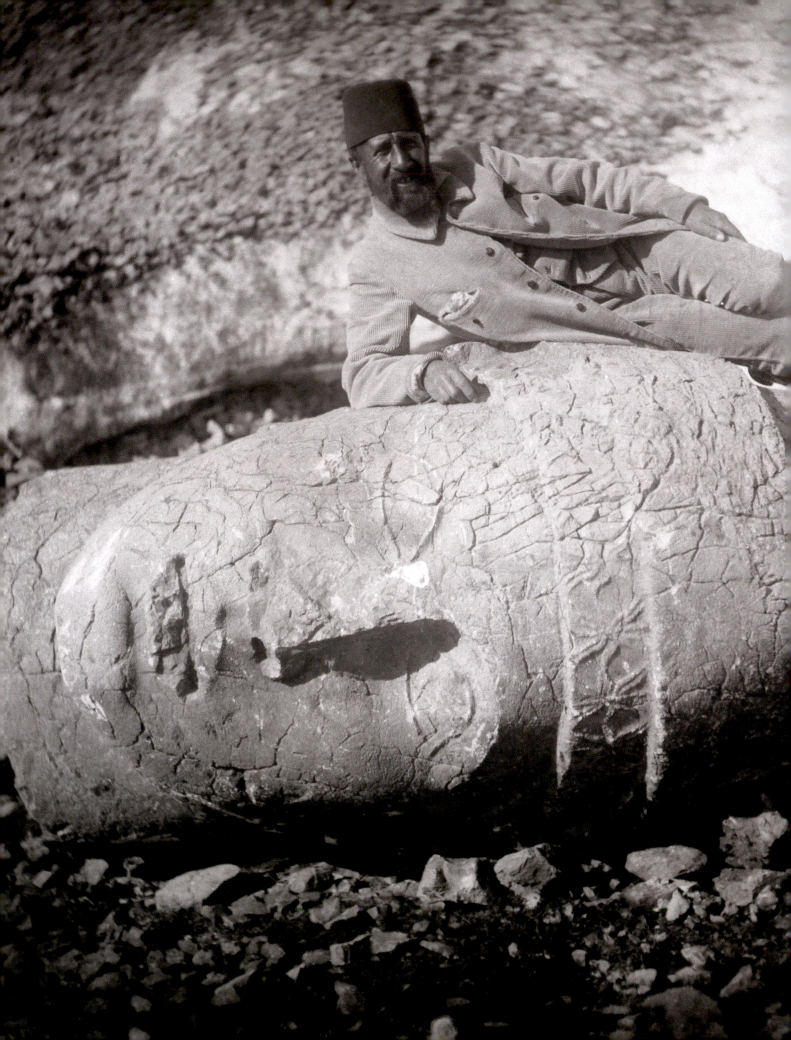

CHAPTER ONE

The Search for Origins:
Mesopotamia and the Cradle of Civilization

Osman Hamdi Bey lies upon the head of
Antiochus at Nemrud Dagh, Turkey, 1883

1 Prehistoric Mesopotamia 9600–3400 BCE

Periods	Aceramic/Pre-Pottery Neolithic c. 9600–7000 BCE
	Pottery Neolithic 7200–6000 BCE
	Hassuna, Samarra, Halaf, Ubaid 6000–4000 BCE
Major centers/sites	Göbekli Tepe, 10th–8th millennia BCE
	Çatal Hüyük, 7th millennium BCE
	Eridu, 6th–4th millennia BCE
Notable facts and events	Ceremonies with burial gifts for the dead are known from Paleolithic times
	Neolithic towns and villages 8000–5500 BCE
	Village farming 8000–5500 BCE
	Irrigation 5000 BCE
Important artworks	Stone circles, sculpture, and architecture at Göbekli Tepe
	Wall paintings at Çatal Hüyük
Technical or stylistic developments in art	Invention of the stamp seal in Mesopotamia and Anatolia (modern-day Turkey), 6th millennium BCE
	Invention of the potter's wheel, around 4500 BCE
	Mother goddess figures

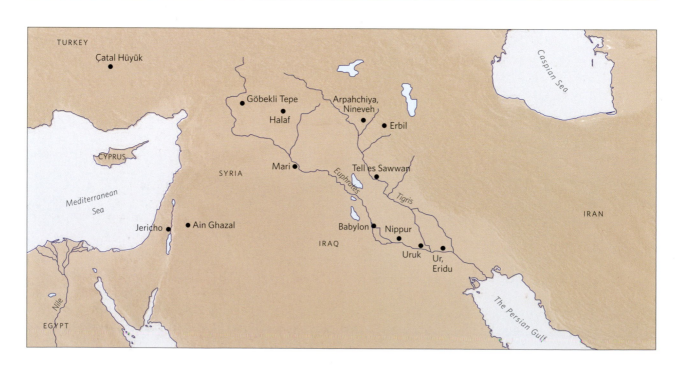

1 The Search for Origins: Mesopotamia and the Cradle of Civilization

nterest in the past has always been part of our human experience. The ancient peoples of Mesopotamia, for example, recounted stories about the origins of the world, recorded the past in writing, kept ancient objects, and even participated in activities that we would now call archaeological excavation and restoration. These are activities that are known throughout recorded history in many parts of the world. In the nineteenth century, however, a new form of archaeology developed that differentiated itself from earlier forms of antiquarianism by calling itself scientific archaeology. This field arose at the same time as the emergence of the modern institution of the museum as a collection of natural wonders and works of art open to the public. During that century, most of the Middle East was part of the **Ottoman Empire**, with its central administration in Constantinople (Istanbul), so as the story of Mesopotamian discovery begins, the region known as Mesopotamia was within the Ottoman domain. The name "Mesopotamia" itself is a Greek word, meaning "the land between two rivers." It refers to the region of the Tigris and Euphrates rivers, which spring up in the Taurus Mountains of Anatolia to the north before making their way down through modern-day Syria and Iraq to the Persian Gulf in the south.

In the latter part of the eighteenth century CE, an increasing number of travelers from Western Europe began to make their way across the vast region that was the Ottoman Empire, through Greece, Anatolia, Syria, and Mesopotamia, with a view to studying ancient remains of former empires and cities, and in order to collect works for the new museums of the Western capital cities, such as the British Museum in London and the Louvre in Paris. By 1846, the Ottoman Imperial Museum (Müze-i Hümayun) was established, bringing together ancient Greek, Roman, and Byzantine objects from across the empire along with ancient Near Eastern artifacts and works of art, and Mesopotamian archaeological finds became a major part of these collections. All these museum collections, European and Ottoman, were arranged and exhibited as a narrative account of history presented in natural objects, artifacts, and works of art, and they had the archaeological past at the basis of their displays. They integrated Mesopotamian antiquity into an account of the infancy of the world's history, a grand historical development that they thought culminated in modern Europe.

This chapter explores the many ways that Mesopotamia has been seen as the place of the world's origins, both in antiquity and in modernity. The chapter moves back through time, following the archaeological method of revealing layers of history. We see that there has in fact been a long history of engagement with the Mesopotamian past—one that precedes the claims of nineteenth-century European explorers—as shown by early Arabic and Persian scholarship. Working back further through time, it is evident that even for the ancient Mesopotamians themselves, myths of origins and ideas of civilized life were associated with the place that is now the

south of Iraq: ancient Sumer. The second half of the chapter presents the earliest archaeological material evidence for the representational or visual arts and architecture in greater Mesopotamia, dating as early as 9000 BCE. Only a century and a half ago, most well-educated people in the Western world believed the world began in 4004 BCE, according to a standard interpretation of the Bible. Today we must also remember that every view of the past is a product of its own time.

Early Interest in Mesopotamia

Although the nineteenth-century explorers might have claimed to discover Nineveh and Babylon, these cities were well known to the local population long before the arrival of the Westerners. Many cities have retained their ancient place names over the millennia, and we can thus trace them in written accounts dating back over many thousands of years.

In historical scholarship, the fifth-century BCE Greek writer **Herodotus** described the monuments of Babylonia in his *Histories*, and even earlier Greek writers touched on the Babylonian and Assyrian past. In the Arabic and Persian traditions, such writers as Ibn Hawqal went to see Babylon and wrote about it in the tenth century CE. The Spanish Benjamin of Tudela, who went to Babylon in the twelfth century CE, reported that the ruins of the palace of Nebuchadnezzar were still visible. From the tenth through the fourteenth centuries CE, such writers as Ibn Jubayr, Abu al Feda, Masudi, Muqadasi, and others regularly described the exact locations of Nineveh and Babylon. In Persia, the Qajar dynasty likened its authority to that of ancient kings and borrowed **iconography** from antiquity.

In the seventeenth century, the Italian nobleman Pietro della Valle and other early travelers from Europe were astounded to find that the names of these places survived in the daily language of the local population, and that they could point out their locations with ease. Carsten Niebuhr, looking for Nineveh in 1765, was told by the locals where it was, as it was still called Ninua, and about Babylon he said that

the locals called all this region the land of Babel. In 1748, Jean Otter, a French scholar of Arabic, wrote about Mosul and Nineveh, quoting Arab geographers for his information. Knowledge about the Mesopotamian past was an interwoven dialogue between the Arabic scholarship of the tenth to fourteenth centuries and later European scholarship.

Before the nineteenth century, most Western knowledge regarding the ancient history of this part of the world remained based on mythical tales and biblical accounts. Images in European art, such as Pieter Brueghel's *Tower of Babel* (1563), became iconic visions of how the ancient Babylon of the Bible might have appeared [1.1]. In this Flemish painting, we see an enormous spiralling tower, somewhat reminiscent of the Coliseum in Rome. Noblemen observing the progress of the construction and builders at work in the foreground are unaware of the chaos that was to follow the completion of the tower, which according to the biblical account resulted in a confusion of many languages (Genesis 11:1–9). The painting, reminding us that the hubris of mankind leads to its demise, takes Babylon as emblematic of the rise and fall of man's accomplishments and acts to warn us against arrogance.

Inspired by other mythical images of Babylon in prints and manuscripts—illustrations that were perhaps based on the monumental spiralling minaret of the medieval Great Mosque of Samarra that had been constructed during the Abbasid dynasty in the ninth century CE [1.2]— the Western picture of Mesopotamia endured for many centuries.

By the nineteenth century, at the same time as the rise of scientific archaeology, German idealist philosophy had incorporated Mesopotamia into the grand narrative of world history. Writers, such as G. W. F. Hegel and Johann Gottfried von Herder, considered this part of the world to be the cradle of civilization. In the study of the arts and aesthetics, *The History of the Art of Antiquity*, written by J. J. Winckelmann in 1764, included Near Eastern sculpture in a comparative aesthetics of ancient art. The history of the Western world and the development of art were thus tied directly to

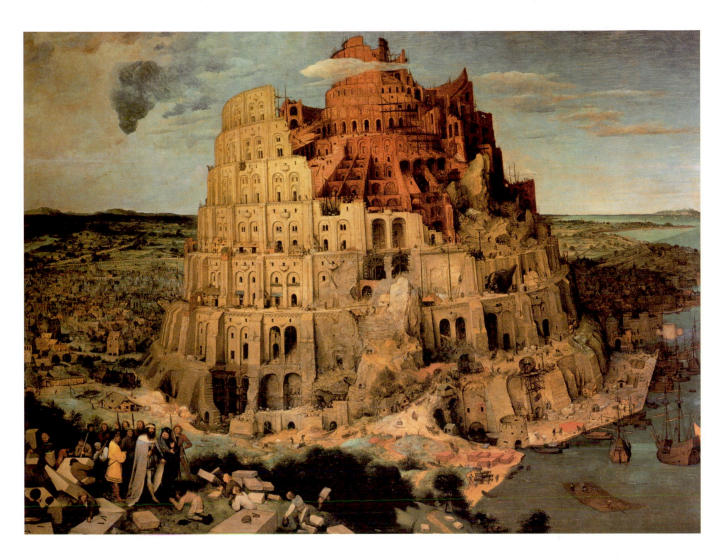

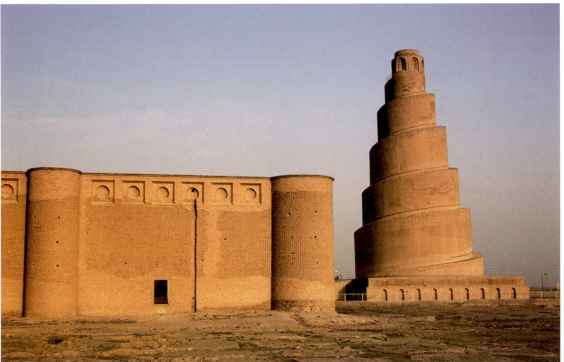

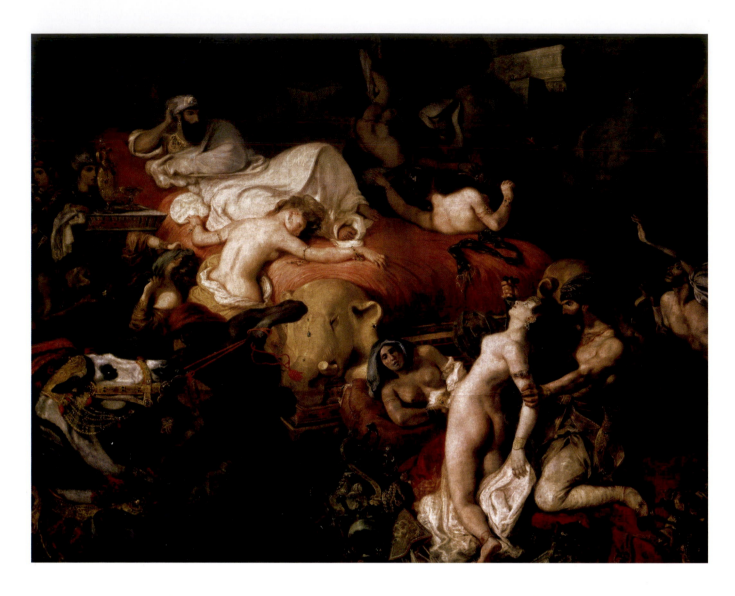

1.3 Eugène Delacroix, *The Death of Sardanapalus*, 1827. Oil on canvas, 12 ft. 10⅜ in. × 16 ft. 3¼ in. (3.92 × 4.96 m)

an Eastern—and specifically Mesopotamian—origin. As the philosopher Hegel in his treatise *Aesthetics* explained:

> The Symbol, in the meaning of the word used here, constitutes the beginning of art, alike in its essential nature and its historical appearance, and is therefore to be considered only, as it were, as the threshold of art.
> It belongs especially to the East and only after all sorts of transitions, metamorphoses, and intermediaries does it carry us over into the genuine actuality of the Ideal as the Classical form of art.

In the European fine arts in this period there was a growing fascination with the region as a representation of biblical admonitions regarding the excesses of worldly kingdoms. Babylon and Nineveh became subjects of great interest, emblematic of the great empire that rises and then falls. Among these works is the painting by the French artist Eugène Delacroix (1798–1863) titled *The Death of Sardanapalus* [**1.3**]. It represents the Assyrian despot reclining on his bed surrounded by slaves and concubines, his riches, and his Arabian stallions, all in a heady tumultuous scene of violent death. When Delacroix painted this scene, practically nothing was known of Assyrian antiquity in the West: the artist relied on Classical accounts of the despots of Babylon and Assyria, and on the work of the English writer Lord Byron [**1.4**], specifically his tragedy *Sardanapalus*, of 1821.

In Britain, the history painter John Martin was devoted to the idea of decline and fall. He produced a series of works on the subject of the Fall of Nineveh and the Fall of Babylon [1.5]; these were not only displayed to vast audiences in London, but were also mass-produced as engravings, which were both sold separately and included in Bibles as illustrations. Martin's paintings predate the earliest excavations in Mesopotamia; his reconstructions of these ancient cities were based on Roman and Indian examples, and on earlier works of art, rather than on archaeological realities.

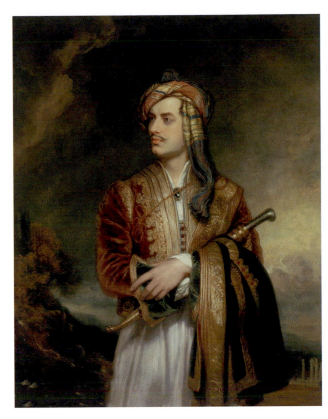

Right **1.4** Thomas Phillips, *Portrait of George Gordon, Lord Byron, in Albanian Dress*, 1813. Oil on canvas, 4 ft. 2 in. × 3 ft. 4⅛ in. (1.27 × 1.02 m). The English poet Lord Byron fought for Greek independence from the Ottoman empire, which he equated with ancient oriental decadence embodied by Assyrian kings. His historical tragedy, *Sardanapalus* (1821), is set in Nineveh and recounts the fall of the Assyrian empire.

Below **1.5** John Martin, *The Fall of Babylon*, 1819. Engraving

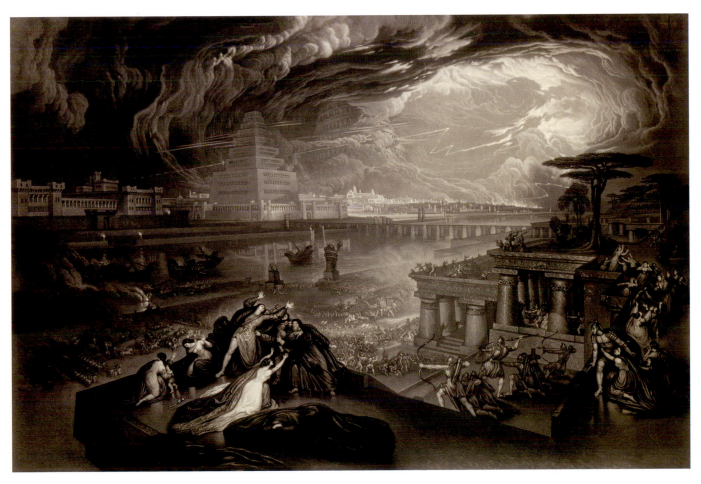

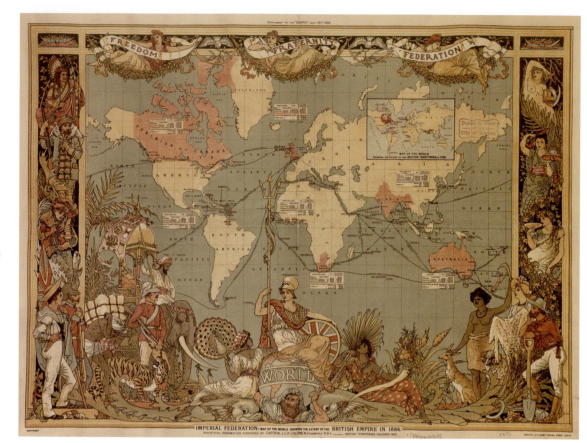

Right

1.6 Map of the world showing the extent of the British Empire in 1886. Published by Maclure & Co., 1886. 33 ⅞ × 24 ¾ in. (86 × 63 cm)

Below

1.7 Babylonian world map, from Sippar, Iraq, *c.* 600 BCE. Clay, 4 ¾ × 3 ¼ in. (12.2 × 8.2 cm)

The creators of both maps chose to organize the world according to their own locations, and to paint the lands beyond as exotic and mythical. In the Babylonian map from the seventh century BCE, the city of Babylon is placed at in the middle of the geographical and cosmic world, encircled by the salt sea; likewise, the world map produced in Britain in 1886 places that country at the center of the world, conveying the seat of Empire and Imperial order. The maps thus show that cartography is always ethnocentric.

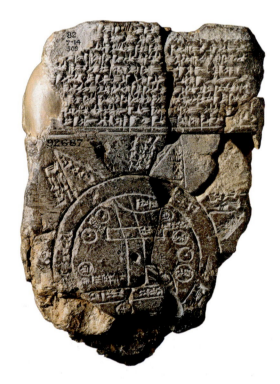

Early Archaeology in Mesopotamia

The Mesopotamia of myth and history lies primarily in the area covered by the Ottoman provinces of Mosul, Baghdad, and Basra, and partly in modern-day Syria and Turkey. European interest in the antiquities of these lands grew alongside its political and economic involvement, which was advanced by the establishment of the British East India Company offices in Basra (1763) and Baghdad (1798). Mapmakers have used their art not only to record geographical information, but also to convey political intentions and build the mythology of a place or a people [**1.6, 1.7**].

Claudius James Rich, an Englishman in the service of the East India Company, was one of the first Europeans to explore the ruins of the Mesopotamian civilization and to publish illustrations of some of the sculptures and **seals** that begun the study of its art. He wrote *Memoir on the Ruins of Babylon* in Baghdad, where he lived, followed by *Second Memoir on Babylon* (1818) [**1.8**].

Although medieval Arabic and Persian scholars had already described Babylon, Nineveh, and other ancient cities, and had recognized the script found in these places as antique, they had been unable to decipher the writing. By 1840, however, the German scholar G. F. Grotefend and English scholar Henry Rawlinson deciphered the **cuneiform** wedge-shaped script, the main writing system of the entire ancient Near East for 3000 years. Scholars soon realized that along with Egyptian **hieroglyphs**, it was one of the two oldest writing systems of the world.

During the nineteenth century, French, British, and German excavators explored the major Mesopotamian sites for antiquities, which they removed and took to museums in Paris, London, and Berlin. They also began to publish systematic studies of these excavations and travelogues of their adventures in the Orient. Ottoman records reveal that by the mid-nineteenth century the Ottoman Empire took an increasing interest in controlling these ancient Mesopotamian sites and artifacts [1.9].

1.8 Claudius Rich, *Second Memoir on Babylon*, 1818. Lithograph illustrating Mesopotamian artworks.

Below **1.9** This early photograph of the Lion of Babylon, still standing in the ruins at the site, comes from a nineteenth-century Ottoman album belonging to Sultan Abdulhamid II. It dates to the time when Ottoman rulers and elites were becoming increasingly interested in the past within their extensive domains, and began collecting antiquities for the Imperial Museum, Istanbul.

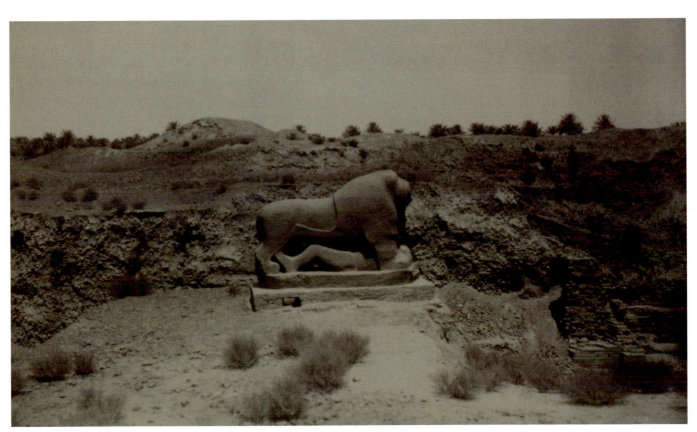

Above
1.10 Austen Henry Layard in native attire, 1843. Watercolor, 11¾ × 8⅞ in. (29.8 × 22.5 cm)

Right
1.11 Hormuzd Rassam, 1854. Photograph after collodian negative by Philip Henry Delamotte

In the 1840s, French and British explorers began to dig in northern Mesopotamia. Paul-Émile Botta, the French consul at Mosul, and **Austen Henry Layard**, a representative of the British Museum [**1.10**], excavated Assyrian sites for antiquities. The main intention at the time was to place finds in the museums in Paris and London. **Hormuzd Rassam**, a local man from Mosul, began excavating with Layard in Assyria and continued also to work in Babylonia in the south of the region [**1.11**]. By the late nineteenth century, **Robert Koldewey**, a German architect, initiated the first systematic scientific excavations at Babylon. Because he was an architect rather than a diplomat or politician, Koldewey was more careful with regard to the scientific documentation of levels of construction and delineating the plans of ancient buildings. Thus, by the standards of the time, Babylon was better excavated than the sites that were dug by Layard.

Hilmi Pasha, the Ottoman governor of Mosul, had also done some digging for antiquities at Nineveh in the 1850s on behalf of the Ottoman government. In 1852, he told the Frenchman Victor Place, Botta's successor, that the Ottomans also wanted these antiquities for their own museums, and had their own claims on the antiquities from these lands. In the 1870s, the French Ernest De Sarzec began secretly digging at Girsu (modern Telloh) in the south, in order to keep the information from his rival Rassam, who held an Ottoman *firman* (legal permit) for excavating, while De Sarzec did not. Thus the competition and rivalries of this era, embedded as they were in the history of imperialism and collecting practices, are an important part of the study of Mesopotamian art history, because they played a large role in the initial digging, interpretation, and documentation of these ancient cultures. In the Ottoman imperial center, **Osman Hamdi Bey** (see p. 12), who was an administrator and artist and the force behind the foundation of the Ottoman Imperial Museum in Istanbul, also became involved in archaeological work when he surveyed and documented the royal tomb **sanctuary** at Nemrud Dagh in southeastern Anatolia in 1884. He also

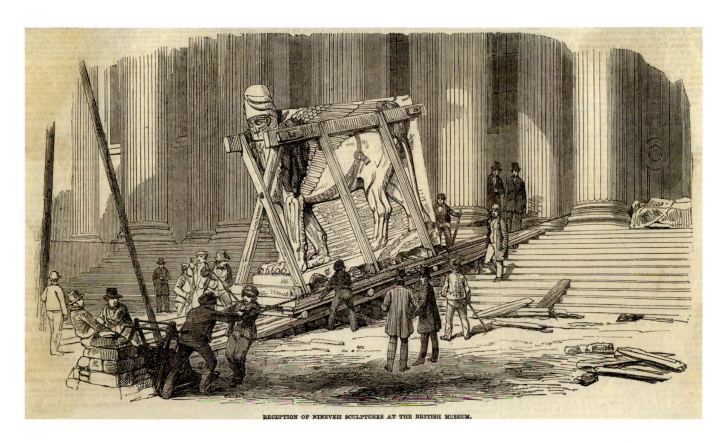

RECEPTION OF NINEVEH SCULPTURES AT THE BRITISH MUSEUM.

directed excavations at the ancient city of Sidon in Lebanon, where he discovered the famous Alexander Sarcophagus. In 1889 Hermann V. Hilprecht, a German professor of Assyriology at the University of Pennsylvania, started work at the Sumerian site of Nippur in the south of Iraq. Both Ottoman and European archaeologists searched for the remains of the past and documented them with precise measured drawings and early photography. The publications that resulted from these field projects were a turning point in the history of archaeology.

The early archaeologists thus made significant scholarly contributions. They traveled and wrote travelogues, they deciphered the difficult ancient scripts and recorded relief sculptures in detailed drawings, and they published ground plans in large atlases of archaeological sites and king lists with chronological orders. Their aim was to develop a science of archaeology.

When the human-headed winged bulls and lions of Assyria first came to England in 1847, London was taken by storm [**1.12**]. Along with the Elgin Marbles from the Parthenon at Athens and the Rosetta Stone from Egypt, the Assyrian sculptures immediately became a major attraction for the British public, who stood in line for hours outside the British Museum's doors in order to have an opportunity to see the new discoveries from Nineveh and Nimrud. The public associated these sculptures with the very origins of art, the beginnings of mankind's past, going back to the biblical origins of the world. British viewers also regarded the sculptures as a mystery and an enigma, as well as a reminder that great empires—including their own—can rise and fall. Dante Gabriel Rossetti, the artist and poet who was part of the group of English artists known as the Pre-Raphaelites, wrote a long poem about the winged bulls called "The Burden of Nineveh." The poem describes what the human-headed bull god had heard and seen over time, and how it traveled to a new empire (Britain) that may in turn be destroyed and forgotten, while the bull will remain standing.

1.12 *The Illustrated London News,* October 26, 1850

Archaeology and Photography

One of the new technological developments that was central to the importance and impact of early scientific archaeology was photography. In 1839, William Henry Fox Talbot in England and Jacques-Louis Mandé Daguerre in France revealed the processes of picture making. Photography rose rapidly alongside scientific archaeology, for which it was used extensively in its earliest years [**1.13**]. Although photography was used as a tool throughout the sciences, early archaeology was the area of its greatest use. Indeed, the two scientific developments were almost made for each other—a pairing of scientific goals and technological invention.

Photography vastly changed archaeology and archaeological methods from studies that had relied on drawings and prints, but it never replaced them. It was an added skill that came to be used with these older tools of representation, so that archaeology relied on several visual systems together, most of which are still in use today.

The photographs of the German excavations at Babylon are of particular interest [**1.14**], as they reveal methods of work and standing monuments discovered at the end of the nineteenth century. Archaeological photographers had to carry all their equipment and their chemicals with them as they developed the images on site.

Archaeological photography was related to travel photography in the late nineteenth and early twentieth centuries. Among the early archaeological photographers were Antoin Sevruguin, a Persian who photographed numerous ancient monuments during the Qajar dynasty in Iran [**1.15**], and Gertrude Bell, the British political

Above **1.13** Photograph by Roger Fenton of a cuneiform tablet, with annotations by William Henry Fox Talbot, 1854. Salted paper print from a glass negative

Left **1.14** Photograph by Robert Koldeway of excavations at Babylon, Iraq, 1899

administrator and writer whose extensive photographic record of Mesopotamia at the start of the twentieth century remains an invaluable resource of images [**1.16**]. John Henry Haynes, who was the first American consul to Baghdad, photographed the archaeological expedition to Nippur in 1888–90, where his images document not only ancient remains but also the immense labor of archaeology. The albums of the Ottoman sultan also included photographs of such archaeological sites as Babylon [**1.9**, see p. 23] and **Assur**.

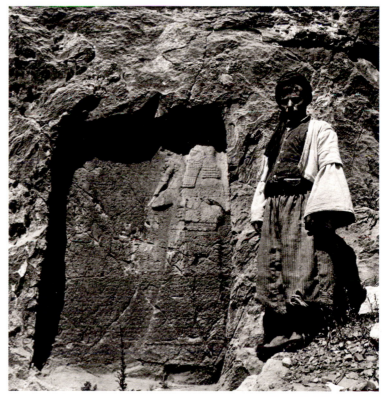

Above **1.15** Photograph by Antoin Sevruguin of the mausoleum of Cyrus the Great at Pasargadae, *c.* 1900. Gelatin silver print

Right **1.16** Photograph by Gertrude Bell of Assyrian rock relief, Judi Dagh, Turkey, *c.* 1909

The Emergence of Art:
Prehistoric Mesopotamia

The explorations in Mesopotamia in the late nineteenth century that supplied the museums of London, Paris, and Berlin with magnificent sculptures had brought to light the historical cities of Assyria and Babylonia. By the early twentieth century, however, prehistory became another major area of exploration in the study of the ancient Near East ("prehistory" refers to the time before writing was invented). As European interest here had to do with the biblical accounts that describe this area of the world as a place of mankind's origins, it became a subject of great fascination to the Western public when these beliefs were in some sense confirmed by the earliest scientific archaeological excavations in the region. As the city names that were mentioned in the Bible emerged as real places, it seemed that the Near East was the historical landscape of these ancient stories.

Architecture, Sculpture, and
Mural Painting in the Neolithic Era

In the mid-twentieth century, as archaeologists excavated a large number of prehistoric-era sites in the larger Near East, their work revealed that the Neolithic village settlements they were uncovering were indeed some of the earliest societies in the world, thus widening the search for origins that had in the previous century been focused on Mesopotamia. Furthermore, the discovery of early art in the prehistoric sites in Anatolia continues to surprise us today. With their large-scale stone carvings and early stone architectural structures, the finds from these sites are the first evidence of truly monumental works created by people from the world's very first farming communities. In the Near East, scholars studied the subsistence activities of prehistoric people and found that their daily lives and social organizations included elaborate forms of representation—paintings on walls, the making of figurines in stone and clay, and the carving of larger sculptures—as well as the increase in use of fine fired clay and painted ceramics. Already in the **Aceramic** or **Pre-Pottery Neolithic** era (*c.* 9600–7000 BCE), in the time of the first farming communities, sculptures in stone were carved and walls were painted with animals and human figures.

Forms of representation have in fact existed from as early as 40,000 BCE. The paintings and carvings discovered in caves and on rocks from this early time of the late Paleolithic era in Europe, Africa, and Indonesia are considered important steps in human cognitive development—acts of creation that are seen as forms of behaviour distinctive of *Homo sapiens sapiens*, or modern humans, our own ancestors. But by the Neolithic period we see the construction of monumental architecture for what were probably sacred spaces, accompanied by great developmental steps in the representational arts.

At the site of Göbekli Tepe in southeastern Anatolia, truly astounding large-scale works of architecture were constructed as stone circles. This was not an agricultural community—no evidence for cultivated plants was found on the site—but one of hunter-gatherers [1.17]. The massive, evenly cut, T-shaped limestone pillars are carved with sculptures of animals in such high relief that they are almost in the round. Each pillar is about 20 ft. (6 m) in height and weighs up to 12 tons. To date, about twenty such stone circles have been found in the area. Archaeologists now believe Göbekli Tepe to be the oldest religious or ritual site that has yet been discovered, and the site with the first known worked architecture and architectural sculptures.

The ancient Near East thus underwent a long cultural evolution in prehistory. Beginning with the Neolithic period, significant cultural developments formed the basis for the later civilizations that arose in this region in the historical era. The development of agriculture, the domestication of plants, and the herding of certain animals permitted people to form groups and societies with permanent settlements. Small agricultural villages that made use of pottery and visual representations arose. The transition from hunting to herding led to tremendous changes for human beings and the way they lived. For example, once three-dimensional sculptures of human and animal

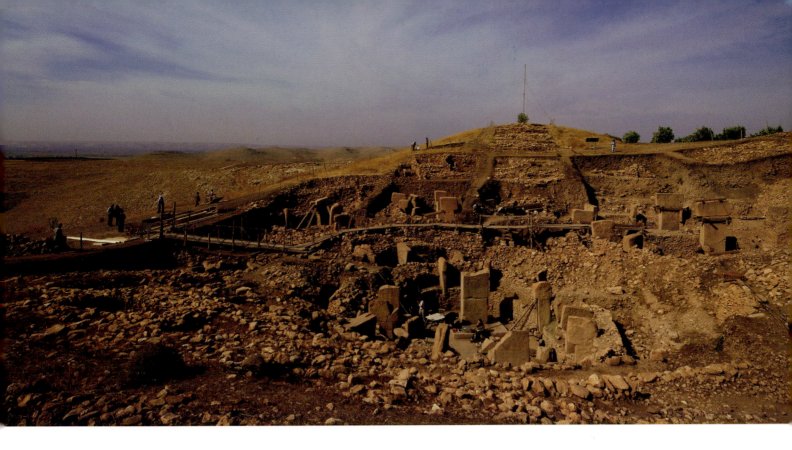

forms were made, and relief carvings that project from a two-dimensional background appeared at a large scale, they continued to increase in use in ancient settlements. Wall paintings in constructed houses came soon afterwards, and pots that were painted with figural and **abstract** designs were made by their inhabitants to use, so that art was not limited to ceremonial purposes but became a part of people's daily lives.

In the next stage of the Neolithic, after the developments of Göbekli Tepe, Çatal Hüyük is recognized by archaeologists as the most important and largest of several sites on the Anatolian plateau in Turkey [**1.18**].

Above **1.17** The sculptures and architecture of Göbekli Tepe date to the 10th–8th millennia BCE and belong to the archaeological era called Pre-Pottery Neolithic A.

1.18 The houses at Çatal Hüyük, Turkey, dating to c. 6500–5500 BCE, were unusually well preserved and produced spectacular finds.

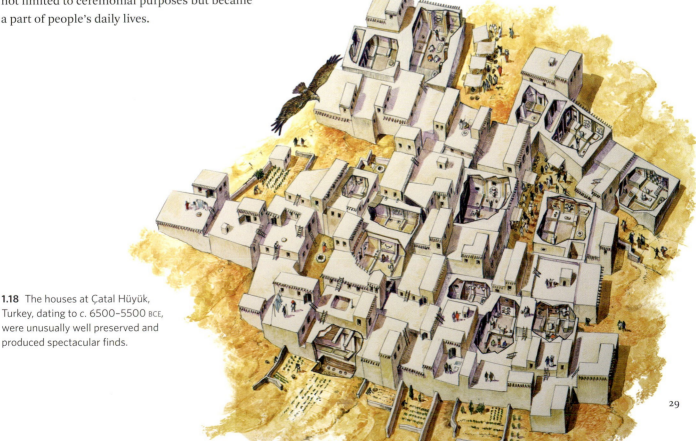

Time and Chronologies

Many cities in the Middle East are today at the top of a **tell**, or archaeological mound, formed by millennia of occupation of one site. A tell, **tepe**, or *hüyük* is thus a constant reminder, within the landscape and daily lives of people, of the great antiquity of this part of the world.

How do we apprehend the past and what are the structures of historical time? The ancient Greek philosopher Aristotle wanted to understand time by looking at entities that change. The ancient Mesopotamians understood these changes partly by means of their own landscape of archaeological mounds, the remains of ancient settlements that are formed by millennia of occupation and rebuilding [**1.19**]. In the study of ancient Mesopotamia, we rely on **absolute dates**, which we are able to get from texts or from **epigraphy**, the study of forms of writing. Absolute dates used in history are set within the artificial construct of the Christian or the Common Era (CE) and the time before it (BCE). These "common era" dates are in fact based on the Gregorian calendar, though they are usually presented as objective and universal. Most of the art and culture of ancient Mesopotamia falls under the time period we designate as BCE. Astronomy, **philology**, and archaeological data are all used for dating. For the first millennium BCE, the absolute dates that we work with are reliable, as they

are anchored on phenomena, such as a solar eclipse of June 15, 763, that can be dated with accuracy. Such dates allow us to construct an **absolute chronology**. For relative chronologies—those that are based on related events and sequences—historians rely on historical king lists and dynastic correlations, artistic styles and technologies, and on pottery chronologies compiled by archaeologists. Another method of dating used in the study of the ancient Near East measures the decay of the radioactive isotope of carbon (Carbon-14) in organic material. It is called radiocarbon dating.

In 1929 a conference was held in Leiden in the Netherlands that set the names for prehistoric and early historic eras of Mesopotamia based on ceramic chronologies. Here scholars agreed on the site names and chronological phases that went with their ceramic sequences, thus demarcating the periods of **Ubaid**, **Uruk**, and **Jemdet Nasr**. The abundant ceramic remains are therefore important tools for archaeology, as their styles, shapes, and decorations change through time and can be used for dating archaeological levels and sites. Prehistoric eras are thus named after particular archaeological sites that produced the distinctive wares.

Prehistoric dating chart

Aceramic/Pre-Pottery Neolithic era	9600–7000 BCE
Pottery Neolithic era	7000–6000 BCE
Hassuna, Samarra, Halaf, Ubaid	6000–4000 BCE

1.19 Erbil, Iraq, is one of the oldest continuously inhabited places in the world, with more than 7000 years of occupation. Rising 105 ft. (32 m) above its surroundings, the citadel walls date to the late Ottoman era and its earliest levels to the Neolithic. The name "Erbil" is first recorded in 2300 BCE.

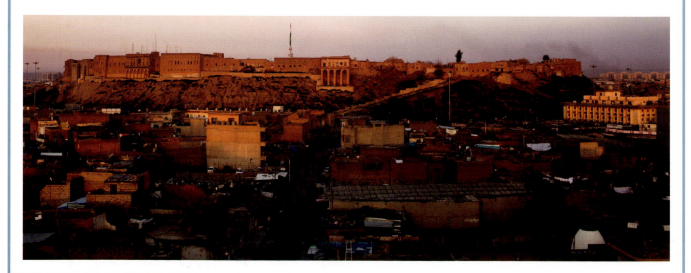

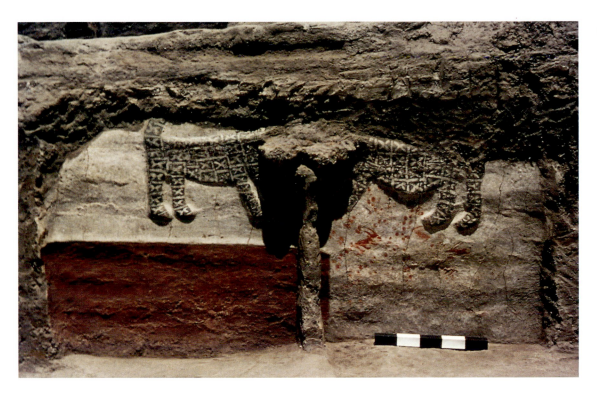

1.20 Painted relief of two leopards, from level VII at Çatal Hüyük, Turkey, 7th millennium BCE

By 7200–6000 BCE (the Pottery Neolithic era) there was a trade in volcanic stone and obsidian for tools in the region. At Çatal Hüyük, murals were painted on the walls of rooms in some buildings, and these reveal an interesting process. They were painted as representational scenes and then plastered over at some point after their use, a practice that helped to preserve them, allowing scholars to study them today. The ancient process of overlaying the painting with plaster might also indicate that they were only visible for short periods of time for the specific purposes of the ancient inhabitants. They were made using local pigments from minerals: ochre, azurite, malachite, cinnabar, manganese, and galena. These paintings include several types of scenes. There are images of male figures wearing leopard skins and carrying bows and arrows surrounding a huge red bull, perhaps participating in some hunting ritual. Other animals depicted were deer or gazelles, boars, wild asses, wolves, bears, and lions, from archaeological levels III–V, and a leopard relief from level VII [**1.20**]. Modeled relief figures and pillars with bull's heads and horns were also placed in architectural settings, and small sculptures in the round were also made [**1.21**].

One particularly important wall painting scene is a landscape mural from level VII dating to the seventh millennium BCE. It represents the area and settlement of Çatal Hüyük itself, depicted as a bird's-eye view, a fascinating image of what these earliest farming communities made of their own

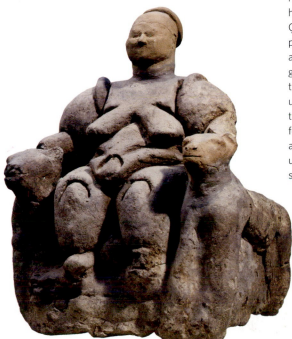

Below
1.21 Enthroned female figure flanked by lionesses (head restored), Çatal Hüyük, Turkey, 7th–5th millennium BCE. Many nude female figures have been found at Çatal Hüyük and popularly identified as mother goddesses. Although their exact uses are unclear, they seem to be associated with fertility. They may also have been used in myth and story-telling.

1.22 Stamp seal from Tepe Gawra, northwest Iraq, *c.* 4500–3500 BCE. Chlorite, h. 1¼ in. (3.16 cm)

home. The landscape is not mythical but attempts to depict a specific lived location, a setting in a terrain that is marked by a double-peaked hill. It is the first landscape known so far by archaeology.

The early mural paintings of Çatal Hüyük were uncommon works of art in the Neolithic era, as there are relatively few examples of representational art before the fourth millennium BCE. **Stylized** human figures and animals in the round were known to be made well before the Neolithic, however. Another **genre** of representational technology, the **stamp seal** [1.22], began to be used in Mesopotamia and Anatolia in the sixth millennium BCE. These small engraved worked stones, with pierced string holes to allow wearing or carrying, bore abstract designs of animals and human figures. They could be stamped onto pieces of clay to create impressions of the images.

In the area of modern-day Iraq, settlements that are less well studied appear to date to approximately the same era of the Neolithic. At Jarmo, Maghzaliya, and Umm Dabaghiayeh in northern Iraq settlements seem to date to as early as *c.* 7000 BCE. In the Pre-Pottery Neolithic era, people held burial ceremonies in which they decorated the bodies of the deceased. At Nemrik in Iraqi Kurdistan, for example, a large number of stone sculptures of birds and other animals were found, as well as a series of round buildings, dating to as early as 9000 BCE, close in time to the Anatolian sculptures from this era. These are just a few of many prehistoric settlements from Iran through to Anatolia and the Mediterranean Sea. They all have local characteristics but were places in contact with each other. At Umm Dabaghiyeh

1.23 Skull from Jericho, Palestine, Pre-Pottery Neolithic B, 8500–6000 BCE. Shell, plaster, human bone, h. 6¾ in. (17 cm)

to the west of the Tigris, a wall painting depicts onagers, animals that were hunted and traded. It is perhaps contemporaneous with some of the murals of Çatal Hüyük.

Ancestral Images in the Neolithic Era

By 6000–5500 BCE, permanent settlements became a constant feature of lower Mesopotamia in the south of what is now Iraq. These settlements produced painted pottery, decorated with patterns that can be identified and classified as belonging to specific cultures. Archaeologists use these sequences of pottery types to understand chronological changes on a site (see box: Time and Chronologies, p. 30). Thus, the conventional archaeological classification for site names and prehistoric cultures was often based on this one aspect of material culture, the ceramic wares. The way that pots were made and decorated changes over the centuries and across settlements. While baked clay vessels had existed before 6000 BCE, they now became more widespread and better made. Ceramic pots were more durable than other materials and easier to produce than stone vessels. When the potter's wheel came into use around 4500 BCE, it permitted mass-production on a larger scale.

At the sites of Jericho in Palestine and Ain Ghazal in Jordan, remarkable developments in architecture and visual representation took place during the Neolithic era. At Jericho, in the fertile Jordan Valley, people built huge walls out of stone boulders and large round towers 32 ft. (10 m) in diameter to protect them. The site of Jericho is well known especially for the way in which the

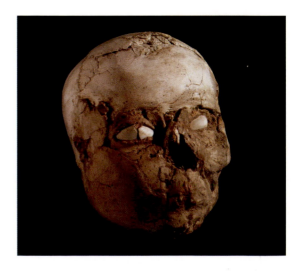

inhabitants created images of their ancestors [1.23]. They used the skulls of the dead as the core of the image. They plastered the surface, and modeled it into a sculpted form. They then inserted shells for the eyes and added red and black paint for hair and details. These Jericho skulls are remarkable because they use the remains of the dead as materials for creating their images, thereby deliberately blurring the boundaries between the image and what it represents.

At Ain Ghazal, just outside of Amman in Jordan, two caches of statues were discovered in 1983 and 1985 [1.24]. These figures were built up over an armature of reed bundles and twine, and their faces and bodies were modeled over this armature in plaster. They were then painted with green, black, and orange mineral paints to indicate hair and clothing, perhaps body paint or tattoos, and may have been dressed in clothes and wigs. Their original function is unknown, but they were later interred together in a ritual burial. These early forms of sculpture often used various materials—bone, reeds, wood, and other organic materials, and clay—that were combined to create the desired effect. While some may explain these works as a primitive, malformed stage in the development of sculpture, made before stone carving, this is untrue—we have earlier and contemporaneous figures carved completely out of stone. Instead it is more likely that the peoples of antiquity considered the materials they used to convey some meaning beyond their utilitarian function as media for representation. The combination of materials may have been a necessary part of making images function as valid forms of representation.

Nude Female Figurines

A type of clay figurine often referred to as **mother goddesses** was made in great numbers in the north of Mesopotamia. These figures are seated females with pinched clay at the top of the neck forming an abbreviated head. They have large exaggerated breasts and thighs with no detailing of lower legs or hands. Traces of paint appear on the body. Bands of black paint may represent armlets and necklaces, and paint is also used to emphasize the pubic triangle and the breasts. These nude females are referred to as Halaf figurines [1.25]; they are named after a site where they were found in abundance.

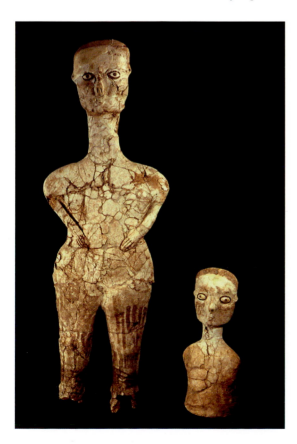

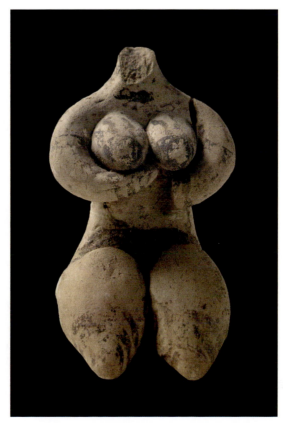

Far left
1.24 Statues, from Ain Ghazal, Jordan, 6750–6250 BCE. Reed and plaster, tallest statue is 3 ft. 5⅜ in. (1.05 m) high

Left
1.25 Halaf figurine, from Chagar Bazar, Syria, c. 5000 BCE. Fired clay, painted, h. 3 in. (7.5 cm)

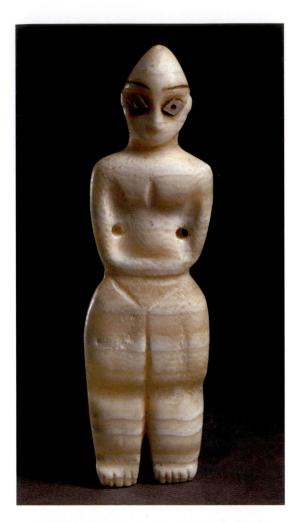

Right and below
1.26, 1.27 Female figure and jar, from Tell es Sawwan, Iraq, *c.* 6300 BCE. Alabaster, figure: h. 5¾ in. (14.5 cm); jar: h. 2½ in. (6.4 cm)

At Tell es Sawwan in central Iraq, more than a hundred graves belonging to the Samarra period (*c.* 6300 BCE) were found below the earliest buildings. Many of them were children's graves containing beads and female figures in alabaster [**1.26**] as well as finely made vessels of alabaster and other stones [**1.27**]. Some of the statuettes have eyes inlaid with bitumen and shell; all of them are highly abstracted figures with angular treatment of parts of the body, which are delineated with emphatic lines cut into the stone. Placing nude statues with the bodies of the deceased was an important part of burial rituals in the prehistoric era, but nude females are found in other contexts also [**1.28**]. Scholars have suggested explanations ranging from goddess figurines to images for instruction, but their function is not yet entirely understood.

By the Ubaid period (5000–3800 BCE), **terra-cotta** figures, representing nude men and women, were placed in burials [**1.29**]. The figures are slim in proportion and shown with painted or applied body decoration. The female form is emphasized by diagonal incised lines to indicate the pubic triangle and painted breasts. At times, they are also shown carrying suckling infants. The male counterparts are also shown nude.

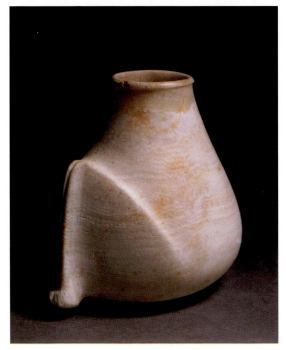

Below **1.28** Figurine, from the Burnt House, Arpachiyah, Iraq, 6000–5000 BCE. Gray limestone, h. 1½ in. (3.9 cm)

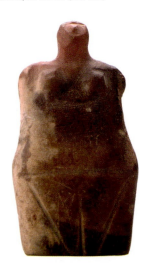

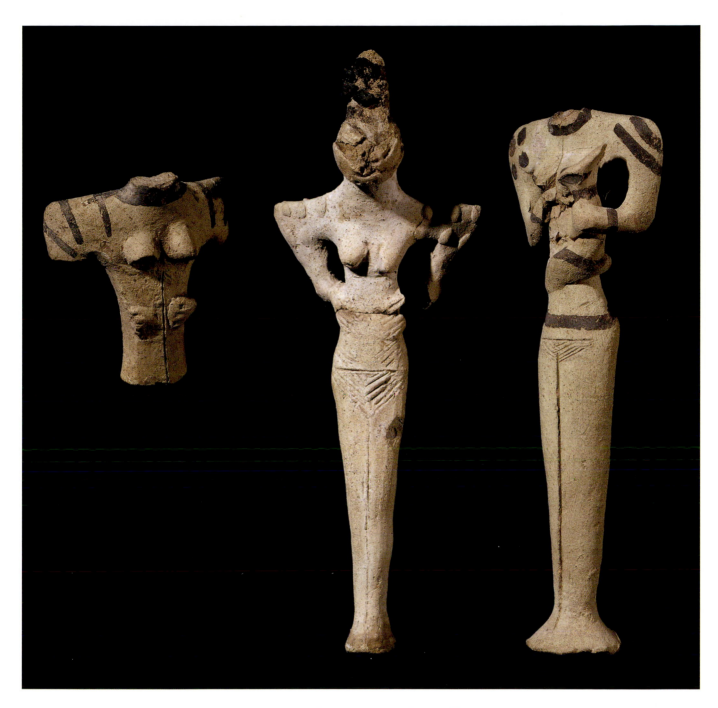

The heads of the figures are elongated and their eyes are indicated as long and linear or coffee-bean shaped. They appear to wear a tall conical hairstyle or headdress. These types of figures have been found with bodies in graves at Eridu and at Ur, in the south of Iraq, and are usually included with pottery and some jewelry.

Ancient Myths of Origins: Eridu

In the Mesopotamia of the historical era, the beginnings of art and architecture and the invention of the technologies of making were credited to the clever god known as **Enki** in **Sumerian** or **Ea** in **Akkadian**. Thus the Mesopotamians themselves had already begun to search for an explanation of the origins of the world. Interest in origins has always existed, and

1.29 Ubaid-era hand-modeled female figurines, from Ur, Iraq, 4500 BCE. Fired clay, painted and incised, h. c. 5 ½ in. (14 cm)

the Mesopotamians were no different from later peoples. As one of the first highly literate cultures of the world, they came up with their own myths of origins and creation of how the world came into being. A Babylonian myth regarding the world's origins explains that the first place to be created by the gods was Eridu. As this excerpt reveals, there was only primordial water before the gods made Eridu:

> A holy house, a house of the gods in a holy place had not been made, reed had not come forth, a tree had not been created,
>
> A brick had not been laid, a brick mould had not been built,
>
> A city had not been made, a living creature had not been placed (within)
>
> All the lands were sea.
>
> The spring in the sea was a water pipe.
>
> Then Eridu was made.

In other words, there was no civilized life before Eridu.

Eridu was the city sacred to Enki, the god of water, wisdom, and craftsmanship. His temple was called the E-Abzu, the house of the Abzu

waters from which life emerged. The site of Eridu is now known to be Tell abu Shahrein in the marshes in the far south of Iraq, where there are still islands of reed huts surrounded by water and dense reed thickets, and where the Ma'dan, the so-called marsh Arabs, still travel by a type of boat used in antiquity. The boats, called *tarada*s, are steered with long poles, like a punt. The people live in reed houses still constructed in the same way as the reed houses of the Sumerian past [**1.30**].

Eridu was excavated in the mid-twentieth century by Iraqi and British archaeologists. They revealed eighteen levels of occupation. The temple they excavated from 1946 to 1949 seemed to go back to the earliest levels (*c.* 5300 BCE), with the original structure rebuilt and enlarged through the millennia [**1.31**].

This earliest Eridu temple began as a small square brick structure, ten-foot square. It had at least two of the principal elements of later temples: a central room with an altar at one end, and a small offering stand in the middle of the room that had traces of burning on it. With time, temples became more complex, with entire administrations attached to the households of the gods. They also developed to include giant stepped towers: these are the famous ziggurats

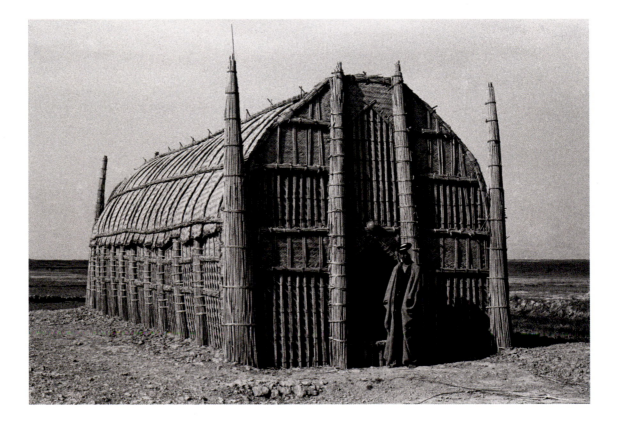

1.30 Marsh Arab reed house, Iraq, photographed in 1956

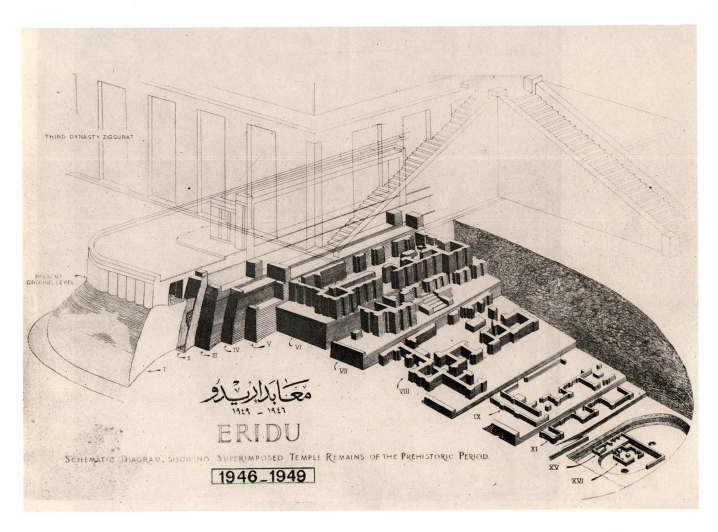

THIRD DYNASTY ZIGGURAT

PRESENT GROUND LEVEL

معابد اريدو

ERIDU

SCHEMATIC DIAGRAM, SHOWING SUPERIMPOSED TEMPLE REMAINS OF THE PREHISTORIC PERIOD.

1946—1949

of Mesopotamia. In Eridu, every generation of rebuilding was placed upon an older structure, so that a raised platform arose that held within it the earlier manifestations of the temple. The tripartite plan that can be seen in level XI–VI consisted of a central room—the **naos**, or *cella*—with an altar and a place for a **cult statue** of a god on one end.

The interest in Mesopotamia as the cradle of civilization was at first part of a European story based on myth and biblical history. With the advent of scientific archaeology, exploration began in the area, and what was revealed seemed to provide striking confirmation of these ideas, as some of the world's oldest settlements were uncovered. The Mesopotamians also had their own stories of origins; they believed that they were living at the origins of the world, where primordial waters became land and people

were created by the gods. The place of art and architecture in this story is important because the developmental stages from hunter-gatherers to agricultural communities to complex cities can be marked also in terms of great changes in the built environment and in forms of representation. These technologies changed the way that people related to their world. In the fourth millennium BCE, with the first cities and the invention of writing, visual art became far more widespread. In addition to techniques of manufacture and the quantity of images being produced, there was an increased complexity in visual content, in narrative representation, and in symbols of abstract ideas, such as cycles of nature and the realm of the divine. It is here, therefore, where we see the first steps toward the major art forms and techniques that we know from later eras, and to which we will turn in the next chapter.

1.31 Eridu temple drawing, 1949. This plan depicts the succession of temple plans, constructed on the same site in Eridu, Iraq, from the early Ubaid to the late Uruk period. At the top, the drawing indicates that King Ur-Namma also built a ziggurat here in 2100 BCE. The sequence, with its origin in the earliest small temple at level XVI, is evidence of millennia of continuity in the same sacred space, a process that resulted in a raised temple platform.

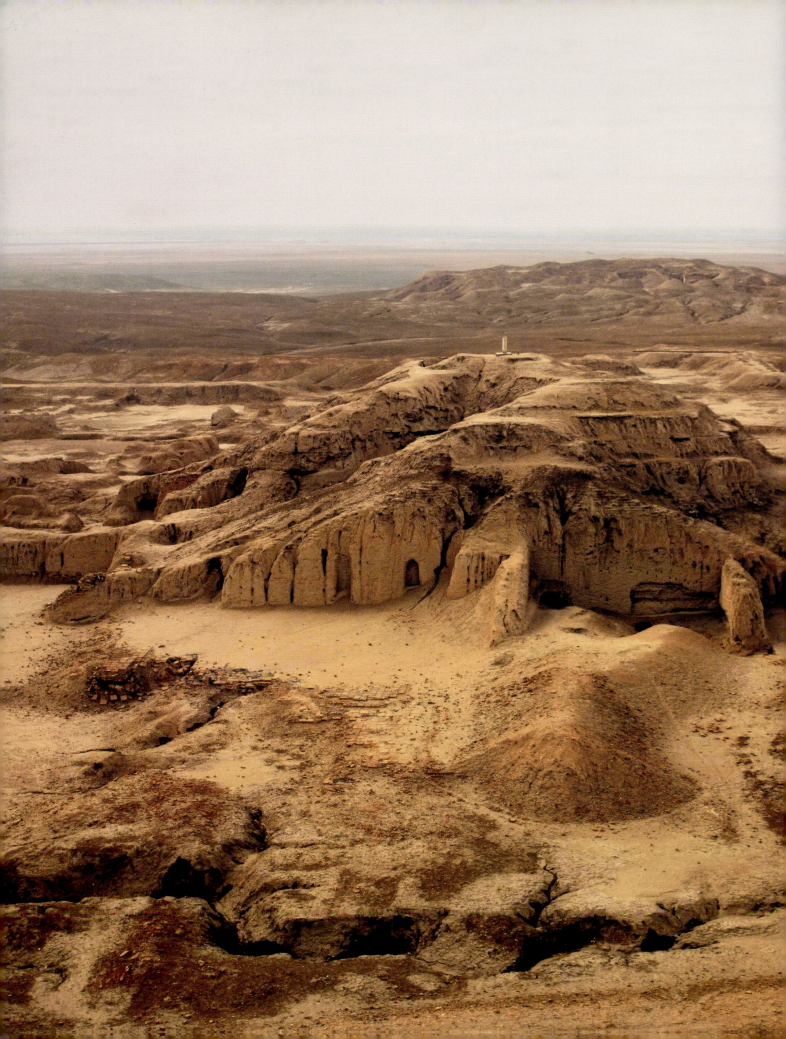

CHAPTER TWO

Uruk: The Arts of Civilization

Remains of ziggurat and Eanna precinct at Uruk, Iraq,
a site spanning from 4000 BCE to the 3rd century CE

2 Uruk: The Arts of Civilization 4200–3000 BCE

Major center	Uruk
Notable facts and events	First cities/urban centers, including: Uruk, Eridu, Susa, Tell Brak
	First system of writing is invented, 3400 BCE
Important artworks	The Uruk Vase, *c.* 3300 BCE
	Head of a composite statue, probably Inanna, 3300 BCE
	Priest-king statues, 3300 BCE
Technical or stylistic developments in art	Cult statues and votive images begin to be made from precious materials
	Visual narratives appear in art for the first time, e.g. The Uruk Vase
	Commemorative relief sculpture appears for the first time
	The performative image is invented
	First use of cylinder seals

2 Uruk: The Arts of Civilization

When **Alexander the Great** entered Babylon in triumph on October 21, 331 BCE, having defeated the Persian king **Darius III** and conquered all of Mesopotamia, what did he see? What did his Greek and Macedonian armies encounter upon their arrival in this ancient land that was different from what they had seen and known in Greece? They found a vast urban terrain, far larger than any city they had seen before in the scale of public buildings and number of standing monuments, rising out of an ancient landscape immersed in history. This landscape and its monuments so impressed the Hellenistic-era Greeks that rather than instigating changes or simply destroying its monuments, as one might expect in warfare and imperial conquest, they adapted to it, took on many of its native traditions, honored its ancient gods, and preserved its religious **sanctuaries** (temple precincts).

One of the cities that was of the greatest importance in the Hellenistic East at the time of Alexander and his followers, the **Seleucid** kings of Mesopotamia, was Uruk. Far from being a new urban development in an empty conquered terrain, Uruk was in fact close to four thousand years old by the time the Greeks arrived in Mesopotamia, and the great antiquity of this city was already known to the ancients, albeit in less scientifically accurate forms of knowledge than our own. Nevertheless, they were overawed. They maintained the ancient temples and cults that were still present and active, and renovated, rebuilt, and repaired architecture in other parts of the site that were no longer in use. They also built new Hellenized Babylonian **monumental** structures, continuing the architectural innovations of the already ancient city of Uruk

into the Seleucid era and thus becoming active participants in its historical development. Uruk, the ancient name of the city, became Orcha in Greek, as mentioned by the Roman scholar Pliny in his *Natural History* (VI.xxvii.31), and that name survived in the Arabic name of the place, Warka, a name that is still in use today.

Indeed, the city of Uruk in the fourth millennium BCE marks the fact that a vital and influential civilization had emerged in what is now southern Iraq, a region also known as Babylonia. It was in this land, which would be called Sumer in the language of the first written texts, that many archaeologists believe the earliest complex society known to us arose, by then already possessing many of the cultural phenomena that we associate with an advanced civilization, a society centered in this city. Uruk, therefore, has a strong claim to being the world's first city, and many historians have described it as such. The elements of social development in fourth-millennium Uruk that led historians and archaeologists to refer to it as the world's first city are primarily structural. They include a stratified (layered) social structure with a leader at the head of the community, the clear existence of institutionalized religion, and economic administration controlled by centralized authorities, but perhaps most importantly the invention of the first system of writing, a cultural advance with absolutely no precedent elsewhere in the world. Along with these socio-cultural advances, we also find the development of the **genres** of images, artworks, and buildings that art historians would place under the category of high art and architecture. Here at Uruk, pre-planned architecture was designed and built to an unprecedented extent and on a massive scale. At the same time we find here the beginnings

of genres of art that were to form the basis of ancient Near Eastern art, aesthetically refined craftsmanship, and image-making through the following millennia.

It may be that the word "art" as we use it today in the English language is not quite accurate for thinking about and describing this early rise of the aesthetic impulse and the making of aesthetically formed objects; the people of antiquity used categories of things in the world that do not always fit with what we might expect. The ancient **Sumerians** believed that the **ME**, a Sumerian word usually translated as "the arts of civilization," encompassed aspects of society and civilized behaviour that included technologies of making fine objects and aesthetically refined things, though they are not exactly "fine arts" as we understand that category today. The ME is better described as the essence of objects and beings, such as a series of **demiurgic** energies that empower their ability to be and to act. The ME is mentioned in the Sumerian texts from Fara in *c.* 2600 BCE, and appears in the literature of the following centuries. The list of 110 ME consisted of such tangible material aspects of the arts that we would recognize as falling under that category today, for example: musical instruments, scribal arts, architecture, woodcarving, the art of the metalsmith, and sculpture; but they also included categories of office, for example kingship or priesthood; such activities as lovemaking; and abstract concepts, including justice, intelligence, and peace on the one hand; and such activities as warfare and prostitution on the other. All of these aspects (good or bad) belonged to the life of the city. Our own idea of civilization also comes from the Latin word *civitas*, meaning city. One of the most important developments at this time was the creation of the city as a tangible entity by means of an ordering of space through architectural design.

Architecture

In ancient Babylonia (southern Iraq) at this time, a spectacular architectural imagining of the landscape emerged. It involved a manner of envisioning space in an entirely new way, as a terrain that could be **articulated** and made to signify. The architects of Uruk choreographed space and buildings into an urban zone, and thus

2.1 The Riemchen Building, as the German excavators called it, Uruk, Iraq. This structure dates to the late Uruk IV phase, *c.* 3200 BCE. It was constructed over an earlier level V stone temple, thus revealing continuity of sacred spaces already in the 4th millennium BCE.

2.2 Kullaba and Eanna are the two main sanctuaries of the Uruk period. The huge buildings, Bit Resh in the area of the Anu Ziggurat, and Irigal, to the south of it, were built by the Greek Seleucid kings between 331–329 BCE. Even later remains, dating to the Parthian era, are also found across the site. They include a temple of the god Mithras (Mithreum), house of the New Year (Bit Akitu), and temple of the Parthian god Gareus. The ancient site of Uruk covered about 1360 acres (550 hectares) and in the 3rd millennium BCE had a tall circuit wall about 5.9 miles (9.5 km) long. According to the most recent archaeological survey, Uruk was still an important site as late as the 7th century CE.

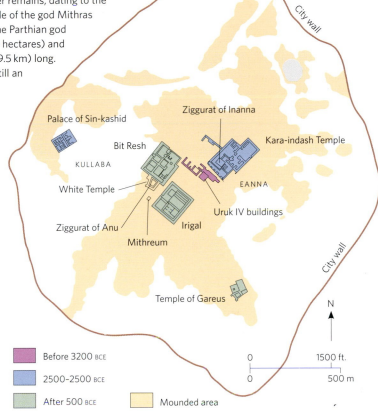

created a new relationship between people and architectural landscape [**2.1**]. The city of Uruk, with its conception of a built environment, was nothing like the earlier settlements in either scale or concept. Of course, Göbekli Tepe and Çatal Hüyük in the Anatolian Neolithic (*c*. 9600–6000 BCE) had already set apart constructions and spaces as areas of specialized activity or sacred ritual, and at ancient Eridu in southern Mesopotamia we can already see the rise of the monumental temple and the sacral space of rituals that accompany this architecture (see chapter 1). But what we find at Uruk is a far more comprehensive vision of the environment as something that can be ordered and articulated into a composition to be played out on a far grander scale than anything that had preceded it. Archaeology, with its interests in the rise of the state, has focused to a great extent on socio-economic concerns and political organization, yet the remarkable rational planning of spaces and surfaces are nothing less than a new spatial order based on exact and measured perspectival logic.

In the fourth millennium BCE, there were two main sanctuaries in the center of Uruk, called Kullaba and Eanna [**2.2**]. They were the sanctuaries of **Anu**, the Sumerian sky god, and of **Inanna**, the goddess of love. By this time (*c*. 3300 BCE) the city of Uruk was already about 500 acres (200 ha) in size, comprising living quarters, public buildings, and temples. Below the late fourth-millennium sanctuaries, archaeologists uncovered a sequence of temples going back to the Ubaid era (fifth millennium BCE). But in the levels of construction dating to the Uruk archaeological

phase (see chapter 1, box: Time and Chronologies, p. 30), architectural design at an extensive scale, with painted walls and mosaic decoration, began to be used for collective ceremonial functions and became representations of the power of the city at the same time. The clearest difference from the Ubaid-era buildings, or the earlier Neolithic settlements, is in the extent and scale of the constructions, but the most significant change was in fact the development of architectural design as a way to map out and differentiate urban space (see the discussion of Anu and Eanna precincts below).

One of the most remarkable architectural innovations at this stage is the use of new technologies of building. Brick architecture continued to be made, but now large-scale stone buildings were also constructed using a locally quarried limestone. The Uruk architects and engineers also developed and used an early form

of mold-cast concrete for load-bearing walls. These materials of construction were concealed within an outer layer of gypsum plaster, differentiating between the work of the building's load-bearing walls and their striking external appearance in much the same way that the Romans would later use structural concrete faced with brick and marble. This carefully considered relationship between the structural work of the building, external appearance, and designs that are visually pleasing makes it clear that architectural planning and design were already fully developed in the fourth millennium, and these buildings, laid out in well-defined spaces, are a sure indication that the ancients had already begun to envision space as an abstract concept and to use that concept in concrete ways.

2.3 The White Temple, rising above the Anu Ziggurat, Kullaba, Uruk, Iraq, *c.* 3300 BCE, is an early example of an elevated temple. It was seen as a house of a god where the cult statue resided.

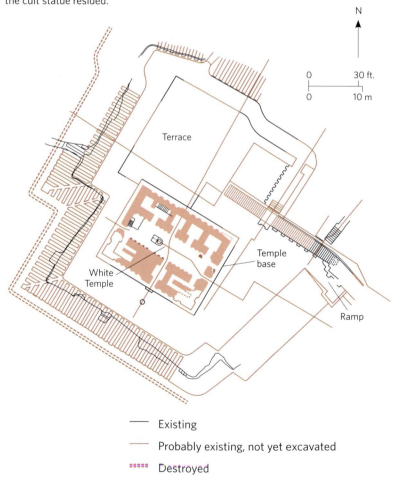

N

0 30 ft.
0 10 m

Terrace

Temple base

White Temple

Ramp

——— Existing

——— Probably existing, not yet excavated

▪▪▪▪▪ Destroyed

Anu Precinct

The Anu precinct at the sacred mound known as Kullaba is located at the western and highest part of the site of Uruk. An artificial raised terrace, called the Anu **Ziggurat** [**2.3**] by its excavators, stood here. The surface of this massive (43 ft. (13 m) high) brick platform was decorated with vertical applied **piers**. It was created by the accretion and reuse of the site of earlier temples upon which newer ones were rebuilt, and this monumental ziggurat must have been a striking sight, visible for miles around, rising from the flat terrain of southern Mesopotamia at a time when large-scale monuments were still rare and unusual structures.

The White Temple stood on the southwest side of this precinct. Dedicated to the god Anu, it measured 57 × 73 ft. (17.5 × 22.3 m) and had floors and walls plastered with a coating of white gypsum. One approached it by means of a monumental stairway and a ramp that led up the side of the sloping Anu Ziggurat platform. Upon reaching the terraced top of the platform, one saw a great arena, open to the sky, which revealed to the worshiper an impressive view: a large and open vista of the city and the plain below. From this court, one turned left before reaching the entrance of the temple itself, enclosed in its massive walls. One could not walk directly into the temple; the stages of entering the sacred spaces were accentuated by architectural zones that controlled entry. Even the experience of climbing upward by means of a monumental stairway was an elemental part of the ritual of approaching the divine: a stairway to heaven. The high open court with vistas of the city and the landscape formed an area for ritualized performance as well as a sacred transition from this exterior zone, open to the sky, before entering the building of the White Temple of Anu. From this moment on, the inclusion of an open court as a transitional zone into the inner sanctum of a temple becomes standard in religious architecture.

The White Temple, raised high above the surrounding plain, had a tripartite plan with a main cella (inner area) and subsidiary rooms in a symmetrical arrangement, and an exterior

with niched walls and grooved **buttresses** where wooden poles had originally been placed. While such poles were necessary for bolstering the wall to begin with, these kinds of structural elements came to be used for decorative purposes to articulate the facade, using the wooden vertical lines to break it up rhythmically. Inside the White Temple, the innermost holy space, the cella, or naos, as it came to be called in the later Greek tradition, was the space of religious mystery where one encountered the **epiphany** (manifestation) of the divine in the image of the cult statue. In this interior enclosed chamber, separated from the profane world, one could, temporarily at least, pass into the sacred zone of the gods and speak to their statues. The Anu sanctuary was enlarged and renewed through ten successive phases of occupation going back to the Ubaid period, *c.* 4000 BCE. It seems to have been deserted

finally by the Uruk III phase (*c.* 3000–2900 BCE), while the nearby Eanna precinct was still in use. The structural aspects of its construction and supports merged into an architectural aesthetic, into a design, as we can see in the Eanna.

Eanna Precinct

Eanna, meaning "the house of heaven" in Sumerian, was the estate of Inanna, the most important goddess in early Mesopotamian history. She was the goddess of love and sexuality, but not a **mother goddess** or a goddess of marriage. Her other attributes, which become more fully developed in her later Akkadian aspect as Ishtar (see p. 101), were also those of a goddess of power and of war. Her Eanna sanctuary was about 1600 ft. (500 m) to the east of the platform that held the White Temple [**2.4**]. The layout of the Eanna precinct in level IV (*c.* 3300–3100 BCE) included

2.4 The Eanna precinct (*c.* 3600–3200 BCE) consisted of a series of monumental buildings related to the cult of the goddess Inanna-Ishtar. Later buildings were often superimposed over earlier ones.

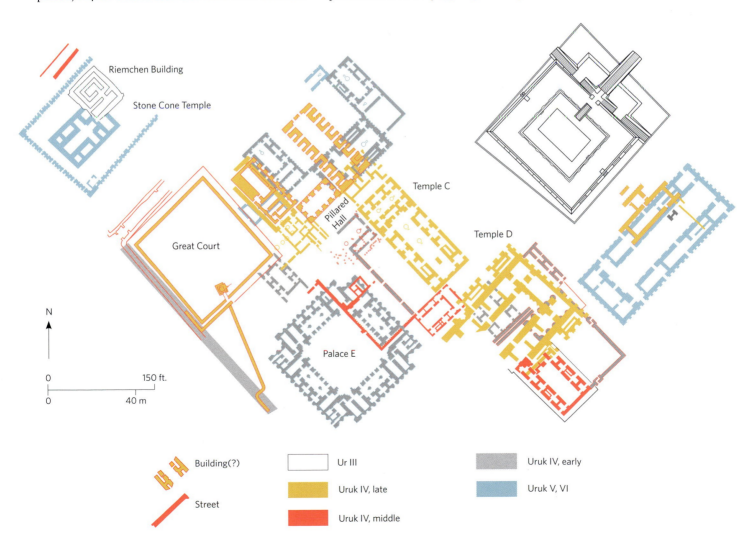

Riemchen Building
Stone Cone Temple
Temple C
Pillared Hall
Temple D
Great Court
Palace E

N

0 150 ft.
0 40 m

Building(?)
Street
Ur III
Uruk IV, late
Uruk IV, middle
Uruk IV, early
Uruk V, VI

an array of spectacular buildings constructed on a grand scale. It was an area of massive buildings, courtyards, and terraces, which continued to be reused when later Babylonian and Assyrian kings were to renovate and rebuild temples here in the centuries to come, and to record these renovations in their historical annals.

To the west of the group of monumental edifices that compose the Eanna stood a large building that the early archaeologists called the Pillared Hall. The building stood out because its brick columns and walls were entirely covered with a multicolored mosaic of geometric patterns made by cones inserted into the walls. A gigantic **portico** 100ft. (30 m) wide, with a double row of freestanding columns each measuring 6 ft. 6 in. (2 m) in diameter, and with half columns on either side, stood on a terraced slant. This large and highly decorated portico building gave access to a complex that contained a number of other buildings, including Temples C and D, the Mosaic Court, and a large square building. To one side of the Pillared Hall was a large court, open to the sky. Temples C and D both had longitudinal central axis plans with **transepts** on one end, similar to the central **nave** of a Christian **basilica**, and surrounding subsidiary rooms.

The entire Eanna was a well laid out sanctuary in which space was conceived as a series of separate sanctified areas, for which the Pillared Hall acted as a monumental gateway building. It permitted the controlled, reverential experience of crossing into a sacred zone, and differentiated this space at the same time. It thus had a similar function to later monumental gateway buildings, perhaps the most famous of which being the Propylaea to the Akropolis in Athens, built in the fifth century BCE. The transition into increasingly sacred spaces that was effected by means of climbing a stairway and rising above the plain in the Anu precinct is here made possible by architectural zones or transitions.

These Eanna temple buildings of the late fourth millennium BCE stood on top of the ruins of nineteen earlier building levels, spanning the fifth and fourth millennia. In addition, second-millennium and later constructions were found here. This was the oldest continuously inhabited or utilized part of the city of Uruk. The highly sophisticated techniques and designs of architecture and urban planning are innovations that—along with the invention of writing and the development of complex administration, economic control, and institutionalized forms of religious practices—we should count as indicative of the turning point that archaeologists and historians call the Uruk phenomenon.

Sculpture

As architectural design and abstract conceptions of space developed into new forms and a new understanding of a built environment, other means of representation changed and grew exponentially in the fourth millennium as well. In the realm of the visual arts, finely carved monumental sculptures emerged that reveal a high standard of technical skill and a new comprehension of both representational processes and monumentality. Cult statues representing the gods and **votive** figures of people and animals (i.e., that were offered to the gods) began to be made from precious materials imported from as far east as the Indus Valley and as far west as Egypt. But what is also fascinating is that the representational arts began to make use of visual narratives for the first time, as can be seen in the monumental alabaster vase carved in relief, known as the Uruk vase.

The Uruk Vase: Narrative and Performative Images
Narrative images are not always a linear narrative of sequential time as we encounter them in the later history of art. Another type of image is the **performative** image, and that too was invented at this time. In a performative narrative, the image represents an event or action, but it also magically produces the expected result by means of its representation. The Uruk Vase [**2.5**], a carved alabaster vessel over 3 ft. (1 m) in height, represents the cycle of life and a ritual of the goddess Inanna, who is clearly identified by a pair of **ring-post standards** shown at the top of the vase. Beginning in the lowest register, we see

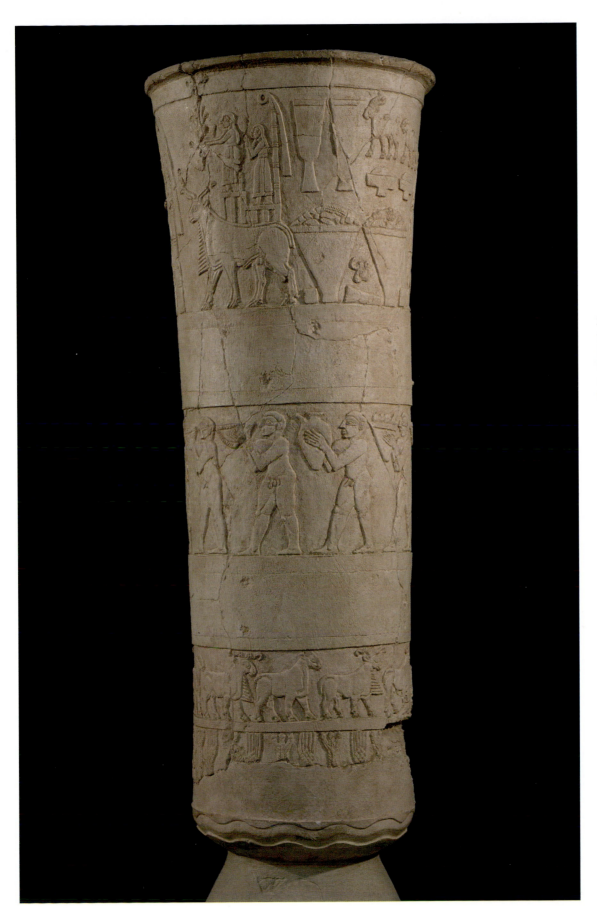

2.5 The Uruk Vase,
from Eanna, Uruk,
Iraq, *c.* 3300 BCE.
Carved alabaster,
more than 3 ft.
(1 m) high

water, above which are rows of ears of barley, male and female goats and sheep—the basis of agricultural life. Above the single file of animals is a row of striding nude males bearing offerings, all of whom look exactly alike except for the varying shapes of the baskets and vessels of abundant produce that they carry. In the top register is the goddess herself, standing at the entrance of her temple. She is about to receive the offerings that are brought to her from lower registers, where the procession of men and animals, plants and water circle the body of the vase in an eternal cycle of the mythic and repetitive time of the festival. In the space before the goddess stands an ornately dressed male figure facing her, accompanied by a long-haired attendant carrying the train of his garment or a textile offering of some kind. A clear identification is difficult because of an ancient break in the vase. Behind the goddess we see the interior space of the temple storehouse, with baskets of offerings, statues of animals, and two small figures of people on pedestals indicating statues. The male holds a stack of bowls the outline of which forms the sign for the title "lord," **EN** in Sumerian, in the newly developed script of the time. The name of the goddess Inanna is also indicated by the reed gateposts before which she stands. This pair of reed poles with a ringed or looped top and streamer is the basis of the writing of Inanna's name in the early cuneiform script. Such reed bundles were used to construct buildings in the Sumerian era, a technique that continues to be used in the marshlands of southern Iraq (see p. 36), and are thus a basic element in architectural construction in southern Mesopotamia. The sign for the Sumerian ME (arts) can also be read in the vessels in the storehouse. We thus have here the earliest known example of a work of visual art that integrates written signs; it is also one of the first works to represent a religious ritual in a fully narrative form.

The upper register of the vase was already damaged and repaired in antiquity in the area above the head of the goddess, where dowel holes and pins can be seen still in place—so the vase must already have been quite old before it was buried in a deposit of cult objects in Eanna around 3000 BCE. It is impossible to determine whether the images in the top register represent Inanna and her divine lover Dummuzi, or a high priestess of Inanna and the ruler engaged in a yearly sacred marriage play as part of a ritual. Rather than being a difficulty or an error in the clarity of the representation, this kind of indeterminate identity was essential for performative rituals and for performative images to be effective in the cult. It was exactly this **liminal** (transitional and ambiguous) zone of representation that was required for the efficacy of sacred images. The blurring of boundaries between gods and their representatives, between images and the divine realm, is a theme that we will continue to encounter in the arts of the ancient Near East.

In art historical terms, visual images that refer to mytho-historical events or rituals are a new conception of narration by means of image; they were to have a significant impact on the world of the representational arts in general for millennia to come. The earliest of these sculpted narrative works also come from the city of Uruk and date to the second half of the fourth millennium BCE, as we shall see in the cult statue and votive offerings described below. Another aspect of these early sculptures that we must recognize is the immense importance they carried in defining the basic qualities and essences of things in the world. The oversize stone vase we have discussed here is a monumentalization of an everyday vessel into a sacred and eternal form. It is literally the material transfiguration of the commonplace into the sacred, and we see this conception of sculpture in other works of art at Uruk at this time.

Cult Statues: Imagining the Invisible

The marble head of a **composite statue** of a woman, probably the goddess Inanna, was found in the sacred precinct of Eanna where her temple stood in Uruk [2.6]. The eyes and eyebrows were originally **inlaid** with shell and precious stones, most likely lapis lazuli or another dark stone set in bitumen, while the body was probably made out of wood and other materials, and dressed in linens and fine jewelry. Perforations at the top and sides of the head in the area of the ears were used for

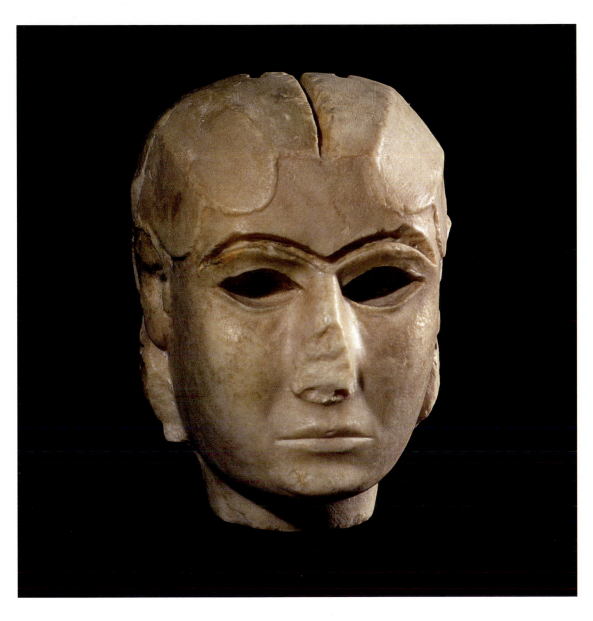

2.6 Head of a composite statue of a woman, probably the goddess Inanna, from Eanna, Uruk, Iraq, 3300 BCE. Marble, h. 8 in. (20.3 cm)

the insertion of earrings and what may have been a horned crown above the ears, to indicate her divinity. The waves of sculpted hair were originally overlain with metal, perhaps **chased** gold (a technique of the goldsmith's work still in use today), to indicate locks of hair or another form of hairstyle. The head, which is flattened on the back, was likely attached with bitumen to another material that formed the back of the hairstyle.

This finely chiseled alabaster head reveals the sculptor's interest in naturalistic modeling in the area of the softly carved lips and rounded cheeks, combining this with the large almond-shaped eyes that, when inlaid, must have created a stunning effect of a frontal gaze, a powerful resolute stare that held the attention of the viewer. Besides the complex combination of materials brought together to create what must have been a lifesize statue, what we have here is a moment of the concretization of the divine into a material image. The invisible divinity is made manifest in the cult statue of the goddess, where the goddess appears as her own image in her earthly home, the Eanna. This kind of image may be naturalistic in its carving style and modeling of the outlines of the face, but it does not show a desire to represent the world in a naturalistically accurate way. It is not "realism" as we usually think of it

in modern art historical terms, where realism signifies the representation of realistic details in our visual environment. Instead, making a statue of a divinity is a way to imagine the invisible, and to permit the divine to become a material and tangible form before us, to enter our world of materiality. Thus we can see that from the very earliest time in Mesopotamia, art forms were concerned more with the imaginative and the abstract made material than with imitating what they saw in the world.

Votive Offerings: The Essence of Beings and Things

Sculptures of animals that followed the forms of nature were also carved, alongside more abstract images. This coexistence of naturalistic modeling and abstract style was a matter of choice and function, not a result of an inability to imitate nature, as we shall see. Many of the small figurines of animals functioned as votive offerings, in which the essence or being of the animal was embodied in a stone statue and the ritual gesture of the offering itself was given material form. A fine example of this genre of votive is a marble bull with silver legs and an original **inlay** of dark stone to indicate patches of fur [**2.7**]. This small sculpture is exquisitely carved in a naturalistic technique, with careful attention

given to such details as the folds of skin where the neck twists to one side, and the soft modeling of the snout. Perforations for the inlay of eyes, horns, and tail indicate that the entire figurine was composed of a mixture of precious and finely wrought materials, each of them clearly requiring expert skill in manufacture, in casting metal and carving stone according to new methods and technologies.

Another Uruk-era bull with perforations for attachments is carved in an abstract style in gray limestone, with emphatic linear incisions to indicate the separation of parts of the body, such as the rear haunches, and with regularized geometric treatment of the area around the eyes and snout [**2.8**]. Though the body of this bull is carved in a far less realistic way than the contemporaneous composite bull with the silver legs, a perforation at the mouth implies an attribution of lifelike qualities. This lifelike quality was not achieved by means of naturalistic or realistic carving, nor simply by means of an attachment in another colored stone or metal to indicate the tongue of the animal, but in the fact that the mouth was opened, imbuing the stone animal with the spirit of life—an attitude and approach to images we shall see fully developed in the centuries to come.

Below
2.7 Bull figurine, Uruk, Iraq, c. 3300 BCE. Marble, silver, and stone inlay

Below right
2.8 Bull figurine, provenance unknown, c. 3200 BCE. Gray limestone, h. 5⅛ in. (13 cm)

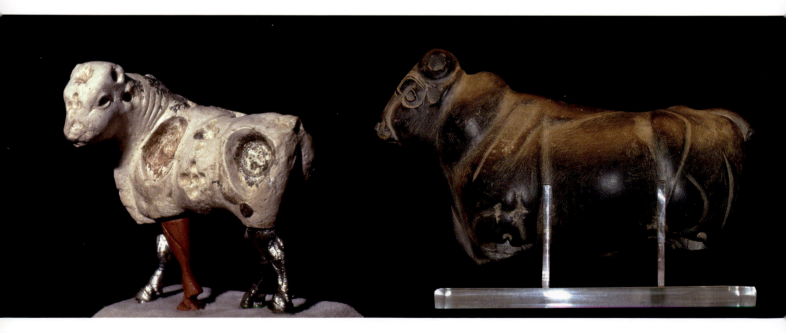

A group of objects called the **Kleinfunde** ("small finds") by the excavators was found buried in Uruk level III of the Eanna [**2.9**]. The deposit included a number of stone inlaid animals and sculpted ritual vessels that were no longer in use in the temple, but rather than being carelessly discarded, they were carefully buried in sacred ground. The deposit provides us with a rare collection of votive statues dating to the late fourth millennium BCE. The small animals are particularly remarkable in that we have here a transfiguration of the votive offering of a real animal for sacrifice into the eternalized form of a gift for all time. The gesture of the sacrificial offer itself therefore becomes eternal, embodied in the votive animal and placed before the statue of the goddess as a continuous and pious act. When a temple was rebuilt, or when the donor of the votive was no longer alive or known, such votive statues could not be discarded. Instead, they had to be collected together and placed into a sacred space, ritually buried within the sacred confines of the temple precinct.

Public Monument: The Spur of Rock in the City

The monument known as the Lion Hunt **stele** is a pictorial relief carved onto a large piece of basalt found in the Eanna sanctuary and dates to *c.* 3200 BCE [**2.10**]. The stone is roughly hewn,

without any attempt to smooth the surrounding edges. We can see it as a spur of living rock brought into the city, a rocky object that has been carved with a pictorial representation. The stele's edges were not smoothed into a standard geometric shape but left to look like an object from the natural environment. Only one surface has been smoothed, polished, and cut with a relief scene that represents a man hunting a lion, presented in a free-form composition. The same male figure appears twice on the relief, in the upper part of the stele at a smaller scale, and below at a somewhat larger scale. He wears a long kilt with a vertical fold at the center held by a wide belt, and seems to have a bare torso and feet. He has long hair pulled back into a twisted knot or chignon, and a beard that falls down his chest.

2.10 Lion hunt stele, Eanna sanctuary, Uruk, Iraq, *c.* 3300 BCE. Basalt, h. 31½ in. (80 cm)

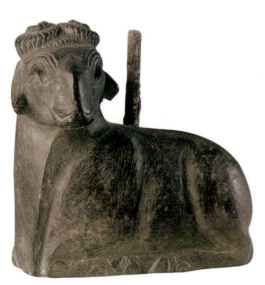

Below **2.9** Kleinfunde votive: seated animal, Uruk, Iraq, *c.* 3300–3000 BCE. Bituminous limestone and silver, h. 4 in. (10.1 cm)

2.11 Female nude figurine, Uruk, Iraq, *c.* 3300 BCE. Alabaster, h. 7⅜ in. (18.6 cm)

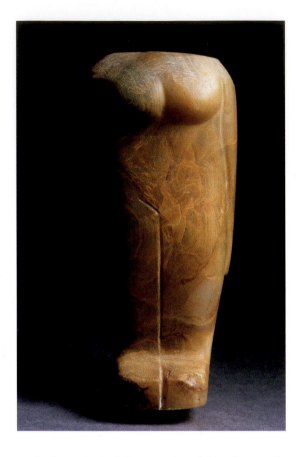

Opposite left
2.12 Palette of Narmer, First Dynasty, Egypt, *c.* 3000 BCE. Green schist, h. 25¼ in. (64.1 cm)

Opposite right and below
2.13 Cylinder seal in green jasper and impression in clay, provenance unknown (acquired by the Louvre in 1877), 3500–3100 BCE.

In the lower part of the scene he wields a bow and arrow, aimed at one of the rampant lions before him. At the top, he harpoons a lion with a long spear. The image appears to be a figure we identify as the EN, the priest-king, based on similarities with other works that were made during the Uruk era, where the priest-king seems to be defined by this hairstyle and a similar skirt. In several of these images and in the basalt stele the forces of the wild are subdued; the priest-king brings order into the city. He wields the weapons—and therefore the technologies—of hunting and war, and thus of power. As the stele retains the natural form of the spur of rock, it underscores rather than erases its medium of representation. That medium, taken from nature and brought into the urban center, becomes part of the message that we read here: the EN (ruler), at the head of the hierarchy of the city, brings security and civilization, commanding the chaotic and the wild—and this is part of a natural ordering of the world.

Are we to see these images of the lion hunt on the stele as two different moments in time, representing the same person hunting the lion with bow and arrow, and with spear? Or are these two separate activities indicating forms of hunt in which the priest-king captures his prey? The two sequential moments of time, or the two powerful actions of the ruler in hunting the lions, are an early form of narrative representation of actions in time. The figure of the same ruler repeated in time is the essence of continuous narrative representation, an art form that will be fully developed in Mesopotamia, and that is one of Mesopotamia's great contributions to the history of art.

Given its format and material, this is a type of monument we call a stele. In later periods, this kind of monument was placed in public view. The image of the king as hunter became a theme of Mesopotamian and ancient Near Eastern art, such as in the images of the **Neo-Assyrian** kings at their palaces at Nineveh and Nimrud (see p. 244); it is used later to represent the prowess of other ancient rulers, for example the Roman emperors. Hunting imagery had already occurred in Neolithic painting (e.g. the Çatal Hüyük murals; see p. 31) but it is here more clearly expressed as the fearlessness of a single man, one who is able to defeat the most powerful beasts in nature.

During the late fourth millennium, styles varied and **iconographies** were transported from one medium into another. The image of the ruler as priest [**2.18**, see p. 59], as hunter, and as warrior is also found in **seal** images of the Uruk era (see p. 54). Alabaster and limestone priest-king statues, sculpted in the round, were also made at this time. An alabaster nude female [**2.11**] is evidence that abstract geometric figures were in use alongside more naturalistic images. Hybrid animal–human creatures, nude masculine heroes, and monstrous dragons with long snake-like necks emerged, and this varied iconography traveled far and wide across the ancient world, and made its way even to Egypt, as seen on the Narmer **palette** [**2.12**]. This is a famous example of Uruk iconography [**2.13**] in early Egypt: we can see the Mesopotamian-style dragons that make up the borders of the circular indentation on the palette.

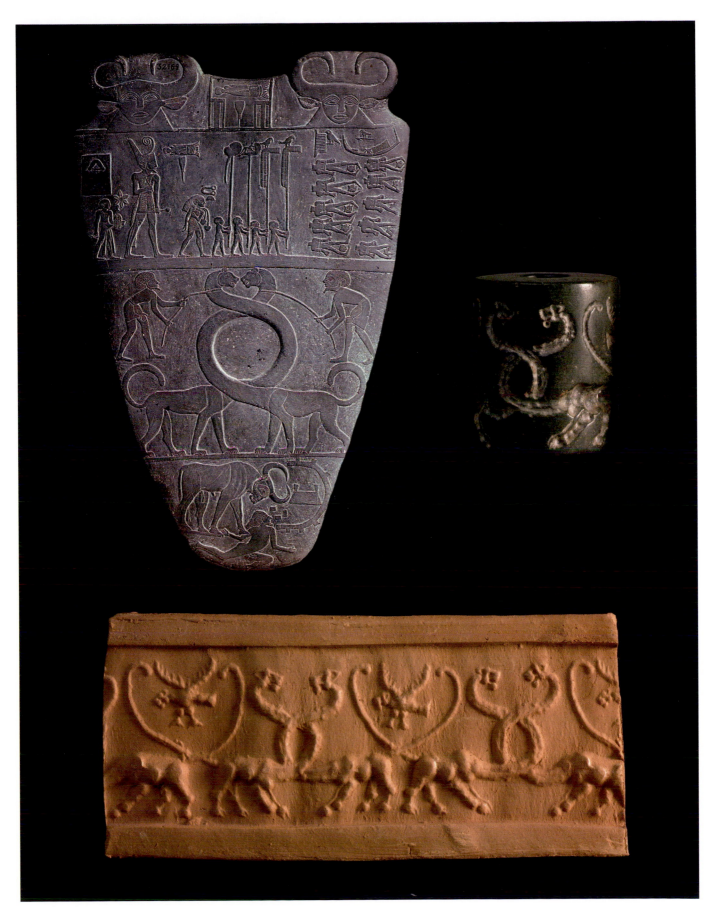

Seals: The Mark of Identity

The use of **stamp seals** is known from as early as the sixth millennium BCE, but the first use of cylinder seals, one of the most distinctive genres of Mesopotamian image-making, began in level VII (*c.* 3600 BCE) of Uruk's Eanna sequence. Cylinder seals spread throughout the ancient Mediterranean and Near Eastern world, including to **Bronze Age** Greece, and continued to be used for millennia to come. They are small, spool-shaped objects, usually carved out of stone with a longitudinal central perforation where a string or a metal pin could be placed. They are carved in *intaglio* in a continuous band across the body of the seal, with designs ranging from abstract patterns to complex narrative iconographies carved in deep relief in naturalistic rounded modeling. The images are carved in reverse so that when the **seal stone** is rolled onto soft clay it leaves a positive impression of the carved image [**2.14**]. Such a design could be impressed in lengthy stretches of repetitions, since it was usual to have more than one rolling of the seal stone. The images and compositions were therefore unbounded by frames. Seal stones were made from a variety of valuable stones, such as lapis lazuli or carnelian, imported from as far as the Indian subcontinent and Afghanistan [**2.15**]. They were used to validate documents and authenticate packages of goods, and they were owned both by men and women, craftsmen, and kings. They were also worn on the person as an **amulet**. The use of seals and sealings to authenticate goods and act as signatures is another art of the first cities, because it indicates the workings of complex administrative and legal systems.

Below
2.14 Agate cylinder seal and modern impression in clay, from Babylon, Iraq, 1250 BCE, h. 1⅞ in. (4.7 cm)

Opposite
2.15 Carved seal stones were made of valuable imported stones, each of which was considered to have amuletic powers.

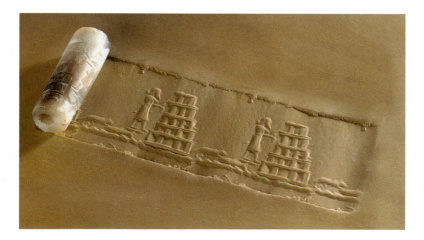

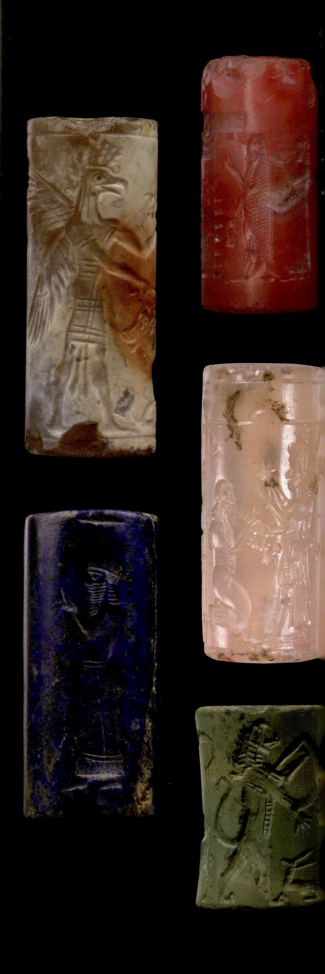

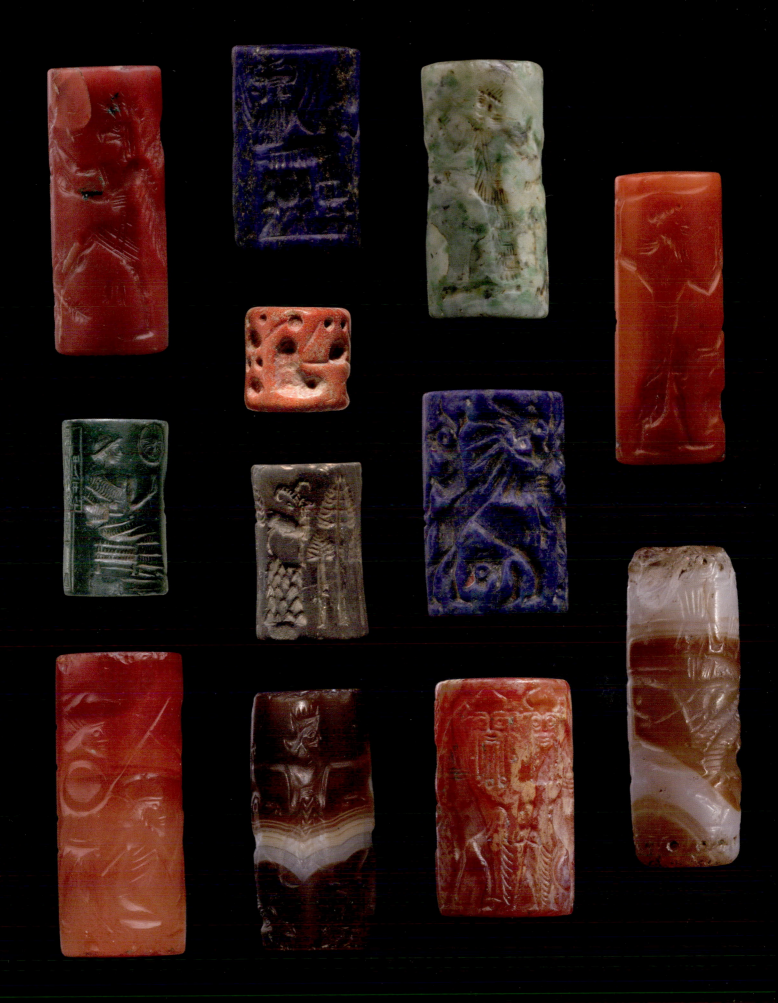

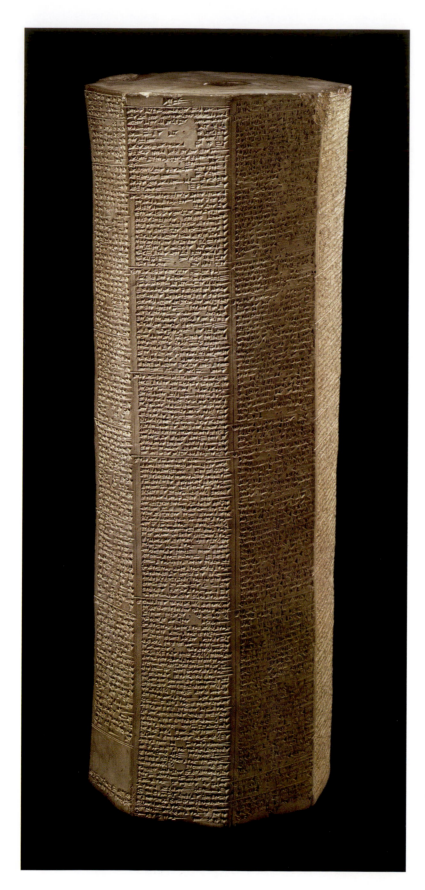

Writing: The Beginning of History

History, historians tell us, begins with the written word. The time before that is usually referred to as "prehistory" both by historians and archaeologists. The invention of writing, therefore, marks a major turning point, and it was here in southern Iraq around 3400 BCE that a system of writing was invented for the first time. Traditionally, that has been the main reason for including Mesopotamia in the concept of world history, a story that was seen as a unilinear evolution leading up to the modern West. The transition that transformed society in the Uruk era is still considered to be one of the most significant turning points in human history. It was part of a transition called, variously, the "urban revolution," by those who primarily consider aspects of urban settlement; the emergence of the "archaic state" by those who place emphasis on socio-political aspects; "the origin of complex society" by those who privilege the socio-economic structures (social stratification, labor specialization, and so on); and those who see writing as an unparalleled instrument for providing knowledge of past societies simply call it "the beginning of history."

It was in Uruk that archaeologists found the oldest written texts, most of which are administrative, recording exchanges of goods, livestock, grain, and other products. Other genres of writing, including poetry, mathematics, and sciences, appeared by the third millennium BCE. The earliest script was to a great extent **pictographic**, where signs resemble what they represent. The head of an ox referred to an ox, a fish referred to fish, and so on, but such

2.16 Octagonal prism, foundation inscription of Tiglath-Pileser I, from Anu Adad Temple, Assur, Iraq, 1109 BCE. Terra-cotta, h. 22 in. (56 cm)

No Uruk invention has received as much attention as the invention of writing, because historians mark the beginning of history with this ability to record and communicate the past. Here we see a historical text, typically written on this prism shape, dating to 1109 BCE. By the time it was written, cuneiform script had already been used for more than two thousand years, and it would continue to be used for another millennium.

signs also came to be used for unrelated objects and ideas through reliance on homonyms and synonyms, and through the phonetic values of the signs. So the script became, at least in part, phonetic, but always retained the possibilities of pictographic readings of the signs within its logic. At the same time, the early pictographic script began to be abbreviated into **cursively** written wedge-shsaped signs, derived from the previous pictograms. The term cuneiform (literally "wedge-shaped") [**2.16**] is now commonly used to refer to this ancient script, wherever it came to be adopted through the ancient Near East.

The language that the oldest script indicates was most likely Sumerian, a language unrelated to **Semitic**, **Indo-European**, Turkic, or any other known language group. By the second half of the third millennium BCE, however, the script came to be used also for Akkadian: a Semitic language related to modern-day Arabic, Syriac-**Aramaic**, and Hebrew. Afterwards, the additional values of possible readings in an entirely different language were also added to the script. What this means is that, as early as the third millennium BCE, the Mesopotamians became great translators. Numerous lists of words were compiled in bilingual dictionaries and lexical lists, and **philological** commentaries and criticisms appeared by the second millennium, and are even among the third-millennium scholarly texts found in Ebla, Syria. Soon after that, cuneiform script came to be used by the entire region of the Middle East for various languages, and by the second millennium BCE Akkadian had become the *lingua franca* (shared language) of all diplomatic correspondences, so that an Egyptian pharaoh writing to a Syrian prince would communicate using the Akkadian of Babylonia.

Archaeology and History: The Uruk Phenomenon

The explosion of cultural developments in the fourth millennium BCE that archaeologists have called the urban revolution was not limited to southern Mesopotamia. Archaeological work in areas beyond modern-day Iraq, in modern-day Syria, southern Turkey, and western Iran, has uncovered sites with similar artifacts. Uruk-type artifacts and buildings considered diagnostic of this culture are recognizable across the Near East. These markers of Uruk culture include a certain type of pottery vessel known as the beveled rim bowl, large monumental pre-planned buildings, the use of cylinder seals indicating complex administration and economic transactions, and, most importantly for historians, early writing on clay tablets [**2.17**].

The name "Uruk," taken from the city, was thus used by archaeologists to refer to material from other sites, in order to indicate that the same time period and culture were also found in archaeological layers there. V. Gordon Childe—the archaeologist who first used the phrase "urban revolution" to refer to the historical situation that had arisen in Uruk and spread throughout the region—saw this era as an outstanding moment in world history, where a number of aspects of culture were developed and came together in one place in southern Mesopotamia. From there, an expansion began that carried this culture and its artefacts across the ancient Near East. Beveled rim bowls, seals, and script soon began to be used elsewhere in the region. The spread of an urban

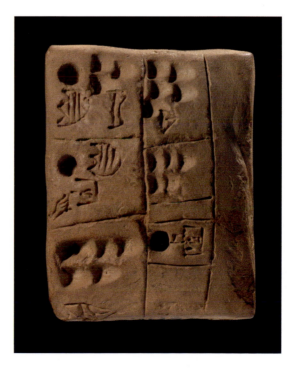

2.17 Administrative text, Uruk level IV, from Uruk, Iraq, *c.* 3400 BCE. Clay

culture over so wide an area is unprecedented and the city of Uruk is certainly the largest and most striking and seemingly the earliest example of such early urban development. How and why did this culture spread from southern Mesopotamia to the rest of the Near East?

In the nineteenth-century concept of a unilinear evolution of human history, one looked for the original place of the first transition from Neolithic "barbarity" to historical "civilization" (to use the terminology of the time). This cradle of civilization, in the theories of that time, was already thought to be in the Near East. At first Egypt was taken as the oldest civilization, but when archaeological discoveries were made in Mesopotamia in the mid-nineteenth century, the latter culture came to be identified as even older than Egypt. Today most archaeologists believe that several centers were involved, and that each case ought to be studied by itself. It is now thought that certain parallel stages of development were realized in various parts of the world and that these occurred at different rates and chronologies. Thus the current stance of archaeology is that the influences of one center on another are not as important a factor as indigenous development. To an extent this stance is a direct reaction to the nineteenth-century tradition of world unilinear evolution, a concept of evolution with cultural hierarchies that are surely questionable, if not actually distasteful.

But some moments in history that constitute world events are turning points, because their ramifications are truly far-reaching. There are certainly times when a coalescence of factors leads to immense changes in all aspects of a society. The innovations involved are so fundamental that they completely alter people's interactions with each other, and with their physical surroundings. And they are irreversible. Those moments gain even more importance when there is an influence over a geographical area beyond the place where they first occur. A recent example of such an event is the Industrial Revolution, the consequences of which are still with us today. Its effects are visible in every facet of life: economy, technology, society, politics, religion, science, the arts, and the way in which we perceive our environment. From its original core in Western Europe it had worldwide repercussions; even the globalization phenomenon today might be considered a consequence of this nineteenth-century revolution.

The Uruk era, therefore, with its multiple cultural developments occurring close together, is one of the first of these events of world historical magnitude. We see the appearance of the state, of writing, of bronze manufacture, of monumental art and architecture, of a stratified society with a ruler [2.18] and an integrated economy that tied together the urbanized core and the non-urban periphery. The Uruk period was truly remarkable because the innovations that took place in Mesopotamia at that time influenced the state of knowledge, experience in space through architecture, and views of reality well beyond the narrow geographical region of the Tigris and Euphrates river valleys. It might be compared to the great flourishing of Iraq in the Abbasid era, when Baghdad under the caliphs became one of the world's most important centers of scholarship and scientific research. In both these periods Mesopotamia's intellectual innovations had a long-term effect on the development of scholarship and world views throughout what we now call the Middle East, North Africa, and a large part of Europe, as well as, to a certain extent, South Asia. These moments are thus comparable to such turning points in world history as the

Opposite **2.18** Priest-king statues, provenance unknown, probably from Uruk, Iraq, *c.* 3300 BCE. Limestone, h. 12 in. (30.5 cm).

Among the remarkable achievements in sculpture in the round are these nude bearded men, with their hands held at the waist and a rolled band circling their heads. They represent the priest-king, the highest-ranking ruler of the first cities. In these statues, the ruler stands in an attitude of prayer. Each statue is give schematic legs and feet, represented as a solid slab with an incised line to separate the legs. The block-like feet form a base that permits the statue to stand upright. In their geometric forms, the statues emphasize mass and solidity. The image of this new political dignitary is known also from cylinder seals and reliefs of the Uruk era.

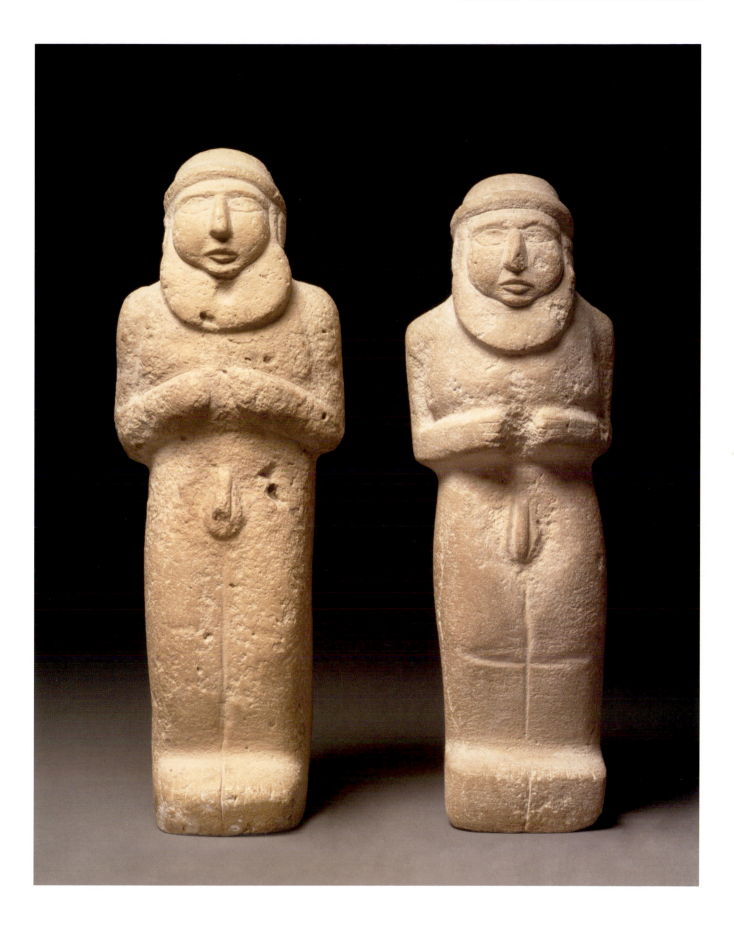

Enlightenment or the Italian Renaissance, eras that had cultural and scientific consequences well beyond the local. This is clearly the case for the Uruk era in terms of the spread of the arts and of artifacts, urbanism and architectural planning, administration, and the technology of writing.

Mythic History

What was Mesopotamia's place at the beginning of what we call history? What is history and where does it begin? What is it that makes Mesopotamia the so-called cradle of civilization? In order to answer these questions we have modern historical studies and archaeological research—for example, V. Gordon Childe's idea of an "urban revolution" stresses the origins of cities at the time—but the ancient Mesopotamians had their own thoughts about these questions, and their own reasons for believing that they were indeed at the beginning of history, and the people who were at the origins of civilization itself.

Enki and the World Order

For the ancient Mesopotamians, the arts of civilization had a name: the ME. As we have seen, ME is a Sumerian word for what is usually translated as arts and sciences in a general sense, although this is perhaps not an entirely accurate translation. The ME are more precisely aspects of civilized behavior and essences of the creations and artifacts of civilized life. The Sumerians and Babylonians tell the story of why their land was the place where human civilization originated, and provided a list of the 110 ME that make up civilized behavior (see the introduction to this chapter). In a Sumerian myth (*c.* 2000 BCE) describing how Uruk became the center of civilization, we are told that the goddess Inanna went to Eridu. Eridu was the nearby ancient city ruled by the god Enki, an architect of the universe, a creative god *par excellence*, god of wisdom and sweet waters. There Inanna challenged Enki to a beer-drinking contest, and while Enki was in a drunken stupor, Inanna, who had outwitted him by remaining sober, managed to convince him to give her the ME. That is the story of how the ME were transferred from Enki in Eridu to the city of Uruk, which was under the patronage of Inanna, making Uruk the center of civilization.

It is interesting that in terms of archaeology, the site of Eridu, also in the south, actually has the older temple structures and was a more important center in the period known as the Ubaid, so that archaeological evidence corroborates the ancient Sumerian assertion of Eridu being the first holder of the ME until it was superseded by Uruk, where an explosion took place in the mid-fourth millennium BCE, making it the site of the greatest urban expansion in history. Thus even at the early date of the myth of the ME, the Sumerians were conscious of what they describe as a major historical event or development.

"Enmerkar and the Lord of Aratta"

Just as the myth of the transfer of the ME or the arts of civilization reveals that the Mesopotamians were conscious of Uruk's important place in history, they also had their own story about the invention of writing, and identified Uruk as the place of its origins, also in *c.* 2000 BCE. In an epic that they called "City, Furious Bull," and which is now commonly known as "Enmerkar and the Lord of Aratta," they give their own account of the invention of writing. In this story we are told that writing was not given as a gift by the gods at the beginning of time, or a technology stolen from the heavens. Rather, it was a truly human invention.

In the myth we are told a story of **Enmerkar**, an early king of Uruk. We are told how the king crossed seven mountains to the land of Aratta, at the side where the sun rises. It was a foreign, mythical, and distant land, abundant with riches, overflowing with gold and silver, copper and tin, and with its mountains laden with lapis lazuli. At first, Enmerkar of Uruk sent a messenger to make known his intentions: he demanded the submission of Aratta. As reply, the lord of Aratta sent him a challenge, which seemed like an impossible task: could he deliver to Aratta, which was suffering from a famine, large quantities of grain, transported in nets rather than in sacks? Enmerkar of Uruk, assisted by the goddess of grain, Nisaba, found the solution. Instead of using

seeds of grain, he filled the nets with grain that had already begun to sprout, and so did not spill from the weave of the nets.

The second time Enmerkar sent his messenger to demand the submission of Aratta, he sent his own scepter to his opponent, and ordered him to cut a second one from its handle, like an offshoot from a tree. The meaning of this challenge was that to cut one's scepter in the same material as that of one's enemy was to accept his superiority. Rather than submitting, the lord of Aratta sent another challenge. He asked Enmerkar to fashion a scepter that was made neither of metal, nor of wood, nor of any known or catalogued precious stone, but that still had all the characteristics of a true scepter. It was only after a period of twelve years of thinking it over, and with the aid of Enki, the god of reeds as well as of intelligence, that Enmerkar found the solution to the question and used a reed as the material for the scepter.

The third time Enmerkar sent his messenger, who brought a scepter as a present. The lord of Aratta immediately saw in it another invitation to submit, did not want to obey, and sent what is presented as a final challenge to his adversary: could he produce one of his champions who is without any color, neither black, nor white, nor brown, nor dark red, nor yellow or green, nor multicolored? Enmerkar found the solution but this time without any help from the gods, by playing on the similarities of words, and replacing the word "champion" with that of "dress." So Enmerkar sent his messenger accompanied by a champion with an unbleached textile. The messenger could not remember the words, so Enmerkar found a solution. Without the help or advice of a god, he molded a lump of clay onto which he wrote the text of the message, thus inventing writing and the clay tablet upon which it is written.

The Sumerians, as well as the Babylonians and Assyrians after them, came to believe in the creative power of script, and in the identity of the name with what it designates. This relation, which closely connected words and things, writing and reality, became a subject of much intellectual thought and scientific reasoning

through the millennia when this script was in use. The invention of writing was, then, not simply an invention of a method of record-keeping or even of literary genres. The inventors had to develop an entirely new system of representation that could signify both physical reality and abstract concepts on the two-dimensional medium of the clay tablet. They had to create an inventory of signs that was logical and agreed upon by all users of the script. This was not merely a technological change, but one through which all perception came to be fully altered. The invention of writing changed the Mesopotamians' conception of the world, of reality, and their interaction with it.

Writing and visual narrative were new technologies that had a profound effect on the way that people conceived of the world around them. At the same time, monumental architecture at a previously unknown scale and level of technical skill and planning appeared in Uruk, yet it is not simply the technical skill involved that is a remarkable new development. Architecture with massive proportions, and with designs that were clearly pre-planned, developed into a new urban medium. Civic magnificence realized through architecture appears here for the first time. The Uruk architects subjected space to an exacting and ordering logic, arranging it into the first civic architectural landscape. The revolutionary conception of architecture as a representational medium in its own right can be seen as yet another innovation of the Uruk revolution. The city was consciously staged as such by means of urban design. Social changes came to be crystallized in architectural form, into the built environment, in a way that was to change the relationship of people to space, citizens to the city, forever. The creation of this first urban society was thus a fundamental innovation that has affected the entirety of world history. Rarely have such changes occurred due solely to indigenous processes, and nowhere else did it happen before it took place in southern Mesopotamia. We can say, then, that Uruk was truly the first city.

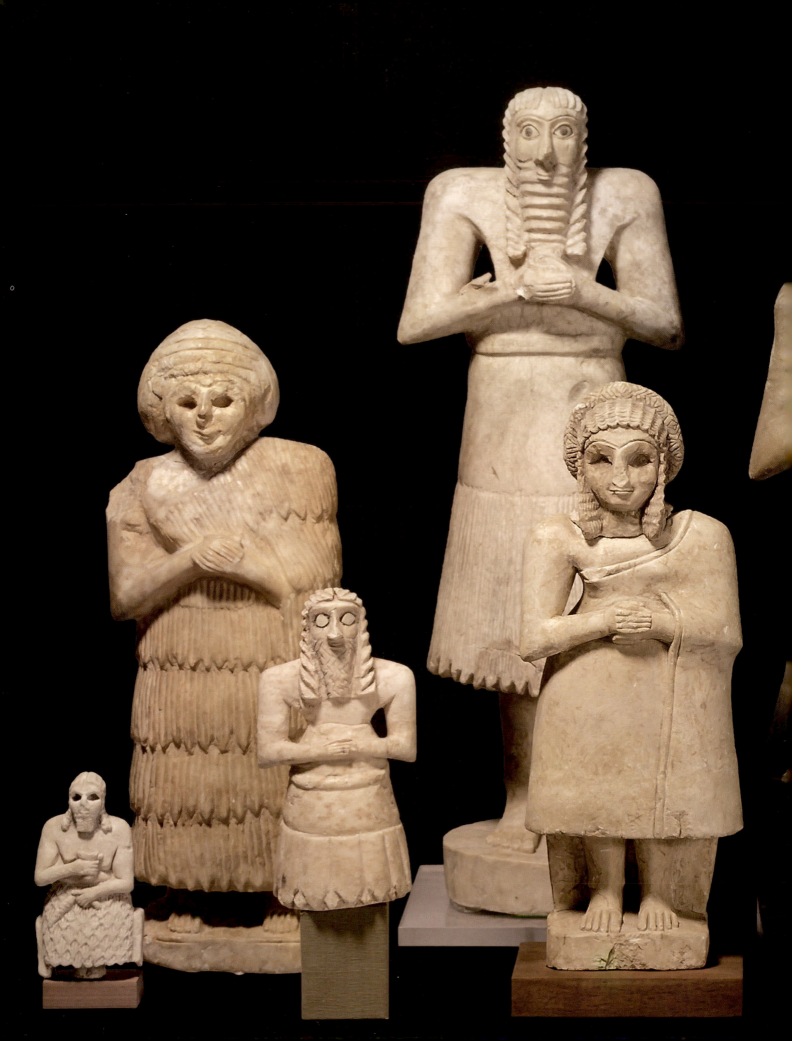

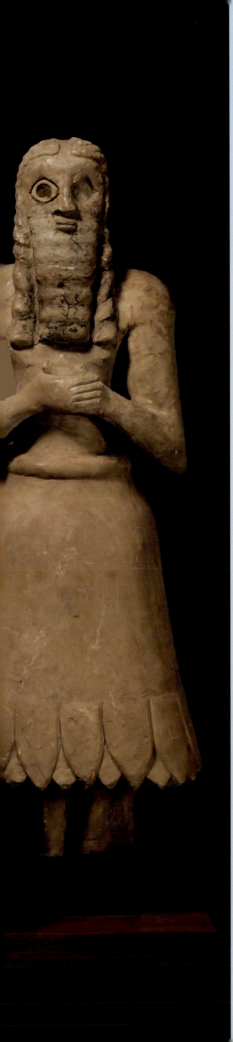

CHAPTER THREE

Early Dynastic Sumer: Images for the People, Temples for the Gods

Sumerian votive statues, Early Dynastic I–II,
2900–2600 BCE. Gypsum, calcite, black
limestone, shell, and bitumen

3 Early Dynastic Sumer 2900–2334 BCE

Periods	Jemdet Nasr: 3150–2900 BCE
	Early Dynastic I: 2900–2750 BCE
	Early Dynastic II: 2750–2600 BCE
	Early Dynastic IIIa: 2600–2400 BCE; Early Dynastic IIIb: 2400–2334 BCE
Rulers	Urnanshe c. 2600–2500 BCE
	Eannatum c. 2500–2400 BCE
	Enmetena c. 2400–2350 BCE
	Ishqi-Mari c. 2400–2350 BCE
Major centers	Lagash, Girsu, Ur, Mari, Diyala region
Notable facts and events	Independently ruled city states arise in Sumer and Akkad
	We see the earliest literary manuscripts and royal inscriptions
Important artworks	Relief sculpture of Urnanshe of Lagash
	Votive statue of Dudu the Scribe
	Diorite statue and silver vase of Enmetena
Technical or stylistic developments in art	Sculptors begin to create portrait images
	Oval plan for temples appears at this time
	Use of the true arch begins
	Architectural rituals and foundation deposits

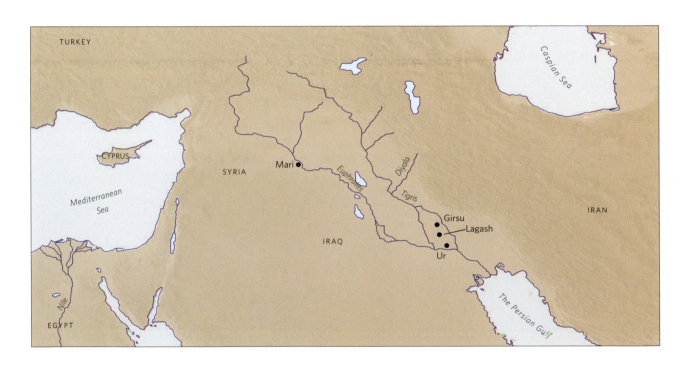

3 Early Dynastic Sumer:
Images for the People, Temples for the Gods

By the third millennium BCE, Mesopotamia had become a land composed of independently ruled **city states**, most of them covering the southern region known as Sumer. At this time, a remarkable change took place in the visual arts, a change that had a broad and far-reaching significance in antiquity. Throughout Mesopotamia—in both the south and north, the areas that are now parts of Iraq and Syria—sculptors began to create images of the people. As simple as this act may seem to us today, historically, it was a turning point in representation. These images were not gods, deities, or other divine or supernatural beings, nor were they limited to kings and princes—this was an art of, and for, the people. This chapter introduces this new genre of sculpture, followed by an explanation of the developments in temple architecture, and architectural rituals that also required the use of images.

The **Early Dynastic** period covers a large stretch of the third millennium BCE in Mesopotamia, beginning around 2900 BCE and ending with the unification of the city states under Akkadian rule about six hundred years later (*c.* 2334 BCE). This era is generally divided into three periods, though these divisions are not as stable and absolute as earlier scholars had thought: Early Dynastic I (2900–2750 BCE), II (2750–2600 BCE), and IIIa and IIIb (2600–2334 BCE). The era that directly preceded the Early Dynastic is referred as the Jemdet Nasr period (3150–2900 BCE) by archaeologists. Little is known about the art of the Jemdet Nasr period, although the south of Mesopotamia seems to have gone through tremendous changes at this time, when the Uruk culture's hegemonic influence over the region suddenly came to an end.

The name given to this historical era, the Early Dynastic period, is derived from an important ancient document called the **Sumerian King List**. A prism-shaped text made from terra-cotta, now in the Ashmolean Museum, Oxford, UK, is the best-preserved version of this dynastic list [**3.1**, see p. 66]. It describes the political structure of that land by explaining the Sumerian idea of kingship as an office that was transferred from city to city across the centuries. Although each city was independently ruled, as in the ancient Greek *polis*, the Sumerians believed that dominant cities arose, at which time the gods transferred supreme kingship to a single one of the cities, allowing it to supersede its neighbors in what was otherwise a federation of city states. Explaining that "kingship descended from heaven," the text provides a long list of the names of kings and the dominant kingships of the land of Sumer and Akkad (southern Mesopotamia) and traces the office of kingship back to a primeval time of mythical history that it describes as the time "before the flood," a mythical event in the distant past. It then continues to list the names of known historical Sumerian and Akkadian kings until it reaches the dynasty of Isin, ending with the rule of Sin-Magir, king of Isin (r. 1827–1817 BCE). More than a thousand years later, the list was housed in the seventh-century BCE Assyrian Royal Library at Nineveh, the archives of the later rulers of Assyria. There are more than a dozen copies known of this text; the document continued to be copied and preserved through the centuries of Mesopotamian history. The first part of the king list appeared even in the writing of Berossus, the Hellenistic Babylonian historian, and one version has been found in a far-away city in Syria.

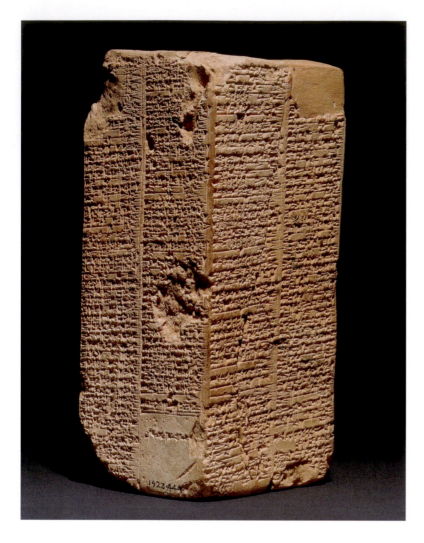

3.1 Weld-Blundell Prism, *c.* 1800 BCE. Prism-shaped text made from terra-cotta, h. 7⅞ in. (20 cm)

The Weld Blundell Prism is not only a historical document, but also an archaeological artifact that we should consider as an object in itself. How was it used and where was it placed in antiquity? Was it used to teach students about the past? The shape of the prism and the material (clay) are known from other texts, some of which were used in archives, while others were interred, placed in the foundations of a building as a way to record the past and transmit it to future generations.

apparently not related to Sumerian, but were loan words from another language—other scholars argued that the Sumerians must have been from elsewhere. This point of view, arguing for a northern or foreign origin for the Sumerians, has now been rejected by philologists who specialize in the ancient Sumerian language. Texts written in Sumerian include a wide array of genres, including works of literature and religious writings, legal texts, loan and sale documents that list names of private individuals, administrative texts related to the palace, royal inscriptions bearing names of specific rulers and their dynastic ancestry and recording their activities both secular and sacred, and also a fascinating and distinctive genre of lexical lists; this last category can help the modern scholar gain an understanding of early scholarly practices that attempt to make sense of language. These early word lists were clearly of importance since they were transmitted and copied for more than a thousand years. For the Early Dynastic era, the main written sources that survive are royal inscriptions and institutional archives.

Sculpture: The Votive Image

At the end of the fourth millennium BCE in Uruk, animal figurines and other carved objects began to be made as votive gifts to the gods (see chapter 2, p. 50). This genre of representation developed in the Early Dynastic period into new forms of sculpture representing the human form, as well as new types of utilitarian objects transformed into votive offerings by means of their materials

The Sumerians are credited with being the people or ethnic group responsible for the beginnings of settled life in Mesopotamia. The term "Sumerian," however, does not refer to an ethnicity but a language. In their own time, the Sumerians called themselves "the black-headed people" and what we now call the land of Sumer they referred to simply as "the native land"; it is only in later Mesopotamian sources that the land and the language come to be referred to as Sumer and Sumerian. The origins of these people are debated. In the early twentieth century many scholars claimed that the Sumerians came from the Caucasus, the region between the Black and the Caspian seas, or elsewhere in the north, because they believed that is where civilized life must have originated. Based on the use of certain words from a substrate language—words that were

and inscriptions. The first clear occurrence of these performative votive offerings was in the late Uruk era. A long, narrow room in the Eanna at Uruk, located between a monumental court with a gateway and a raised terrace, contained such offerings in stone. The animals included sheep, calves, goats, cows and bulls, lions, gazelles, fish, and birds. The limestone calf [**3.2**] is a **composite statuette** of limestone inlaid with lapis lazuli, an exotic dark blue stone imported from Afghanistan. It is a small figurine, only about 2 in. (5 cm) in height, but it asserts a realistic and permanent presence through the naturalistic modeling and the materials that are used. The young animal's legs are tucked under its body, and folds of soft skin are indicated above the eyes and at the snout, as well as creases in the inner ears and tiny knobs of horns that have not yet emerged from the head. It is a new calf, full of the potential of life. Made in shining polished stone, it is both a naturalistic miniature and a precious jewel-like object at the same time.

This kind of statuette belongs to a class of objects that were votive images, small-scale statues of animals and objects that were given as offerings to the gods. Made to be placed inside their temples, they were offered up as gifts in a system of exchange that was meant to invite or perhaps even to oblige divine favor to the donor of the votive. These votives could take various forms: an animal or a tool, a person in prayer, or a food offering. In some cases the votive statue seems to crystallize and make permanent an action or sacrifice, such as the act of sacrificing an animal to the gods made permanent through the effigy of a small calf or sheep, or the gesture or act of prayer offered up to the god or goddess in the form of

a statue of a worshiper. Yet the statues were no simple copy of the sacrificial animal as a token in miniature form. They were finely carved objects, often **inlaid** with semiprecious stones or overlaid with precious silver or gold attachments.

In these types of votive statues, the making permanent of an offering that was perhaps otherwise ephemeral and the idea of exchangeability behind the object given to the gods in order to receive blessings in return seem to be the most important features. Most of the votive objects appear to have been made specifically for use as gifts to the gods. Besides statues, finely made vessels sculpted out of stone or cast from silver or copper, tools and weapons, and jewelry were also dedicated to the gods as votive offerings. Many of these objects were also made specifically for this purpose, although sometimes items that originally had been used in daily life were then taken out of circulation and designated as sacrificial votives for the gods.

One fascinating votive object, the limestone mace head of Barakisumun [**3.3**, see p. 68)], is perforated vertically through the center in order to permit its placement on top of a large staff. A mace is a tool or a weapon, a utilitarian object that is here transformed into a ceremonial sceptre for a god. The oval-shaped stone is carved with a pictorial relief that circles the rounded body of the stone. We see a group of three men depicted in a mixed profile view, with their upper torsos turned toward the viewer so that the entire expanse of the shoulders is depicted and both arms are shown, while the heads are clearly in profile. The first figure has his hands clasped in a gesture of prayer, the second is carrying a spouted **libation** vessel, and the third carries a staff, perhaps the staff that was meant to bear the mace head itself before it was offered to the god. The first man in the row is taller than the two behind and wears only a tufted kilt that reaches to his waist but leaves his chest bare. The two men following him wear plain skirts and fringed mantles that cover their left shoulder and arm. The figures are depicted in Lagash style with large sloping noses, defined on the side by an emphatic line that merges into the arc of the brow, surface-incised almond-shaped

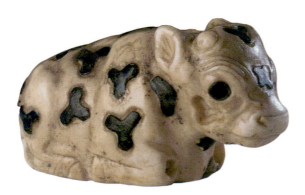

3.2 Small calf votive statue, from Eanna, Uruk, Iraq, 3200 BCE. Limestone inlaid with lapis lazuli, h. 2 in. (5 cm)

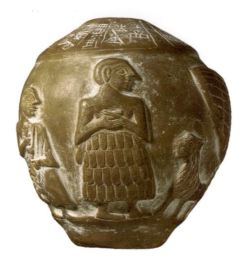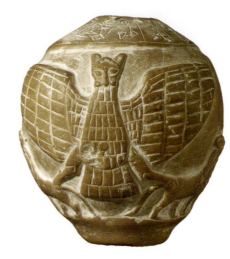

3.3 Mace head of Barakisumun, from Girsu, Iraq, *c.* Early Dynastic IIIb, *c.* 2450 BCE. Limestone, h. 4⅝ in. (11.7 cm)

eyes, and elongated, stylized ears in a leaf shape. The men are approaching a heraldic emblem of the **Imdugud** bird, a lion-headed eagle, which is grasping two lions in his claws. This is an emblem associated with **Ningirsu**, the storm god and the patron god of the city of Lagash in south-central Sumer. The votive mace head is inscribed near the opening at the top:

> For Ningirsu of Eninnu, the workman of Enannatum, ruler of Lagash, Barakisumun, the emissary, dedicated this for the life of Enannatum his master.

The object is fascinating because it is not an offering made by a ruler or a king but by Barakisumun, a man whose name survives because of this offering and who was, according to his own dedication, a workman in the service of the king. He dedicated the mace to Ningirsu, and prayed for the life of his master, but his own name is remembered into our own time.

Stands, vessels, weapons, and instruments were also often given as offerings to the gods. The Silver Vase of Enmetena is the most opulent example of a votive vessel that survives from the Early Dynastic era [**3.4**]. The silver vessel is set on a copper stand. An inscription on the neck of the vase identifies it as a dedication by **Enmetena**, the ruler of Lagash, who describes it as a vessel made from refined silver from which the god Ningirsu will consume the offerings of oil. Below the inscription two engraved registers separated by

Opposite
3.4 Silver Vase of Enmetena, from Girsu, Iraq, Early Dynastic IIIb, *c.* 2400 BCE. Silver and copper, h. 13¾ in. (35 cm)

a narrow band of **herringbone** pattern decorate the surface. Recumbent calves circle the upper register. In the main representational register the vase is a circled by four images of the Imdugud bird, the lion-headed eagle associated with the god Ningirsu, which grasps pairs of lions, goats, and oxen. All the heraldic groups, each of three figures, are intertwined by the actions of the animals, which clasp each other in a continuous relation of tripartite units in a closed ring. Whatever the specific animals represent in the mythological sphere of the god Ningirsu and his storm-cloud bird, the Imdugud, this is not an image of the same bird at different moments in time. Instead, it shows coexisting manifestations of the divine creature that are ever-present and eternal.

Such pictorial scenes as the circular repetition of the powerful Imdugud on the silver vase tell us a great deal about how the ancient Mesopotamians understood the power of the image and its relationship to the sacred and to their experience of daily life. Even in the cases where objects were not originally made as votives, and only later were taken away from their original use and dedicated to the gods, these practices indicate that the world of things for the ancient Mesopotamians was an enchanted world where nature and divine order were intertwined. Exotic materials were brought from faraway lands and subjected to complex manufacturing processes, which carefully considered the material qualities of the statues, vessels, and other offerings.

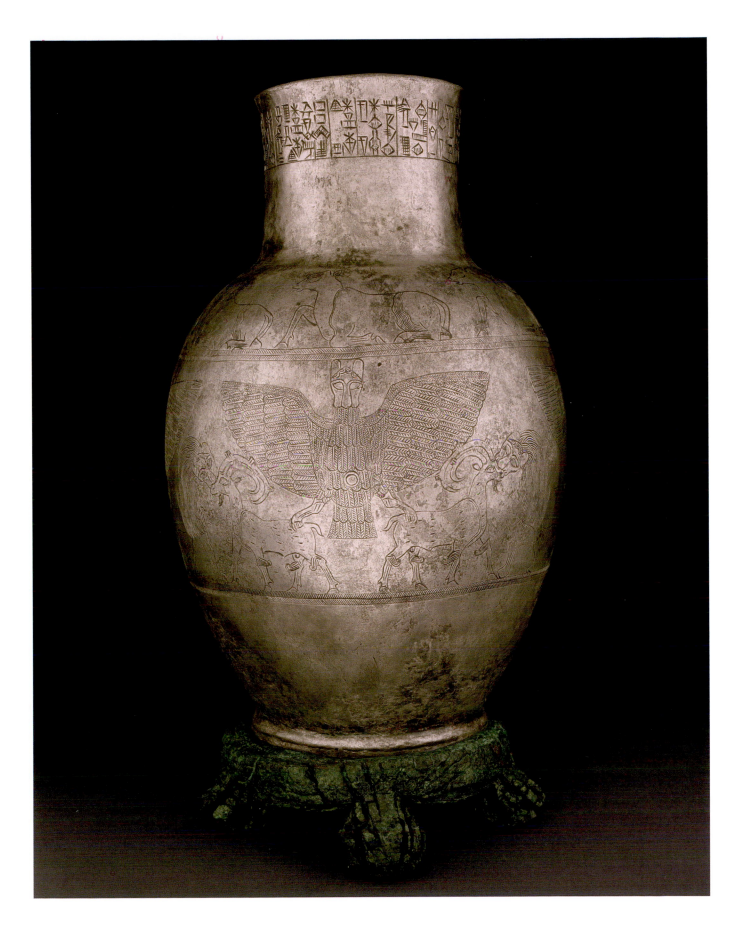

Sumerian Gods and Myth

The major Sumerian gods were regarded as aspects of the forces of the universe. They were associated with the elements of nature, the earth, the sky, and with astral phenomena, such as the moon, sun, stars, and planets. They were **anthropomorphic** in conception but their cosmic aspects could also be depicted in the arts as symbols and emblems, and each had a specific iconography. Some of them were also associated with a particular animal **attribute**. Each of the Sumerian city states was protected by a patron deity, a god or goddess who looked after the city and had a main temple there in which the cult statue was kept: Inanna was associated with Uruk, **Enlil** with Nippur, Enki with Eridu, **Nanna** with Ur, and so on. Thus, while the gods lived in the heavens, they also had a permanent presence on earth.

The **polytheistic** Sumerians counted more than 3600 gods by the end of the third millennium BCE, but not all are known. Myths, legends, and hymns to the gods were recorded in writing from c. 2500 BCE, and these were constantly rewritten as late as the first century BCE. In many cases we know several versions of the same story written and transformed in different historical eras. Long before the myths were first written down, they must have existed in oral traditions. Often, these myths allow us to identify gods and their attributes in the visual arts, but there are also a remarkable number of visual themes and iconographies that are not yet paralleled in any of the known written texts, which indicates that the Mesopotamians had a rich tradition of myths and legends beyond what has been preserved in writing.

Texts tell us that many offerings sacrificed or given to the gods were organic goods—the first fruits of the harvest, oil and butter, grain and textiles—yet many seemingly utilitarian things were also translated into precious materials and dedicated to the gods. We can understand these votive statues and vessels as a transfiguration of a commonplace object into something sacred by means of these choice materials and fine methods of manufacture.

The Portrait as Text and Substitute Images

Among votive statues, perhaps the most important category was that of images of the people. While from the Uruk era, some statues in the round have been found that seem to represent the EN or "priest-king" ruler figure (e.g. chapter 2, p. 59), in the Early Dynastic I era (2900–2750 BCE) we see a remarkably large number of votive statues of citizens rather than rulers, and these images became the most characteristic works of Early Dynastic art. The emergence in the archaeological record of statues of men and women carved in stone and dedicated as votive offerings in temples raises the question of what it may mean to dedicate an image of oneself to the gods. The reciprocal nature of the votive that we saw at

work behind the figurines of animals and other figures (see p. 50) is also an important feature of these images in human form. The figures of people stand in for the person represented, and capture the gesture of prayer, so that the statue stands in the act of worship or prayer before the gods for a long duration. The offering is meant to be the start of a reciprocal exchange, given in the hope that the god will answer the prayers and give something in return, such as a long life or good health or divine favor for the donor and the donor's family [3.5a, b, c].

At Tell Asmar (ancient Eshnunna) in the Diyala region of modern-day Iraq, a group of statues dating to the early third millennium BCE was found in the Square Temple. A number of these statues were buried in a **cache** beneath the altar. Numerous worshiper statues of this type were uncovered from the Diyala region, as well as from Nippur, Ur, and other Sumerian city states. The statues were also found in the north, at such sites as Assur and Mari. Carved out of limestone and alabaster, they represent the male and female figures in frontal poses with hands clasped at the waist in front of them, and with enlarged, staring eyes, with a gaze that is transfixed upon what is before them. The figures are abstracted images of men and women, who are shown reduced to

basic geometrical shapes. The skirt is either a cone or a rectangular slab with little **articulation**, so that we are unable to see the shape of the body beneath. The ends of the skirt are bordered with a row of tassels indicated by incised carvings on the surface, beneath which the cylindrical legs and rectangular feet emerge. Most of the figures seem originally to have stood on rectangular bases, enabling the statues to stand upright without support. The upper part of the body, crossed by the arms, is also geometricized into simplified planes. The male heads are often bearded and long-haired, with rows of horizontal waves of thick hair that appears to imitate the working of a soft material, such as clay, transformed into stone. This style of carving perhaps indicates that some sculptors may have worked first with clay maquettes. Some of the male figures are depicted as clean-shaven with shaved heads. The female figures generally

have uncovered braided hairstyles, or, at times, wear a turban-like headdress that circles the top of the braids.

These statues represent people as worshipers, though it is not clear who they are or what level of society they belong to in this case, as most of them are uninscribed. A personal image— that is, a statue made to represent a particular individual—was first made for the purpose of encountering the gods. The statues were active forces that were believed to possess agency. They did not just portray the individual through a physical or external resemblance, but were able to channel the life force of the individual in the statue for all time. They therefore also represent the act of prayer itself, or the abstract notion of worship embodied and made concrete in the

Left to right
Standing male figures with clasped hands. Gypsum, shell, black limestone, bitumen
3.5a from the Abu Temple, Tell Asmar, Iraq, EDI–II, c. 2900–2750 BCE, h. 11⅝ in. (29.5 cm); **3.5b** from the Nintu Temple, Khafaje, Iraq, EDI–II, c. 2750–2600 BCE, h. 9 in. (23 cm); **3.5c** from the Nintu Temple, Khafaje, Iraq, EDI–II, c. 2750–2600 BCE, h. 14⅝ in. (37 cm)

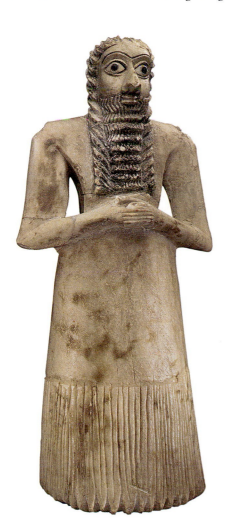
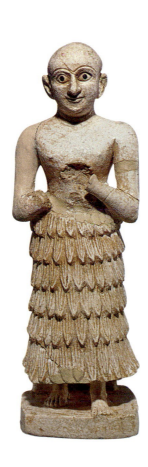
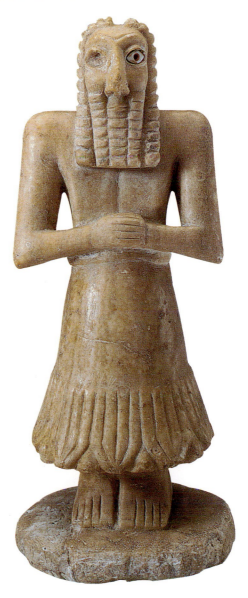

The Inscription on the Statue of Enmetena

On the statue's right shoulder and upper back:

For Enlil of Eadda—Enmetena, ruler of Lagash, chosen in her heart by Nanshe, chief executive for Ningirsu, son of Enannatum ruler of Lagash, descendant of Urnanshe King of Lagash, built the Eshdugru for Ningirsu and built him the Ahush, the temple he looks upon approvingly. He built his palace of Urub for Lugalurub; he built the Eengura of Sulum for Nanshe; he built Abzupasira of Enki, king of Eridu; he built the giguna of the sacred grove for **Ninhursag**; he built Antasura for Ningirsu and built him the Shapada; he built the temple of Gatumdug; he built her lofty giguna for Nanshe, and restored her temple for her; and he built the Eadda-Imsaga for Enlil.

At the time, Enmetena fashioned his statue, named it "Enmetena Whom Enlil Loves" and set it up before Enlil in the temple.

Enmetena who built the Eadda—may his personal god, Shulutula, forever pray to Enlil for the life of Enmetena.

On the statue's right arm:

Enannatum had ceded 25 bur (162.5 hectares) from Surnanshe. 11 bur (71.5 hectares) of rushes, land in the marshes of Nina, adjacent to the Holy Canal, and 60 bur (390 hectares) already belonging to Enlil, land in the Guedena, Enmetena ruler of Lagash to Enlil of Eadda.

3.6 Enmetena of Lagash, from Ur, Iraq, Early Dynastic IIIb, c. 2400 BCE. Black diorite, h. approx. 3 ft. (91 cm)

statue, enabling the repetition of this activity into the future through the permanence of the image. The idea that the statue could continue to utter the prayer in place of the donor becomes clear when inscriptions clearly stating this function are added onto such statues. A statue of Meansi of Lagash (2400 BCE), for example, has a long inscription that gives his lineage and lists his accomplishments. At the end of the text we read that Meansi

> fashioned his statue and set it up before Lugalurub in his temple. May it pray to Lugalurub in the palace of Urub for the life of his father Enannatum, for the life of his mother Ashume-eren, and for his own life.

Statues were sometimes broken and repaired in antiquity, showing the long duration of their use. Even when they were no longer placed in front of the god's image, they were never discarded randomly. Instead, like the group from Tell Asmar, they were buried within the sacred space of the temple.

A large stone statue of Enmetena, the ruler of Lagash, was discovered at Ur [**3.6**]. The statue's head has been broken but it is otherwise well preserved. It is in the form of a typical votive figure, but much larger in size and carved from an exotic and valuable dark stone—diorite—which

was imported from Magan (modern-day Oman) for use in royal statues, more commonly in later generations, though it was not restricted to royal commissions (see the statue of Lupad described

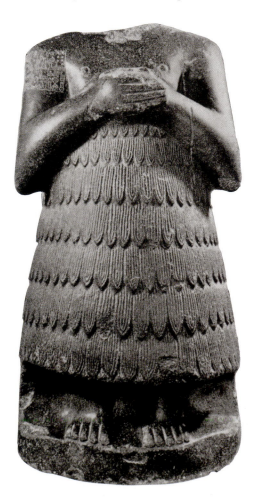

on p. 74). This statue is the earliest example of the use of diorite for royal works. It bears a long inscription at the right shoulder and upper back dedicating the image of Enmetena to the god Enlil. The inscription tells us about Enmetena's lineage and how the gods favor his rule. It also tells us of his pious acts—the numerous temples he has built for the gods. The inscription ends by stating that the statue itself has a name. It reads, "At that time, Enmetena fashioned his statue, named it 'Enmetena Whom Enlil Loves' and set it up before Enlil in the temple." The statue thus describes its own function very clearly. The fact that the statue bears its own name, not simply the name of the king but a statement name that can be understood as a performative declaration—that Enlil loves Enmetena—allows the name and image to work together to effect that desired outcome. The Enmetena statue is an early example of the Mesopotamian practice of combining word and image in a dialectical relationship to enact the power of the image (see also p. 46). All statues in the third millennium BCE probably had names. When an inscription survives, we see this practice of naming the work, and such names also appear in inscriptions for standing monuments made during the same time. The names are not, however, the same as the descriptive titles of works of art from later historical eras with which we are more familiar. They are names that are more closely tied to the essential identity and function of the sculpture or monument.

These statues were substitutes of sorts, and were considered to be direct representations of individuals. They can therefore be considered as portraits, even if the close relationship between the statue and the person represented is not based primarily on an external physical resemblance, as in later notions of portraiture known in the West. The Sumerian statues stood in the place of the person represented and could function as a very real form of presence of that person. They were, therefore, linked to the person in ways much closer than our modern notion of portrait, since they capture an essence of the person, which continues to exist in the statue. Numerous ancient texts attest that an image had

a very real agency and was therefore a powerful object for the Mesopotamians.

Such portraits were not limited to images of the royal family, but included other members of society, including professionals, courtiers, and craftsmen, both men and women. At Girsu (modern Telloh), in southern Sumer, a scribe called Dudu placed his basalt statue in the Temple of Ningirsu [3.7]. The inscribed statue represented the seated scribe, wearing a heavy fleece garment, his upper body bare and his feet resting on the statue base. He holds his arms close to his body and his hands are joined together in prayer. The compact shape and closed forms used by the sculptor for this image emphasize durability and thus longevity.

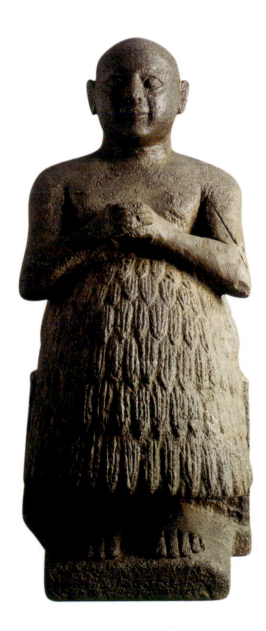

3.7 Dudu the Scribe, from Girsu, Iraq, Early Dynastic IIIa, 2500–2450 BCE. Basalt, h. 17¾ in. (45 cm)

A statue of a man called Lupad of Umma best exemplifies the interplay of text and image that is one of the hallmarks of Mesopotamian art [3.8]. The statue, made of diorite, represents Lupad in a blocky rectangular form, a stout body with arms crossed in front of him and hands joined in prayer. His head and beard are both clean-shaven, and his eyes and brows are stylized into elongated linear forms. He sits in a frontal, solid, and immovable position. Lupad's body, translated into the solidity of the rectangular block of diorite, is literally transformed into a monument. The body also becomes a surface for the text: an inscription carved across his chest and shoulders, curving toward his back, tells us that he is Lupad, the field recorder of Umma, the son of Nadu, who was also a field recorder, and carefully lists the land transactions in which he was involved, the size of the fields, their locations, and what was paid for each of them. His identity is tied to his name, to his paternal line, and to his professional activities.

Below
3.8 Lupad of Umma, from Girsu, Iraq, Early Dynastic IIIb *c.* 2400 BCE. Diorite, h. 16½ in. (42 cm)

Right
3.9 Female votive statue, from Nippur, Iraq, Early Dynastic IIIa, *c.* 2550 BCE. Greenstone and gold, lapis lazuli, and shell, h. 4⅞ in. (12.4 cm)

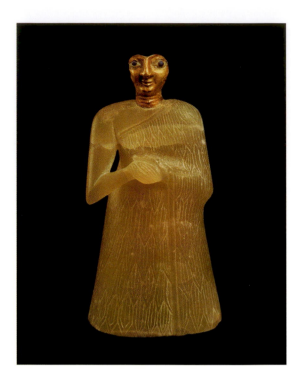

The repeated reading of his name and identity in the text, combined with the substantial presence of his diorite image—both a body and a text placed before the gods—ensured that he would not be forgotten.

A remarkable example of a green translucent stone statue of a standing woman comes from the Inanna Temple at Nippur [3.9], her head formed of gold, with eyes inlaid with shell and lapis lazuli, and her hair originally made of another material now missing. Although it has no surviving inscription telling us the identity of the woman who commissioned it, she must have been a wealthy individual. The Nippur statue is important because it is an indication of the types of votive statues made out of other precious materials that are now lost to the archaeological record.

At the site of Mari in northeastern Syria, a large number of votive statues were discovered that indicate a tradition coexisting with that in southern Mesopotamia. Stylistically, however, the statues here are recognizably different: they are often more deeply carved and show greater movement and more rounded modeling than from those of the south [3.10, 3.11]. Among the Mari statues one dedication is unusual in that it represents a seated figure with long hair and

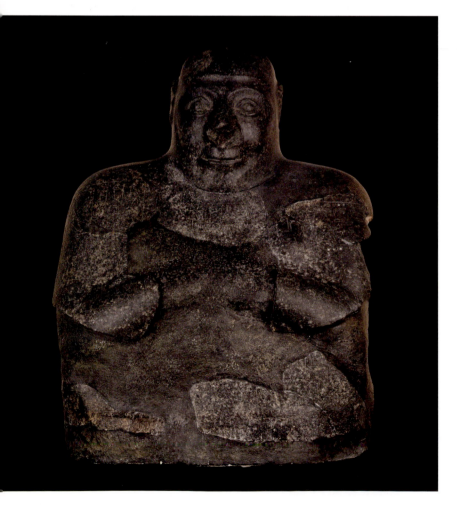

no beard [**3.12**]. Seated cross-legged on a round woven cushion, he wears a tufted skirt and was originally holding a lyre, most of which is now missing. The inscription on the statue identifies him as Urnanshe the Master Musician. The figure follows neither masculine nor feminine ideals of representation, despite the fact that the name is masculine, so that it is an image that seems to resist normative gender. This image, commissioned by the singer himself to represent him for eternity, perhaps reveals something about the extent to which the input of the patron was involved, as it does not follow the standard types of male votive images but instead makes particular choices for the representation of this musician.

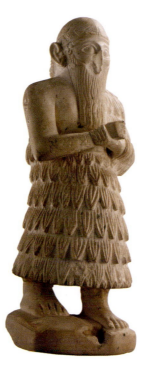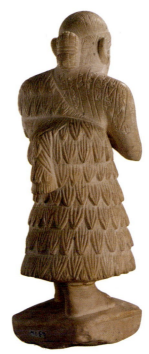

Left
3.10 Ishqi-Mari (front and back), from Ishtar Temple of Mari, Mari, Syria, Early Dynastic IIIb, c. 2400–2300 BCE. Alabaster, h. 10⅞ in. (27.7 cm)

Below left and center
3.11 Ebih-il (front and back), from Mari, Syria, Early Dynastic IIIb, 2400 BCE. Alabaster, shell, and lapis lazuli, h. 20⅝ in. (52.5 cm)

Below
3.12 Urnanshe the Musician, from the Nini-zaza Temple, Mari, Syria, Early Dynastic IIIa, c. 2450 BCE. Gypsum, shell, and lapis lazuli, h. 10¼ in. (26 cm)

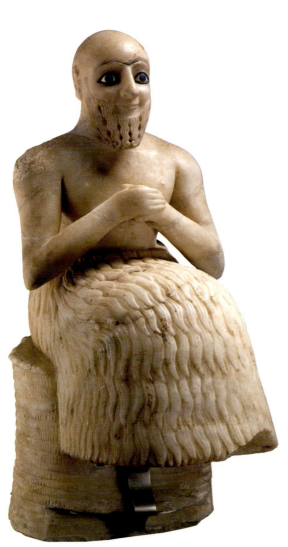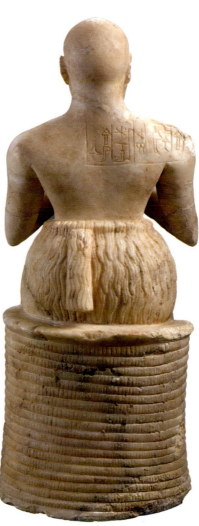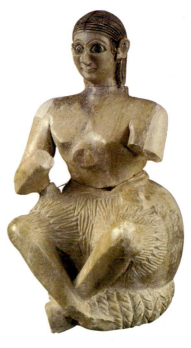

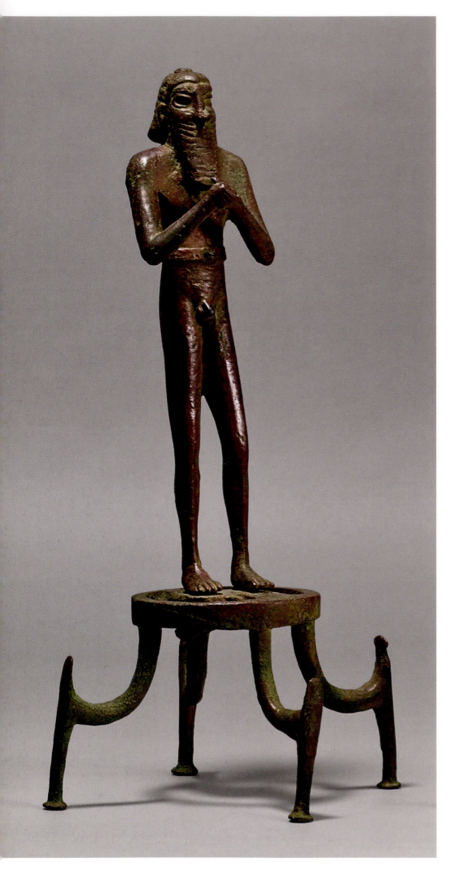

Metalwork

During the third millennium BCE, the urban centers of Mesopotamia produced or refined most of the metalwork techniques known in antiquity until the Roman era. The techniques of casting using the lost-wax method and with stone molds were both known to the metalsmiths of Mesopotamia. Both solid and hollow cast objects were made. Metal objects of copper or silver sheets were **hammered** and worked into tools or used in sculptures over a core of wood or bitumen, their surfaces then decorated with chased designs and inlays of colored stones. Wrought and cast objects convey spectacular and skilled craftmanship as well as a remarkable knowledge of the technologies of metallurgy at this early date.

Nude males depicted as tall, slender, long-limbed figures [**3.13**] are naturalistically modeled in a different way from the stone statues, although they date to the same period and are found at the same ancient locations. The figures are completely nude other than an elaborate belt tied at the waist. They may represent people or heroes similar to those in the images on contemporary cylinder seals (see p. 54).

A copper statuette of a charioteer from Tell Agrab (near ancient Eshnunna) may have been a votive offering [**3.14**]. In this small work, movement is conveyed by the angle of the charioteer's skirt drawn backward and away from his legs as he stands upon the treads above the axle, holding the reins and steering the animals forward. The four onagers (small equids related to the horse) that draw the chariot are not evenly placed, giving a sense of randomness to their movement. This kind of work in metal shows

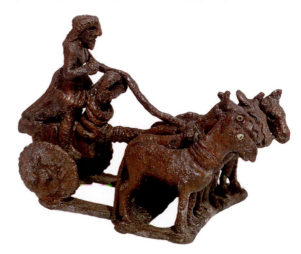

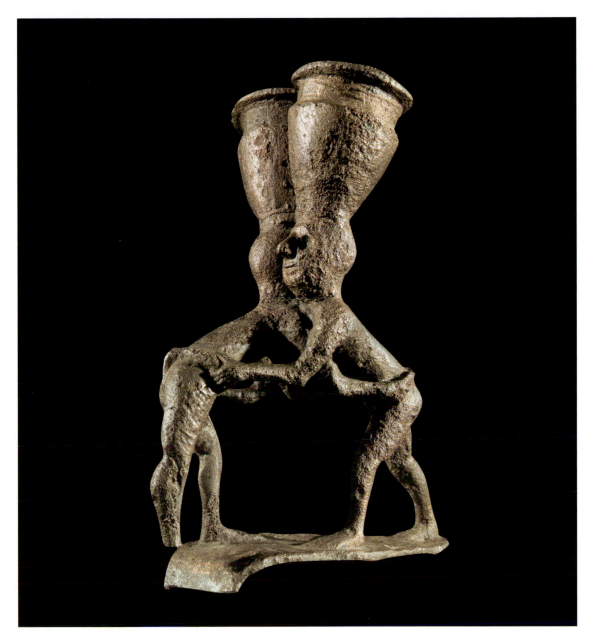

a greater focus on naturalistic modeling and the capturing of movement in space than work in stone. This difference can also be seen in the copper wrestlers, also from Tell Agrab, now in the Iraq Museum [**3.15**]. It may be that unlike the worshiper statues, which capture the perpetual presence of the person in steadfast prayer, here the activity of wrestling itself is conveyed and offered to the divine as an expenditure of energy.

A large foot cast in copper, found at Tell Agrab, which must have belonged to a life-size sculpture, indicates that metal was used in large-scale sculptures, though few of these monumental works in metal survive. The distinctive forms of stone and metal sculptures in the Early Dynastic era are worth examining more closely. The two styles have little in common and do not seem to belong to a shared approach, but were each influenced by the material used—whether metal or stone—the method of manufacture, the modeling and casting processes used by the metalsmith or the carving method and visual forms of the stonecutter, as well as the function or use of the sculpture.

Architecture

Early Dynastic-era buildings are recognized by their most distinctive feature, the **plano-convex** brick, their most basic unit of construction. This type of brick, flat on one side and curved on the other, was produced with the use of a brick mold. **Corbeled** vaults made of roughly trimmed stone and arches made of plano-convex bricks were both used at this time, while roughly hewn stone was used for the foundations of buildings. Main temple shrines were usually raised on platforms, constructed of mud brick and continuously restored and rebuilt, one on top of the other, as part of a process of piety and preservation that expressed that piety. The temple was the bond of heaven and earth.

There was no standardized temple plan or design that was adhered to during the Early Dynastic period. In many places, the orderly tripartite plan for the innermost shrine of the temples that was prevalent in the previous Uruk era and earlier (see p. 44) was expanded and renovated continuously into the Early Dynastic era. Mud brick continued to be the most prevalent building material, at times with kiln-baked brick facades and stone steps, thresholds, and vaults. Elaborate decorative elements were added to the surfaces of walls and columns, using various materials—such as colored stones and mother-of-pearl—and temples had architectural sculpture of hammered and cast copper, as well as figural narrative **friezes** of contrasting white and dark stone.

A new type of plan also seems to emerge at this time that indicates some change from the previous archaeological levels and eras: the temple oval sanctuaries. Temple ovals existed at Khafajeh (ancient Tutub), in the Diyala region; at Tell Ubaid, near Ur; and at Tell al Hiba, ancient Lagash [3.16]. The temple ovals are so-called because of the monumental oval outer wall that enclosed the sacred precinct of the temple, a precinct that consisted of various shrines and buildings that served the gods. These structures included not only places for the worship and maintenance of the gods, but also administrative offices and craftsmen's quarters. At Khafajeh, the outer wall was 8 ft. 2 in. (2.5 m) in thickness and the inner wall was 13 ft. 1 in. (4.5 m). The oval covered an area of about 328 ft. (100 m) at its greatest length.

The Ibgal was a temple oval at the city of Lagash, dedicated to the goddess Inanna. First built by Urnanshe (c. 2600 BCE), it was rebuilt during the reign of his grandson Enannatum I. Although the superstructure of the Ibgal is not preserved, the foundations remain and give a clear sense of the layout and the method of construction. In the renovation, the lower walls of plano-convex bricks of the earlier building phase were incorporated into the renovated building's foundations. The floors and walls were removed, and the area was filled with new, clean earth. On top of this, a second foundation platform was built, and buried within it were foundation deposits. Each deposit consisted of a copper figurine and an inscribed stone tablet placed behind its head [3.17a, b]. The inscriptions stated that this was the Ibgal of Inanna, dedicated by Enannatum. It also stated that the copper figure was Enannatum's personal god, Shulutula, and that he will forever pray in the Ibgal for the wellbeing of Enannatum.

At Lagash, we learn a great deal about the Early Dynastic building techniques. The walls of many buildings were **buttressed**, and doorways were

3.16 The Ibgal of Inanna in Lagash was built by Urnanshe and rebuilt by his grandson Enannatum in c. 2450 BCE. We can see clearly the oval-shaped plan; the grid and triangular lines are the archaeologists' working map.

Temple structures

Oval enclosure wall

Temple structures

N

0 80 ft.

0 20 m

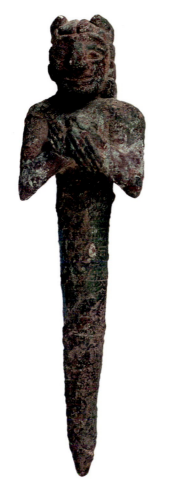

surmounted by wooden lintel blocks or with brick arches built as **true arches**—usually referred to as Roman arches, these were in fact already used by the Sumerians. For walls, plano-convex bricks were laid on edge and leant diagonally against one another in alternating directions, thus creating a herringbone pattern on the face of the wall. Roofing was composed of palm trunks and reeds plastered with clay.

A temple, called "house of the god" in Sumerian, included many rooms and facilities that one might expect to find in a large household or palace at this time, such as kitchens for cooking, breweries for making beer, and workshops of various kinds, where everything was prepared for the maintenance of the cult statue and the household of the god. The main naos, or cella, the shrine of the god, was a rectangular room, with an entranceway at the end of one of the long walls, so that access to this holiest of rooms required turning ninety degrees in order to approach the god: one could not walk in and face the god directly. Inside this room, alongside the walls, benches or tables were built upon which the worshiper statues could be placed, so that the person represented in the statue would be present for all time in front of the god. As the worshiper's essential identity or spirit was personified and embodied in the image, the statue permitted a constant communication with the divine presence of the cult statue within the sacred space of the naos. It is clear, therefore, that the religious practices of the Sumerians were inextricably tied to representation.

The temple furnishings made from brick, and the altars, tables, and benches that were built within the shrines, were whitewashed as part of a regular ritual of purification. After a time, the layers of plaster and white paint became so thick that movement was actually hindered. Access to the holiest rooms of the temple was clearly restricted: the spaces into the inner shrines did not allow for large groups of people to move around, or enter and exit the naos. The idea of upkeep was applied to the worshiper statues placed within the shrine as well. Many of the excavated examples show signs of breakage and

3.17a, b Foundation figure representing Shulutula, the personal god of Enannatum I; in situ with its inscribed brick at Tell al Hiba, Iraq, c. 2450 BCE. Foundation figure: arsenical copper, h. 10 in. (25.4 cm)

3.18 The White Temple at Umm al Agarib (*c.* 2400 BCE) is one of the most remarkable buildings of the Early Dynastic period. Its monumental entrance court, massive almost 10-feet-thick (3 m) walls and huge columns were all plastered with white gypsum. Umm al Agarib may be identified as ancient Umma.

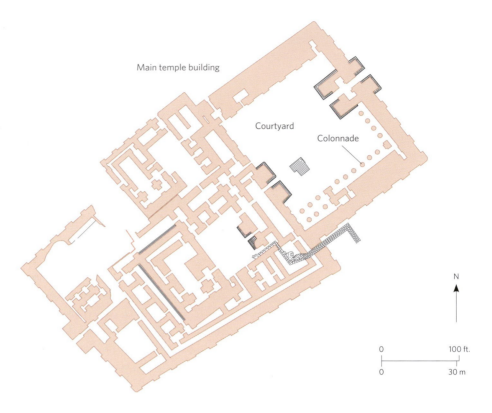

Main temple building

Courtyard

Colonnade

N

0 100 ft.

0 30 m

repair made in antiquity, while they were in use, placed upon the temple furnishings in front of the god. When at a certain point the statues had to be removed, they were buried within the sacred ground of the temple, or even within the offering tables, or used in the construction of the temple installations as building materials. This last practice may seem to lack reverence, but it permitted continuity within the sacred space, even though the statues were unseen by any human eye.

At Umm al Agarib in southern Mesopotamia, excavations have revealed a number of large-scale public buildings, including a large temple built of plano-convex bricks, which the excavators called the White Temple [**3.18**]. Seventeen massive columns [**3.19**] each had a diameter of 5 ft. 3 in. (1.60 m), and the tallest had a **surviving height** of 7 ft. 5 in. (2.25 m) made of brick and plastered with a white gypsum plaster, which created a shaded colonnade at the east and south side. Some of the columns were molded to resemble palm tree trunks. A large palace with brick columns was also discovered here. A foundation inscription

3.19 Photograph of excavation in 2001–2 of the White Temple at Umm al Agarib, Iraq, *c.* 2400 BCE.

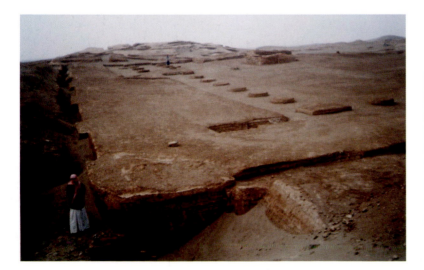

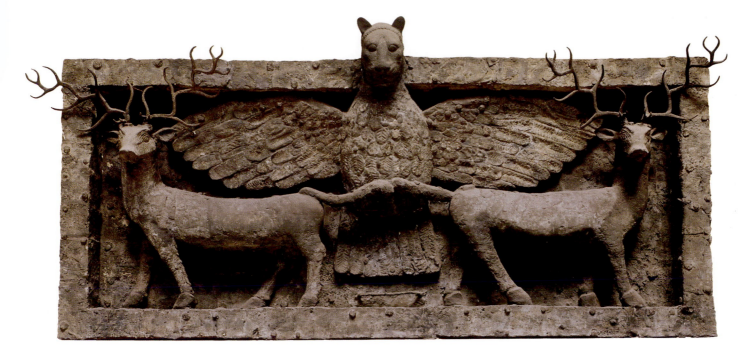

uncovered in the area of the temple records the battle between Lagash and Umma in the reign of Enmetena, thus giving a date of about 2400 BCE.

The identification of certain large buildings as palaces is uncertain, but at Kish, two edifices enclosed by a large buttressed wall were identified as Palace A.

At Nagar (modern Tell Brak in Syria), a large building with curved walls has been identified as an administrative building; and in the city of Lagash a large administrative building was uncovered where a number of texts mention the names of the most important kings of its dynasty (see chapter 4, fig. **4.23**, p. 107).

According to legend, the goddess Ninhursag was also known as Ninmah. When her son, Ningirsu (also known as Ninurta in Akkadian literature), defeated the demon Asag and his army of stone allies, he built the mountains of stone and gave his mother a new name: the lady of the mountain. Her association with her son, the warrior and storm god, would thus explain the iconography of this god at her temple.

According to a stone foundation tablet found there, A'anepada king of Ur was the patron of a temple built at Tell Ubaid for the goddess Ninhursag, the lady of the mountain, who was also known as the mother of the gods. This temple was elaborately decorated with columns that had surfaces covered with a mosaic design, and large-scale architectural sculpture adorned the upper parts of the building.

A sculpted panel from the temple made of copper and limestone depicts a scene of people milking and participating in other farming activities, perhaps associated with Ninhursag's role as a goddess of fertile land. The bodies of the calves on the frieze are carved in relief, while their heads were cast separately in copper and attached. The relief **frieze**, which must have originally been placed high up on the exterior wall, was found buried near the temple.

A heraldic panel of a lion-headed eagle flanked by stags [**3.20**] was found at the same temple, where it must have been used to decorate the lintel on top of a main entranceway, perhaps supported by the mosaic columns. The relief composition is made of a large panel of hammered and cast copper alloy. It represents the Imdugud bird of Ningirsu (the storm god) and two stags. The heads of all three animals are cast separately and attached to the rectangular panel. The lion head and stag horns protrude from the confines of the frame, bursting into the space of the viewer. When the panel was in place high up on the temple **entablature** and viewed from below, the Imdugud bird would appear to look down upon those who entered the sanctuary.

3.20 The Imdugud Relief, from Tell Al-'Ubaid, Iraq, Early Dynastic III, c. 2500 BCE. Copper-alloy on bitumen, with fragments of lead, 3 ft. 6 in. × 8 ft. 6⅜ in. (1.07 × 2.6 m)

Architectural Ritual

During the Early Dynastic period, the building of a temple was decreed by divine command and was considered one of the most important acts of a Mesopotamian ruler. Later texts indicate more clearly how the processes of building required intricate rituals. The **ground plan** and location for the building was revealed by the gods through **divination** or dreams, which were seen as omens, and the foundations were then laid down and ritually secured in place with nails, cones, or pegs that were made in anthropomorphic form known as **foundation figures** [**3.21a**]. These foundation figures were often cast as the image of the ruler or of his personal god, their lower body in peg form in place of the legs. The statue was then placed within the foundations of the temple with an inscribed tablet [**3.21b**], literally pinning down the foundations, and sometimes driven through the center of the inscribed stone tablet. Numerous foundation figurines have been found at such cities as Lagash, Girsu, Uruk, and Adab: this highly distinctive genre of images was created for the sake of monumental buildings in the south of Mesopotamia.

A limestone relief of Urnanshe of Lagash, from Girsu [**3.22**], represents the commemoration of an architectural ritual related to temple building. We see two registers of figures separated by a ground line on the right side of the plaque. On the upper left stands Urnanshe, the ruler of Lagash. Clean-shaven and clothed in a fleece skirt, he

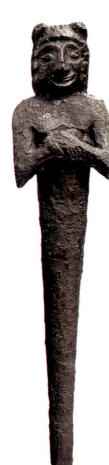

3.21a, b Foundation peg and tablet of Enmetena, from Girsu, Iraq, Early Dynastic IIIb, c. 2400–2250 BCE. Peg: copper alloy, h. 13¾ in. (35 cm). Tablet: alabaster, with cuneiform inscription in Sumerian

carries a workbasket with earth on his head from which the mud is taken to make and then to lay down the first archetypal brick for the temple of Ningirsu in Girsu. Standing before him we see a row of his children, each labeled by name. The first one is a girl called Abda, the second one is Akurgal, who would later become Urnanshe's successor as ruler of Lagash, followed by three more sons. In the lower part of the relief we see Urnanshe again, but this time he is seated and holding a cup in celebration of the completion of the building. Next to the seated Urnanshe the standing figures are labeled as Sagantuk the Cup Bearer behind the throne and Balul the Chief Snake Charmer before him, followed by three more sons of Urnanshe. What we have here is two moments in time: above, before the laying of the first brick, and below, the completion of the act, which is celebrated and also recorded in this dedicatory plaque in both image and inscription.

The inscription in the Urnanshe plaque identifies the figures, lists the temples he commissioned, and describes the lengths to which Urnanshe went for his building campaign. On the right side we are told that he had ships sent to Dilmun (modern-day Bahrain) in order to transport timber from foreign lands and bring it to Lagash. The inscription is not neatly organized and squared away into its own area but scattered across the relief, interspersed between the figures and placed upon their bodies. The relief sculpture is thus one that is composed equally of words and images, both a text and a visual narrative scene, a tablet and monument. It breaks the boundaries of what we might expect of an artistic genre. The use of the text is also linked to the images in interesting ways. The courtiers and children of Urnanshe are labeled clearly and individually, whereas the ruler himself is not. Instead, he is surrounded by the literary description of his acts above and below. Each lengthier segment of text envelops the body of the ruler and begins with the declaration "Urnanshe, king of Lagash" followed by his accomplishment. His label thus extends from the image and spills into the background spaces of the relief, covering every surface that is not

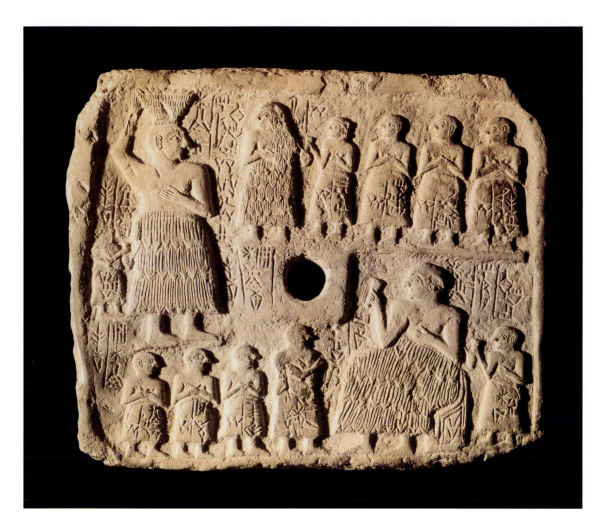

3.22 Relief of Urnanshe of Lagash, from Girsu, Iraq, Early Dynastic IIIa, *c.* 2600 BCE. Limestone, h. 18½ in. (47 cm)

This kind of square plaque, perforated in the center, was attached to the wall of the temple by means of a clay or stone peg inserted into the perforation. The nail heads were either semi-spherical or carved into the heads of animals. These square or rectangular stone relief plaques often represent a banquet scene or offerings being given to the gods.

otherwise sculpted with an image, and creating the type of artwork—referred to by art historians as an **image–text dialectic**—in which both text and image construct the meaning of the work.

In the cities of the Early Dynastic era, remarkable changes took place in the realms of sculpture and architecture. There was an extraordinary increase in the number of votive images of men and women, the images of the self that were placed before the gods in perpetual prayer. These statues were connected to their sacred locations within the temple: after their initial use, they were buried there, indicating the strong ties between the function of images and their architectural context within the city. At the same time, architectural techniques and rituals developed, as increasingly monumental buildings were built as households for the gods. Some of the Sumerian architectural rituals required the interring of images within the sacred ground, meant to remain there in perpetuity. In chapter 4, we will consider the Early Dynastic arts related to death and the afterlife, the invention of the first historical public monument, and the making and uses of cylinder seals.

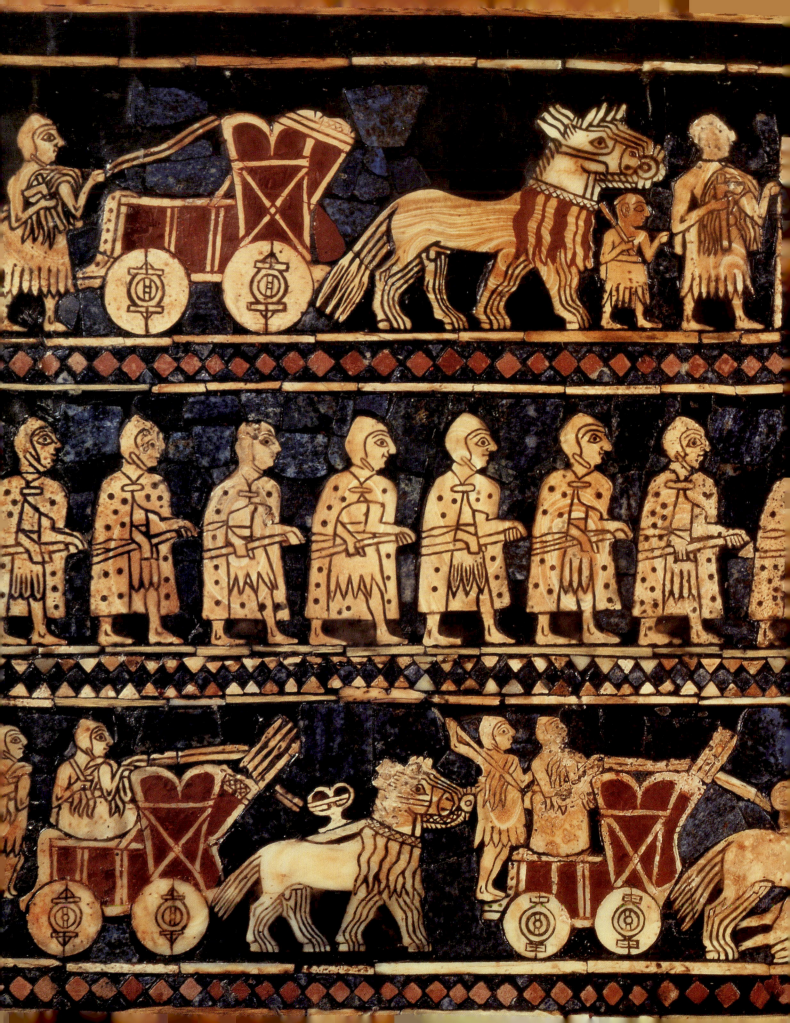

CHAPTER FOUR

Early Dynastic Sumer: Art for Eternity

Detail from 4.11b Royal Standard of Ur, from tomb 779,
Ur, Iraq, Early Dynastic IIIa, 2550–2400 BCE. Lapis lazuli,
red limestone, 7⅞ × 18½ in. (20 × 47 cm)

4 Early Dynastic Sumer: Art for Eternity 2900–2334 BCE

Periods	Jemdet Nasr: 3150–2900 BCE
	Early Dynastic I: 2900–2750 BCE
	Early Dynastic II: 2750–2600 BCE
	Early Dynastic IIIa: 2600–2400 BCE; Early Dynastic IIIb: 2400–2334 BCE
Rulers	Queen Puabi and King Meskalamdug
Major centers	Ur, Mari, Lagash, Girsu, Umma
Notable facts and events	Evidence of human sacrifice at Ur
Important artworks	Ushumgal stele
	Royal Standard of Ur
	The great lyre from the death pit of King Meskalamdug is one of the earliest examples of a stringed musical instrument from anywhere in the world
	The Mari treasure
	The stele of Eannatum of Lagash is the earliest known historical public monument
Technical or stylistic developments in art	Jewelry and goldsmithing techniques develop
	By the Early Dynastic era, cylinder seals are even more widely used; seals become personal items; earliest use of the term "seal carver" in Sumerian
	Lapis lazuli is especially favored for seal stones, 2600–2334 BCE

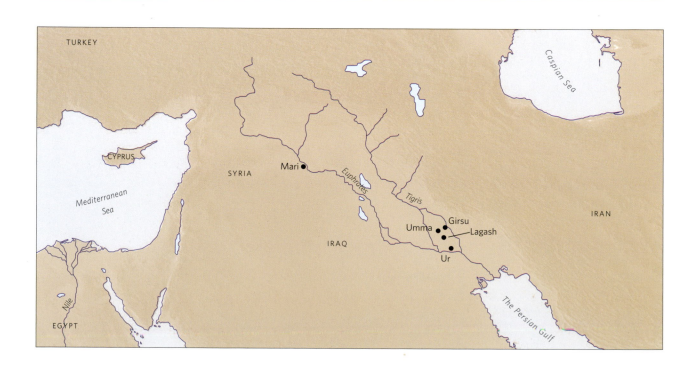

4 Early Dynastic Sumer: Art for Eternity

The Early Dynastic city states were bustling urban centers in which temple and palace architecture grew increasingly complex, and involved ever more intricate building rituals and grand designs, as we have seen in chapter 3. The temples were filled with statues of people, worshiper figures that began to appear in astounding numbers and are some of the earliest images representing people of the community. In this chapter, we will consider works of art, jewelry, and other precious objects made for the remarkable tombs of the Royal Cemetery of Ur in the middle of the third millennium BCE. The excellence in craftsmanship and technologies used for these works is especially noteworthy; the same jewelry-making and goldsmithing techniques were still used centuries later, in the art of European and Islamic traditions. The works found in the Royal Cemetery also reveal clear links between Mesopotamian city states, including the city of Mari (in modern-day Syria), where developments in the arts occurred at the same time as in the southern cities. We will then turn to another Mesopotamian innovation in the history of art and architecture: the historical public monument.

The Art of Death: The Royal Cemetery of Ur

We would know far less about the arts of Early Dynastic Sumer if it were not for the incredible discovery made by the British archaeologist **Leonard Woolley** and his team in the 1920s at the ancient city of Ur in southern Iraq [**4.1**, see p. 88]. More than a thousand graves were uncovered here dating to the Early Dynastic IIIa (2600–2450 BCE), including a number of rich tombs of the rulers of Ur, filled with spectacular treasures of gold and silver gifts, exquisite jewelry, and even a vast human sacrifice of retainers and courtiers who went to their deaths with the principal owners of the tombs. Some of those interred in the most elaborate tombs were members of the royal family, buried with large numbers of attendants, including harpists and singers, charioteers and soldiers. In one tomb, seventy-four attendants had been buried along with the main body. Often, these attendants were found with a small cup or goblet by their side, as if they had been drinking right before the moment of death, leading archaeologists to speculate that they had willingly drunk poison.

The elaborately made precious objects included in the tombs, such as musical instruments made of precious stones, wood, shell, and mother-of-pearl, and the personal attire and intricately made jewelry of the interred, were so marvelous, and the vast human burials such a macabre spectacle, that this archaeological find became a sensation in the British and American press [**4.2**, see p. 88]. Indeed, no excavation has excited as much public interest as the Royal Cemetery of Ur, other than the discovery of the pharaoh Tutankhamun's intact tomb in 1922. At the time, Ur fascinated the world of Europe and the Middle East even more than Egypt, because it was known as the birthplace of the biblical patriarch Abraham. When Woolley found the tombs he quickly sent a telegram to the museum at the University of Pennsylvania, with which he worked, but as he did not want the amazing news to be intercepted along the way, he wrote the telegram in Latin [**4.3**, see p. 89]. It said, "I found the intact tomb, stone built and vaulted over with bricks, of Queen Shubad adorned with a dress in which gems, flower crowns and animal figures are woven. Tomb magnificent with jewels and golden cups."

4.1 Leonard Woolley with foreman Hamoudi, photograph from 1930

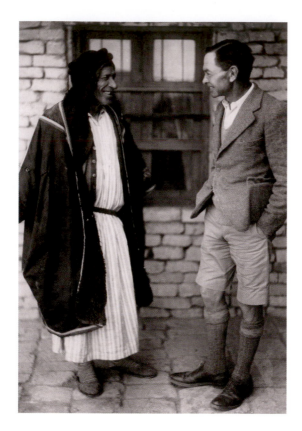

Below
4.2 Reconstruction painting of shaft tomb PG 789 at Ur, Iraq, from *The Illustrated London News*, June 23, 1928

Although there are examples from elsewhere in the world of rulers having been buried with their entourage of soldiers and courtiers, nothing like the Royal Cemetery of Ur has been found from other times and places in Mesopotamian history, so that it seems to be a segment of time in which human sacrifice somehow became acceptable to the **Sumerians**, and was considered appropriate for royal burial. For this reason, scholars still debate the meaning and the identity of this cemetery, and why such an extravagant sacrifice of goods and people was made here. Were these elaborate spectacles of death produced for the royal family of Ur? Were they rituals in honor of Nanna, the moon god and the patron city god of Ur, whose ziggurat still dominates the ancient city of Ur?

We know less about Sumerian rituals of death at this time and the offering of burial gifts with the body of the deceased than we would like (see box: Death and the Afterlife). At Ur, the cemetery Woolley and his team discovered was very large,

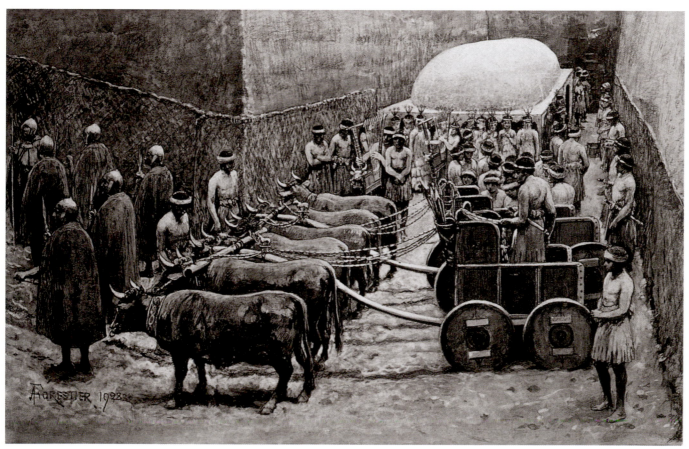

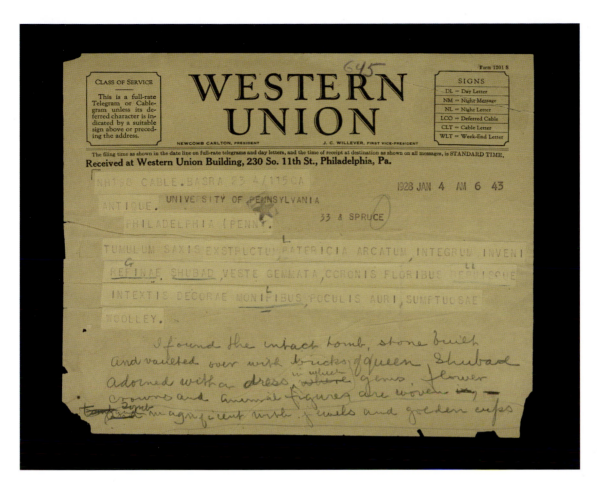

4.3 Leonard Woolley's telegram from Ur to the University of Pennsylvania, January 4, 1928

and was in use for three centuries, but not all the tombs there were royal or endowed with elaborate burial gifts and human sacrifice. Most of the hundreds of graves there were simple individual burials, including those of poor people as well as those of the wealthy. Only sixteen of the tombs Woolley discovered were differently made, with elaborate constructions of bricks, entrance shafts, and vaulting, and richly equipped with objects made of gold, silver, and gemstones. These sixteen tombs, constructed over the course of about one century, *c.* 2500–2400 BCE, were the ones filled with finely made objects of precious materials and containing numerous attendants dressed in rich attire and large amounts of jewelry. The names of at least some of the main occupants of these tombs were found, inscribed on some of the burial gifts, thus enabling the identification of some of those buried as members of the royal family of Ur, covering about four generations.

Royal Tombs and the Afterlife

In Tomb 800 [**4.4**, see p. 90] a woman was buried in a magnificent golden headdress made up of hammered leaves and gold ribbons, topped by a gold rosette crown [**4.5**, see pp. 90–91]. She also wore earrings and hair rings of gold and vast amounts of precious stones were placed upon her body. The woman is identified as Queen **Puabi** (in Woolley's time her name had been incorrectly read as Shubad), wife of King **Meskalamdug** of Ur, by means of a Sumerian inscription on a cylinder seal that was part of her attire [**4.25**, see p. 109]. Five men bearing daggers of copper were found at the entrance of the **dromos** of her tomb, the burial shaft that led to the stone tomb chamber. At the southern end of the shaft lay ten women wearing elaborate jewelry and headdresses. Some were carrying such musical instruments as a harp and a lyre. The rectangular tomb chamber contained four more bodies besides that of the queen.

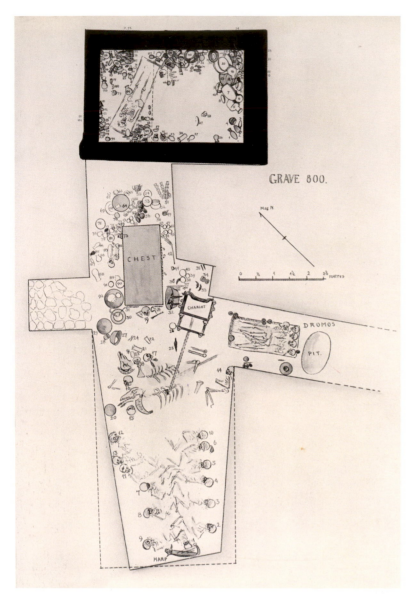

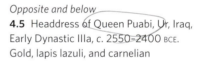

GRAVE 800.

4.4 Drawing by Leonard Woolley of tomb 800, Queen Puabi's burial, Ur, Iraq, Early Dynastic IIIa. Five armed men guarded the ramp that led down into the burial chamber, and the queen was also accompanied by two rows of lavishly dressed women and two oxen led by four men.

a helmet must have been reserved for ceremonial wear, rather than for utilitarian use in battle, and it is possible that the helmet was made specifically for use in death.

The tomb also included elaborately made weapons belonging to Meskalamdug [4.8, see p. 93]. One of them is a dagger with a solid gold blade and an attached handle of lapis lazuli, with gold **granulation** at the handle in a triangular pattern. The accompanying gold sheath is made of intricate **filigree** work, with additional gold granulation. The techniques of goldsmith work found on the objects at the Royal Cemetery at Ur, including **repoussé** and filigree, granulation, hammering, and chasing—all of which are known from later periods of jewelry making in the European Middle Ages and Renaissance and in Middle Eastern metallurgy of the Islamic era— are found here for the first time.

Opposite and below
4.5 Headdress of Queen Puabi, Ur, Iraq, Early Dynastic IIIa, *c.* 2550–2400 BCE. Gold, lapis lazuli, and carnelian

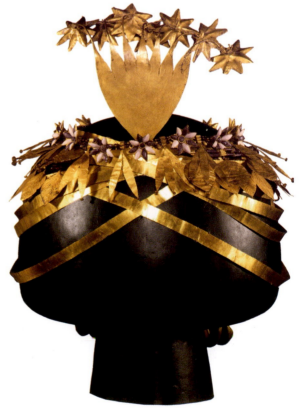

The tomb of the King Meskalamdug of Ur was richly equipped with war gear and royal attire made of gold, silver, and electrum (an alloy of gold and silver). It included a helmet [4.6, 4.7, see p. 92] wrought into the form of an elaborate braided hairstyle of long hair drawn into a chignon at the back, and held in place by a fillet (ribbon). It was made of sheets of electrum, hammered into shape from the inside outward, and then incised and chased on the exterior to depict the details of locks and waves of hair, and thick braids that were wound around the forehead. The perforations at the lower edges of the helmet permitted attachment to a layer of leather or cloth. Such

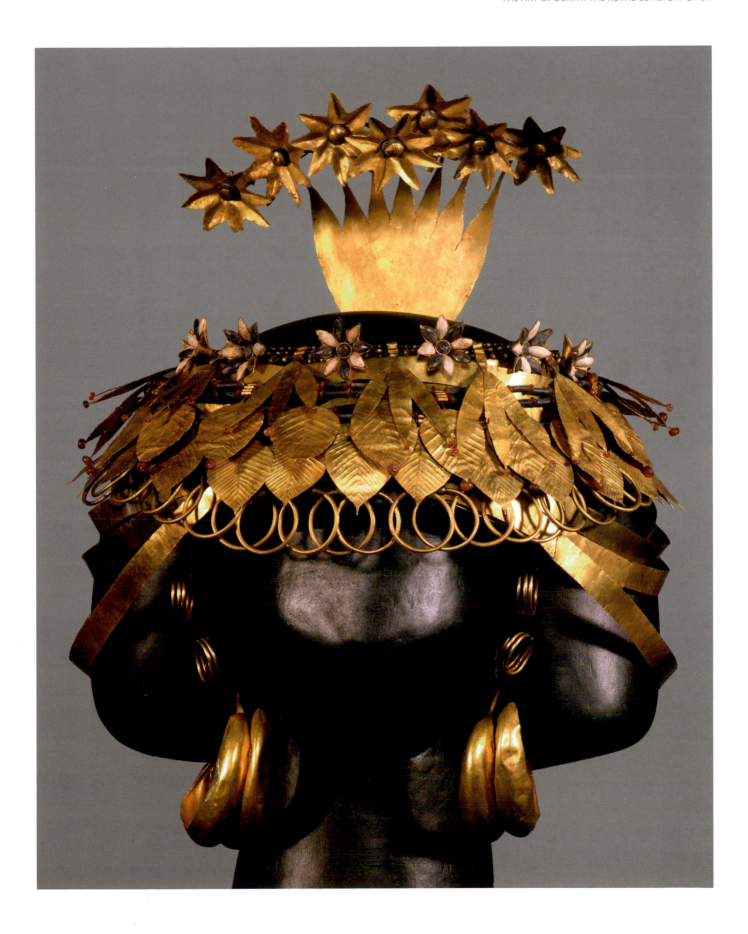

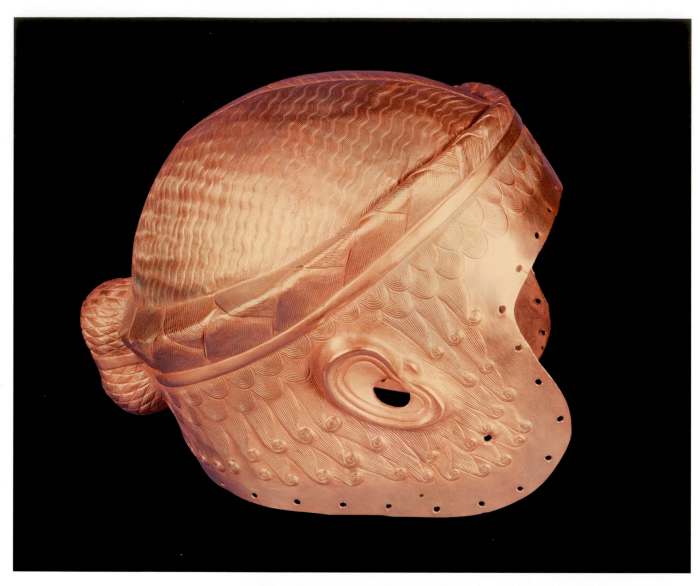

4.6 Helmet of Meskalamdug, Ur, Iraq, Early Dynastic IIIa, c. 2550–2400 BCE. Gold, h. 9 in. (23 cm)

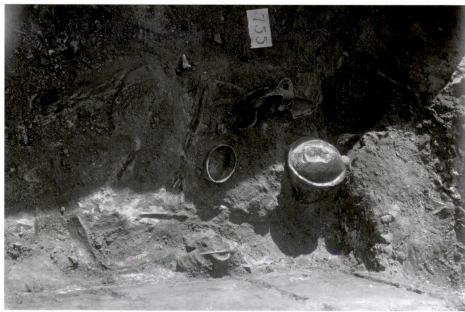

4.7 Photograph by Leonard Woolley of Meskalamdug's helmet in situ

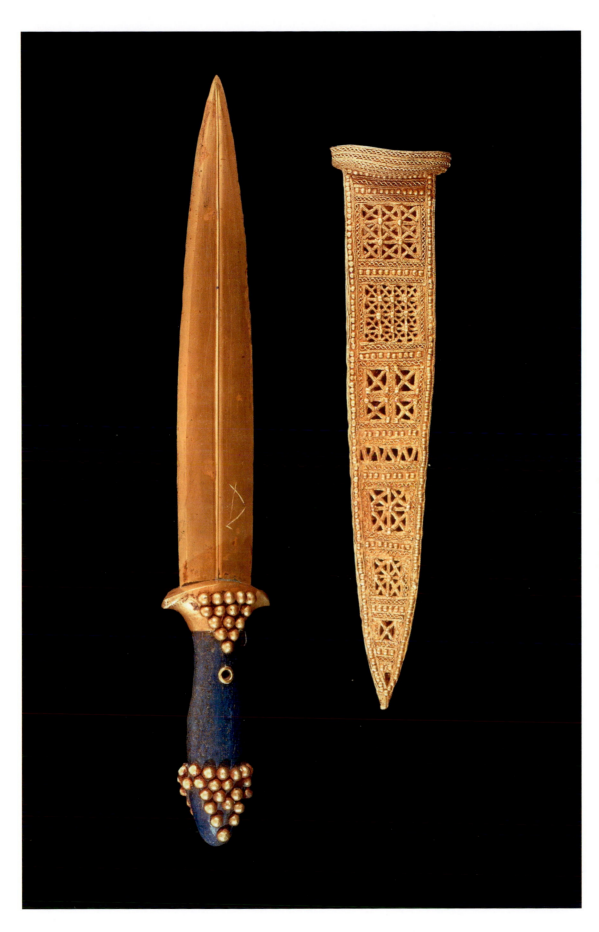

4.8 Dagger and sheath of Meskalamdug, Ur, Iraq, Early Dynastic IIIa, *c.* 2550–2400 BCE. Gold with lapis lazuli handle

The Goat in the Thicket Statues

The tombs of Ur were not only stunning in their inclusion of intricately made and technologically impressive jewelry, but they also contained some of the most remarkable examples of the representational art of the Early Dynastic period.

Perhaps best known are the two statues of male goats standing erect against golden branches topped with rosettes [4.9a, b, 4.10]. They were found as a pair in a large tomb at Ur, but are now divided between the University of Pennsylvania and the British Museum, the two institutions that had funded Woolley's excavations at Ur. These goat statues were once part of a stand, which carried something above them. They are made of various materials, a mixed media approach to sculpture favored by the Mesopotamians of all eras but which is clearest here in these Early Dynastic sculptures from Ur. In the goat figures, precious and exotic colored stones, such as lapis lazuli and red limestone; white shell; and sheets of hammered gold and silver were attached to a core of wood with bitumen. This mixture of metals, stones, and shell was worked individually to indicate parts of the anatomy and the fleece of the animals so that the color of the statue was not applied in pigment or paint, but was assembled as part of the materiality of the statue itself.

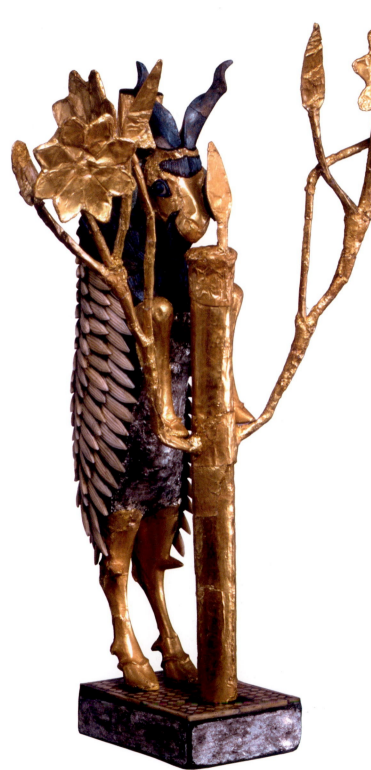

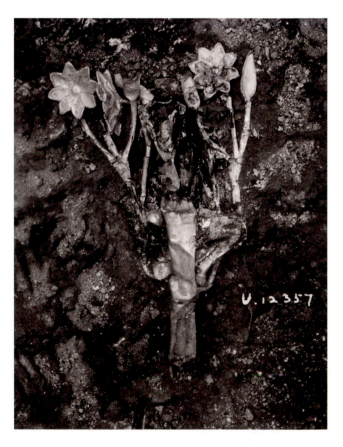

U.12357

Burnished metal and polished worked stone create brilliant surfaces: legs of gold, underbellies of silver, copper ears, fleece of shell and lapis lazuli. They also contain within them, as constituent fabric—stone, metal, or shell—values and powers that the Mesopotamians thought were inherent to these materials, mystical powers that they were given by the gods at the moment of their creation. As materials, they decorate and form the sculpture, but they also impart life and infuse the image with the numinous.

The goats are not simply decorative or farmyard animals in this context of the tomb. They are clearly related to fertility and reproduction, both by means of their animal nature and through their **iconographic** details. A gold penis sheath and golden testicles are preserved on the British Museum goat, indicating clearly that it was male. The rosettes on the branches are emblematic of the goddess of love, Inanna, so that the male element of the goat and the feminine aspect of Inanna are literally intertwined here. But who were the viewers of these shimmering and finely wrought statues? Were these treasures seen in a ceremony before burial, and by whom? Or were they intended as gifts, brought into another world to ease the transition of death? Until the moment of death, the attendants and courtiers buried with the main royal bodies seem to have been participating in a ceremony that included what must have been ritual procession, music, and song.

The Royal Standard of Ur

A wooden rectangular box, inlaid with a figural mosaic design of shell, lapis lazuli, and red limestone, was found in a fragmentary condition in the death pit of a grave, close to the shoulders of the man who carried it at the moment of death. Woolley had identified the object as a standard carried on a pole by the man, but that identification is now questioned. Now restored, the long side panels of this box-shaped inlaid object represent two main scenes, each subdivided into three registers. On one side [**4.11a**, see p. 96], we see the banquet celebration scene. It depicts people drinking and musicians playing stringed instruments above, with the image of the Lugal, the king, at the far left, recognizable by his elaborate tufted skirt and his slightly larger size. Below is a peacetime scene of people in

[4.11a, see p. 96]

Opposite

4.9a The ram is one of a pair; both statues were found in the Royal Cemetery, and this one is now located at the University of Pennsylvania Museum of Archaeology and Anthropology, Philadelphia. The goat standing upright next to a rose bush has often been described as "Ram Caught in a Thicket," because of the biblical reference in Genesis 22:13 thought to fit this sculpture.

4.9b Photograph of the ram in situ, as excavated by Leonard Woolley in 1928/29.

Left

4.10 The Ram in the Thicket, from the Royal Cemetery, Ur, Iraq, Early Dynastic IIIa, 2500 BCE. Wood, silver, shell, red limestone, lapis lazuli, gold, h. 18 in. (45.7 cm), located in the British Museum, London.

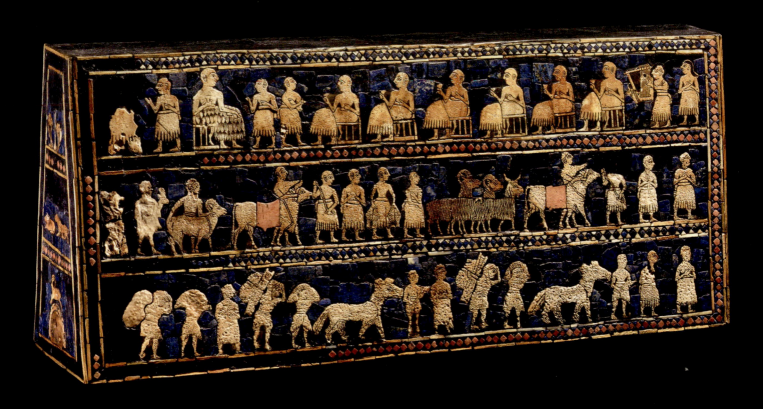

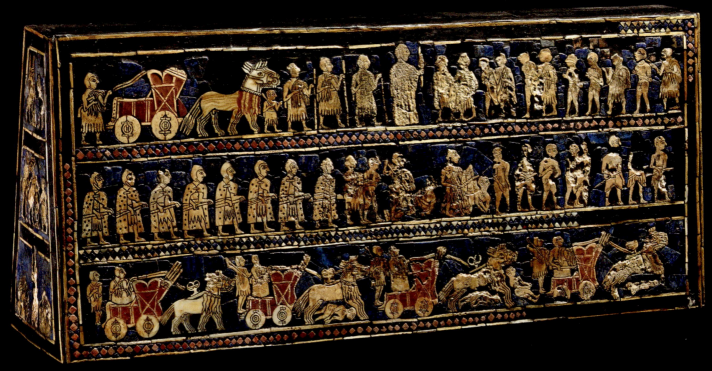

4.11a (top), **4.11b** (bottom) Royal Standard of Ur, from tomb 779, Ur, Iraq, Early Dynastic IIIa, 2550–2400 BCE. Lapis lazuli, red limestone, 7 7/8 × 18 1/2 in. (20 × 47 cm)

a procession bringing domestic farm animals forward, perhaps to the palace.

On the opposite side [**4.11b**], soldiers and charioteers are depicted moving toward the right, the onagers that draw the spear-laden chariots forward treading over the bodies of dead and naked enemies. In the middle row, soldiers in cloaks and helmets carry spears and lead prisoners of war forward, some of them depicted with cuts and wounds on their bodies. There is no other differentiation between the soldiers and the enemies; only their nudity conveys the defeat and utter subjection of these fellow human beings, who in the uppermost register are brought before the ruler, the Lugal, or king. The Lugal, whose title means literally "big man," is depicted in the center of the top register at a slightly larger scale than the other figures. He is not so much larger as to be unbelievably different from his troops, but stands out among the men by his size, the scepter that he holds, and his long dress and mantle.

Taken together, the two sides are understood as representing war and peace, the king in his aspect as military leader and as benefactor of his people. The mosaic technique of the Royal Standard uses small pieces of lapis lazuli for the dark background, pale shell for the figures of the men and onagers, and red limestone for the chariots and other decorative details.

Music for Death

A magnificent lyre, more than 4 feet (1.4 m) long [**4.12**], found near the attendants in grave 789, called the King's Grave by Leonard Woolley [**4.13**, see p. 98], is one of the most famous objects from Ur because it is one of the earliest examples that we have of a stringed musical instrument from anywhere in the world. The lyre, now in Philadelphia and one of several found in the tombs, along with many other musical instruments, such as harps, pipes, drums, cymbals, and sistra, was a complicated and

4.12 The Great Lyre, from the death pit of King Meskalamdug, grave 789, Ur, Iraq, Early Dynastic IIIa, *c.* 2550–2400 BCE. Gold silver, lapis lazuli, bitumen, and wood, 4 ft. 7⅛ in. (1.4 m) long

advanced musical instrument with eleven strings each producing a different sound. Other lyres from Ur are now at the British Museum and in Baghdad. It was lying near three bodies of women, who were the most elaborately dressed and coiffed of all the attendants in the tomb chamber. They were the musicians and singers who took part in the death rituals, and may have been the singers of laments or funerary dirges, types of song that we know existed from the Sumerian textual record. But it is not clear whether these musicians collapsed and died during the ritual, or if the lyres were placed on top of the bodies when the musicians died in a theatrical staging of an event. These and many other questions regarding the cemetery remain unanswered.

The sound box or body of the lyre has a bull's head made of precious materials attached to a wooden core. On the front side of the sound box we see four inlaid scenes of shell set into the wood with bitumen. At the top, a long-haired nude hero grasps two upright rearing human-headed bulls, all of their faces depicted in a frontal, direct way, gazing outward at the viewer, while the body of the hero is in partial profile. This grouping seems to stand over the other scenes, both physically and spiritually. In the three registers below this scene, we look into a fantastic world of animals acting as humans. A lion carries a vase and a libation cup, and a jackal or hyena, carrying a dagger at his belted waist, stands before an altar laden with animal parts; an ass or an onager plays a harp or lyre with a sound box in the shape of a reclining bull, exactly like the lyre on which these images are depicted; and a scorpion man and a goat carry drinking vessels. The lyre therefore depicts itself as part of the fantastic world of the supernatural, the image underscoring its function. This image on the front side of the lyre can be described as a hypericon, a type of self-conscious and self-referential image that is distinctive of Mesopotamian art, a visual effect that implies that the ancient artists wanted to underscore the power of representation. This kind of doubling of image and object tells us that even at this early stage in Mesopotamian history artists had been thinking attentively about the power of representation and how it works. Again the question of viewership and use of these finely made objects arises. How is it that such carefully thought-out works that combine the most skilled craftsmanship and complex representation were made for burial, never to be seen? Were they first used in life and then buried with the dead? Or were they a genre of artworks that we can only understand as the art of death? In either case, the finely worked precious materials and images at Ur must lead us to reconsider and expand the notion

4.13 Drawing by Leonard Woolley of grave 789, Ur, Iraq, 1934. This drawing shows the placement of skeletons in the dromos.

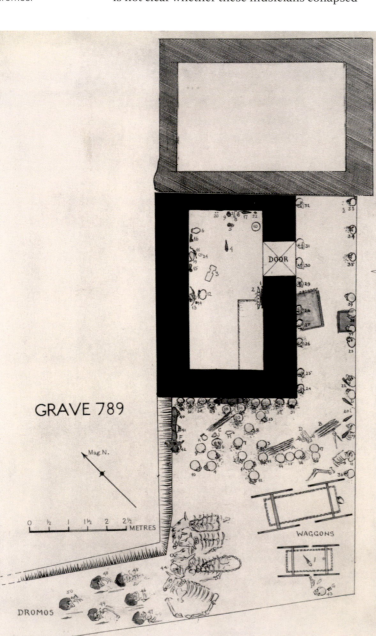

GRAVE 789

Mag.N.

0 ½ 1 1½ 2 2½
METRES

DOOR

WAGGONS

DROMOS

Death and the Afterlife

The astounding burials of the Royal Cemetery of Ur are unique in the archaeological record of Mesopotamia, and even among its royal tombs they stand out as the most opulent and sumptuous displays of funerary goods. In contrast, most ordinary people were buried in simple graves with only a few offerings of ceramics, strings of beads and pins, and perhaps a cylinder seal. Throughout their history, Mesopotamians practiced interment, either in cemeteries or beneath the floors of houses. They made libation offerings of food, drink, and oil to the dead, which they poured into the ground through clay pipes so that their spirits would have something to consume. Unlike the ancient Egyptians,

Mesopotamians had a bleak outlook on the afterlife. Death was final, as it led to "the land of no return," the Sumerian name for the underworld, a place below Earth where the dead consume dust and clay in utter darkness. The underworld is ruled by the gods **Ereshkigal**, the queen of the dead, and her husband, **Nergal**, who are assisted by gatekeepers, scribes, and messengers of the underworld. The Mesopotamians, unlike the Egyptians, believed in no judgment of individuals upon death. Their names were simply called by Ereshkigal, and written upon a tablet by her scribe Geshtinana. What was important to them was having descendants who would take care of them in the afterlife.

of spectatorship in relation to the visual arts of antiquity. While contemporary art historians often place a great deal of emphasis on the role of the viewer or the spectator, in ancient Mesopotamia, art was often made never to be seen (for example the foundation figure in chapter 3, p. 82).

The Mari Treasure

Another important discovery related to the Ur cemetery and the people buried within it was made at a city in the north of Mesopotamia, at Mari in eastern Syria. A large jar filled with a number of finely made works of sculpture and other objects was found buried beneath the floor of a courtyard in the palace there. Two small bowls had been used as a lid to cover the jar. Inside it, someone had placed more than one hundred objects, including gold jewelry, beads and amulets, carved **seal stones**, and small statues. The treasure contained one elongated eight-faceted lapis lazuli bead inscribed with the name of Mesanepada, the king of Ur [4.14]. Mesanepada was the son of Meskalamdug whose tomb was among those found at Ur, thus linking the treasure to the city of Ur in the south of Mesopotamia and the fabulous remains of the Royal Cemetery there. Perhaps the cache of treasures had been a gift from the king of Ur to the king of Mari, or perhaps

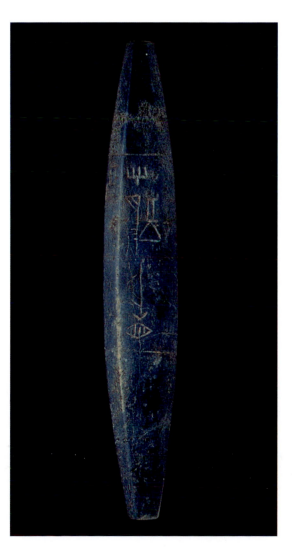

4.14 Bead inscribed with the name Mesanepada, from Mari, Syria, Early Dynastic IIIb, c. 2400–2250 BCE. Lapis lazuli, h. 4⅞ in. (11.8 cm)

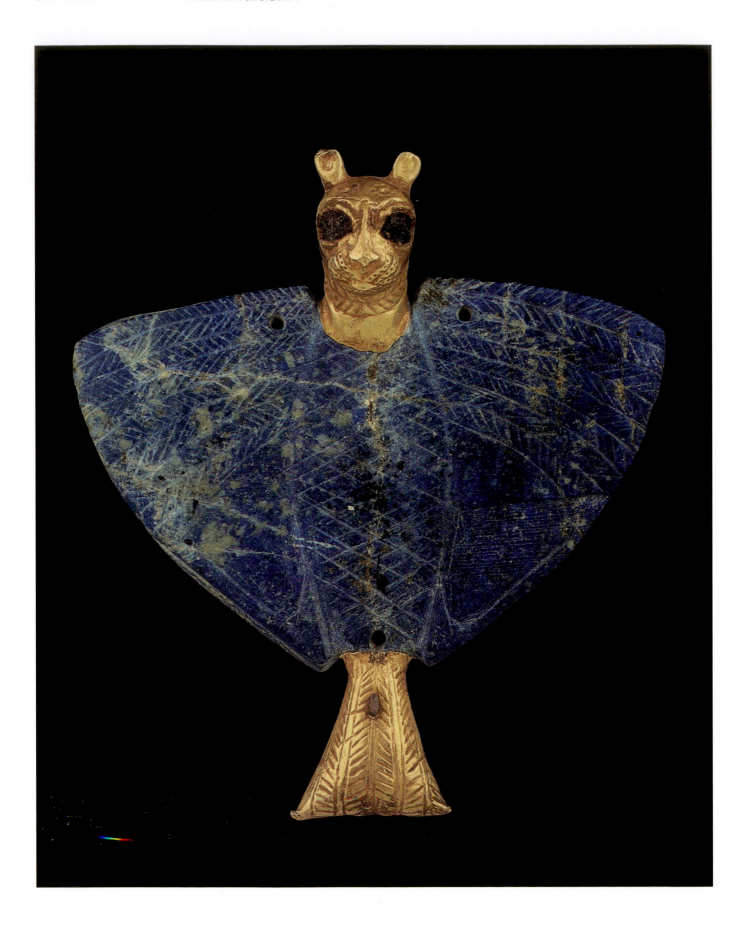

the treasure was made in Mari and intended as a gift to be sent down to Ur. Whatever the intended ownership or gift giving may have been, a closer look at the methods of manufacture and the style and techniques used indicates that the collection of objects had been of varied origins, rather than all being made in one place.

The Mari Treasure is of importance for our chronological knowledge of the ancient world, because it ties the city of Mari in northern Mesopotamia with the city of Ur in the south, and allows archaeologists to date the Mari palace (underneath which the treasure was found) to the same time as the kings buried at the Royal Cemetery of Ur. It is also interesting to consider this treasure as a whole. Why were these objects brought together and buried here? Where were they made? Were they intended as a collection to be used as some kind of sacred offering or were they kept for the market or use value of the materials, perhaps to be reused in other ways? These are questions that are still being studied and debated in Mesopotamian scholarship.

A lion-headed eagle of lapis lazuli and gold was among the objects buried in the Mari treasure [4.15]. It represents the legendary Imdugud bird associated with the god Ningirsu. The body is carved out of a single piece of blue lapis into the form of an eagle with outspread wings, its feathers indicated by incised lines. A head and tail of hammered gold on a core of bitumen were attached to the stone body with copper wires. The bird could have been displayed or worn as a pendant, or attached to another object by means of the perforations at its wings and tail.

Two of the most interesting objects in the Mari cache were nude female statues, one cast of copper alloy and another carved out of ivory. The copper statue represents a goddess, identified by the small horns that emerge from her head, a signifier of divinity in Mesopotamian art [4.16]. Her hair is overlaid with silver, and the hairstyle is held in place by a gold ribbon that circles her head. Lapis lazuli is used as an inlay for her eyes. The goddess is represented nude, in a frontal pose with her arms raised, and was originally holding some objects, perhaps the weapons of the fierce goddess

Inanna (Ishtar in Akkadian). The body is rendered in strong geometric lines that give a sense of powerful straight shoulders, and triangular hips and thighs that echo the straight line of the shoulder. The sculptor has emphasized the details of her body associated with the feminine: the narrow waist, with accentuated navel and nipples that must have originally held an inlay of bright stone, and the incised line of the vulva. As Inanna-Ishtar is the goddess of love, sexuality, and war, the figure's nudity combined with weapons represent all three aspects of her powers.

The small ivory nude that accompanied the copper goddess is entirely different in style [4.17]. The figure of the woman here is naturalistically modeled, and carved with rounded forms to portray her femininity. The small feet are also given special attention, with delicately carved toes. The figure holds her hands clasped in front of her, at her high waist. This is a gesture of

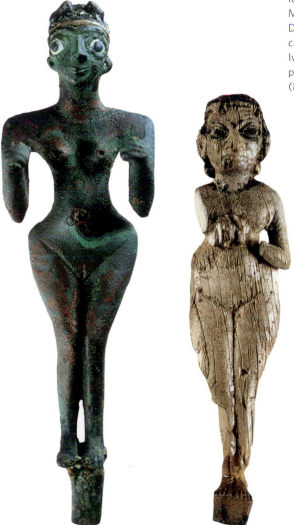

prayer and indicates that the figure is a mortal woman rather than a goddess. She has no horned crown, but an elaborate hairstyle that was painted with black, and inlaid eyes. A necklace was indicated by paint, with a small section of its clasp shown hanging at the back of her neck. This small statue was intended to be seen from more than one direction, as all the sides, front, and back are equally carefully worked. A small base below the feet indicates that the statue was placed upright, so it was perhaps intended as a praying votive figure. It is difficult to know whether these two statues were made at Mari or collected from the south of Mesopotamia and brought here. At some point, they came to be included with other objects and to be buried under the floor of the palace courtyard.

Inventing the Public Monument

Most of us are familiar with public monuments that stand in our cities and commemorate historical events, but it is in ancient Mesopotamia that the historical public monument was created for the first time. These monuments—called ALAM in Sumerian, *naru* in Akkadian, and victory **steles** in modern scholarship—are usually freestanding slabs of stone, limestone, basalt, or diorite. They are carved in relief on all sides and inscribed with texts. Names of rulers and historical events appear on these monuments alongside images that depict aspects of these events. Archaeologists use this information to reconstruct historical accounts, the histories of politics or warfare, and the chronological relationship of kings and their contemporaries, but the monuments are important in their own right. As a genre of art, a concept of commemoration, and the making of history by means of monuments, they stand at the beginning of a long tradition in which we still participate today. They were displayed either in an open court of a temple or in a public space in the city, or even, in some case, in an open field. At times, some of these steles were also kept in interior and less accessible places within temple precincts. They were monuments meant to stand for all time, a fact that is made clear by many of the surviving inscriptions on these works that come down to us.

The earliest public monument that we know of to date as a monument that was tied to a known historical event is the stele of Eannatum of Lagash, sometimes referred to as the stele of the vultures, now in the Louvre Museum [**4.18**]. The stele was carved and erected after the settlement of a border dispute between Lagash and the neighboring **city state** of Umma. At issue was a tract of land between the two states over which the two had disputed for some years until the defeat of Umma by Lagash. We only have the side of the story as it is told by Lagash, both from this and from other surviving inscriptions that verify the monument's story, and little information from the defeated city of Umma to counteract the claims of Eannatum that his war was justified and supported by the gods. The observation that history is written by the victors is already valid here.

The stele of Eannatum is in very poor condition, having been found in numerous fragments in the 1880s. Enough remains, however, to reconstruct a flat, worked stele, about 6 ft. (almost 2 m) high, with a semicircular top, completely carved on two sides with images and text representing two aspects of power, militaristic and divine. This is a victory in war that occurred at both the terrestrial and the celestial level. On one side we see a battle scene. In the top register, Eannatum is shown as a warrior in a battle, holding a battle-ax and leading his troops. They follow him in a military phalanx formation, appearing as a **cipher** for a large group of men, tied together by their singular task and their war gear of shields and spears. Advancing in an orderly manner, the troops march directly over the bodies of the dead enemies. In the second register, Eannatum, wielding a spear, leads the troops in his war chariot. Above, a group of vultures hovers in midair waiting to devour the dead. At the lower level of the stele, a fragment shows a libation scene, perhaps a post-battle victory celebration or a pre-battle entreaty to the gods. To the left of this scene is a pile of naked corpses. Several men bearing baskets on their heads climb the side of the mound of corpses to cover the heap with earth. On the opposite side

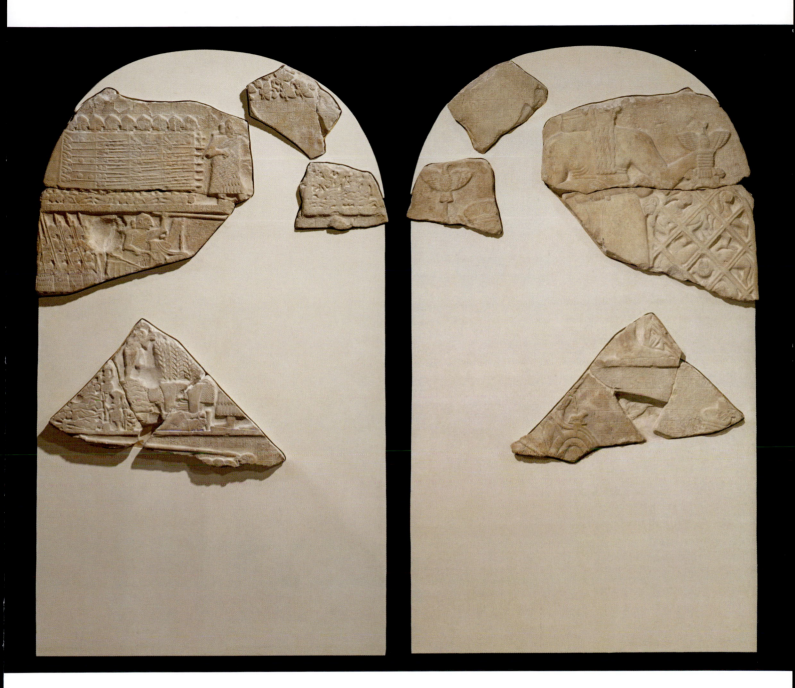

of the stele, a large bearded male figure dominates the space. This is the god Ningirsu, who grasps the lion-headed eagle and the mythical **Sushgal net** of the Sumerian gods, a battle net in which the dead and dying enemies of Lagash are shown defeated and trapped in the hands of the god.

The stele of Eannatum is a monument of a particular historical war, yet rather than simply commemorating the war, it is also a contractual agreement to terminate the war. It declares the

end of the battle and proclaims the geographical boundaries. A large part of the inscription bears oaths repeatedly sworn by the ruler of Umma on the battle nets of the gods that he will not transgress the boundary. The inscription is written across the whole of the relief, in between the figures, wherever there is any space not covered with image. Although the text and the images relate the same account, they tell the story in different ways. Some of the details of the long

4.18 Stele of Eannatum, from Girsu, Iraq, Early Dynastic, c. 2450 BCE. Limestone, h. 5 ft. 10⅞ in. (1.8 m)

narrative text appear in the images, but one does not illustrate the other. Here again, as in the Urnanshe relief and other works (see p. 83), there is a deliberate counterbalance of text and image that is used purposefully in a monument meant to stand for eternity.

One early and important example of a monument that creatively combines writing and images is the Ushumgal stele at the Metropolitan Museum of Art in New York [4.19]. The stele was purchased in 1958 (rather than excavated), so we know little about its original archaeological provenance and use other than what we can learn from the text. A four-sided block of gypsum, wider at the bottom than at the top, is carved with inset framed figures of men and women and covered with inscription. The Sumerian text records a land transaction, which includes the transfer of three houses, fields, and livestock. The main figure represented on the stele is a bearded and long-haired man who wears a long fringed skirt. A Sumerian inscription on the skirt identifies him as "Ushumgal the *pab-shesh* priest of the god Shara." Pab-shesh is a type of priest. He stands next to a building, perhaps the representation of a temple. Opposite to Ushumgal, on the side of the stele, is an image of a woman in profile. She wears a dress that covers her left shoulder and she holds a vessel. The text written along the side of her cloak identifies her as Shara-igzi-Abzu, the daughter of Ushumgal, and she appears to be a participant in the transaction. It is not clear whether the stele records a grant, a transfer, or a sale of these properties, but the prominence of the two figures of Ushumgal and his daughter is clear. They are the main participants in this transfer of property. Four more figures, three men and one woman, are depicted at a smaller scale on the other sides of the stele, and they too are identified by name and profession. The text is written across

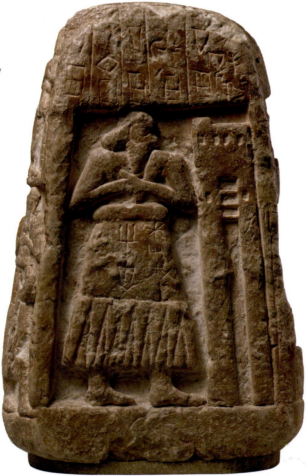
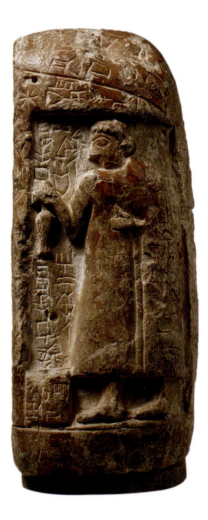

4.19 Stele of Ushumgal (view of two of the four sides), unknown provenance, probably from Umma, Iraq, Early Dynastic I, c. 2900–2700 BCE. Gypsum alabaster, h. 8⅞ in. (22.4 cm)

the relief, upon and in between the figures in several places.

The stele integrates and closely weaves together images and text on its surfaces so that we cannot easily classify it as either a textual document or a pictorial representation. The Ushumgal stele seems to **monumentalize** and make permanent, by means of the inscription in stone and the addition of images of the people involved, what is essentially a legal transaction. The end of the inscription is fascinating as it records the name of the person who carved it, "Enhegal the creator of the stele." This signature makes the Ushumgal stele the earliest work known in world history in which authorship or the name of the maker or artist is recorded. Other works of this era record the names of the scribes who wrote them, but Enhegal distinguishes himself by stating that he is the maker of the stele.

Seals and Sealings

By the Early Dynastic era cylinder seals became even more widely used, and it is also at this time that we begin to find information about the seal cutters who made them. Hard stones, such as obsidian, and exotic stones, such as lapis lazuli, were used, as well as softer stones, for example marble, calcite, serpentine, and steatite. In the Early Dynastic III period, lapis lazuli was especially favored for seal stones. Its use decreases later, because contact lessened with the only known source for lapis that was known in antiquity, Badakshan in northern Afghanistan. Files, gouges,

and rotary drills were used in the fourth and third millennia BCE and by the Early Dynastic III period we find the earliest use of the term for seal carver in Sumerian (BUR GUL). They must often have worked closely with scribes to add inscriptions to seals, and some of the seal carvers may have been literate themselves. The carvers appear to have worked in groups in workshops, as workshop styles and the hands of particular carvers are at times recognizable in numbers of seals. The images, impressed onto sealing clay on objects that traveled near and far, vessels and containers, became widespread and may be considered the most public form of art in the Bronze Age.

Iconography and Style

The style of Early Dynastic seals of the third millennium BCE ranges from abstract gouged lines and drilled forms to highly naturalistic modeled forms, worked carefully with minute and realistic details. These seals and sealings (clay sealings bear the impressions of seals) are important evidence for dating living strata in archaeological fieldwork, since the inscriptions and the styles of carving provide reliable dates when found in their original context. The style and iconography of the seals are also fascinating in their own right. They take us into a world of images that gives us a glimpse into mythology and religion, and even some aspects of daily life and occasionally rituals.

The pictorial scenes on the seals of this period include files of farm animals but also mythic scenes of hero–animal combat that include wild beasts and supernatural creatures [4.20].

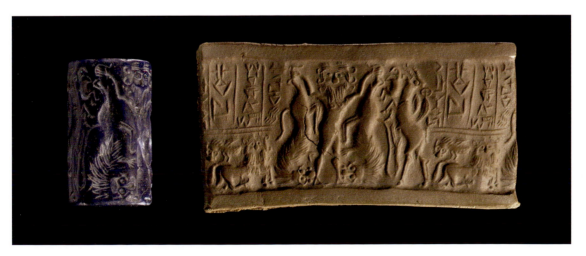

4.20 Cylinder seal of Ishma-ilum, Prince of Kisik, unknown provenance, Early Dynastic III, c. 2450 BCE. Lapis lazuli, h. 1½ in. (3.7 cm).

A nude, long-haired hero grasps two lions by their hind legs, protecting the herds from wild beasts. An inscription is placed above two mythical beasts: a recumbent, bearded bull and lion-headed eagle.

Cutting and Using Seals

Cylinder seals were made from stone, but at times clay, **faience**, shell, ivory, and even wood were used [**4.21**]. They were carved into small spool-shaped objects with a central perforation, using flint and copper tools and smoothed with abrasives such as quartz or emery, the latter perhaps imported from the Cycladic Greek islands in the Aegean. Eventually, these were fixed to a wheel. Drills were used for cutting, but handheld tools, such as a burin or a graver with varying thicknesses of lines, were mostly used for the details of design. By the early second millennium BCE, the seal cutters made greater use of the bow drill and cutting wheel. There is no evidence for the existence or use of magnifying lenses. We know from ancient texts and archaeological evidence that seal carvers worked in workshops and groups, with older master craftsmen taking on apprentices. These stone-carvers not only cut stone, but also are most likely responsible for the invention of new man-made materials that emerge from these workshops, such as glass and faience.

Clay sealings found in excavations bear the impressions of seals (made when the seals were impressed upon clay), not all of which survive. The reverse or underside of the pieces of clay can be studied also, as they reveal the impression of the objects upon which the sealing clay was placed, and are an excellent source of information for evidence that would otherwise be untraceable in the archaeological record. Impressions of wood grain and twisted rope, necks of vessels, and woven matting are all commonly found on these pieces of clay. They reveal that sealings were impressed on string or rope and wrapped around a doorknob or peg in order to fasten and secure an entrance into a room [**4.22**].

4.21 The making of cylinder seals: the seal is cut out of a block of stone and perforated through the center; the seal stone is smoothed down on the abrasive stone and then carved with a burin.

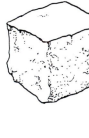

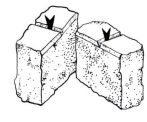

4.22 Examples of seal stone uses, from left to right: a sack tied with string and sealed; a wooden box; a vessel; and a door-lock, all sealed with clay, and impressed with seal stones.

These combat scenes, some of them inscribed with the names of the owners, depict a horizontal continuous frieze of interlocked heroes, shown nude and long-haired, battling with lions and other powerful creatures. The interwoven scenes are evenly distributed across the compositional space of the seal. In the earlier part of Early Dynastic I–II, the pattern is even and continuous, leaving no open space in the background. In the Early Dynastic III era, we see a loosening of the composition, with separated groupings of heroes engaged in combat and some open space. Inscriptions naming the owner of the seal were neatly sectioned off into their own space within the composition [**4.23**].

The seal designs of this era are remarkably creative in both their animate iconography carved at a miniature scale and in their depiction of a fantastic world of mythological creatures and heroes [**4.24**]. Naked heroes and mythical bull-men battle with upright lions, wild oxen, and predatory beasts. At times, it is difficult to tell the natural from the supernatural creatures, as there are animals behaving as humans or anthropomorphic figures with animal parts, goats with two heads, and male figures whose lower quarters subdivide into two more beasts in a seemingly never-ending potential of metamorphosis. The order of the world and the nature–culture divide is deliberately transgressed and blurred in these images, and while we may not be able to identify any particular myth or

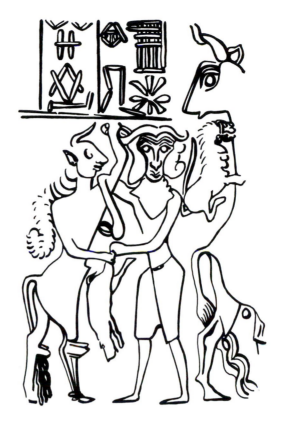

4.23 Sealing of Eannatum of Lagash, from administrative building C, Early Dynastic IIIa, 2450 BCE. This fragment of a clay seal impression in fully modeled style depicts a contest scene with a hero and mythical bull-man below the royal inscription.

story that is recounted or referenced in the contest scenes, we can certainly observe something of the way in which the Sumerians thought about the order of nature. Even more impressive is the way in which the seal carvers found solutions to adapting this complex iconography to the decorative requirements of the cylindrical seal stone. Compositions of creatures depicted in an emphatically linear style, or at times in abstract

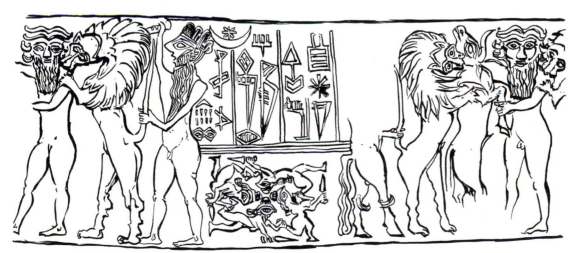

4.24 Sealing of Mesanepada of Ur, Early Dynastic IIIb, c. 2400–2350 BCE. A long-haired, nude hero is in contest with lions to protect bovine animals. Below the inscription is a group of nude heroes, perhaps in a dance.

linear designs, covered the surface of the seal to form a continuous frieze of even density. When the seal was impressed onto the wet clay surface, it revealed a wonderful horizontal composition that was unrestrained by any framing or ending of the scenes, so that any number of rollings of the seal would unfold a coherent and pleasing composition of rhythmic repetition.

The seals had to be individual and distinctive, as they functioned either as personal or institutional markers and signatures. There were thus numerous variations on the themes that were taken up by the seal cutters of this time. Styles and carving methods changed over time during the long era of the Sumerian city states. In the latter part of the Early Dynastic period the sculptors prefer a deeper carving into the sealstone, and begin to depict the figures with a more rounded modeling of bodies. The creatures in the preferred animal contest scenes are tightly woven together in upright compositions, but they continue to make use of the wonderful and creative solution of the unrestrained composition that will come to influence the world of ancient art.

The two-register banquet scene that appears on the seal of Puabi from the Royal Cemetery of Ur [4.25] is also distinctive of Early Dynastic seal carvings. These scenes, a type that may have been related to funerary banquets, represent kings and queens, and perhaps priests and priestesses, drinking what is probably a thick brew of beer from conical cups or straws straight from large beer jars placed on the ground before them. Both the hero and animal contests as well as the banquet scenes occur in other representational arts at this time too, but the exact meaning of this iconography remains unclear. In northern Mesopotamia—at Mari (modern Tell Hariri), Nagar (modern Tell Brak), Shehna (modern Tell Leilan), and elsewhere—different local types of iconography and carving styles are found; they are used at the same time as the distinctive styles of southern Mesopotamia, which had traveled north in various ways on the seals themselves or on sealings attached to movable containers. Among the local styles, we see a type of image of chariots drawn by onagers or asses.

This iconographic detail was perhaps linked to the breeding of and economic dependence on these equids in the north.

Seals were administrative tools used for economic or legal purposes, as most scholarship on these objects tends to emphasize, but they were much more than that. Seals in the Early Dynastic period became personal items, and closely associated with the identities of their owners, an aspect of seal function that was to continue and even increase in significance in later eras of Mesopotamian history. As they came to be associated with the protection of their owners, they were also worn as jewelry and considered to have an amuletic power, both in the selection of iconography and, more importantly perhaps, the type of stone that was used. We know from later Mesopotamian texts that lapis lazuli provided power and divine favor, whereas rock crystal brought a good name and fortune, and green marble attracted numerous favors bestowed by the gods.

Seals were talismans and amulets, they were inherited as heirlooms, and at times reused and reinscribed across several generations. One of the last kings of the Assyrian Empire, Esarhaddon (r. 680–669 BCE), is known to have used a seal that was over five hundred years old to seal a political treaty with a foreign vassal state. Seals were owned by men and women, kings and queens, and even by gods and goddesses, who kept them in their temples or wore them upon their **cult statues**.

The written tablets of the Early Dynastic era, however, are not impressed with seals, even though such sealing of tablets had occurred in the earlier Uruk period, and it was to be a hallmark of later writing practices in Mesopotamia. In most of the third millennium BCE, it seems that writing and sealing were distinct forms of communication or representation. The way in which images convey meaning is significant, as it had developed into complex systems of iconography by this time. Perhaps even more importantly, the development of writing into a wholly independent technology of communication was a profound change. The dialectical relationship of words and images that was present in the Uruk era, however,

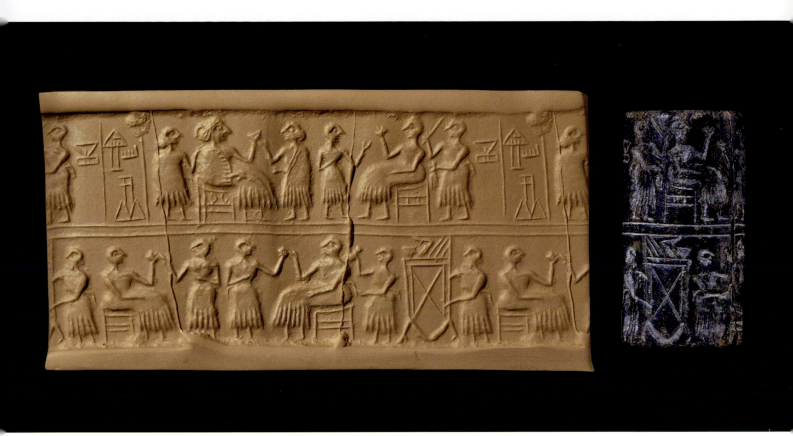

continued in the works of monumental art and votive objects, as we have seen, exemplified on such monuments as the stele of Eannatum of Lagash and the numerous smaller-scale private offerings to temples that functioned primarily by means of this combination of word and image converging into one work of art or monument.

Because they were intricately carved and polished gemstones with mysterious and yet undeciphered images and texts, seals were always thought of as fascinating objects, and were collected in Europe for a long time before antiquarians knew what the seals actually were. The Italian philosopher Francesco Bianchini's *La storia universale* (universal history), published in 1697, included illustrations of a **Neo-Babylonian** seal of the sixth century BCE and two other ancient Near Eastern seals. The Dutch collector Jacob de Wilde's *Gemmae selectae antiquae* (select ancient gems), published in Amsterdam in 1703, also included some Mesopotamian seals, while the collection of Greek antiquities owned by the Scottish antiquarian William Hamilton and

sold to the British Museum, London, in 1772 also included cylinder seals.

The Early Dynastic period lasted for 550 years, ending when King Sargon of Akkad (2334–2279 BCE) unified the region. While important political changes came with the end of the period, the innovations in sculpture, architecture, and cylinder seal carvings that had emerged in Early Dynastic Sumer formed the basis for the new developments that were to follow, as we shall see in chapter 5.

4.25 Cylinder seal of Queen Puabi, from Ur, Iraq, Early Dynastic IIIa, 2600 BCE. Lapis lazuli, h. 1⅞ in. (4.9 cm)

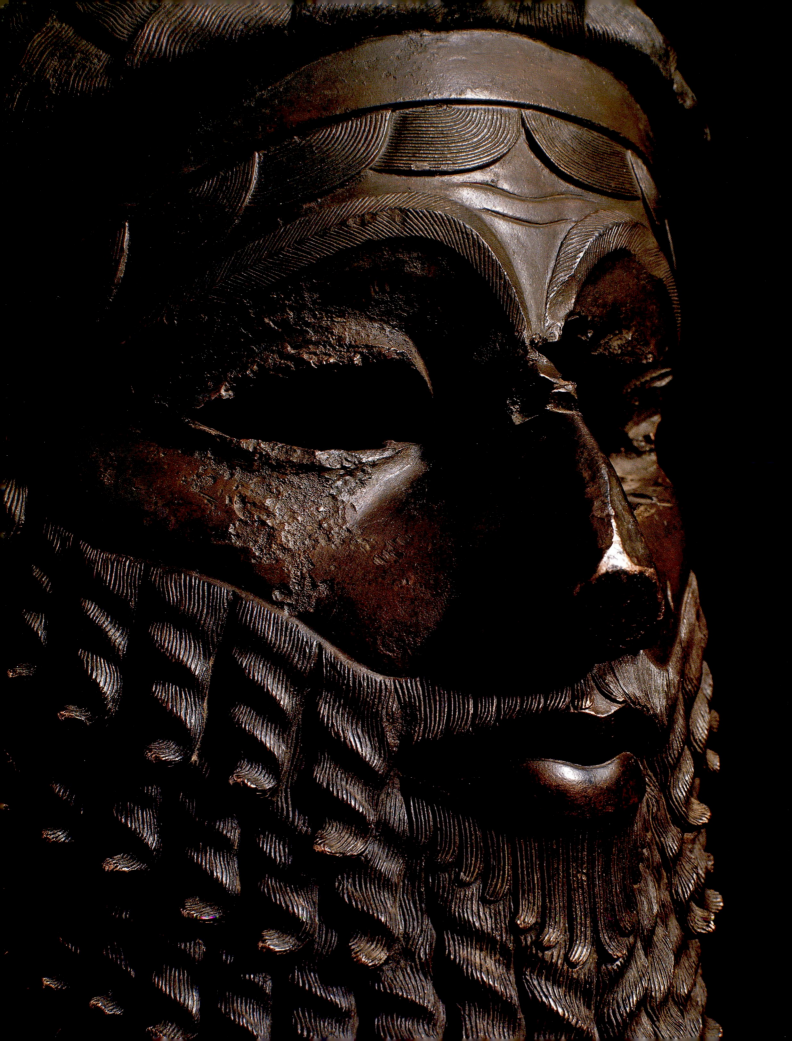

CHAPTER FIVE

Art of the Akkadian Dynasty

See **5.3**, p. 117: Head of a king, from Nineveh, Iraq,
2250 BCE. Bronze or copper alloy, h. 13¾ in. (35 cm)

5 Art of the Akkadian Dynasty 2334–2154 BCE

Rulers	Sargon of Akkad: r. 2334–2279 BCE
	Manishtushu, the son of Sargon: r. 2269–2255 BCE
	Naramsin, the grandson of Sargon: r. 2254–2218 BCE
Major centers	Agade, the capital city of the Akkadian dynasty
	Major urban centers: Nagar (modern Tell Brak), Urkesh (modern Tell Mozan), Shehna (modern Tell Leilan), Kish, Ur, Sippar, Susa, Assur, Tell Asmar (ancient Eshnunna), Khafajeh (ancient Tutub)
Notable facts and events	Akkadian becomes an official language, alongside Sumerian
	Akkadian expansion (from west Iran to the Mediterranean sea) makes it the first known empire
Important artworks	Disc of Enheduanna
	Diorite statue of Manishtushu
	Head of Akkadian king
	Stele of Naramsin
Technical or stylistic developments in art	Invention of the hollow-cast lost-wax method, used to make large-scale metalwork statuary
	A new emphasis on verisimilitude in sculpture
	Many more royal commemorative monuments are carved and installed in both public and sacred spaces

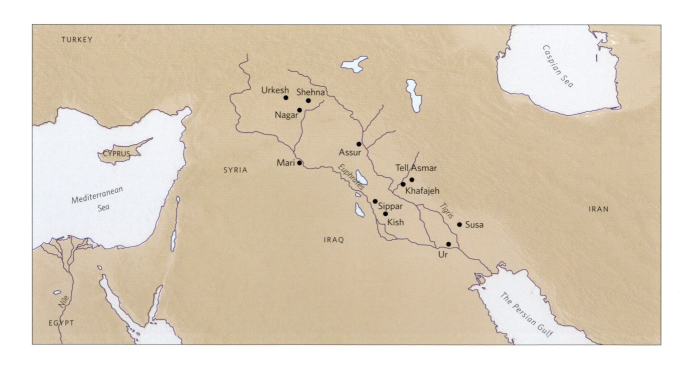

5 Art of the Akkadian Dynasty

During the Akkadian Dynasty, in the reigns of **Sargon of Akkad** (r. 2334–2279) and his successors, the visual arts became increasingly concerned with naturalistic details and carving styles, a development that we can observe in every genre of representation. As we shall learn in this chapter, although carved steles or monuments had already been in use since the Uruk era, many more royal monuments were now carved and installed in both public and sacred spaces. Along with developments in the carving of stone steles, large-scale metalwork statuary began to be made using the hollow-cast lost-wax method. This technological innovation in metallurgy marks the earliest known occurrence of this casting method in the history of art.

Sargon of Akkad, who according to the later ancient tradition was once the cupbearer to the king of Kish, was of humble birth and background. He had been found in a basket in the river when he was a baby, but he was destined to become the founder of the mighty Akkadian dynasty. He consolidated his power in southern Mesopotamia, bringing together all of the independent Sumerian city states under his authority, and administered the region from the newly established capital city of Agade. By means of military conquests that were unprecedented in extent, Sargon and his descendants expanded Akkadian rule over a large part of the ancient Near Eastern world, across Mesopotamia to Anatolia, Arabia, Iran, and as far west as Cyprus in the Mediterranean Sea, conquering what the texts refer to as the four quarters of the world, and creating what has come to be known as the first empire. The Akkadian dynasty lasted one-and-a-half centuries, from 2334 to 2193 BCE.

The written historical sources from Mesopotamia from this time are both more numerous and better understood by historians than those of the earlier eras, thus they provide more substantial information about this historical period. The primary language of the texts and scribal activities in general also changed. The Akkadian dynasty was from the upper part of Babylonia where people spoke a Semitic language: Akkadian. In the south, the dominant language was Sumerian, which is unrelated either to Semitic, Indo-European, or any other language groups in use today. While both Sumerian and Akkadian coexisted in what was always essentially a bilingual culture, Akkadian now became the dominant language. The cuneiform script, which had been developed for Sumerian, was adopted for Akkadian, and became increasingly used for the syllabic and grammatical forms of that language, developing what came to be known as Akkadian writing, which was used for the new administration. At the same time, local people and rulers continued the use of Sumerian for their own purposes, especially for literary, scholarly, and religious texts.

Royal Monuments and Sovereign Power

Ancient texts tell us that Sargon had a mysterious birth and rise to power. One legend of his birth describes him as being the son of a priestess, who conceived and gave birth to him in secret. She then set him in a wicker basket made watertight with a bitumen lining and cast the basket into the river. There a simple water-drawer or gardener found the baby in the basket and raised him as his adopted son. When the goddess Ishtar noticed

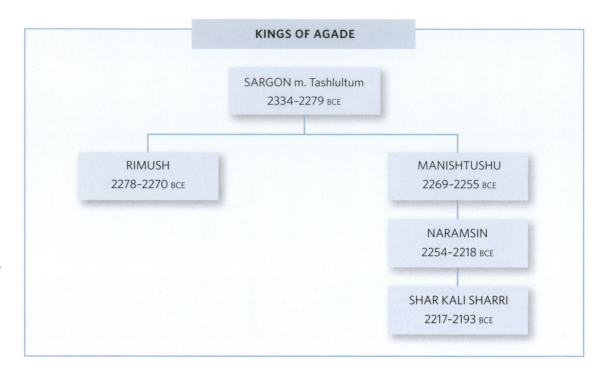

KINGS OF AGADE

SARGON m. Tashlultum
2334–2279 BCE

RIMUSH
2278–2270 BCE

MANISHTUSHU
2269–2255 BCE

NARAMSIN
2254–2218 BCE

SHAR KALI SHARRI
2217–2193 BCE

Family tree of the main kings of Akkad. According to the Sumerian King List, this was a family of city rulers who held kingship over Sumer and Akkad.

him, she gave him the kingship. When Sargon founded the dynasty he took on the **throne name** Sharru-kin (Sargon), which means "the king is legitimate." His successors also assumed the title King of Kish, which had been used in the Early Dynastic era to imply the first among equals, but which in the Akkadian era came to mean "king of the world." Sargon thus became the founding ruler of a new dynasty with not only a dominant new language and capital city but also a new form of authority and kingship, a sovereign power that had not existed before this time in the system of city states of the Early Dynastic era. Whatever the stories—some of which were written after his lifetime— say, he clearly became a powerful ruler, a military commander, and a warrior king. It was written that "daily 5,400 men ate in his presence," which seems to imply the existence of a standing army at his service, the first of its kind.

That Sargon constructed a new identity for himself seems clear from the ancient literary tradition of Mesopotamia, and that identity was formed and formulated both in his royal images and in his monuments. What we see from these monuments is the image of the warrior king, rather than the pious or peaceful ruler that was also emphasized in the Early Dynastic arts.

The sculpted works that survive from Sargon's reign include a broken monument that bears an image of the king himself, identified by an inscription. Known as the victory stele of Sargon [5.1], it is an oblong boulder with rounded sides hewn from diorite and given a minimum amount of rough shaping to its outer form. It bears a continuous orderly frieze of carved relief on separate registers, only two of which survive. On the lower register, King Sargon leads a procession of men. The marching warriors, depicted in profile, follow the rough contours of the stone, adjusting to its shape. They circle the stone in single file, with feet placed on the same ground line, a method we have seen used before as early as the Uruk Vase carvings (see p. 47). Sargon himself, who is at the front of the procession, is identified by an inscription placed before his head. It states simply, "Sargon the king," as if nothing more were needed than this declarative sentence of his authority. While the lower part of the relief is damaged here, we can see the king in his tufted garment, with his long hair braided and pulled back into a chignon and held in place by a diadem. Both his abundant hair and long beard emphasize his vigorous masculinity, while his head pushes the frame of the register

above, so that he in fact breaks out of his allotted space. In his right hand he holds a battle mace, which is also a scepter of kingship. Behind him the military men in his entourage wear thick cloaks, which cover one shoulder, and carry raised weapons. The first figure behind Sargon appears to be carrying an umbrella, a sunshade for the king. Given their attire, which is elegant and luxurious, we can assume that they are dignitaries rather than conscripted troops. They differ from the king in their hairstyles and lack of beards.

The frieze above is broken in the middle, but we can see the lower part of a row of naked prisoners of war with their wrists bound, driven forward by Akkadian soldiers wearing battle kilts. On the opposite side of the boulder, some of the prisoners have collapsed and are beaten by the troops. Their nakedness deprives them of their power to act, and also of their identity as soldiers. In the lower register of that side, vultures and dogs are circling what must be the bodies of the dead. The dogs have pointed ears and short curling tails, and seem to be domestic hunting dogs rather than wild ones. Below this fragmentary scene an inscription recording a victory in battle is partially preserved.

The carving of the relief places particular emphasis on rounded forms, details of the body being incised into the relief as sharp lines, for example in the areas of the knees. The beginnings of an interest in the realistic and anatomically correct representation of the body can be seen here, indicating the artist's close observation of nature, a key characteristic of Akkadian sculpture. The dark diorite stone used for the Sargon stele is distinctive for its rich and lustrous surface. It was brought to Mesopotamia from Oman, a land on the southeast coast of the Arabian Peninsula, at the opening of the Persian Gulf, and was thus an exotic and valuable imported stone. Diorite came to be favored in most monumental sculpture of the Akkadian dynasty and continues to be associated with royal monuments in successive eras into the second millennium BCE. Akkadian military expansion had permitted the acquisition of more valuable materials from farther lands than before, including metals and stones that were used in the visual arts of the royal dynasty. At the same time, distant travel led to peaceful and reciprocal trade with other lands, and the ports of Akkad became the destination of foreign merchants who came to trade their goods. One inscription from Sargon's reign tells us that many ships from Oman docked in the southern part of Babylonia, bringing their wares and raw materials for trade.

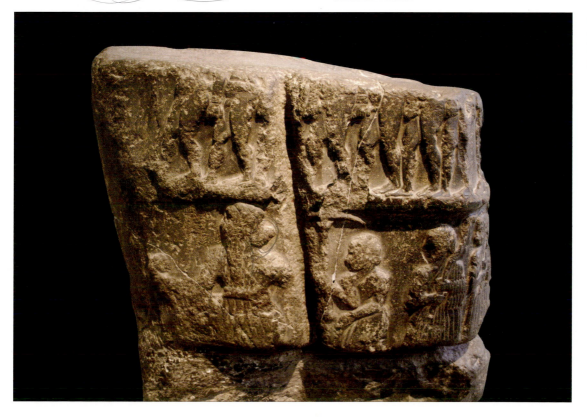

5.1 Victory stele of Sargon, Susa, Iran, c. 2300 BCE. Diorite, h. 35⅞ in. (91 cm)

Connoisseurship and Archaeology

Works of ancient art can be studied for the aesthetic and the socio-historical knowledge that they provide about the past. They can also be studied for dating criteria, and assist archaeological knowledge in that way. Close visual observation, an art historian's method, is also used in field archaeology. The stele of Sargon (see p. 115), for example, can tell us both about the political era and about the forms of sculpture and uses of monuments that developed at that time. In terms of the details of the relief, and the way that the dignitaries behind Sargon are depicted, both continue traditions from the past and demonstrate new standards and forms of carving. The close observation of locks of hair that radiate from the center of the top of the head and end in curls at the forehead and back of the neck is an example of dating by **connoisseurship**. A similar treatment of masculine heads can also be seen in statues-in-the-round of the same era [**5.2**]. This method of depicting the hair combed forward in radiating curls is new in the Akkadian era; it differs markedly from the sculpture of the Early Dynastic period and is therefore a good diagnostic stylistic or visual marker of Akkadian works when they are taken out of their original archaeological context and have no inscription to clarify the dating. Such close visual analysis can assist in dating objects and assemblages. This method is similar to the way in which the shapes, manufacturing techniques, and wares of ceramics are used by archaeologists for chronological sequencing in excavations. Art historians of antiquity must always keep in mind, however, the possibility of the use and survival of works of art and monuments over several generations and even centuries. This means that the relationship between dating archaeological levels and works of art is quite different from the ceramic dating practices used in field archaeology. The challenge, then, is to consider the work of art within its context of creation, but also the lifetime of the work and the history of its reception, which, like works of art today, usually outlasts the generation of its moment of creation. For this reason also, the archaeological context is of the utmost importance. It can tell us about the making or original production of the artwork, but also about how that work was viewed by the peoples of antiquity.

5.2 Head, Susa, Iran, 2270 BCE. Diorite, h. 2⅝ in. (6.7 cm)

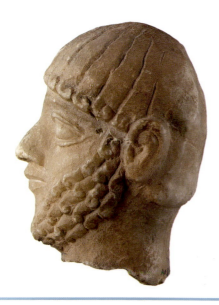
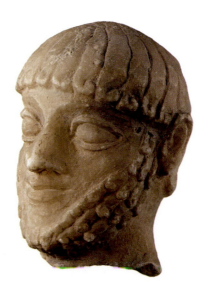
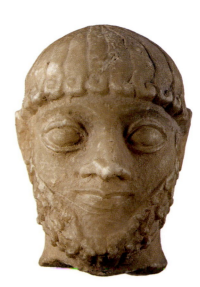

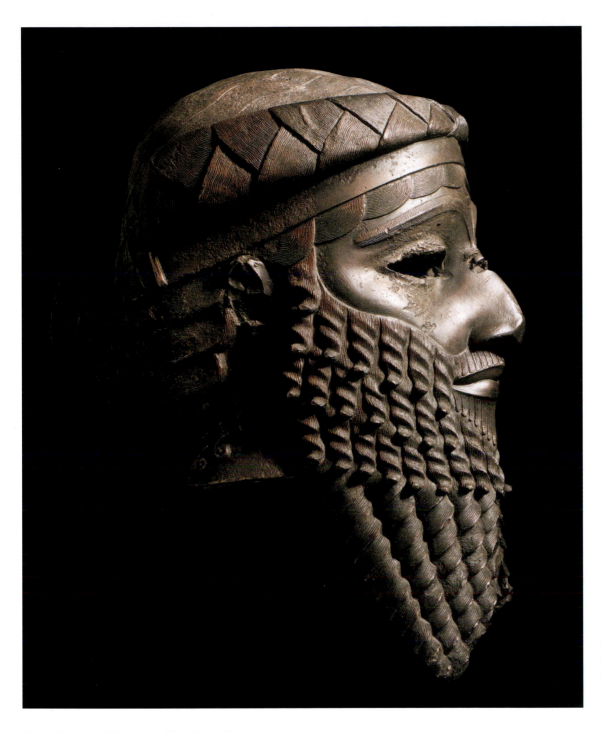

5.3 Head of a king, from Nineveh, Iraq, *c.* 2250 BCE. Bronze or copper alloy, h. 13¾ in. (35 cm)

Portraiture and Identity: The Royal Image

Among the most impressive artistic achievements of the Akkadian dynasty are the statues cast in an alloyed copper, an early form of bronze, in the hollow-cast lost-wax method (see box, p. 119). The head of a king, found in 1931 at the Temple of Ishtar in Nineveh in northern Iraq, is an excellent example [**5.3**]. The head was most likely part of a full-scale figure of the king, perhaps combining other materials to create the body and attire. It is not possible to identify the king represented here, but based on the stylistic details it is likely to be **Manishtushu,** the son of Sargon and founder of the Temple of Ishtar in Nineveh, or one of the succeeding kings, perhaps the mighty **Naramsin,** the grandson of Sargon. The superb quality of

117

execution indicates that it was made during the fully developed phase of Akkadian art, often referred to as classic Akkadian style and clearly distinguishable in the cylinder seal carvings of this time (see p. 129) and in the diorite statue of Manishtushu found in Susa [5.6; see p. 120].

The magnificent hollow-cast head combines in one work Akkadian naturalism in representation—an achievement not only for antiquity, but also for all the history of art—with a detailed play of pattern. Physical ideals of masculinity and Akkadian kingship are emphasized in the thickly braided and wound hairstyle, held in place by a flat diadem placed at the forehead over the scalloped waves of hair. The eyes, which no longer survive, were originally made of another material, most likely shell or ivory with an inlay of lapis lazuli for the dark pupils. The main form of the head is cast in the lost-wax method, and incised chased surface details are added with a chisel. The regular patterns of the curling beard and hair set off the smoothness of the lips and face, which are finely modeled with exact proportions and naturalistic detail. The head conveys serene majesty. The elaborate hairstyle of kingship echoes earlier examples, such as in the hammered gold helmet of Meskalamdug from Ur [4.6; see p. 192], and in some of the carved images of Early Dynastic rulers, such as Eannatum of Lagash and Ishqi-Mari of Mari. References back to the earliest images of authority, the Uruk-era priest-king figures, demonstrate a strong sense of continuity in image making.

When the copper alloy head of the king was discovered it was still unclear to archaeologists if this sophisticated hollow-cast lost-wax technique could indeed have been known and used in the third millennium BCE, and some thought it must date much later in time. The dating of this technique was confirmed in the 1970s, however, when an almost life-size copper alloy statue of a seated youth, cast in the lost-wax method, was found during the construction of a road near the town of Bassetki in Iraq [5.4]. The statue represents the body of a nude youth seated on a round base and holding the lower part of what must have been a standard pole. The youth is nude except for the belt tied at his waist ending in a side knot with tassels. Unfortunately, the upper part is missing but what remains of the lower body is sensitively modeled in an extremely naturalistic style, and reveals a very close observation in its depiction of the musculature of the calves and thighs, a stylistic marker of Akkadian era sculpture. The **iconographic** details that survive indicate that this is a **guardian figure** of a heroic nude youth, similar to the ones we see represented on the cylinder seals of this time, which are usually shown with long locks of hair and beards, kneeling and holding gatepost standards, as in the red jasper seal now at the Metropolitan Museum of Art [5.17, see p. 132].

The Bassetki statue is seated on a round base, perfectly preserved with its inscription. The text on the base, neatly placed in a rectangular panel before the legs of the hero, tells us that Naramsin had won nine victories in one year, and that the people of Agade built a temple for the king, who had now become a god. After this time, the name of Naramsin was always written with the **divine determinative**, a sign used to indicate the name of a god in the system of Akkadian writing. Given the fact that the heroic figure is a standard-bearer who

5.4 Nude male standard bearer, from Bassetki, Iraq, 2254–2218 BCE. Copper alloy, diam. of base: 26 3/8 in. (67 cm)

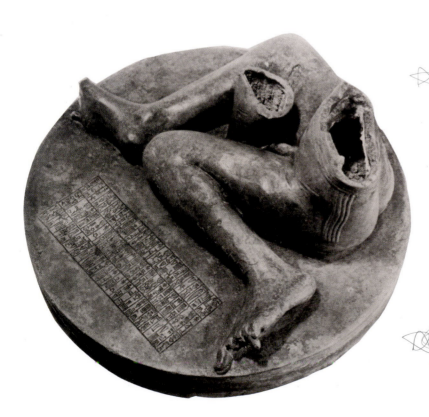

Lost-Wax Casting

Lost-wax hollow-casting, a technique of making sculpture usually associated with the Classical Greek era, was in fact a development of the ancient Near East during the fourth and third millennia BCE [5.5]. One of the most impressive achievements in the history of technology and art, it enables the production of large-scale bronze and copper alloy works that are lighter in weight and more easily modeled than solid cast sculpture. The technique requires first making a model with a clay core [1], covered by a detailed wax layer [2], and the addition of sprues [3]. The whole model is then covered (invested) with clay [4], strengthened by core supports (chaplets), and then fired in a kiln. The firing process melts the wax, which seeps out through the sprues provided in the clay mold [5]. Molten metal is poured into the mold; the channels facilitate the flow of the metal to individual areas and allow venting of the air and gases so that the metal can access all parts of the mold [6]. Once cooled, the clay mold is removed [7] and the sprues sawn off before the object can be polished

and considered finished [8]. The material used at this early stage was 98 percent copper, and contained no tin or lead, which was sometimes added in Classical antiquity. Instead, the copper was alloyed with arsenic and nickel, along with iron and cobalt. It is thus identified as copper alloy rather than bronze, which is an alloy of 90 percent copper and 10 percent tin.

In the Akkadian era the lost-wax hollow-casting technique was used for impressive large-scale sculpture in the round, including the life-size head of a king found in Nineveh [5.5, see p. 117] and the Bassetki statue (see opposite). The latter has been estimated to weigh more than 440 lb. (200 kg) in its original state. These Mesopotamian works represent the earliest hollow-cast large-scale sculptures known from the ancient world. The earliest hollow-cast statues from Egypt are dated to the Middle Kingdom (first half of the second millennium BCE), and those from Greece to the sixth century BCE, thus quite some time later than those from the Near East.

5.5 The lost-wax hollow-casting method

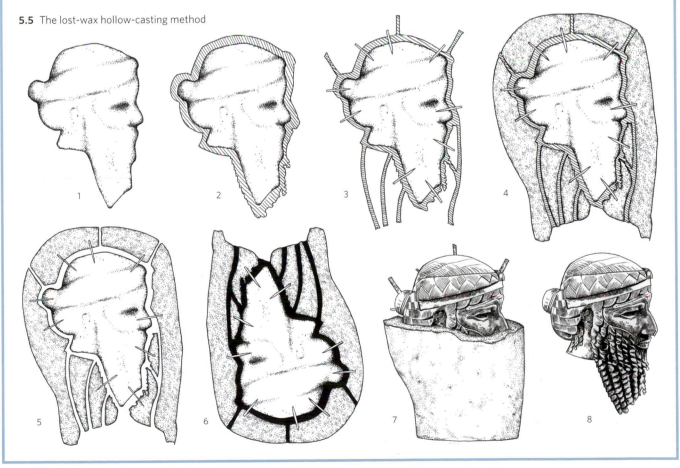

119

often appears in seal carvings in pairs or groups, we might assume that the surviving Bassetki statue was one of a pair, or even several, that stood at doorways, entrances, or other highly charged and significant locations. The new developments in techniques of casting would permit the perfect reproduction of these magnificent, gleaming copper images. The historical importance of the statue thus lies both in the significance of a securely dated early work of impressive metallurgical skill, but also in the content of the inscription itself, which states that it was created for Naramsin. *grandson of Sargon*

Stone sculpture in the round from the Akkadian era survives mostly in damaged or fragmentary form in examples excavated at the **Elamite** city

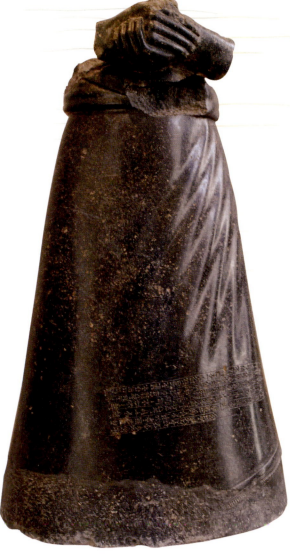

5.6 Manishtushu statue, from Susa, Iran, 2269–2255 BCE. Diorite, h. 3 ft. 3⅜ in. (1 m)

of Susa in southwestern Iran. One such diorite statue is a life-size image of King Manishtushu, the son of Sargon, standing with his hands clasped [**5.6**]. Only the lower part of the statue from the waist down survives, but the treatment of the hands and the folding cloth of the gown displays extraordinary skill and detail. The hands, held in a gesture of prayer, project outwards in front of the body, freely carved and minutely detailed. The garment he wears is carved in a manner that introduces new forms to Mesopotamian stone sculpture. The fringes of the skirt, which wraps around the side of the statue, are indicated by small and tightly organized repetitive patterns that contrast with the smooth surface of the highly polished stone. A series of rippling folds on the front of the garment are carved realistically in a way to suggest soft cloth that has been pulled up and tucked into the waistband. This treatment of the folds makes use of the subtle play of light on the surface and juxtaposes the soft and naturalistic folds with the bold geometric shape of the statue. The carving reveals the skill and dexterity of the Akkadian sculptors in working with very hard stones, such as diorite, a material that is much more difficult to carve than such stones as marble. It also shows a clear concern not only with a realistic representation of the king, or the movement of cloth as it is gathered and worn, but also—in its use of shapes, light, and contrasts—with the aesthetic formal qualities of sculpture. The style that is known as classical Akkadian sculpture can thus be said to begin with the reign of Manishtushu, though it is mostly associated by art historians with the era of his successor, Naramsin.

Another important and impressive monument from the reign of Manishtushu is not a work of pictorial or representational art but a diorite stele in the form of a large quadrilateral **obelisk**, which was also found in the Elamite city of Susa, and is exquisitely carved with a long text that demonstrates the achievement of the **calligraphic** art of inscription in the Akkadian era [**5.7**]. The monument, which stands 60 in. (1.5 m) high in its present state, records the purchase of eight large fields in Babylonia by the king, Manishtushu, who

5.7 Obelisk of
Manishtushu, from
Susa, Iran,
2269–2255 BCE.
Diorite, h. 4 ft. 7⅛ in.
(1.4 m)

most likely bought this rich agricultural land from their owners in order to be able to redistribute it to his own supporters. What we have here, therefore, is a land contract carved as a monument. It makes use of a fine, calligraphic form of cuneiform writing that was used specifically as a display script. The carving of the text exemplifies the considerable skill of the sculptor, who in order to cut such an evenly spaced and beautifully executed inscription must have been able to read and write himself. The sculptor and scribe must have carefully planned the placement and positioning of each line and cuneiform sign before beginning the stone cutting process into the hard diorite surface. Once a mistake was made, it was almost impossible to rectify. Conceptually the obelisk of Manishtushu is an interesting work because it monumentalizes the act of land transfer into a royal edifice, declaring the rights of the king in the distribution of land under his authority. It is a turning point in the form of kingship as well as in the form of monument making, in which the abstract form and aesthetic concerns of a text are given the same careful and skilled treatment as the pictorial monuments of Akkad.

Assailing the Images

On the front of the skirt of the diorite statue of Manishtushu [**5.6**, see p. 120] we see a panel of text, an inscription added by the Elamite king **Shutruk-Nahunte** informing the viewer that he raided Akkad and took this statue to Elam. This battle took place in 1158 BCE, thus more than a thousand years after the end of the Akkadian dynasty, yet their statues and monuments were clearly still standing in cities and in sacred temple precincts when the Elamite invasion took place. The statue of Manishtushu is one of numerous Mesopotamian monuments and works of art that were taken as war booty to Susa, where they were uncovered in archaeological excavations in modern times. Many of them have had their original inscriptions broken off, erased, or scraped away, and a new inscription added by the Elamites with dedications to one of their own local gods, Inshushinak. It is important to note that the Elamite inscriptions are not scrappy graffiti,

added on the spur of the moment. The invasive inscriptions demonstrate a careful and well-thought-out positioning of the text and carving technique for the cuneiform script, here used for the neighboring Elamite language of Iran.

These acts, ostensibly of theft and destruction, reveal a great deal about the ancient belief in the power of monuments and images. Most Akkadian sculpture known today was excavated in a secondary context at Susa: it was not found in its original location where it had been erected by the Akkadian kings, but taken as war booty in battle, and carried to the neighboring land of Elam as an act of victory in war. Monuments and works of art were assaulted and even, one might say, abducted, during wars. Since wars aim to annihilate the enemy and control the land, public monuments, architecture, and other works of art were destroyed or removed as part of the strategy of war. This was an elaborate and complex practice in the ancient Near East, which is recorded in the historical annals and other ancient texts known from numerous battles and eras in Near Eastern and Classical antiquity. Furthermore, records reveal that at times wars were fought specifically for images. **Cult statues** of gods and royal monuments were deliberately stolen, and wars were sometimes said to be launched in order to retrieve these stolen images that had been carried off by an enemy army in an earlier battle. The theft of images, especially when it involved the cult image of a god or goddess, was seen as a form of banishment or exile that had profound repercussions for the entire land. It was considered a terrible event, a form of occultation, when divine power and protection were removed from the city. The theft of monuments and statues, therefore, was not for material wealth or prestige, nor was it an impulsive act of war during a raid on the enemy. The power of images of cult statues on the one hand, and public monuments and royal images on the other, was such that the removal of any of these was believed to have serious consequences for the state, as each of these works was considered to be connected to the city and to the land, to the inherited historical ancestral space of time and memory.

Likewise, the mutilation of images and inscriptions was not random. Statues, such as the diorite image of Manishtushu, had new inscriptions carefully added by a highly skilled stone carver. These monuments were also extremely heavy, and required a large amount of manpower to carry back to Elam. If destruction had been the aim, they would have simply left them there, defaced and fragmentary, but clearly the control of the monuments and their removal from the site were also integral to these iconoclastic acts of war. When you look closely at the copper alloy royal head from Nineveh [**5.3**, see p. 117 and p. 119] , the traces of deliberate damage are visible. The inlays of the eyes have been gouged out and the ears have been cut away. Part of the nose appears to have been attacked with a hammer. All these details are not accidents of damage due to the passing of time, but deliberate acts that selectively targeted images of kings. There was a strong belief in the connection between the representation or image and the thing or person it represented, and the accompanying idea that one could harm the latter by harming his or her image. This is one of the most distinctive aspects of the system of representation in the history of ancient Near Eastern art, which we can see expressed in omens regarding statues, such as this later Babylonian omen, which reads:

> If the image of the king of the country in
> question
>
> The image of his father, or the image of
> his grandfather
>
> Falls over and breaks, or if its shape warps,
> this means
>
> That the days of the king of that country will
> be few in number.

Among the monuments stolen in battle were the stele of Sargon [**5.1**, see p. 115] and the stele of Naramsin, the grandson of Sargon [**5.9**, see p. 124]. With the transformation of Naramsin into a deity and his elevation into the world of the gods—a transformation that is recorded in the text of the Bassetki statue—the iconography

of royal authority had to change, just as the writing of the royal name took on a divine determinative. Steles were made to celebrate the victories in battle of Akkadian kings, but, in Naramsin's reign, the might of the transitory and earthly kingship was combined with the concept of the divine in a new visual rhetoric. This new vision of kingship is represented on the limestone stele of Naramsin. The stele, which has a rounded top, was originally erected in Sippar, the city of the sun god in the south of Mesopotamia, but it was excavated in Susa, where it had been taken as war booty in 1158 BCE. It represents a victory in battle over the **Lullubi**, a battle that took place in the rocky landscape of the eastern Zagros Mountains in the north of Mesopotamia. It adopts a compositional system that no longer separates registers of carving into neat levels. Nor are the figures placed on the same ground line, as in the

5.8 Feet of Naramsin, from Susa, Iran, 2254–2218 BCE. Diorite

This base bears the feet of a life-size statue of Naramsin that was destroyed in antiquity, when it was looted along with other Akkadian statues that were brought to Susa in Iran in 1158 BCE. The feet are carved with close attention to naturalistic details, such as the careful delineation of each individual nail cuticle and the bone structure of the foot below the surface of this skin. Although only the feet remain, the carving and naturalistic modeling apparent in the large-scale metal casting are evidence of the achievement of the Akkadian stone sculptors. A partially preserved inscription states that Naramsin conquered Magan (modern Oman), and in its mountains he quarried diorite stone and brought it to Agade (his city) and fashioned a statue of himself. The inscription ends with a curse against the erasure and destruction of the statue.

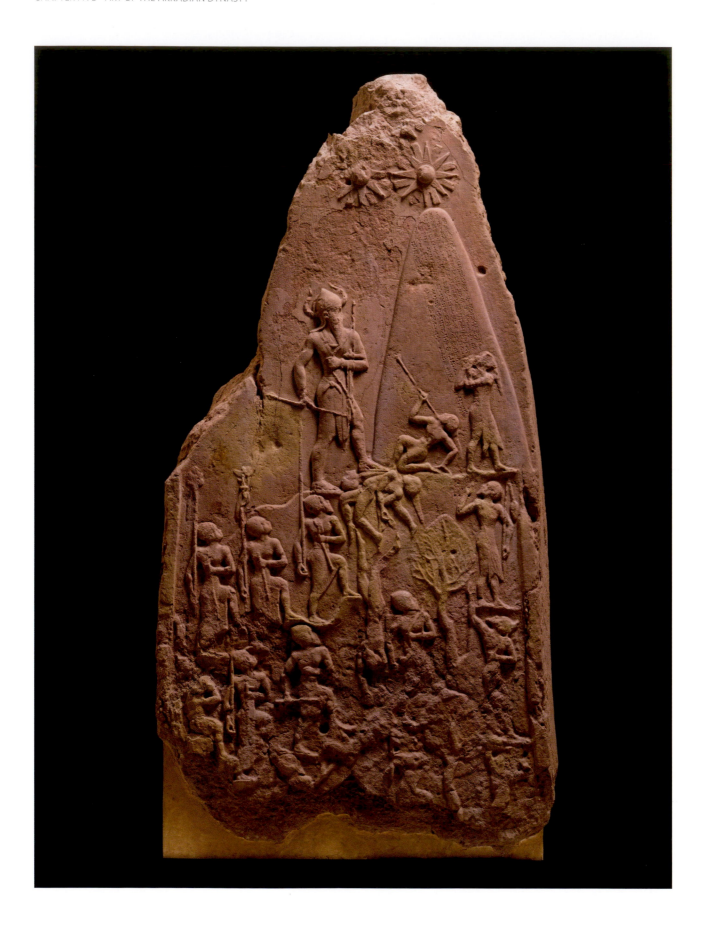

stele of Sargon, or pulled into the same pictorial surface space. Instead, the Akkadian troops and the Lullubi enemies are distributed throughout a recognizable landscape marked by coniferous trees that signal this particular mountain location to the viewer. The scene takes place after the battle is over. The troops climbing the precipitous cliffs of the rocky mountainside give the impression of a relentless and orderly force making their steep ascent. The king himself, larger than life, is iconic and timeless in representation, set apart from his troops below, but this iconic image of kingship is placed within a naturalized landscape setting. He is the focus of the scene, standing in his battle gear at the top of the mountain, separated from the soldiers below by size and by placement within an open space, silhouetted against the sky. The entire composition is organized in a series of ascending diagonals that echo the rise of the mountains and culminate in the figure of the king at the center and the astronomical emblems of the gods in the arc of the top of the stele.

The king's divine power is marked by his pointed horned helmet, as horned crowns are usually reserved for the images of the gods. The muscular perfection of his body indicates that he is destined to rule. He stands with his foot placed upon the naked bodies of the defeated Lullubi warriors, who collapse dead before him. One enemy soldier has been hurled head-first down the mountainside. Before Naramsin, on the right side of the stele, we see a Lullubi leader pleading for mercy, and another who has been transfixed with a spear collapsing before him. The enemies are shown with long hair worn in a single braid, and wearing what appear to be animal skin cloaks. The dead and dying are shown in different stages of undress, indicating that nudity is used here as an iconographic device to mark the stages of death and defeat.

Two inscriptions survive on the stele. The first is a fragmentary text, the remains of the original Akkadian inscription on the upper left, which has been damaged or scraped away, and the second one carved onto the mountain top to the right of the stele, added in the twelfth century BCE by the stone carvers in the employ of the Elamite king.

Images of Royal Women

Besides the images of the kings of Akkad, we have some works of art depicting Akkadian royal women. The princesses of the dynasty were given important positions in the religious hierarchy. The daughter of Sargon, Enheduanna, was appointed as the entu priestess, that is the high priestess, of the moon god at Ur, and held this position continuously into the reign of her nephew Naramsin. An alabaster disc, sculpted with a ritual scene in a horizontal relief band, represents Enheduanna participating in a ritual in the temple precinct [5.10]. The frieze, which resembles cylinder seal images of the time, represents four figures in a row in front of an altar and multi-stepped structure to the far side, which seems to be a ziggurat. The first figure is pouring a libation from a spouted vessel upon the altar; the second one—Enheduanna—is dressed in a multi-tiered flounced garment and a rolled, banded headdress that reveals curls of hair falling to the sides of her head. Following the conventions of royalty, she is shown slightly larger than the figures before and behind her, and she is further identified by the headdress known as the *aga*, belonging to the office of the high priestess. The two figures

Opposite
5.9 Stele of Naramsin, from Susa, Iran, *c.* 2250 BCE. Spicular limestone, h. 6 ft. 10⅝ in. (2.1 m)

5.10 Disc of Enheduanna, daughter of Sargon, from Ur, Iraq, *c.* 2300–2250 BCE. Alabaster, diam. 10⅛ in. (25.6 cm)

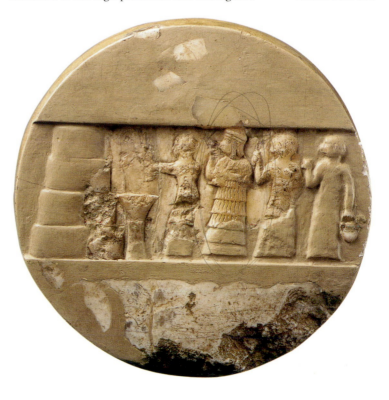

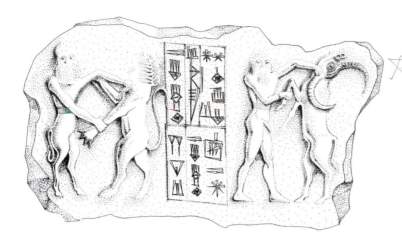

5.11 Drawing of a clay seal impression of Tar'am Agade, daughter of Naramsin. The seal depicts contest scenes with two groupings of heroes and animals: a bull-man fighting a lion, and a nude hero with a water buffalo.

In northern Mesopotamia, cylinder-seal impressions found at Urkesh (modern Tell Mozan) provide some important information about diplomatic relations and Akkadian influence. Seals there record the name of a local ruler, Tupkis, who is referred to as *endan*, a local word for ruler. They also tell us that his wife has an Akkadian name, Uqnitum. Another ruler there was married to Tar'am Agade, a daughter of Naramsin, as we can see from this seal inscription. This kind of diplomatic marriage formed links between north and south, and the seal carvings demonstrate that carving styles and iconographies could travel on small portable objects, or possibly with the craftsmen who traveled back and forth with members of the court and royal family.

standing behind her carry a sistrum—a musical percussion instrument still in use in the Middle East today—and a convex-based vessel with a handle for use in the ritual. The ritual takes place outdoors, in the sacred precinct under the open sky, as would be appropriate for the god of the moon at Ur.

The disc was found in the excavations at Ur, in a building known as the Giparu, the administrative center of the priestess that included storerooms and cultic areas. It was dedicated during the Akkadian era, but it survived in its original location into the eighteenth century BCE. The two-sided disc bears an inscription on the back:

> Enheduanna zirru-Priestess, wife of the god Nanna, daughter of Sargon, king of the world, in the temple of the goddess Inanna-ZA.ZA in Ur, made a socle and named it, "dais, table of the god An."

The entu priestess was selected by divination to stand in for the consort of the god, in this case the goddess **Ningal**, wife of the moon god Nanna. The priestess was seen as the living embodiment of the goddess, at least within the context of ritual performances that took place at important moments in the religious calendar. The position was a religious one, but it was also clearly a political appointment since the entu was selected from among the people, but was a princess of royal birth and upbringing. Enheduanna, the high priestess, was also a highly educated woman who wrote poems and hymns to the goddess Ishtar, which she signed with her own name, thus making her the earliest known poet and author in world history, regardless of gender.

Naramsin had several daughters. Two of his daughters, Shumshani and Me-ulmash, dedicated votive objects in Mari, Their names are preserved on two bronze bowls found there. Shumshani was entu priestess of the sun god **Shamash** in Sippar; another daughter, Tuta-napshum, was entu priestess of Enlil, the sky god in Nippur; and Enmenana was entu priestess of Nanna in Ur. His daughter Tar'am Agade's seal is known from Urkesh in Syria [**5.11**], thus the daughters and sisters of Akkadian kings held high positions in both north and south Mesopotamia. Later on, cults for the dead kings Sargon and Naramsin were maintained in the royal Syrian city of Mari.

Non-Royal Works

The era following Akkadian rule is a period characterized as one of chaos and confusion by the Sumerian King List (see p. 133). Mesopotamian works of art nevertheless continue the traditions of earlier times. A limestone wall relief [**5.12**] with a Sumerian inscription demonstrates this continuity well. The traditional square votive relief, with a perforated center for attachment to a wall, depicts two figures in the act of drinking a libation, a scene that we might typically expect to find on an Early Dynastic votive panel. A large part of the relief is an elegantly carved text that makes up the space against which the figures are placed. The inscription is a dedication by

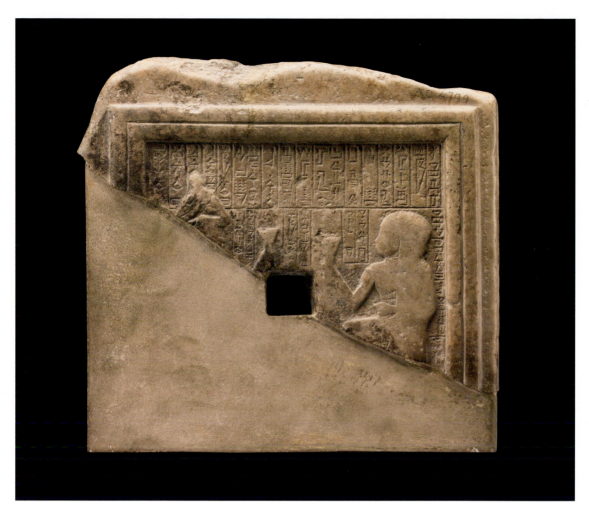

5.12 Votive relief of Nidu-pae, unknown provenance, probably Umma, Iraq, 2150 BCE. Limestone, h. 7⅞ in. (20 cm)

Nidu-pae, the scribe and archivist of the city of Sarrakum in the south of Mesopotamia. He states that his father was a scribe before him, and dedicates his votive offering for his own life and the lives of his wife, Geme-mug-sagana, and his children. He adds the name of a local lord, Sharratigubisin. Given his profession as a scribe and archivist, the emphasis on the text and its fine and skilled carving seems to fit well with the identity of this donor, a man not of royal descent but of a proud lineage of scholars. It is an excellent example of the artworks that were not commissioned by the king as royal ideological messages, but by artisans, scribes, and others of the professional class.

Architecture

Agade, the capital city of the mighty Akkadian dynasty, has never been found, though many archaeologists believe that it must be close to modern-day Baghdad, if not indeed underneath it. It is mentioned in numerous texts, and even in inscriptions on some of the looted monuments, such as the statue of Manishtushu, which we are told was removed from Agade by the Elamites. No foundation text or brick has been found with the name of Agade on it, however, thus no identifiable remains of the capital have been yet been excavated, even illicitly. Architecture of the Akkadian era is better known from the outposts of Akkadian influence and authority, in upper Mesopotamia, the area of modern-day Syria, rather than in the heartland of Akkad in Iraq. Nagar (modern Tell Brak), for example, is a site on the upper Habur plains in northeastern Syria,

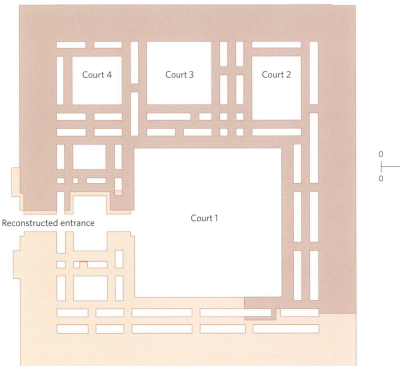

5.13 Palace at Nagar, Syria.

Naramsin's palace at Nagar was a massive building, around 108,000 feet square (10,000 m. sq.), with outer walls measuring 30 ft. (c. 10 m) thick. Many of the square bricks were stamped with the name of King Naramsin of Agade. The palace must have been an impressive symbol of authority, and was an administrative center for imperial control of the Khabur region.

a strategic location for trade. Although the site was settled from the Neolithic era until about 1200 BCE, it reached the height of its importance in the Akkadian era when it was one of three urban centers along with the ancient cities of Urkesh (modern Tell Mozan) and Shehna (modern Tell Leilan).

At Nagar, a monumental building, identified in the 1940s by the excavator Max Mallowan as a palace, has been uncovered from this time. The palace was an administrative center under the reign of Naramsin, whose inscriptions were stamped onto the bricks. It is a massive square structure of about 2.5 acres (1 ha) in size, giving the impression of a fortified building rather than an imperial household. The plan is orderly and **rectilinear** with a large square central courtyard surrounded by smaller courts and rooms [**5.13**]. The massive outer walls and buttressed single entry into the complex also give the impression of a fortification. Another building identified as an Akkadian palace was found at Tell Asmar (ancient Eshnunna) in the Diyala region of Iraq, near the Abu Temple of the Early Dynastic era, which was also rebuilt and renovated at this time.

The Akkadian Northern Palace had elaborate drainage facilities and paved areas [**5.14**]. In layout it does not give the impression of a pre-planned fortification, such as the building at Nagar. In fact, the Northern Palace was adapted to an irregular site, and was based on its predecessor, a residential building of the Early Dynastic era. There is evidence of extensive occupation in the Diyala region dating to the Akkadian era, including private houses, some of which contained works of sculpture, demonstrating that representational arts were not limited to the domains of the palace and the temple. Although dedications of statues were made in the Early Dynastic era by private individuals, less is known about households from that time. The excavation of private houses in the Diyala thus revealed more regarding people's use of images at home.

Archaeologically, the dating of Akkadian buildings can be ascertained by inscriptions, such as the stamped bricks bearing the name of King Naramsin, or by objects found within them that were used during their occupation. The dates can also be determined by the construction techniques: brick shapes, for example, in the

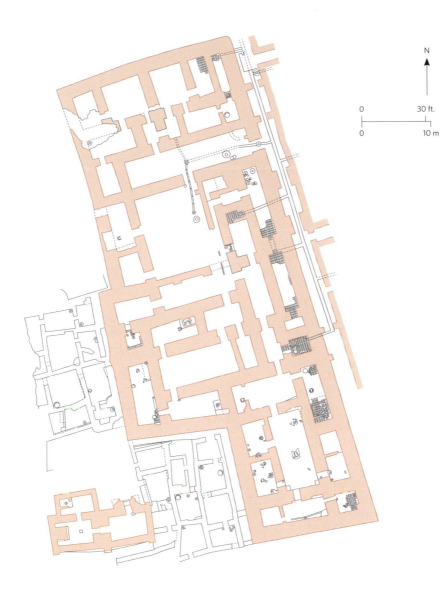

N

0 30 ft.

0 10 m

5.14 Northern Palace, Tell Asmar, Iraq, 2260–2200 BCE. This large complex, built with flat Akkadian type bricks, was most likely an administrative building with various functions. It had a series of open courtyards surrounded by rooms and storage areas, and a large number of water installations, lavatories, and drainage systems.

heartland of the Akkadian kingdom differ markedly from the plano-convex-shaped bricks of the Early Dynastic era (see p. 78).

The two other major Akkadian outposts in Syria, those of Urkesh and Shehna, also have monumental and fortified buildings. At Urkesh, a temple and palace dating to the Akkadian dynasty survive; however, it is unclear to what extent the rulers of Urkesh were independent in their authority or were under Akkadian domination. At Shehna, large-scale fortifications erected at this time appear to be directly related to the Akkadian south. In Nineveh, Manishtushu is credited with founding the Ishtar Temple where the bronze head was found [5.3, see p. 117], but the remains from the Akkadian era here and in nearby Assur are few.

Cylinder Seals

During the Akkadian dynasty, cylinder seal carving reached a level of skill that is truly remarkable. The naturalism of the forms modeled in the minute carvings in precious stone at this time is unparalleled in ancient art, and a very large corpus of cylinder seals, rich in both iconography and style, exists from this period.

Chronology and Iconography

Akkadian seal carving is divided into three stylistic and chronological groupings correlating with the reigns of Sargon (Akkadian I), Rimush and Manishtushu (Akkadian II), and Naramsin and **Sharkalisharri** (Akkadian III). In the Akkadian I phase, seals depict a wealth of images of the

divine **pantheon**, and the iconography of gods and goddesses becomes standardized at this time. Some of the themes and methods of the Early Dynastic era continue to be used, while a linear form of carving images of gods begins. Hero–animal combat friezes no longer overlap: they are now distributed in space across the field of the seal, and groupings are placed against more open backgrounds. The scenes in the friezes are more thinned out, as greater modeling is introduced, focusing more on the figures and their corporeality [**5.15**], or the depiction and details of the iconography, than the patterned and decorative intertwined friezes of the Early Dynastic era did. In the Early Dynastic, the ingenuity of the overall design was given precedence over the detailing of individual figures—the iconography can even be seen as a pretext for the skills of the artist in distributing figures into a tightly woven composition—but this emphasis shifts in the Akkadian era with its growing interest in the naturalistic and concrete depiction of figures, whether they are of mortal men and women, or the realm of the supernatural and the divine.

In the Akkadian II style of seal carving, more modeling is used and we see a new emphasis on verisimilitude—that is, close resemblance to real bodies—in the depiction of musculature and details of hair and facial features. By the time of Manishtushu, a style of seal carving emerges in which the seal carvers make use of highly formal compositions that often rely on symmetrical scenes. The carving style is modeled in intaglio, with a naturalistic corporeality in the representation of figures. This desire for realistic representation in the Akkadian II phase of seal carving corresponds to what we can observe in the large-scale stone carving of royal monuments, which reveals a similar interest in realistic forms, and in the depiction of such concrete physical details as bone structure, musculature, and locks of hair or beards. This is referred to as classical Akkadian style.

The classical style is most fully developed during the reign of Naramsin and Sharkalisharri, his successor [**5.18**, see p. 133]. In this third Akkadian phase, forms with greater volume and deeper modeling appear, and the seals are cut in deeper relief. Seal cutters seem to be interested in creating compositions that are balanced and uncrowded. Traditional subjects of hero–animal combat continue, but they differ in the carving style and the distribution of forms in the composition. Fierce struggles between heroes and wild animals, and skirmishes in battle scenes, are given a new vigor. There is a careful distribution of

5.15 Seal of Kalki, scribe of Ubil-Eshtar, brother of the king, unknown provenance, probably Babylon, Iraq, 2300 BCE. Diorite, h. 1¼ in. (3.32 cm)

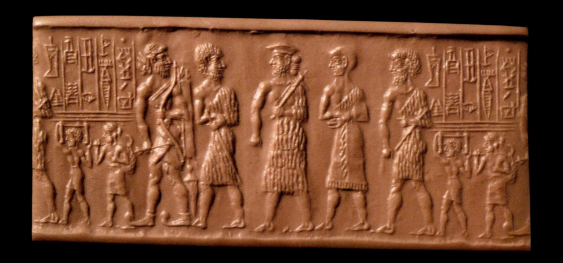

details within the scenes, with figures in upright, often heraldic, positions, and inscriptions placed into panels in between. The contest scenes of the Akkadian III style are frequently dual competitions, isolated into agonistic pairs. The nude hero, wearing only a belt at his waist, battles a lion, bison, or bull with which he is equally matched in strength. The hero's face is shown frontally regardless of the events taking place. His long curly hair and beard are signs of his virility, along with his heroic nudity, which always puts emphasis on the taut and strong musculature of his body. Bull-men appear alongside the heroes, both as victors in these scenes. It seems likely that this is the style developed in the royal workshops connected with the palace, since several of the seals that embody the style bear inscriptions with royal names. These then inspired the forms of seals made for other people who were in the professions, such as scribes. Serpentine, jasper, lapis lazuli, and rock crystal were all favored for seal carving in the Akkadian era.

The stylistic division of seal carving into three chronological phases was made on the basis of the hero–animal contest scenes and is a useful aid for their study. Other types of scene fall less easily into this system, however, which is therefore to be used as a guideline rather than a strict categorization.

The rich repertoire of subjects covers the mythical and divine world, as well as daily life. The gods of the pantheon and the main astral and the earthly deities acquire their emblems and signs, their divine **attributes** and iconographies, which continue to be used into the future.

A seal carved out of greenstone bears an inscription identifying it as the seal of Adda the scribe [**5.16**]. The seal fits best in the Akkadian II style, with some attention to naturalistic details but not the full modeling and deeper carving of Akkadian III. It depicts five gods, each wearing a pointed headdress with multiple horns, the horned headgear identifying their divine nature. A deity with streams of water and fishes emerging from his shoulder is climbing a mountainside. He is Ea, the god of wisdom and sweet waters, whose Sumerian name was Enki. Behind him stands his vizier, **Usmu**, who can be identified by his two faces. Ea reaches out towards a bird with his right hand. In front of him we see the upper torso and head of a god holding a serrated dagger emerging from the scale pattern, which indicates the mountainous terrain. Rays of light emerge from his shoulders, identifying him as Shamash, the sun god (**Utu** in Sumerian). The blade enables him to cut through the mountainside in order to appear at dawn, and in his role as the god of

5.16 Seal of Adda the Scribe, unknown provenance, probably Sippar, Iraq, 2260 BCE. Greenstone, h. 1½ in. (3.9 cm)

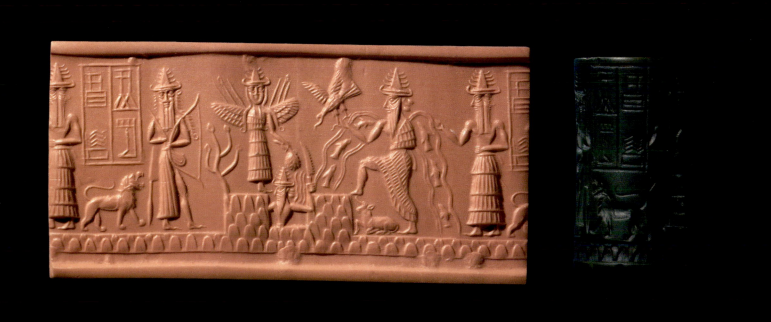

law and justice he uses the blade also to cut the decisions of jurisprudence.

Standing in a frontal position and wearing a layered multi-tiered dress, with outspread wings, is the goddess Ishtar (Inanna in Sumerian), the goddess of love and war. Weapons issue from her shoulders; her face, unlike the bearded male gods, is feminine; and she is given prominence by her frontality and her stance on the mountain. To her right, a bearded male deity, standing in profile but with the upper torso and head frontally positioned, is an archer god, followed by a lion, above which the inscription of Adda is placed.

Kalki's seal [5.15, see p. 130] represents a group of five men walking outdoors. The first man carries a bow and a quiver with arrows. He has long hair, pulled back behind his head, and is bearded. He wears a kilt and upturned shoes. Behind him are two bearded men in flounced garments, one short-haired and one long-haired. A shaven-headed man, the third figure in the row, appears to be a scribe, holding a tablet, and is thus most likely the seal owner Kalki. He is followed by a fifth figure also in a flounced garment, with an ax in the crook of his arm. Two small figures, depicted at an entirely different scale from the others, are positioned under the inscription, separated by three horizontal lines. These men carry objects including a stool, a crook, and a net. The scene is depicted with careful modeling and attention to musculature and bones. The sculptor has also given the image a sense of liveliness

by representing the first two figures in the act of turning backward while they walk, perhaps to discuss something with their companions. The modeled style of this narrative scene belongs to the Akkadian I phase.

The developed classical style of Akkadian seal carving is exemplified by a red jasper seal, which depicts four nude heroes each wearing only a belt with three strands [5.17]. The heroes have long, curly hair and beards, and each holds a gatepost standard in both hands, while kneeling with one upraised bent knee. The figure holding the standard post is similar to the copper alloy statue from Bassetki inscribed with the text of the king Naramsin [5.4, see p. 118]. This seal iconography therefore provides further evidence for understanding the partial remains of the Bassetki statue. In the red jasper seal, an inscription identifies it as belonging to Shatpum, son of Shallum, but his profession or official title is not mentioned. Behind and above the kneeling nude heroes we see a series of symbols: a lunar crescent, a sun disc, a jar with flowing streams of water, and a fish.

A magnificent serpentine seal bears a perfectly symmetrical heraldic scene of two kneeling long-haired nude heroes holding jars with flowing streams of water in front of two water buffaloes, which drink from the streams [5.18]. An inscription panel between them reads "Sharkalisharri, king of Agade, Ibni-Sharrum, the scribe, is his servant." The image of a jar with flowing water is a symbol

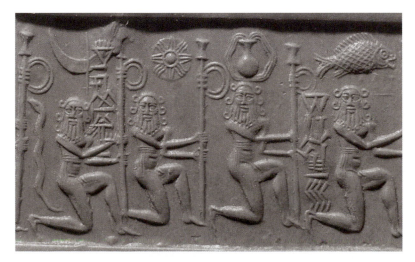 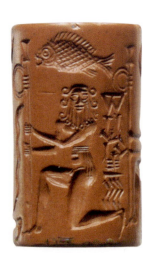

5.17 Seal of Shatpum, son of Shallum, unknown provenance, probably southern Iraq, 2220–2193 BCE. Red jasper, h. 1⅛ in (2.8 cm)

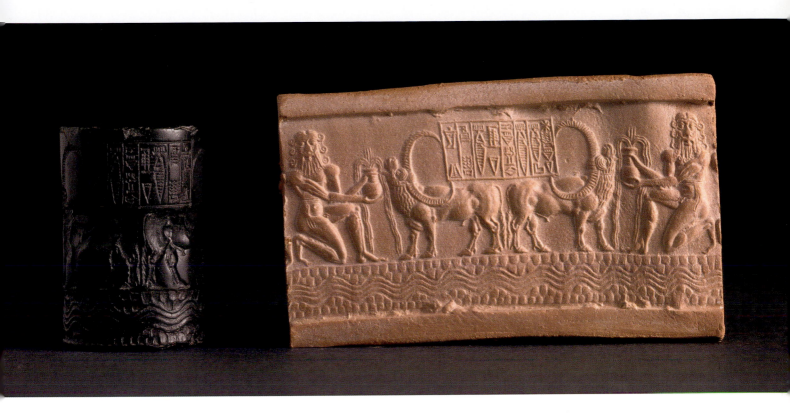

of fertility and abundance. Below the scene, the ground line is made up of a scale pattern for the earth, and wavy lines for streams or a winding river course. The image of the water buffaloes first appears in the time of Sargon of Akkad; they were exotic animals that came from the Indus Valley to Mesopotamia, and must at first have been seen almost as mythical beasts of great power from the distant East.

The art of the Akkadian dynasty introduced monuments of kingship and royal power and war and conquest, which were sculpted in increasingly naturalistic carving styles and great representational detail. The categories of monuments and statues that had already existed in the previous centuries were thus transformed into artforms that expressed the sovereign power of a new form of kingship. In the following centuries these forms would change yet again, but some of the most inventive images of kingship and victory created by Akkadian sculptors would reappear through the ages, borrowed by later rulers for their own iconography. The memory of the great Akkadian kings remained in the monuments that they left

behind, which were studied by later scholars and scribes in the era of **Hammurabi** (see chapter 8). The Akkadian era ended in 2193 BCE, during the reign of Sharkalisharri, and was followed by a period of competition and upheaval. Instead of providing dynastic lineages, the Sumerian King List indicates this chaos with the statement, "Who was king? Who was not king?"

5.18 Seal of Ibni-Sharrum, scribe of Sharkalisharri, unknown provenance, probably southern Iraq, 2217–2193 BCE. Diorite, h. 1½ in. (3.9 cm)

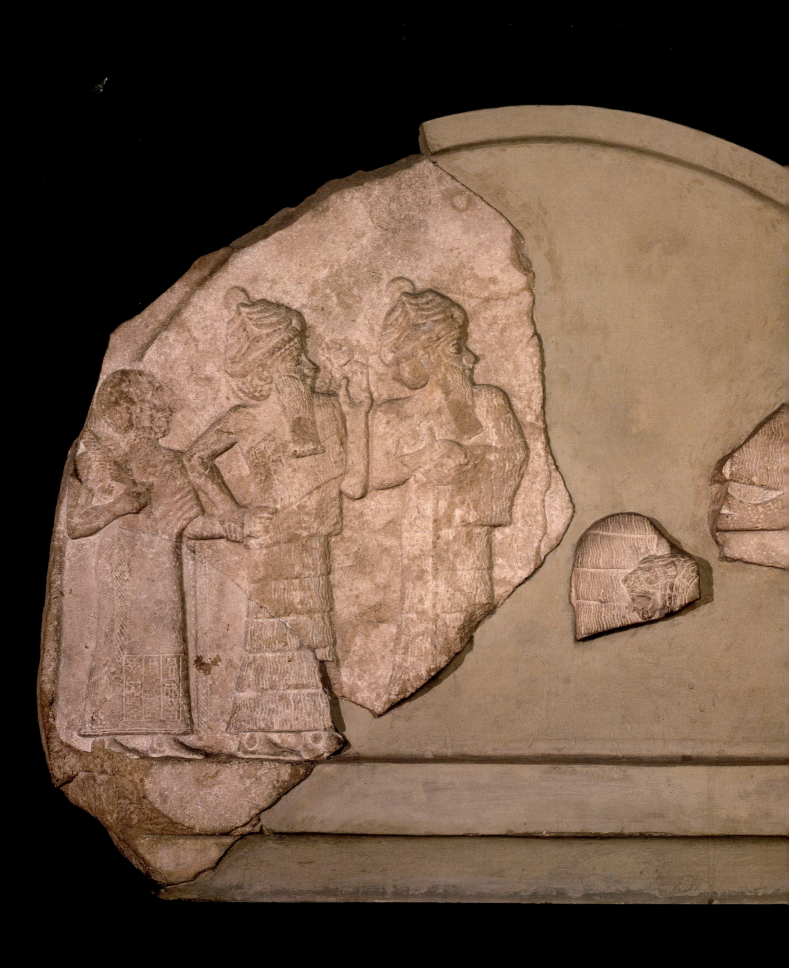

CHAPTER SIX

Gudea: Royal Portraits and the Lifespan of Images

Stele with presentation scene: Gudea being introduced to a god by an interceding deity, from Girsu, Iraq, c. 2140 BCE. Limestone, h. 24¾ in. (63 cm)

6 Gudea: Royal Portraits and the Lifespan of Images 2150–2000 BCE

Period	Second Dynasty of Lagash 2175–2100 BCE
Rulers	Gudea of Lagash: r. 2150–2125 BCE Urningirsu (Gudea's son): 2125–2100 BCE
Major centers	Lagash, Girsu, Ur, Mari
Important artworks	Gudea statues
Technical or stylistic developments in art	Emergence of colossal portrait statues and sculptures featuring long inscriptions Architectural ground plans are depicted in art; descriptions of the architectural process and works of art are recorded in terra-cotta cylinder texts *c.* 2150 BCE

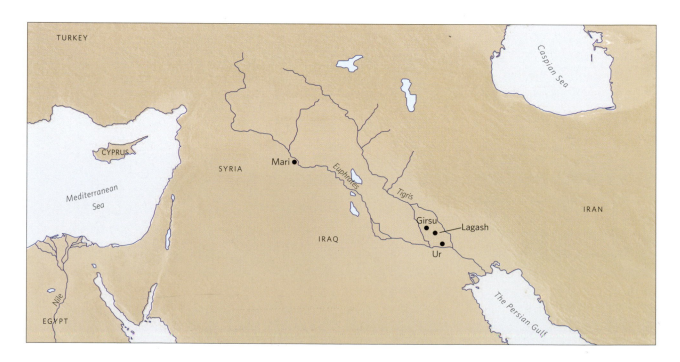

6 Gudea: Royal Portraits and the Lifespan of Images

The art of the reign of **Gudea** of Lagash raises a central art historical question: what is a portrait? By what criteria can we define the genre of portraiture? At this time in southern Mesopotamia, lengthy inscriptions came to be incorporated into statues of people, giving us clear indications of their use and function. These statues and their texts provide some of the world's earliest sources of evidence regarding the complex practices surrounding the making and function of images, how the ancient Mesopotamians thought of them, and where the sculptures were placed within the temple. The texts indicate clearly that the statues were thought to have a life of their own and were intended to stand in for the person being represented for all time. We also learn from the inscriptions that statues were considered to be animate beings, to have an agency of their own. The art historical terms that emerge from the study of these works include: **perceptual** and **conceptual** art, portraits, statue installation, and performative images. The choice of stone as a material for sculpture rather than metal, and the sources of stone as a raw material, are also explained in the statue inscriptions. In addition, we see the first-known architectural groundplan, held by a statue of Gudea of Lagash.

The inscriptions that are carved onto these statues are incorporated into the images in an important and integral way: they were considered to be part of the design rather than a supplement, and their placement upon the statue was taken into account carefully by the sculptor. The texts were given as much attention in terms of the beauty of the carving as any of the other details of the image. At the same time we see that the concerns of the text were to recount the name of the person represented, as well as the name of the statue. We can therefore say that the genre of portrait at this time was not only a visual work of art representing a particular historical individual, but also a word–image sculpture that combined both modes of representation.

In the time between the collapse of Akkad's hegemony (2193 BCE) and before the next dynastic rule—centered in Ur—began (in the **Ur III** period, 2112 BCE), some city states in Mesopotamia became independent, returning to an order of government that had characterized the Early Dynastic age. One of these autonomous urban centers was the city state of Lagash in southeast Sumer. Modern scholars sometimes refer to the period of independence as the Second Dynasty of Lagash in order to distinguish it from the Early Dynastic era before it. Gudea was one of the members of this dynasty. This ensi, or governor, of Lagash, commissioned so many statues, literary texts, and temples that he is one of the best-known rulers of ancient Mesopotamia, and his works are a remarkably rich source of information for the production of sculpture and architecture in the ancient world. Although the duration of his reign and the exact dates of his dynasty are still debated, his was a family-based dynasty that gradually became incorporated into the larger Ur III state that was to take over the greater part of Mesopotamia at the end of the third millennium BCE (see chapter 7).

The Emergence of Portraiture

There was a long tradition, with its origins in the Uruk period, of depicting the ruler in the form of a statue that was meant to represent his living personality [**6.1**, see p. 139]. This type of statue was first made as an **ex voto**, an offering that the

donor would place as a sacrosanct donation within one of the temples of the gods, and one that could not be removed from the sacred precinct. We have seen already that in the Early Dynastic era such statues began to be inscribed with texts that identify the specific person whose effigy it was meant to be, and that the **Sumerians** began to give them names. These statue names can be described as performative since it is the name that enabled them to perform their votive tasks in perpetuity so that the statue's agency and power could continue into the distant future. The act of naming was, therefore, a vital part of a ritual that permitted the transformation from stone or metal to valid representation imbued with the presence of the person it depicted. The undeniably close tie of identity that linked the image and the person in these images means that we can identify them as portraits in art historical terms. But the use of the word "portraiture" to describe images from antiquity has first to be clarified in this context.

In the Western history of art, the idea of a portrait is based on a close physical resemblance between the sitter and the portrait representation, such as that found in certain traditions of European painting after the Renaissance or in modern photography. In these cases, external resemblance is taken to be the first criterion of portraiture: it is the physical approximation that links the image to the person depicted. Because of this traditional definition, there has been some discussion among art historians of the appropriateness of categorizing Mesopotamian images of individuals as portraits. These definitions and arguments are now no longer accepted without question by historians of art. It can easily be demonstrated that even in the Western tradition of portrait sculpture other factors are involved besides the desire for external resemblance. In the case of Italian Renaissance paintings, produced in a period that relied most heavily on concepts of naturalistic resemblance, portraits were very self-consciously used to convey such things as social position, profession, and ancestral lineage, besides more obscure aspects of the sitter's character, personality, and virtues that were considered to be reflected in the facial

features. Thus, since the days of Giorgio Vasari, the sixteenth-century Italian scholar of art, it became standard in the study of portraiture to look at the image as an index of personality of the person represented.

The common understanding of the portrait as a resemblance of the person and his or her inner characteristics and traits came to be applied universally, and thus the artistic traditions of some cultures have been found lacking or inadequate, because they do not fit into this criteria. The definition of "portrait" that was developed specifically in the context of the social and economic requirements of early modern Europe included such things as establishing the rank of the newly emerging merchant classes. Yet even in the Western tradition portraiture had different requirements at different times and places, and the standards of representative verisimilitude to the individual varied. Other traditions of art, for example in China or Africa, chose to depict individuals in ways that do not adhere to the European criteria. These portraits offer us ways of thinking about representing people and their identities and destinies by means of **encoded physiognomies**—the body was considered to bear meaningful signs. Such ideas of identity, inscribed in the body, open up new directions for thinking about representation and expand the concept of portraiture in interesting ways.

The link of image to person can also be made without physical resemblance, as in some Modernist and abstract art traditions. In the ancient Near East, the image of a person represented that person carefully and attentively, though not primarily through a physical resemblance. Their images were idealized representations of the individual, following paradigms of beauty and appropriate representations of rank and social station. But they also conveyed what was considered to be the destiny of the person in the way that they were depicted, and the image could even act as a substitute for the person. By means of the texts, the statues of Gudea of Lagash demonstrate this tradition. The Lagash dynasty statues can thus be defined as portraits even though they

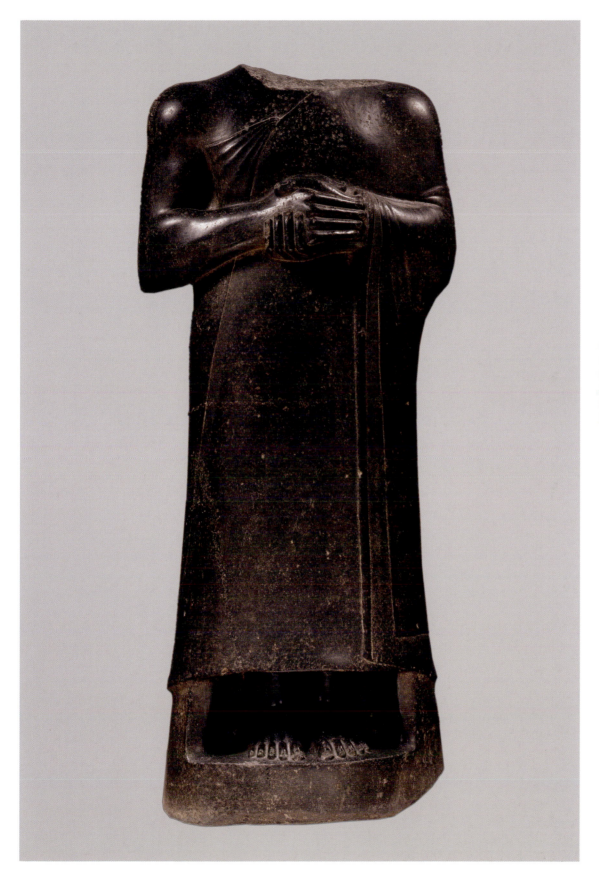

6.1 Gudea standing
with clasped hands,
Girsu, Iraq,
2150–2125 BCE.
Diorite, h. 4 ft. 7⅛ in.
(1.4 m)

are conceptual rather than perceptual works of art, because they function as images that are closely linked to the person depicted. That is to say, they function as abstract images rather than on the basis of perceptual approximation or physical resemblance.

Statues and the Forms of Representation

A large number of statues survive from the Second Dynasty of Lagash, most of which are images of Gudea, the ensi of Lagash [6.2, 6.3]. The sculpture of this era is difficult to place in a stylistic development even though we can be certain of some chronological order based on the statues of Ur-Bau, the father-in-law of Gudea, and **Urningirsu**, Gudea's son and successor. (It is possible to distinguish the images of Gudea from those of his son Urningirsu because the inscriptions carved on the statues provide the identity of the person represented.) Nevertheless,

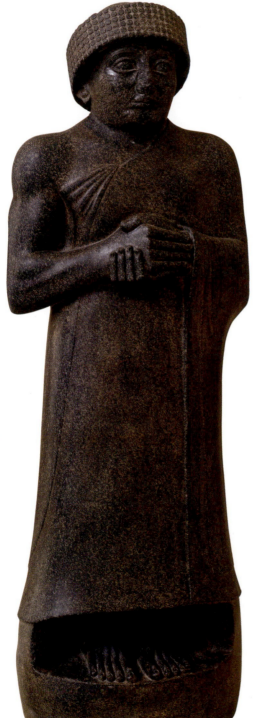

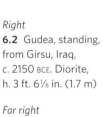

Right
6.2 Gudea, standing, from Girsu, Iraq, *c.* 2150 BCE. Diorite, h. 3 ft. 6⅛ in. (1.7 m)

Far right
6.3 Gudea, unknown provenance, probably Girsu, Iraq, *c.* 2130 BCE. Diorite, h. 30¾ in. (78 cm)

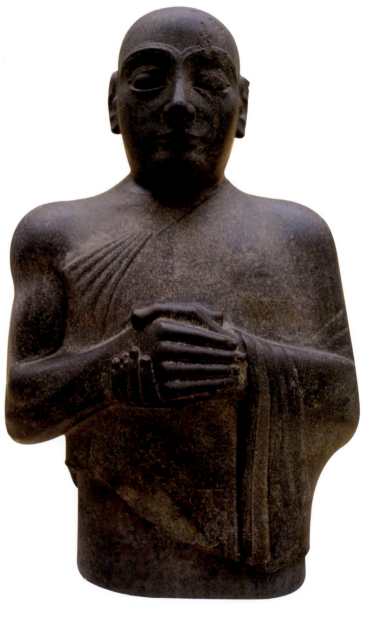

we can see that the diorite statue of Ur-Bau illustrated here [6.4] is a compact and linear statue, blockier and more similar to the Early Dynastic geometricized abstraction of bodily form, and those of Urningirsu [6.10, see p. 147] are somewhat softer, with more sinuous outlines of the figure, without the sharp planes of the majority of Gudea's statues.

Images of Gudea, Prince of Lagash

There are twenty-seven statues of Gudea known today. Early in the twentieth century, they were assigned letters to identify them according to their original exhibition placement in the Louvre Museum, where they were taken after they had been excavated in Girsu (modern Telloh) between 1909 and 1929. Later, letters were assigned to other statues of Gudea regardless of their provenance, so that those statues that came from clandestine excavations were also labeled in this way alongside the statues that were found at the ancient site of Girsu. For the sake of clarity, scholars continue to use these letters to identify them. Among the known statues are full standing figures of the ensi sculpted at a large scale; seated figures of differing sizes, from small [6.6, see p. 143] to colossal; and fragmentary heads that can be identified as surviving from other statues of this well-documented ruler. Many of the statues from the Second Dynasty of Lagash bear long inscriptions that identify the images securely, a fact that is very helpful for art historical attributions and dating in relationship to the study of style and carving techniques, aspects that we address here. But, as already mentioned, the texts carved onto these statues also provide a great deal of information on the function, production, and purpose of these images. They are therefore a rich source

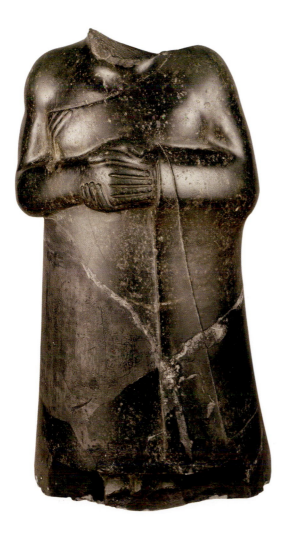

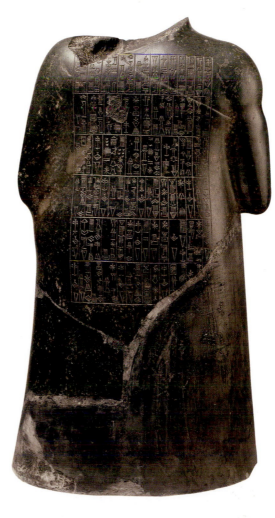

6.4 Statue of Ur-Bau (front and back), from Girsu, Iraq, 2175 BCE. Diorite, h. 20¾ in. (68 cm)

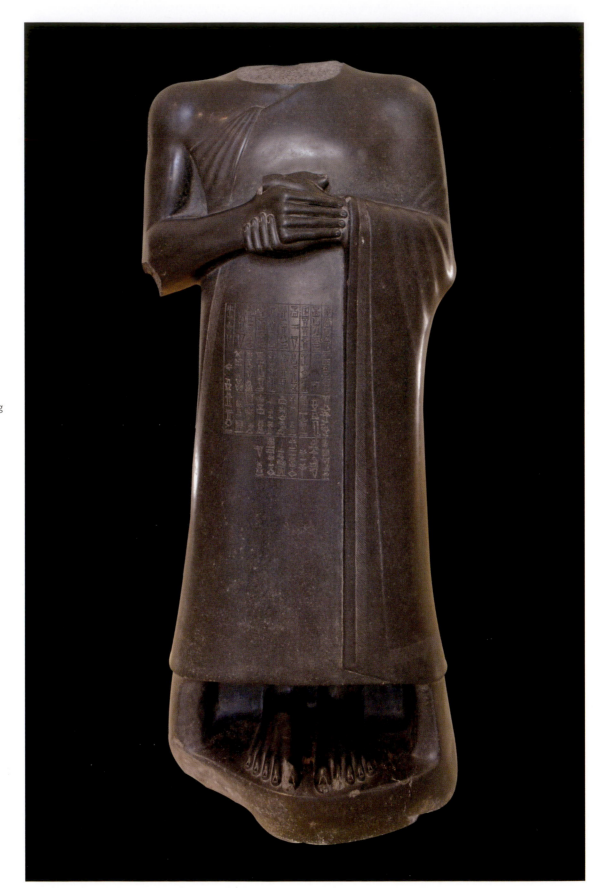

6.5 Gudea, standing (Statue A), from Girsu, Iraq, 2150 BCE. Diorite, h. 4 ft. (1.24 m)

of information about the making and installation of royal votive sculpture of the third millennium BCE, many of which practices seem to continue into later forms of Mesopotamian votive portraits. The large figure of Gudea at the Louvre Museum, known as Statue A, is a good example of a standing votive image, although the head is missing [6.5]. It represents a man in prayer before his god. His clasped hands are carved with sharp planes, and the body covered in a mantle is cylindrical in form. A flat stretch of cloth in the front is used for the inscription panel. The folds of the mantle that cover the left arm and shoulder are softly modeled, while the edge of cloth over the arm is carved sharply and with detail to contrast with the smooth surface of the taut fabric of the garment. That the feet were cut together with the base continued an Early Dynastic method of incorporating the base into the carved form of the image. Inscriptions on the right shoulder and on the garment dedicate the statue to the goddess Ninhursag (a mother goddess, also identified with the goddesses Ninmah and Nintu). The text also states that Gudea brought it to her in her temple in Girsu, for at the end of the text we read,

> The lady who makes firm decisions for heaven and earth, Nintu, mother of the gods, let Gudea, who built the house, have a long life ... (this is how) he named (the statue) for her sake, and he brought it to her into (her) house.

Seated and compact in form, the Metropolitan Museum Statue P [6.6] represents Gudea facing forward and looking contemplatively at something before him, which was presumably the cult statue of the god to whom it was to pray in perpetuity. He is beardless and wears a woolen cap with a wide brim, which is represented with six strictly aligned rows of curls. The lower part of his ears and his earlobes emerge from the cap. The large heavy-rimmed eyes and thickly carved brows that join at the bridge of the nose are typical features for the statuary of this time. His softly carved cheeks and determined square jaw are aspects that we recognize as characteristic of Gudea's images, as are the shape of his nose and mouth with the lightly undercut lower lip. All the statues

represent the ruler as a man in the prime of his life. The features convey the physically ideal man, but the body is also encoded with a **physiognomy** that was considered to carry aspects of the able-bodied ruler. The style in which his body is carved is therefore not just a matter of form, or a formal element of the work. Aspects of the body were carved in order to express meaning. The visual properties of the statue have a strong similarity to textual descriptions from the time of the **attributes** of the good ruler. The head—which is large in proportion to the body—is similar to the textual description of Gudea as having "the rightful head made to stand out in the assembly by the god **Ningiszhida**." In other words, the large head is a sign of distinction and authority appropriate for the ruler, the man who stands out among the people. In the same way, the emphasis on the exposed muscled right arm indicates his strength and ability to rule. The image was intended to show Gudea with "his life abundantly within him," as Sumerian texts say. This statue bears the name "Let the life of Gudea, who built the house, be long."

Perhaps the best-known statue of Gudea is the life-size seated Statue B, in which he holds an architectural plan on his knee [6.7, see p. 144]. It is remarkable for the originality of the composition as well as for the excellence of its carving and the quality of the smooth and unblemished surface of the diorite monolith out of which it is carved. The statue's lower part and back is extensively covered in inscription, so that the text turns the statue into a written monument at the same time. The text begins at the back, which suggests that the statue was positioned facing the god, and that the inscription was there for the mortal viewers who would enter the temple.

Gudea's Statue B, which lacks its head, represents a man seated on a stool with curved legs. He wears a long mantle that covers one arm and shoulder, and is tucked under the other arm, forming a series of folds. He is

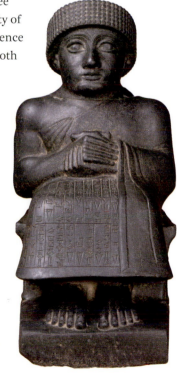

6.6 Gudea, seated (Statue P), probably from Girsu, Iraq, 2150 BCE. Diorite, h. 17⅜ in. (44 cm)

barefoot and holds his hands together in a gesture of prayer. The sculptor has treated the hands and feet with great detail and skill. The fingers and toes are elongated and carefully carved, the outlines of each of the nails are delineated in double lines, while creases at the knuckles are shown as three incised lines, joined at the end into a stylized pattern. This emphasis draws attention to the hands and feet in contrast to the rounded smooth surfaces of the musculature of the body. The skirt is depicted in rectangular form, giving the statue a sense of a strong presence, solid and stable, retaining the qualities of the block of stone out of which it is carved. Both the chair and the skirt are covered with an extensive text, carved with careful attention to the aesthetic qualities of the script, so that we can see that the text has to be understood as an integral part of the design and function of this work of art.

The plan drawn onto the tablet that Gudea holds on his lap is a clear **orthogonal** projection. It depicts the outlines of the enclosure of the sanctuary of Ningirsu at Girsu called the E-ninnu (House of Fifty). We can see this as a structure of thick walls reinforced by external buttresses along its length and incorporating six fortified doors equipped with **redans** (arrow-shaped embankments) and flanked by towers. This type of temple wall with buttressed facades, in both baked and unbaked brick, is known to have been used in ancient Mesopotamian architecture.

In the lengthy inscription, we read that the statue is carved out of diorite, a material that Gudea brought from the distant land of Magan in what is now the Persian Gulf. The text states:

> From the foreign land of Magan, he (Gudea) brought diorite and sculpted it into the form of a stone statue. He named it: 'For my Lord, I built his house, life is my reward' and he brought it to him in the E-ninnu. Gudea gave word to the statue.

Further on the text states:

> For this statue nobody was supposed to use silver or lapis lazuli, neither should copper or tin or bronze be a working material.
>
> It is exclusively of diorite; let it stand at the libation place.
>
> Nobody will forcibly damage the stone.

6.7 Gudea, seated (Statue B) (front and detail), from Girsu, Iraq, *c.* 2150 BCE. Diorite, h. 36⅝ in. (93 cm)

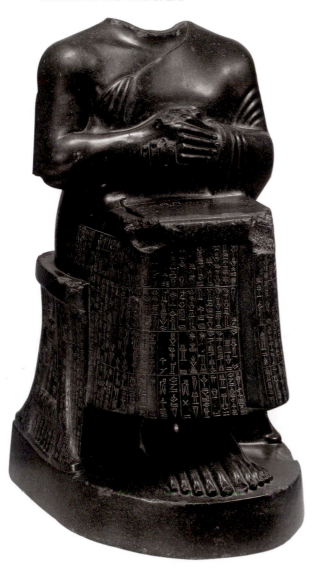

This statement is more than a boast about the valuable and exotic materials that Gudea could bring to Lagash from distant lands or how far his ships could sail. It is also an exaltation of the properties of this stone that is paralleled by some literary texts narrating myths in which the visual and material qualities of stone are described as being part of their destinies, bestowed by the gods. Just as the diorite is difficult to carve, it is also durable and difficult to destroy, making it an appropriate stone for such a sculpture. (For the practices of destroying and defacing sculpture, see pp. 122–25.)

Gudea holds the plan of the E-ninnu on his lap, indicating the purpose of the statue as the perpetuation of this offering of both votive image and temple construction as a pious act. The inscriptions also state that the god gives him this project as a divine blueprint: the plan was sent to him in a dream image on a lapis lazuli tablet. It is thus both given by the god and a gift to the god, a reciprocal votive exchange of a man and his god that is beautifully made concrete in this statue of Gudea.

Another architect statue of Gudea, Statue F, holds a blank slate, a stylus, and a graduated rule on his lap [6.8], instruments that were used for creating plans or models to correct scale. This is the earliest evidence for the use of ground plans and graduated rules that we have preserved from antiquity. The image of a ruler as a pious temple builder is an old tradition, as we have seen in the Early Dynastic III example of the Urnanshe relief plaque, in which the king of Lagash carries the basket for the laying of the first brick in the building of the temple [3.23, see p. 83].

The Detroit Gudea is an unusual statue from this dynasty [6.9, p. 146]. It uses the semi-translucent properties of green paragonite to create its visual effects. Easier to carve than diorite, this softer stone translates into the softer curves and fluid contours of Gudea's figure. Gudea's broad shoulders and narrow waist are emphasized in a way that is not paralleled in the other standing Gudea statues. The fringe of the garment at the bottom of the dress is represented in some detail. His right hand clasps his left wrist, a different gesture from the other statues. The statue is inscribed on the back

6.8 Gudea, seated (Statue F) (front and detail), from Girsu, Iraq, 2150 BCE. Diorite, h. 33⅞ in. (86 cm)

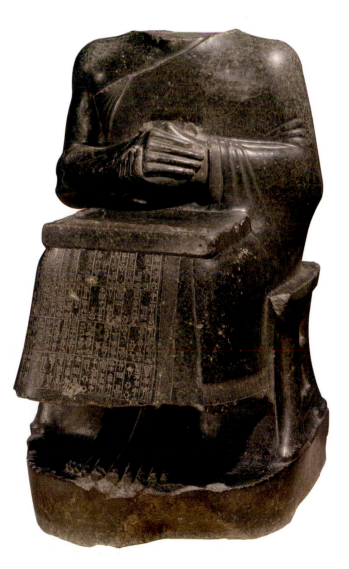

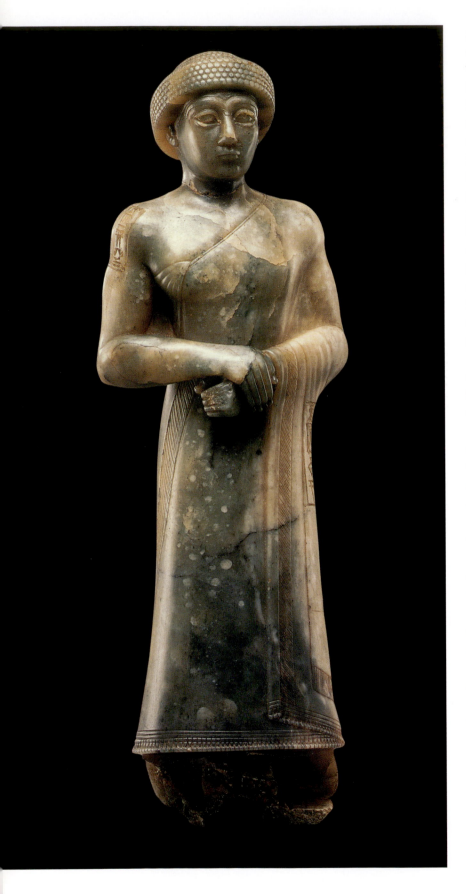

and right shoulder, dedicating it to the goddess Geshtinanna, the wife of the god Ningiszhida. We read that Gudea built a temple for her in Girsu, and placed the statue in her temple. The authenticity of the Detroit Gudea has been questioned because of the unusual choice of stone and some of the details of the carving. The statue (as with some other Gudea images) was bought on the antiquities market. The lack of archaeological provenance raises different kinds of art historical problems, both historical and ethical, since the illicit looting of antiquities destroys the historical context and related information. In the case of the Detroit Gudea the evidence in favour of the authenticity of the statue includes its complicated inscription, which would have been difficult for a skilled forger of statues who was not also an expert in the Sumerian language.

The statuary of Gudea is introspective, in a state of rest, unlike for example the statue of Manishtushu, the king of Akkad [5.6; see p. 120], where movement is seen in the rippling of the skirt. There is a serenity in these smooth stone images of Gudea and a sense of piety in the figure with hands clasped in prayer. They are powerful not so much in the sense of royal power and authority—as in the Akkadian ruler's image—but more in terms of the forceful presence of Gudea within his images. Physical power is conveyed by the emphatic and well-defined musculature of the exposed right arm and shoulder, carved in a way to express strength. In the Sumerian-language epithet sometimes given to Gudea, "strength-given one of Nindara," the word for strength can also be read as "strong arm." The carving of the arm in this way may be a means of inscribing the body quite literally with his epithet as the strong ruler of his people. This emphasis is not new in Gudea's reign but harks back to the earliest images of kings, from Uruk-era sculptures through to the Akkadian images, which also stress a powerful

6.9 Gudea, standing, unknown provenance, probably from Girsu, Iraq, 2150 BCE. Paragonite, h. 16⅛ in. (41 cm)

masculinity. The sculpted emphasis on the
musculature of arms in royal sculpture thus had
a long history, constituting a traditional form of
conveying royal authority that is adopted in the
images of Gudea.

Images and Texts of the Lagash Dynasty

The son and successor of Gudea, Urningirsu, is
known from only three statues that identify him
by inscription. The most complete and also the
most impressive example of these is a chlorite
statue that is owned jointly by the Metropolitan
Museum of Art in New York and the Louvre
Museum in Paris [6.10]. The face of Urningirsu
and his standing pose with hands clasped in
prayer follows the tradition of the Gudea statues
closely, but there is a softer contour to the body,
perhaps due to the use of chlorite, a far softer
stone to carve than diorite. Beneath the standing
Urningirsu we see the base, carved together with
the statue. It depicts a row of kneeling bearded
figures that wear a short, belted kilt and a plumed
turban or crown. They carry baskets of offerings
to the ruler. They have been identified either
as tribute from vassals or as a depiction of the
offerings necessary for the continuing life of the
statue. The figures are interesting for several
reasons. Their identity may tell us something
about the purpose of the statue, but also the way
that they are depicted is of importance. They are
shown in absolute profile, unlike the mixed profile
that was normally used for royal figures and gods.
The sculptor has carved the shoulder and arm of
each figure that is farthest away from the viewer
in a way that attempts to push it back behind the
figure into space, layering the second arm beneath
the first. This form of profile is markedly different
to the formal poses that we see used for images
of gods and kings in which the upper part of the
torso is turned forward so that we see the entirety
of the shoulders and both arms (for example, the
stele of Gudea in Berlin, p. 134). The inscription
on the back states that Urningirsu dedicated the
statue for Ningiszhida, his personal god, and that
the name of the statue is: "I am the one beloved
by his god; let my life be long."

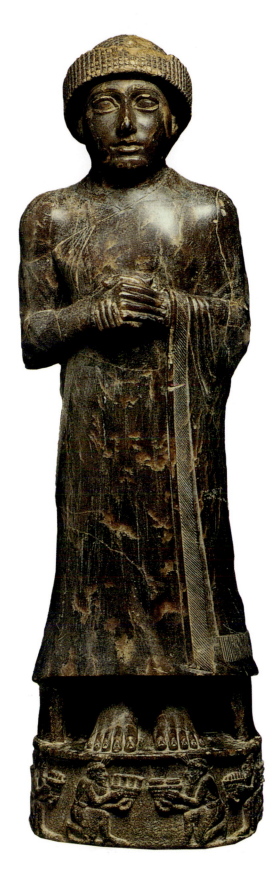

6.10 Urningirsu, son
of Gudea, unknown
provenance, probably
from Girsu, Iraq,
2100 BCE. Chlorite,
h. 21⅝ in. (55 cm)

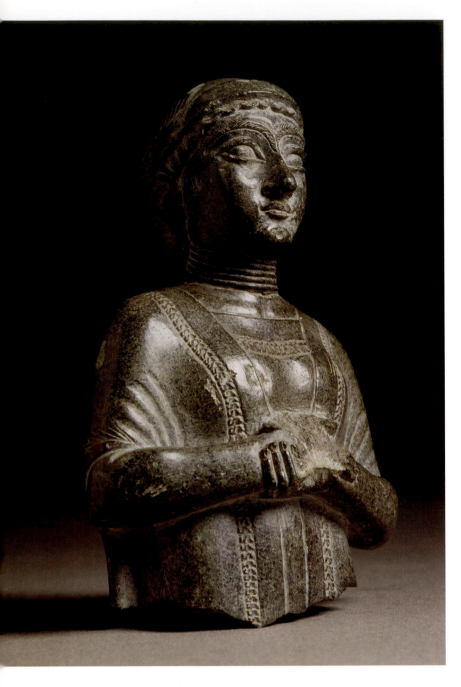

6.11 Statue of a woman, from Girsu, Iraq, 2150 BCE. Chlorite, h. 7 in. (17.4 cm)

Along with the statues of Gudea and Urningirsu, a number of statues that were found at Girsu represent women of high rank. Most of them are made of limestone or chlorite rather than diorite. The statue illustrated, which would have been about 12 in. (30 cm) when complete, represents a woman in an attitude of prayer [6.11]. The thick brows and heavy rimmed large eyes are carved in the same way as the Gudea statues. Elite women during this era (the third millennium BCE) seemed to have enjoyed a great deal of independence and legal rights. We know that women could be the primary inheritors of property and of land, a right that is in fact mentioned in the text of Gudea's Statue B as part of the advantages of his city. We also know that women had the ability to commission and dedicate works of art, both for their own lives and for those of family members. The number of female statues that were commissioned and carved in southern Mesopotamia during the second half of the third millennium BCE is unparalleled in Near Eastern history. These statues are distinctive not because of their medium—sculpture in the round—but because of their function. They are not images of goddesses or supernatural mythical figures; they are statues of known historical individuals, women who lived in antiquity.

Although the texts state that Gudea erected stone steles, very little remains of these works, unlike the numerous statues in the round that have survived intact. The top part of a relief in Berlin depicts a **presentation scene**, similar to the types of scenes of introduction that we know from cylinder seal images. A lesser deity leads Gudea by the hand into the presence of an enthroned god. The figure of the supplicant is identified by an inscription on the lower part of his robe as "Gudea, ruler of Lagash." The god leading him by the left arm can be identified as Ningiszhida from the dragon heads that emerge from his shoulders. Before this god stands another, whose skirt is covered with flowing water. The three surviving divine figures in the scene all wear multiple horn crowns topped with a disc, and layered flounced robes, while Gudea wears a mantle with a fringed border and holds a palm frond in his right hand.

The statue of Urningirsu had been plundered in the 1920s and its head was deliberately cut off from the body so that the statue could be sold as two separate pieces on the antiquities market. The Louvre acquired the body, and the Metropolitan Museum of Art the head. When they were found to belong together they were rejoined, and now the repaired statue travels back and forth between Paris and New York.

The fragmentary enthroned god on a lion throne may be Enki, lord of the fresh water. The relief is in a very fragmentary condition but it nevertheless preserves some of the iconography of the divine and of ritual in this era.

Texts: Building a House for the God

Among the extensive texts that survive from the Second Dynasty of Lagash, two large terra-cotta cylinders are inscribed with a composition about Gudea's building project for the E-ninnu, the Temple of Ningirsu at Girsu. One text (cylinder A) [**6.12**] describes the events leading up to the construction. The other text (cylinder B) records the rituals of the inauguration of the temple. In 1877, French archaeologists found these texts under a wall of a building that may have been part of the E-ninnu temple, but which has never been fully recovered. These cylinders are among the longest Sumerian literary texts known at present.

The cylinder text describes the images from the dream of Gudea, a dream that was sent to him from heaven as an omen for building the temple. The text describes Gudea as seeing the god Ningirsu in a "night vision" and that the god let E-ninnu "stand before his eyes." At first, Gudea found the dream image enigmatic and so he went to have the dream interpreted. He said to the interpreter that he saw someone in his dream:

> enormous as the skies, enormous as the earth was he. That one was a god as regards his head, he was the Thunderbird as regards his wings, and a flood-storm as regards his lower body. There was a lion lying on both his left and right side. He told me his house should be built ... There was a woman coming forward (with) sheaves. She held in her hand a stylus of shining metal, on her knees there was a tablet with heavenly stars and she was consulting it. Furthermore, there was a warrior who bent (his) arm holding a lapis lazuli plate on which he was setting the ground plan of a house ...

In the temple of the goddess Nanshe the meaning of his dream is revealed to him. Gudea is told that the enormous one is Ningirsu, who wishes the E-ninnu to be built, and that the woman with the shining stylus and tablet of stars is the goddess Nisaba, who is "announcing the bright stars auguring the building of the House"; also that another god, Ninduba the warrior, handed to Gudea the lapis lazuli tablet with the details for the ground plan of the temple (see pp. 143–44). The literary texts thus provide information about how gods were envisioned, how they communicated with people through omens and dreams, and how their requirements were met. Poetical imagery is another place where we can study aesthetical practices of the Mesopotamians. The textual and the visual were closely interconnected in many ways as visual images often incorporate aspects of literary metaphors and similes, and the literary works, in turn, often refer to visual imagery.

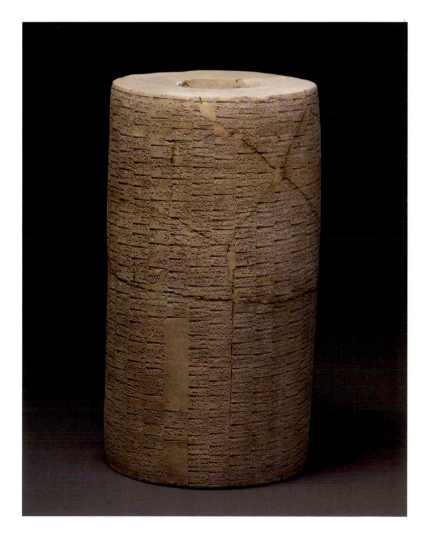

6.12 Gudea cylinder A, from Girsu, Iraq, 2150 BCE. Terra-cotta, h. 23⅝ in. (60 cm)

6.13 Foundation figure: kneeling god holding a peg, probably from Lagash, Iraq, 2150 BCE. Copper alloy, h. 13¼ in. (33.5 cm)

Foundation figures take on a new form at this time, one that appears alongside other types of foundation figure that had already been in use in previous centuries. This kneeling figure is a deity holding a large peg to be inserted into the ground; it was placed within a foundation deposit. In the literary texts of Gudea such figurines are described as being in the form of wizards. We also learn that boxes with offerings were placed deep into the ground; they are called "boxes of the Abzu," the name of the primordial sweet groundwater. The boxes were to be placed so deeply into the earth that they reached the water table. The texts of Gudea thus give us evidence for the architectural rituals and the types of images that were necessary for them.

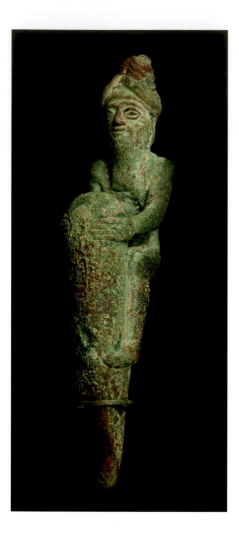

The Function and Lifespan of Images

The earliest details of the making and use of statues are found already in the Early Dynastic-era statue inscriptions, but by the time of Gudea the details are clearer and more extensive. There is a remarkable amount of information from the end of the third millennium BCE regarding the practices of image making and the response to images, from the acquisition of the stone to the installation of the statue in the temple.

In the architect Statue B, for example [**6.8**, see p. 145], the inscription states that Gudea "installed the statue in order to convey messages" and that the statue is to "stand at the libation place." The inscription provides lists of the materials for building the temple, types of wood, precious stone, metals, and so on, and describes the activities and accomplishments of Gudea's life.

In other words, the statue encapsulates much more than Gudea as a person. Other Gudea statues also make use of this play of visual and textual representation. Statue B and Statue F both represent Gudea with the tools and methods of an architect. In Statue B, Gudea holds a complete groundplan (based on an image sent by the gods as a dream omen), and in Statue F he holds a blank slate with a slide rule and stylus, ready to begin a new work. In addition, the text inventories the acquisition of the raw materials that were involved in the process of building. Thus, the statues encapsulate the process of the pious work, from dream sign into architecture, from divinely sent vision to the votive gift of the temple. The votive, then, is not only the statue of Gudea as a man, but also the gift of the entire temple building, the labor that went into it, including the labor of Gudea himself, and the raw materials transformed to sacred structure according to the vision sent down by the gods. In turn, the temple is likened to the city, so that the entire project has an impact on the city state.

The Early Dynastic tradition of naming statues and monuments continued into this era. These names give a clear indication of the function of each work. The name reiterates and underscores the visual presence of the person in the statue by means of the inscription, enabling the statue to function as a substitute for the person represented. In that sense, the statue becomes a valid substitute for the person in perpetuity, to take his or her place in the act of prayer, and thus—through both image and performative text—to provide a form of immortality. The name "May Gudea who built the temple have a long life," for example, is not only descriptive, but it also plays and replays this incantation into the future. The portrait statues were animate substitutes for the person represented both during their own lifetime and long after.

This belief in the animate nature of the statue is clear from the text. The inscription on the back of the architect statue B begins with a list of food offerings to be given to the statue, as if it were a living being. It is to receive a liter of beer and a liter of bread, half a liter each of flour and emmer

groats (crushed wheat). The statue inscription says specifically: "For the statue of Gudea, ensi of Lagash, the man who built E-ninnu," and then instructs the people of the future to continue to provide it with these offerings of food and drink. As the statue stood in the Ki-a-nag, "the place of the pouring of the water" where libations were made to the deceased, the offerings were to continue after the person represented had died. Offerings of food and drink were already made to statues in the Early Dynastic era, indicating that this was an old tradition and system of belief. Despite these offerings, the statues are not divine themselves but sit or stand before the god, as the inscriptions make clear. They were essentially living beings, a continuation of the life force of the represented person in statue form. The offering-bearers depicted on the base of the statue of Urningirsu [6.10, see p. 147] may represent this ritual, bringing food as part of the maintenance of the statue.

In statue B, Gudea also speaks to the statue, saying, "Statue, would you please tell my lord," and he follows this request with a list of his good deeds and accomplishments. The statue is thus specifically requested to repeat the message to the god Ningirsu. In the Detroit Gudea, statue M [6.9, see p. 146], as in several other examples, the text states that the statue "stands in constant prayer."

The statues were thus placed in the temples as a perpetual representation of the ruler before the gods. His images had power and they were sustained by offerings of food and drink. Dedicatory inscriptions tell us a great deal about these statues, how they were credited with a life force and how they functioned in the temple. They were also a means of immortality for the ancient rulers in that they lived on through their images. At the end of the inscriptions, curses were added. They state that if in future a ruler were to end or curtail the regular food offerings to the statues, or if anyone in the future were to erase the inscription or damage the statue, a terrible curse would come down upon him. The gods will "tear out his foundations and make his seed come to end," meaning that he would not have any children or descendants and that his name and memory would die out. In the same way that children continue the name and memory of a person, so too does the living substitute image. Destroying the statue was thus seen as a form of ending the immortality of the person represented.

The importance of the place of the installation and the maintenance of the rites is evidenced in the Early Dynastic era, and curses were already written on statues in Akkadian times. These attitudes toward images, and the animate nature of statues, were typical of ancient Mesopotamia and great parts of the ancient Near East also. These statues were not simply carved stone but a type of essential presence embodied in images meant to stand for all time. Archaeological evidence is also revealing: we learn something about the belief in the animate nature of images and the importance of their care from the archaeological findspots, when they are carefully recorded in a scientific excavation. We see from the site of Mari in Syria, for example, that the statues of rulers of Mari who were contemporaneous with Gudea continued to be maintained in the palace during the following centuries. There too we see similar concerns on the statue inscriptions regarding the erasure or destruction of the statue. The statue of one of these local Mari rulers, Puzur-Ishtar, was taken to Babylon in the south of Mesopotamia where it was found by the German excavators at the end of the Ottoman era [6.14, p.152]. The inscription is in one column around the lower part of the skirt and the **cartouche** below the right arm:

Turam-Dagan, general of Mari

Puzur-Ishtar, his son

To the god [Ea], Lord of [the Assembly], he

[Dedicated] this st[atue of himself] f[or his own life]

[As for the one who re]moves this inscription

may the gods Ishtar, Dagan, Ea, lord of the assembly, tear out his foundations.

Cartouche: Puzur-Ishtar, general of Mari

Sillakka, lieutenant is his brother.

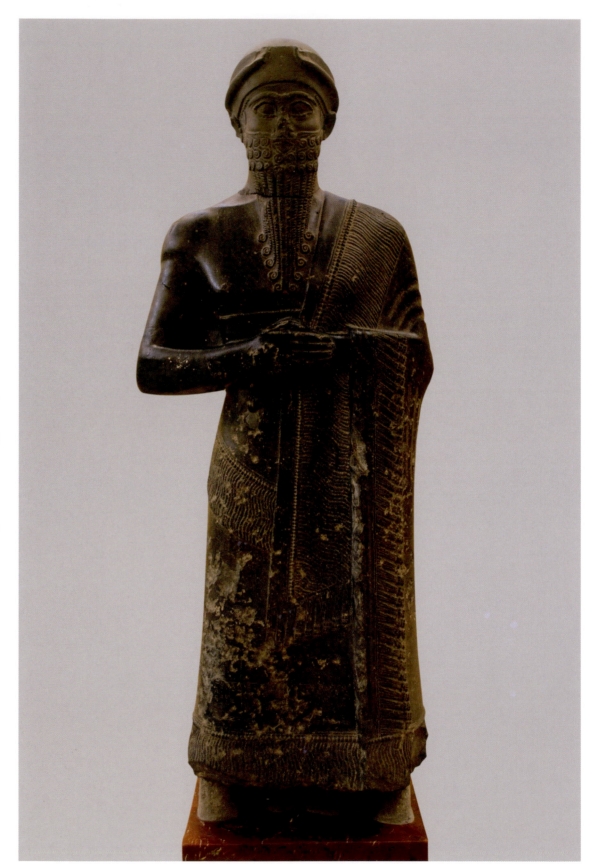

6.14 Puzur-Ishtar, from Babylon, Iraq, c. 2100–2000 BCE. Diorite, h. 5 ft. 6⅞ in. (1.7 m)

The head was bought on the antiquities market before the start of excavations at Babylon in 1899; the body was excavated in Babylon.

The statue of the general Iddi-Ilum was found in two pieces—one in the courtyard and one at the great portal of the palace of Mari—which were found to fit together [**6.15**]. It bears an inscription in one column on the skirt:

Iddi-Ilum, general of Mari

For the goddess Ishtar

Dedicated a statue of himself

As for the one who removes this inscription, may

The goddess Ishtar destroy his progeny.

All of these statues, including the statues of Gudea and those of the governors of Mari (known by the Akkadian title of *shakanakku*), have biographies that can be followed. They were created in the late third millennium BCE but they continued to be seen, and to be the focus of rituals, for centuries after their original era of creation. Often, these statues were relocated and we are able to trace their movement and reuse in antiquity. Statues were kept for centuries and even millennia as significant historical works of ancestral kings, although these practices of collecting at times included also the taking of booty from other lands. The largest collection of Gudea statues is now in the Louvre Museum in Paris, where they are exhibited as antiquities in a modern European cultural institution. This is only the most recent of a series of uses in the lifespan of the statues, however. The French archaeologists who took these sculptures to Paris had excavated them in the palace of a Hellenistic governor in the south of Iraq, where they were already two thousand years old when this ruler had displayed them in his court at Girsu. The statues remained at Girsu after Gudea installed them there, but they were re-discovered, and re-installed in the palace of the later ruler. We will return to this ruler, **Adad Nadin Ahhe**, and his collecting practices in chapter 14.

The statues of Gudea and his dynasty reveal a great deal about the uses and lifespans of ancient Mesopotamian sculptures, especially about portraits of individuals. By means of the combination of texts and images and complex

rituals of production, statues were constructed as forms of essential presence of the person represented. These attitudes towards images that become so clear in the Gudea statues and statue texts seem to be typical of the Mesopotamian understanding of the power and longevity of images. In the following chapter we will see how the kings of the Ur III dynasty emphasized the eternal order of their ancestral line by means of the image of the builder-king.

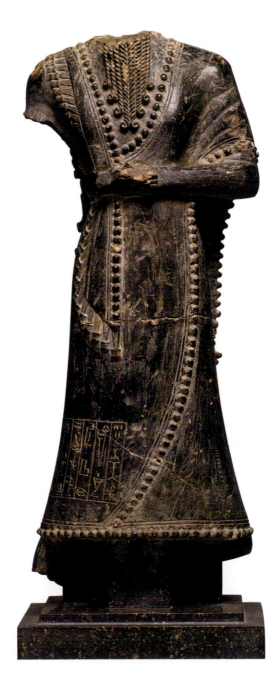

6.15 Iddi-Ilum, from Mari, Syria, c. 2090 BCE. Steatite, h. 16⅜ in. (41.5 cm)

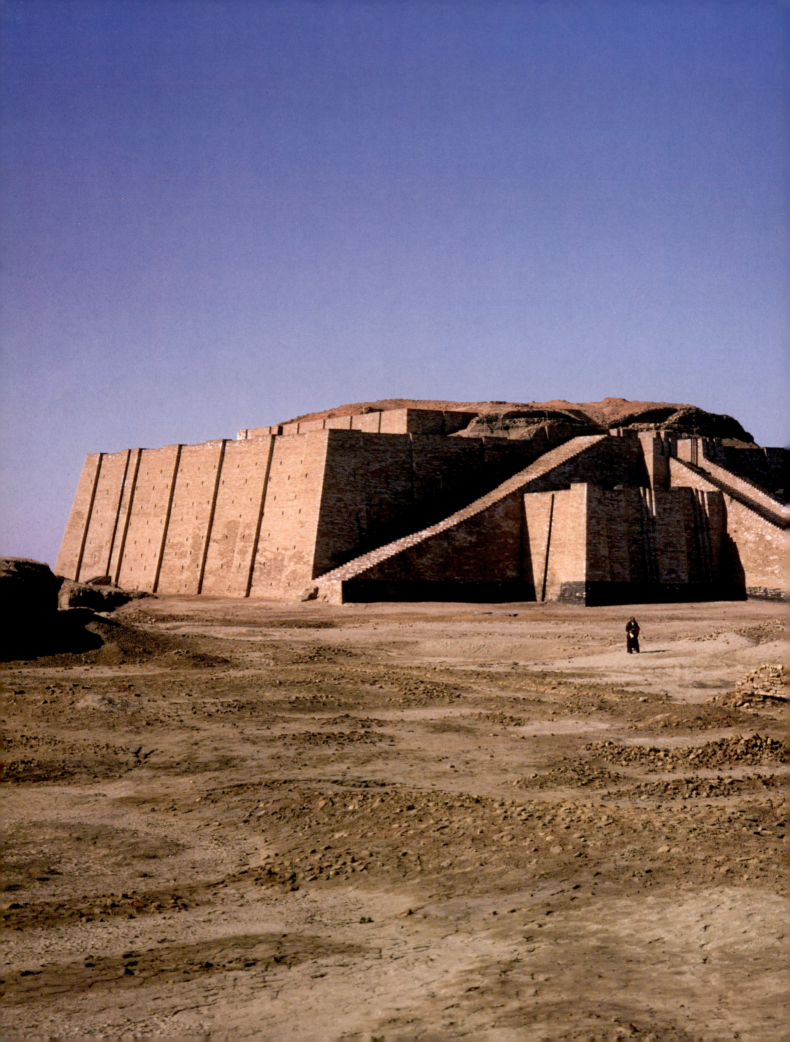

CHAPTER SEVEN

The Third Dynasty of Ur

Ziggurat at Ur, Iraq, 2112–2047 BCE

7 The Third Dynasty of Ur 2112–2004 BCE

Periods	Ur III Dynasty 2112–2004 BCE Collapse of Ur III 2004 BCE
Rulers	Ur-Namma: r. 2112–2095 BCE Shulgi (son of Ur-Namma): r. 2094–2047 BCE Ibbi-Sin: r. 2028–2004 BCE
Major centers	Ur, Uruk, Nippur, Susa
Notable facts and events	Standard weights and measures are now used throughout the region
Important artworks	Ziggurats at Uruk, Nippur, and Ur Temenos of Ur Foundation figures of kings Derbend i Gawr rock relief
Technical or stylistic developments in art	The development of the classic stepped ziggurat form Monumental rock reliefs are carved into the landscape

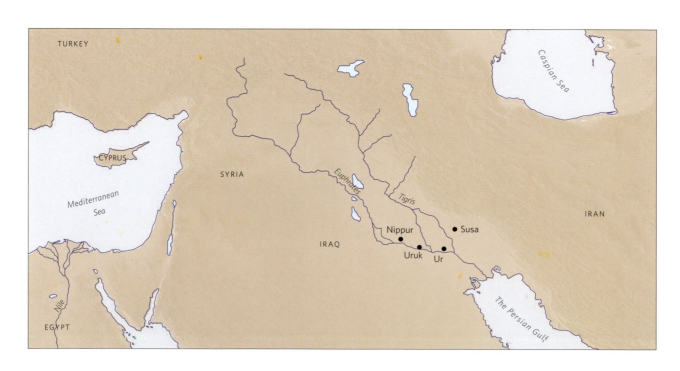

7 The Third Dynasty of Ur

The Third Dynasty of Ur ushered in an era of great building campaigns in the south of Mesopotamia, leading to innovations in architecture that were to influence the region for centuries to come. The Ur III kings presented their rule as orderly and peaceful. Rather than emphasizing warfare or military might as aspects of royal power, the kings of this dynasty instead preferred the image of the pious builder king, constructing temples in the service of the gods. In this chapter we turn to the most important site for the dynasty, the city of Ur, with its new ziggurat dedicated to the moon god, its extensive sacred precinct, and its monumental dynastic tombs. With these building campaigns, there was an increasing complexity of architectural rituals in which the king was a central participant.

According to the Sumerian King List, after the collapse of the Akkadian supremacy, Ur held the kingship bestowed by the gods for the third time. The period of chaos and fragmentation that followed the end of Sharkalisharri of Akkad's reign (2193 BCE) was recorded by the King List as a time of disorder, confusion, and a lack of political leadership. The reunification of the land, and the return to centralized rule in Babylonia, occurred approximately eighty years after the fall of the Akkadian dynasty. This was when King Utu-hegal of Uruk, who related the events of the time in his inscriptions, claimed that he expelled the invading Gutians from southern Babylonia and returned kingship to Sumer. Utu-hegal was succeeded by his brother, Ur-Namma (r. 2112–2095 BCE), who established the rule of a new dynasty. He chose Ur as his capital city, reviving it as a site of royal splendor through a major program of building and renovation. Toward the end of his reign Ur-Namma took on the title "King of Sumer and Akkad," thus asserting his rule over the entire region of Babylonia in southern Mesopotamia. Ur-Namma first gained control over the local kings and their cities. He then campaigned to the east of Mesopotamia, and gradually even Susa—the foremost Elamite city in Iran—came under the control of the Ur dynasty. For close to a century, this dynasty governed the entirety of Babylonia, most of northern Mesopotamia, and a large expanse of neighboring areas to the east in Iran, as well as having great political and cultural influence over Syria. Archaeologists and historians refer to this era as the Third Dynasty of Ur, or sometimes simply Ur III.

There is a profusion of documentation from this era that records the details of daily interactions and transactions, and as such we have a a good glimpse of the lives of people and their households, as well as the practices of businessmen and craftsmen involved in the arts. These are some of the most detailed texts that survive from the ancient world. Though the focus of these texts is on bureaucratic records, we know that during this time wars occurred because year names established in the newly set standardized calendars refer to battles and conquests of the Ur III kings.

The visual arts, however, reveal nothing of the militaristic side of royal authority; they focus instead on the pious acts of the king in the religious sphere and represent him as continuing the ancient traditions of the Early Dynastic era, thus reaching back into an earlier past for the new royal iconography, rather than following the style and iconography of the Akkadian imperial arts.

The dominant administrative language of the Ur III dynasty was Sumerian, and texts and visual images both seem to revive earlier Sumerian

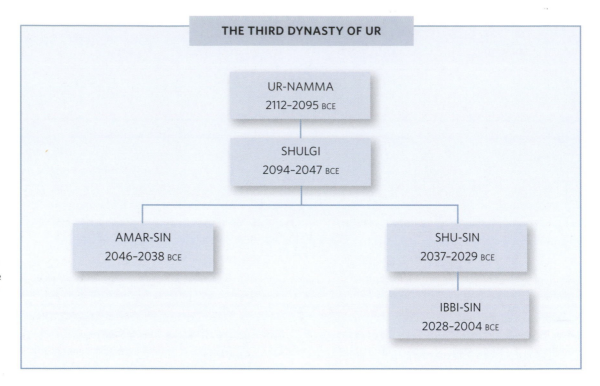

THE THIRD DYNASTY OF UR

UR-NAMMA
2112–2095 BCE

SHULGI
2094–2047 BCE

AMAR-SIN
2046–2038 BCE

SHU-SIN
2037–2029 BCE

IBBI-SIN
2028–2004 BCE

The Third Dynasty of Ur was a ruling house of five generations of kings from the same family, beginning with Ur-Namma. It is also known as the Ur III Dynasty.

traditions, thus leading art historians to refer to the Ur III era also as a **Neo-Sumerian renaissance** or revival. Despite what seems to be a return to Sumerian practices and a strong stress on piety, there is some contradiction in ideological messages, since the Ur III kings, beginning with **Shulgi** (r. 2094–2047 BCE), the son and successor of Ur-Namma, revived the idea from Naramsin of Akkad that the king is divine, and took on the DINGIR determinative, the prefix used for the gods, before the writing of their own names also. The divination of a king during his lifetime was unusual in Mesopotamia, as it was an act of hubris that placed him on the level of the gods. The ideology of the pious builder-king, a human following the instructions of the gods, thus did not fit neatly with this divine status.

Architecture

The building campaigns of the Ur III kings were extensive. Construction during Ur-Namma and Shulgi's reigns significantly altered the cityscape of some of the most important and most ancient cities of Sumer. Buildings were constructed by Ur III rulers in places as far away as the royal city

of Susa in Iran. These buildings were often new in form, size, and structure, yet they also stressed continuity by means of architectural rituals and the utilization of the sacred precincts of earlier eras. They combined new building designs with ancient traditions of architecture in a distinctive way. Ziggurats were built for the patron gods of a number of southern Babylonian cities, including for Inanna at Uruk, for Enlil at Nippur, and—the most famous and best preserved—the ziggurat of the moon god Nanna at Ur, the dynastic capital. Unlike the earlier remains of **temple towers**, this is the first time when the ziggurat is found in the classical form that was to influence the famed temple towers of Babylonia and Assyria (see chapter 12. p. 285) for centuries to come.

The Ziggurat at Ur

The ziggurat at Ur [**7.1, 7.2**] was begun by Ur-Namma in honor of the god Nanna, and completed during the reign of his son Shulgi. It was named E-temen-ni-gur-ru (house whose foundation platform is clad in terror/carries shivers), a name that may imply that the building was meant to inspire a dreadful awe. The massive stepped tower, rectangular in outline and

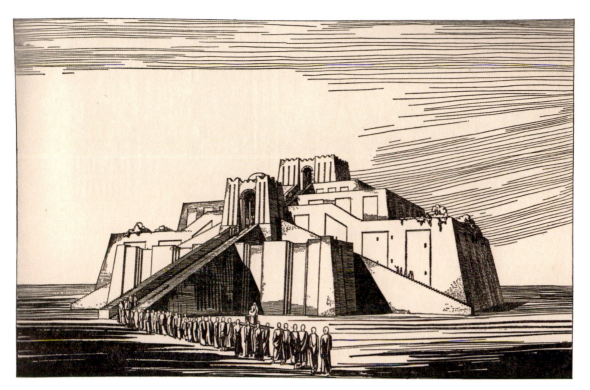

7.1 Drawing of the ziggurat at Ur, Iraq, by Marjorie V. Duffell for C. L. Woolley, 1937

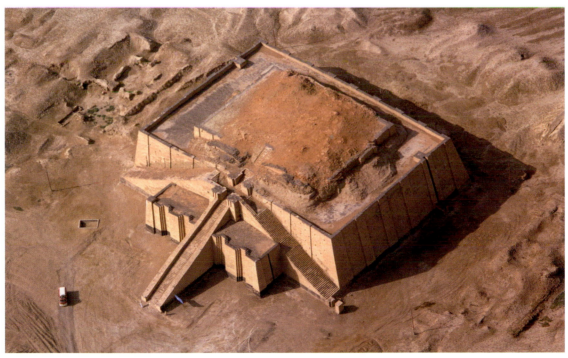

7.2 Aerial view of the ziggurat at Ur, photograph taken in 1973

constructed in brick, stands with its corners aligned to the cardinal points. The inner core is made of mud brick with layers of reed matting and mortar placed in between brick courses. The thick outer face was made of baked brick set in bitumen mortar, forming a strong **revetment** about 8 ft. (2.4 m) thick. Narrow slits called "weeper holes" were cut into this baked brick casing in order to allow interior moisture to seep out. The rectangular lowest level of the structure measured 198 × 149 ft. (60 × 45 m) and it was 50 ft. (15 m) high at the lowest level alone. In its original

condition, the ziggurat must have been more than double that height.

One approached the ziggurat from the northeast side, where three staircases led upward and converged at the second level into a great gateway that led up to the second stage. At the lowest stage, one of the staircases is set at right angles to the building, while the other two lean against the lowest level wall. A third level was presumably reached by means of another flight of steps from level two, though little archaeological evidence remains of the uppermost part of the structure or the third level. In later eras we learn that ziggurats could reach multiple stages, that these could be accessed by spiral stairways leading to the top, and that colored glazed tiles were sometimes used to decorate the surfaces. The ziggurats of the Ur III dynasty are the first classic ziggurats, identifiable as such by the stepped stages of the structure. Some scholars feel that the earlier temples of the Uruk era, set high upon a raised platform, are not strictly speaking stepped towers, whereas those built by Ur-Namma and Shulgi all had several stages and tripartite stairways of baked brick that meet at right angles to permit a ceremonial ascent.

The Ur ziggurat has no straight walls or lines: all of the lines of this edifice are diagonal and slope inward toward the top. The lowest level wall reveals a somewhat convex curve at the ground line also. Was this a deliberate avoidance of strict **rectilinearity**, calculated to produce a visual effect similar to the **entasis** used in ancient Greek temples, such as the Parthenon on the Athenian Akropolis? There is some debate about these possible architectural refinements, the design of ziggurat structures, and what the shape and height may mean, but no conclusions have been reached on the matter. Does the ziggurat wish to elevate the sacred space above the terrain of daily life? Since in the Western tradition ziggurats are mostly associated with the biblical story of the great Tower of Babel, the idea remains that the towers were a means of spanning the space between man and the gods. From an architectural perspective, the experience of a ziggurat was one of reverential climbing upward in a ceremonial manner, of stopping and turning in certain places, a course necessary for religious procession. The sacred space raised high above the city at the top of a series of stages was, therefore, planned as a ritual of ascent. The ritual space is vertically conceived and lifted above the city. In this way a ziggurat is different from the horizontal array of buildings in Early Dynastic temples and more similar to the temples of earlier eras like those of Uruk.

The Sacred Precincts

In the sacred precinct or **temenos** of Ur, a number of buildings—including the massive ziggurat of the moon god—and open courts were built by the Ur III kings and renovated by later rulers of Mesopotamia [**7.3**]. The rectilinear building plans and open courtyard surrounded by enclosure walls defined and organized the sacred space in new ways. The Uruk-era sacred precincts that had been built more than one thousand years earlier (chapter 2, p. 42) had already begun the tradition of the massive elevated temple and extensive sacred precincts with numerous monumental buildings. The architectural works of the Ur III Dynasty refer back to that ancient past, but with new designs and innovative construction methods, innovations that can be best seen in the design and structure of the ziggurats. These stepped, solid mass structures that rose high above the flat southern Mesopotamian landscape established the new classic ziggurat form for many centuries to come.

The Giparu, a square complex with a surrounding corridor and buttressed external walls, stood close to the E-temen-ni-gur-ru. It included the residence of the entu priestess— a position that continued to be given to royal princesses—and a small Temple of Ningal. Across from the court of Nanna that preceded the court of the ziggurat another square building called the Ganun-mah (the great storage house) was the temple treasury. To the southeast, the E-hursag (house, the great mountain), a building identified by an inscription in the paving, was a palace dating to the reigns of Ur-Namma and Shulgi, and the Edubla-mah (the Exalted Portal) was the name given to a grand gateway that was mentioned in

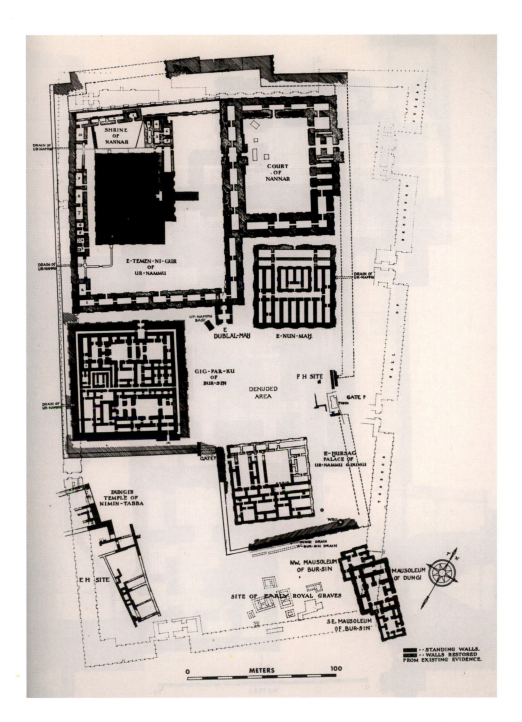

7.3 Plan of the temenos of Ur, Iraq, 2112–2004 BCE, drawn in 1922–30 by F. G. Newton and A. S. Whitburn, architects working under C. L. Woolley

the reigns of the later king of **Kassite** Babylonia, **Kurigalzu II,** as the Great Gate, the Ancient One.

At the southeast side of the temenos was a complex of royal tombs. Corbeled vaulting and a flight of steps led down into vaulted rooms beneath a building that was perhaps used for ceremonies for the dead [**7.4**, see p. 162]. Although the building was devoid of contents, the remains of gold leaf and stones indicate that the walls were overlaid with sheets of gold **inlaid** with agate and lapis lazuli, and the painted ceiling depicted tiny stars. The corbeled vaults themselves are constructed by means of parallel courses of brick masonry, each of which projects slightly over the one below until they meet at the apex of the arch. The technique required thick side walls to support the vaults and was used in third-millennium BCE Mesopotamia alongside the type of vault or arch

7.4 Photograph by Leonard Woolley of corbeled arch and flight of stairs leading up from a tomb at Ur, Iraq, 1930

7.5 Inscribed brick from Ur, Iraq, 2046–2038 BCE. Clay, 13 × 13 in. (33 × 33 cm)

Enlil and his consort **Ninlil**. The Nippur ziggurat was constructed with a core of unbaked bricks and an outer facing of baked bricks. Centuries later, it was encased in Kassite and Assyrian era reconstructions of the sanctuary. At Uruk, too, the ziggurat there was included in the major constructions of the Ur III period. This kind of rebuilding and encasement of shrines of earlier eras, even centuries after their first construction, had occurred already in the Jemdet Nasr temple platforms, such as that of the Anu Temple at Uruk (see p. 44). At Ur, for example, the ziggurat was restored 1500 years later by the Babylonian king **Nabonidus.**

The instruction to build a temple came from the gods. The design of the plan, the measurements, and the placement were relayed to the king directly via a private communication sent to him in a dream or a vision, as we have seen was the case with Gudea of Lagash whose statues depict him as an architect (see pp. 143–45). This idea of the king as the bearer of the architectural plan from the gods, and as a builder who participates in translating the plans of the gods into brick and mortar, can be observed in the visual arts of the Ur III dynasty.

Sculpture

The sculptural works that survive from the Ur III dynasty include architectural figures or deposits, votive statues, and monumental reliefs. Some of these works were intended to be seen by viewers, while others were made to be interred immediately into the ground. The latter are copper foundation figures, an integral part of architectural construction, as we have already seen in chapter 3.

Foundation Figures

Most of the foundation figures of the Ur III era known to us today represent the king. A cast copper alloy figure of Ur-Namma from the E-Kur of Enlil at Nippur [7.6] represents the king bare-chested and wearing a long belted skirt inscribed on the front with a panel containing a Sumerian text. His feet appear below, set upon a small base, and he has a clean-shaven head and face. His

known as the **true arch**, or Roman arch, which is already attested in the Early Dynastic architecture of Sumer. We can identify the tombs as belonging to the Ur III dynasty by means of inscribed bricks of the kings Shulgi and Amar-sin [**7.5**].

At Nippur, Ur-Namma built a ziggurat for Enlil in the E-Kur (the mountain house) as the main shrine of the sanctuary that belonged to

upraised arms hold in place upon his head the basket for the clay mortar for laying the bricks. The builder-king is personified in the foundation figure in a new and different way from the deity foundation pegs of the Early Dynastic era and Gudea's reign. The king is divine and takes the place of the peg god, but he is shown in the most pious and humble activity, that of a builder, a laborer who carries the basket of brick and mortar. He also becomes part of the construction itself by being the foundation, as he is perhaps, in a parallel way, the foundation for the state.

The copper Ur-Namma figure from the E-Kur was part of a deposit of numerous items. It was placed in a box with faience beads and pieces of gold, carnelian, agate, lapis lazuli, and silver, and accompanied by an inscribed tablet. These kinds of valuable and exotic stones and pieces of precious metal were also strewn over the foundations in the Early Dynastic III temple at Lagash (modern Tell al Hiba in the south of Iraq) and at the Eye Temple at Nagar (modern Tell Brak in Syria), indicating a similar ritualistic use in both northern and southern Mesopotamia at an earlier time.

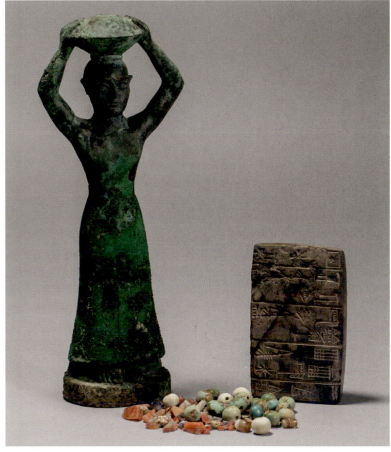

Unlike the Ur-Namma statues, the foundation figures of Shulgi known to us occur only in the peg-shaped anthropomorphic type known from the Early Dynastic era. It is not a god, however, but the king who is represented here, bare-chested and carrying the work basket on his head. The lower part of the body is reduced to an inscribed peg. By the Ur III period the placement of foundation deposits became very regularized. Archaeologists have found these deposits placed carefully in the ground, at the corners and doorjambs of buildings [7.7]. At times they were still wrapped in the remains of a linen cloth that had been placed around the statue before burial in the foundation box.

Stele of Ur-Namma

A tall limestone stele discovered at Ur is attributed to the first king of the Ur III dynasty, Ur-Namma [7.8, see p. 164]. Once more than 10 ft. (3 m) high, it was found in the sanctuary of the moon

7.6 Foundation figure of Ur-Namma and foundation deposit of stones and text, from the E-Kur of Enil, Nippur, Iraq, 2112–2095 BCE. Figure made from copper alloy, h. 13 in. (33.5 cm)

7.7 Foundation figure of Shulgi, in situ at the Temple of Innana, Nippur, Iraq, 2094–2047 BCE. Arsenical copper with fragments of linen remaining, h. 12¼ in. (32.4 cm)

163

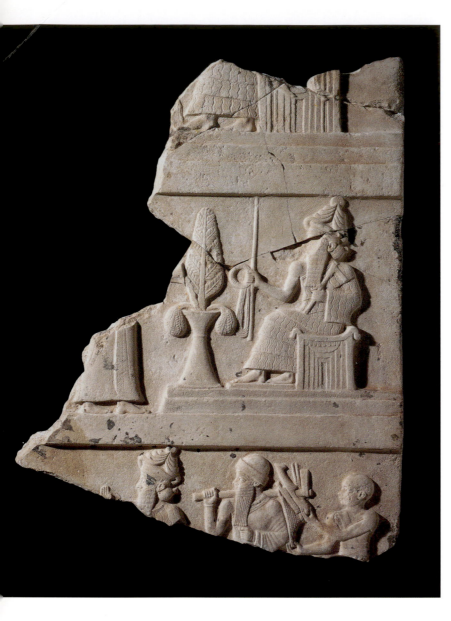

7.8 Fragment of the Stele of Ur-Namma, from Ur, Iraq, c. 2097–2080 BCE. Pink-buff limestone, h. 3 ft. 5⅜ in. (1.05 m)

god Nanna, near the ziggurat of Ur, broken into numerous widely scattered fragments. Originally, the stele consisted of five registers of relief carving on each side of a flat slab of limestone with an arched top. In 1927, soon after the stele fragments had been excavated by Leonard Woolley, Paul Casci, a restorer who worked at the Galleria degli Uffizi in Florence, reconstructed the whole edifice. By 1989, however, close analysis and careful re-examination of the pieces led to a reconsideration of the stele's format. It was dismantled and studied closely piece by piece, and another reconstruction was proposed based on the analysis of the stone and the iconographic details.

The stele has two carved sides, obverse and reverse. The top register on both sides depicts the king in an act of worship before the gods. The second register from the top on the obverse side is the best preserved, and reveals the width of the stele to have been 5 ft. (1.5 m). The right-hand side shows the enthroned god Nanna wearing a four-tiered horned crown terminating in a lunar disc and a flounced multi-layered woolen garment that covers his left arm and shoulder only. In his left hand he holds an adze, a builder's tool, and his right hand, extended forward, holds a measuring rod and reel of string. The rod and reel are instruments of the architect, used to lay out the measurements and outlines of the design on the ground before construction begins. By holding them toward the king, who stands before him, we see that the god Nanna's instructions for the building of a temple were given directly to Ur-Namma. Nanna sits on a throne that depicts the niched facade of his own temple, and before him is an altar upon which is a leafy plant, and perhaps bunches of date clusters below. The god is depicted in the typical Mesopotamian mixed profile view, with head and eye depicted in profile from the side, but shoulders turned so that they are shown fully to the viewer. The enthroned god and his altar are placed upon a stepped pedestal, raised from the ground level where the king stands before him, ready to pour the libation and to participate in the act of worship. To some extent this relationship was reciprocal. The king gives the god his sacrificial offerings and provides the pious construction works, and the god in turn bestows upon him a long life and a successful reign.

On the far left of the same register, the scene is repeated with slight changes. In the place of Nanna the moon god we see the enthroned figure of his consort, the goddess Ningal, the great lady, who also sits on a dais ready to receive the offering, but does not carry the rod and reel of the divine architectural decree to Ur-Namma. The scene of this most complete register gives us a good sense of the preferred composition on this side of the stele. It is still and symmetrical. The god and the goddess anchor the left and the right as stable sides by facing inward into

the scene. Before the gods, the king repeats the libation, backed by an interceding minor goddess in a pleated dress, who raises both hands in supplication on his behalf. In the registers below, there appears to be a change in tempo. Rather than the stable and symmetrical composition of worship, we see a narrative scene, with figures participating in activities. One side shows the king himself carrying the tools of a builder on his shoulder. We see an ax or adze, a hoe or hand plow, a compass, and a basket to be used for the mortar and the bricks. Behind the king, an attendant helps to keep the basket from sliding off the king's shoulder. We can identify the king from his headdress, his beaded necklace and bracelet, and fine woolen garment. Below this register, two more registers depict laborers in

the process of construction work, erecting the temple for Nanna, who sits above, looking over the construction with pleasure. The reverse side, in poorer condition, shows animal sacrifices, musicians, and festivities. At the top, a fragment of a flying minor goddess with a horned crown pours water down upon the scene. The figure of the god Nanna on the upper right side of the stele bears the enigmatic remains of a smaller person, perhaps the goddess Ningal, who was seated on his lap.

A partially preserved Sumerian inscription describes the canal projects of Ur-Namma, and this has led to the identification of the king on the relief. The inscription ends with a curse directed against anyone who is malicious to the monument or erases its inscription. The king is pious in his

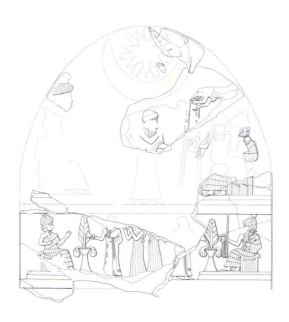

7.9 Drawings of two sides of the stele of Ur-Namma, a monument that represents him as the builder-king. On the left, the building activities of Ur-Namma are presented below the upper registers, which show scenes of pious offerings to the enthroned gods. On the right, festivities with musical instruments celebrate the building projects of the king.

165

temple building, and as the canal builder, he also provides water for the life of the country.

The image of the builder-king is one we have seen already in the reliefs of the Early Dynastic period (see pp. 82–83). Here, however, the imagery has become more elaborate and the carving more naturalistic. The sculptor pays attention to the modeling of musculature and outlines of anatomy are visible. Even under the clothing, the form of the body can be seen in a way that is very different from the Early Dynastic tradition that this ritual and its representation come from. Here the builder and architect king's iconography is fitted into a larger narrative tale, more detailed and monumental. It brings into the scene the image of the god, pleased with his temple; the builders at work, climbing a ladder; and the brick walls as they are erected. Both the fabric and the labor of the temple on this stele are rendered as central parts of its iconographic programme, and we see also the god overseeing this sacred and impressive creation. The scene fits well with what we know from Sumerian hymns of this time, in which praise is addressed to wondrous temples as beautiful and striking constructions. An architectural structure was seen as a divine being of some kind, worthy of hymnal praise in its own right. In fact, these hymns did include detailed descriptions of impressive architectural works, some of the earliest aesthetic descriptions in antiquity.

Representations of Shulgi

Although texts record the existence of inscribed royal statues from the Ur III dynasty, as well as the installation of royal statues across Babylonia and the provinces, and list the offerings of beer and food that they were to receive, the foundation figures are all that remain of statues in the round of Ur-Namma. For his son and successor, Shulgi, only fragmentary works are known. One diorite sculpture at the Iraq Museum is a figure of Shulgi. The head, left arm, and left side of the upper and lower body are missing. The king wears a mantle tucked under his right arm, the fringe of the edge of the cloth indicated by a series of diagonal lines, a pattern found also

7.10 Shulgi, unknown provenance, probably Girsu, Iraq, 2094–2047 BCE. Hornfels, black stone, h. 10¼ in. (26 cm)

on some Gudea sculptures. The inscription on the back of the statue identifies it as a votive offering, a dedication from the king to the god Nanna:

> For the god Nanna, his Lord
>
> Shulgi, mighty man, king of Ur, king of the lands of Sumer and Akkad [----]
>
> Dedicated this statue for his own life. The name of this statue is "The god Nanna is my fortress."

A standing figure of Shulgi now in New York is made of a black mottled stone, and is missing the upper part of the body [**7.10**]. Remains of an object at the front part of his waist may indicate that the king was holding an offering vessel. The remaining smooth and conical shape of the skirt, which is preserved from the waist down, bears a long and informative inscription divided into four columns. In addition to the ancient name of this sculpture—"Shulgi, who has been given life by Nindara, is the breath of life of the city"—the text tells us that it was a statue dedicated for the life of the king Shulgi, not by

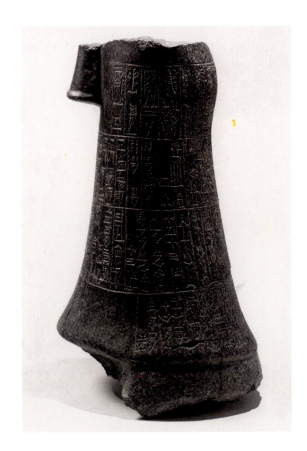

the king himself but by a royal retainer called Shulgi-ki-ur-sag-kalam-ma. After the dedication proper by the courtier, the text lists the gifts, rights, duties, and privileges of artisans of the god Nindara, the consort of the goddess Nanshe. (The gifts the artisans gave and the supplies and services they provided included the fields that they cultivated.) This votive sculpture, although fragmentary in condition, provides important information regarding the economic practices of artisans of the time and tells as something about the uses of votive sculpture in the Ur III era.

Other Sculptures

A number of heads of stone sculptures survive that can be dated to the Ur III era on stylistic grounds. They must have belonged to full-figure statues of either standing or seated votive figures. A limestone head from Uruk, for example, represents a clean-shaven man wearing a cap with a wide brim, similar to the ones worn by the images of kings [7.11]. The large and heavily rimmed almond-shaped eyes and arched brows are hollowed out to receive an inlay in another material. Typical for this period is the small, bow-shaped mouth, slightly turned upward, and the broad planes of the full cheeks. The head is a good example of the sculpture of this time, even though the body of the statue is missing. Other votive statue heads from this era, both male and female, demonstrate the same attention to heavily rimmed eyes and joint brows above, and depict the mouth as small, with lips slightly upturned at the corners [7.12]. Sometimes eyes are inlaid, as in the case of a small marble female head [7.13]. Her eyebrows are joined at the bridge of the nose, and she has a small mouth, slightly turned up, and

Top **7.11** Head of a man, from Uruk, Iraq, *c.* 2100–2000 BCE. Limestone, h. 5 in. (12.7 cm)

Center **7.12** Head of a man, from Girsu, Iraq, *c.* 2100 BCE. Diorite, h. 6⅝ in. (16.7 cm)

Below **7.13** Female head, from Ur, Iraq, *c.* 2100 BCE. Marble with shell and lapis lazuli inlay for the eyes, h. 3¾ in. (9.5 cm)

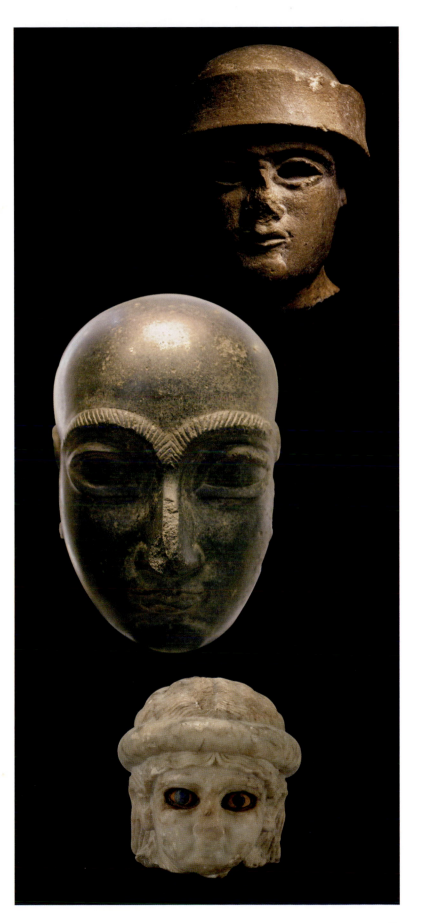

thick waves of hair held in place by a rolled band at the forehead. The heads most likely survive from full statues that represented the men and women in an attitude of reverent prayer in front of their gods.

Representations of supernatural creatures, such as bovines with human heads, were also made as votive offerings and, at times, to be part of a larger stand or temple furnishing. The human-headed bull is a protective creature associated with the sun god Shamash. A statue of a bull in the Louvre Museum wears a five-tiered horned crown and has a human head with bovine ears [7.14]. The bull's legs are tucked up under his recumbent body, and his head is turned to the side. The body, made out of steatite, has cavities for inserts of stone or shell in a different color. One lozenge-shaped shell remains in place at the foreleg. At the upper part of the bull's back there is an elongated cavity, which was used to fit the leg of an offering table, or to hold a removable offering vessel placed there.

Other sculpture in the round appears to have had a more pragmatic purpose. Weights were sometimes carved in stone in the form of small animals. Often they take the shape of a duck, resting with the head turned back into the body, the head and neck carved in relief onto the duck's form. A duck weight from the reign of Shulgi is a good example of the type [7.15], which exists in a large range of weights and sizes. It bears the inscription:

> For the god Nanna, his lord
> Shulgi, mighty man, king of Ur, king of the
> four quarters
> Confirmed this weight stone to be two minas.

Weights are also at times carved in abstract shapes, such as a four-sided pyramid bearing symbols of the gods. Standard weights had existed before in cities, but with Ur III they became standard across the whole region.

Regional Art

The Ur III kings commissioned buildings and votive offerings not only in their own urban centers in the south of Mesopotamia, but also throughout the region where they wielded power. In Syria, as we have already seen in chapter 6, sculptures of the governors of Mari in the later third millennium BCE have some similarities to the Sumerian sculpture of southern Mesopotamia. The Mari governors were vassals of the Ur III kings, but the city remained independent to a great extent. Elsewhere the Ur III kings constructed buildings and made votive offerings to the local gods [7.16]. The styles that we see in Syria or Iran at this time are influenced by the southern Sumerian cities, but they also continue using local iconographies and sculpting techniques that were apparently more suitable or acceptable in their own cities.

Below
7.14 Recumbent bull with human head, unknown provenance, probably from Ur, Iraq, *c.* 2050 BCE. Chlorite with inlays, h. 4¾ in. (12.1 cm)

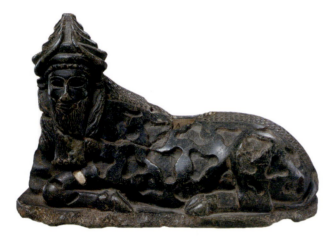

Below **7.15** Duck-shaped weight, from Ur, Iraq, 2094–2047 BCE. Diorite, length: 5½ in. (14 cm), weight: 5 lb 8 oz (2.5 kg)

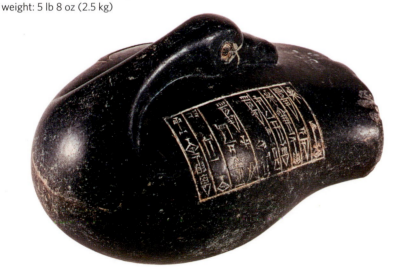

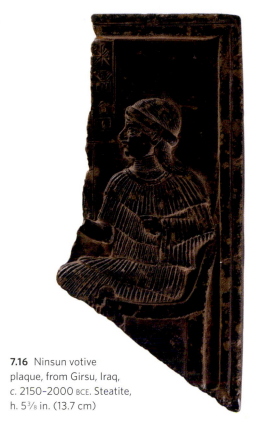

7.16 Ninsun votive plaque, from Girsu, Iraq, *c.* 2150–2000 BCE. Steatite, h. 5⅜ in. (13.7 cm)

The tradition of votive plaques carved in relief with images and inscriptions continues into the Ur III era. A fragmentary plaque from Girsu (modern Telloh) represents a woman seated on a throne, perhaps a princess and priestess who has donated this offering to the goddess Ninsun, as the inscription indicates. The woman is shown from the left side in mixed profile, with long waves of hair held in place by a rolled band at her forehead, and falling loose at her back. She wears a layered dress and a high necklace made of multiple strands.

In Iran, during the **Old Elamite** era (2400–1600 BCE), **Neo-Sumerian** arts and iconography strongly influenced the artists of its main center, Susa. It had been under the rule of Akkad between *c.* 2400 and 2200 BCE. After the collapse of the Akkadian empire, Puzur-Inshushinak, a king of Awan in western Iran, rose to power in Susa, but the city was soon conquered again during the reign of Shulgi and remained under Mesopotamian control until about 2000 BCE when the Shimashki dynasty of kings took over Susa. Akkadian and Ur III rule brought about a large-scale borrowing of Mesopotamian styles

and genres of art and manufacture, as well as the adoption of Old Akkadian writing and administrative systems. Susa then became a point of shipment for goods and commodities, and for the deployment of troops for further expeditions to the east.

The material culture of Susa was influenced by Mesopotamian arts, but we see also some local variations in the borrowings, and the inclusion at times of bilingual inscriptions in both Elamite and Akkadian, which was also one of the spoken languages of Susa at this time. A foundation boulder uncovered at Susa carved in relief and inscribed in linear Elamite is a good example [**7.17**]. The inscription is of Puzur-Inshushinak, a contemporary of Ur-Namma of Ur, an Elamite king listed on the Susa King List who had many monuments installed on the acropolis of Susa,

7.17 Foundation boulder of Puzur-Inshushinak, from Susa, Iran, *c.* 2100 BCE. Limestone, h. 22¼ in. (55 cm)

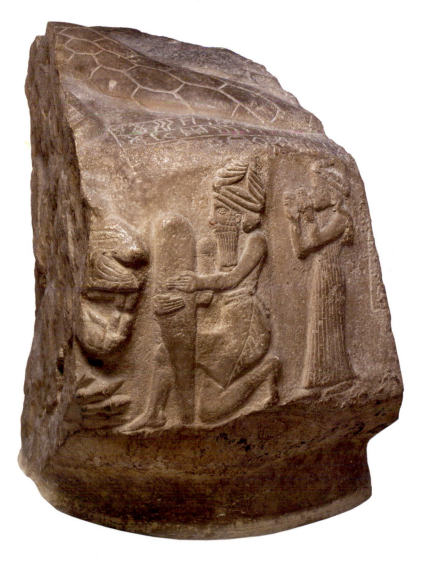

some of them with bilingual inscriptions in Elamite and Akkadian. The image carved around this roughly shaped boulder is that of a kneeling foundation deity wearing a multi-tiered, horned crown and holding a large peg ready to insert into the foundations. Before him are the remains of a large lion's snout and right paw, and behind him is the typical Sumerian interceding goddess in pleated dress and horned crown. At the top of the boulder, a snake lies coiled around a vertical hole, which must have been in the center of the stone.

A ceremonial weapon or standard top of King Shulgi was discovered at Susa [7.18]. It is a cast bronze **shaft-hole** hammer with two birds' heads emerging from three plumes, each of which ends in a curl. The bronze object bears a Sumerian inscription that names King Shulgi: "The divine Shulgi, the mighty hero . . . king of Ur, king of Sumer and Akkad." Shulgi controlled part of Elam in his reign, and was responsible for the construction of several buildings at Susa. Although the inscription is clearly Mesopotamian, the bronze itself is a type of votive weapon closely related to bronzes from eastern Iran and Bactria, in Central Asia, and double-headed mythological birds are known from the rich iconography of fantastic animals that has its origins in eastern Iran.

In Iraqi Kurdistan, at Derbend i Gawr (the Pagan's Pass), close to the modern city of Suleimaniye/Slemani, a rock relief carving survives high up on the cliffs of the Qara Dagh mountain range [7.19]. This very large relief, more than 10 ft. (3 m) in height, has no inscription, but it can be dated to the end of the third or the beginning of the second millennium BCE based on the style and iconography. The relief depicts a warrior in profile, striding up the mountainside, with left leg raised at the knee. He wears a short kilt held in place by a four-stranded belt and a cap with a folded edge. The warrior carries a bow in his left hand and holds a battle-ax in his right hand. He is shown with the bodies of the dead beneath his feet, who look similar to the defeated Lullubi on the stele of Naramsin (see p. 124). They have long hair worn in a plait or pigtail that falls down their backs. While the image of a king climbing up a mountainside and trampling the enemy dead beneath him owes its imagery to the stele of Naramsin, there are enough differences here to suggest a later date. The ruler here does not wear horns on his wide-brimmed cap, and his beard is not rendered in the way that Akkadian era beards are, nor is the body carved with the rounded forms of the Akkadian era. His extremely broad shoulders are angular, and the outlines of the body are rendered with sharp lines and hard edges. The Derbend i Gawr warrior also wears bracelets at his wrists and a distinctive beaded necklace that is more similar to the necklaces of the end of the third and early second millennia BCE, thus putting this relief well after the era of the Akkadian empire. The beard, which curls close to the face and then falls in long wavy lines, is carved in a way that is typical of the Ur III dynasty and later. The relief was carved near a stream, and water has worn off the area below the kilt. Its massive scale and its location on a formidable and precariously steep height is impressive. That vast scale is further underscored by the difference in proportion between the body of the warrior king and those of the dead enemies beneath his feet, who are depicted at a much smaller scale. The king climbs upward in victory, and the sculptor has emphasized this

7.18 Hammer with Shulgi dedication, from Susa, Iran, c. 2060 BCE. Bronze, h. 4¾ in. (12.3 cm)

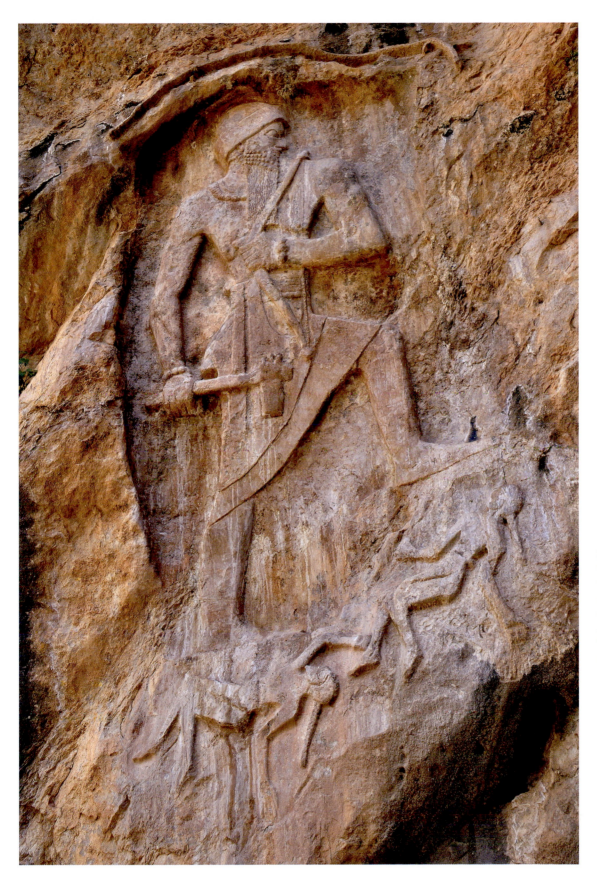

7.19 Rock relief at
Derbend i Gawr,
Qara Dagh mountain
range, Iraqi
Kurdistan,
c. 2090 BCE.
More than 10 ft.
(3 m) high

ascent by including the horizontal sedimentation layers of the cliff face as part of the image. He has deliberately positioned the king's climb upon these layers, integrating him into the mountainside. The sculptor has, therefore, utilized the natural terrain as well as scale within the composition to emphasize the colossal power and might of this king and his conquest of the forbidding rocky terrain of northern Mesopotamia.

Cylinder Seals

Cylinder seal imagery of the Ur III dynasty is far more limited in iconographic scope than the preceding rich range of iconographies and themes that are known from the Akkadian era. The contest scenes of the Akkadian seals, accompanied by inscriptions, continue into the early part of the dynasty, but for reasons unknown, the great variety of mythological and narrative themes of Akkad are no longer favored for seal representations in the Ur III era, although they

7.20 Cylinder seal of Hash-Hamer with a presentation scene, from Ur, Iraq, 2112–2095 BCE. Greenstone, h. 2⅛ in. (5.3 cm)

The seal of Hash-Hamer represents this governor being presented to the King Ur-Namma, who sits enthroned on the right. Hash-Hamer, who is depicted bald and clean-shaven, wearing a fringed robe wrapped around his body, is led forward by a goddess in a horned crown and pleated, tiered garment. Behind them stands a lama goddess with upraised arms. The inscription identifies the governor as the owner of the seal and states that he is the servant of Ur-Namma.

were revived again in the following eras. Instead, typical of Ur III **glyptic** carving is the presentation scene. In the standard composition, a form of royal decorum appears to have been established, where the king is placed enthroned on the right side of the scene, similar to the position of an enthroned god. The king often holds a cup or a small vessel resting on his fingertips. Interceding figures of **lama goddesses** introduce the owner of the seal into the presence of the king or the god. The scenes with presentations to a god were those most commonly used, but in many cases we see the king in this position, identified by his headgear. Sometimes, however, the king is shown wearing the flounced layered garment of the gods. Such scenes were limited to important officials of the realm, as in the seals of Ilum-bani and Inim-Shara, and sometimes the inscription states that the seal is the gift of the king to the owner. [**7.20**]

Most cylinder seals of the Ur III era were inscribed with a text. Cylinder seals came to be regularly impressed onto sealed goods and documents—economic, administrative, institutional, and personal texts. The inscriptions indicate that the person's seal was the equivalent of a signature at this time, and administrative seals guaranteed the contents and goods of sealed commodities that were transported across the realm. Yet seal ownership was open to all who had the means to commission one, from royal courtiers to slaves—materials and quality varied, and some were more expensive than

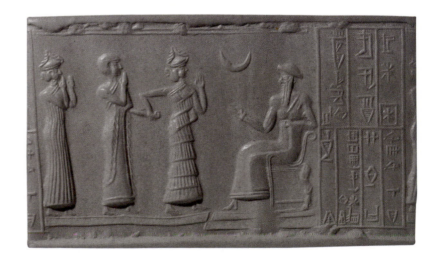

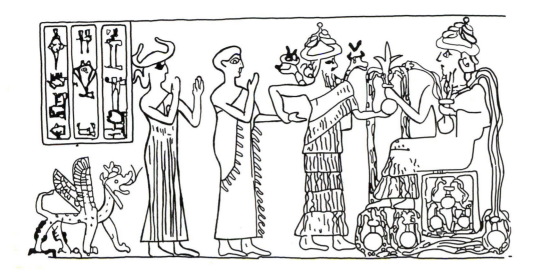

7.21 Tracing of the Sealing of Gudea, 2150 BCE.

Gudea wears a fringed garment and is presented by Ningiszhida to an enthroned god. Behind Gudea, a lama goddess with upraised hands appears for the first time in seal iconography, an image that becomes standard in presentation scenes. A winged dragon follows the procession. The inscription identifies the seal owner as "Gudea of Lagash."

others. As many seals were inscribed or identified as the seal of a particular person when they were rolled onto the text, we can learn a great deal about seal ownership and uses.

Gudea of Lagash (see chapter 6) was contemporaneous with the early Ur III dynasty, and his seal impression [7.21] uses the preferred presentation scene composition; however, here Gudea is being presented to a god, rather than a king. The god is seated on an elaborate throne surrounded by flowing streams of water that emerge from round, convex-based jars. Gudea is introduced by Ningiszhida, whose horned vipers emerge from his shoulders, and behind him stands a goddess with a horned crown and pleated dress. The composition of the Ur III presentation scenes, which often placed the king enthroned on the right, was one that derived from presentations to the enthroned gods. Seals of this era depicted presentations of both types.

Many of the forms of representation that appeared in the era of the Third Dynasty of Ur stressed continuity with the Sumerian past, and deliberately revived some earlier images—such as that of the pious builder-king. Architectural projects were presented as adherence to tradition and the preservation of sacred sites, but they nevertheless introduced impressive new monuments, for example the classic ziggurat forms of Mesopotamia. All of these Sumerian traditions were to see both change and transformation in the following centuries.

The end of the Ur III dynasty was a result of invasions from both east and west, but the final collapse was due to an attack from the east. The last king of Ur, Ibbi-Sin, was taken into captivity to Susa in chains, and for the next seven years Ur was ruled by the Elamites. The literary tradition of Mesopotamia records this sad fate in laments and dirges written specifically for the loss of cities. The lament over the destruction of Sumer and Ur, written about 2000 BCE, records the devastation of temples and architectural sculpture, among other things. Poignant passages from the poem are some of the earliest literary descriptions of works of sculpture that we have from antiquity:

The great door ornament of the temple was felled; its parapet was

Destroyed; the wild animals that were intertwined on its left and

Right lay before it like heroes smitten by heroes; its open-mouthed

Dragon and its awe-inspiring lions were pulled down with ropes like

Captured wild bulls and carried off to enemy territory.

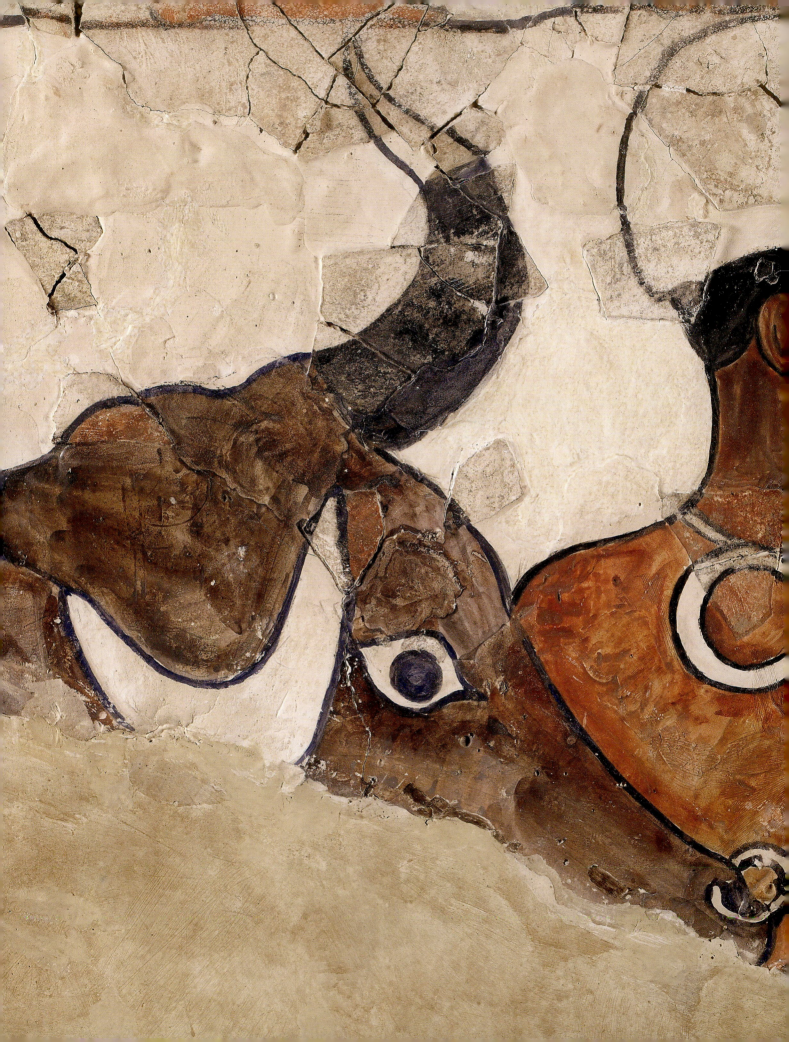

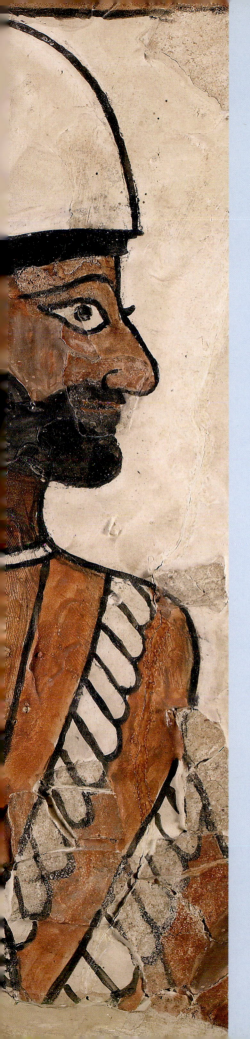

CHAPTER EIGHT

The Age of Hammurabi

See **8.14**, p. 188: south wall of court 106 (detail),
Palace of Zimri-Lim, Mari, Syria, c. 1780 BCE.
Tempera wall painting

8 The Age of Hammurabi 1894–1595 BCE

Periods	Isin-Larsa 2000–1763 BCE Old Babylonian 1894–1595 BCE
Rulers	Hammurabi of Babylon: r. 1792–1750 BCE Zimri-Lim of Mari: r. 1775–1762 BCE Dadusha of Eshnunna: r. ?–1780 BCE
Major centers	Ur, Susa, Mari, Babylon, Sippar, Larsa, Erbil, Shubat Enlil (modern Tell Leilan), Tell Asmar (ancient Eshnunna), Kanesh (modern Kültepe)
Important artworks	Codex Hammurabi Stele of Dadusha Palace at Mari
Technical or stylistic developments in art	Fresco techniques are used for wall paintings A statue with flowing water at Mari is the first automaton Open-mold technique enables mass production of terra-cotta images The first evidence of aesthetic discourse, and the first catalogues and preservation of ancient artworks and monuments

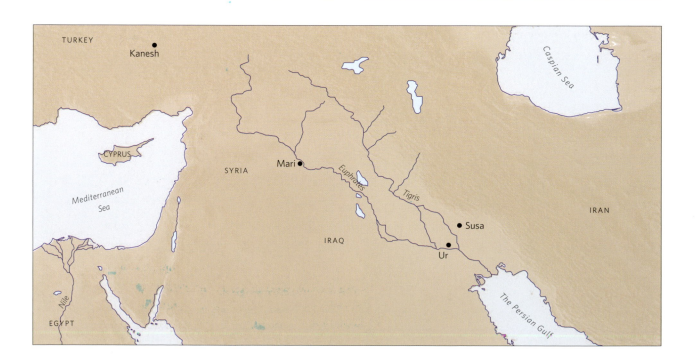

8 The Age of Hammurabi

I n the first half of the second millennium BCE, the **Old Babylonian period,** there were new and astounding developments in the visual arts, their reception, their study, and their preservation. Unlike the pious images of the Ur III kings, public monuments at this time focused on other aspects of authority and qualities of the king, such as justice and martial power. A more extraordinary development was that for the first time in this era there began a clear aesthetic discourse in commentaries on the qualities of works of art and a type of literary description of visual arts. Babylonian scribes began to catalogue monuments and their inscriptions in annotated texts. We will focus on public monuments and the ancient practices related to their installation and reception as a way of understanding this distinctively Mesopotamian genre of art as tied to concepts of time and history. These monuments are best exemplified by two works: the Codex Hammurabi and the Stele of Dadusha, one a law stele and the other a monument to a victory in war. While royal monuments and other forms of high art developed in fascinating new directions, one area of art production that we will consider is the creation of artifacts apparently intended for everyday use. The chapter also takes a closer look at the growing domain of art for the people, as evinced in the terra-cotta plaques found in increasing numbers at this time.

When Hammurabi came to power in 1792 BCE, the land of Babylonia had seen two centuries of devastating wars and turmoil. The word "Babylonia" is a term that modern scholars use to refer to the south of Mesopotamia, extending from around the city of Baghdad to the Persian Gulf. It is derived from the name of the city of Babylon. When the first dynasty of Babylon rose to power in the nineteenth century BCE, and especially

in the reign of Hammurabi, the city became increasingly powerful, and came to dominate all of Mesopotamia. The ancient Mesopotamians themselves began to use a term that translates as "Land of Babylon" in the later part of the second millennium BCE.

After the fall of the Ur III kingdom, the south had split up into competing city states that vied for power and political hegemony over the entire land. It was Hammurabi, often referred to in texts as "the man of Babylon," who unified the region after a string of brief but successful military campaigns. It took Hammurabi only a few years to defeat the kings of the main cities of Babylonia, and then to continue northward to capture the celebrated city of Mari in northeastern Syria. This era, which began with the reign of Hammurabi and ended in 1595 BCE with the **Hittite** attack on Mesopotamia, is known to historians as the Old Babylonian period. In Mesopotamia, the Old Babylonian period was preceded by a shorter phase that historians refer to as the **Isin-Larsa period.** During the whole of the period between c. 2000 BCE and c. 1600 BCE the landscape of the Near East was occupied by rival states from Iran to the Mediterranean Sea. A small number of powerful kings from southern Babylonia and western Syria took control, splitting the region into numerous vassal kingdoms. The alliances and counter-alliances between these states were constantly changing as a series of coalitions emerged between the most powerful kings of Babylon, Larsa, Eshnunna, Ekallatum, Mari, Qatna, and Yamhad.

During these political upheavals, the Akkadian language and the cuneiform writing system of Mesopotamia continued to be employed throughout the region. Writing in cuneiform script became a common skill known from southwestern

Iran to Anatolia and western Syria. The Babylonian dialect of Akkadian came to be used as a lingua franca everywhere by speakers of other languages for communications and literate culture, although Sumerian continued to be used as a high scholarly language in Babylonia itself for quite some time, in the same way that Latin saw a long scholarly life in the Western world well into the nineteenth century CE.

In Mesopotamia, the main genres of the visual arts that we have seen already—the votive image, the standing stele or monument—continued and developed into new versions that incorporated increasingly lengthier and more complex texts, such as the Codex Hammurabi [8.1]. We can also observe the use of new technologies of carving and developments in metallurgy that facilitated new forms of sculpture.

There appears to have been a growing use of visual images in household contexts, indicating that the new processes that had emerged at the end of the third millennium BCE permitting mass production of clay images had made artworks for personal use possible. Terra-cotta (fired clay) plaques and other mass-produced works can therefore be described as the rise of an art for the people. Among these developments in the arts, perhaps the most remarkable change in the historical record at this time is the fact that from the early centuries of the second millennium BCE, we have the first clear textual evidence of a discourse that concerns itself with artistic excellence, and that we can define as the language of aesthetics. In addition, the cylinder seal, that distinctively Mesopotamian artifact that had been invented in the fourth millennium BCE, came to be even more widely used across the ancient Near East, with distinctive styles of seal carving and workshops of stonecutters emerging in the main political centers.

8.1 Codex Hammurabi, originally installed in Babylon, 1760 BCE, excavated at Susa, Iran. Black basalt, h. 7 ft. 4⅝ in. (2.25 m)

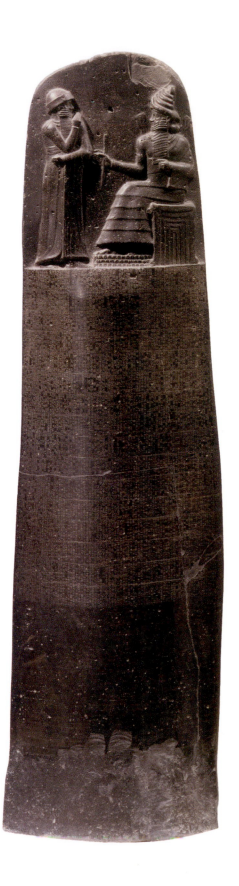

The Codex Hammurabi

Perhaps the most famous work from ancient Mesopotamia dates to the Old Babylonian era—the monument known as the Codex Hammurabi, a naru or stele that records the accomplishments of Hammurabi and presents the law of the land. It is a monolithic pillar, more than 7 ft. 6 in. (2.25 m) high, made from black basalt and brilliantly polished to a high, almost metallic, sheen. The larger part of the oblong pillar is covered with cuneiform script. The elegant and beautifully carved script is conceived as a form of calligraphy, and uses a deliberately archaizing form of writing. Twenty-three horizontal columns of text appear on the front (the last seven of these columns at the lower front side were erased, perhaps to make space for the addition of an Elamite inscription, when the monument was looted in 1158 BCE) and twenty-eight columns on the back. Five columns of text at the beginning and at the end are written as a prologue and an epilogue to the list of laws. More than three hundred cases are compiled on the inscription. They do not cover all areas of law. Rather, they are extensive examples of legal decisions as found in modern "case law." The stele represents Hammurabi as the just king. It is not a law code as such, but a monument of the law—or, rather, jurisprudence, the theory and study of law—as an abstract phenomenological concept (that which appears and can be experienced directly).

At the top part of one side, a scene carved in relief appears above the text. Hammurabi is shown standing and facing to the right, directly in front of the god Shamash, who is seated on a throne before him. Shamash is the sun god, but he is also

The Laws of Hammurabi

The laws of Hammurabi cover cases and situations in a formulation of parallel punishments of the type that may be familiar to most readers as the biblical "eye for an eye" (Exodus 21:24). These laws are also dependent on the social class of the individual; parallel punishments would be meted out when both parties were of the same rank. In cases where the accuser and accused were of different social ranks, the members of the elite would compensate the lower classes financially. An *awilu* was a gentleman of the upper class, whereas a *mushkennu* was a commoner, and a *wardu* a slave. Women appear in the code not only to protect their legal rights in marriage and in family life, but sometimes also as business entrepreneurs in their own right. Additionally, the laws cover other areas of life, such as business practices and the legal rights of individuals. Some of them, for example those concerning medical malpractice and regulations for builders, have remarkable resonances with today's world. The Codex Hammurabi (excerpts from which are given in the right-hand column of this box) makes it clear that legal rights for all, and courts and judges free from corruption, are the fundamental bases of justice.

Law 196: If a man (awilu) should blind the eye of another man (awilu), they shall blind his eye.

197: If he should break the bone of another man, they shall break his bone.

198: If he should blind the eye of a commoner (mushkennu) or break the bone of a commoner, he shall weigh and deliver 60 shekels of silver.

218: If a physician performs major surgery with a bronze lancet upon a man (awilu) and this causes the man's death, or opens a man's temple with a bronze lancet and thus blinds the awilu's eye, they shall cut off his hand.

220: If he opens his (a commoner or slave's) temple with a bronze lancet and this blinds his eye, he shall weigh and deliver silver equal to half his value.

229: If a builder constructs a house for a man but does not make his work sound, and the house that he constructs collapses and causes the death of the householder, that builder shall be killed.

232: If it (the collapse) should cause the loss of property, he (the builder) shall replace anything that is lost; moreover, because he did not make sound the house which he constructed and it collapsed, he shall construct anew the house which collapsed at his own expense.

111: If a woman innkeeper gives one vat of beer as a loan, she shall take 50 silas of grain at the harvest.

the god of justice. Hammurabi's proximity to the god is significant: he enters his world. The spaces of the sacred and the secular are merged in the Codex Hammurabi in ways that are perhaps even more striking than in the stele of Naramsin, the monument from the height of Akkadian imperial power, which also depicts Naramsin's transfiguration of himself into a divinity by means of wearing the horned crown of the gods [5.9, see p. 124]. Hammurabi has come face to face with the god. In the usual Mesopotamian presentation scene, depicted in cylinder seal carvings or in the stele of Ur-Namma [7.8, see p. 164], for example, the worshiper is often separated from the god by an altar or by the presence of an interceding minor deity. Hammurabi's proximity to the god is close and his access is direct.

Shamash appears on the right of the stele. He wears a divine, multi-tiered, horned crown, and is seated on a throne that takes the shape of a temple. With his right hand the god holds the emblem of rule before the king. Hammurabi holds his right hand up to his lips in a gesture of worship, and he wears the attire and headdress of a mortal. There is nothing about him that would indicate a body that is more than human. He is smaller than Shamash, yet very like him in many respects. Physically, Hammurabi is a mere man. He is not a divinity in the way that Naramsin is depicted as divine in his stele, nor is he shown in his militaristic aspect. He holds none of the weapons of the warrior king, despite the fact that the prologue of the text describes his remarkable and extensive military conquests. Here, the king is mortal, but he is nevertheless enclosed in the space of the god. By means of the image we can say that the stele of Hammurabi is a monument that configures the place of the ruler in relation to the law. The king is given the authority to present the law, and to dispense legal decisions as the king of justice, who makes the law accessible to the people. At the end of the stele the inscription declares:

> May any wronged man who has a case come before my image as king of justice, and may he have my inscribed stele read aloud to him. May he hear my precious words and may my stele clarify his case for him.

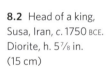

8.2 Head of a king, Susa, Iran, *c.* 1750 BCE. Diorite, h. 5⅞ in. (15 cm)

Portrait Sculpture and Vital Images

A diorite head excavated at the Elamite city of Susa may also represent the king Hammurabi [**8.2**]. It was once part of a full-figure statue of a ruler, bearded and wearing a headdress with a wide, undecorated rim that crowns his forehead in a similar way to the headdress of the Ur III kings. The statue is unusual in that it combines highly naturalistic facial features with a stylized treatment of the hair and beard. The ruler is depicted as an aging man, with sunken cheeks and sagging under-eye folds. The eyelids are heavy, and especially prominent at the lower rims. Lines incised at the forehead, above the joined brows and the bridge of the nose, indicate the wrinkles of a man who is no longer young. At the same time, the sections of the beard are treated as an evenly spaced pattern of curls that lie close to the face, and ropes of longer locks of hair below, reaching to his chest. The treatment of the waves of hair in an undulating wavy pattern emerging from below the headdress, and the method of carving the beard in a bipartite arrangement of horizontal rows of curls ending in long locks of hair, allows art historians to date the carving of this statue to the era of Hammurabi of Babylon, despite the fact that it was not excavated in its original place of manufacture or first use, but found in a much later context in Susa.

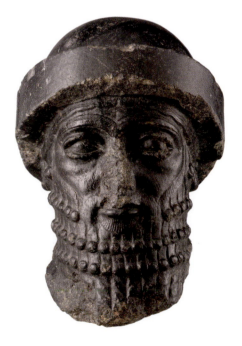

This interest in the naturalistic representation of age that we see in the Susa royal statue is highly unusual and has few parallels in Near Eastern antiquity. Similar concern with the depiction of age can be seen in some statuary from Middle Kingdom Egypt (2055–1650 BCE), yet it seems unlikely that the influence of such Egyptian royal sculpture can account for images here in Babylonia, as other aspects of direct contact between Mesopotamia and Egypt are not known at this time. This era saw a large amount of international trade in raw materials, such as copper and tin, which were combined to create the alloy—bronze—that began to be used for statuary as well as for weapons and tools. There was also diplomatic and military interaction throughout the Near East, but to what extent Babylonia was in contact with Egypt in this era is unclear. That other Near Eastern kingdoms had relations with Egypt is clear, however. A series of wall paintings in Beni Hassan, Egypt, dating to the 12th Dynasty, depict numerous Asiatic merchants with caravans bringing luxury and other goods from Syria and the Levant to Egypt. The world of the Middle Bronze Age was large and open. It included direct and indirect interactions between the Black Sea and the Persian Gulf, Central Asia to Greece and Egypt. Objects traveled far across the geographical boundaries of the time, some of them as war booty. One such monument that traveled was the Codex Hammurabi itself, discovered in 1902 in Susa in Iran where it had been taken as war loot from its original location in Babylon, a fate that seems to have befallen many monuments during times of war. (For a discussion of the relocation and destruction of monuments, see pp. 122–25.)

A nearly life-size statue of a seated ruler of Tell Asmar (ancient Eshnunna) was also discovered among the collection of Mesopotamian war booty found at Susa in Iran [8.3]. It is carved out of a large block of diorite, and reveals the continuation of a long tradition of royal portraiture in diorite for dedication in temples that goes back to the mid-third millennium BCE. The statue is now headless, but the long beard that appears in

relief against the chest reveals a carving style that can be dated to the early second millennium. The treatment of the beard in long rope-like locks is similar to the so-called diorite head of Hammurabi from Susa. The original inscription that had been on the lap of the Eshnunna statue has been erased. Another text was carved in its place, stating that Shutruk-Nahunte, king of Anshan and Susa and ruler of the land of Elam, had destroyed Tell Asmar and taken this statue away. The statue must have been about seven hundred years old when the Elamite king looted it in battle in order to give it as an offering to the patron god of Susa, Inshushink.

The tradition of votive statues continued in this period. A small statue dating to the same time as the reign of Hammurabi, a fine example of the Babylonian votive portrait, portrays a man

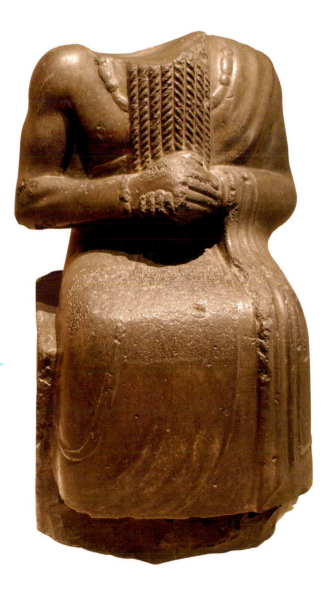

8.3 Seated ruler of Eshnunna, excavated at Susa, Iran, c. 1900–1800 BCE. Diorite, h. 35 in. (89 cm)

Kanesh, an Assyrian Trading Colony in Anatolia

About 13 miles (21 km) northeast of modern-day Kayseri in Turkey lies the site of Kültepe, ancient Kanesh, where an Assyrian mercantile colony flourished in the twentieth to nineteenth centuries BCE. More than 25,000 clay tablets have been found there, containing the correspondence of merchants, their business associates, and their families at home in Assyria. The tablets provide much information on their trading activities in tin and high-quality textiles, revealing the types of goods, the methods of transportation, the financing of the trade, and many other matters. The letters and other documents were often placed in clay envelopes or cases and then sealed with cylinder seals. The impressions of the seals reveal that the local stone carvers developed styles and iconographies that were distinctive to Kanesh. They used Mesopotamian themes, such as processions of figures approaching an enthroned deity, but they surrounded them with local Anatolian motifs and emblems. The traders of Kanesh at times also used cylinder seals that were carved in a **Modeled Babylonian** or **Old Syrian style**, or made in a more linear **Old Assyrian style**. Thus we find that several styles of cylinder seals were in use at the same time. In the example illustrated here we see a legal document and its original case, rolled with two different seals on all sides [**8.4**]. The tablet is a legal deposition in which two merchants swear upon the dagger of the Assyrian god **Assur** and accuse each other of theft. Assyrian traders kept such documents and their cylinder seals in locked rooms called *massartum*, as loan or business documents were used as proof in legal claims, and they were also bought and sold amongst merchants.

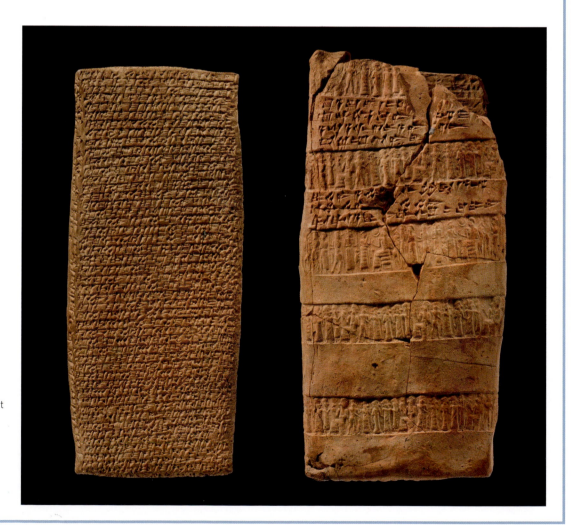

8.4 Cuneiform tablet and case: record of a lawsuit, from Kültepe, Turkey, c. 1900–1800 BCE. Clay, h. 6⅝ in. (16.8 cm)

kneeling on his right knee [8.5]. His right hand is raised to his face in an act of worship, his thumb and forefinger held together in a gesture of reverence and prayer. The figure is made of unalloyed copper and cast in the lost-wax method, while the eyes originally would have been inlaid with precious stones. The gold leaf covering on the hands and the face survives intact. The worshiper wears a tunic with fringed edges that end at the knees. A round cap with a wide rim covers his head. His short beard is stylized as a row of grid-like curls. He kneels upon a hollow trapezoidal base also cast in copper. A small basin is welded to the front of the base, placed there for receiving oil or incense. The base bears a horizontal cuneiform inscription modeled and chased into the metal. It states that Lu-Nanna, son of Le'I, dedicated this votive to the god Martu/Amurru for the life of Hammurabi, king of Babylon, and for his own life. This inscription also declares that the statue is a suppliant made of copper and that its face is plated with gold. The epigraph thus describes the statue, its function, and the materials out of which it is made. In front of the inscription, on the right side of the base below the worshiper, an image appears in the relief depicting an enthroned deity with a long beard and a multi-tiered gown typical for images of gods at this time; this is the god Martu/Amurru. In front of the god is the kneeling suppliant in the same pose and with the same gesture as the statue itself. On the opposite side of the base we see a relief of a recumbent ram, an appropriate offering for the god Martu/Amurru, who is considered a master shepherd. There is a parallel drawn here between the votive ram and the suppliant image: both are gifts to the god.

This work therefore refers to itself and to its own function as a suppliant and votive figure. It does so in the relief images of the base as well as in the text that describes it, creating what art historians refer to as a hypericon, an image that self-consciously refers to itself by means of a secondary representation of itself within the larger composition. We saw this process already at work in the Uruk vase of the late fourth millennium BCE [2.5, see p. 47]. It is a sophisticated concept—an image that continuously refers back to itself in an endless, mirroring process. The artist who created this statue seems to be concerned with the magic of representation—the image magic that was fundamental to Babylonian religious practices in which the votive represented the worshiper in an act of perpetual prayer.

A votive statue that predates the Lu-Nanna votive by about two centuries represents a princess and daughter of Ishme-Dagan of Isin (r. 1953–1935 BCE) [8.6]. It was found in Ur, where Enanatuma was the entu priestess of the moon god. The statue has also been identified as the goddess Ningal; the ambiguity is probably deliberate, since the priestess could represent

Below left
8.5 Votive statue dedicated by Lu-Nanna, from Larsa, Iraq, *c.*1750 BCE. Copper and gold, h. 7¾ in. (19.6 cm)

Below right
8.6 Votive statue of *entu* priestess and princess, Enanatuma, from Ur, Iraq, 1953–1935 BCE (heavily restored). Diorite, h. 20 in. (50 cm)

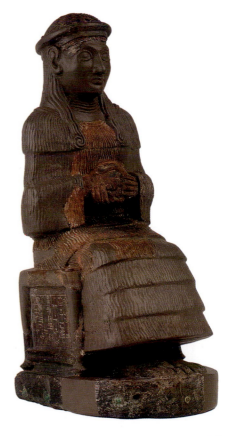

the goddess in rituals. This enthroned female figure wears a multi-tiered woolen dress with a high neck. Her hands are clasped at her waist in a gesture of prayer, in a similar way to the statues of the reign of Gudea, though they are given more volume and do not have the fine linear carving style we see in the Gudea statues. Because it bears an inscription carved into the side of the seat, this votive can be dated to the Isin-Larsa era, before Hammurabi's conquest of Babylonia.

A number of other votive statues, both carved in stone and cast in metal, were also discovered by Leonard Woolley at Ur in the same sacred precinct as the Enanatuma votive as well as in other temples [8.7]. They vary in size and function, and, as well as votive images, include statues of the lama goddesses, the interceding deities. Some of these were found in situ in interesting contexts and positions.

One statue, made of white limestone [8.8], and measuring around 20 in. (51 cm) in height, was standing in the courtyard of the Hendursag

chapel in Ur. It is an image of a woman wearing a multiple-tiered pleated garment and a cloak. Her hands, clasped in front of her, are depicted in relief between the folds of the cloth. Her long hair is worn in ringlets at the front, with a thick mass of hair at the back, held in place by ribbons. Yellow paint would have been used to indicate that the ribbon was gold, and the eyes would have been inlaid in black steatite and shell set into lapis lazuli. The ears are pierced to hold earrings. The nose is attached in plaster: clearly an ancient repair.

The repaired statue was placed on a base in which a smaller lama goddess [8.9] was found, together with a decorative carved bone pin. This small, copper lama goddess wears a pleated garment and horned crown. The arms, which would have been made separately and attached, are now missing. She also wears a necklace with a long counterweight at her back.

A standing figure with his right hand raised up in a gesture of reverence is an image of

Below left
8.7 Photograph by Leonard Woolley of excavations at Ur, Iraq, showing statue in situ, 1920s

Below right
8.8 Statuette, from Shrine of Hendursag, Ur, Iraq, 1750 BCE. White limestone, h. 20⅛ in. (51 cm)

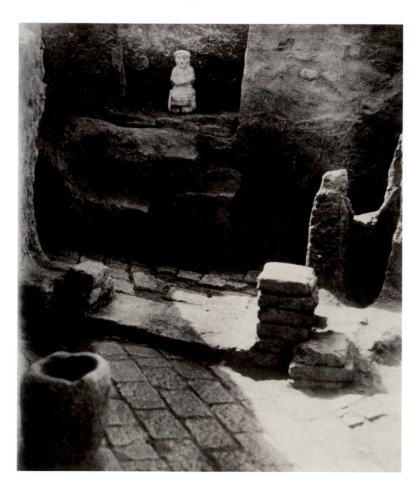

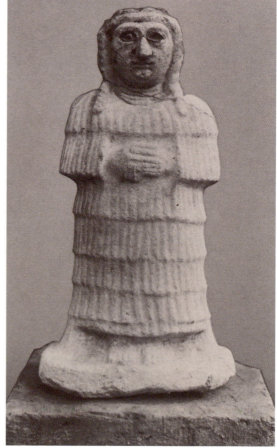

a beardless male [**8.10**]. He wears a long garment with folds and thick rolled edges, and a crescent pendant at his neck and what appears to be a turban-like headdress. There is a faint four-line inscription on the back that states that this is the image of Etel-pi-Shamash, an official from Isin. This statue was purchased in 1890, so it lacks an archaeological context, but it is a good example of a votive image in metal from this time.

Below
8.9 Statuette of the interceding lama goddess, from Ur, Iraq, *c.* 1800 BCE. Copper, h. 3⅞ in. (9.8 cm)

Right
8.10 Standing male votive figure, unknown provenance, *c.* 1800 BCE. Copper/bronze, h. 13¾ in. (34.9 cm)

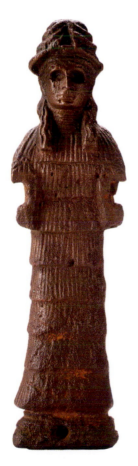

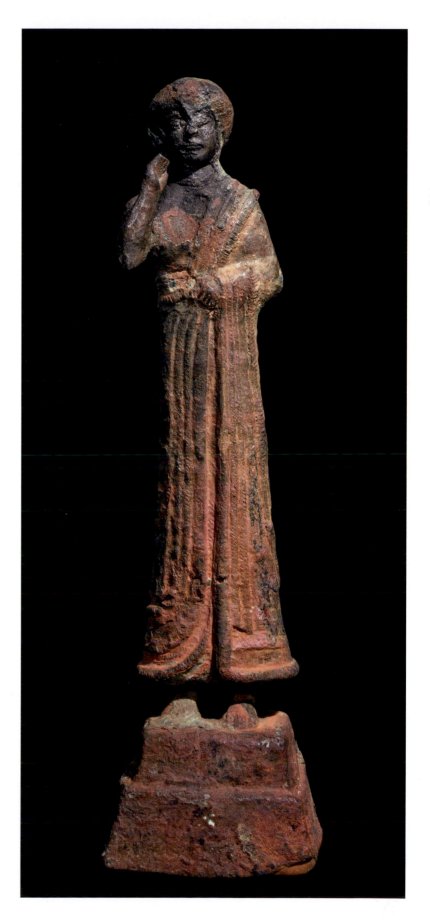

The Palace at Mari

In the thirty-second year of his reign, Hammurabi conquered the great city of Mari on the Euphrates in eastern Syria. The palace that stood at Mari at this time was built between the Ur III era and the Old Babylonian period, with walls towering to 16 ft. 6 in. (5 m) in height and 13 ft. (4 m) thick; it covered 30,000 square yards (25,000 m²) with at least two stories surrounding a series of courtyards [8.11]. The palace had more than 260 rooms and included living quarters and administrative areas. It was a fabled palace, known throughout the eastern Mediterranean world and the Near East for its splendor, and remains one of the best-known palaces of the ancient Near East. We know that a king of Ugarit on the Mediterranean coast made a special request to travel to Mari in order to see the palace. Another letter from the king of Ugarit to Hammurabi of Babylon requested that the latter intercede on behalf of his son and present him to the court of King Zimri-Lim at Mari so that the young man would be given permission to stay at the palace in order to broaden his mind. The palace was there already in the time of Yahdun-Lim, Zimri-Lim's father, and Shamshi-Adad's son Yasmah-Addu (who became viceroy of Mari in 1795 BCE when the city was annexed by Assyria, a powerful new state with its capital at Assur on the Tigris). But many bricks stamped with the name of Zimri-Lim (1775–1762 BCE) indicate that this king conducted a great deal of renovation. The Old Babylonian era thus provides us with a unique example of a palace that survived in good condition. The architecture of the palace follows the Mesopotamian tradition of the courtyard plan, yet the objects found within indicate that Mari had wide contacts across the ancient world. The 22,000 cuneiform tablets discovered here, covering both state and personal subject matter relating to the palace personnel, give us an idea of what life in an early second-millennium palace and kingdom was like. The archive proves that the king maintained an active and regular correspondence with other kings and governors in the region, and with his many agents in distant cities and kingdoms. It paints a picture of an early international world of close contacts and diplomatic marriages. The king of Mari, Zimri-Lim himself, traveled to Aleppo in the ancient kingdom of Yamhad and all the way to the Mediterranean coast of Syria to visit the maritime city of Ugarit.

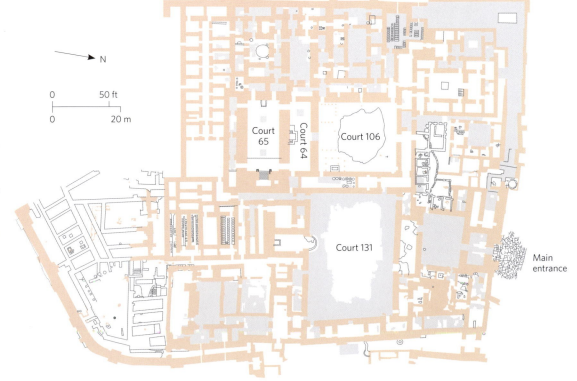

8.11 Plan of the Mari palace, dating from Mari City Phase III, 2200–1760 BCE

The palace had more than 260 rooms on the ground floor, and walls painted with murals. The entrance gate on the north side brought the visitor in through two courtyards and an antechamber before he or she could enter the throne room. It was known as a wonder of the ancient Near East.

N

0 50 ft

0 20 m

Court 65

Court 64

Court 106

Court 131

Main entrance

The Discovery of Mari

In 1933 some local Syrians were digging a grave at Tell Hariri and in the process unearthed a statue. The Department of Antiquities in Syria, at the time directed by a Frenchman, Henri Seyrig, identified this statue as distinctively Sumerian in style. Based on the find, an expedition was sent out from Paris, headed by René Dussaud, to explore Tell Hariri. André Parrot, who was to take over the excavations for many years, arrived by the end of 1933. Within the year, statues bearing inscriptions were discovered that made it possible to identify this ancient city as Mari [**8.12**, **8.13**]. Excavations were halted by the Second World War in 1939 but resumed in 1951, revealing a great Old Babylonian capital to rival the city of Babylon itself, a center of the arts and culture in the eighteenth century BCE. Numerous statues and small objects used in daily life were discovered here, as well as more than 20,000 cuneiform tablets comprising the diplomatic and economic archives of the state; they give a clear picture not only of the city and its life, but also of all of Mesopotamia in the age of Hammurabi.

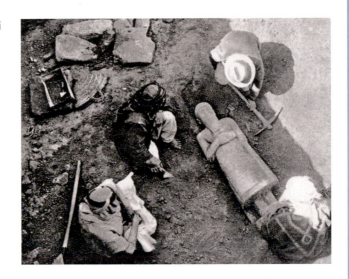

The texts also reveal information about the activities of royal women, palace priests, and diviners, and the practices and transactions of artists and craftsmen who worked for the royal court.

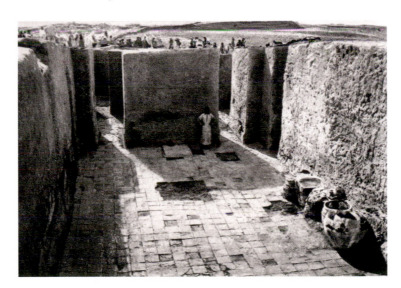

8.12, **8.13** Photographs by André Bianqui of excavations at Mari, Syria, 1930s.

Above right: clearing the statue of the governor Ishtup-Ilum

Right: excavation photo showing paved floors and walls preserved to 13 ft. 1½ in. (4 m) in height.

The former splendour, luxury, and refinement of the palace can be reconstructed to some extent. The throne room, measuring 40 × 82 ft. (12 × 25 m), where the king appeared to his subjects, was magnificent in its design. The throne was placed on one side on a podium, facing the doorway. From this seat the king had a high vantage point that permitted him to oversee his subjects, visitors, and vassals. Opposite the throne area was a high platform upon which the statues of ancient rulers were placed. In order to enter the throne room, visitors passed through the Court of the Palms and past an antechamber, or **atrium**, where they encountered a statue of a goddess holding

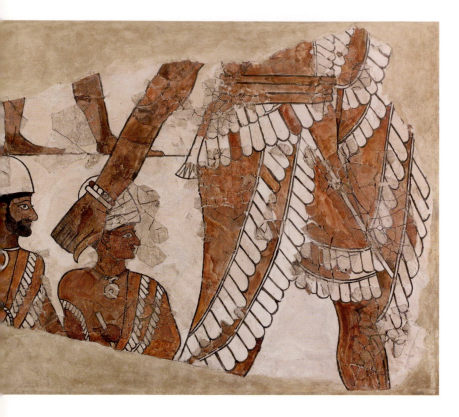

8.14 South wall of court 106 (detail), palace of Zimri-Lim, Mari, Syria, c. 1780 BCE. Tempera wall painting

The Neo-Sumerian style survived longer here than in the south. Though Mari's contacts were both with western Syria as well as with southern Mesopotamia, its artistic production can be seen as a specifically local style distinctive of Mari, and not an imitation of another. As in the Early Dynastic era sculpture, we see some strong similarities and influences from the south, but also many differences that indicate local workshops of sculptors and artists.

One of the most striking features of the Mari palace is the wall paintings, which were placed high on the upper sections of the walls. A large court leading into the throne room was painted with a mural depicting the investiture of the king and sacrificial processions [**8.14**]. The murals were painted on a layer of mud plaster in a manner that suggests that the **true fresco** technique was known to the ancient painters. These are among the oldest frescoes known to us, using the same techniques that would be used by later artists.

The most extensive composition was painted on an outer wall adjoining the throne room in the courtyard (court 106) [**8.15**]. An awning supported by posts covered the painting while still permitting it to be seen in the bright outdoor light. At the center of the painting is a ceremonial scene depicted in two panels. In the upper panel we see the investiture of the king. The ruler, facing to the right, wears an elaborate fringed garment and tall rounded headdress. He stands before the goddess Ishtar, who is dressed in battle gear, armed with weapons, and stands with her foot resting upon the back of her lion, an animal associated with her iconography. With her right hand she reaches out toward the king and hands him the rod and the ring, the divine emblems of rule and authority. Flanking this interaction of Ishtar and the king are two interceding lama goddesses in flounced multi-tiered gowns and horned crowns, holding both arms upraised in their typical gesture of intercession. A male deity stands to the right overseeing the scene. In the lower register, two water goddesses in pleated dresses and horned crowns stand at the left and right of the panel, each one holding a vessel out of which water flows both downward before them and upward, creating

a water jar, out of which a fountain of water was flowing. The vestibule led into the impressive throne room itself, with the throne dais at one end and the raised platform on the other, upon which stood the statues of the ancestral rulers.

A main entrance with a guardroom allowed visitors to enter the palace via the large courtyard, parallel to the throne room. From here, a three-sided audience chamber was reached by stairs. The life of the building was concentrated around two main courtyards, which formed the focal points of the palace's architectural arrangement. A carefully segregated suite of rooms in the northeast can be recognized as the royal residence and had such amenities as bathrooms and mural decoration in the main rooms. A smaller room between this area and the inner courtyard contained the palace archive. There were also scribal and clerical offices, a treasury, and storerooms. To the east was the courtyard with the painted chapel; to the west the Court of Palms, a name we know from the Mari texts. The Ishtar temple—or the painted chapel, as it is called—was on the more public side, accessible via the larger court. The chapel had the oldest paintings in the palace.

a border of water for the scene in which we see small fish swimming upstream.

The central, two-register investiture scene is enclosed and framed by multiple border images set within larger frames. On the inside, closest to the investiture scene, is a pair of stylized trees, and beyond, a pair of date palms flanks it. The latter has pairs of men climbing up to retrieve the fruit or perhaps to fertilize the plant, while a bird with outspread wings flies above the scene. Between the two sets of trees we see three rows of mythical hybrid creatures: winged **sphinxes** with feathered crowns and **griffins** with whirligig tails above, and human-headed bulls who turn to face the viewer below. A second pair of identical lama goddesses, larger in scale, stand at the outer perimeter of the scene and the entire composition is surrounded by a continuous **guilloche** pattern and an outer border that resembles the edges of a textile.

Another painting, perhaps of a slightly earlier date, shows male figures in fringed robes and animals brought for a sacrifice in a procession. One fragment shows the sacrificial bull dressed for the ceremony (p. 174). His horns have silver tips capping them, and a crescent decorates his forehead. Unlike the investiture scene, this part was painted on thick gypsum plaster, with the figures rendered in a number of colors and outlined with bold black lines.

A large statue of a goddess holding a vase [**8.16**, see p. 190] is one of the most inventive statues of Near Eastern antiquity as it incorporates running water into the composition, creating an early form of figural water fountain or automaton that was no doubt meant to impress visitors to the palace. The goddess, found broken into pieces in room 64 and court 106, is almost life-size. A short-cut fringe of hair appears at her forehead above her

8.15 Investiture of Zimri-Lim (detail), palace of Zimri-Lim, Mari, Syria, c. 1780 BCE. Tempera wall painting

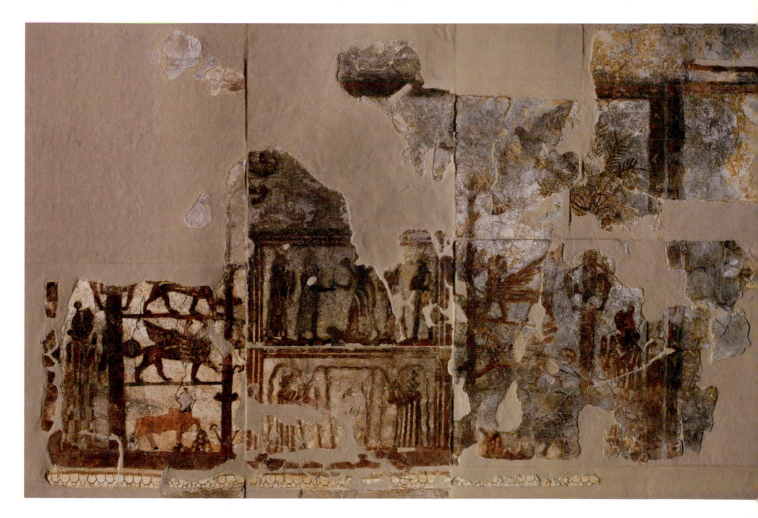

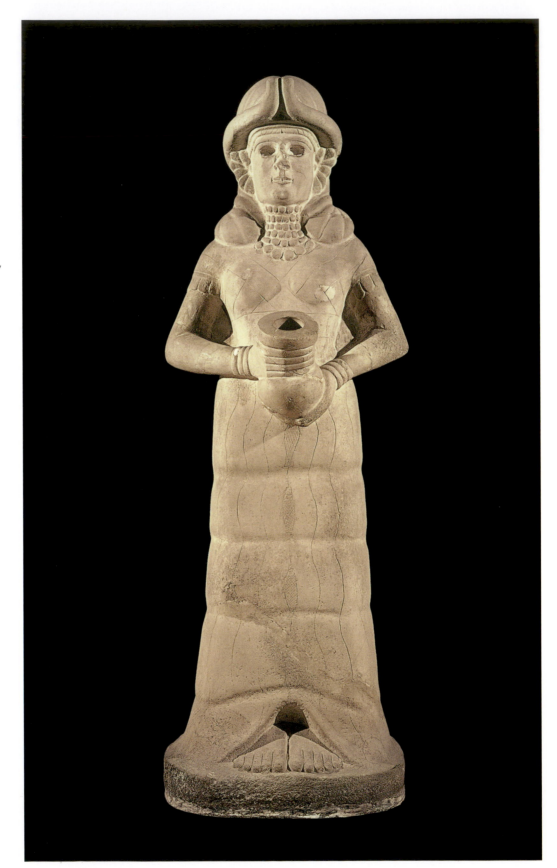

8.16 Water goddess, from Mari, Syria, 1900 BCE. White stone, h. 56 in. (142 cm)

Opposite
8.17 Ishtup-Ilum, governor of Mari, from Mari, Syria, c. 2000 BCE. Black basalt, h. 4 ft. 11⅞ in. (1.52 m)

thick joined eyebrows, thick hair is clustered at shoulder level, and she wears a short-sleeved dress with crossed bands at her chest. She has full but softly modeled cheeks and her eyes were originally inlaid with other materials. The goddess wears a massive horned crown and has six rows of beads at her neck, triple bracelets at her wrists, and earrings. The heavy necklaces are balanced by a long counterweight that is suspended down her back. She tilts the jar forward. An internal pipe, running vertically from the base to the vase, and connected to a tank of water, permitted the water to flow; streaming down her robe, the etched water would have covered the lower part of the statue in rippling forms that were echoed by the incised water patterns and fish carved upon her dress. At the hem of her garment, the water ends in a series of undulating spirals. This statue was contemporary with the palace, unlike the royal sculptures found there that had been maintained as historical and ancestral objects. It is a traditional treatment of this subject of a water goddess, referring back to the Ur III iconographic type. It is also stylistically similar to Ur III sculpture in the **volumetric** hairstyle and squareness of the jaw. As the investiture wall painting depicts two of these goddesses standing in a symmetrical arrangement below the main scene, it is tempting to conclude that originally there was also a pair of stone goddesses with water vases at the entranceway to the throne room.

A life-size statue of Ishtup-Ilum, governor of Mari [**8.17**], is a good example of the large-scale sculpture in basalt and diorite that was produced in Mari at the end of the third and the start of the second millennium BCE. The ruler, standing upright with hands held together at his waist, wears a cap with a folded band and a toga-like garment that covers his left shoulder and arm. The border of the cloth is depicted with sharp incised lines. His beard is long and cut into a block-like rectangular form subdivided into a horizontal row of curls at the face and long wavy locks of hair beneath. The inscription is carved on his exposed right shoulder. Everything about Ishtup-Ilum is simplified into geometric forms and flattened planes, giving the figure an

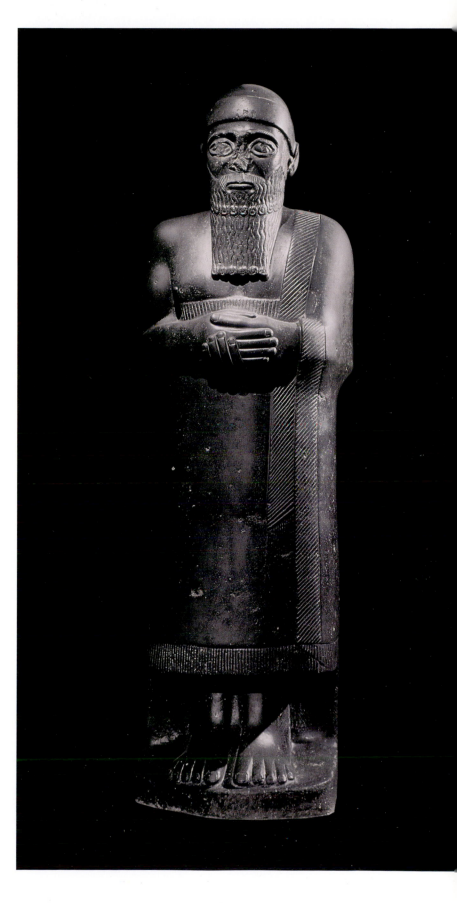

appearance of massive strength. Stylistically, this sculpture is different from the other statues of Mari rulers of a slightly earlier date, where we see a far greater interest in decorative surface detail and sinuous profile in the modeling of the body, and where the clothing closely envelopes the outlines of the body. The statue of Ishtup-Ilum was found in the throne room, at the foot of the stairs leading up to the platform of the statues of the ancient kings.

8.18 Models of sheep's liver for omen reading, from Mari, Syria, *c.* 1800 BCE. Each one: h. 4 in. (10 cm)

In the same area, a smaller steatite statue of Iddi-Ilum, an earlier governor of Mari, was found in court 148. A statue of Puzur-Ishtar, a deified ruler of Mari who has bovine horns on his crown, was found in Babylon in a late Babylonian context. We know from its inscription that it was originally from the palace at Mari (**6.14**, see p. 152). That statue was most likely also placed with the collection of ancestral images. Texts from Mari record rituals that were conducted on behalf of the ancestors; the continuing presence of these statues, which were already several centuries old by the time of Zimri-Lim, may have something to do with this need to honor the ancestral rulers and forefathers.

Mari was destroyed in 1762 BCE after the conquest of the kingdom by Hammurabi of Babylon and three years of occupation by his troops. The largest number of tablets date to the final twenty-five years or so of the life of the palace, but there were also historical and religious texts that had been kept in the palace [**8.18**]. Mari later became part of the **Middle Assyrian** kingdom ruled by **Tukulti-Ninurta** I (r. 1244–1208 BCE).

Among the inscribed objects found at the Mari palace were models of sheep's livers used in divination. These terra-cotta models are extremely naturalistic portrayals of the liver, marked with anatomical details and inscribed with names of the parts of the liver. They are annotated in order to help the diviner understand how to read the liver of a sacrificial animal to divine the future. These liver omens were to some extent historical in nature. The ancients believed that a type of event that had occurred in the past could be predicted to occur in a similar form in the future. Studying the past was therefore a means for understanding things that were to come. The reading of the entrails and liver of a sacrificial animal permitted this knowledge, as the god Shamash had written the signs into the animal's body. These signs could then be read by the *baru*, the diviner priest, in a systematic manner.

The Beginnings of Aesthetic Discourse

A monumental stele (naru) was discovered accidently by agricultural workers in the Diyala region of Iraq in 1983 [**8.19**]. It is a large, grey four-sided monolith carved in pictorial relief on one side, and covered in a long cuneiform text across the remaining three sides (see excerpt in box, p. 193). Although its center has been damaged by a vertical groove, the stele is otherwise very well preserved. The sculpted side of the stele is subdivided into four figural registers. Two figures stand in the upper register. A figure on the left is in mid-stride, his left leg forward and his arm raised to deal a blow. He presses his foot on the chest of a fallen enemy. A man in a gesture of reverence stands opposite him, while a sun disc of Shamash, encircled by a crescent moon of **Sin**, the moon god, soars above. The figures in the top scene stand on a register that takes the shape of the buttressed walls of a citadel. This citadel is seen from a bird's-eye view, as if it were a ground plan or a blueprint, rather than being depicted from the same perspective point

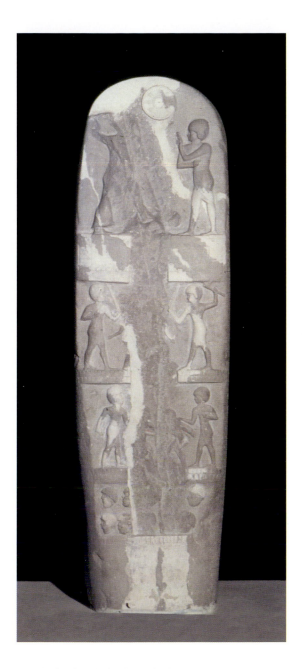

Monument Inscriptions

Excerpts from the Dadusha Stele:

Above, Sin and Shamash, who strengthen my weapons, in order to lengthen the years of my reign, they are clearly shining.

Above the walls of Dur-Qabara is Bunu-Ishtar, the king of the land of Arbil. I bound him in my power. I stand upon him. He whom I furiously defeat with my powerful weapon, I am standing on top of him. I am standing like a young hero. Below, ferocious heroes hold enemies carefully with a rope.

Its carving has no equal. In the craftsmanship of its carvers it is superior. It is worthy of praise, and it will be praised in the future.

Daily before Adad, the lord who created me, it will perform good things

For me and it will renew the destiny of my rule. In E.TEMEN. UR.SAG, the house of Adad, the god who raised me, I did set up indeed forever.

Excerpt from the Nippur scribes' catalogue:

The Monuments set up in the middle of the courtyard the E-Kur

Monuments of Sargon, Rimush, and Manishtushu such as they are found in the E-Kur

[after a long text copied from an Akkadian statue]

He dedicated this to the god Enlil in Nippur

Inscription is on his shoulder. The statue stands at....[break in text]

Inscription on the side of the monument facing the great statue of Sin-iribam

8.19 Stele of Dadusha, king of Eshnunna, found near Tell Asmar, Iraq, 1790–1780 BCE. Grey stone, h. 5 ft. 10⅞ in. (1.8 m)

of view as the warriors above it. In the middle two registers we see warriors capturing enemies whose outstretched and helpless arms can be seen as they fall. The warriors stand on ground lines made of scaled mountain pattern, indicating that they are in the north of Mesopotamia. In the lowest register the narrative is abandoned and we see instead two rows of severed heads in profile,

facing left. A vulture pecks the mouth of the head on the upper left, and another pecks at the nose of the head on the upper right.

Both the long text and the images describe a specific historical event, a military victory by Dadusha of Eshnunna over Bunu-Ishtar of Arbil at the battle of Qabara (*c.* 1785 BCE). The uppermost victory scene is placed on the buttressed walls of the citadel of Qabara. Each mode of representation—text and image—relates the event in different though similar terms, forming an **image–text dialectical** relationship that was

standard in Mesopotamian art. Alongside the written narrative of the battle, we read the most important actors in this historical event. What is remarkable about this monument is that it inserts into the narrative description a discussion of the monument itself, its installation and purpose, as well as its visual qualities. It is also describes the scenes that are carved upon it. These lines can be identified as an ekphrasis, a description and a commentary on a work of art. This is the earliest example of a work that presents this kind of aesthetic commentary; it was to have a long tradition that is better known from the much later examples from ancient Greece.

In the city of Nippur in the south of Iraq a group of scribes began a new scholarly practice. They made catalogues of the known standing public monuments of earlier times, going back to the Akkadian dynasty nearly five hundred years earlier. They carefully recorded the inscriptions that were carved upon the ancient statues or monuments that remained standing from earlier eras of history (see excerpt in box, p. 193). They also described the monuments themselves and the exact position of the inscribed texts on them. These practices are the earliest known examples in the world of the systematic recording of statues and steles made in earlier centuries. The Babylonian scribes set the stage for a new discourse of antiquarian concerns—cataloguing works and providing careful written descriptions of these works—a discourse that has some resonances in our own modern discipline of art history.

Life and Clay: Terra-cotta Images

An area of artistic production that grew tremendously in the latter part of the third and the early second millennium BCE is that of images made for personal use. Most of these works were small plaques or figurines made of clay [8.20-8.23]. Clay was an abundant alluvial material, used for architecture and sculpture, and in the Mesopotamian worldview, it was considered to be the basic material from which life was created. Clay was not simply an inexpensive material, therefore: it was symbolically charged—as we learn from the ancient omen texts, magical incantations, and works of literature—and it influenced the conceptual and the mythological spheres of ancient Mesopotamia to a great extent. In socio-cultural terms it was no less influential in that it permitted the creative production and dissemination of images across social classes and areas of the city, taking the visual arts well out of the arenas of the royal palace and its elite adjuncts (including the temple precincts) and bringing them into the day-to-day lives of the people and their households.

Clay enabled the invention of reproducible images and mass-produced artifacts. The first use of the clay open mold for the production of mass-produced terra-cotta plaques with figurative representations is already known from the Akkadian era. The use of this technology for reproducing images continues into the Hellenistic era, and the iconographic types sometimes have a remarkable continuity in terms of the lifespan of the image across the centuries. The use of clay molds as a technique is related to the making of brick stamps, and may have been developed at the same time. An exuberant variety of images and scenes were produced in clay, providing us with one of the richest sources for the study of ancient iconographies. These molded terra-cotta plaques were produced in the greatest numbers and are especially well attested in the archaeological record for the end of the third and early second millennium BCE. Among the most popular figurative representations was the nude female figure, depicted in a frontal position, often with hands clasped at the waist. Associated with fertility, sexuality, and reproduction, the material of the clay and the matrix itself were appropriate mechanisms for this iconography. In some ways similar to the water goddess of Mari, the ancient sculptor's interest in technology was incorporated into the artwork, and sometimes references to it were at play in the images.

How these objects were used is still debated. Unlike stone statues and reliefs, they rarely have

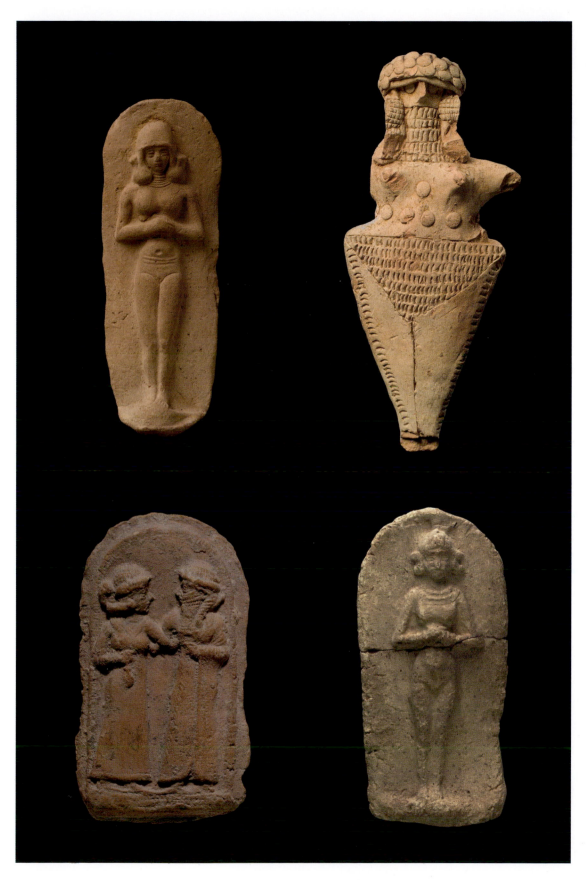

8.20–23 That we can observe an increase in the number of terra-cotta plaques made for personal use in the later third millennium and early second millennium BCE may in fact be an accident of recovery; by the 1920s archaeologists started to excavate private homes, rather than just palaces and temples, as they had done previously. The technology of the open mold (first invented in the late third millennium BCE), however, certainly made the increase in the production of such images possible.

Clockwise from top left
8.20 Standing nude female figure, from Larsa, Iraq, *c.* 1900 BCE. Terra-cotta, h. 5⅛ in. (13 cm)

8.21 Standing nude female, from Tell Asmar, Iraq, *c.* 2000–1750 BCE. Ceramic, h. 6 in. (15.2 cm)

8.22 Plaque with female nude, from Ur, Iraq, *c.* 1900 BCE. Terra-cotta, h. 5 in. (12.7 cm)

8.23 Molded plaque with couple, unknown provenance, *c.* 2000–1700 BCE. Ceramic, h. 5 in. (12.7 cm)

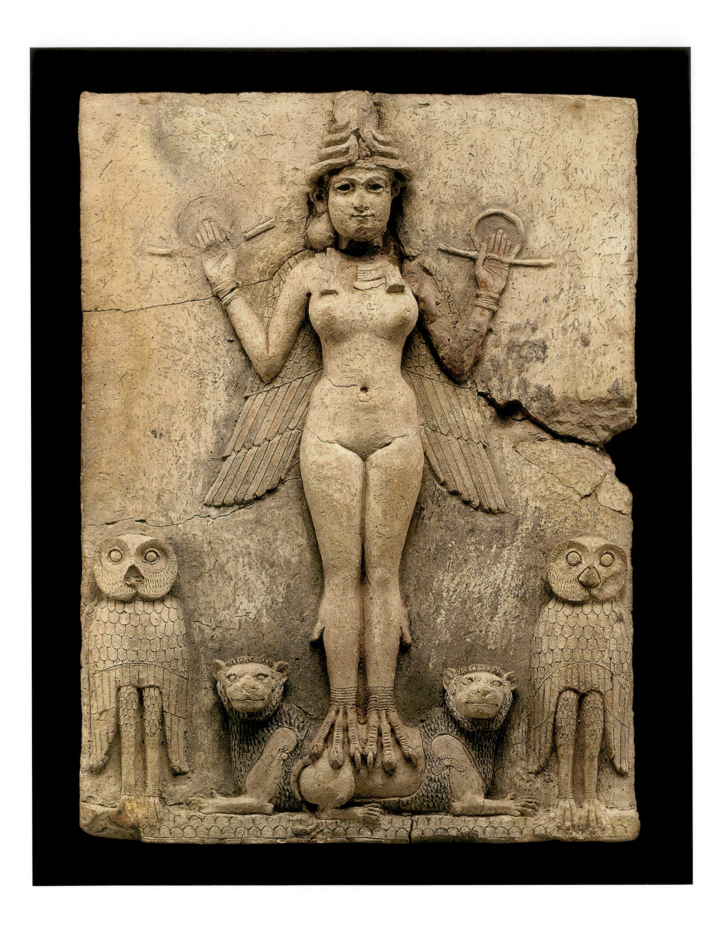

inscriptions. They were clearly used in houses of ordinary people, as nearly all the excavated terra-cotta plaques were found in households, while a few came from burials and temples. None of the plaques was found displayed in its original context, leading some scholars to conclude that these were transitory images meant for quick disposal after use. Clay anthropomorphic figures in three-dimensional forms were also very common at the same time, and seem to be works for the people, regardless of social class. In the textual references, clay figures are often associated with religious beliefs and magical rituals. Some of the images were possibly performative in their function, when incantations would animate them or transform them into valid substitutes for the represented person. The metaphorical parallel between people and clay figures is well attested, continuing as late as the biblical references to people turning into clay at death.

One of the best examples of the art of terra-cotta sculpture is a high-relief mold-made plaque depicting a nude goddess [8.24]. The large central figure of the goddess is perched upon two addorsed (i.e., placed back to back) lions and symmetrically balanced by her owls of the night. The goddess wears a four-tiered horned crown; on top of which we see a planetary disc. In her hands she holds two emblems that are associated with the goddess Ishtar. The goddess is presented to the viewer frontally; her arms, raised as if in an act of revelation of the body, reveal a voluptuous femininity, a physical allure that is referred to in Akkadian by the term *kuzbu*. The beauty of this goddess is nevertheless menacing. She has the wings and the talons of a bird of prey and, similarly to her sacred animals, the lions and the owls, is a predator. This combination of beauty and predatory power is typical of Ishtar—who is both a goddess of love in all of its forms, including physical and erotic love, as well as being a goddess of war—although the figure has also been interpreted as Ereshkigal, the goddess of the underworld, or simply as "The Queen of the Night."

Straw-tempered clay was pressed into the mold from the back so that the figures and the background became one piece. Incised details were added to the pressed relief before the clay was fired. Traces of paint remaining on the surface reveal that the entire relief was painted. The work shows the finest quality of production and is at a larger scale than most terra-cotta plaques. It is also an excellent example of the female nude body in the visual arts referring not to fertility or reproduction but to beauty and allure. There was no taboo on the representation of female nudity: it is an image that we see in Mesopotamia and across the ancient Near East throughout antiquity [8.25].

A fragmentary figure of an enthroned god wearing a four-tiered horned crown was excavated

Opposite
8.24 Plaque with nude goddess: "Queen of the Night," unknown provenance, probably southern Iraq, c. 1850–1750 BCE. Ceramic and pigments, h. 19½ in. (49.5 cm)

Below
8.25 Statuette of nude female, from Khafajeh, Iraq, c. 1900 BCE. Bronze

Representations of female nudity were commonplace in the iconography of the 2nd millennium BCE in Mesopotamia, and this is especially true for the small terra-cotta plaques and figurines found in household contexts. The female nude also appears often on cylinder seals, and is known from statues in the round in stone and in cast metal. Both goddesses and mortal women could be shown nude. A good example is this statuette of a seated woman with her legs tucked under her, which was found in the Diyala excavations. She has thick, shoulder-length hair and wears a multi-strand necklace fitted close to her neck, emphasizing the female allure of her body.

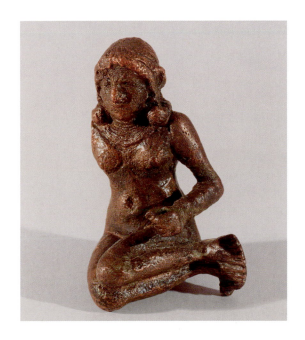

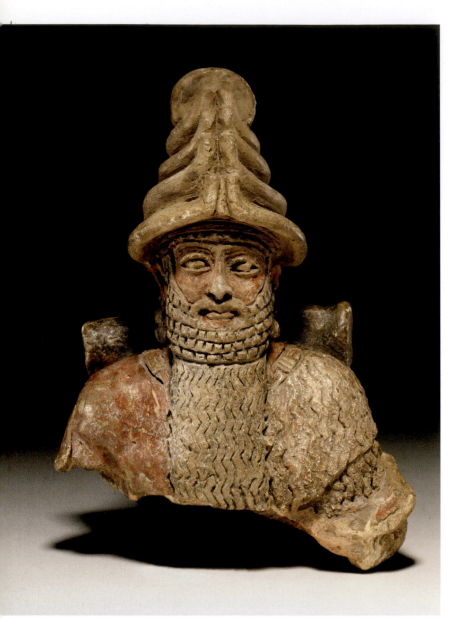

in Mesopotamia, which does not often subsist on other images in anything more than a few traces. This deity was found in the archaeological fill of a chapel that was equipped with a baked brick altar and belonged to a private house in a residential neighborhood.

A large-scale terra-cotta portrait of woman at the British Museum also retains traces of red paint on the surface [8.27]. It is a finely made work depicting a woman in an attitude of prayer with hands clasped under her breasts. She is elaborately coiffed and wears bracelets and a necklace. It indicates that patrons might have commissioned votive statues of themselves in clay rather than in stone or metal, and that these figures reached life-size proportions. Fired clay was therefore a versatile material that could be used for both lesser and finer quality works and was not simply a cheaper substitute for stone or metal. These works of art, made neither for the temple nor for the palace but for citizens of Babylonia, are best-known from this era, but they continue to appear throughout the coming centuries, well into late antiquity.

The Old Babylonian era ended in 1595 BCE, and although we will see some changes in art and architecture during the following Kassite period, many of the Old Babylonian forms of sculpture—from the large-scale public monuments to the terra-cottas used in households—continued to appear in much later eras, albeit with differing styles and themes. Most importantly, perhaps, the discourse of cataloguing, studying, and describing statues and monuments, which we can first recognize clearly in the Old Babylonian period, proved to be an intellectual turning point—giving such aesthetic matters new scholarly significance.

8.26 Painted deity, from Ur, Iraq, 1850–1750 BCE. Ceramic, h. 2⅞ in. (7.3 cm)

at Ur [8.26]. The back of the chair behind the god indicates that the figure was seated. The small clay figure was originally painted and much of the paint survives on the surface, revealing that the garment worn by the god was white with black outlines in between. The face and the shoulder not covered by the cloth have a reddish-brown color. The hair and the beard were painted black, while the crown was yellow, perhaps to indicate gold, and the necklace of red and yellow may have been intended to simulate gold and precious stones. The paint that survives on this figure is important evidence for the use of **polychromy**

Opposite **8.27** Female votive statue, Khafajeh, Iraq, *c.* 2000–1700 BCE. Painted terra-cotta, h. 16 in. (40.2 cm)

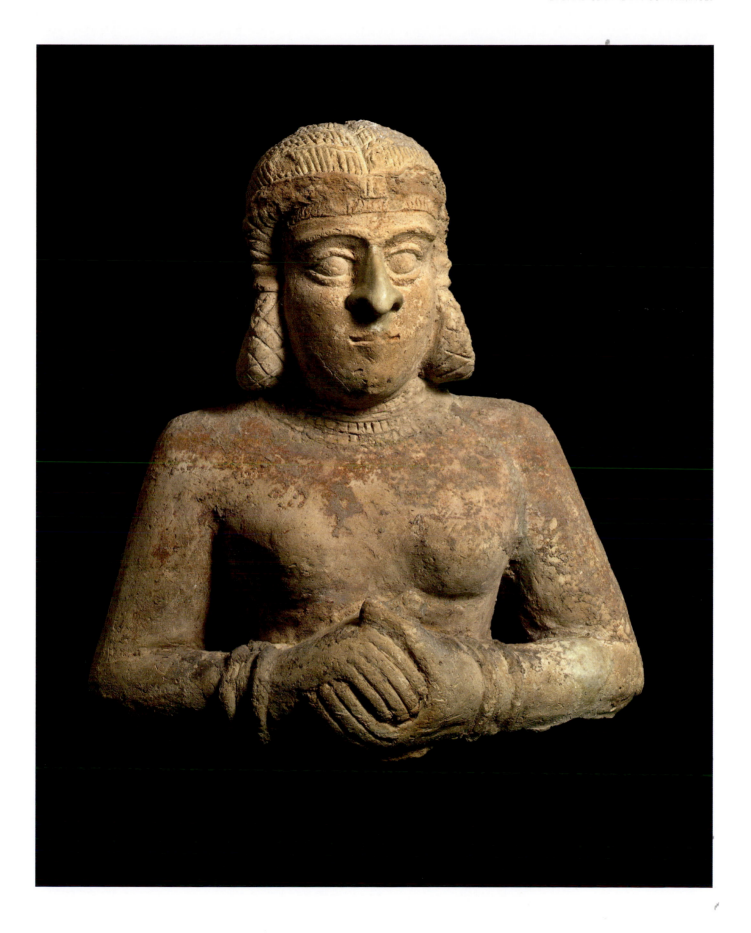

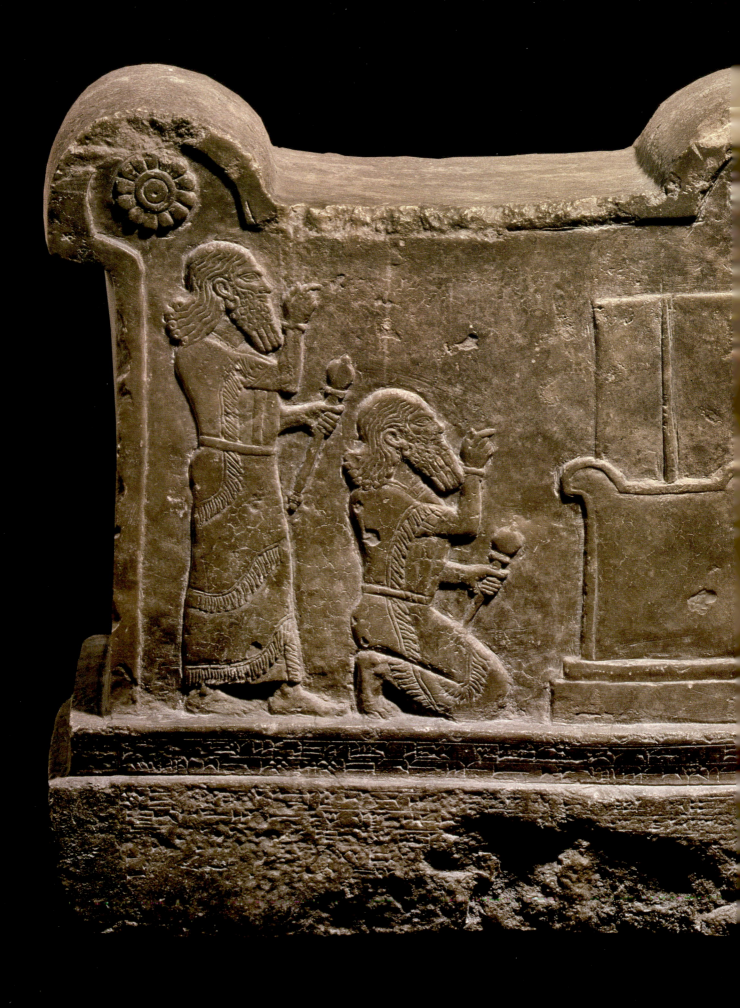

CHAPTER NINE

Kassite and Assyrian Art at the End of the Bronze Age

Altar of Tukulti-Ninurta I, from Assur, Iraq,
1243–1207 BCE. Alabaster, h. 23⅝ in. (60 cm)

9 Kassite and Assyrian Art at the End of the Bronze Age 1595–1155 BCE

Periods	Late Bronze Age 1595–1110 BCE
	Kassite dynasty 1595–1155 BCE
	Middle Assyrian 1363–1000 BCE
	Dark Age 1100–900 BCE
Rulers	Babylonia: Burnaburiash II: r. 1359–1333 BCE; Meli-shipak: 1186–1172 BCE
	Assyria: Tukulti-Ninurta I: 1243–1207 BCE; Assur-bel-kala: r. 1073–1056 BCE; Tiglath-Pileser I: r. 1114–1076 BCE; Eriba-Adad: r. 1390–1364 BCE
Major centers	Kassite capital city: Dur Kurigalzu; major cities: Babylon, Uruk
	Assyrian major city: Assur
Notable facts and events	Amarna archive in Egypt: evidence of international royal correspondence in Akkadian language
	Iconoclasm and removal of statues is extensively recorded
Important artworks	Inanna Temple, Uruk
	Altar of Tukulti-Ninurta I
Technical or stylistic developments in art	Kassite kudurru
	Assyrian art: continuous narrative images

9 Kassite and Assyrian Art at the End of the Bronze Age

The art and architecture of Mesopotamia described thus far were all made in the archaeological era known as the Bronze Age. This chapter deals with its last centuries (the late Bronze Age), from 1595 to 1110 BCE. This final phase of the Bronze Age was characterized by extensive networks of diplomacy and great political upheaval across the ancient Near East and eastern Mediterranean world. In the context of this mixture of cultural interconnections and encounters, the chapter addresses some basic art historical questions regarding style and its relationship to political or ethnic groups, to ideas of the indigenous and the foreign, the local and the international. In the late Bronze Age, we see new genres and developments in the visual arts that signal the fresh directions that art would take in the Iron Age in the early first millennium BCE. We also see the solid and unwavering continuation of earlier traditions in the manufacture and use of images and monuments. During this time, the beginnings of an emerging Assyrian art in the north of Mesopotamia become clear. We will follow this royal art into the next millennium, the era of the great empires of the ancient Near East. In the south of Mesopotamia the Kassite kudurru appears as a new, distinctively Babylonian type of monument. These kudurrus tell us about the uses of steles and ways of viewing them, about the visual theology of the divine and the ontology, or nature, of images. At the end of the late Bronze Age, two Elamite invasions of Babylonia that ended the mighty Kassite dynasty bring us again to the issues of iconoclasm, the abduction of images in war, and finally to the rescue of the captured cult statue of the god **Marduk** by the Babylonian king **Nebuchadnezzar I** (r. 1125–1104 BCE).

These practices of the assault and abduction of images are chronicled at length in ancient texts and the statue epigraphs, comprising one of the best-preserved art historical and archaeological records concerning the reception of and response to the power of images.

Kassite Art and the Question of Style

In the south of Mesopotamia, the Kassite dynasty that rose to power at this time consisted of a foreign elite who imposed their rule over Babylonia. Their original homeland was either the Zagros Mountains or another area to the east of Babylonia, but its exact location is uncertain. The name "Kassite" comes from the Akkadian name for these people, *kassu*, and the earliest references to them appear in texts of the age of Hammurabi, when they entered the historical record as a people of nomadic origin, unrelated to the Babylonians. By 1595 BCE, when the Old Babylonian dynasty fell as a result of the Hittite attack from Anatolia, the Kassites had already become a strong force within the population of Babylonia, where they had come to work both as agricultural laborers and as mercenaries (hired soldiers). The vacuum in power after 1595 BCE allowed the Kassites to establish a new domination in the south of Mesopotamia that lasted more than four centuries. In time, their Babylonian dynasty became a major international power in the world of the late Bronze Age until the Elamite attack in 1155 BCE. Nevertheless, they continued to live in the region and integrated into the population; people with Kassite names are attested in the historical record well into the time of the Persians and Alexander the Great in the fourth century BCE.

The question arises as to whether we can distinguish a Kassite style within the history of Mesopotamian art and architecture. This question of **attribution**—which comes up especially in relationship to the Kassites and to other ruling elites that gained political power in Mesopotamia—is relevant to the study of ancient art and material culture in general, as we often categorize ethnic groups in the historical record in relation to their material culture, especially to their styles and technologies of art and architecture. How can art or material culture reflect a particular ethnic group? If the Kassites were a foreign ruling elite unrelated to the indigenous Babylonian population, is their foreign origin evident in the art and architecture produced under their patronage? In the cultural sphere we see that the Kassite kings continued the traditions of Babylonia rather than imposing styles of art, and that they also strongly supported and patronized Babylonian traditions in the arts and sciences. At the major Babylonian temple precincts, they piously maintained the ancient cults and sacred rituals of the land. The Akkadian language continued to be used locally, and as a lingua franca in the region. In its Babylonian dialect, it was the language of international diplomacy, used throughout the Near East and the eastern Mediterranean, including in Egypt. Even Sumerian continued to be used in a scholarly context under Kassite rule. In fact, the Kassite language that these rulers spoke was not related to any known language group that we recognize in today's linguistic categories, and though their personal and divine names and a few terms for things are known, any record that they left is written in the local Babylonian language that they adopted for their administration. In terms of the visual arts and architecture we see similar continuities. In sum, although they ruled Babylonia for more than four centuries, little remains that can be easily categorized as Kassite art or architecture, differing in any significant way in styles or techniques of production from previous Mesopotamian arts. The Kassite kings seem to have preferred to continue the age-old established traditions in art and ritual.

Architecture

One place where we can glimpse something of the Kassite presence is at the archaeological site of Aqar Quf, on the outskirts of modern Baghdad. It is here that they built their newly established capital city of Dur Kurigalzu, a site that still boasts the massive remains of a ziggurat. The city was built at the end of the fifteenth century BCE as a new administrative capital, while Babylon continued to be used as an important sacred city. This in itself was an unusual decision on the part of the Kassites, as earlier kings of Babylonia preferred to position their rule in the context of ancient and well-established city states as capitals. Yet the new Kassite city was built following the traditions of Mesopotamian architecture. The ziggurat of Dur Kurigalzu stands in a sanctuary of Enlil, the supreme Mesopotamian sky god whom they worshiped along with the other gods of the local pantheon and some of their own Kassite deities. At Nippur, for example, a city sacred to Enlil but which housed temples to several other gods and goddesses, the Kassite kings bestowed their patronage after a period of decline and neglect, and they supported the work of Nippur's scribes and scholars.

Excavated between 1942 and 1945 by a team of Iraqi archaeologists led by Taha Baqir, the site of Dur Kurigalzu covers a large area of 555 acres (225 ha) dominated by the remains of the ziggurat [**9.1**]. The remains, which reveal a mud-brick core reinforced with layers of reed matting that are still visible today, stand 187 ft. (57 m) high and measure 226 × 222 ft. (69 × 67.6 m) at the base, but originally this temple tower rose to an even higher level. A nucleus of buildings consisting of at least four palaces was found about 0.6 miles (1 km) northwest of the sacred precinct [**9.2**]. The main excavated structure, palace H, had a large courtyard surrounded by long galleries and rooms. **Fresco** paintings depicting a procession of courtiers and officials decorated the walls. Rows of men outlined in black and painted on a yellowish background flanked doorways into reception rooms. Two horizontal lines of scarlet paint forming a linear border with rosettes in black, red, yellow, and blue created a repeating

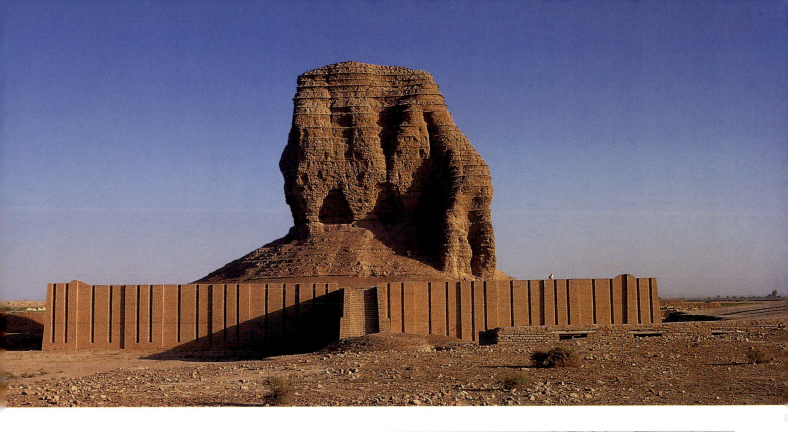

Above **9.1** Ziggurat at Dur Kurigalzu, Iraq, end of the 15th century BCE

Right **9.2** Photographs of the excavations of palaces at Dur Kurigalzu, Iraq, 1940s

pattern. The paintings were retouched and conserved already in the Kassite era, revealing long periods of use of these palace spaces.

Very few works of sculpture were found in the palace, however. The head of a man and several animals in terra-cotta are all that remained here [**9.3**, **9.4**, p. 206], and these works fit comfortably within the styles and techniques known from earlier Mesopotamian terra-cotta arts. In the 1940s, when the small statues were found, some scholars who had been influenced by mid-twentieth-century European racial theories saw in them a different style that they described as "non-Semitic." There is nothing in these terra-cotta sculptures that indicates any racial or ethnic difference of the maker, however, either in technique or style or in the form or features of the represented figures. The clay sculptures are made by hand with soft and naturalistic modeling of forms, such as can be seen in the rendering of the folds of slack skin at the mouth of the lioness.

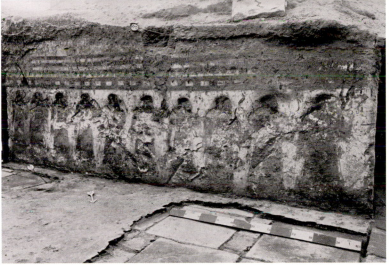

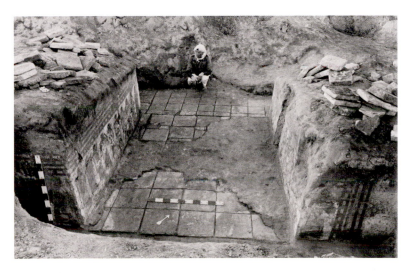

9.3 Head of
a bearded man,
from palace H,
Dur Kurigalzu, Iraq,
end of the 15th
century BCE.
Terra-cotta

9.4 Lioness,
from palace H,
Dur Kurigalzu, Iraq,
end of the
15th century BCE.
Terra-cotta

This attention to detail seems to imply a careful observation from life, especially in the way that the lioness is depicted. The statues also bear traces of black and red paint—most clearly visible on the image of the bearded man—and surface details are incised with a sharp tool to indicate his hair. They give us some idea of the statuary in the round, now lost, that must have filled the rooms of the palaces of Dur Kurigalzu.

Besides the founding of a new capital city, another important Kassite architectural project was at Uruk, one of the most ancient cities of the south. Here, the Kassite king Karaindash renovated the temple precinct of Inanna in the mid-fifteenth century BCE and added bricks inscribed in Sumerian in which he dedicated this temple to the goddess Inanna. The architectural project was in itself an act of veneration, as we have seen (pp. 162–66), following a long tradition of the builder king as the pious patron of the sacred precincts of the gods. In the new temple of Inanna—constructed of brickwork and placed in the same Eanna sanctuary that we know from the Uruk era, some way off the previous ancient remains—we see some innovations. Heavy stepped buttresses are added at the corners of the rectangular temple; these are the element that we see for the first time. The long

cella is entered via a small antechamber through a door in the narrow wall, following a direct axis plan, which is also uncommon [**9.5**]. The most striking aspect of this temple is its introduction of large-scale architectural sculpture. It featured a high-relief sculpted facade constructed of molded bricks with figures that are almost in the round [**9.6**]. This facade consisted of rows of standing and frontally positioned water and mountain deities in alternate niches holding the traditional flowing vase (the *hegallu*) in both hands. They wear crowns with a single pair of horns, indicating their divine status. Their lower body is enveloped by a columnar skirt bearing either a water or a mountain pattern. The mountain gods are bearded and masculine, while the water deities are goddesses. Each figure appears to bolster the side of the building like a buttress. They are both sculptural and architectural elements, like the later **caryatids** of Classical Greece.

The motifs of these deities, whose bodies incorporate the natural phenomena of water or mountain, are not new (the water goddesses can be seen in the murals of the palace at Mari, for example) but the elongated style of the figures, adapted so well to the architectural space and structure, appears to be a Kassite era innovation. This creative use of brickwork for figural

Right **9.5** Innana Temple, Eanna precinct, Uruk, Iraq, built by Karaindash, 1415 BCE

Below **9.6** Molded brick facade of the Temple of Inanna, Eanna precinct, Uruk, Iraq, *c.* 1415 BCE. Terra-cotta, h. 6 ft. 6 in. (1.98 m)

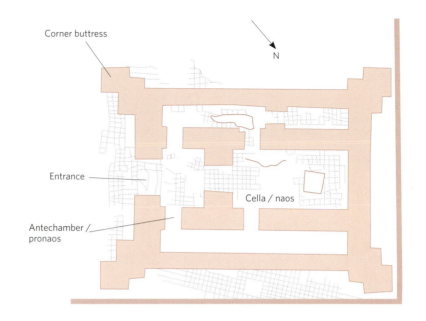

Corner buttress

N

Entrance

Cella / naos

Antechamber / pronaos

representation developed from the techniques of molded brick palm-tree-shaped columns known from the earlier second millennium BCE. The deified natural elements here stand as **apotropaic** guardians of the temple, warding off evil and serving the divine presence of the great goddess Inanna within. Between these gods of the facade, projecting **pilasters** carry symbols of streams of water above pairs of stele-like objects. This architectural sculpture is a truly impressive innovation. Far from being an inexpensive

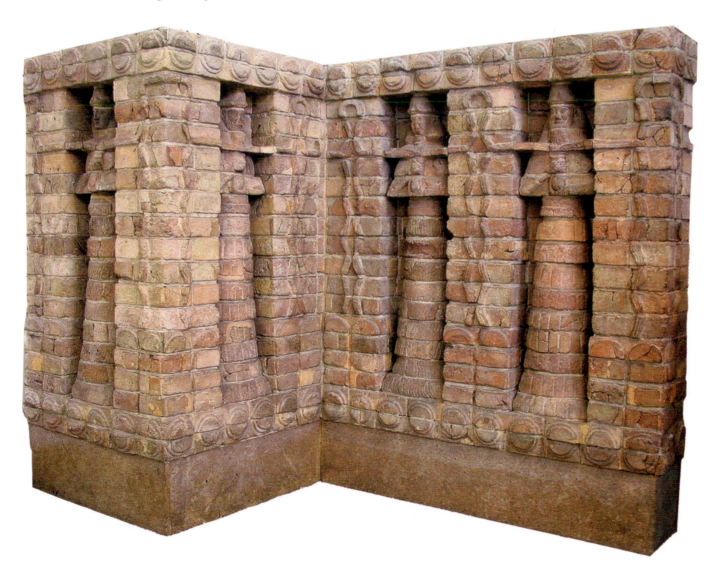

The Amarna Archive

The age of internationalism in which the Club of Great Powers (as historians refer to this political network) ruled the ancient Near Eastern world is recorded in one of the most important diplomatic archives of antiquity. Discovered in Egypt at the modern site of Tell el Amarna, this collection of more than 350 letters written on clay tablets in Babylonian cuneiform dates to the reign of the pharaoh Akhenaten and his predecessor Amenhotep III between 1365 and 1333 BCE. The letters mostly reveal an ancient Near Eastern world of Syro-Palestinian vassal states controlled by Egypt, their minor kings referring to themselves as servants of the king of Egypt. But they also include letters from the kings of the major powers of the time who considered themselves equal to Egypt and addressed each other as "brother." These "Great Kings" included the rulers of Babylonia, Assyria, Mitanni, Hatti, Alashiya, and Arzawa. Although the Amarna letters cover a rather short period of time, they give us an indication of the type of correspondence that was commonly maintained at the royal courts of the late Bronze Age. In the state archives of the Hittite capital, Hattusa, similar letters have been found, also using the Babylonian language and writing materials, which indicates how the Babylonian literate culture held sway over the ancient Near East. Among these royal correspondences are letters in which one king requests particular works of art from another court, or where a ruler requests that a particular artist be sent to his court for a time. The Babylonian king Burnaburiash, for example, writes to the Egyptian pharaoh a very precise description of a work that he would like to have: "Trees are to be made of ivory and colored. Matching plants of the countryside are to be carved, colored, and taken to me" (letter EA 11). Such diplomatic letters allow us a glimpse into the world of artistic exchange and patronage in the midst of the better-known political concerns of the time.

imitation of stone sculpture, a molded baked-brick facade demands a highly complex technique of production, similar to large-scale mosaic design. Each element of the brick that composes the figures in relief is molded separately, measured to fit in a repeating visual pattern that is then laid in place. Some of the bricks still retain traces of the original paint that must have covered a large part of the surfaces. The facade of the Inanna Temple thus provides us with a very early example of the molded brick facades that were later perfected by Neo-Babylonian sculptors, especially in the spectacular glazed walls of the city of Babylon.

The Kudurru

A monument that is often associated with the Kassites is a type of artifact now often referred to by the name *kudurru*, an Akkadian word meaning "boundary" or "border". Appearing in the fourteenth century BCE, kudurrus are stone boulders (usually of limestone or basalt), which have been carved into roughly ovoid or oblong shapes, often tapering toward the top.

Their polished surfaces are carved with lengthy inscriptions alongside symbols or representations of the gods. Kudurrus may have been introduced by the Kassite dynasty. Most of them seem to be from southern Mesopotamia where the Kassites held power, but they continue to be made until the seventh century BCE, long after the Kassite rule had ended. The lengthy inscriptions on the kudurrus record land grants, usually involving the king and dignitaries, or land sales. The inscriptions conclude with oaths and curses that invoke the god's wrath upon those who break the agreement. When they have been found in an archaeological context, we see that they had been placed in temples. In earlier times, some scholars had thought that the kudurrus were copies of other such stones that had once stood in open fields, at borders and boundaries, but this theory is no longer accepted. The inscriptions on these stones refer to them as naru (monument), so that name is in fact a more accurate description of these objects, although the word kudurru is now commonly used for them. This is a genre that we

can best describe as a monumentalized document, a legal contract and oath that is given the solid form of a boundary stone.

One example from the late Kassite era is known as the Meli-shipak kudurru [9.7]. It records a transfer of a vast domain of land from King Meli-shipak to his daughter, Hunnubat-Nanaya. The front side of the monument is carved in a low relief with a familiar presentation scene. The king approaches the enthroned goddess Nanaya, who sits at the left of the scene wrapped in a great woollen cloak and wearing a tall crown. The king's right hand is raised in a gesture of reverence, while with his left he holds his daughter's hand as he leads her toward the goddess. The princess, Hunnubat-Nanaya, wears a fringed dress and carries a harp. An incense burner stands before the goddess. Above, astral symbols represent Ishtar, Sin, and Shamash. In this kudurru we see that there are two different modes of depicting the divine: the astral god symbols and the anthropomorphic image of the enthroned Nanaya. They appear together within the same space. The ritual act of introduction in which the king and his daughter approach the goddess may indicate that we are to read the enthroned image as the cult statue of Nanaya, but there is a deliberate ambiguity between the cult statue and the presence of the divine that is in play here. An actual ritual event is recorded—the presentation of the princess by her father and the grant of land that is bestowed. This event is overseen by the divine world, but the presence of the gods hovers between the material statue and the supernatural appearance as abstract symbols. Another interesting aspect of this kudurru's history is that its sculpted side bore a further inscription that has been effaced, perhaps to make space for a new text to be placed there by the Elamite king who took this object to Susa as war booty.

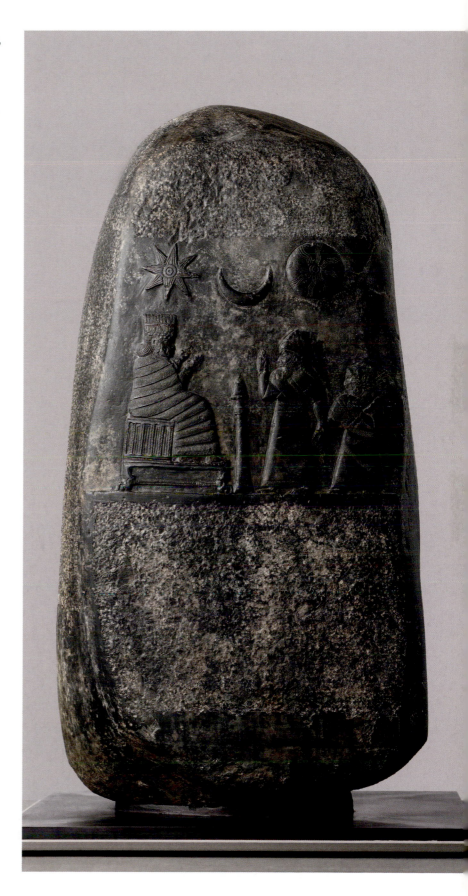

9.7 Meli-shipak kudurru, from Susa, Iran, 1186–1172 BCE. Dark gray calcite, h. 32½ in. (83 cm)

Even after Kassite rule ended in 1155, kudurrus continued to be used in the south of Mesopotamia. The kudurru of Ritti Marduk [9.8], the captain of the chariots, sets out the details of an award from Nebuchadnezzar I in which the king frees his town from tax duties and prohibits the billeting of imperial soldiers there. The military commander, Ritti Marduk, had served in the campaign in Elam. The text mentions thirteen officials who were present at the official event of the award. Nine gods are invoked in the text and another twenty gods appear in the iconography of the monument, arranged in rows of divine symbols that span six registers of

9.8 Kudurru of Ritti Marduk, from Sippar, Iraq, 1125–1104 BCE. Limestone, h. 25 ¼ in. (64 cm)

Depicted: Face A. Faces B and C each bear a single column of inscription, the lines running the full width of the stone. The top of the stone and Face D have been left blank, except for the serpent, which has been carved to the left of the emblems on Face A. Inscribed with a charter from the reign of Nebuchadnezzar I.

First register
Astral symbols of:
(1) Ishtar
(2) Sin
(3) Shamash

Third register
Altars with symbols of:
(7) Marduk
(8) Nabu
(9) Ninmah

Fifth register
(14) Gula enthroned with her dog
(15) Scorpion man

Second register
Horned crowns on altars:
(4) Anu
(5) Enil
(6) Ea

Fourth register
(10) Eagle staff of Zababa
(11) Lion mace of Nergal
(12) Horse and rainbow for a Kassite god
(13) Bird on perch: standard of Ninurta

Sixth register
(16) Lightning-bolt and bull of Adad
(17) Turtle for Ea
(18) Scorpion for Ishara
(19) Lamp of Nusku
(20) Serpent at bottom is Ishtaran or Nirah

relief carving. **Nirah**, the snake of the boundary, delineates the space between the emblems of the gods and the inscription. Nirah is the minister of **Istaran**, the god who adjudicates border disputes.

Nirah is also depicted as a serpent on an unfinished kudurru found in Susa [**9.9**]. He has a pair of upright horns and encircles the circumference of the base as if to indicate that the entire region around this walled citadel is protected. Another smaller snake coils itself at the top of the monument. Above the **crenellated**

9.9 Uninscribed kudurru, Susa, Iran, c. 1160 BCE. Limestone, h. 21 ¼ in. (54 cm)

walls of the citadel, we see symbols of the gods and a procession of musicians and animals. This kudurru bears no inscription, but the blank space of the citadel wall most likely was meant for inscription. It is possible that the kudurru was not yet finished when it was looted and taken to Elam.

Middle Assyrian Art

The early history of Assyria is still not well known. The Assyrians presented their own history as a long succession of kings who ruled the city state of Assur, now at the site of Qal'at Sherqat, and it was certainly occupied from the Early Dynastic era in the mid-third millennium BCE, and came under the successive rule of the Akkadian and the Ur III dynasties. In the early second millennium, Assur became a major capital of Assyria, and in the Middle Assyrian period it was the capital of one of the most powerful kingdoms of the time.

The name "Assur" designates both a god and his city, which was built on an outcrop of limestone, rising to a considerable height above the Tigris river. Raised upon this triangular promontory and almost surrounded by water, the site made use of the natural defensive qualities of the land. Under Tukulti-Ninurta I (1243–1207 BCE), temples and a palace were built here, as well as a great ziggurat and monumental city gates and a fortified circuit wall, as described in the ancient texts. The old Ishtar and Assur temples were restored, and he also built a new city just two miles to the northeast, named Kar Tukulti-Ninurta.

A temple dedicated to Ishtar had existed at Assur already in the Early Dynastic era. There is a good amount of information regarding the era of Shamshi Adad I, the ally of Dadusha of Eshnunna, who included the city of Assur and its environs in his northern kingdom, but the long stretch of time between Ishme-Dagan (c. 1775 BCE), the contemporary of Hammurabi, and Assur-uballit I (r. 1363–1328 BCE), the first Assyrian ruler to call himself the king of Assyria, is barely documented. It was only during the period of the Amarna letters that Assyria arose as a competing state in the Club of Great Powers, and it became especially

important after the collapse of the Mitanni state, which had dominated the north and restricted Assyria to the environs of the city of Assur. With Assur-uballit, the center of Mesopotamian power shifted to the north and a new form of Assyrian art emerged that was distinctive in the way it played with narrative forms and open-ended and repeating compositions. This formed the foundation for the later Assyrian royal arts of the empire that would reach their height in the early first millennium BCE.

Sculpture and Narrative

An alabaster monument carved in relief with an uncommon scene was found at the Ishtar Temple in Assur (see p. 200). It is formed in one piece as a pedestal on top of a double-plinth rectangular base, the front side carved with a scene while the back is left undecorated. Semicircular projections at the top are carved with rosettes. The main scene of the sculpted side of the altar depicts two male figures in profile, one standing and the other kneeling. The figures represent the same person, who is bearded, wearing the same mantle and tunic, earring and bracelet, and holding the same scepter. The hand gestures of the two figures, with forefinger and thumb extended, are also the same, as are the details of their physiognomy. This is Tukulti-Ninurta I, the king of Assyria (r. 1243–1207 BCE), carrying the royal scepter. He is shown twice within the same pictorial space, first approaching the altar and then kneeling in front of it. These are two distinct moments, a visual division of time and movement that shows a new approach to pictorial narrative. This interest in continuous movement in narrative is an important new direction for Assyrian art and it is interesting to consider it alongside the simultaneous development of a new literary interest in longer descriptive historical texts. Both of these are developments in Middle Assyrian creativity that were to reach remarkable heights in the following centuries of the Neo-Assyrian Empire, when a vibrant sense of pictorial narrative becomes the hallmark of the art of the Assyrian palaces.

The monument that Tukulti-Ninurta I approaches in the carved relief image is

a representation of the same monument on which it is represented. Self-referential in its imagery, it consciously depicts its own cultic and supernatural function. Thus it figures fully in a Mesopotamian tradition that we have seen as early as in the Uruk Vase (**2.5**, see p. 47). Yet the sequential approach is an innovative step in the development of narrative art. The altar depicts the cultic scene of worship within the relief on the side, and it also stages the appearance of the divine within the cultic scene by depicting the presence of a god symbol as if it were an epiphany appearing supernaturally before the worshiping king. The signifiers of representation are overtly stressed. That is, rather than avoiding the representational aspect of ritual, the scene plays with it, showing the symbol's presence on the altar and the repeated movement of the king toward it. When the king approaches the altar he performs the same action as the relief, his material body replicating his image. The king is thus within the space of the representation and outside it at the same time, joining the image and the act of worship in order to allow the act of ritual and the magic of images to function. The relief both depicts the act of worship and establishes it as a perpetual act in the image. The king offers his prayers, but the representation of the act of praying can be understood as yet a second offering to the god, echoing the first. The altar is a space of epiphany, where the god becomes visible and the future is decreed for the worshiper.

The iconography of the relief has been debated by scholars because of the inscription on the base. It states that the king offers his prayer to the god Nusku and declares that the pedestal belongs to this god. The tablet and stylus depicted on it are not the usual symbols of the god Nusku, who is a god of light usually associated with a lamp. Rather, they are associated with **Nabu**, the god of writing. There is a simple explanation, however. Nusku is also the god of dreams, which were understood as a means by which the gods sent signs to the people. The king waits for the signs to appear. The tablet and the stylus are therefore the instruments and space of a possible destiny, a destiny that is to be written as an omen of the

future. The altar of Tukulti-Ninurta I is a complex and remarkable work of art that seems to refer deliberately to the shifting relationship between representation and reality, and that provides us with evidence of the nature of images in Assyria.

A nude female figure discovered in Nineveh [**9.10**] is one of the few examples of sculptures in the round that survive from the Middle Assyrian era. It was found in the Ishtar Temple in 1853 by Hormuzd Rassam, a local archaeologist from the city of Mosul. The head and parts of the arms and legs are missing, but it is nevertheless a fine example of a large-scale female nude. The body seems to be that of a young woman whose

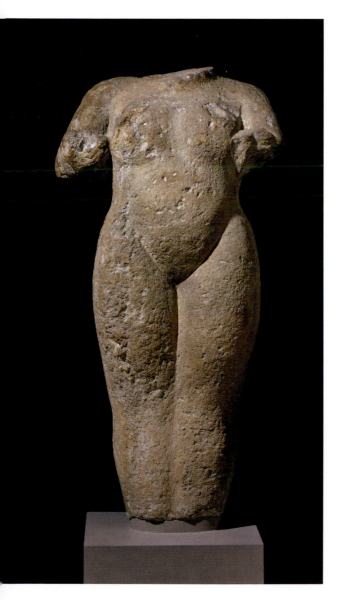

rounded breasts and full thighs are emphasized, as is the pubic triangle, which is carved in low relief with rows of curls. The statue bears an inscription on the back that not only allows us to date it to the reign of Assur-bel-kala (r. 1073–1056 BCE), but also is especially important for its statement regarding the statue's purpose. It says that the king had these sculptures made and set them up in the provinces, cities, and garrison for visual pleasure or titillation. The inscription ends with a curse in the name of the Sebitti, the seven, the warrior gods also known as the Pleiades. Like the majority of the smaller terracotta female nudes of Mesopotamia, we do not know the identity of the Nineveh nude; we understand this female body as an object of visual pleasure. Rather than being associated with fertility and reproduction (as ancient statues of female nudes are often interpreted), the inscription places emphasis on the statue's beauty and even erotic allure.

9.10 Nude torso, from Nineveh, Iraq, 1073–1056 BCE. Limestone, h. 36⅝ in. (93 cm)

Texts and Seals

During the Middle Assyrian era, royal inscriptions become increasingly complex and reveal a remarkable concern with their own nature as historical artifacts. Literary developments thus have some similarities with the concerns of the visual arts. By the reign of King **Tiglath-Pileser I** (r. 1114–1076 BCE) a new genre of royal inscriptions appears: the royal annals. These texts are detailed and chronologically organized historical accounts that become ever more extensive and numerous. The eight-sided prism of Tiglath-Pileser I is an architectural foundation text from the Anu and Adad Temple in Assur (**2.6**; see chapter 2, p. 56). Commissioned at the time of the restoration of this temple by the king, it contains lengthy descriptions of military and historical events. These episodes are listed in chronological order, marking a turning point in the development of narrative texts. At the same time, the prism itself is a remarkable object. The craftsmanship demonstrates a perfectionism on the part of the maker, with its skilled, even distribution of the text across the surfaces, each line ending with a verb. The beginning of the text is marked by

a logogram—a SAG sign meaning "head"—so that a reader would be able to know where on the eight-sided prism to begin reading. This attention to the act of reading and to the visual display is all the more interesting considering that the prism was made as an object to be immediately buried. The intended viewers are the people of the distant future and the gods.

Middle Assyrian seals are among the finest works of this era produced in the palace workshops of Assyria, where the most excellent seal carvers were employed. These seals reveal a new interest in complex designs that make use of the cylindrical seal shape and format in order

to explore the relationships of medium, object, and composition. Continuous and repeating patterns are deployed in designs that play upon the open-ended and border-free compositions that cylinder seals permit. A chalcedony seal at the Metropolitan Museum of Art is a good example of this approach [9.12]. It depicts a winged horse galloping to the right, with an inscription above the horse. Rolling out the cylinder in order to read the entire text forces the repetition of the horse. The seal carver has positioned the text and the image in such a way as to require a repeated rolling out of the seal. The composition thus emphasizes an open-ended design that is meant

A Seal Collection from Thebes

A large hoard of cylinder seals found in Thebes in northern Greece provides fascinating evidence of collecting practices and the international movement of objects in the late second millennium BCE. The collection of seals was found in a room in a Mycenaean palace that archaeologists believe may have been a craftsman's workshop. It includes seals made in various lands, from Mesopotamia and Syria to Hittite Anatolia and Cyprus, which had been kept together in a wooden box. Some of them were several centuries old already, and had been re-worked by a later stone carver. Among the seals was a lapis lazuli cylinder inscribed with a text that

identifies it as belonging to a court official of the Kassite king Burnaburiash II (r. 1359–1333 BCE). The exquisitely carved seal [9.11] bears an image of a long-haired and bearded mountain deity emerging from between two peaks, surrounded by olive trees. He grasps streams of water that flow from jars. A large inscription panel, characteristic of Kassite glyptic design, is next to the scene. The Theban seal collection was found with other precious objects of agate, ivory, and gold, all of them revealing something of this age of international movement of artifacts that were valued and exchanged across the eastern Mediterranean world.

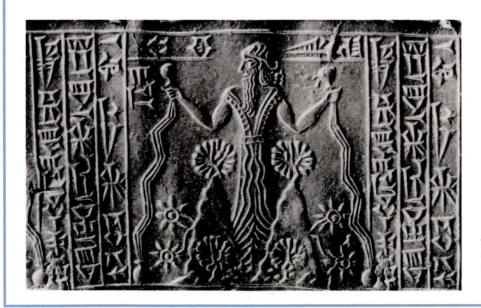

9.11 Seal of Kidin-Marduk, royal official of Burnaburiash II, Thebes, Greece, Kassite, 1359–1333 BCE. Lapis lazuli, h. 1⅝ in. (4.2 cm)

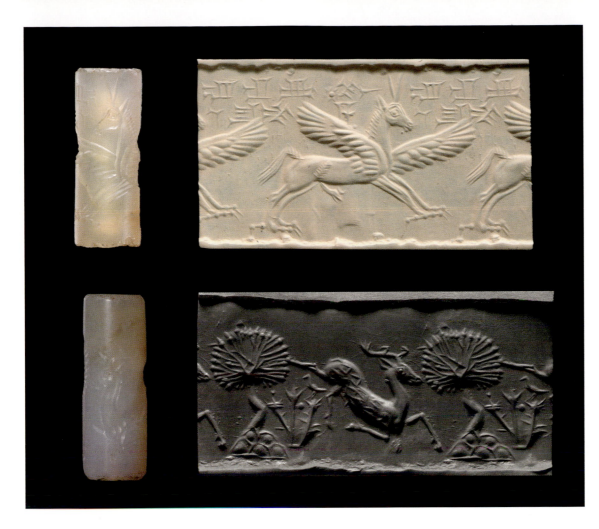

Left above
9.12 Seal with winged horse, unknown provenance, Middle Assyrian, *c.* 1300–1200 BCE. Chalcedony, h. 1⅜ in. (3.6 cm)

Left below
9.13 Seal with leaping stag in landscape, unknown provenance, Middle Assyrian, 1300–1200 BCE. Milky chalcedony, h. 1⅛ in. (3 cm)

to repeat infinitely, a concern common in Middle Assyrian seals. A chalcedony seal represents a stag in a landscape [**9.13**]. The leaping stag's foreleg is poised to land, while a hind leg is stretched behind it. When the seal is rolled, the olive tree and bush with a resting bird are repeated so that they are both before and behind the graceful stag. The depiction of animal combats with supernatural creatures is also favored in much of the glyptic iconography. The royal seal of Eriba-Adad I (r. 1390–1364 BCE) is a good example of the use of hybrid creatures, which are depicted with distinctive Assyrian dynamism and energy. The royal seal impression, which survives on clay tablets [**9.14**], displays supernatural iconography with its **griffins** and stylized trees borrowed from the kingdom of Mitanni (which had flourished in northeast Syria until its defeat by Assyria) and winged sun disc originating farther west in Egypt. The heraldic composition uses opposed groupings of battling griffins distributed in a tightly woven pattern across the surface of the seal. The motifs,

which echo foreign elements, show that the language of internationalism and royal authority was more important for the more widely visible glyptic arts than for monumental sculpture in Mesopotamia.

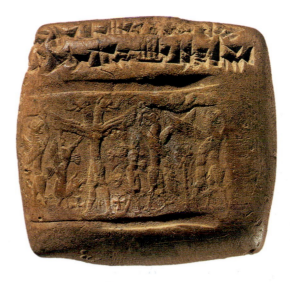

9.14 Contract impressed with seal of Eriba-Adad I, from Assur, Middle Assyrian, *c.* 1390–1364 BCE. Clay, h. 1¾ in. (4.4 cm)

Image Wars

As we have seen (pp. 122–25), assaulting and abducting the statues and monuments of a city was a strategy of war in the ancient world [9.15]. Such activities are recorded, for example, on the stele of Dadusha [8.19, see p. 193] and are known to have occurred earlier in the Early Dynastic era. Major monuments were often attacked, effaced, and stolen. Statues of the gods were taken, but these images were always carefully carried, without any harm to the statue, which was considered powerful and divine even if it was one of the gods of another land. Taking away the cult statue of the main god or goddess of a city meant that the power of the deity would be removed and chaos would ensue because the city no longer had his or her divine protection. Texts record that in times of war several cult statues might be amassed in one city so that their power would strengthen the protection of that place. The presence of the cult statues was understood as the actual presence of the gods in the city.

The best archaeologically recorded example of the ancient practice of theft of statues (and the accompanying iconoclasm of royal images) is the Elamite theft of Mesopotamian objects and their removal to Susa in the war of 1158 BCE, one of two consecutive wars that ended the rule of the Kassite kings in Babylonia. While Babylonia had held great political power for some time, after 1200 BCE Elam became a major force in the political struggles of the ancient Near East. Much of what we know about the Elamites at this time comes from building inscriptions that mention kings and letters that refer to dynastic marriages. The Elamite Shutruk-Nahunte, for example, was married to a Babylonian princess, the eldest daughter of the Kassite king Meli-Shipak (1186–1172 BCE). Despite this marriage, relations between the two lands became strained, leading to the war of 1158. Shutruk-Nahunte invaded Babylonia and brought back statues and monuments as booty, dedicating them in a temple as offerings to one of his own gods.

9.15 Scene depicting the removal of statues of the gods of war, relief of Tiglath-Pileser III, Nimrud, Iraq, c. 730 BCE. Mosul marble, h. 8 ft. 11⅛ in. (2.72 m)

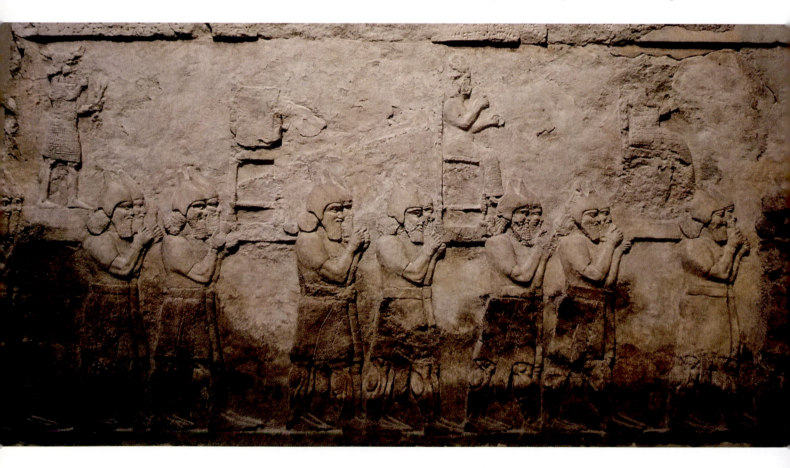

Cult Statues

The creation of a cult statue was a complicated process. Unlike other sculptures, statues of the gods were not made simply from stone or metal. Rather, they required a number of materials that were considered to have inherent qualities appropriate for their use. The body of the god or goddess was made from special wood, cut according to specific ritual requirements and accompanied by incantations. The bodies were covered in gold and had some parts of the anatomy inlaid with precious stones and additional materials. Beginning in the Old Babylonian period, we have clear evidence that the statues were put through a ritual called "the opening of the mouth." This procedure enabled the deity to enter the image. The gods manifested themselves in the cult statue; it was much more than a representation. The Akkadian word for statue or image, *salmu*, is no longer used after the consecration. Instead, the cult statue is referred to by his or her name. The temples of the gods had kitchens and breweries to provide for these gods, who needed daily meals. The statues were also bathed and provided with comfortable beds. They had musical entertainment and traveled by boat to other cities. The statues owned large wardrobes of jewelry and clothing that was regularly changed and laundered. One Old Babylonian text from the reign of the king Samsuiluna lists the belongings of the goddess Ishtar-Inanna. They include dresses and cloaks, finger rings and other jewelry, several types of ribbons for her hair, and other personal items. The statues must have been visually stunning, sumptuous

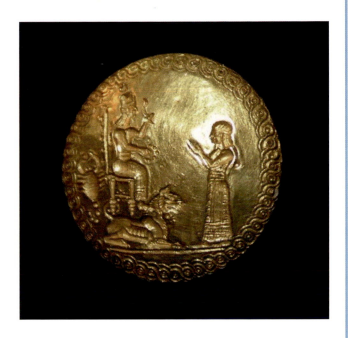

9.16 Gold stamp seal of Queen Hama, from Tomb 3 at Nimrud, Iraq. Hama was the queen of Shalmaneser IV (782–773 BCE). The scene depicts the queen worshiping in front of a cult statue of Ishtar-Ishara enthroned on a lion.

works. Because of the materials from which they were made (wood, ivory, gold and silver, inlaid with precious stones and dressed in real clothing), the majority of these statues have not survived. The only statues of gods that do survive are those of minor deities.

His inscriptions claim that he ransacked 700 cities. Numerous heavy pieces of victory steles and royal statues were carried the long distance from Babylonia to Elam. Among these works were objects that were already very ancient by the twelfth century BCE—such major works as the Codex Hammurabi [**8.1**, see p. 178], which had been standing in a public space for over six hundred years before it was taken as part of the war booty. The collection also included the famous stele of **Naramsin** [**5.9**, see p. 124], a monument that was by then more than one thousand years old and therefore already an antique even at

that time. Many of the monuments had their inscriptions partly erased and a new inscription in the Elamite language added to explain that they had been taken from the cities of Babylonia and brought to Susa. These new texts explain who had commissioned the original statue or stele, and where it was captured. After the reign of Shutruk-Nahunte, his son and successor, Kutir-Nahunte, claimed that he was the rightful heir to the throne of Babylonia because his mother was a Babylonian princess—but the Babylonians rejected his claim. He then invaded Babylonia once again in 1155 BCE, and removed the statue of the great god Marduk.

In our study of these ancient iconoclastic acts a set of questions arises: were these monuments carried about 250 miles (400 km) to Susa for their economic or aesthetic value? Were they damaged in the general violence of war? Are we to understand these as acts of religious iconoclasm, to annihilate what were seen as false gods or idols, as in the later Christian–Byzantine version of iconoclasm? The answer has to be no on all counts. This theft was an act neither against false gods nor for economic gain. Yet it was clearly no mere whim in the midst of the chaos of war. Most of the statues, steles, and monuments were large monoliths carved of heavy stones and it must have been tremendously difficult to transport them to Susa. If the reason was mere political violence and iconoclasm, the Elamites could easily have damaged them and left them in place in Babylonia. If they were taken for economic or aesthetic value, no damage would have been done to them at all. The statues of the gods were unharmed, but the royal monuments were often effaced or even smashed. The Elamite destruction and theft was a deliberate act of abduction that required these royal monuments and images to be under their control.

These acts of war reveal a great deal about the power of images in the ancient world: monuments were imbued with an ancestral power of place and history, and removing or damaging them were acts of appropriation and iconoclasm that had an impact on the person represented in the statue, and whose name was inscribed upon it. They also had an impact on the entire land. We can see this clearly in the curses that were added to the end of the original inscription on the statue, which called for the destruction of the descendants of anyone who would damage the statue or the monument. An Akkadian statue inscription includes this text:

Whosoever should deface my statue

And put his name on it and say

"It is my statue," let Enlil, the lord of this statue

and Shamash tear out his genitals and
 drain out

his semen. Let them not give him any heir.

A Babylonian omen text declares:

If the image of the king of the country
 in question

The image of his father, or the image of
 his grandfather

Falls over and breaks, or if its shape warps,
 this means

That the days if the king of that country
 will be few in number.

These are only two of hundreds of examples of these kinds of texts, giving us a clear indication that the power of the image extended to the person represented and—in the case of kings and ancestral rulers—to the entire land. The removal of the gods removed the divine protection from cities, while the destruction and abduction of ancient and royal monuments worked to annihilate the land and its identity.

In analysing these acts of iconoclasm in the ancient world, we can also consider how such fears impacted on the choices that were sometimes made in the creation of statues. The statue of the Elamite queen Napir-asu [9.17] is an excellent example of a life-size work of metallurgy from Iran with a technique that continues to astound those who study it. It is also a wonderful example of the corresponding Elamite concern with the potential theft of statues. The rare full-figure portrait of the queen is made of copper, cast in the lost-wax method over a core of solid bronze. Weighing 3760 lb (1750 kg) it is the heaviest bronze statue preserved from the ancient world. The copper outer shell was made of a single casting, and grooves at the side indicate that the entire statue was overlaid with a sheet of gold or silver to form the final surface. An inscription on the front identifies the queen and curses anyone who would seize or smash the statue or erase its inscription. The curse, as in many others of this kind, calls down the wrath of the gods and states that he who destroys the statue shall become barren, his name shall become extinct. This was considered to be an eye-for-an-eye form of punishment of the type that we have seen in the earlier laws of Hammurabi. The destruction of a statue and the erasure of its

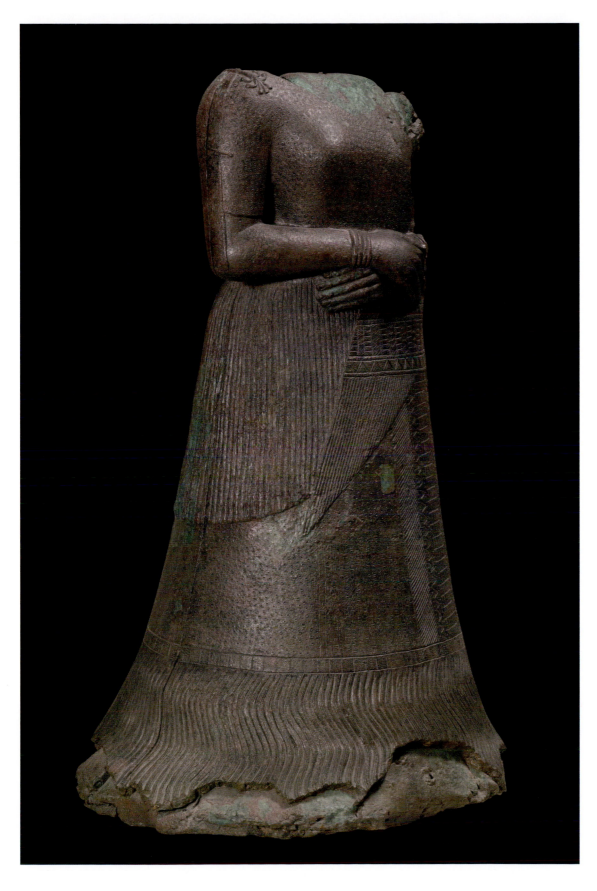

9.17 Queen Napir-asu, wife of Untash-Napirisha, from Susa, Iran, c. 1340–1300 BCE. Bronze and copper, h. 4 ft. 2 ¾ in. (1.29 m)

inscriptions were seen as equivalent to the ending of one's progeny and memory. In this particular case, the weight of the Napir-asu statue prohibited or at least challenged any possible movement from its place, while the curse at the end of the inscription was meant to act as an additional deterrent to theft and defacement. It is a further example of how the ancients considered their monuments to be tied to the place in which they were installed, where they were meant to stand well into the future.

The Travels of the Statue of Bel-Marduk

The theft of a city god was an even more dreaded act, as it resulted in chaos for the entire land. It is known most famously from the case of the cult statue of Marduk, the patron god of the city of Babylon (referred to as Bel-Marduk, or Lord Marduk). The statue was stolen several times over the centuries until its return to Babylon in 1110 BCE. Ancient texts tell us that in 1594 BCE the Hittites attacked Babylon and soon after took the image of Bel-Marduk and his consort Sarpanitum from Babylon to the land of Hatti in modern-day Turkey. The statues, however, do not seem to have made it all the way to Hatti but were left at Hana where the Kassite king Agum-Kakrime of Babylon recovered them. The gods were later stolen again by the Assyrians under Tukulti-Ninurta I, who overthrew the Kassite ruler Kashtiliash IV and took the statues to Assur in 1225 BCE. Marduk and his consort remained in Assyria until the mid-twelfth century BCE when they returned to Babylon. But the Elamite attack of 1155 BCE soon carried Marduk off to Elam, along with Nabu, the god of writing. In 1110 Nebuchadnezzar I of Babylon waged a war against Elam in order to bring the statue of Marduk back to his home.

A text called the Marduk Prophecy describes the travels of this supreme Babylonian god [**9.18**]. The god is described as living in exile in Anatolia, Assur, and Susa, and wishing to return home. We are told that it was Marduk himself who gave the order to the king to be brought back to Babylon. The king received the command through an oracle handed down after a consultation with

the god Shamash. These omens are very detailed. In addition to the making of the arrangement of the journey, there are also instructions for how the statues of the gods were to be treated and cared for while their temple was being prepared to receive them again. The gods rested on cedar thrones, and specialist craftsmen came to see to their restoration. Their clothing and jewelry were renewed and their sanctuary was prepared and purified. The return of Bel-Marduk to Babylon—to his original home city and to his temple, E-sagila—marks a turning point in the history of Babylon. Epics and hymns commemorating this event were written and Marduk rose to an ever-more prominent place in the pantheon of Babylonia.

In Kassite art, architectural sculpture in brick facades reached new levels of excellence and complexity of design, and Kassite kudurru steles turned contracts into word-image monuments. Middle Assyrian art and texts introduced new narrative forms that were to become the basis of Neo-Assyrian art and writing. Archaeological and textual information regarding practices of attacking statues and monuments in war reveals a great deal about the power of images at this time, and the importance of returning cult statues to their home cities.

At the end of the twelfth century BCE the entire region—from the Aegean Sea to the Persian Gulf, from the Mycenaean civilization to Mesopotamia and Elam—encountered a series of events (entered a **Dark Age**) that ended the Bronze Age cultures. The causes of this collapse of cultural and political systems are still a mystery. There are some indications of an invading group of marauders (referred to as the Sea Peoples), and there are some signs that climate change may have been an additional cause of populations fleeing and cultural life diminishing. These forces of disruption were strongest in the area of the eastern Mediterranean coastal cities. For about two centuries we have only few and scattered works of art and architecture until we enter the era of the empires of the first millennium BCE.

Opposite
9.18 Drawing of the seal of Marduk by Walter Andrae, 1898 CE.

The lapis lazuli seal discovered in Babylon represents Marduk and his *mushhusshu* dragon. It is much larger than a normal seal because it belonged to the cult statue. The inscription says that it was set in gold, to be worn by Marduk around his neck. The seal was dedicated by the Babylonian King Marduk-zakir-shumi (854–819 BCE). It was 7¾ in. (19.8 cm) high

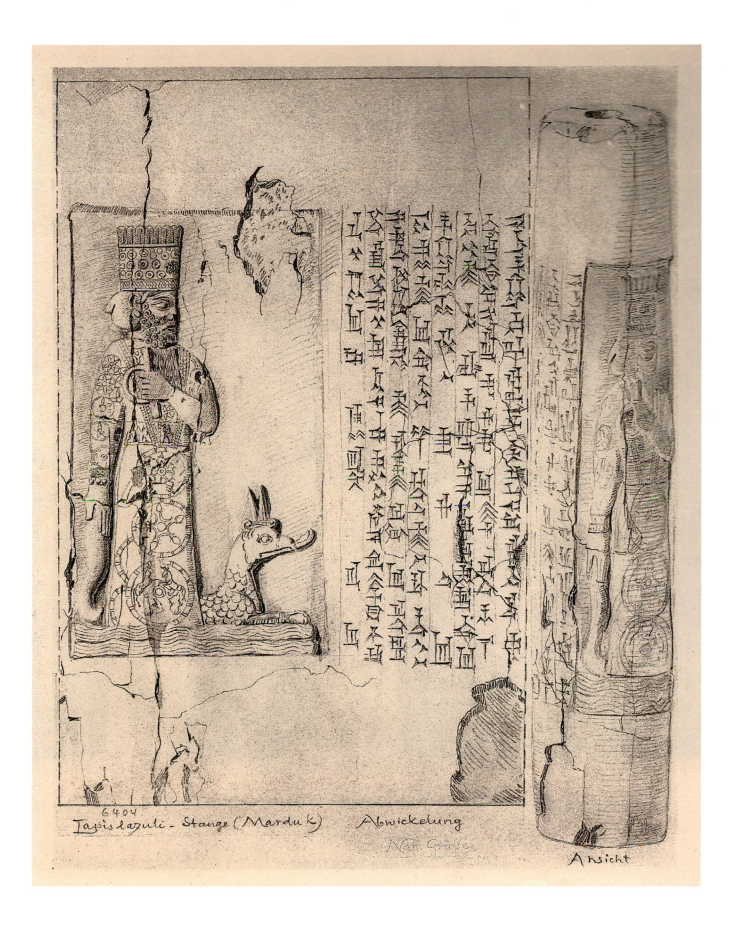

6404
Lapislazuli - Stange (Marduk) Abwickelung
 Nat. Größe

 Ansicht

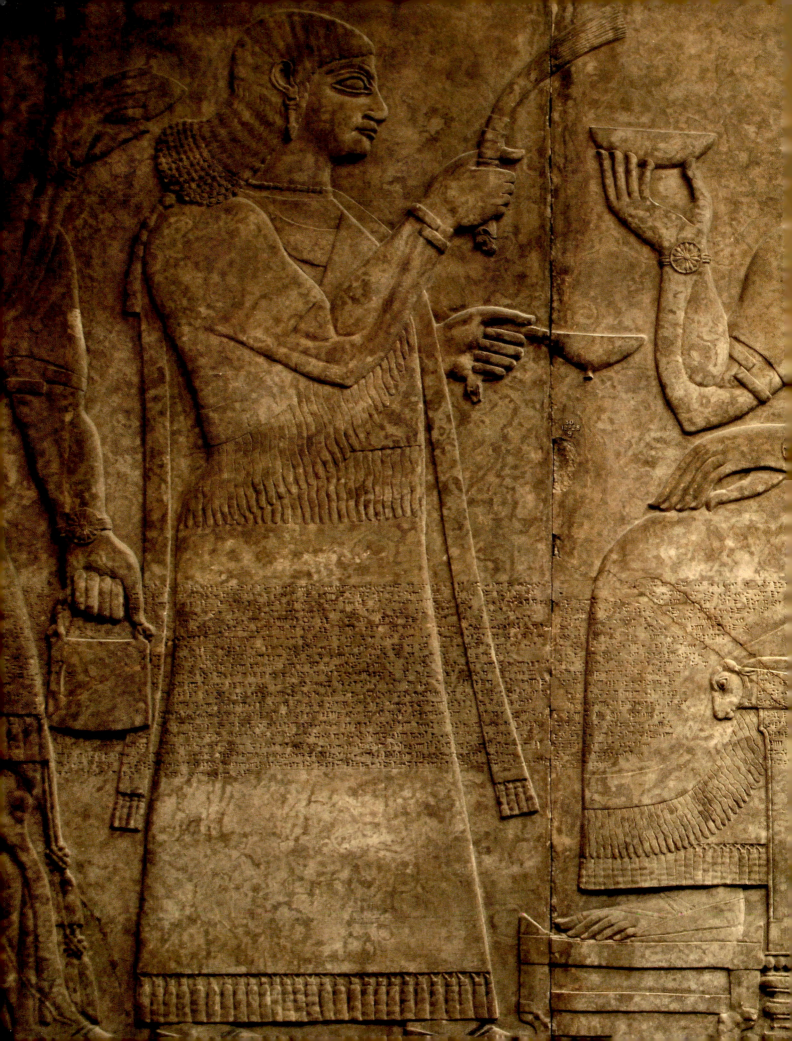

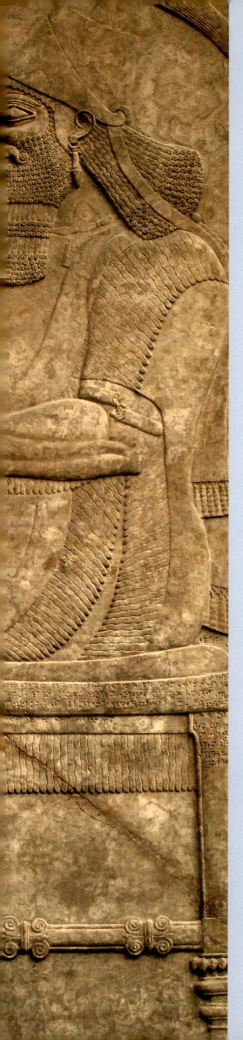

CHAPTER TEN

Assyrian Art: Narrative and Empire

Ashurnasirpal II and courtier, relief from the Northwest Palace, Nimrud, Iraq, 865 BCE. Gypsum alabaster, traces of paint

10 Assyrian Art: Narrative and Empire 900–612 BCE

Periods	Neo-Assyrian Empire c. 900–612 BCE
	Ashurnasirpal II r. 883–859 BCE
Rulers	Sargon II r. 721–705 BCE
	Sennacherib (son of Sargon II) r. 705–681 BCE
	Ashurbanipal r. 668–627 BCE
Major centers	Nimrud (ancient Kalhu); Dur Sharrukin (modern Khorsabad); and Nineveh
Notable facts and events	Assyrian empire extends from Iran to the Mediterranean Sea
	Ashurbanipal collects literature and scholarship in his vast library at Nineveh
	Battle of Til Tuba 653 BCE
	Destruction of Nineveh in 612 BCE ends the empire of Assyria
Important artworks	Palace wall reliefs
	Lamassu statues
Technical or stylistic developments in art	Large-scale continuous pictorial narratives
	Realism in art

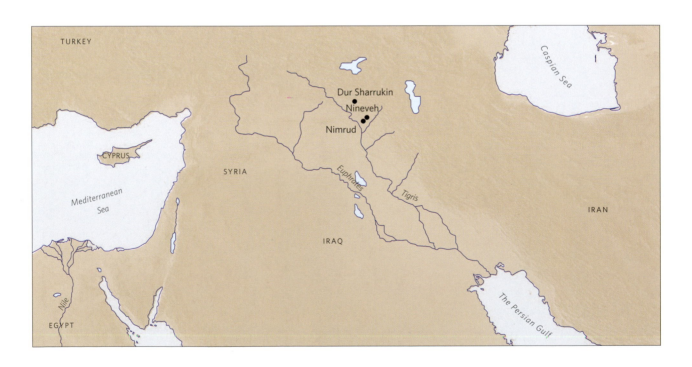

10 Assyrian Art: Narrative and Empire

Among the most impressive achievements in the history of the visual arts are those that occurred during the era of the **Neo-Assyrian** Empire in Mesopotamia (*c*. 900–612 BCE). Monumental sculptures and steles as well as small-scale decorative arts produced under the patronage of the courts of Assyria reached an unprecedented level of skill and creativity, exceptional in the ancient world. Although the work of Assyrian court artists was based on the older traditions that we have studied in the previous chapters, they now began to explore larger and more ambitious themes, deploying them within compositions that they planned at a truly grand scale. Exquisitely carved sculptures brought together the narrative and the heraldic, merging historical representations with repeating symmetrical schemes that were designed to define royal space. In particular, we can observe the development of two levels of courtly arts, the first and best-known being the massive compositions of the royal palaces with their colossal architectural sculptures and striking wall reliefs. These pictorial relief narratives—featuring minuscule detailed content within monumental and epic compositions—are in some respect paralleled by developments in forms of writing and literary compositions, particularly in detailed historical annals and their comprehensive records of imperial achievements. At the same time, imposing standing monuments, steles, obelisks, and majestic rock reliefs became increasingly common in the Assyrian heartland, and were also created and set up throughout the empire as statements of power and imperial authority. These monuments will be the subject of chapter 11, along with the second area of unprecedented artistic skill and creativity, that of the small-scale decorative arts of the royal palaces.

In the present chapter we will consider the royal sculpture from three Assyrian imperial capitals and their palaces: Nimrud (ancient Kalhu, also known as Calah in the book of Genesis); Dur Sharrukin (modern Khorsabad); and Nineveh, a place that retains its name as Nainawa/Ninua and is now encompassed within the city of Mosul. These palaces span the era *c*. 900–*c*. 600 BCE. One of the most interesting aspects of Neo-Assyrian artworks in this era is that, at both the most monumental and the smallest scale, they played with compositional devices and the materiality of stone in increasingly sophisticated ways. Although relief sculpture was already in use in Assyria and neighboring lands during the second millennium BCE, the massive building campaigns of the Assyrian kings, beginning with **Ashurnasirpal II** (r. 883–859 BCE), saw the development of a new sculptural form: the continuous relief sculptures that stretched across the extensive lengths of the palace walls. Designed as vast compositions with epic visions of the empire and its rule, they represent one of the most outstanding achievements of pictorial narrative to come down to us from antiquity.

Nimrud

Ashurnasirpal II's city at Nimrud was a new vision of a city fit for the king of the four quarters of the universe. The city had been extensively developed by Shalmaneser I on an ancient settlement going back to the sixth millennium BCE in an area that lies about 19 miles (30 km) southeast of modern-day Mosul. Reserving the traditional capital of Assur for religious rituals, Ashurnasirpal II chose Kalhu as his new administrative capital, making it the central city of Assyria. He began a major building campaign

here that took some fifteen years of continuous work. He ordered the construction of nine temples and a ziggurat, massive fortifications 4.7 miles (7.5 km) long, and several palaces, which he described as renovations for an ancient city that had fallen into ruin.

Ashurnasirpal II's choice of Kalhu—a city that had been neglected for some time—enabled him to built a new capital on ancient ground yet without having to take constant care to not disturb earlier monuments and constructions. The new city developed by his architects and engineers was approximately square-shaped, its longest side 1.25 miles (2 km) long. Built upon the earlier settlement mound, a raised citadel was placed within it, where the main palaces and temple buildings were built during the reign of Ashurnasirpal and his successor, **Shalmaneser III**. The entire walled city covered 890 acres (360 ha).

The Northwest Palace and Its Guardians

The greatest wonder of the ninth-century city was the Northwest Palace [**10.1**], the building and inauguration of which was described in great detail on a stele known as the Banquet Stele [**10.2**], where Ashurnasirpal II calls it "the joyful palace, the palace full of wisdom." Like all Assyrian palaces, the Northwest Palace was constructed of mud-brick walls and reinforced with timber framing. The walls were then covered with sculpted revetments, designed as low reliefs, their lines emphasized in varying degrees from

The Neo-Assyrian Empire

The Dark Age that followed the collapse of the Bronze Age political and economic system around 1200 BCE lasted for several centuries. All states were weakened through social upheaval and military conflict with people from outside their borders. Kings and palace elites continued to commission works of art and architecture, but productivity was far more limited. Textual sources are rare and historians have a hard time reconstructing what happened exactly. The first state to emerge from this period of confusion with some strength was Assyria. Supported by a highly militarized society, in the late tenth century BCE its kings began a policy of constant expansion from their heartland in northern Mesopotamia, and slowly they regained the territories Assyria had dominated in the Middle Assyrian period. The kings campaigned almost annually, initially leading their troops, especially to the west where they encountered a politically fragmented opposition. By the mid-ninth century they had reached the Euphrates river and great wealth began to flow into Assyria, which enabled kings to build new palaces and cities.

The creation of the empire was not a smooth path: regularly the Assyrian army had to return to areas it had defeated before, and around 800 BCE internal strife caused major setbacks. But from the middle of the eighth century, a sequence of strong and mostly long-lived rulers managed to create an empire with an unprecedented extent. Assyria not only annexed territories to its west in Syria, but also annihilated all its powerful neighbors: Babylonia in the south, Elam in the southeast, and Urartu in the north. In the middle of the seventh century Assyrian troops twice invaded Egypt, the second time capturing its religious capital, Thebes. Everywhere they seized massive amounts of booty and imposed heavy annual tribute upon the defeated populations, many of whom they deported in order to enlarge Assyria's own labor force. At its height, the empire extended from the mountains of southwest Iran to the Syrian Mediterranean coast and reached deep into southern Anatolia. It had an extensive administration to rule all these territories, which had the flexibility to adapt to local circumstances, and it made serious efforts to pacify the regions in order to benefit from most of their assets. Opposition to Assyria was always strong, however: there were many rebellions and attempts to gain independence. The end of the empire came relatively fast, seemingly as a result both of internal power struggles at court and of the wish of subject peoples for independence. In 612 BCE the imperial capital, Nineveh, fell at the hands of Babylonian troops and people from the Zagros Mountains. Although resistance to the new Babylonian rulers remained strong for several years, by 605 BCE all traces of the Assyrian Empire had vanished and Babylonia had superseded it.

1 Throne room facade

2 Throne room

3 Throne

4 Reception suite

5 Paved courtyard

6 Ceremonial complex

7 Residential area

N

0 100 ft.

0 30 m

Left
10.1 Plan of the state apartments, Northwest Palace, Nimrud, Iraq. 879–865 BCE

Below
10.2 Banquet stele of Ashurnasirpal II, Northwest Palace, Nimrud, Iraq, 865 BCE. Stone

incised to deeply cut. Many of the friezes were also topped by an upper level of fresco painting, but these are mostly lost to us now. The stone revetments consisted of thick slabs of gypseous alabaster, a local stone known as Mosul marble. The high citadel walls could be seen from far away, each of its monumental gates guarded by enormous human-headed, winged bulls and lions (see pp. 228–31).

This excerpt from one of the palace inscriptions tells us about the new city and the Northwest Palace:

> The ancient city Kalhu, which Shalmaneser, king of Assyria, a prince who preceded me, had built—that city had become dilapidated; it lay dormant. I rebuilt that city … I cleared away the old ruin hill and dug down to water level. I sank (the foundation pit) down to a depth of 120 layers of brick. I founded therein a palace of cedar, cypress, dapranu-juniper, box-wood, meskannu-wood, terebinth, and tamarisk as my royal residence for my lordly leisure for eternity. I made beasts of the mountains and seas in white limestone and parutu-alabaster, stationed them at its doors.

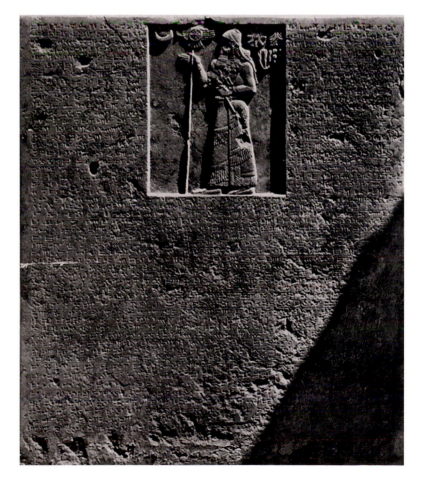

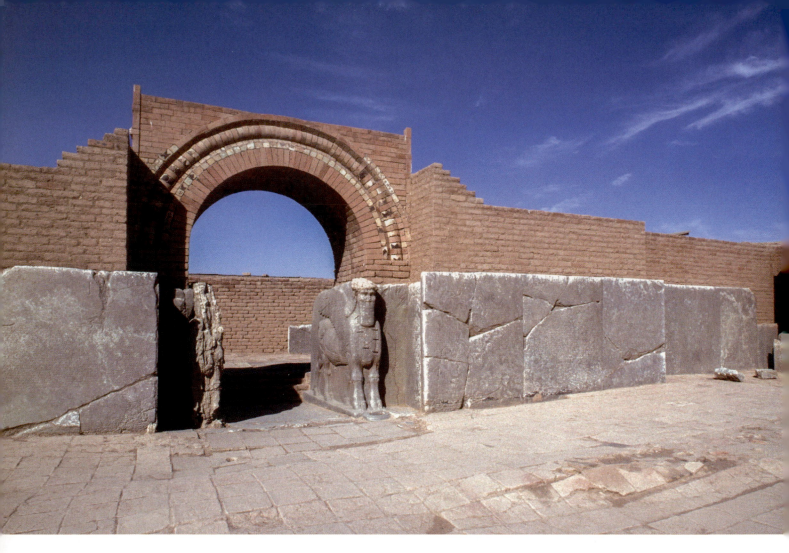

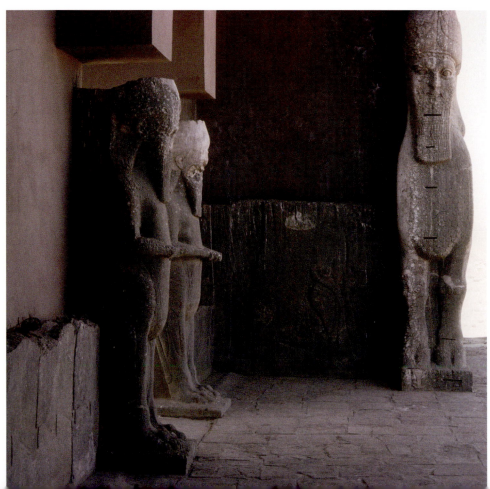

Above
10.3a *Lamassu* guardians at arched portals, Nimrud, Iraq, 865 BCE. Gypseous alabaster, with inscribed alabaster slabs to the left and right.

Below
10.3b Human-headed lion colossi at left, and a human-headed winged bull (right), portal guardians at the Northwest Palace, Nimrud, Iraq, 865 BCE. Gypseous alabaster

Opposite above
10.3c Colossal winged, human-headed bulls and lions leading into the state apartments, Northwest Palace, Nimrud, Iraq, 865 BCE. Gypseous alabaster

Opposite below
10.3d Wall reliefs with king holding a bow at the center, flanked by winged genies and bird-headed *apkallus*, in situ at Northwest Palace, Nimrud, Iraq, 865 BCE. Gypsum alabaster

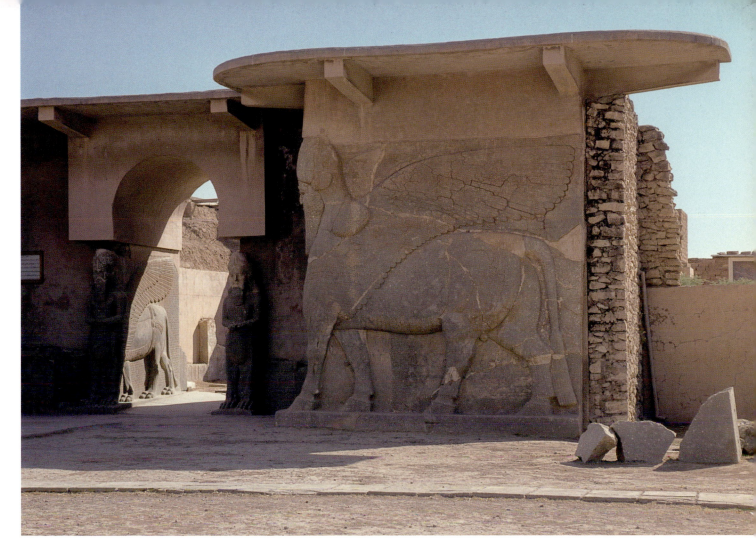

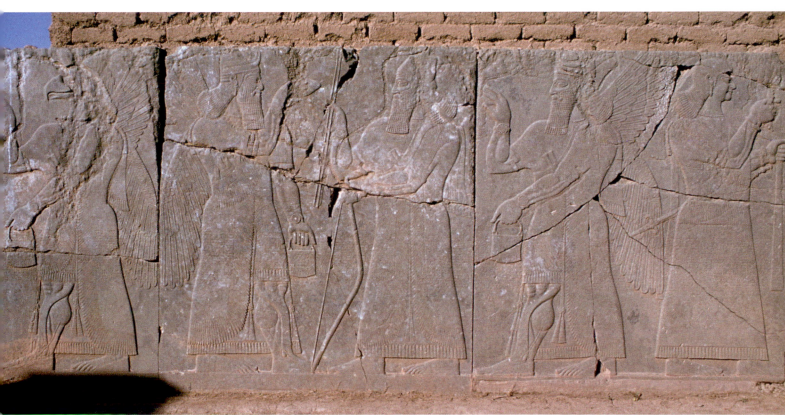

A visitor entered the Northwest Palace through a large courtyard. A long wall carved with large figures of tribute bearers stretched along the south side [**10.4**]. These tribute bearers must have seemed to participate in the procession of actual visitors, mirroring their approach into the palace and drawing the visitors in with them. Three portals here permitted entrance into the grand throne room. Each great portal was guarded by two colossal winged creatures with human heads and the bodies of bulls or lions. These are known in Akkadian as the **shedu** and the **lamassu**, the apotropaic magical beasts that guard the palace [**10.5**].

These mythical guardians of the gates are monumental works that can be categorized neither as independent sculptures nor as purely architectural elements. They are not sculpted fully in the round, but they cannot be described as relief sculptures. They are in between genres of stone carving, just as they are beasts that are hybrid creatures. Their bodies are either of a bull or of a lion, with clawed feline paws or the hooves of a bovine animal. The wings are of a large bird of prey, such as an eagle. The anthropomorphic masculine heads wear horned crowns indicating their divine nature. They wear their hair and beards in thick luxurious curls, depicted in

10.4 Tribute-bearer procession, court D, Northwest Palace, Nimrud, Iraq, 865 BCE. Gypsum alabaster

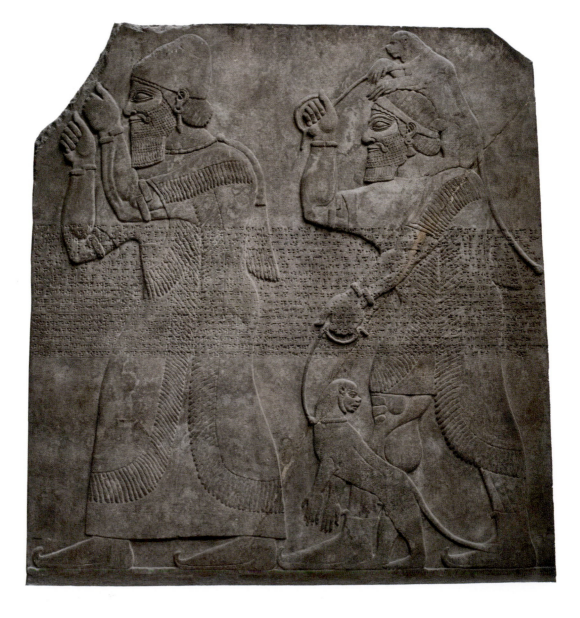

orderly patterns. At the waist of some of these creatures we see a belt, which is tied with tasseled ends. This is the belt that is associated with the nude hero of ancient iconography, echoing the cylinder seal art of the third millennium BCE; it is depicted here to add to the heroic nature of these creatures. They are carved with great naturalistic attention to the powerful muscles and sinews of the legs and hindquarters, while the wings and the hair are ordered into neat rows of feathers and curls. The lamassu guardians at Nimrud, which stand facing forward, are carved with five legs.

As the visitor approaches the portal the lamassu appears to be standing sentry at the gate, legs together in front of him. But as the viewer walks into the portal, the lamassu viewed from the side appears to be in a striding position. With four legs presented in a state of movement, as if on the prowl for enemies, these supernatural guardians pace back and forth at the palace gates.

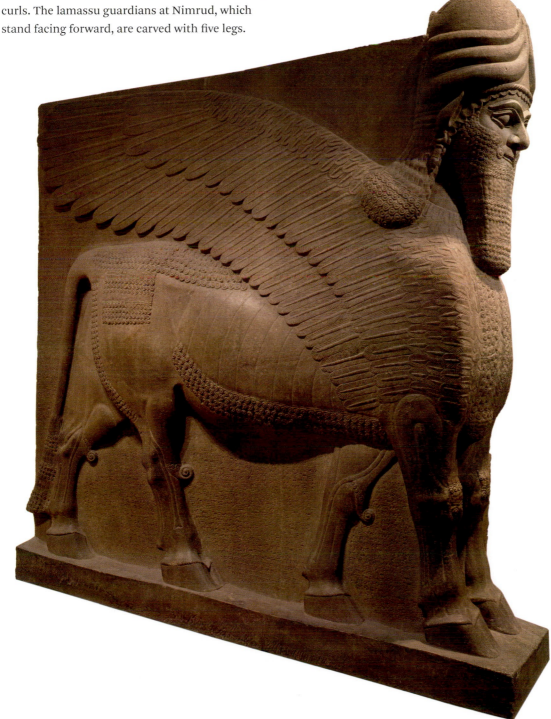

10.5 Human-headed winged bull (*lamassu*), portal sculpture from Nimrud, Iraq, *c.* 883–859 BCE. Gypsum alabaster, h. 10 ft. 3½ in. (3.14 m)

Wall Reliefs

The sculptures of Nimrud are works that are essentially architectural in that they are linked to the structural and spatial aspects of the palace. This is especially clear in the wall reliefs. Their creation required a leading artist to be in charge of the project, and a large team of sculptors and architects working with him. The texts that describe the building campaign and the inauguration of the palace mention the various specialists involved in the project. There were architects and sculptors, but also diviners, magicians, and priests. The magicians and priests ensured that magical figures were carved at locations where they would offer the best protection. The placement and compositions were first decided at the largest scale. Then the slabs were put in place and the scenes were sketched out or incised by a master sculptor. We can see that several different sculptors were in charge of various places within the palace because of the slightly differing styles of carving that were used. In some cases, for example, the same iconographic types and figures are carved with thicker or thinner forms. Several teams of sculptors working under the supervision of the head artists then came in to carve the large expanses of the walls. They used chisels for the main carving and then finer tools to incise and to smooth out the details in the stone. The creation of the palace was such an important event that when the building was completed the inauguration festivities lasted ten days and 69,574 people—men and women from all over the region as far as Tyre and Sidon on the Mediterranean Sea and the land of Hatti (in what is now modern-day Turkey)—were invited as guests to the banquet.

War and Hunting Scenes Two compositional types of relief sculpture covered the palace walls. Some were long narratives friezes of war or of hunting, while others consisted of the courtly heraldic scenes depicting rituals or providing the palace with the divine protection of winged genies. The subject matter of the narrative panels included the imperial wars, depicted in detail: focusing on the experiences of the soldiers in the tumult of battle, the ordinary or mundane aspects of camp life, as well as the brutalities and violence of warfare. These scenes were placed on horizontal slabs in a continuous composition. Even as we view them out of context today within the museum galleries, we observe that a sense of forward narrative movement leads the eye of the viewer across the stretch of the palace wall, from one panel to the next. In these scenes of battle, we see that the king is powerful, but he is not divine or superhuman. He is depicted at the same scale as the soldiers in his army and the courtiers in his court. He is one among the men. In fact, we can barely make him out in the scenes. Only his headdress permits us to find him in the clamour of the battle. We see him drawing his bow while the god Assur watches over him and his army.

The pictorial epics of military might covering the walls narrated the glories of imperial power—but they were placed in the inner spaces of the palace. They were not for the consumption of the general public, but for the viewing pleasure of the king and his courtiers. The reliefs that narrated the glories of imperial power and the pastimes of the king, such as lion hunting, were placed in the innermost areas of the throne room where few visitors would have been permitted entrance. These detailed illustrations of military campaigns or the royal hunts are two distinctive genres of Assyrian art, and the iconography of kingship comes to be adopted as a standard imperial iconography in later eras also. Yet here at Nimrud, the narratives were visible only to those who entered the audience chambers.

Inside the throne room of Ashurnasirpal II, the 125 ft. (40 m) long chamber was lined with sculptures carved in relief. In both the war and hunting scenes, dramatic and dynamic epic narratives are presented in minute detail and run continuously across wall panels. In some places a vignette stops the eye of the viewer. We pause and observe a detailed scene: an encampment of soldiers or a sacred rite after the hunt. These scenes act as rhythmic points of observation within the continuous compositions. Whereas earlier in Mesopotamian art, narrative scenes are summarized into iconographic types

or moments depicting sacred rites or forms of kingship, here we see an ever-increasing interest in the depiction of realistic elements at the smallest scale within the large compositions.

The palace sculptures also made extensive use of written texts, a fact that permits us to date the works with precision. The cuneiform text in Ashurnasirpal II's palace was placed in between the narratives and incorporated into the relief surfaces also; scribes had to work closely with sculptors in order to lay out the panels composed of texts and images. Neo-Assyrian art is thus not only a stylistic genre but also a historical category, in that the works that we study are, for the most part, tied to royal inscriptions that permit us to date them to the regnal years of specific kings.

Courtly Scenes While the war reliefs are perhaps the best known of the Assyrian sculptures today, a large part of the palace reliefs in fact depicted religious and courtly scenes. The king and his attendants are surrounded by winged genies or bird-headed anthropomorphic beings who participate in the sacred rites and the courtly life of the city. The supernatural realm was brought into the palace; it surrounded the king and his courtiers in order to protect them from evil and illness.

The audience chamber, a long throne room of Ashurnasirpal II (where he received state visits), was covered in relief sculpture. A large stone panel above the throne where he sat was sculpted with an enigmatic scene. This carved relief, made as part of the wall revetment for this room, depicts a stylized tree [**10.6**]. The king is shown twice, standing both on the left side and the right side of this tree. The double king who faces the tree wears the royal regalia and carries the scepter in both images. The tree is a palm, not native to the north but to the south of Mesopotamia. Flowing streams of water surround the tree, interlacing their flowing patterns with small **palmette** branches that emerge from the sides. The king appears to perform a ritual act. Behind him, two winged genies flank the scene. The floating winged disc above the scene is one of the gods of the Assyrian pantheon. Strong symmetry is the basis of this composition. At first glance the image gives the impression of being a mirror image, but it is not. The left and the right side of the relief

10.6 Ashurnasirpal II and sacred tree, wall panel 23 from the Throne Room, Northwest Palace, Nimrud, Iraq, c. 865 BCE. Gypsum, h. 6 ft. 4¾ in. (1.95 m)

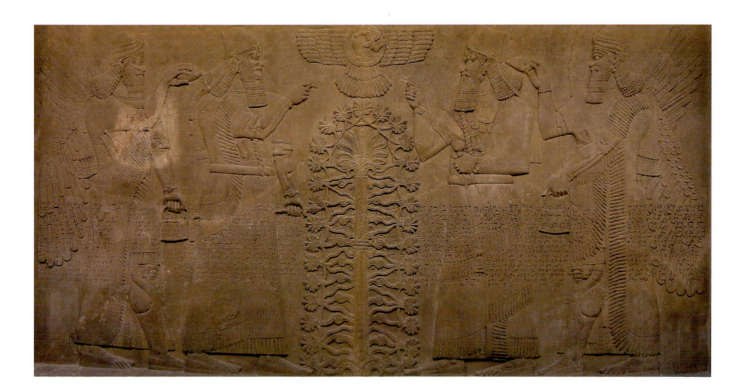

10.7 Kneeling genies and sacred tree, with bird-headed *apkallu* standing below, relief panel from Nimrud, Iraq, *c.* 883–859 BCE. Gypsum alabaster, h. 7 ft. 6½ in. (2.3 m)

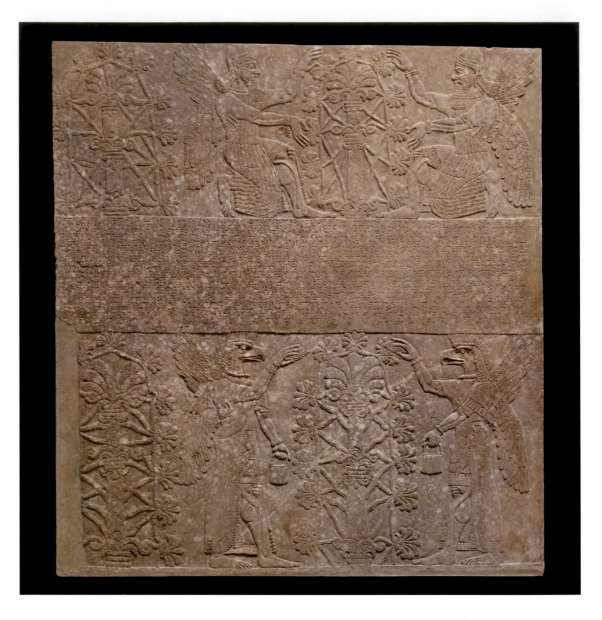

differ from each other in some of the details of dress and the position of the king's left hand. A similar panel, repeating this composition, was placed above the central door into the audience chamber. These kinds of deliberate repetitions of images—duplicates with subtle differences—were a means of underscoring the power of images in the palace by compounding their presence.

The greatest extent of the palace walls was lined with reliefs of stylized trees and winged genies, some with the heads of birds and others with human features and horned crowns [**10.7**]. These symmetrical groupings were placed in multiples, varying slightly from one panel to the next, and placed in repeated rhythmic patterns across the walls. The sacred trees may indicate the tree of abundance and the tree of riches known in Akkadian texts as *ish rashe* and *ish mashre*. The genies hold ritual buckets (*banduddu*) and cones used as a purifier (*mullilu*). They participate in a ritual blessing that protects the palace and its inhabitants. The apkallu wear short kilts that allow us to see their massive and powerful musculature, emphasized by linear cutting of the relief [**10.8**]. These groupings echo the position of the king's panel above the throne. The genies were a means of protecting the palace and the king in supernatural ways.

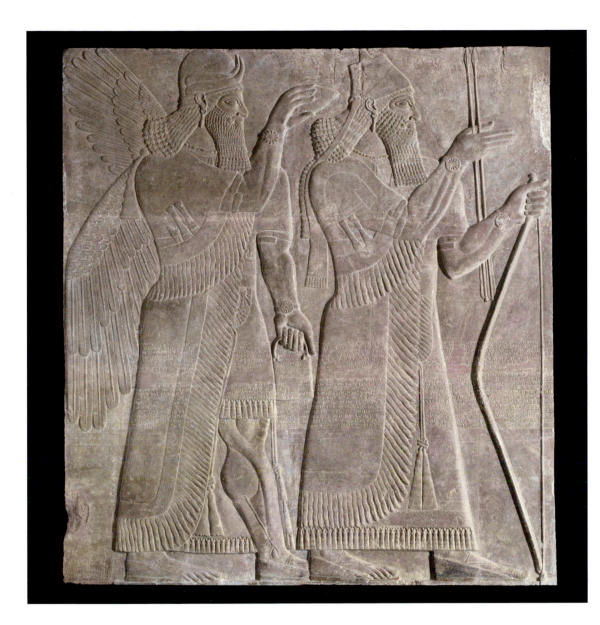

10.8 King and genie, relief panel from Northwest Palace, Nimrud, Iraq, 883–859 BCE. Gypsum alabaster, h. 93 in. (2.36 m)

10.9 Griffin demon sages (*apkallu*), from a group of seven clay figures found in a brick box buried in the foundations of the royal palace of Adad Nirari III at Nimrud, Iraq, 810–783 BCE. Each one is 4¾ in. (11.9 cm) high

Other forms of magically protective images were utilized within the palace. The apotropaic figures of genies that are repeated with the tree across the palace walls were also made as figurines in the round, molded out of clay and placed in the foundations under the floors of the building. Yet such figures were not limited to royal use but were employed in private contexts also, as Assyrian texts tells us that they should be placed beneath the floors of houses to protect against evil spirits. These types of foundation figurines, similar in iconography to the palace reliefs, were also found in the excavations of other Assyrian palaces [**10.9**]. These genies and demons flanking

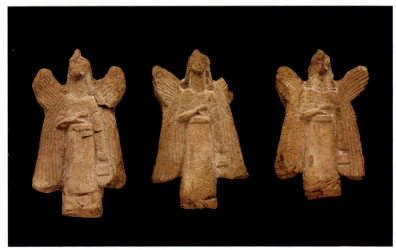

sacred trees also appear in the minute detail of the incised robes in the Northwest Palace reliefs; not visible at first glance to the casual viewer, they were intended to provide multiple dimensions of protection for the palace and the king.

In the magical and courtly scenes, the inscription was often carved directly over the relief panels, cutting across the center of the marble slabs through the figures of the king, genies, and trees. The inscriptions repeat the same account of the various accomplishments of the king, culminating in his building of this palace at Nimrud. This text, known to historians as the Standard Inscription, was written in a beautifully carved display script by sculptors who knew how to read and write. It was thought out as an integral part of the composition from the start: the positioning of the text had to be planned in connection with the size of each panel, so that it would fit neatly and precisely within the overall design of the reliefs.

The sculptural programme of Ashurnasirpal II's Northwest Palace at Nimrud was a design conceived at the largest scale. It was a remarkable innovation in terms of the extent of narrative composition, the depiction of action-filled battles and hunts, and the stately scenes of the king and courtiers protected by the supernatural realm. These narrative compositions and iconographies

were taken up by later kings and even influenced the royal arts of other dynasties that were to follow, but in Assyria itself some significant changes were to take place by the end of the eighth century.

Dur Sharrukin

In 710 BCE King **Sargon II** (r. 721–705 BCE) removed the capital to a new location at Khorsabad, 12 miles (19 km) northeast of the modern city of Mosul [**10.10**]. He called it Dur Sharrukin (Fortress of Sargon). It was constructed as a heavily defended square citadel. The detailed texts from this era record that King Sargon II was directly involved in the design of his new city. He seems to have kept track of the orders for the building materials and the workers' contracts. All the magnificent public buildings and fortifications of Dur Sharrukin were built in a very short time, yet it was a short-lived city regardless of all its splendor. When Sargon died during a military campaign, his city was abandoned, perhaps because of the ill luck associated with its founding monarch. **Sennacherib**, his successor, then moved the capital to the fabled city of Nineveh, where it would remain until the fall of the Assyrian Empire in 612 BCE.

The main change we can observe in the palace sculpture at Dur Sharrukin is a turn to greater

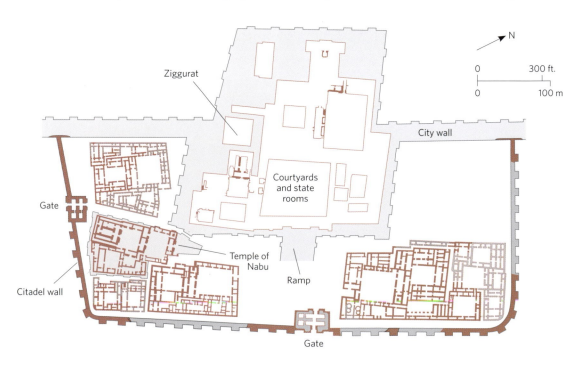

10.10 Plan of the palace citadel, Dur Sharrukin (modern Khorsabad), Iraq, 710 BCE. The palace stood within the new walled city named "Fortress of Sargon," a square fortification of 1.16 sq. miles (300 ha), with 66-feet-thick (20 m) walls.

Ziggurat

City wall

Courtyards and state rooms

Gate

Temple of Nabu

Ramp

Citadel wall

Gate

N

0 — 300 ft.
0 — 100 m

monumentality. Larger representations of the king and court were used, and scenes covered the entire expanse of the wall. The apotropaic magical figures and gate guardians reached their most colossal form. Many of the palace reliefs consisted of massive figures, some of them more than 15 ft. (4.55 m) high. Processions and courtly scenes, as well as the heroic and magical beasts, all came together to great effect by means of their sheer scale, powerful musculature, and the frontal outward stares that directly engaged visitors passing through the palace. This is especially notable in the colossal winged lamassu figures that turn to face the viewer with their direct gaze. Near the lamassu, the massive long-haired hero holding a lion seems to look down upon the viewer [**10.11**]. His head—carved almost in the round, at a deeper level of relief from the body—permits this downward glance from his enormous height.

While the narrative reliefs of Ashurnasirpal II's palace at Nimrud present a self-contained world that we can observe as viewers outside the scenes, in Dur Sharrukin the colossal sculptures have distinct front and side views, unlike their counterparts from Nimrud; they interact more directly with the viewer by turning their heads in a frontal direction to face the passerby. We have seen some of this interaction with the spectator in the Nimrud lamassu portal sculptures that seem to move as one enters the gate. Here at Dur Sharrukin, the figures turning their heads toward the viewer cast their apotropaic gaze upon us in a unyielding, direct way. Both in scale and composition within the wall panels, Sargon II's sculptures differ from those of Nimrud, even though the themes and stylistic forms are similar. As at Nimrud, all the colossal figures at Dur Sharrukin are given fine engraved ornamental details in the clothing and jewelry. The figures have squared outlines, as if

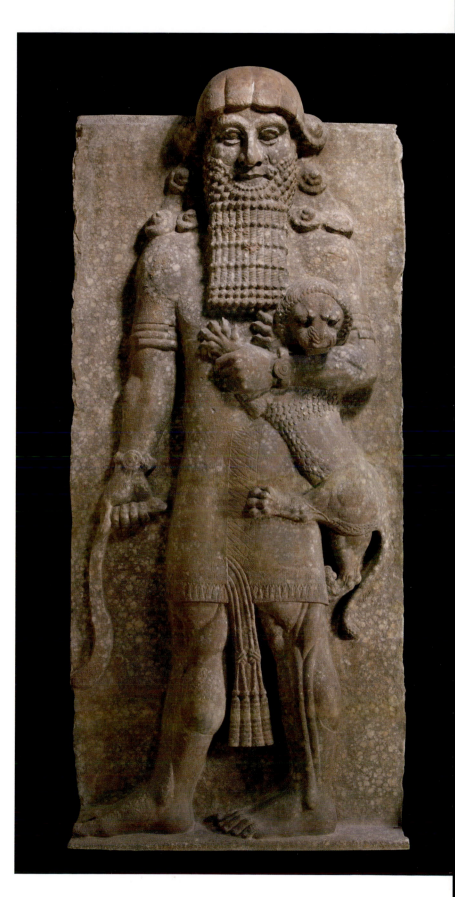

10.11 Hero holding a lion, from Dur Sharrukin, Iraq, 721–705 BCE. Gypseous alabaster, h. 15 ft. 5 in. (4.7 m)

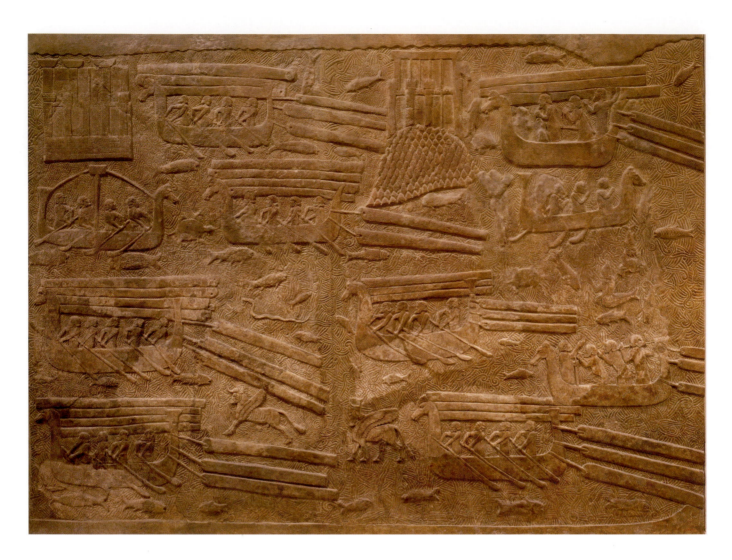

10.12 Relief depicting the transportation of timber, from Dur Sharrukin, Iraq, c. 710 BCE. Alabaster, h. 9 ft. 11¾ in. (3.03 m)

the sculptor wanted to give them a more block-like appearance, preserving the fact that they are carved from huge monoliths. Rather than hiding the stone with deeply rounded modeling and realistic carving techniques, he seems to display the qualities of the block in the overall design, especially in the colossal apotropaic figures.

Some narrative reliefs depict how the massive stone lamassu statues came to the city. There is a lively scene with ships carrying materials for the construction of the palace. The methods of building and the transport of stone from quarries or timber for the construction is recorded on the reliefs. Another maritime scene depicts a fleet of ships on the Phoenician coast [10.12]. They supervise the transport of timber logs while the winged bulls and lamassu float in the water next to them, overseeing the transport and arriving at the

palace of their own accord. The entire background of the relief is covered with a pattern of swirling water, leaving no space uncarved. We see the scene as outside observers, reading the details of a story that is narrated to us, a technique of exact and detailed depiction that is used in pictorial narrative accounts to convey a sense of realism and accuracy. The court scenes of Sargon II's palace were carved in a different way, with larger uncrowded compositions presented in profile views. These finely executed images of state are distinctive of his reign. They exploit the potential of the large-scale stone surface in an entirely different way from those of Nimrud. Rather than stressing the continuous linear narratives laid out in horizontal stretches across the palace, or the symmetrical play of heraldic groupings in Ashurnasirpal II's palace, Sargon II's sculptors

stressed royal might as a fact in itself, present in the existence of courtly life.

The emphasis at Dur Sharrukin was on royal power and authority. Narratives of the king's feast or prowess are less important here than the stately processions of tribute bearers. They represent courtly ceremonies rather than specific historical events. This emphasis on power and court life includes the image of the sovereign himself placed within the scenes of palace life. A royal portrait depicting King Sargon II and the crown prince, Sennacherib, standing before him serves as an example of this non-narrative approach to royal images at Dur Sharrukin [10.13]. The king wears the royal crown, earring, and bracelets, and carries the royal mace ending in

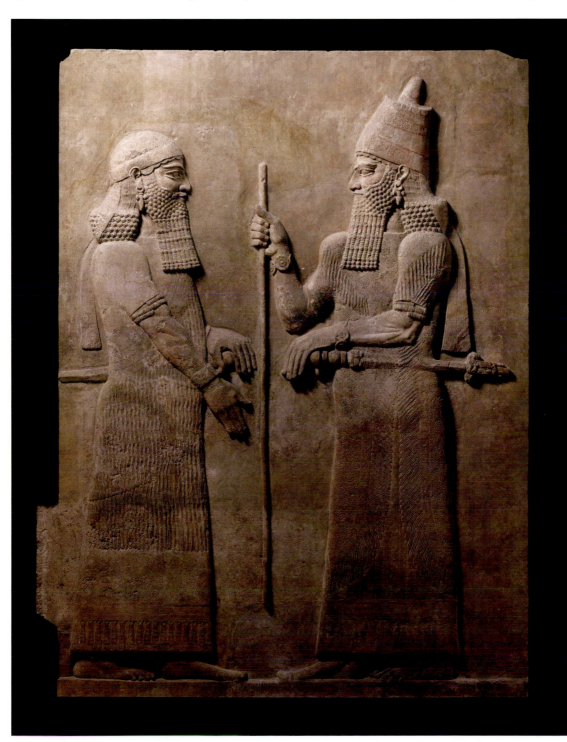

10.13 Sargon II and Sennacherib, Dur Sharrukin, 710 BCE. Alabaster, h. 9 ft. 11¼ in. (3.03 m)

lion **protomes** (terminals) at his waist. The prince is equally elaborately dressed, but wears a diadem instead of a crown. The figures are carved with a strong, deeply cut outline, with lighter internal incisions to indicate the details of dress and the well-groomed curls of their thick beards and hair. Traces of the original paint can still be seen on the crown and clothing. As in the other reliefs at Dur Sharrukin, the scale is larger than those of Nimrud. The full height of the stone slab is used for the figures, but the king and prince are silhouetted against an undecorated background, and thus seem to be close to the space of the viewer. The royal figures, which stand well over 10 ft. (3.3 m) in height, are carved with their feet protruding from the edge of the ground line: they thus break out of the space of the image and into that of the spectator. This subtle detail of carving added by the sculptor is a kind of blurring of the boundary between narrative representations that relate events—such as those of the transport of timber or scenes of war or hunt—and the older tradition of substitute image in which the king and the prince are a real and tangible presence

10.14 Pencil drawing depicting a relief with a colossal *lamassu* being cut in a quarry and dragged on a sledge to Sennacherib's palace, Nineveh, Iraq. From a bound set of original drawings made at the time of the nineteenth-century discoveries in Assyria. Many of these drawings were used by Austen Henry Layard in his publications of the 1840s and 1850s.

in the space of the palace. The effect is one of the timeless power of kingship standing before us.

Nineveh

When Sargon II died in a military campaign in 705 BCE, his grandiose city was abandoned. Sennacherib (r. 705–681 BCE), his son, moved the administrative capital to Nineveh. This legendary place was celebrated as an exalted city, full of wisdom and protected by the goddess Ishtar, whose temple there already existed in the reign of King Manishtushu of Akkad (r. 2269–2255 BCE). Nineveh is mentioned in the Bible: in the book of Jonah it is described as "the great city" and in Genesis it is named as the city founded by Nimrod, son of Noah, after the great flood. It was certainly a great city in the Neo-Assyrian period, covering an extensive site measuring 620 acres (750 ha) surrounded by massive crenellated double walls over 7.5 miles (12 km) long. Fifteen monumental gates provided access into the city. Although it was not a new site, having been settled continuously from the prehistoric era, an ambitious building

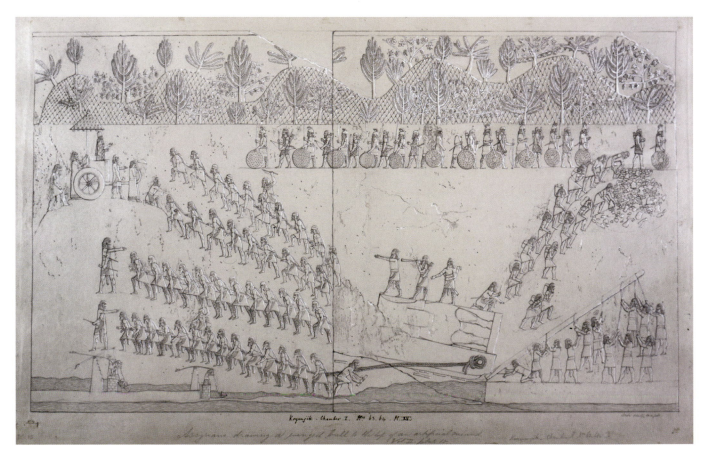

campaign in the lower city under Sennacherib and his successors raised palaces on two high citadel mounds [**10.14**]. The new palaces were lined with sculpture recording Assyrian military campaigns. According to texts and images, Sennacherib's palace had large columns, each of which stood on the back of a base made in the form of a striding bronze lion. The later North Palace of **Ashurbanipal** (r. 668–631 BCE), built *c.* 645 BCE, was covered with splendid relief sculpture, which are among the greatest achievements of Assyrian art. Here in the lion hunt scenes of Nineveh the sculptors transformed an ancient iconographic theme into superbly realistic art. Reliefs depicted military campaigns with an almost ethnographic attention to correct detail. Artists traveling with the army observed the clothing of foreign peoples and the landscapes of conquered lands. The detailed accounts of warfare we read in the historical annals of Assyria were thus often conveyed in an equally detailed pictorial form in the palace reliefs.

In Nimrud and even in Dur Sharrukin the realm of the supernatural upholds the power of the king and protects the palace. At Dur Sharrukin the mighty lamassu and colossal heroes guarded the royal sphere. In Nimrud the symmetrical units of genies and tree unfolded in swathes across the palace walls. By the time of Sennacherib and Ashurbanipal's palace reliefs, we see a turn to the realistic. The minutiae of details increase here, imparting a greater sense of truth, as if these were documentary scenes faithfully recording events as they took place during the campaigns for the empire. Armies in battle, war engines, scenes of physical torture, and the deportation of conquered populations are all vividly portrayed in graphic detail and with a great variety of observation. The place of the gods diminishes in these narrative scenes. Even the king's place is relatively minor. The subject is not the king but the empire, and the relentless power of its military force. Since these reliefs were designed as large-scale compositions, it is difficult to appreciate the entire work outside of its original architectural and spatial context. We can only look at images as highlights of these complex narratives. The reliefs

illustrate the power of the empire surrounding the king, as they did in the earlier palaces, but the disposition of figures in space at Nineveh is new. Here they are strewn across the surface, seen from a bird's-eye view, a position well outside and above the scene.

Sennacherib at Lachish

One series of reliefs in Sennacherib's palace depicted the capitulation of the ancient city of Lachish, now in Israel. The large surfaces of marble were covered completely with the crowded and anxious drama of war. The background of the stone relief was entirely filled in with landscape motifs, which indicated the distinctive conquered landscape. Vines and olive trees sprout out of a craggy terrain of rocks and hills. The scale pattern that forms the textured background of the scene evokes the setting, giving the viewer the sense of an actual historical event rather than a generic victory or capitulation. We see King Sennacherib seated upon an elaborate throne made of ivory, its sides carved with rows of **caryatid** figures that hold up the seat of authority. Dressed in his richly embroidered royal attire and crown, he receives the commanders of the Assyrian army, who bring him the war booty [**10.15a**, p. 242]. Before Sennacherib we see also the Israelite prisoners, who bow down and pay homage to the king of Assyria. The distribution of the figures surrounding the king, and even the tilt of the landscape, allows the scene to be taken in at once by the viewer. Yet the differences between levels, foreground, and background are indicated in subtle ways. The king's throne and tent are set up on a small spur of the hill, its curved outline sketched out under the throne and the feet of the king's officers, while the grooms and horses below appear closer to the foreground. The reliefs are carved with great attention to the naturalistic portrayal of the anatomy of people and animals. All figures are modeled with rounded forms, giving them a sense of three-dimensionality, and incised with sharp and crisp outlines and internal details. The figures are shown in perspectival profile views, with the far shoulder and arm receding into the pictorial space. The use of this visual device

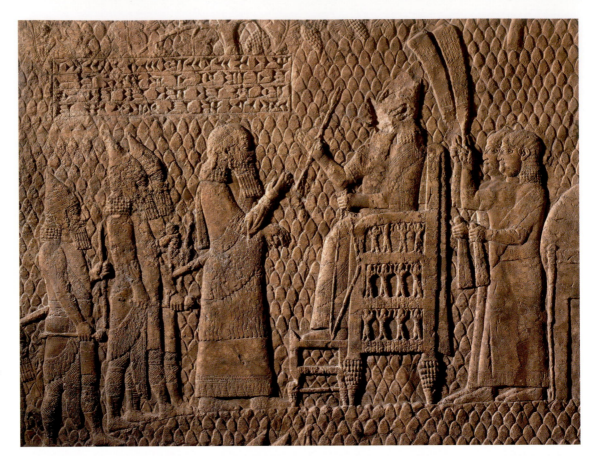

Right
10.15a Sennacherib receives the booty of Lachish, detail from wall panel 12, room XXXVI, Southwest palace, Nineveh, Iraq, 700–692 BCE. Gypsum alabaster, full panel: h. 8 ft. 2⅞ in. (2.51 m)

Below
10.15b The battle of Lachish, detail from wall panel 7, room XXXVI, Southwest palace, Nineveh, Iraq, 700–692 BCE. Gypsum alabaster, full panel: h. 5 ft. 6⅛ in. (1.68 m)

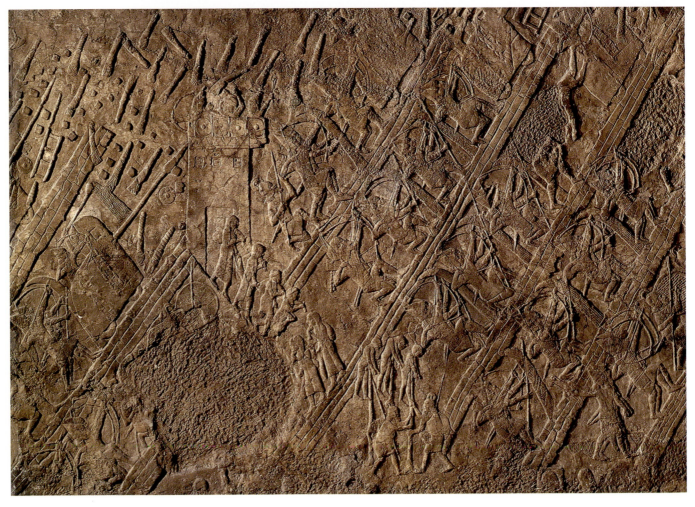

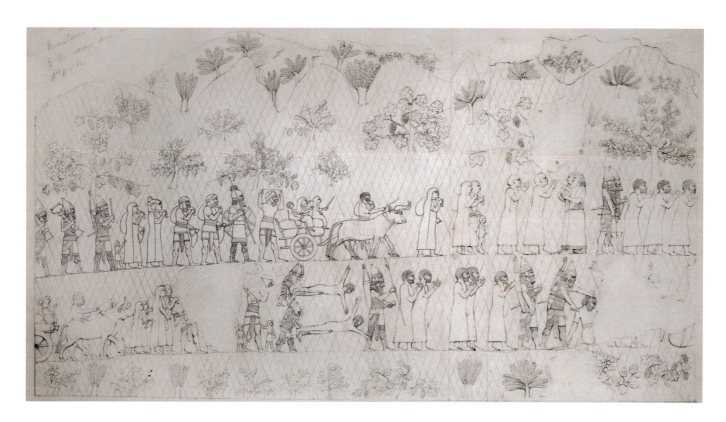

is a practice we have already seen in the Nimrud reliefs (p. 235).

Another segment of this narrative cycle shows the battle of Lachish itself [**10.15b**]. Archers and battering rams attack the city, depicted in repeated diagonal rows of soldiers. The repetition is used to great effect to give a sense of the relentless attack that caused the collapse of the enemy. After this scene, the deported Israelite population is shown: men, women, and children are all traveling on foot or in wagons, carrying some of their belongings as they are forced into exile [**10.15c**]. There seems to be little interest in the depiction of background or foreground in these compositions. All the scenes are distributed across the surface with little regard

Right **10.15d** Detail from wall panel 11: an Assyrian soldier executes a prisoner, room XXXVI (OO), Southwest palace, Nineveh, 700–692 BCE. Gypsum, h. 8 ft. 5⅛ in. (2.57 m)

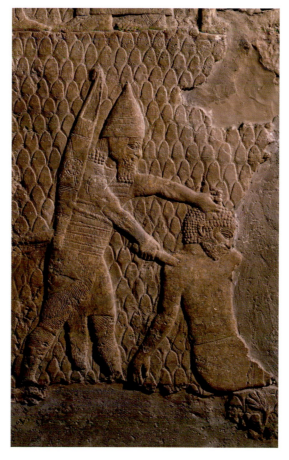

Above
10.15c Drawing by Austen Henry Layard depicting a row of deported people—men, women, and children—their wagons and their goods form a procession. Behind, Assyrian soldiers carry spoils of war. Below, high-ranking prisoners are executed.

for depth or for the types of registers that we observe in the earlier reliefs of Ashurnasirpal II at Nimrud. Nevertheless, there is certainly a sense of space and perspective, a wide sweeping glance over the entire event that imparts an even greater sense of epic historical event. Rather than laying out a clear sequential narrative within the space of the palace, the Lachish reliefs depict all the aspects of this conquest at the same time in a vast panoramic image of imperial victory.

The North Palace of Ashurbanipal

The later kings of Assyria continued building in Nineveh, with architectural sculpture depicting military campaigns and other themes. The pictorial narratives of war became ever more precise and recognizable as battles in specific locations through the empire: they parallel and complement the written annals in providing information about the extent of the imperial victories of Assyria. Among the sculptures of the later kings, those from the North Palace of Ashurbanipal stand out. Built c. 645 BCE, the palace was covered with scenes of the royal hunt

and epic views of battle. The narrative cycles became even more complex: the sculptors now begin to use self-contained scenes within larger epic compositions. In some of the compositions, a straightforward linear narrative is abandoned in favor of a complicated distribution of episodes, circular positioning of events, or the use of concurrent episodes in time; and repeated figures are explored to new effect, creating what are arguably the most complex and sophisticated narrative representations in ancient art.

Ashurbanipal's palace boasted the largest number of lion-hunting scenes. The sport was considered the king's prerogative and represented his prowess, his ability to control the forces of the wild. One of the palace corridors was carved on each side with large-scale hunting scenes covering an extensive stretch of the walls [10.16]. We see Ashurbanipal dressed in his elegant and royal attire, wearing a crown, gold armbands, wrist cuffs, and large pendant earrings, attacking the lions from his chariot with the aid of his men. The dramatic scenes reveal great observation of the animals and their movements. The fierce lions

10.16 Lion hunt, detail showing a lion springing toward the chariot of Ashurbanipal, from wall panel 14, room C, North palace, Nineveh, Iraq, 645–635 BCE. Gypseous alabaster, full panel: h. 5 ft. 4⅛ in. (1.63 m)

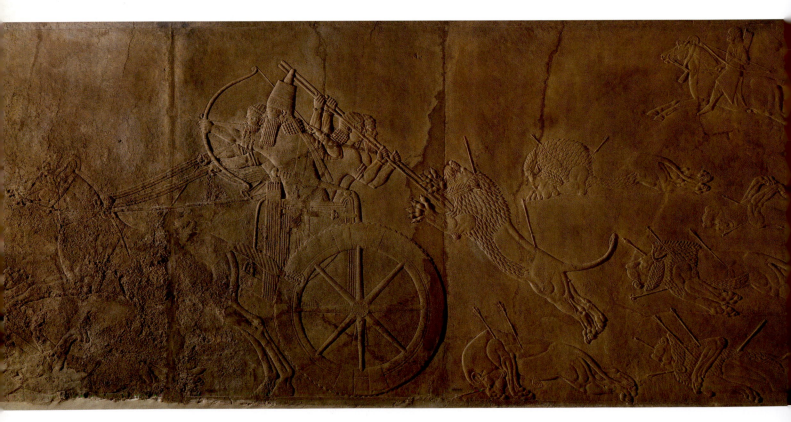

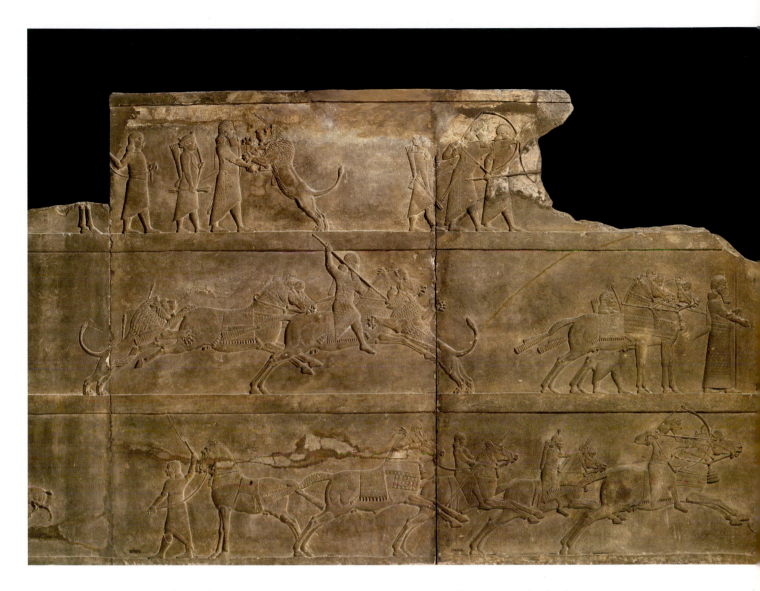

in combat, their tense muscles and expressions of agony at the moment of death, the horses beautifully groomed with braided tails, the alert and anxious mastiff hunting dogs—are all given as much attention as the human protagonists. The action in the hunt converges toward the middle of a scene, full of drama and diagonal movement emphasized by the lines of the spears, the bodies of the galloping horses, and the leaping lions. A more private chamber in Ashurbanipal's palace was covered with a hunt relief in three registers [10.17]. At the top we see the king killing a lion released from a cage, in another scene he attacks a lion at close range, while in the final scene the king, standing before an altar with elaborate feet and surrounded by his courtiers, is pouring a libation over the dead animals lying at his feet.

The war scenes of Ashurbanipal are more crowded and detailed than those commissioned by his predecessors. The Nineveh panels that depict the battle of Til Tuba—a battle against the Elamites in 653 BCE, which took place on the banks of the River Ulai—are carved in this new style [10.18, see pp. 246–47]. Every surface is covered with small detail, and the enemy is observed with ethnographic precision. Labels are used to describe small, detailed vignettes within the larger-scale scenes of war. Unlike the large narrative texts that covered Ashurnasirpal II's reliefs at Nimrud, these texts are concise and relate the events in an exact way. This battle is recorded

10.17 Lion hunt in three registers, Nineveh, Iraq, 645 BCE. Gypseous alabaster.

At the top, the king kills the lion with a sword in a battle of equal antagonists. Depicted with extraordinary realism of detail, the motif is ancient one, echoing the Uruk stele (see p. 51) and early cylinder seal imagery.

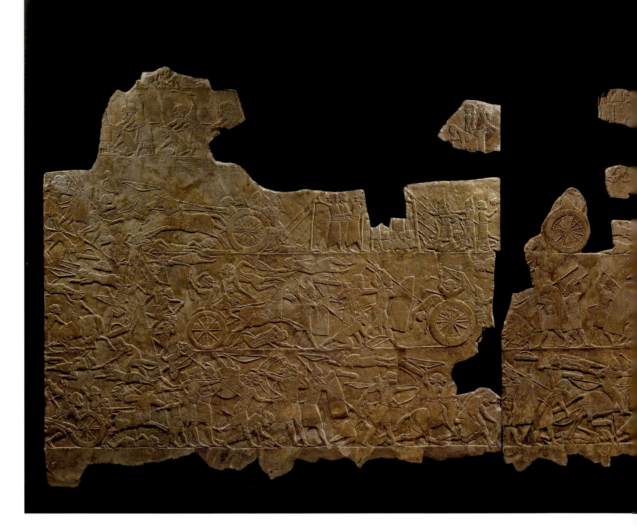

10.18 Battle of Til Tuba panels, Nineveh, Iraq, 650 BCE. Gypseous alabaster, h. 6 ft. 8¼ in. (2.04 m)

This tumultuous battle scene depicts the chaos and violence of war in astonishing detail. It represents a historic war with Elam that took place in 653 BCE.

in great detail in both the written historical texts and the narrative cycle of wall reliefs in the palace. The Assyrian annals relate that Teumann, the king of the Elamites, was beheaded in the midst of battle, and that the head was carried in a triumphal chariot, first to the city of Erbil and then to Nineveh. Within the dynamic boisterous expression of the tumult of war, the king's head appears in the reliefs repeatedly as a sign both of violence and of victory. In one panel in the palace we see the king's head displayed in triumph.

The narrative of the fate of Teumann and his son, the Elamite prince Tammaritu, can be followed as a chronological series of events.

Realistic details of the ferocious battle with the Elamites, routed at the Ulai River, are represented from a bird's-eye view. The river

is a vertical band of swirling threads of water seen from above. Bodies of dead and wounded Elamites, their weapons and horses, are scattered among fish and crab. The most important vignettes of the story are labeled with epigrams (short texts). These were already in use in the reliefs of Sennacherib, for example in the panel that depicts the king enthroned at Lachish, but here the labels seem to participate even more in the narrative. A case in point is the small vignette where an Assyrian soldier approaches an Elamite archer who has fallen to the ground. The Assyrian pauses, leaning on his spear, seemingly undecided about the next step he must take, but the epigram states that the Elamite pleads with the Assyrian to kill him quickly, presumably a preferred end to that of

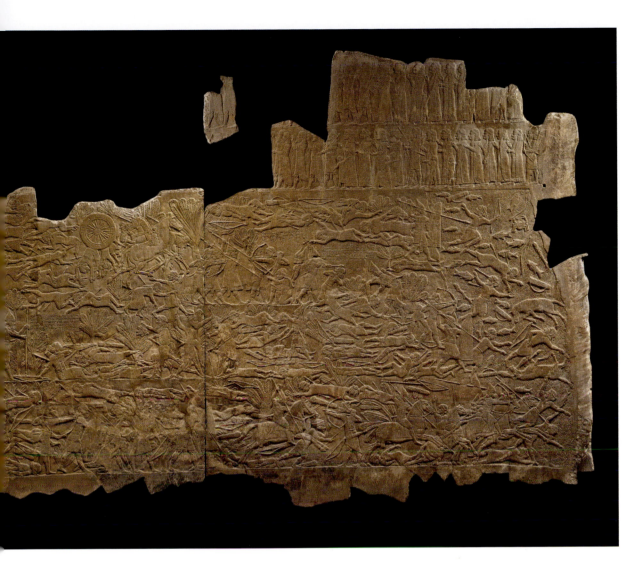

being taken prisoner. Not far from this episode we see a gruesome scene in which the Elamite king, Teumann, is being beheaded by an Assyrian. Across his legs we see the dead body of his son, the Elamite crown prince Tammaritu, who has already been decapitated in front of his own father—an explicit depiction of the most horrific violence. Slightly below and to the left of this scene, an Assyrian soldier carries the head of the king, striding through the battlefield, stepping over the dead and dying, their strewn weapons creating a sense of linear order and perspective in a scene of utter chaos and tumultuous violence. Yet the Elamite king and crown prince are shown as brave warriors, taking a last stand against the great might of the Assyrian army before they are finally killed.

By contrast, under a grape arbor in the gardens of Nineveh, we see King Ashurbanipal reclining on an ivory chaise longue drinking from a golden cup, while the queen, Ashursharrat, wearing a crenellated crown, sits on an elaborate throne facing him [10.19, p. 248]. They are surrounded by attendants and musicians. It is a peaceful and idyllic setting, but for one detail that disturbs the scene. To the left of the royal festivities, the head of the enemy king hangs in the branches of a pine tree. The celebration at the end of the battle is not depicted in the same tightly woven surface composition seen from a high, sweeping perspective. Instead we see the stately, calm feast laid out on a single ground line, the upright figures, all in profile, taking up the entire height of the stone panel. As in the battle cycles, the

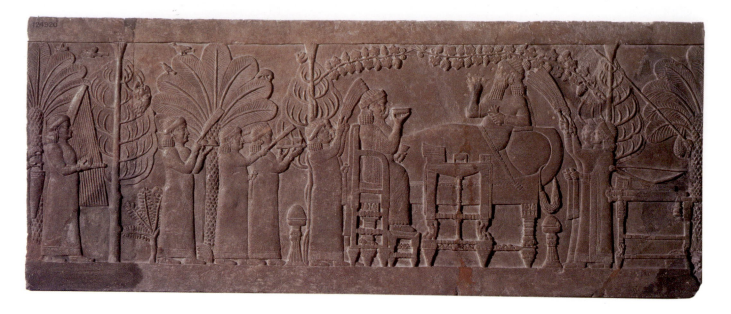

10.19 Ashurbanipal in the garden, from the North Palace, Nineveh, Iraq, 645 BCE. Gypseous alabaster, h. 23 in. (58.4 cm)

viewer remains an outside observer, but here the perspective is close-up and intimate. Because the panel was part of a much larger cycle of reliefs, it is not possible to understand the full effect of the composition or its original placement within the palace. Nevertheless, the shocking inclusion of a severed head within an otherwise peaceful garden creates a powerful and unnerving scene.

The destruction of Nineveh in 612 BCE by an alliance of Babylonians and Medes ended the mighty empire of Assyria. A Babylonian chronicle reports that Nineveh fell after only a three-month siege and that the Babylonian king **Nabopolassar** triumphantly held court there as part of the victory. The Greek historian Diodorus, however, states that the city fell after a two-year siege, and even then only after its defensive walls were destroyed by a river flood. Whatever the political weaknesses that led to its demise, after the fall of Assyria, the Nineveh palace reliefs were

The Library of Ashurbanipal at Nineveh

Discovered in the North Palace in Nineveh in the 1850s, the Library of Ashurbanipal is the oldest royal library in the world. It was stacked with more than 30,000 tablets. Copies of literary works, some of them centuries old and from all over the empire, were collected by the scholars of the Assyrian court. They included omen texts, divination, and magic as well as scientific, medical, and lexical texts. Scholarly texts that clarify the meanings of ancient works were also found here: commentaries on difficult words and sentences in ancient texts enabled readers to understand their meaning. These forms of writing are a fascinating records of intellectual activities of the scholars of Assyria.

King Ashurbanipal prided himself on his ability to read and write, and to understand scribal practices.

He was thus a strong patron of scholarship and its conservation. The goal of the library was to collect all the known scholarship and literature in Akkadian and Sumerian, to preserve it, and to make copies and write explanatory commentaries when the text was fragmentary or difficult due to its antiquated style or language. An ex libris (inscription) of Ashurbanipal's library was added to the texts in a similar way to great collections that exist today, for example the Library of Congress in Washington, D.C. or the British Library in London. The texts preserved in the Nineveh library form one of the most important sources of ancient Near Eastern scholarship. It is also significant for what it reveals about archival and collecting practices in Assyria.

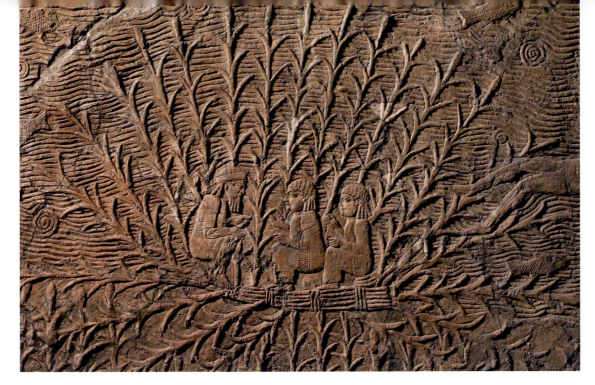

10.20a, 10.20b
Left: detail from Sennacherib's campaign in Babylonia.

Below: the deported Babylonian people.

Nineveh, Iraq, 630–620 BCE. Gypseous alabaster, full panel: h. 4 ft. 11⅞ in. (1.52 m)

subjected to systematic iconoclastic defacement. The face of the enthroned Sennacherib at Lachish was hacked away, yet the other figures and the entire narrative cycle was otherwise left intact. The image of King Ashurbanipal feasting in his garden was likewise singled out for defacement, while the attendant figures and surrounding scene was unharmed. This selective iconoclasm was not a random act of anti-image ideology that opposed pictorial representation, such as those of later historical iconoclasms. It was a means of annihilation of the memory of very specific men. Because they had used their images as a means of militaristic triumphal commemoration, their destruction became likewise an act of war. The development of unprecedented complexity of pictorial narratives patronized in the courts and executed in the sculptural workshops of Assyria [**10.20a, b**]—the representations of royal power that the Neo-Assyrian kings cultivated—were never to disappear, however. They became some of the most standardized images of royal power, borrowed by later kings and empires, both in the ancient Near East and in the European traditions that were to follow.

Another military campaign takes place in the marshlands of Babylonia. Here the sculptors have used a similar perspectival view to that of the Elamite battle reliefs to show the water and reed boats. Other scenes from the Babylonian campaign depict the forced deportation of the civilian population. The sculptors often depict these people with sympathy. A woman in the procession of Babylonian prisoners stops along the way to give her child something to drink, and other women near her carry baskets and bags as they are forced to leave their homes. Other figures are crowded into boats with Assyrian soldiers. The location is identified by a background of palm trees.

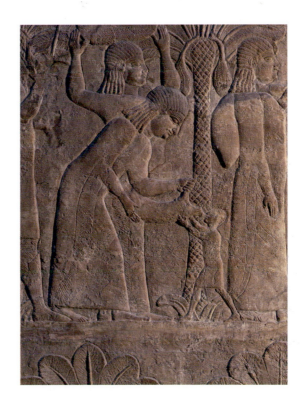

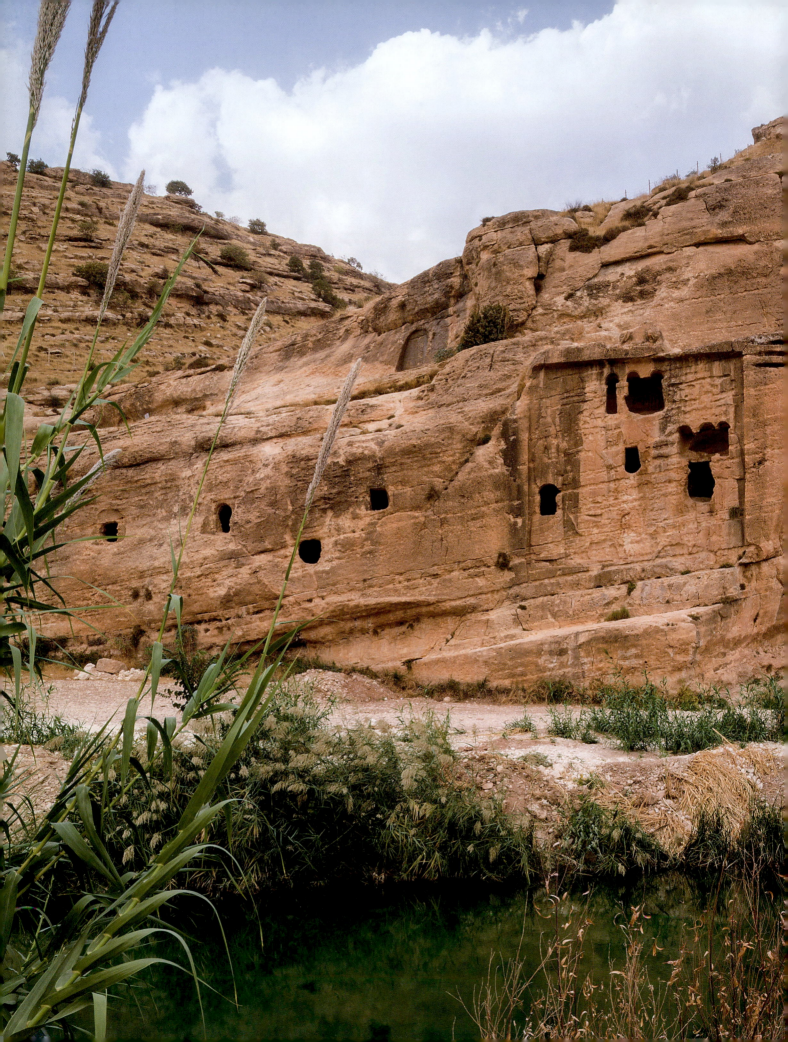

CHAPTER ELEVEN

Assyrian Art in Context

Khennis rock reliefs in situ
(ancient Khunusa), Iraq, 704–681 BCE

11 Assyrian Art in Context 900–612 BCE

Rulers	Ashurnasirpal II r. 883–859 BCE
	Shalmaneser III (the son of Ashurnasirpal II) r. 858–824 BCE
	Tiglath-Pileser III r. 744–727 BCE
	Shalmaneser V r. 726–722 BCE
	Sargon II r. 721–705 BCE
	Sennacherib r. 704–681 BCE
	Ashurbanipal r. 668–627 BCE
Major centers	Nimrud (ancient Kalhu); Nineveh; Dur Sharrukin (modern Khorsabad); Assur
Important artworks	Assyrian palaces at Nimrud, Nineveh, and Dur Sharrukin
	Royal burial gifts from the tombs of the Assyrian queens
Technical and stylistic developments in art and architecture	Obelisks, steles, and rock reliefs are found throughout the empire
	By the end of the ninth century BCE, cylinder-seal designs are cut with the use of a cutting wheel and drill

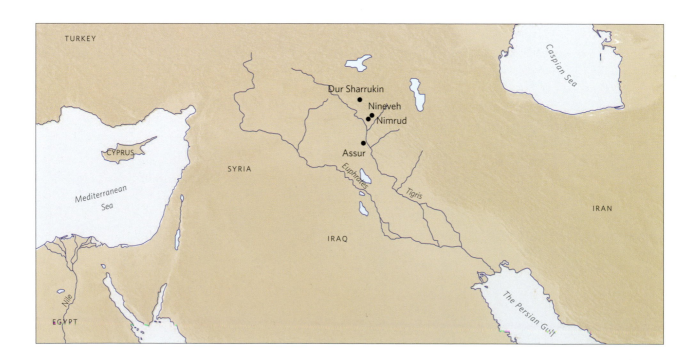

11 Assyrian Art in Context

Architectural sculpture set within the great Assyrian palaces of Nimrud, Nineveh, and Dur Sharrukin introduced dramatic narratives and powerful new images of empire. These masterful works are the best-known of the Neo-Assyrian arts of the ninth to the seventh centuries BCE, but alongside the sculpture from these three imperial capitals, artists excelled in the small-scale decorative arts of the royal palaces. They also created imposing standing monuments, steles, obelisks, and majestic rock reliefs, as we shall see in this chapter.

Art in Death: Royal Tombs of the Assyrian Queens

In the excavation seasons of 1988–90, archaeologists in Nimrud made a spectacular discovery. While working in the Northwest Palace of Ashurnasirpal II in the city of Nimrud (ancient Kalhu), they found four large vaulted tombs beneath the south end of the palace. These tombs were evidence of the burials of several wives of the kings of Assyria, from the ninth and the eighth centuries BCE. All of the queens had been interred with vast amounts of precious jewelry, royal crowns and diadems, and decorative personal objects made using the finest Assyrian craftsmanship; the archaeologists found exquisite gold and crystal vessels as well as finely made objects, such as mirrors inlaid with precious stones, gathered from distant lands of the empire and beyond. The artifacts demonstrate the Assyrian court's taste for a wide variety of fine decorative arts—locally made Assyrian works as well as Syrian, Cypriot, Phoenician, and Egyptian—objects, styles, and methods of manufacture. What was also surprising was the sheer amount of personal adornment and luxury objects that were included in the burials: about 10,000 pieces of jewelry and 120 larger decorative objects were found. These give us a glimpse into royal burial customs, as well as into the remarkable and original decorative arts of Assyrian courtly life. We learn from them something of the goldsmithing techniques that were used, and the extraordinary originality of miniature designs in stone and precious metals that often repeated the large-scale images and iconographies we know from the palace relief carvings; but they are also evidence of a large international network of imported luxury objects.

The first burial was found beneath the floor of room MM of the Northwest Palace. The **barrel-vaulted** tomb housed a ceramic **sarcophagus** that had been sunk into the floor. This sarcophagus contained human bones and many pieces of jewelry and works of art made of precious materials. Among the burial gifts were 200 items of gold, including many pairs of almost identical lunate (crescent-shaped) earrings decorated with fine granulation and gold flowers, some with cone-shaped pendants; also large bracelets with miniature figural designs resembling the scenes of genies and sacred trees carved on the palace walls, but made with tiny pieces of inlaid stones set into gold **cloisonné** segments formed into figural scenes.

The second subterranean tomb was uncovered in room 49 of the palace. The **barrel-vaulted** chamber was reached by a long shaft leading to two stone doors. Here, a rectangular stone coffin held the remains of two bodies. Hundreds of pieces of jewelry and vessels of gold, silver, and semiprecious stone had been deposited with them. More than seventy pairs of earrings and numerous necklaces were found, but most noteworthy was an elaborate diadem of woven gold thread with tasseled fringes, embellished with agate and lapis lazuli blocks inserted into the

Clockwise from top
11.1a gold crown;
11.1b gold bracelets inlaid with lapis lazuli, carnelian, turquoise, agate;
11.1c gold necklace with deer-head clasp;
11.1d gold elements of a diadem inlaid with semiprecious stones. All from the Queen's tombs at Nimrud, Iraq, Neo-Assyrian, 9–8th century BCE.

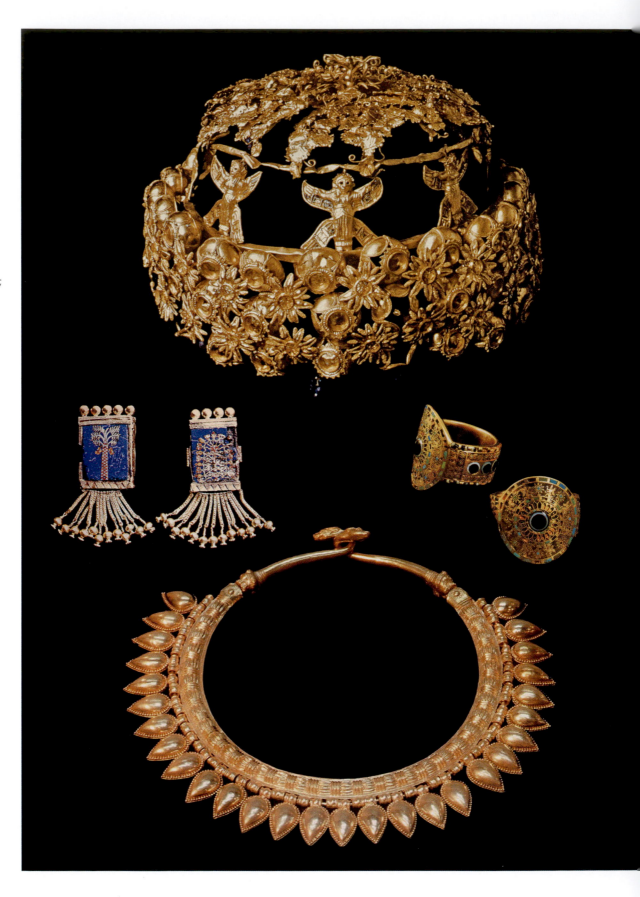

rectangular gold forehead plaque. A third tomb contained the most splendid crowns, one of gold rosettes and the other one in the form of a golden arbor with lapis lazuli grapes.

The magnificent crowns and diadems—of superb craftsmanship, with precious stones inlaid in minuscule mosaic within gold cloisonné and stone settings—are some of the most impressive works known from antiquity [11.1a–d]. Another diadem with two lapis lazuli pendants was also inlaid. The dark-blue stones are encased in gold frames that have granulation and **beading** at the edges. From one end, braided gold chains terminate in tiny golden pomegranates, a fruit that is plentiful in Assyria and that was often used in the royal iconography to symbolize abundance and the fertility of the land. The lapis lazuli stones were inlaid with two differing tree motifs. One is a palm tree, its trunk and date palms created with tiny pieces of carnelian set in gold, and the other is the stylized tree of life that is depicted so often on the palace walls of Nimrud, here made in an inlaid cloisonné of colored stones and gold.

Other pieces of jewelry from the tomb also paralleled articles of adornment worn by people depicted in the Assyrian palace reliefs, and the decorative details reflect the magical genies, trees, and motifs that we can observe on the palace walls. For example, a pair of gold bracelets or cuffs in gold, inlaid with agate and turquoise stones with a large banded agate **eye-stone** in the center, depict a minuscule version of the kneeling winged genies and central tree motif, next to rows of rosettes and smaller eye-stones around the cuffs. One of the most interesting objects in the royal tombs was an intricately made gold crown that takes the form of a grape arbor held up by a series of eight female deities with outspread wings. These divine winged creatures stand upon rows of pomegranates, originally inlaid with colored stones. The pomegranates interspersed with flowers form the lower part of the crown that surrounded the forehead of the queen. From below, and in the interior of the crown, tiny bunches of grapes made out of lapis lazuli are suspended from the canopy of golden grape leaves, vines, and flowers with tiny gold wires.

The selection of jewelry for all these burials, which included vast amounts of earrings and pendants, was extraordinary and reveals something of the needs of the deceased queens in the afterlife. Often dozens of pairs of exactly the same kind of earrings were accumulated in the burial. A gold repoussé bowl with a Nilotic scene (based on Egyptian-style images of waterside entertainment) was inscribed with the name of the queen Yaba', wife of Tiglath-Pileser III (r. 744–727 BCE) [11.2]. This bowl seems to have been made in an earlier century and was probably already an antique when her name was added to it, perhaps for her marriage trousseau. Queen Yaba's bowl was made either in Phoenicia or in Egypt. It is the type of object that was greatly valued and collected throughout and even beyond the Assyrian Empire. A similar bowl, for example, was found in an Etruscan tomb (the Regolini Galassi tomb) in central Italy, thus showing the wide international connections of

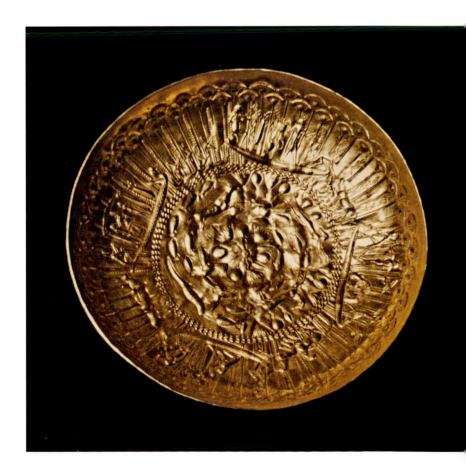

11.2 Bowl with Nilotic scene, tomb of Yaba', wife of Tiglath-Pileser III, Northwest Palace, Nimrud, Iraq, Neo-Assyrian, 744–727 BCE. Gold, diam. 7 in. (17.7 cm)

the first millennium BCE, evidenced by traveling works and, most likely, traveling artists also. Two of the inscribed bowls found in the tombs bore the names of other queens: Banitu, queen of Shalmaneser V (r. 726–722 BCE), and Talya, queen of Sargon II (r. 721–705 BCE). As for the identification of the interment itself, a stone slab at the entrance of the second tomb bore an inscription identifying the burial as that of Yaba', wife of Tiglath-Pileser III, and cursing anyone who breaks the seal of the tomb and disturbs the burial.

A third tomb was found in room 57, where an entrance shaft led to an antechamber sealed by an inscribed stone slab. Here three bronze coffins contained skeletal remains and approximately 50 lb (23 kg) of gold objects of magnificent workmanship, including the crown in the form of a grape arbor made in **openwork** gold. Beyond the antechamber with the bronze coffins was a barrel-vaulted stone tomb chamber with a stone sarcophagus. Inscriptions here identify the earliest tomb as that of Mullissu-Mukannishat-Ninua, the wife of Ashurnasirpal II.

The burial gifts found in the tombs of the Assyrian queens, like much of the decorative arts of the Assyrian court, reflect the taste in Assyria for collecting finely made things from Syria, Egypt, Cyprus, and beyond. They also provide a rarely seen technical perspective on the arts of the ancient jewelers of the Assyrian court—their method of goldsmithing; their use of imported stones, such as carnelian, turquoise, garnet, and lapis lazuli; as well as their ability to create miniature iconographies of winged genies, sacred trees, scenes of royal hunting and water sport, and magnificent hybrid animals protecting the rims and handles of vessels—all giving us a glimpse into the material culture of the imperial court.

Ivories from the Empire

The decorative arts of the Assyrian court included furniture made of exotic woods and inlaid with carved ivories. Some of these furnishings can be seen in the Assyrian palace reliefs, where ivory beds and thrones are represented in great detail (for example, the relief of Ashurbanipal in the garden from Nineveh [**10.19**, see p. 248]), and they are affirmed by the archaeological finds of objects, both in the court styles of Assyria and with influences from abroad [**11.3–11.6**]. Carved ivories made in Syria and Phoenicia, often adopting Egyptian motifs and styles, were used in furniture, horse trappings, and other decorative arts, and were favored by the kings of Assyria and their courtiers. Thousands of these finely carved ivory figures, objects, horse trappings, and furniture attachments were found at Assyrian palaces, the majority of which were excavated at Nimrud. They include plaques depicting such supernatural creatures as sphinxes and griffins, seated figures, animals, and the faces of beautiful women with bejeweled hairstyles, shown frontally and framed in an elaborate window casement.

Furniture was brought to the imperial capitals either as war booty or commissioned by the kings directly from specialist craftsmen and artists who traveled to the courts of Assyria. The ivories, made from both hippopotamus and elephant tusks, were carved with figural scenes and plant motifs and were also used to make small objects, such as boxes, handles of personal items, and combs. Panels of ivory, carved in relief or made in openwork, were set into the decoration of large pieces of furniture. The panels then could by dyed with colors and inlaid with multicolored materials, such as vitreous pastes (i.e., those derived from glass) and **frit**, or even semiprecious stones, and in some parts overlaid with gold leaf before they were inserted into, or joined with, the wooden furniture members. Many of these furnishings were imported finished objects requested by the court, but they were also given as gifts from vassal kings, or seized as war booty from conquered lands and their palaces. Records of tribute paid to Assyrian kings and inventories of booty often list furniture among the most valuable objects. Ashurnasirpal II states that he carried off tables, chairs, and couches of precious woods, such as boxwood inlaid with ivories and covered with sheets of silver and gold. These carved ivories from Syria and Phoenicia, often bearing Egyptian motifs and iconographies, reveal something of

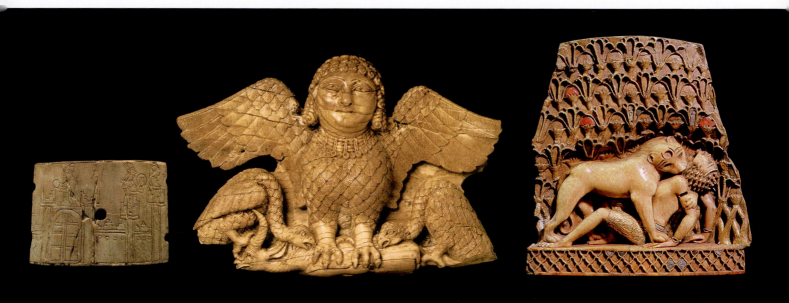

Above, left to right

11.3 Assyrian-style cosmetic box with musicians and royal attendant, from Nimrud, Iraq, *c.* 850 BCE. Ivory, h. 1⅞ in. (4.8 cm); **11.4** Syrian-style element: bird of prey with a female head (harpie) and vultures, residential wing of the Northwest Palace, Nimrud, Iraq, *c.* 850 BCE. Ivory, h. 3⅞ in. (9.9 cm); **11.5** Phoenician-style plaque with lioness and Nubian, from Nimrud, Iraq, (one of a pair), *c.* 800 BCE. Ivory, gold leaf, and glass paste, h. approx. 4⅛ in. (10.4 cm)

The ivories discovered in Assyrian courts include three different styles made in various workshops. The first is the Assyrian style, in which designs depicting Assyrian royal figures and iconographies are incised with sharp lines onto flat ivory plaques that were inserted into other materials. The second group can be identified as Syrian-style ivories, which are distinctive for their deep carving and rounded modeling, the depiction of nude female figures with thick spiraling curls and tall decorated crowns, as well as supernatural winged creatures and decorative motifs. The Phoenician-style ivories, which seem to have been perhaps the most highly prized, combine Egyptianized motifs with Near Eastern iconographies. They are superbly carved in detailed naturalistic forms, and often embellished with dyes and colored stones. Some of these ivories still bear the Phoenician signs on the back that were added by the craftsmen as instructions for how to insert them into the larger works that they were making.

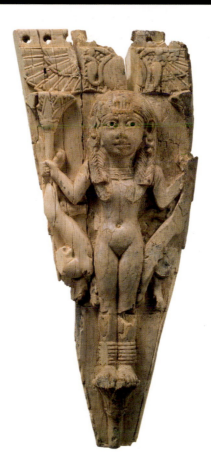

Left **11.6** Horse frontlet, carved with Mistress of the Animals grasping lions, and Egyptian winged disc above, from Nimrud, Iraq, *c.* 9th–8th century BCE. Ivory, h. 6⅜ in. (16.2 cm)

Asian elephants were once native to Syria. The penchant for the collecting of fine ivory furnishings led to extensive hunting of elephants and their eventual extinction in the region. Hippopotamus tusk came from Egypt to the Levant, where it was also worked by local craftsmen.

the international artistic and economic exchange that existed in the Assyrian Empire and adjacent lands. Some of these types of highly prized objects, especially ivories and metalwork, reached as far as Italy and Spain's western coast on the Atlantic Ocean. The taste for imported objects in the decorative arts of the palace is not as evident in the main royal monuments of Assyria, however: here

a traditional Assyrian style and Mesopotamian iconography was most often preferred for images of royal power and authority, even when the monument was set up in a conquered land.

Monuments in Place

Tribute from vassal states, luxury furniture, and exotic animals are shown on some of the palace wall reliefs of Assyria, but they are also depicted as part of the ceremonial act of presenting tribute to the Assyrian king. A basalt monument known as the Rassam obelisk, for example, shows tribute given to Ashurnasirpal II. Among the objects presented are upholstered chairs and various types of tables with legs that end in lion's paws or the hooves of a bull; these provide further evidence of the types of furniture within which the ivories discovered at Nimrud might have been inserted, but more importantly, they give us an idea of the rituals of diplomatic gifts and tribute-giving and how these rituals were presented in the visual arts to a public viewership.

The distinctive type of monument set up in public places by the Assyrian kings is usually referred to as an obelisk because it is in the shape of a stone pillar, square in section, and carved on each of its four sides with images and text. The obelisk type was inspired by Egyptian monuments and appears at a smaller scale in Assyria by about 1100 BCE, with the addition of a stepped top rather than an Egyptian obelisk's pointed peak. The Black Obelisk is the best example of its kind, carved out of black alabaster on each of its four sides with scenes of the subject people of the empire and vassal kings bringing various forms of tribute to King **Shalmaneser III**

(the son of Ashurnasirpal II; r. 858–824 BCE), including such exotic animals as elephants, rhinoceros, and apes from Egypt [**11.7**]. The scenes form part of a single composition that consists of framed vignettes covering four sides of the pillar, surrounded by text. The text on the Black Obelisk includes epigraphs describing the scenes above each of the panels. A longer continuous text covers all four sides, from the stepped upper part to the

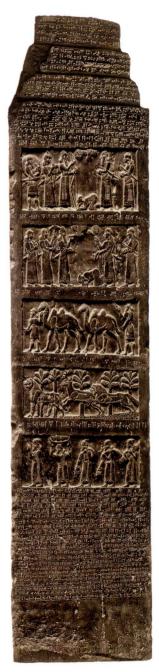
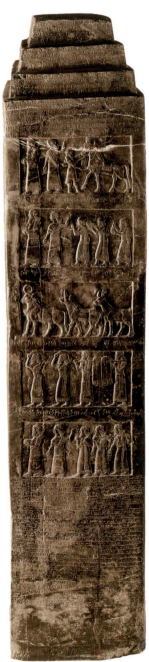

Right and opposite
11.7 Black Obelisk of Shalmaneser III, from Nimrud, Iraq, *c.* 825 BCE. Black alabaster, h. 6 ft. 5½ in. (1. 97 m)

In the first vignette (seen right, top of first view of Obelisk), Shalmaneser is depicted as the triumphant warrior king, holding two arrows in his right hand and a large bow in his left. Ishtar, the goddess of war, is the emblem closest to the king, a star floating above the scene. Next to the star is a winged disc of Assur. A ruler of the land of Gilzanu in Iran is prostrate before the king of Assyria and kisses the lower part of the bow. Armed guards and courtiers attend the scene.

space below the reliefs. In it the campaigns of Shalmaneser III are described for every year of his reign, ending in 824 BCE, thus giving us a good date for the creation of the monument.

When it was discovered, the Black Obelisk soon became very well known for the fact that a scene toward the top of one side depicts Jehu of Bit Omri (ancient northern Israel), the king of Israel, bowing before the king of Assyria. Jehu is not a

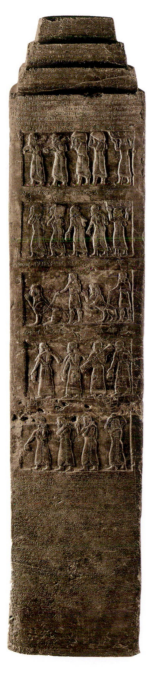

conquered enemy but a tribute bearer who has pledged allegiance to Assyria, and it is significant that he is one of only two kings shown near the Assyrian monarch. His distinctive soft woolen cap identifies him as a foreigner from the Levant. The epigraph states:

> I received tribute from Jehu of the house of Omri: silver, gold, a gold bowl, a gold tureen, gold vessels, gold pails, tin, the staffs of the king's hand, and spears.

King Shalmaneser stands in front of the kneeling Jehu. The king is holding a cup, while a courtier carries a sunshade behind him. The winged disc of Assur and the star burst of Ishtar float above the scene to show that the realm of the divine beneficently oversees this creation of order in the empire—an order that is conveyed by the iconography of vassal kingdoms and rulers submitting to the king of Assyria, but also by means of the orderly and compartmented composition, subdivided into well-defined registers with intervening inscriptions. This controlled, contained composition gives a sense of the imperial world order at the same time. As a compositional plan or visual organization, the design of the obelisk is unlike the dynamic narratives that were favored for the palace walls. Monuments like the Black Obelisk stood in an open piazza or central square in the city of Nimrud, and were accessible to the public, unlike the palace sculptures, which were architectural sculptures within the palace (chapter 10). Other forms of relief monuments and steles, known from the earliest times, continued to be set up in Assyria's cities and also in its distant provinces.

Another distinctive type of royal stele, consisting of a large smoothed double-sided slab of stone with an arched top, became widely used in the Neo-Assyrian era, both at home and abroad. The most common type depicts the king standing in a gesture of prayer, while before him and above his head are the astral emblems of the supreme gods. Inscriptions allow us to identify these as a type of image-monument that the Assyrian kings referred to as the "image of my kingship." The inscriptions seem to imply that

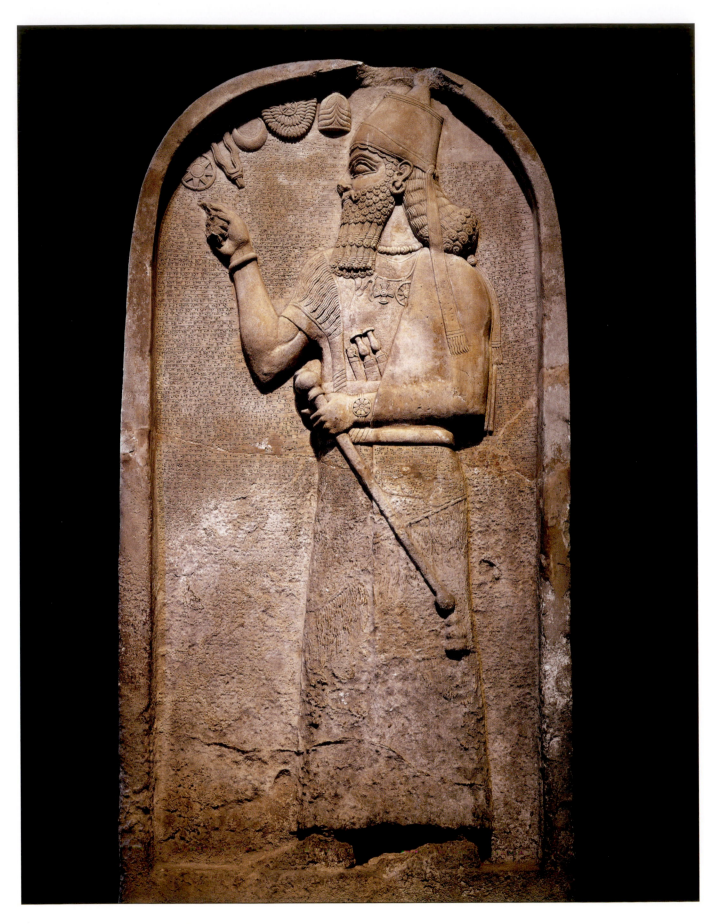

a stele identified in this way was conceived of as a combined word–image entity, neither one nor the other alone but a combination of the two forms of written and visual representation of the king. The written description was devoted to his deeds and acts, his heroism and piousness, while the image showed him in his ideal kingly form, overseen by the planetary gods above. This type of stele—consisting of an arched panel that frames the standing king—becomes a classic form of freestanding stone monument. They were set up throughout the empire, sometimes in or near temples but often elsewhere in public places in the cities.

In the stele of Ashurnasirpal II from the entrance of the Ninurta Temple at Nimrud, for example, the king stands with his right hand held in a gesture of worship [11.8]. Above his head are the emblems of five gods: a horned helmet for Assur, a winged sun disc for Shamash, the crescent in a circle for the moon god, Sin, the forked thunderbolt for the storm god, **Adad**, and the encircled starburst (the planet Venus), the astral symbol of the goddess Ishtar. The king wears a necklace with similar divine symbols, earrings, and bracelets. In his left hand he holds a scepter of kingship, and weapons are placed at his waist. He wears a royal headdress surrounded by a diadem, and a short-sleeved tunic with fringed borders. The entire framed space within which the king stands in an act of perpetual worship is filled in with a long text. The writing crosses over the garments of the king, and covers the back of the monument also. It is as if his body and the symbols of the gods are woven within a monument conceived as a textual surface. The movement of the text across the body of the king is not randomly placed but pulls his figure in and weaves it into the inscription. The lengthy text ends with a curse regarding the image of the king, calling for the demise of anyone who would harm the monument in any way.

These types of stele were set up throughout the empire as monuments of victory to be seen in distant lands. A stele of Sargon II, for example, was found in 1844 in Larnaca in Cyprus during the construction of a church [11.9]. It is a victory stele that bears the image of the Assyrian king standing in profile wearing the royal crown, with his right hand in the prayer gesture and the left hand bearing a scepter. Before his face we see the emblems of the gods of Assyria. The inscription was partly erased in modern times, the back of the stele having been unfortunately chiseled down to make it lighter to transport. The inscription on the front, however, states clearly that the stele was set

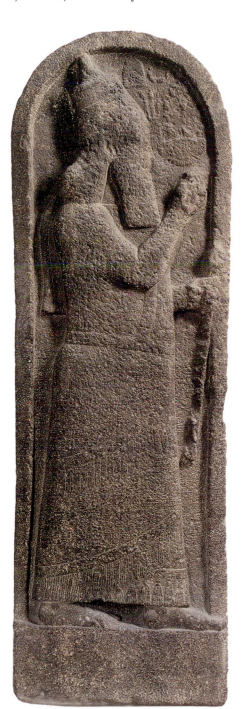

Opposite
11.8 Stele of Ashurnasirpal II, Ninurta Temple, Nimrud, 883–859 BCE. Limestone, h. 9 ft. 7¾ in. (2.94 m)

11.9 Stele of Sargon II, from Lanarca, Cyprus, after 707 BCE. Gabbro/basalt, h. 6 ft. 10¼ in. (2.09 m)

11.10 Ashurnasirpal II, from the Temple of Ishtar, Nimrud, Iraq, 883–59 BCE. Magnesite, on red dolomite plinth, h. 3 ft. 5¾ in. (1.06 m)

up on "Ba'il-hurri, the mountain located at the top of the land of Adnana." The stele originally stood high above the coast at Larnaca, on one of the highest peaks. The stele also mentions a victory celebration that took place in 707 BCE in Babylon, where seven kings of Cyprus were present, bringing gifts of gold, silver, and ivory, thus also providing a reliable date for the stele.

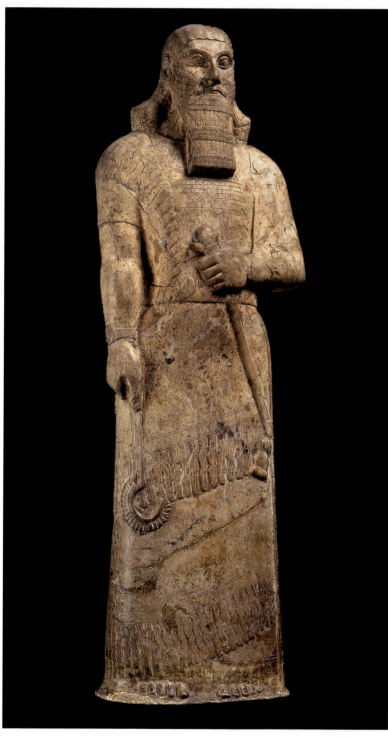

A portrait of the king Ashurnasirpal II is known from a statue in the round from Nimrud; it was discovered at the Temple of Ishtar, where it stood in prayer on its original pedestal of red stone [11.10]. The frontally conceived figure represents the king bare-headed, without his crown of authority but carrying the sickle sword and scepter as symbols of his rule. The king's body is depicted as a solid slab of marble enveloped by a tasseled robe; the lower part is rectangular and carved in low relief with the fringed edges of the cloth wrapped diagonally across his body. Below, the feet appear just at the edge of the garment, not carved fully but indicated in a deep relief. His muscular arms and direct gaze give him a look of power. The statue has a sense of solidity and stillness that gives it a sense of enduring presence. A neat cuneiform text is sharply incised on the robe at the area of the chest, integrated into the garment as if it were a part of the fabric. The text declares the statue to be Ashurnasirpal II the great king, listing his royal lineage. This declarative statement enabled the statue to act as a valid representation of the king, a form of effective or living portrait, able to stand in prayer before the goddess in perpetuity. It was not an image of royal power aimed at the general public, but a religious votive image meant for the interior space of a temple.

This type of image can be better understood if we consider the Akkadian word "salmu," the term for "representation" that refers to image, applying both to statues in the round and to sculptures in relief, such as those on the steles. Unlike the word "representation" that we use, the aim of the salmu was not to be secondary to the person represented, but to take his or her place as a substitute presence before the gods. It is the central concept of representation in Mesopotamian art that can be traced back to inscriptions on statues in the third millennium BCE. The term shows that representation was not always aimed at imitating real things in the world, but was also for creating sculptures and images that participated within real spaces with their own agency. The making of a portrait or representation of a king, such as the statue of Ashurnasirpal II, was a complicated process. The image had to have

certain idealized features of masculinity, such as strong musculature or a thick, luxurious beard, but more importantly it had to be inscribed with the name of the person represented because it was the inscription that worked to transform the statue into the portrait of a specific person and not anyone else. After the image was carved from stone by the sculptor, the statue was put through a ritual performed by priests. This ritual was known as the **mouth-opening ceremony**. In the ceremony the statue was called by the name of the king, and in some sense brought to life by the ritual opening of the mouth. Through this magical transformation the image of the king became a valid presence or substitute. In many cases, the statue is no longer referred to by the word salmu, or representation, but simply as the king. This process was also used for the consecration and inauguration of the statues of the gods so that they could function as effective appearances of the divine in the realm of the living. In both cases—kings and gods—the notion of representation, salmu, was understood not as a mimetic form of resemblance that approximates the outward appearance or individual physical features, but as a portrait that could take the place of the represented person both in the present and in the future.

At the same time, the statue had to be aesthetically pleasing and well made, as we can see in the statue of Shalmaneser III from Nimrud [**11.11**]. The statue depicts the king standing with his hands joined at his waist in prayer. His thick, squared beard is detailed with rows of carefully groomed curls that are also carved into his thick shoulder-length hair, all aspects of his beauty and masculinity. His elaborate fringed garment is covered in its entirety with a long cuneiform text. Here Shalmaneser III dedicates the statue to the god Adad, god of storms, and narrates his great accomplishments, describing his conquests as far as the Lebanon and the land of Hatti and as far as the source of the Tigris in the land of the Urartians, in modern day Turkey. The text concludes with a statement about the statue:

I had made a holy, shining, precious statue of alabaster, the workmanship of which was

beautiful to look at and the appearance of which was excellent. I erected it before the god, Adad, my lord. When the god Adad, my lord, looks upon the statue, may he be truly pleased and so command the lengthening of my days, proclaim the multiplication of my years, and daily decree the removal of illness from my body.

We can read here that that excellence and skill were important aspects of the sculpture, and that through this image Shalmaneser III hoped to gained the god Adad's favor and protection in order to lengthen and ease the days of his life.

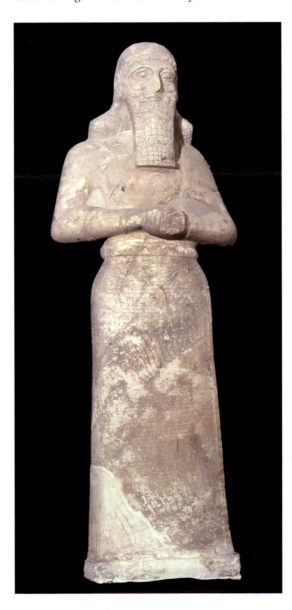

11.11 Shalmaneser III, from Nimrud, Iraq, 859–824 BCE. Alabaster, h. 3 ft. 4½ in. (1.03 m)

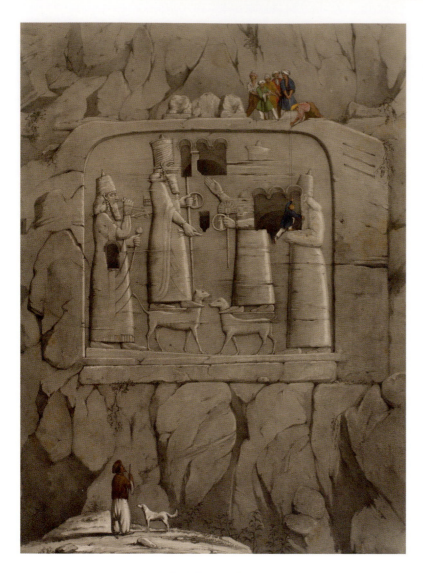

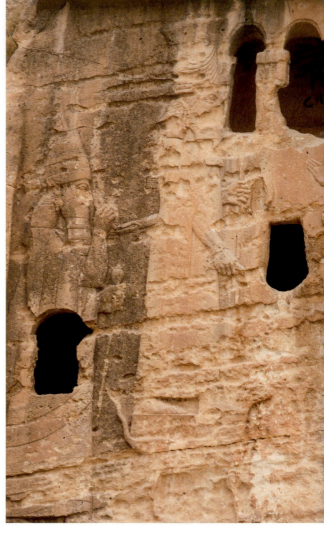

Rock Reliefs: Landscape as the Terrain of Kingship

Monumental Neo-Assyrian sculpture also took the form of rock reliefs, carved high up in the mountains of Assyria and in the cliffs of modern Turkey and Iran, and as far west as Lebanon. As the empire expanded, public monuments were installed, and rock reliefs were carved further afield in the imperial domains. The reliefs are in some way declarations of the power of Assyria and an appropriation of terrain for the empire; however, they are not always easy to reach, or even to find, and were not as visible to viewers as one would expect such propagandistic images to be. Although the reliefs are outdoors, the human viewer does not seem to be of primary importance to their location. They are both visible and hidden. It is better to understand these reliefs as the harnessing of the elementary force of nature.

The fact that the stone surface was still part of the rocky terrain, and the significance of the exact place of the carving within the landscape, were important in the placement of these rock sculptures. This kind of transformation of a natural site into an arena or theater of sculptural representation is best seen at the site of a water source of King Sennacherib's (r. 704–681 BCE) great project to bring water to Nineveh and its agricultural lands. Cliffs on the bank of the Gomel River at Khennis (in Iraqi Kurdistan) were carved with a series of reliefs [**11.12**].

In the main Khennis rock relief—the largest, at *c.* 100 sq. ft. (9.5 sq. m) [**11.13a**]—a royal figure is next to the divine pair Assur and Ninlil, the first standing upon a lion griffin and dragon, and the second on a lion. The king is Sennacherib, who appears twice, standing in profile position, left and right of the gods. Sennacherib holds

a scepter, while the gods, depicted as larger in scale than the double king, each hold a staff and a ring. Inside each divine ring we see a smaller image of the king, held within the protection of the gods. The composition is symmetrical and balanced—left and right, gods and king, all facing the central space. The double king is then also echoed within the ring of authority. Above this square panel within which the scene is carved we see the remains of recumbent lion-sphinxes, which are shown in a frontal position, as guardians of the image.

Some of the reliefs were placed high up and carved in a low relief, while others were cut into the spurs of rocks close to the water's edge and are sculpted so deeply that they are almost statues in the round. The years of exposure to the elements have resulted in a great deal of weathering of these carvings. Nevertheless, it is still possible to see that the winged human-headed lamassu (the guardians of Assyria's royal portal) as well as anthropomorphic genies, and images of the gods that we know already from the palace walls, are all present here at the water's edge, protecting the source of clear rushing water at the Gomel.

11.13b Khennis rock relief, Gate monument, 704–681 BCE

11.13c Khennis rock relief, 704–681 BCE: the king stands before the astral symbols of the gods as in a typical royal stele with arched top (see **11.8**), 1 of 14 panels, h. 6 ft. 6 in. (1.98 m)

This sculpture at the water's edge is referred to as the Gate monument, as it was seen as a conceptual gate at the head of the canal [**11.13b**].

At the water's edge, winged lamassu are accompanied by a frontal composition of a colossal hero grasping a lion in the crook of his left arm and holding a sword in his right hand. Above is another relief bearing an image of the king, this time flanked to left and right by Assur and Ninlil mounted on their sacred animals. These reliefs were probably also painted brilliant colors in antiquity, and were part of a massive complex overlooking the course of the water.

The main composition of the worshiping king is similar to cylinder seal designs (see p. 268), whereas another fourteen inset panels, each c. 6 ft. 6 in. (2 m) in height, placed higher up on the cliff, are cut in the form of a stele with a rounded top [**11.13c**]. Each of these bears an image of the king before the astral emblems of the supreme gods of the pantheon, and each of the stele-shaped reliefs are also inscribed. Below the area of the main relief, a scene was later added within an earlier Assyrian one, known today as the Rider Relief. This relief, originally measuring 13 ft. (4.2 m) high and 22 ft. (6.7 m) wide, represents a man on a horse; it was carved in the Parthian era, six centuries after the fall of Assyria.

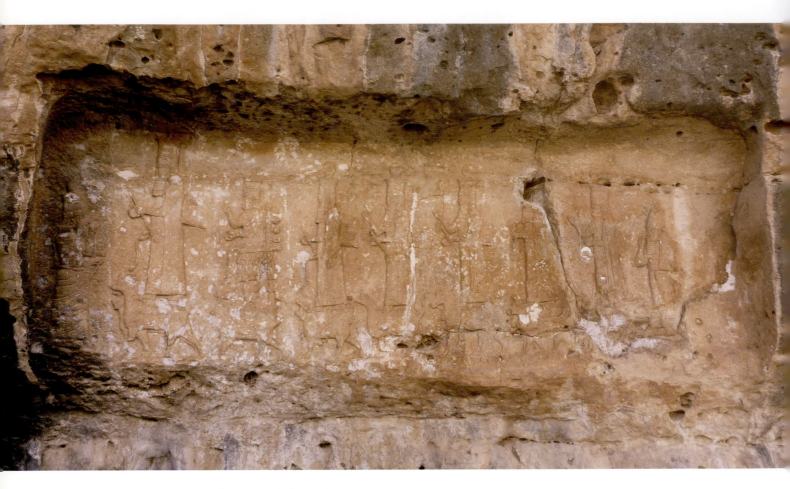

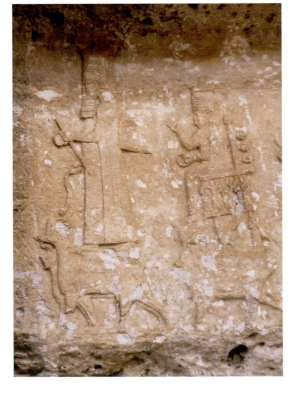

Above
11.14a Maltai relief in situ, Maltai, Iraq, *c.* 690 BCE. Limestone cliff face

Right
11.14b Maltai relief detail: Assur standing on a lion and dragon, and Ninlil-Mulissu enthroned and carried by a lion.

The carved figures from left to right are:

1. An Assyrian king, probably Sennacherib, facing right wearing a royal crown. He holds a mace in his left hand.

2. The god Assur. He stands on a *mushhusshu* dragon and a horned lion, the first covered by the second.

3. The goddess Ninlil/Mulissu wife of the god Assur. She holds a ring in her left hand and is seated on an elaborately carved throne carried by a lion.

4. The moon god Sin. He wears a crown with a crescent moon and stands on a hybrid horned and winged lion, with the hindquarters and tail of a bird.

5. The god Anu or Enlil. He holds the rod and ring of authority in his left hand and stands on a *mushhusshu* dragon.

6. The god Shamash, the sun god. He can be identified by the solar disc on his crown. He stands upon a horse.

7. The god Adad, the storm god. He holds the lightning bolts and stands on a horned lion. On panel II, his lion is accompanied by a bull, his animal attribute.

8. The goddess Ishtar standing on a lion. She holds a ring in her left hand.

9. An Assyrian king facing left. This image is most likely the symmetrical image of the same king, Sennacherib.

At Maltai, near the modern city of Dohuk, a series of four horizontal reliefs are carved into the limestone cliff face [**11.14a, b**]. They are set high up in the mountainside on a narrow ledge about 650 ft. (200 m) high, where the carving process must have presented a number of challenges for the ancient sculptors. Although no inscription has been discovered here, the iconography and carving style allow us to date them to the reign of Sennacherib. Each relief is 20 ft. (6 m) wide and 6 ft. 6 in. (2 m) high. Three are grouped together and one lies about 160 ft. (50 m) to the right of them. The reliefs each depict the king twice, at the start and the end of a procession of the main gods of the Assyrian pantheon. Each god stands upon a divine beast and holds identifying emblems of power. The composition is repeated across the reliefs so that each panel consists of nine figures with small variations. These reliefs can be dated to *c.* 689 BCE on the basis of the depiction of the beasts upon which the god Assur stands. We see two overlapping creatures, a horned lion and a **mushhusshu** dragon, the animal attribute of the god Marduk, supreme god of Babylon. This iconographic choice for the state god of Assyria, Assur, indicates that Babylon had been conquered by the time of the carving of the relief.

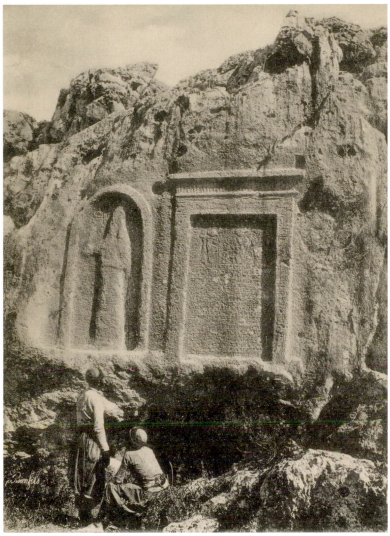

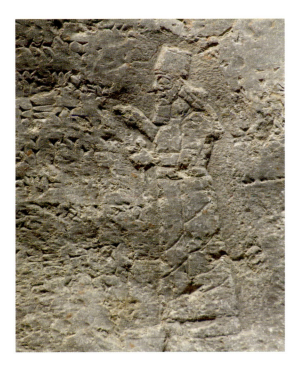

Assyrian rock reliefs are also found across the empire. In the north, kings carved images at water sources, such as the origin of the Tigris river in southeastern Anatolia [**11.15**]. To the west, the Nahr al Kalb (Dog River) reliefs in Lebanon still stand [**11.16**]. Here the Egyptian pharaoh Ramses II had already carved a series of relief steles in the thirteenth century BCE. Esarhaddon of Assyria, who conquered Egypt, added his stele-shaped relief to the left of that of Ramses II. Several other kings of Assyria had reliefs carved here also. They were followed in this practice at Dog River by Babylonian, Hellenistic, and Roman emperors, Islamic rulers, and by the French emperor Napoleon III in 1861. Steles continued to be added until the end of the twentieth century CE.

Left
11.15 Mouth of Tigris relief, lower cave wall, Birkleyn, Turkey, 1114–1076 BCE

Above
11.16 Rock reliefs at Nahr al Kalb, Lebanon, photograph from a postcard, early 20th century CE

Cylinder Seals

Cylinder seals of the Neo-Assyrian period were often made of such stones as serpentine, jasper, chalcedony, and carnelian, and by the end of the ninth century BCE the designs began to be cut with a cutting wheel and drill. Some of the mythical imagery from earlier periods continued, but new themes and iconography, similar to the scenes on large-scale relief sculptures of the time, were also introduced. The finest seals often featured the same modeling and emphasis on musculature of genies and griffins that is familiar from the carving styles of the palace reliefs.

Worshipers before images of divinities mounted on their sacred hybrid beasts, similar to those on the rock reliefs, is a major theme of Assyrian cylinder seals too, showing that some of the standard seal iconography changed in this era. Whereas freestanding steles depict the king under astral symbols (see p. 260), seal carvings show that the anthropomorphic cult statue was central to religious ritual, and could too be represented with astral symbols above the scene. A carnelian seal depicts a ritual scene in a symmetrical composition that is reminiscent of the palace reliefs [11.17]. A central sacred tree is flanked by fish-cloaked apkallu, a worshiper, and a heroic hunter grasping an ostrich; a winged disc of Assur hovers over the scene. The stone for these seals was imported from the west of India.

On another carnelian seal from the Pierpont Morgan Library we see a male worshiper standing before divinities [11.18]. A male bearded god standing upon a dragon holds the double-wedge emblem of the god Nabu, the god of writing. The dragon is the creature associated also with his father, Marduk. There is also a female deity, surrounded by a nimbus of sparkling stars, standing to the right. The worshiper stands to the left with his hands raised in prayer. Above him, seven globes represent the rising of the constellation of the Pleiades, which coincided with the time of the harvest. In the field above the anthropomorphic gods is a smaller god surrounded by a nimbus of stars.

11.17 Seal with hero grasping ostrich, fish *apkallu* flanking sacred tree, unknown provenance, 701–601 CE. Carnelian, h. 1½ in. (3.7 cm)

11.18 Seal with worshiper standing before the gods Nabu and Ishtar. Unknown provenance, 9th/ early 8th century BCE. Carnelian, h. 1¾ in. (3.9 cm)

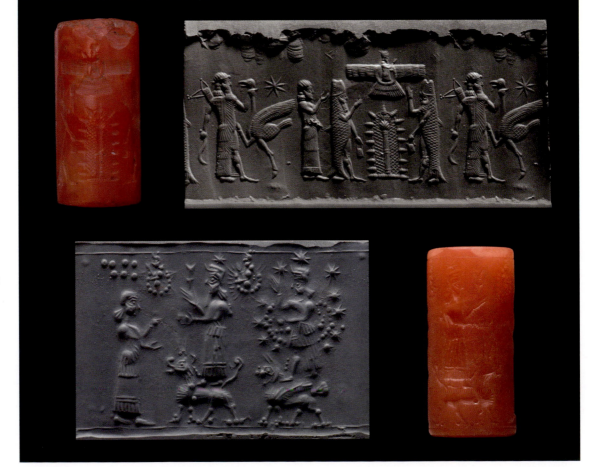

A steatite seal is inscribed with the name Bel-taklak, an Assyrian governor of Isana, a town south of Assur, but it was dedicated as a gift to the goddess Hera at her temple in the island of Samos in eastern Greece [11.19]. An Assyrian seal of blue chalcedony with a bronze mount was also found in the Temple of Hera [11.20]. It depicts a bearded worshiper between the cult images of Ishtar—the goddess of love and war—on a platform, and Adad the storm god, who stands on a bull; a winged sun disc floats above the scene.

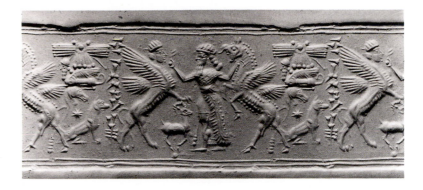

A green garnet cylinder seal carved with exceptional skill also depicts Ishtar, although here her strength as a warrior is stressed as she wears battle gear and stands upon her lion [11.21]. Her association with the date palm is an ancient connection with fertility that goes back to her first incarnation as the goddess Inanna in the south of Mesopotamia. The crown is a representation of the goddess as the planet Venus, the evening and morning star; thus the astral and the anthropomorphic are merged into one image. Green garnet was a very rare material, imported from the area that is now Pakistan.

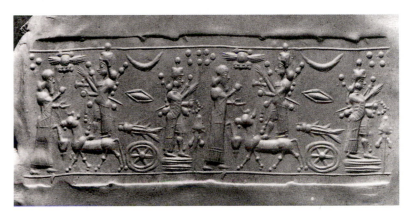

After the fall of Assyria in 612 BCE, the iconography and rhetoric of empire was taken up, transformed, and adapted by the dynasties that followed. The names of the last kings of Assyria became legendary as the fall of the empire became an instructive historical tale of the evils of despotism and corruption. Later peoples attributed its demise—especially the sack of the great city of Nineveh—to divine retribution meted out for Sennacherib's sacrilege in attacking Babylon, as well as for the series of military incursions into Israel. Sardanapallos, the Greek name for Ashurbanipal, was described in Classical Greek and Roman historical texts as decadent and concerned only with his life of luxury, a theme that was to become very popular in the arts of nineteenth-century Europe, when Assyria again rose to prominence, this time as an area of archaeological exploration and collection.

In the next chapter, we shift our focus once again to the south of Mesopotamia, where Babylon became the imperial center of a new dominant power after the fall of Assyria.

Top
11.19 Seal impression with hero battling griffin and sphinx; seals found in the Temple of Hera at Samos, Greece, Neo-Assyrian, c. 700 BCE., h. 1⅝ in. (4 cm)

Above
11.20 Seal impression with worshiper and gods; seals found in the Temple of Hera at Samos, Greece, Neo-Assyrian, c. 700 BCE, h. 1⅝ in. (4.2 cm)

Left
11.21 Seal depicting worshiper in front of Ishtar, unknown provenance, c. 720 BCE. Green garnet, h. 1⅜ in. (4.3 cm)

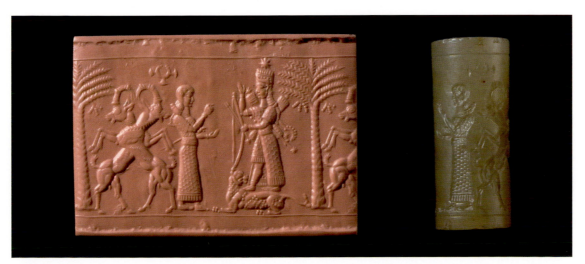

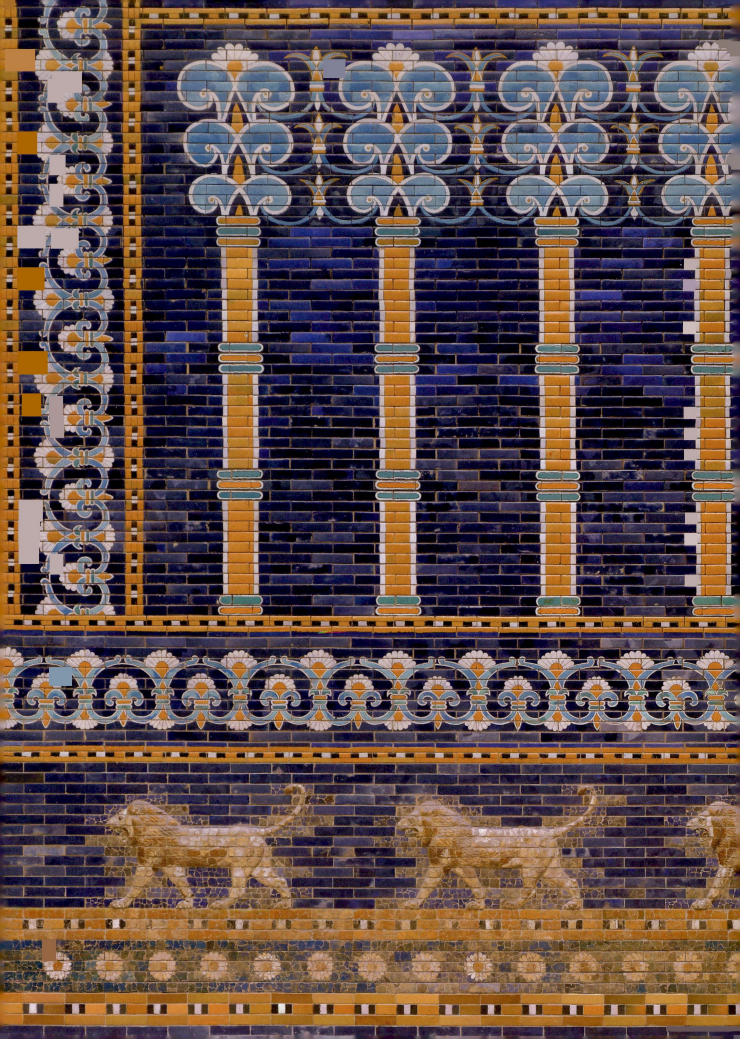

CHAPTER TWELVE

Babylonian Art

Lion procession and stylized palm trees, detail from throne-room wall, Palace of Nebuchadnezzar II, Babylon, Iraq, 604–562 BCE. Glazed terra-cotta bricks, approximately 46 ft. (14 m) high.

12 Babylonian Art 1000–539 BCE

Periods	Neo-Babylonian dynasty 626–539 BCE
Rulers	Nabopolassar r. 626–605 BCE Nebuchadnezzar II r. 604–562 BCE Nabonidus r. 555–539 BCE
Major cities	Babylon, Sippar
Notable facts and events	Nebuchadnezzar II captures Jerusalem in 597 BCE; destruction of the temple in 587 BCE; Jewish exile in Babylonia; Fall of Babylon 539 BCE
Important artworks	Esagila sanctuary of Marduk The Ishtar Gate Processional Way reliefs Etemenanki ziggurat
Technical and stylistic developments in art and architecture	Architectural sculpture: enormous wall reliefs are made with molded glazed bricks Increasing use of stamp seals

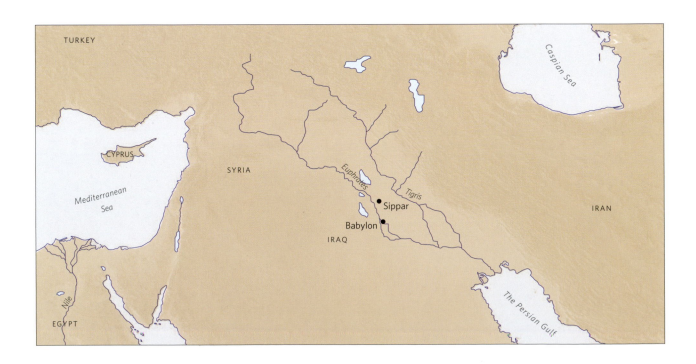

12 Babylonian Art

The legendary city of Babylon, described in the Bible and by ancient Greek and Roman scholars, is the city that stood in the era of the Neo-Babylonian Empire (626–539 BCE). In Akkadian, the city was called Babili, meaning the Gate of the Gods, and it had already been a major capital more than one thousand years earlier. During the reign of Nebuchadnezzar II (r. 604–562 BCE), the city was reconstructed in a glorious fashion, making it the magnificent metropolis of historical renown. Babylon had already long been described in Mesopotamian literature, including poetic descriptions of the city as a gemstone suspended from the neck of the sky. According to ancient Greek historians, the extraordinary walls of Babylon were among the wonders of the ancient world. The technique of glazed-brick relief sculpture was developed into a monumental form for the shining **polychrome** walls and gates of this magnificent city, and it was these walls that acquired legendary fame. Sculpture and other genres of the visual arts took on a distinctive character in Babylonia, especially in the way that these works drew upon the past for images, iconographies, and genres of steles in order to create a new version of Babylonian royal art for the present. Assyrian artists had invented new approaches to realistic narrative scenes of war and hunt. They had developed complex new forms of extensive open compositions, and experimented with repeating rhythmic patterns within these works. They had also created powerful, distinctively Assyrian forms of imperial monuments. Rather than looking to the new or to the impressive example of Assyria in the north, Babylonia instead reached into its own history as a source of cultural capital and for traditions of representation anchored in the past.

During the final years of Assyrian rule, Babylon arose as an independent kingdom, pulling itself away from the Assyrian hegemony over the land. After several contenders to the throne of Babylon, Nabopolassar (r. 626–605 BCE), a member of the Chaldean tribes who had long contested Assyrian rule over Babylonia, became the successful ruler of the new dynasty at Babylon, which became the center of a new dominant power after the fall of Assyria in 612 BCE. His successor, **Nebuchadnezzar II** (r. 604–562 BCE), began a major building program in Babylon. He is also the king who infamously captured Jerusalem in 597 BCE during a campaign initiated to control the western territories in general. Nine years later, after the puppet ruler of Jerusalem, a local king installed by Nebuchadnezzar II, rebelled, the Babylonian armies returned and an eighteen-month siege began, at the end of which Nebuchadnezzar II destroyed the Temple and deported thousands of its people, as well as Zedekiah the king of Judah himself, resettling them in Babylonia. This deportation became remembered as one of the most traumatic events in Jewish history. This phase of Babylon's history is given the modern designation the **Neo-Babylonian** Empire.

Babylonian Sculpture: Looking to the Past

Even during the era of the Assyrian control over Babylonia, the visual arts of the south had maintained their own traditions and forms within the larger context of Assyrian imperial visual culture. The Babylonians emphasized the age-old traditions in several ways. The urge to look to antiquity for forms of monuments and cult statues was often framed in religious terms and regarded as a way of discovering more authentic primordial images and iconographies. We can clearly see this desire and explanation at work in the fascinating case of the renewal of the image of the sun god, Shamash, for his main temple in Sippar.

12.1 Shamash tablet, from E-Babbar Temple, Sippar, Iraq, 887–855 BCE (reign of Nabu-apla-iddina). Gray schist, h. 11½ in. (29.2 cm)

According to the written text on a stone tablet [**12.1**], sculpted with a scene in relief at the top, the image of the god in Sippar was restored correctly, according to the direct visual evidence from an ancient archaeological discovery. The ninth-century text explains how a chance find of an ancient clay image of the god Shamash, hidden in the ground by the river bank, permitted the restoration of the lost cult statue of this god in his main city of Sippar. The original cult statue, which had resided in the E-Babbar Temple of the sun god here, had been destroyed some two hundred years earlier during a war. While the statue was missing, it was replaced as the focal point for the cultic rituals by the sun disc, an abstract astral symbol. King Nabu-apla-iddina (r. 887–855 BCE) decided

to have the cult statue of Shamash restored in its original form, and in the thirty-first year of this king's reign the new statue was completed and placed in the temple.

This revival of the anthropomorphic statue of Shamash is recorded on the stone foundation tablet that was buried in the Shamash temple until it was discovered in the nineteenth century of our own era. The rectangular tablet is covered with a long inscription on both front and back. At the top of the obverse side, a scene carved in relief represents the event of the exchange of the divine sun disc for the cult statue. Both these images, sun disc emblem and anthropomorphic form, were valid forms of the presence of the divine in the worldly realm, and both forms are known in the earlier millennia of Babylonian religious images. The exchange depicted in the relief occurs at the same time as a presentation scene in which Nabu-apla-iddina, standing between a priest and an interceding lama goddess, is brought to the entrance of a sacred space. A throne-like altar stands before them and from its seat a large sun disc is being hoisted up with a rope by divine attendants. On the right side is the cult statue of the god Shamash. According to the detailed text, it is made out of lapis lazuli and gold. Shamash wears the multiple horned crown and the tiered fleecy garments of antiquity, while he holds the rod and ring of power in his right hand. His throne is supported by two bull-men, sacred to the god of the sun. Above the god's head is an identifying inscription and three emblems of Venus, the moon, and the sun—Ishtar, Sin, and Shamash.

12.3 Clay molds from the Shamash tablet, from Sippar, Iraq, c. 620–610 BCE (reign of Nabopolassar). Fired clay, h. 6⅞ in. (17.5 cm)

The god statue is placed within an architectural space, separating him and setting him apart in space by means of a column surmounted by a **capital** with **volutes** on either side. His image is depicted in a deliberately archaizing style that references images of the late third and early second millennia BCE, and the entire scene takes the form of a traditional presentation scene of a type that was known especially from compositions on cylinder seals and kudurrus.

Yet the ancient story of the Sippar tablet does not end there. The stone tablet was found buried in a foundation deposit in a pottery box of a later era [12.2]. The box bears an inscription of King Nabopolassar of Babylon, who ruled more than two centuries later. When, during restoration work at the temple, his workmen discovered the tablet in the foundation deposit, it was carefully studied and replaced. The Neo-Babylonian king had clay casts of the stone tablet made [12.3], marked one on the reverse with his own inscription so that future discoverers would not confuse it for an object made earlier in time, and placed everything into the box before he returned it to the ground. It was eventually found in 1881, by the Mosul-born archaeologist Hormuzd Rassam, who was then working for the British Museum. These kinds of activities, recorded by both archaeological context

12.2 Ceramic box of Shamash tablet, with Nabopolassar inscription, from Sippar, Iraq, 620–610 BCE. Ceramic, 15½ × 19 × 7 in. (39.4 × 48.3 ×17.8 cm)

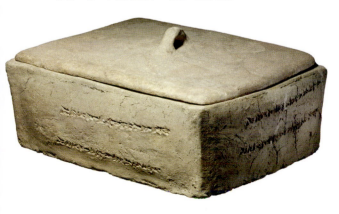

and text, present solid evidence for the Babylonian concern with preserving the past.

The Neo-Babylonian interest in the past is also a feature of the reigns of Nebuchadnezzar II and Nabonidus (r. 555–539 BCE): Nebuchadnezzar II restored temple walls of the mid-second millennium BCE, walls that were already 750 years old at the time, while Nabonidus restored buildings from the reign of Hammurabi, already 1200 years old, and architectural remains as early as the reign of Naramsin of Akkad (r. 2254–2218 BCE). These activities are described by the kings as pious acts of preserving the traces of the past, the works of great kings and dynasties that came before them and with which they aligned themselves as the inheritors of that ancient

12.4 Kudurru of Marduk-apla-iddina II, unknown provenance, dated to year 7 of the reign of Marduk-apla-iddina, 715 BCE. Black marble, h. 18 in. (45.8 cm)

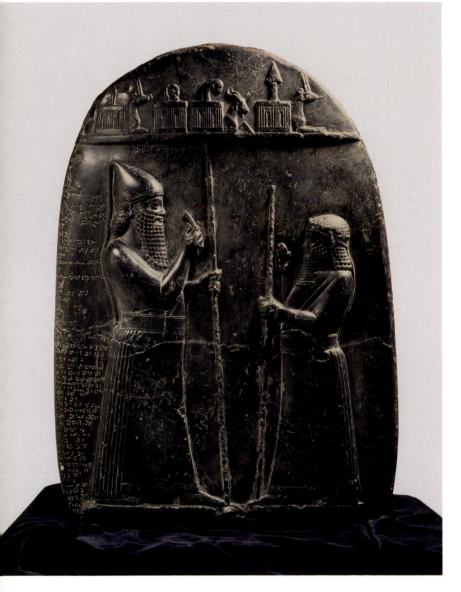

legacy. These Babylonian activities and the written accounts that describe them are among the world's first clear records of an archaeological consciousness or archaeological approach to the past.

The distinctive kudurru monuments of the **Middle Babylonian** Kassite era—roughly rounded inscribed stone steles sculpted with images in relief (see pp. 208–11)—continued to be utilized to commemorate land transfers in Babylonia. Gifts of land were given to vassals of the king to secure their loyalty, and were guaranteed both by the written text and the visual image. In a black marble monument with a rounded top [**12.4**], the king Marduk-apla-iddina II (r. 721–711 BCE) grants land to an official by the name of Bel-ahhe-eriba. The king stands on the left holding a large staff of office. He wears a pointed royal headdress with a long ribbon that falls down his back and a Babylonian belted tunic with many folds at the side. The recipient stands on the right, holding a smaller staff and raising his hand in deference to the king. He is dressed in a similar garment. Both figures are depicted in complete profile, each with one shoulder receding into the pictorial space and their feet placed on a solid ground line below. The sculptor has abandoned the mixed profile views that were favored especially for royal images or for archaizing images of the gods in earlier eras. A separate register above bears a row of gods represented in their symbol forms, placed on altars out of which their divine animals also emerge. These gods are (from left to right) Marduk, Nintu, Ea, and Nabu, and further gods are depicted on the other side of the kudurru. They oversee the legal transaction, which is recorded in a long text carved on the sides and back of the monument.

Monuments made in the Babylonian tradition and with southern Mesopotamian iconographies were not only commissioned by the rulers and elites of Babylonia, but also by Assyrian kings who, despite the innovative dynamic narrative representation of their palace sculptures, still revered Babylonian traditions. Indeed, Babylonian literary, artistic, and religious traditions had long been admired in Assyria. Babylonian texts and

scholarship were studied by Assyrian scholars who were connected with the courts of the kings, and collected in their libraries (see chapter 10, p. 248). During the time of the Assyrian hegemony, the great Assyrian king Ashurbanipal dedicated a relief stele inscribed with a long text in the Esagila temple in Babylon [**12.5**]. The text commemorated the restoration work he commissioned there at the shrine of the god Ea, god of wisdom, within the Esagila sanctuary. On this small and thickly formed stele with an arched top, we see a frontally portrayed image of the king, who holds a basket of earth for making and laying the bricks. While he wears the attire and royal crown of Assyria, he is at the same time the builder-king of antiquity, referencing ancient images of correct rule. The royal representation echoes the foundation deposits of the late third millennium BCE, where the ruler takes the form of a foundation figurine, a laborer for the day, placing the first brick. Such ancient figurines were no doubt discovered in excavations of the first millennium and during restoration of architectural works and sanctuaries, leading to a renaissance of these images in the Neo-Babylonian era.

Three kings held the throne of Babylon in quick succession after Nebuchadnezzar II's reign ended. Nabonidus was the fourth. He was the son of Adad Guppi, priestess of the moon god at Harran in northwest Mesopotamia (southeast of Urfa in modern Turkey). He paid special attention to the moon god, but he also worshiped the gods who were prominent in Assyria, leading historians to believe that his background was in part Assyrian. Like Ashurbanipal, Nabonidus claimed that he was very literate and learned. He considered himself to be a scholar, was actively involved in intellectual endeavors, and had strong antiquarian interests in preserving ancient sculptures.

A basalt stele said to be from Babylon probably represents Nabonidus standing in prayer before the emblems of the crescent moon god Sin, Shamash the winged sun disc, and Ishtar who was associated with the planet Venus [**12.6**]. The emblem of the god Sin, a crescent moon, is placed closest to the body of the king and is

Below left
12.5 Ashurbanipal Kudurru, from the Esagila temple, Babylon, Iraq, 668–655 BCE. Marble, h. 14 ½ in. (36.8 cm)

Below
12.6 Nabonidus stele, Babylon, Iraq, 559–539 BCE. Basalt, h. 22⅞ in. (58 cm)

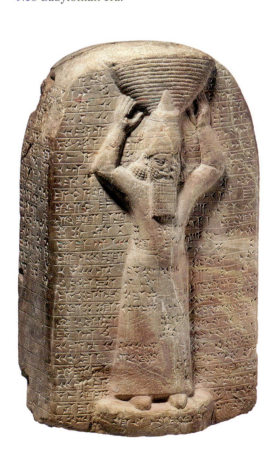

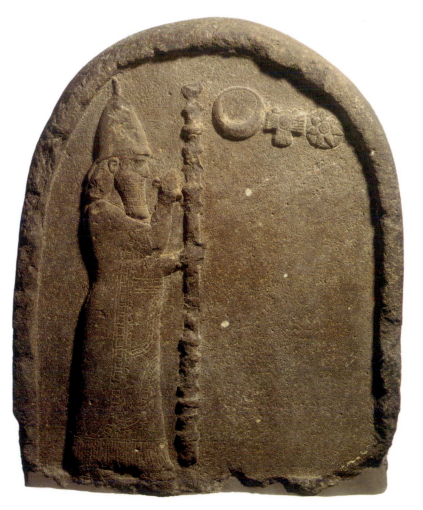

larger than the other two symbols. Otherwise, the stele form adheres to the type of Assyrian arched-top royal stele in which kings are shown standing in profile, with the astral emblems of the gods above. The king in this image wears the traditional Babylonian dress and holds a staff. Although part of the text is erased, comparisons with another stele—the Harran stele, now in the Urfa Museum—indicates that it is Nabonidus. In the latter stele the king stands before three astral symbols, the crescent moon closest to him, and carries a large staff [12.7]. The long text below the arched inset scene identifies the king as Nabonidus. As he was a usurper of the throne, Nabonidus was not of the family of Nebuchadnezzar II and Nabopolassar. His son was Belshazzar, who was in charge of Babylon while his

12.7 Nabonidus Harran stele, Harran, Turkey, 559–539 BCE. Basalt

father was away at Harran. It was then that he was defeated by **Cyrus the Great** the Persian, aided by the priests of Marduk; the Marduk priesthood felt that the royal house had become sacrilegious and that Marduk, the supreme Babylonian god, had been neglected by the king.

Babylon: The City as a Work of Art

The Neo-Babylonian period was an era of great prosperity for Mesopotamia. Nebuchadnezzar II used the enormous wealth of the empire to renovate and rebuild the city of Babylon. The Babylon best known by historians, the remains of which still stand today, is the city as it was reconstructed by Nebuchadnezzar II and his predecessor, Nabopolassar [12.8, 12.9].

This new city of Babylon was so large—covering 2,225 acres (900 ha)—that no other city came close to its size in antiquity until the construction of imperial Rome six hundred years later. It stood upon both the east and the west banks of the Euphrates river. The inner city, covering a space of about 1 sq. mile (2.75 sq. km), contained the main public buildings, the royal courts, and the temples. The Babylonians thought of this center as the heart of the universe, a world they depicted as a flat disc surrounded by the Salt Sea (**1.7**, see chapter 1, p. 22).

The city was surrounded by three lines of walls enclosing the outer triangle, and three lines of walls enclosing the inner city, where sections of them can still be seen today. They were so wide as to permit a four-horse chariot to ride on top of them, according to the Greek historian Herodotus, who claims to have seen Babylon himself. These walls were counted among the seven wonders of the ancient world in early versions of the list. Eight monumental gates permitted entrance into the inner city, the most important of them being the Ishtar Gate [**12.10**, see pp. 280–81]. This was not just a portal but also effectively a massive **propylon** (monumental gateway building) in the center of the northern wall of the inner city. The Ishtar Gate had a more important role in the cultic calendar than the other gates, as it was the entrance into the city during the New Year festival

12.8 Map of Babylon, 6th–5th century BCE

The name of the city, Babili, means Gate of the Gods. In its Greek form it was called Babylon. The name Babil continued to be used by local people for this site, and has survived to this day in the modern name, Babil.

that took place at the spring equinox every new year. (In Akkadian it was called the **Akitu** Festival.) A few days before this festival, the cult statues of the gods were taken out of the city for one night. On the festival day they came back to Babylon, entering by way of the Ishtar Gate with great pomp and celebration, involving all the gods and the royal court of Babylon. The king had to meet the anthropomorphic statues and welcome them when they came in, before they continued along the processional way to the Esagila sanctuary of Marduk, where more aspects of the ritual took place, thus turning the entire city, its gates, and roads into a space where the sacred entered into the world. The name of the city—Babili, the Gate of the Gods—illuminates the sacred nature of this location for the annual re-entry of the gods into the space of life.

The Ishtar Gate [**12.10**, see pp. 280–81], which stood 50 ft. (15 m) high, was a double-gate propylon building. It had a gate in the outer wall and a gate in the inner wall of the city, with

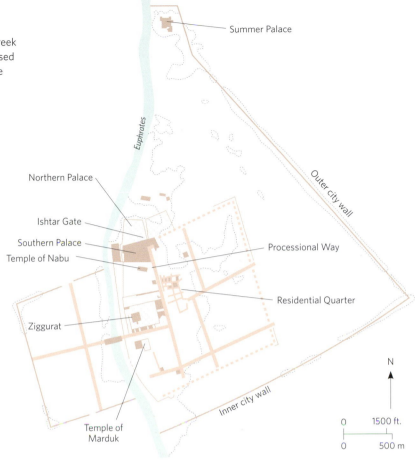

Below **12.9** Photograph by Robert Koldewey of excavations at Babylon, Iraq, *c.* 1902 (see also p. 26)

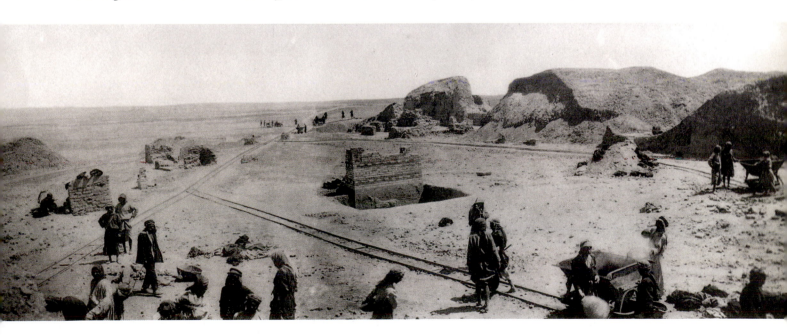

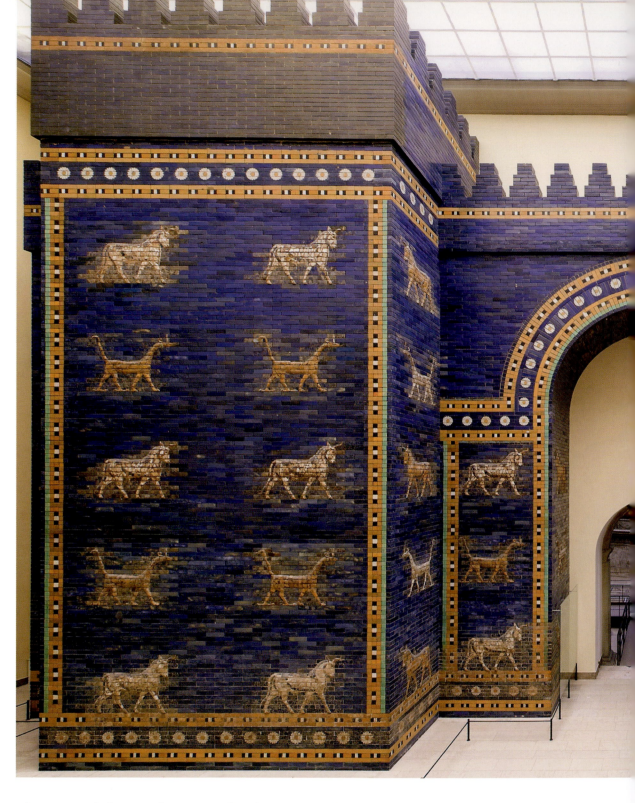

12.10 The Ishtar Gate, from Babylon, Iraq, reign of Nebuchadnezzar II, 605–562 BCE. Glazed terra-cotta bricks, h. 46 ft. 11 in. (14.3 m)

a long passage in between that measured 157 ft. (48 m). One first entered into an antechamber, then an elongated chamber or passageway in the inner wall of the city. The gate was faced with glazed brick reliefs of approximately 575 bulls and dragons in alternating rows, depicted in yellow and ocher, dark blue, brown, and white on a lapis lazuli blue background. Two massive towers protected the passages from the outside. Its doors were made of cedar and had bronze fittings, and all the thresholds were also made out of metal. The bulls of the storm god Adad and the mushhusshu dragons of the god Marduk stood out in molded brick relief work from the

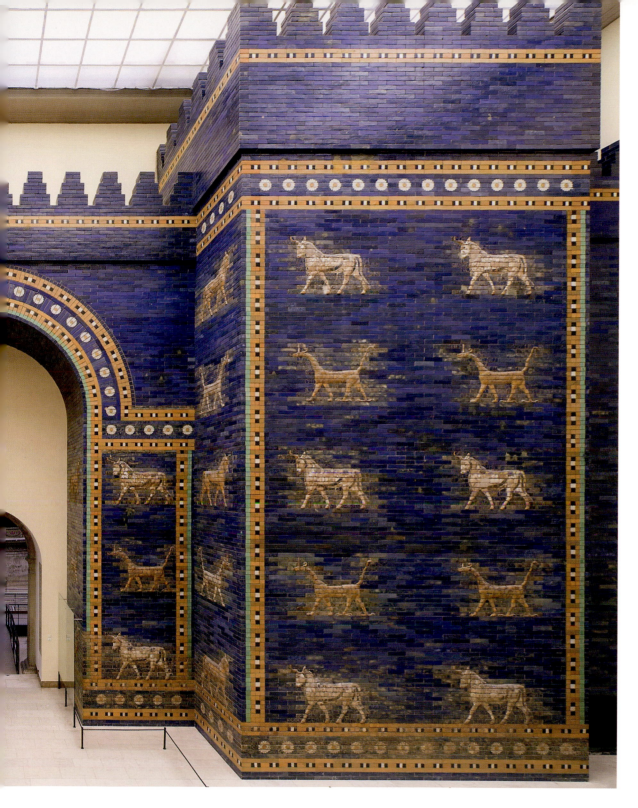

glazed bright blue background. The divine beasts placed on the walls of the gate were intended to ward off evil and to keep away enemies. Below this glazed brick level was a large expanse of wall with more reliefs of divine beasts. These reliefs were no longer visible when the polychrome bricks were added above them in the next building

phase, as the ground level rose higher over time. Here too there had already been brick reliefs with striding bulls and dragons covering the walls [**12.11**, see p. 282]. The unglazed wall reliefs are also remarkable as they embed the figures of these magical beasts, hiding them within the brickwork so that they seem to emerge from the

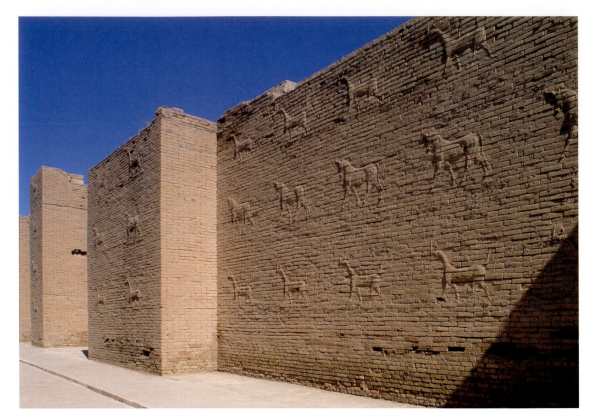

12.11 The *mushhusshu* dragons of Marduk and bulls of Adad at the Ishtar Gate Propylon, Babylon, Iraq, 605–562 BCE. Molded brick relief

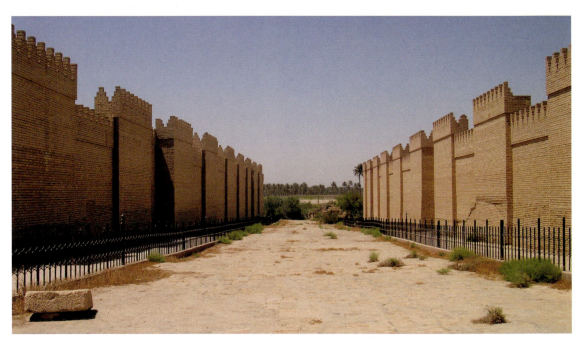

12.12 The Processional Way, Babylon, Iraq, photograph taken in 2004

wall, as if they were woven within the fabric of the brick itself. Although not glazed, the beasts are impressive in their own way as they seem to have an organic quality, emerging naturally from the clay of the bricks to protect the city. Indeed, the original name of the gate was "Ishtar is the one who defeats her enemies."

The Processional Way, a long road on a north–south axis through the heart of the city [12.12], ran past the Southern Palace and the temples of Ishtar

and Nabu, then approached the ziggurat and the Esagila sanctuary of Marduk. It was approximately 2625 feet, about half a mile (800 meters) long. To the north it passed through the Ishtar Gate and led to the Akitu House outside the city where the gods spent the night before re-entering the city along the same road. For at least 600 ft. (180 m), the Processional Way beyond the Ishtar Gate had walls decorated with a glazed brick frieze of lions [12.13], the animal associated with the goddess Ishtar, and even the paving of the road here was colored stone. The lions, depicted like the beasts of the gate upon a bright blue glazed brick background, were framed above and below by a border of white and gold rosettes, encased within linear bands of dark and light stripes resembling agate insets in a gold border. The striding lion's paws emerge in very high relief from their golden ground line and seem ready to pounce into the space of the procession. They are in constant movement, protecting the road of the Processional Way.

There were fourteen different sanctuaries at the heart of the city and another twenty-nine throughout the rest of the outer city. The sacred precincts of Babylon were all centered on the ziggurat, called the Etemenanki (a Sumerian name, meaning "Home of the Foundation Platform of Heaven and Earth"), the famous Tower of Babel mentioned in the Bible [12.17, see p. 285]. This was a massive structure with a base covering 980 sq. ft. (91 sq. m). In elevation it was a seven-story stepped pyramid with a flat top, where Nebuchadnezzar II had dark blue glazed bricks adorn the surface so that it appeared to merge with the blue of the sky. The Marduk temple next to it, called the Esagila ("House Whose Top is High"), was already in existence in 1850 BCE and was recorded as still standing in 100 CE. The god Marduk, the patron deity of Babylon, resided here, and this was where he held court as the supreme king of the gods. His paramour, Zarpanitum, also lived in Esagila in a suite called E-hal-anki ("House of the Mystery of Heaven and Earth"). Here also was located the "Pure Hill," the place that according to myth had emerged from the primordial sea, the first appearance of solid ground and thus the place of the start of creation.

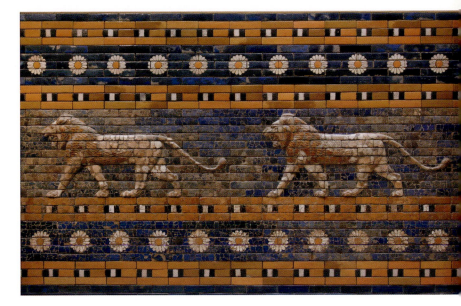

The god Nabu, son of Marduk and Zarpanitum, arrived for the Akitu festival in Babylon by barge from Borisppa, 12 miles (20 km) southwest of Babylon, where he had his permanent residence. His boat docked on the east bank of the Euphrates at the Red Gate quay. From there, he entered the city the following day for the festival and went to the Esagil, where he and his father sat on a gold-plated platform called the Dais of Destinies. There they brought order to the cosmos and were honored and praised by the gods.

Two main palaces stood near the Ishtar Gate. The old palace, the Northern Palace, had been built by Nabopolassar but was abandoned by Nebuchadnezzar II for a new palace, the Southern Palace [12.14, 12.15, 12.16, see p. 284]. The older building (Northern Palace) continued to be used as the residence for the foreign kings who became permanent guests after they were deported to Babylon when their lands were conquered and became provinces of the empire. Jehoiachin of Judah, for example, lived here in 597 BCE along with his retinue. The new palace of Nebuchadnezzar II, the Southern Palace, was built on a large rectangular plan, wider on the eastern side, that contained a series of five main open courtyards surrounded by numerous rooms and massive external walls. It was an enormous building, even by today's standards, measuring 355 by 240 yards (325 by 220 m). The throne

12.13 Lions and rosettes, detail from the Processional Way, Palace of Nebuchadnezzar II, Babylon, Iraq, 575 BCE. Clay brick with colored glaze

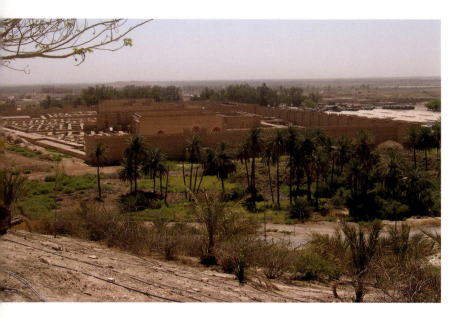

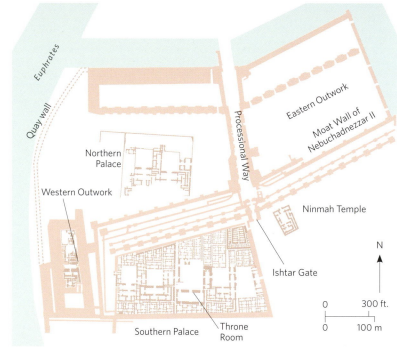

and all were framed by rosettes and bands of gold inset with agate-colored strips. As the king sat on his throne dais with such a wall gleaming behind him, the effect must have been spectacular.

Among the objects found in the Southern Palace were statues and monuments from earlier eras and faraway places, demonstrating further the late Babylonian interest in past history and its preservation. These ancient objects include two statues of Puzur-Ishtar of Mari [**6.14**, see p. 152], a man who ruled that Syrian city *c.* 2000 BCE. These statues were thus already about 1500 years old at the time that they were used in the palace of Nebuchadnezzar II, and may have arrived in Babylon centuries earlier, perhaps even during the time of Hammurabi in the early second millennium BCE. Other ancient and foreign objects here included a stele of a Syro-Hittite storm god from *c.* 900 BCE, perhaps taken from Aleppo; several bowls with Hittite inscriptions; a stele of a Shamsh-risha-usur from *c.* 710 BCE; and the Lion of Babylon, a monument of uncertain age and origin found in the Ottoman era. It is a large basalt monument carved in bold simple lines showing a lion trampling on the body of a defeated enemy [**1.9**, see p. 25].

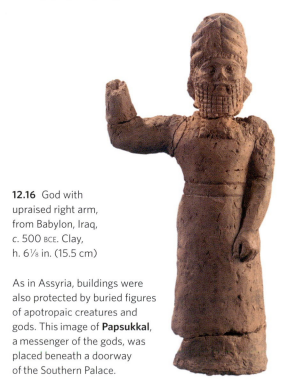

Top
12.14 Palace of Nebuchadnezzar, photograph 2004

Above
12.15 Plan of Nebuchadnezzar's Southern Palace

room was in the area to the south of the central court, with a 184 ft. (56 m) facade that had three entrances, the middle one leading to the throne. Here, too, glazed brick reliefs decorated the high walls. In the throne room, a brick facade followed the scheme of blue background covered with images (pp. 270–71). A row of striding lions was surmounted by a series of stylized palm trees in gold and turquoise blue. These trees were surrounded by a design of interlaced palmettes

12.16 God with upraised right arm, from Babylon, Iraq, *c.* 500 BCE. Clay, h. 6⅛ in. (15.5 cm)

As in Assyria, buildings were also protected by buried figures of apotropaic creatures and gods. This image of **Papsukkal**, a messenger of the gods, was placed beneath a doorway of the Southern Palace.

Babylon the Center of the World

An annotated clay map of the world from Sippar depicts the world as a flat disc floating in the ocean, called *marratu*, the "Salt Sea" in the text [**1.7**, see chapter 1, p. 22]. At the center, a rectangle is identified as Babylon, with a long curving line bisecting it, which represents the Euphrates. Babylon is shown as both the geographical and cosmic center of the world. On the outer edges of the sea are triangular zones; they are the places where mythological creatures and people from the ancient mythic-historical past reside. The central perforation remains from the pair of compasses that were used to create the perfect circles of the world. The Babylonians, like the Greek cartographers, believed that an ocean surrounded the inhabited world. The scribe—whose name is no longer visible from the text, but whose father's name survives (Issaru, descendant of Ea-bel-ili)—states that he copied this exemplar carefully from an older tablet.

Babylon was considered the *axis mundi*, or pole that holds the universe together. It was called "the bond of heaven and the underworld." This bond was further made visible in the city by means of the ziggurat, the famous Tower of Babel, which accentuated the idea of the vertical axis [**12.17**]. From afar, a visitor would have seen the city as a vast form emerging out of the waters that surrounded it as if from the primordial waters of the creation story.

The ziggurat acquired legendary fame in the Bible, where in the book of Genesis it is a symbol of the human hubris of those who tried to reach the heavens [**1.2**, see p. 19]. The Greek historian Herodotus describes its base as a square, with each side covering one stade, that is, 600 ft. (180 m), and states that the tower was eight stories high. According to a Babylonian text called the Esagila Tablet (known from a late Babylonian version of 229 BCE), the tower was as high as it was wide and was seven stories high, each stage smaller than the one below it. At the top level, the god Marduk dwelt, suspended between heaven and earth. Little remains of it today beyond a small part of the foundations.

Many ancient texts were concerned with describing the city of Babylon. Foremost among these is a composition called Tintir=Babylon by the ancient scribes. It describes the city, and its Sumerian epithets (names), which are explained in Babylonian Akkadian. This composition consists of more than sixty tablets dating from 700–61 BCE, although the text was composed hundreds of years earlier. It begins with fifty-two Sumerian names of Babylon, of which Tintir is the first name. This list of names celebrates Babylon and describes its buildings, gates, walls, landmarks, and other features, all organized according to city quarters. In the first century BCE, this list was translated into Greek, which had become the language of the elite of Mesopotamia.

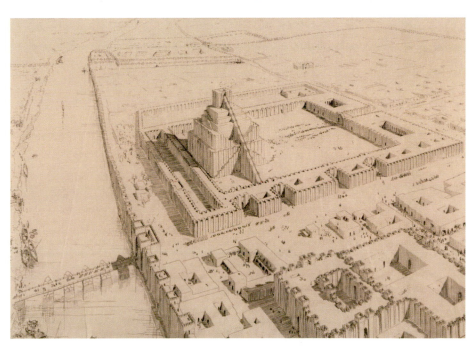

12.17 Sketch by Robert Koldewey of a view of the ziggurat and sanctuary of Marduk at Babylon, Iraq, *c.* 1910. Pen on paper

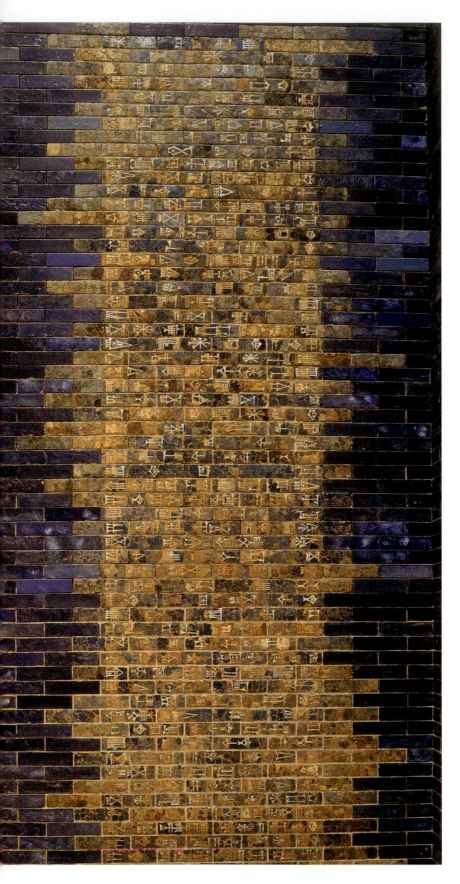

Calligraphic Texts

The superb glazed brick decoration of the walls of Babylon was not limited to figurative representations or floral patterns: it was also used for calligraphic monumental texts. A glazed brick inscription from the Ishtar Gate complex—the text that describes Nebuchadnezzar II's provisions for the Esagila and the Ezida precincts—is a remarkable example [**12.18**]. The text is in gold upon a blue background, and the bricks on their outer edges appear to merge gradually and fade into the blue. The archaizing script used for this public inscription imitates the epigraphy of the era of Hammurabi. Such monumental inscriptions are in marked contrast to inscribed stamped bricks used throughout the city [**12.19**].

Another remarkable monumental inscription of Nebuchadnezzar II records his building works, though this text was destined for the foundations of the building [**12.20**]. The commemorative text is in the shape of a clay tablet, but is much larger in size and made of stone rather than clay. The inscription looks to the past and uses deliberately archaizing epigraphic forms: the sculptors who cut the calligraphic text into the stone imitated perfectly the characters in use at the time of Hammurabi in the eighteenth century BCE, thus more than a thousand years earlier. The archaic cuneiform signs are, like the visual images, a deliberate preference for anchoring the Neo-Babylonian world in its own venerable, historical past, which was encountered in ancient things found in the ground, and which could then be copied or imitated as objects with the cultural authority of antiquity.

The East India Inscription, now named after the East India House Museum in London where it was first taken in 1803, describes Nebuchadnezzar II's pious building activities, such as the restoration of the Akitu House (the New Year's house) and the Processional Way, the Ishtar Gate, and the Southern Palace. It commemorates work on many

12.18 Panel with royal inscription, Babylon, Iraq, 605–562 BCE. Clay brick with colored glaze, height of wall panel: 47 ft. (14.3 m)

Right **12.19** Brick with stamp inscription of Nebuchadnezzar II, Babylon, Iraq, 604–562 BCE. Baked clay, h. 13¼ in. (33.5 cm)

This brick shows the use of a stamp with the cuneiform inscription cut in reverse, a method that was used to identify the bricks with the building campaign of the ruler. These texts would be stamped upon the wet clay when the brick was made. The name of the brick maker, Zabina, is written here on the side in Aramaic, a language (closely related to Akkadian) that was spoken commonly in Mesopotamia in the preceding centuries, but which started to appear in written form more often at this time. This is one of many examples of graffiti that were made by ancient brick makers and builders in Babylon.

Below right **12.20** The East India House Inscription, unknown provenance, probably Babylon, Iraq, 604–562 BCE. Stone, h. 22¼ in. (56.5 cm)

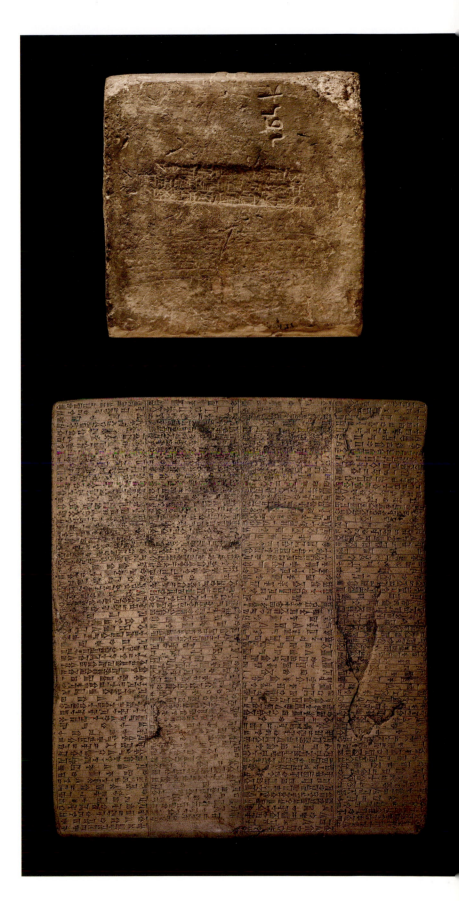

Babylonian temples and describes the works and materials in some detail. It also mentions the reconstruction of the processional boat of Marduk in some detail, giving us a glimpse into some of the sacred rites that involved the statues of the gods and their movement in the city and its environs.

Cylinder Seals

Babylonian seals differ in some respects from Neo-Assyrian works of the era of empire, when Assyria dominated over the south. More hardstones were used in Babylonia than in Assyria, and Babylonian technical expertise in carving small designs into hard stones was unequalled. Some of the designs seem to have been derived from Middle Assyrian styles of the thirteenth century BCE. Unlike other areas of sculpture, in seal carving it seems likely that Babylonian seal cutters consciously turned to these Middle Assyrian works, which were filled with lively depictions of winged creatures and heroes in creative compositions and used naturalistic modeling with intricate details, and turned away from the Kassite designs of the preceding era in the south.

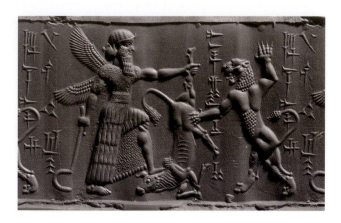

12.21 Seal with winged hero with scimitar, bull and lion, unknown provenance, probably Babylon, Iraq, 701–601 BCE. Carnelian, h. 1½ in. (3.9 cm)

A hero holding a sickle sword in his hand and battling mythical beasts, griffins, or a lion-demon is a distinctive subject in the Babylonian seal iconography. A chalcedony seal with the inscription of Marduk-apla-iddina (r. 721–710 BCE), for example, is carved with a contest between a hero and an upright lion. Such contest scenes become favored in the Persian era that was to follow the fall of Babylon.

A carnelian seal at the Pierpont Morgan Library in New York is another excellent example of its kind [12.21]. The contest is between the bearded winged hero and an upright lion-demon, who are battling over the collapsing, overturned body of a bull. The outstretched sharp claws of the lion-demon and his menacing snarl are no match for the superhuman calm certainty of the winged hero. The figures are carved with superb skill, their rounded and smooth musculature emphasized in contrast to the carefully detailed ornament of the hero's fleecy skirt and the

12.22 Seal of the god Adad, Babylon, Iraq, 9th century BCE. Lapis lazuli, h. 4⅞ in. (12.5 cm)

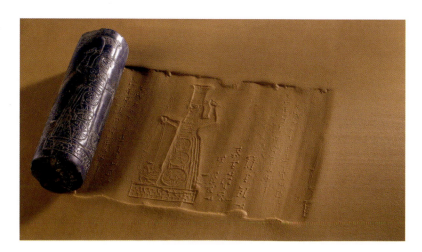

patterned fur of the lion's belly. The hero wears a pointed diadem at his forehead, which is a feature typical of such scenes. The contest scenes of Neo-Babylonian glyptic art go back to the earliest cylinder seal art, such as the Sumerian seals of the Early Dynastic era (mid-third millennium BCE; see pp. 105–7). The composition has been transformed here, however, into a duel.

The carnelian stone is carved with the owner's name: "(Belonging) to Nabu-nadin-shumi son of Ashur ... may Nabu grant (him) life." The inscription appears to have been carved after the seal was first made. Carved in relief, it can be read directly from the seal stone as a normal inscription, rather than having been carved in intaglio (in reverse) to appear with the impression. The text is also inserted into a small a space too small for it to have been planned as part of the original composition. The seal was, therefore, most likely reused by Nabu-nadin-shumi as a votive object long after it was first carved.

A cylinder seal of lapis lazuli found in Babylon is carved with an image of the storm god Adad, who is depicted as a long-haired and bearded figure wearing a tall crown, and wielding a thunderbolt in each hand [12.22]. Three discs with star-shaped patterns are arranged on the front of his Babylonian-style garments, and smaller star discs embellish his upper body. With his left hand, Adad also holds a leash that is tied to a lion griffin and a bull. The image of the god indicates how cult statues appeared in the first millennium BCE.

The seal is unusual in its large size and also in its inscriptions, which were added at three different times. The main text reads "Seal of

the god Adad." At some point later, a second inscription was added that says, "Treasury of the god Marduk ... from the Esagil Temple." It was found among a group of objects, ornaments, jewelry, and precious stones that had been collected in baskets in antiquity between the Etemenanki and the Esagil sanctuaries. The seal stone had a long history before it was placed in this collection for the god. After its creation in the ninth century for Adad, it was stolen, along with other objects from the Marduk temple treasury, in the seventh century by Sennacherib, the Assyrian king. His successor, Esarhaddon, then brought it back to Babylon as an act of conciliation in order to placate the Babylonian gods. It was then that the third inscription was added to the seal, the text of Esarhaddon, dedicating the seal to the supreme Babylonian god, Marduk. The lapis lazuli cylinder is in the shape of a seal with a longitudinal perforation, but it is not likely to have been used as one. As it was much larger than a normal seal, and carved in relief rather than in intaglio, it was instead perhaps worn by the cult statue of Adad.

During the late Babylonian era, stamp seals became more popular and were made from such stones as chalcedony, often cut as a small prism with a rounded top and a flat bottom that was engraved with a scene in intaglio [12.23]. Often these seals depicted a worshiper or a priest standing before an altar carrying the symbols of the gods, similar to those known from the Kassite kudurru monuments. The change to stamp seals reflects the change in writing practices at this time. During the first millennium BCE the increasing use of Aramaic,

written on parchment, gradually replaced clay text in cuneiform. Documents were folded or rolled up in scrolls and tied with a string. The knot was then secured with clay and stamped with a seal.

Older was better for the Babylonians, both in their artworks and in other areas of Babylonian culture. When ancient artworks were discovered they were preserved. We learn from a text that Nabonidus's workmen had found a statue of Sargon of Akkad and set it up in a temple, where it was provided with regular offerings. When temples were restored, their earliest foundations were identified and preserved, indicating that something similar to modern scientific archaeology was already in place. Nabonidus states that his predecessor Nebuchadnezzar II's work in Sippar had failed to find the original foundations so he continued to work there until a foundation deposit of the Akkadian era was found, allowing the temple of the sun god Shamash to be rebuilt properly. Nabonidus and his scholars determined that Naramsin, whose foundation deposit was discovered, had ruled 3,200 years earlier. Although this was a miscalculation, it reveals that the great antiquity of the land was understood by the Babylonian scholars. In their scholarship and archaeological concerns, as in their works of art, they saw themselves as belonging to an age-old tradition, studying, copying, and adding comments to ancient manuscripts, collecting and recording antiquities that they found in the ground. The innovative and forward-thinking scholarship of the Babylonians was much admired in antiquity, in both East and West. It was their advanced mathematical and astronomical knowledge that led to the development of those sciences in the Persian and Hellenistic eras that were to follow. The Persians, Greeks, and Parthians did not interrupt Babylonian scholarship but continued to sponsor and support it as a venerable tradition; thus Babylonian culture continued long after the fall of Babylon in 539 BCE to Cyrus and his Persian armies. The Persians were to take up both Babylonian and Assyrian traditions and reunite them into a new visual rhetoric of empire that would change the ancient world.

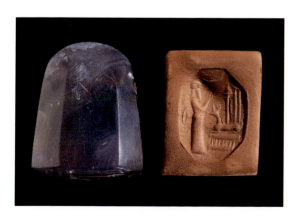

12.23 Seal with worshiper before altar with *mushhushu* dragon and divine emblems. 6th century BCE. Chalcedony, h. 1¼ in. (3.3 cm)

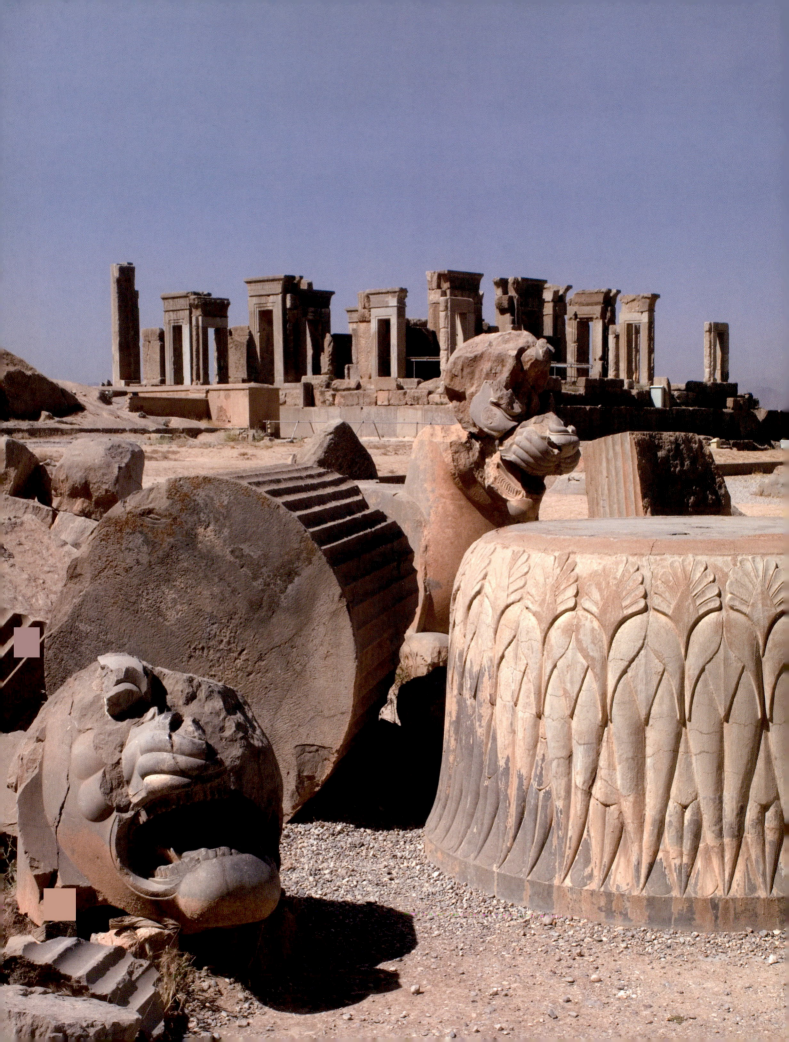

CHAPTER THIRTEEN

Achaemenid Persian Art

Persepolis, Iran; view of the Apadana
(audience hall) with the Palace of Darius I
in the background, 522–425 BCE

13 Achaemenid Persian Art 559–331 BCE

Rulers	Cyrus the Great r. 559–530 BCE
	Darius I r. 521–486 BCE
	Xerxes I r. 485–465 BCE
	Artaxerxes I r. 464–423 BCE
	Artaxerxes II r. 404–359 BCE
Major cities	Babylon, Pasargadae, Persepolis, Susa
Notable facts and events	At its height, the Achaemenid empire includes Iran, Mesopotamia, Syria, Egypt, Asia Minor and its Greek cities, Thrace, parts of northern India, and Central Asia; the empire ends in 331 BCE when Alexander of Macedon defeats Darius III; Alexander regards himself as the heir to the empire and the ruler of Babylon
Important artworks	The Cyrus Cylinder
	Rock-cut tombs of Qyzqapan and Ishkewt i Kur-u-Kich
	Bisotun Darius relief
	Rock-cut tombs at Naqsh-i-Rustam

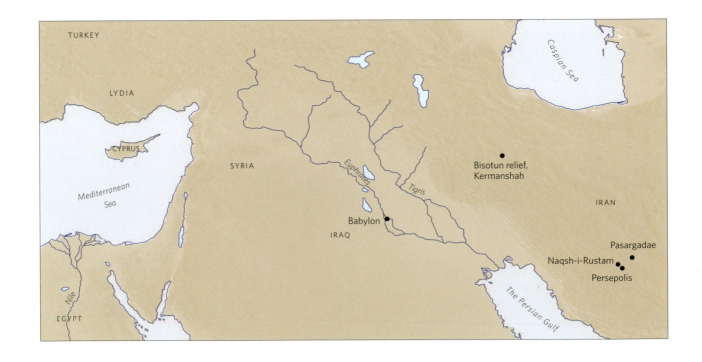

13 Achaemenid Persian Art

On October 29, 539 BCE Cyrus the Great entered the city of Babylon. He had defeated this vast and sprawling capital of legendary fame and claimed the royal titles of Great King, King of Sumer and Akkad, and King of Babylon. The title King of Babylon, like that of the Roman Emperor in later centuries, carried great symbolic weight and ancient associations. Thus the **Achaemenid** Persians, who controlled one of the most extensive and powerful empires in antiquity, initiated a new era of rule in Mesopotamia. Cyrus and his armies had already defeated King Astyages of Media, who had controlled much of Iran and eastern Anatolia. They went on to battle the Lydians of western Anatolia, defeating King Croesus and conquering the Lydian capital, Sardis. Cyrus's son Cambysus then also conquered Egypt. At its height, the Achaemenid Empire included Iran, Mesopotamia, Syria, Egypt, Asia Minor and its Greek cities, Thrace, parts of northern India, and central Asia. Babylonia was one of its central and most prosperous provinces, and the city of Babylon became one of the main places of residence for the Achaemenid court.

Works of art and architecture in Mesopotamia, and in the city of Babylon, where Cyrus chose to reside for a time, continued to adhere to the local traditions and methods despite the arrival of a new foreign ruling house. As with the Kassite dynasty in the mid-second millennium BCE, the Persian dynasts not only permitted local religious cults and artistic traditions to continue, but they also actively participated in their maintenance and provision. Additionally, as there was no earlier tradition of monumental royal art that was specifically Persian, they adopted aspects of Mesopotamian visual arts for their own. By the latter part of the sixth century BCE, the cuneiform script was also adopted for writing the Persian language. The Persian cuneiform writing was utilized in calligraphic inscriptions on monuments and works of art, as well as on luxury royal metalwork artefacts. It was thus primarily a new display script related directly to imperial images and luxury objects.

The Achaemenid Persians looked to the Assyrian and Babylonian works that preceded them, but they also created their own royal art by weaving together Iranian and Near Eastern traditions with those of farther parts of the empire. All of these works were created under the close supervision of the king and royal house in the service of a new imperial ideology. This ideology was one in which the empire was an ordered world, diverse yet unified under the aegis of the Achaemenid king. Achaemenid imperial art, therefore, stressed the nature of empire more than it did the individual person of the king. As the major imperial monuments reveal, Achaemenid art also stressed the concept of timelessness rather than the strong leaning towards historical specificity and extraordinary events that we have seen throughout much of Mesopotamian art, which reached its apogee in the Assyrian palace reliefs. Instead, in much of Achaemenid art the mythical and the heroic realms appear as allegories of the order of the empire, while images of kings and courtiers, warriors and diplomats, are elevated into the timeless and the eternal.

Although Babylon remained an important administrative city under Persian rule, new capitals arose elsewhere in their lands. In the new imperial centers in Iran, the Achaemenid kings employed craftsmen, sculptors, and architects from all over the Persian Empire, who used materials from across their extensive

domains to create a distinctive and original imperial style, integrated into entirely new designs and compositions. They built great new cities in Persis in southern Iran (modern-day Fars), the original home of the Persians. For their newly formed visual expressions of kingship and empire, they drew upon Babylonian and Assyrian arts and architecture, as well as the Iranian Elamite tradition. These forms were inflected with the visual traditions of Egypt and the craftsmanship of Greek sculptors and stonemasons, resulting in a distinctive new form of imperial art that is best exemplified by the magnificent city of Persepolis, one of the most impressive ancient cities of antiquity that still stands today.

Babylon

The Cyrus Cylinder

One of the most important artefacts of the Achaemenid era documents the arrival of Cyrus the Great in Babylon [13.1]. Known today as the Cyrus Cylinder, it is often described as the first bill of human rights, permitting peoples to return to their homelands. The clay cylinder is a foundation deposit text. It was made to be buried beneath the city wall of Babylon, and it takes the well known cylindrical form of Babylonian royal inscriptions. The text, which is in the local Babylonian script

and language, explains that the victory of Cyrus was given by the gods, making him the legitimate successor. It describes how the Babylonian king Nabonidus had neglected the cults and holy rites of the Babylonian gods, including the main patron deity of the city, Marduk. It also criticizes Nabonidus for imposing forced labor on the free Babylonian population. The inhabitants of Sumer and Akkad, we are told, had become like corpses because of severe poverty. The god Marduk thus sought a just ruler for his city to replace the neglectful Nabonidus. The Lord Marduk took Cyrus by the hand, and "for dominion over the totality he named his name." In this building inscription that he commissioned, Cyrus is thus presented as a liberator rather than as a conqueror—one who was divinely selected by the local gods to free Babylon from the oppressive and corrupt rule of the previous king.

Under the new rule of Cyrus (r. 539–530 BCE), the ancient cults that had been neglected by Nabonidus were attended to once again with great care. Offerings were given to the temples, and a reconstruction of Imgur-Enlil, the inner city wall, was instigated. During the digging required for the construction and renovation process, a foundation deposit of Ashurbanipal, the seventh-century BCE Assyrian king, appeared. The Cyrus account relates that this earlier artifact was carefully preserved,

13.1 The Cyrus Cylinder, from Babylon, Iraq, 539 BCE. Clay, h. 9 in. (22.9 cm)

according to its edicts. Cyrus was thus continuing an age-old tradition of Mesopotamian kingship, that of the pious king who protects the historical works and monuments of the past. The cylinder text presents the new king as doing the work of Marduk, bringing about a restoration of just and peaceful rule. As Cyrus was also responsible for the returning of displaced people and their gods to their own homes, he acquired the reputation of a good and tolerant king.

The Cyrus Cylinder is therefore a quintessential Babylonian foundation text. Although commissioned by Cyrus, it is also written from a Babylonian point of view and within the context of the ideology of Mesopotamia. It was made for an architectural ritual, one of the most ancient traditions in Babylonia, where clay foundation cylinders had already been in use in barrel or prism shape for about two thousand years. In the ancient Mesopotamian tradition and the images that were part of it, the king carried the work basket and laid down the first brick in the construction of a temple. Cyrus thus participated in this age-old ritual of the builder-king, legitimizing his own rule within the antiquity the Babylonian tradition. The Cyrus Cylinder is thus of great importance archaeologically, because the text allows it to be dated with accuracy. It also reveals that the Persian rulers of Mesopotamia, having entered and taken over this remarkable ancient civilization and its renowned urban centers, their arts and architecture, preferred to stress continuity of tradition rather than the imposition of foreign forms.

The City of Babylon

Despite the conquest, numerous surviving documents in cuneiform and Aramaic (Mesopotamian forms of writing) show that Babylon remained a major economic center under Persian rule. It was a cosmopolitan city: documents from the Persian period show that besides Babylonians and Iranians, Jews, Arabs, Phoenicians, Egyptian, Indians, and Greeks also lived there. The evidence from Mesopotamian texts demonstrates that major temples in Babylon, Nippur, and Uruk—and their

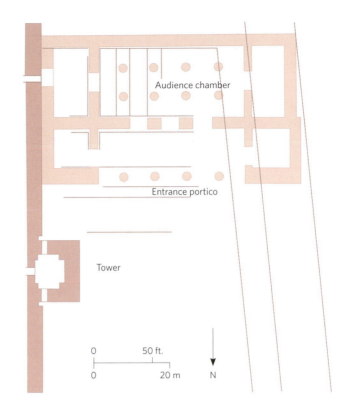

13.2 Plan of Achaemenid palace at Babylon

employees—continued to function uninterrupted, as did merchant activities and legal transactions concerning contracts, loans, and inheritance. The major Babylonian banking houses of the powerful families of Egibi and Murashu went on as if there had been no change at all. In local texts, we read that Cyrus "took the hands of the god Marduk," thus becoming a legitimate Mesopotamian ruler who was favored by the Babylonian gods.

Babylon also remained one of the principal residences of the Achaemenid kings, each of whom spent several months of the year there. Rather than building new palaces, the Persian kings continued to use those of the Neo-Babylonian kings for the most part. There are, however, the remains of one small palace or pavilion that was commissioned by **Artaxerxes II** (r. 404–359 BCE), built in a purely Iranian style with a rectangular columned hall (**hypostyle**) audience room and a pillared portico of four columns flanked by square towers [**13.2**]. The plan is similar to buildings at Pasargadae and Persepolis and differs from the local Babylonian open court plan. The bell-shaped column bases are of dark stone

Right
13.3 Female head, Babylon, Iraq, Achaemenid era, 5th–4th century BCE. Ivory, h. 1⅛ in. (3 cm)

Below
13.4 Miniature amphora with enamel eye-shaped decoration, found in grave 109, Babylon, Iraq, second half of the 6th century BCE. White opaque glass made with sand-core technique, h. 2⅝ in. (6.8 cm)

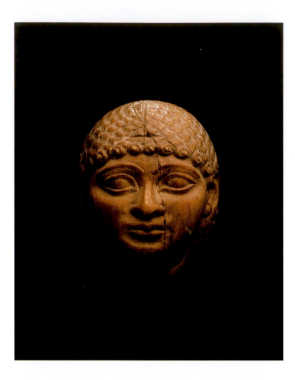

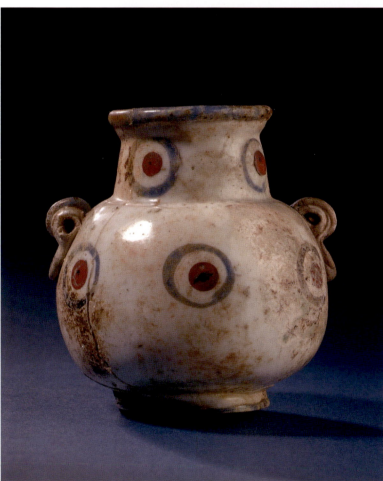

decorated with leaf patterns, a form known from Achaemenid architecture. (The columns have not survived.) Glazed brick decoration with rosettes and images of the Persian royal guard were used for the exterior walls. They represented colorful processions of the king's select guard, the Ten Thousand Immortals, carrying bows and quivers on their backs, and striding forward with long spears before them. Some of the panels were executed in glazed relief, while others were painted scenes on bricks composed of a mixture of sand and lime.

Due to the excavation methods of the early twentieth century and the rebuilding work of the post-Persian period, and because the Persians continued the Babylonian traditions that were in place, only a few Babylonian artifacts can be dated with any certainty to the Achaemenid presence. A small finely carved ivory female head in Berlin [**13.3**], found in Babylon, has the rounded face, large almond eyes, and neatly arranged curls of hair that are seen in earlier Syrian-style ivories from Nimrud and in images of women in terra-cotta. A group of vessels in opaque colored glass can also be identified as belonging to this era [**13.4**]. The shapes of the vases—an amphora and a cylindrical alabastron—are types known from Greece but were made in a local workshop. Although some small artworks can be dated to this era from the excavation find spot, or based on stylistic criteria, they have not yet been well studied.

Pasargadae

Cyrus set up his new capital in Pasargadae in modern-day Iran [**13.5**]. According to ancient Greek sources (Strabo of Amasia, a Greek topographer who was writing 500 years later), this city was founded after Cyrus's victory over Astyages the Mede in 549 BCE, at the exact location of the battle. He built three palaces there, edifices with hypostyle halls and porticoes and with architectural details that show a strong Ionian Greek influence. The columns had black and white bases and were surmounted by capitals in the form of addorsed (back-to-back) animals.

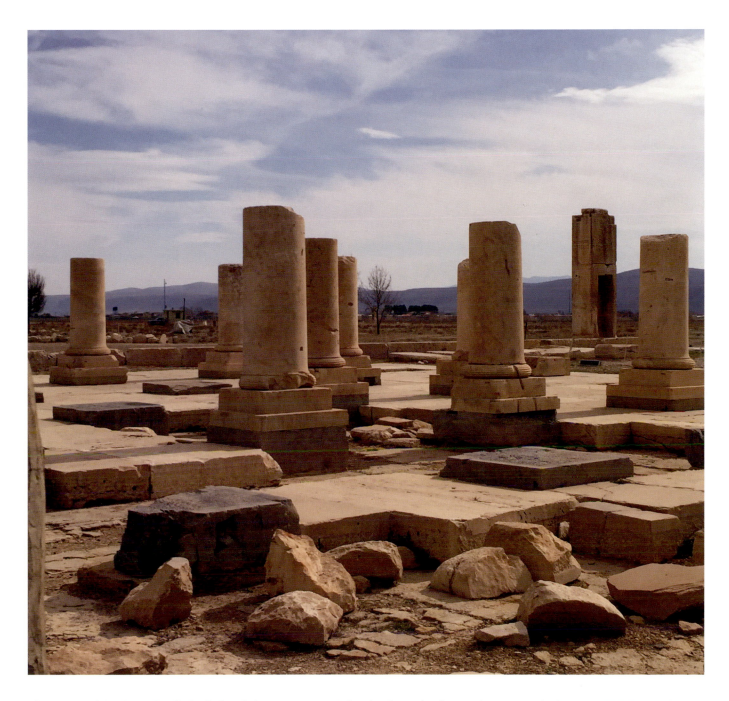

The western kingdom of Lydia had already been conquered by this time and stonemasons from the west were brought to Iran to work on the new city. All these palatial buildings were placed around cultivated and irrigated formal gardens, literally a paradise, as the Persian word *paradeisos* referred to such gardens. While the masonry techniques of the architecture originated in western Asia Minor (Turkey), the iconography was adopted from the Assyrian royal arts.

A doorjamb carving in a major gateway is the only well preserved relief at Pasargadae [13.6, see p. 298]. It represents a four-winged genie, placed as if walking into the gatehouse. He is dressed in Elamite attire but he wears an Egyptian-style triple Atef crown, recalling the crown of Horus. A trilingual cuneiform inscription—in **Old Persian**, Elamite, and Babylonian—above the figure read "I Cyrus, the King, the Achaemenid [built this]." The same inscription was placed elsewhere on

13.5 Pasargadae, hypostyle hall of the Residential Palace of Cyrus, 535–530 BCE. The limestone columns stand on bases with two colors of limestone, and a black limestone plinth below.

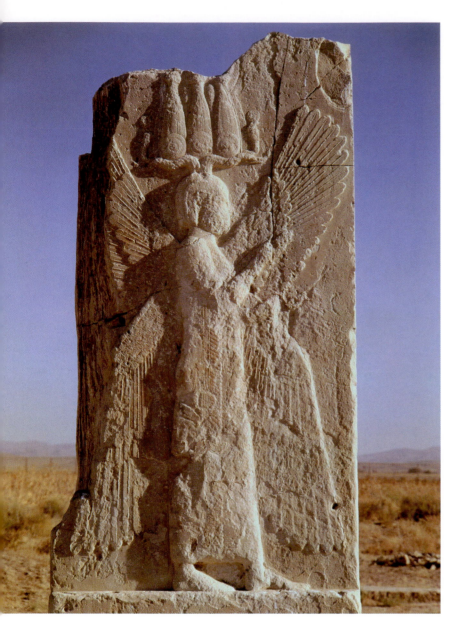

13.6 Four-winged genie relief, gate R, Pasargadae, Iran, 559–530 BCE. Limestone

The relief had an inscription that stated, "I Cyrus, the King, the Achaemenid [built this]"

The winged figure of the gate guardian was inspired by Assyrian art. It was one of several such figures that guarded the doorjambs at Pasargadae and recalls the figures from the palace of Sargon II at Dur Sharrukin (see chapter 10, p. 239), but in its amalgamation of details, which include Phoenician Egyptianizing forms, it differs from these predecessors. It expresses a new imperial vision that consciously deploys but does not simply imitate the earlier royal arts.

The grandiose tomb of Cyrus was erected in a royal park at Pasargadae where a grove with many trees and an elegant garden were planted [**13.7a, b**]. The massive tomb was an entirely new type of burial in this region because it is a freestanding monumental stone sepulchre. Although freestanding monumental tombs of finely cut stone are known from Asia Minor, in this region rock-cut tombs and subterranean interments were the usual forms.

The Cyrus tomb is constructed of ashlar (cut stone) masonry and is rectangular in shape. A stone chamber with a vaulted pitched roof was elevated upon a raised stepped platform, the original structure standing 33 ft. (10 m) high. An inscription on the tomb read: "O man, I am Cyrus who founded the empire of the Persians and was king of Asia. Grudge me not therefore this monument." According to the Greek historian Arrian, inside the chamber was a golden sarcophagus in which the body of Cyrus was placed. A couch was placed by its side with feet of wrought gold. A Babylonian tapestry and purple carpets covered the interior space, and garments of Babylonian workmanship, magnificent blue robes, necklaces, daggers, and earrings could be seen within. This description gives us some idea of what the interior of Achaemenid royal tombs were like, although most of them were rock-cut burials. The tomb of Cyrus, however, is more in keeping with the tradition of large stone tombs of western Asia Minor, an area that became incorporated into the Persian Empire.

corner wall blocks in the palaces of Pasargadae. Scholars believe that the inscription was added at a later date, during the reign of **Darius I** (r. 521–486 BCE), because Persian cuneiform script was not used before his reign. There is a statement in the Bisotun relief inscription of Darius (see pp. 302–6) suggesting that Darius created the script deliberately. As the script that arose at this time is an invented script, this claim is probably truthful. Nevertheless, the use of such trilingual inscriptions, in cuneiform script and including the Babylonian language, remained a standard practice for Achaemenid monuments.

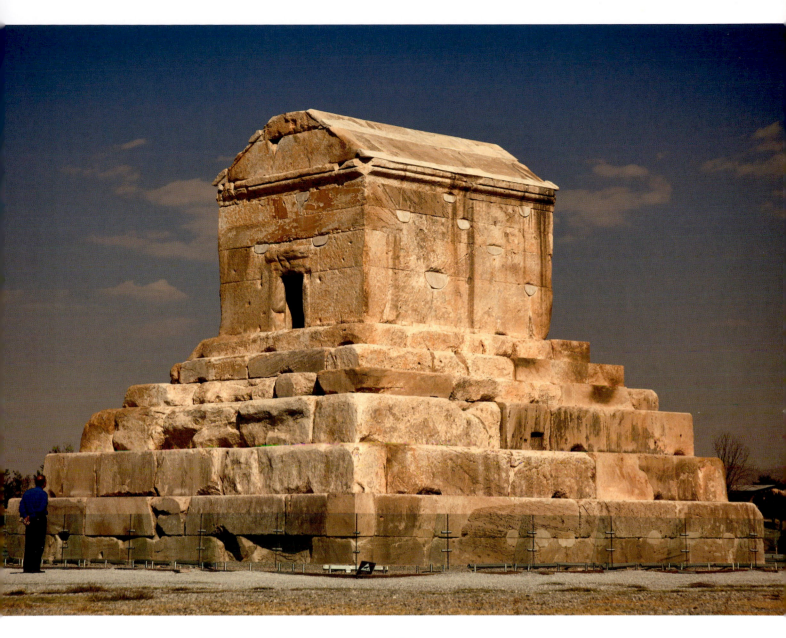

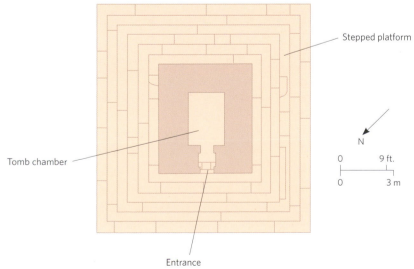

13.7a, b
Cyrus Tomb, 530 BCE.
36 ft. 5 in. (11.1 m) high,
rising above a six-stepped
platform resembling a
ziggurat, with a base of
44 × 40 ft. (13.4 × 12.3 m)

Stepped platform

Tomb chamber

Entrance

N

0 9 ft.

0 3 m

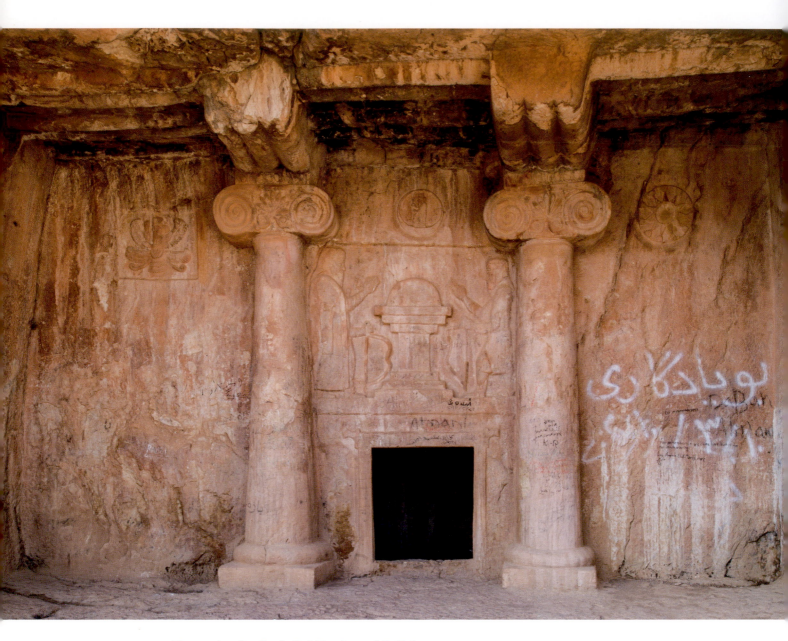

13.8 Rock-cut tomb, Qyzqapan, Iraqi Kurdistan, 6th–5th century BCE

Mesopotamian Rock-Cut Tombs and Reliefs

The rock-cut tombs of Qyzqapan and Ishkewt i Kur-u-Kich in northeastern Iraqi Kurdistan are excellent examples of elite burials from the Achaemenid era in Mesopotamia, although the exact dates of both tombs are still debated.

The Qyzqapan tomb is 23 ft. 6 in. (7.13 m) wide, 16 ft. 6 in. (5 m) high, and 9 ft. (2.78 m) deep, cut into the rock face about 26 ft. (8 m) above rocky ground level [**13.8, 13.9a, b, c**]. This high position, difficult to reach today, raises the question of why such tombs were placed in remote and lofty locations. The tomb carvers had to make use of a ledge or scaffolding that is no longer present, and work at this inaccessible place with great difficulty for many days. Were such sites selected for purposes of protecting the tombs from damage and looting? Or was the location within the natural terrain related to some aspect of the landscape nearby that held significance for the ancient inhabitants? Was the elevation required for religious purposes? The position of the tomb may have been chosen with the surrounding natural features in mind, aspects of the terrain that held meaning, in particular the high peak that is still visible directly across from the elaborately

carved entrance portico of the tomb. Whatever the case may be, the selection of the place and the extent of highly skilled labor required for carving such a monumental rock-cut tomb indicate that it was a burial place for an important family.

Inside the Qyzqapan tomb, there are three burial chambers and spaces for coffins hollowed into the rock. As these spaces are too small for an outstretched adult body, they may have been *astodans* (Persian *sotodan*), ossuaries where the bones of exposed bodies were collected and placed. The facade of Qyzqapan is carved with an entrance consisting of two Ionic-style half-columns flanking a door. The roof of the entrance porch is carved into the rock in a way that imitates wooden beams. A large relief carving above the door depicts two men flanking a stepped altar. Each man is shown raising his right hand and holding a bow in his left that rests with one end on the tip of his foot. The men wear Median-style dress with a long tunic and loose trousers. The man on the right also wears a *kandys*, a coat with long sleeves hanging loose at the side, draped over his shoulders. The headdress is also a Median type known as a *bashlyk*. Above this scene and in the spaces between the capitals that top the engaged columns there are three divine emblems. A circle with a crescent bearing a bearded male deity facing to the left is in the center. To the right is a star burst with eleven rays, which is reminiscent of the goddess Ishtar's emblems. On the left is a four-winged symbol thought to be an image of the Achaemenid god **Ahuramazda**. The star emblem still bears traces of its original paint in red and gold, indicating that the facade was painted in vibrant colors. A smaller rock-cut tomb, known locally as Kur-u-Kich, lies *c.* 1.5 miles (2.5 km) south of Qyzqapan. This smaller tomb has engaged columns but is otherwise undecorated

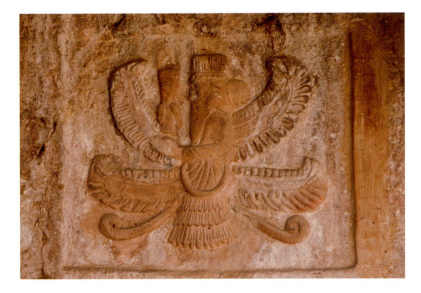

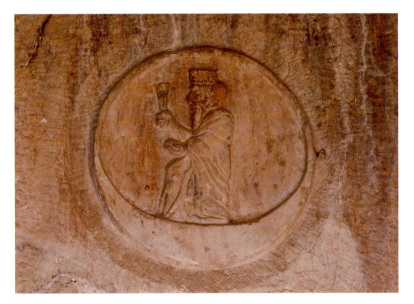

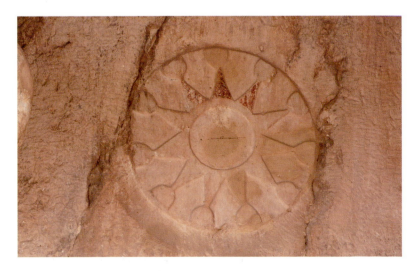

From top to bottom
13.9a A bearded god, perhaps Ahuramazda, holding a barsom (ritual object)
13.9b A bearded god in long robes, holding a barsom, standing in a crescent moon
13.9c A star-burst emblem, perhaps for Ishtar-Anahita, with traces of original paint

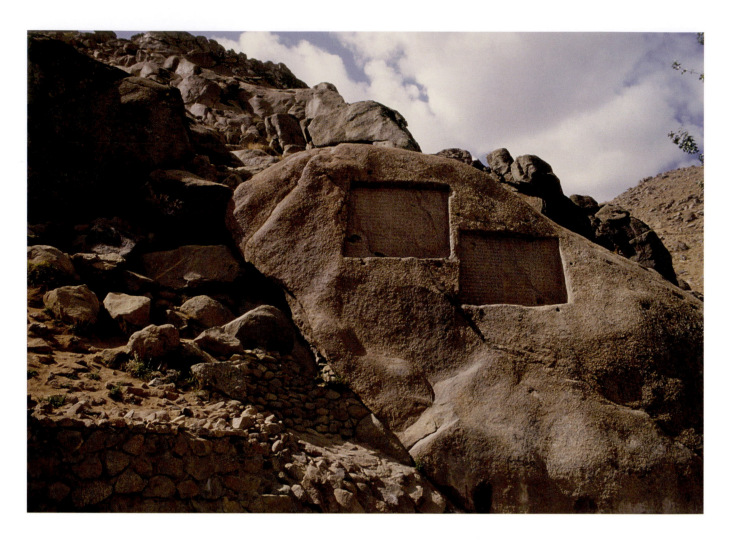

13.10 Calligraphic rock relief at Gandj Nameh, Alvand mountains, Iran, 6th–5th century BCE

Two almost identical trilingual inscriptions of Darius I and Xerxes, near the waterfall of Gandj Nameh, praise the god Ahuramazda. Here the writing becomes the monumental form itself. The texts are in Babylonian, Elamite, and Old Persian.

of Gandj Nameh near Ecbatana (Hamadan) [**13.10**]. This calligraphic carving was pure monument, not a tomb or place of burial. The Persians took the cuneiform script and the idea of presentation texts and transformed them into a new form of written monument meant to last for all time.

with sculpture, perhaps indicating that its facade was painted instead.

Beyond Mesopotamia, in Iran itself, rock-cut tombs and rock reliefs can be studied as sculptural forms in which the artists of the **Achaemenid dynasty** excelled. Although earlier rock reliefs had existed in this region, the new Achaemenid works were without parallel in scale and complexity of the visual program. They took monumental texts to a new level by creating rock reliefs that were purely calligraphic, such as in the inscriptions carved upon the rock surface of the waterfall

The Bisotun Relief

At Bisotun ("Bagastana" in Old Persian, meaning "place of the gods") near Kermanshah a major monument of the Achaemenid era still remains, carved high up above the plain on a cliff face in the Zagros Mountains on the Khorasan road leading from Babylon to Ecbatana in the heart of Media [**13.11**, **13.12**, **13.13**, pp. 304–5]. Here a large-scale relief with a trilingual inscription in Old Persian, Babylonian, and Elamite is still visible. As at Gandj Nameh, this site is pure

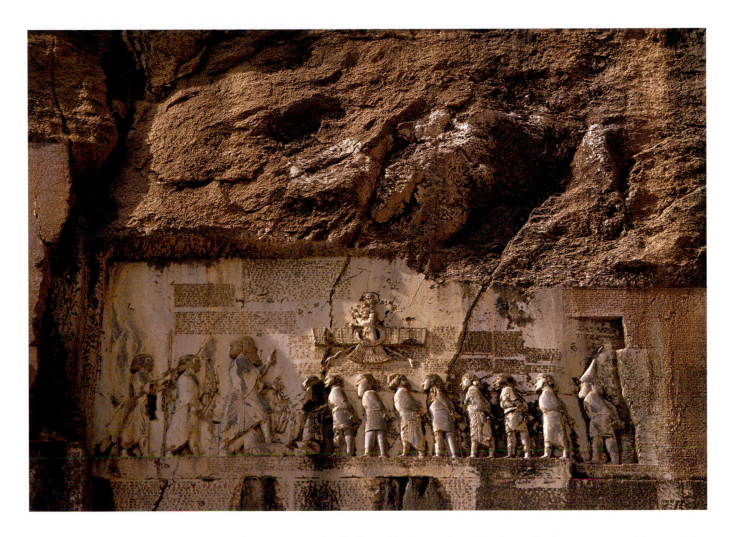

monument, not a tomb or place of burial. It is carved upon a smoothed rectangular panel of cliff face measuring 10 × 18 ft. (3 × 5.5 m). The extraordinary fact that the monument was some 250 ft. (75 m) above the plain makes it all the more impressive as a declaration of power. Steps were originally cut into the rocks below in order to create a position from which the sculptors and scribes could carve the relief, but these work ledges were later shaved down to flatten the surface, as can be seen by examining the surface of the rock. The stone carvers had to work on a very narrow and elevated space in what was an extremely precarious situation. It is all the more remarkable as we know that the relief had a later section added to it when a figure of a defeated king on the far right was included.

Bisotun is the most carefully studied of the Achaemenid monuments, and it stands at the beginning of the long reign of Darius. It depicts this king standing in profile at the left of the single-register scene, and facing to the right. In his left hand he grasps a bow, while his right hand is raised with the palm turned outward. A row of men, from various parts of the empire, who had rebelled against Darius are lined up before him, all standing on the same ground line formed by a narrow ledge of inscription. The men on the right, smaller in scale than Darius, are tethered together at the neck by one long rope, their hands bound behind their backs. Each of the rebels is labeled by name and nationality and wears distinctive clothing from his land. Behind Darius, two attendants wearing Persian robes are smaller than Darius but bigger than the defeated enemies. Below the left foot of Darius is a defeated enemy, who is labeled Gaumata, the pretender to the throne. Darius treads upon

13.11 Bisotun relief, Zagros Mountains, Iran, 520 BCE

13.12 Drawing by Pascal Coste of the Bisotun relief in *L'itineraire de 'un voyage en Perse de 1839-1842*, vol. I, published 1851–54 CE

him as a sign of power, while Gaumata stretches out his arms to beg for mercy. Skunkha, the ruler of the Scythians, with a pointed cap, stands at the end of this file of the conquered. His image was added slightly later: he was defeated in the third year of Darius's reign (519 BCE), an event that was added in a paragraph at the end of the inscription. Above, placed centrally over the scene, is a winged disc with an anthropomorphic figure (presumably Ahuramazda) wearing a triple-horned crown topped by a seven-pointed star facing toward Darius. There is no indication of depth or background space in the relief. Instead, the figures

appear as deeply carved relief forms that emerge out of a surface that is primarily a textual space.

The scene depicts the story of Darius's accession to the throne, which we know both from the Greek historian Herodotus and from Ctesias, a Greek physician and writer from Knidos (now in southwest Turkey) who lived at the Persian court during the reign of Artaxerxes II. The text on the monument also explains the scene, recounting in detail the rise of Darius to power and his victories over his enemies. Sequential time is compressed so that the victory over Gaumata and the later defeats of the rebels—which had taken place at different times and in different places—are all placed together in the same image. Rather than presenting events as a continuous narrative, as the Assyrian historical reliefs did, the Bisotun monument is a timeless emblematic image. Different historic episodes are pulled together into one triumphal event, with the god Ahuramazda placing the rebels under Darius' control. The great king accuses the rebels of being pretenders and liars, while he himself swears to be truthful, thus presenting a duality of truth and falsehood as part of the tale of the justification of his triumph.

Carved high up on the cliff face, the relief is visible from a public road, where people have been able to see it through the centuries. It was not the content of the text, however, that had the strongest impact on viewers, even though the inscription was written so carefully in three languages. The inscription could not be read from such a distance. Instead, the impact on the traveler was made by means of the sculpture alone, especially its lofty position and immense scale. Even those who scaled the rock face in order see it may not have been able to read the text given the limits on literacy in antiquity. It is thus the power of writing as writing that is harnessed for the monument here—the written word in and of itself as a technology of communication through time—even more so given that fact that writing was not used for the Persian language, other than as a display script (archival documents of the Achaemenid dynasty were instead written in such languages as Babylonian, Elamite, and Aramaic). The Bisotun relief is a public monument of victory

in which the power of writing coalesced with the power of images to convey the triumph of Darius, King of Kings.

Because of the role that the Bisotun relief played in the history of the decipherment of cuneiform script, more attention has been given to the text than to the images or to the concept of the monument as an entire work. The trilingual text was the first to be deciphered by modern scholars (see chapter 1, pp. 23–25). The inscription has also been studied as an important historical document, because it was composed in order to underscore Darius's descent from the Achaemenes and his membership in the Achaemenid dynasty, and it focused on the historical event of Darius's accession to the throne. If, however, we consider the text as part of a larger work that consists of image, text, and stunning location, we can understand how this remarkable sculptural monument conveys its power and authority in an integrated manner.

Just as the form of the script in the inscription had been adopted from earlier Mesopotamia and Elam, so too the Bisotun image was directly influenced both by earlier Mesopotamian and by Elamite arts, in particular the Ur III and Old Babylonian rock reliefs that in turn reference earlier Akkadian art. The Achaemenid sculptors were able to see some of these reliefs in the surrounding landscape. The commemorative rock relief of the king Anubanini (c. 2000 BCE) located c. 100 miles (150 km) west of Bisotun also depicts a king striding upon the body of a defeated enemy, a motif that we first encountered in the stele of Naramsin of the Akkadian era [5.9, see p. 124]. At least four ancient Iranian rock reliefs could be seen in this region, going back to the third millennium BCE. In the Elamite era, in the second millennium BCE, rock reliefs were also carved in southern Iran. The sculptors working for Darius knew these monuments: they were part of their historical horizon, carved into the environment millennia earlier, representing one of the ancient and distinctive forms of art in Iran.

The scale of the king in the Bisotun relief—larger than the defeated men and the attendants behind—is a convention that was to appear in

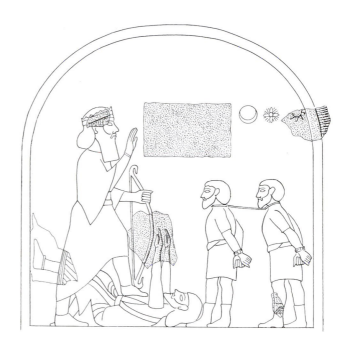

subsequent Classical Achaemenid art, as are other details within the relief, such as royal attire. The king wears a crenellated crown with stars and lotus flowers, and the attendants wear rosette-covered headbands. Persian courtly robes belted at the waist with billowing sleeves and diagonal folds with a central vertical pleat become the standard convention. The image of the king triumphant in a historical setting, however, is extremely rare. Indeed, the Bisotun relief is remarkable as it is the only Achaemenid monument to show a known historical event—all the more interesting given the fact that it was such a vast empire that had experienced so many victories. Achaemenid royal art thus differs from Mesopotamian art's extensive references to the historical, depicted as single events or as series of events in palace reliefs or on monuments. This is an interesting change in the visual ideology of the time, which moves away from the specific and the historical to universalized and transhistorical images of royalty. Instead of focusing on the personal identities of kings it explores the nature of kingship, which came to be portrayed as a timeless aspect of the natural order of things in the world.

The Bisotun relief was linked to Babylonia and the empire in a direct way. In the city of Babylon, excavators found several fragments of a copy of the relief [13.13]. The Babylon version was smaller

13.13 Drawing of an ancient copy of the Bisotun relief made of basalt, found in Babylon, Iraq

in scale and may have represented only the main section of the scene with Darius and the defeated kings. These fragments were also inscribed in Babylonian cuneiform. It was the same text as the Bisotun inscription, with a slight change: in place of the name of the **Zoroastrian** Persian god Ahuramazda, the name of the Mesopotamian god Marduk was inserted as the one who had brought about the victory. Thus the Babylonian god was invoked as the one who oversaw and approved Achaemenid rule in his own land.

Darius wanted to create a new visual rhetoric for the empire that he had taken over, and the Bisotun rock monument accomplished this. It was the beginning of a new image of kingship, and the start of a new Classical style, an Achaemenid visual rhetoric that presented the empire as part of the natural order of the world.

Persepolis

Persepolis, "the city of the Persians," is the Greek name for Parsa, one of the capitals of the Persian Empire, constructed for the most part during the reigns of Darius and Xerxes I (r. 485–465 BCE) and completed by **Artaxerxes I** (r. 464–423 BCE) [**13.14, 13.15**]. It was finally destroyed during the occupation of **Alexander of Macedon** in 330 BCE. Persepolis was the heart of the empire and the place where royal coronations were held. The new year's celebrations also took place here, when dignitaries came from all over the world to pay homage to the Persian king. The fortified citadel of Persepolis was part of a large complex including the burial grounds of the kings and the nearby city where common people lived, which has not yet been uncovered by archaeologists. The rock-cut tombs of the Achaemenid kings were cut into the nearby cliffs, at a place known today as Naqsh-i-Rustam, about 3.5 miles (6 km) to the north (see pp. 314–15). Even after the destruction of the site by Alexander of Macedon the remains were still visible and visited by travelers through history. It was one of the first ancient Near Eastern places to be recognized by Europeans and it remains one of the best-preserved sites from antiquity.

Rising about 46 ft. (14 m) above the plain, the platform or *takht* of the Persepolis citadel forms a quadrilateral with irregular sides, measuring about 1400 by 1000 ft. (428 by 300 m). Grey limestone blocks cut from a nearby quarry fitted together without mortar were used for the construction. On the south side of the terrace wall, Darius had a Babylonian inscription carved where he proudly describes his empire as a land of diverse nations and languages, divinely given.

One entered the monumental arena of vast columned halls through the propylon known as the Gate of All Lands, begun by Darius and completed by Xerxes [**13.16**, p. 308]. The gatehouse was guarded by colossal Assyrian-style winged apotropaic guardians on both sides, following the tradition of Assyrian palace portals with their lamassus. The Persepolis lamassus are not sculpted from monoliths as in Assyria but from several blocks put together, their bodies and upright wings merging into the blocks of the doorframes. As in Assyria, they wear horned crowns of divinity upon their human heads, and have thick curling beards and hair arranged in orderly patterns, though their proportions are broader and more massive. An inscription on the inside of the doorframe, above the profile view of the lamassu, declares that Xerxes built this gate as the "gate of all nations" and that he continued the work of Darius before him. It also states that what has been built at Persepolis and is beautiful was built with the favor of Ahuramazda. This inscription thus describes Xerxes' pride in the aesthetic qualities of the city.

Opposite
13.14 View of the ruins of Persepolis, Iran

13.15 Plan of Persepolis, Iran

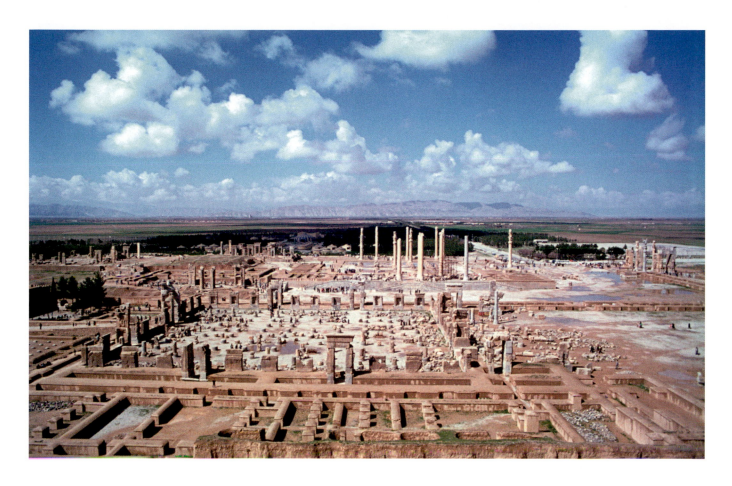

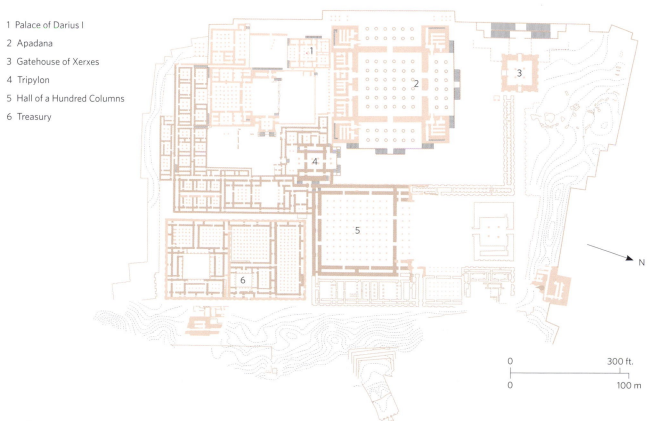

1 Palace of Darius I

2 Apadana

3 Gatehouse of Xerxes

4 Tripylon

5 Hall of a Hundred Columns

6 Treasury

N

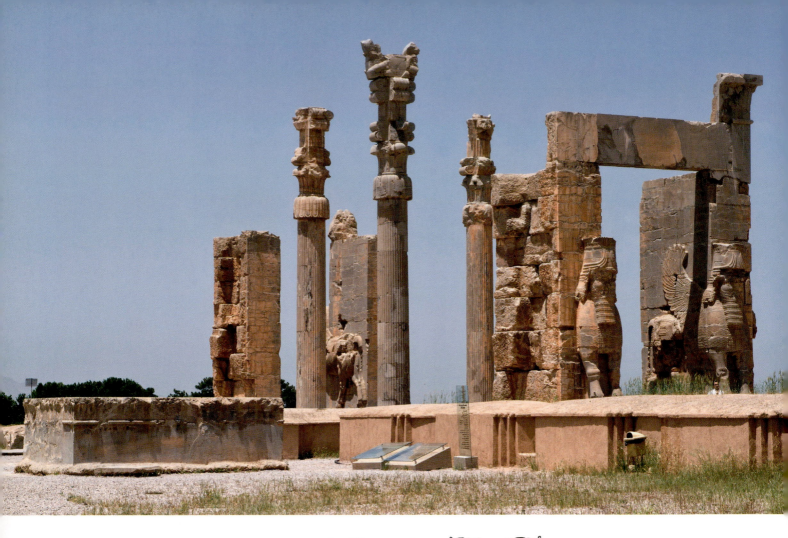

Above
13.16 Gate of All Lands,
Persepolis, Iran, 5th century BCE
(485–465, reign of Xerxes I)

Right
13.17 Achaemenid column types.

Fluted columns stood on bases
made of two elements (lotus
leaves and torus) and were
topped with (*from left to right*)
1 Capitals with multiple volutes
and lotus leaves;
2 Horned bulls;
3 Horned lions.
The columns stood up to 65 feet
(19.8 m) high.

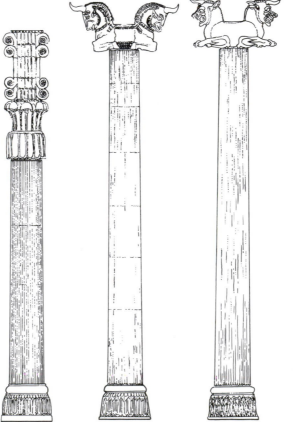

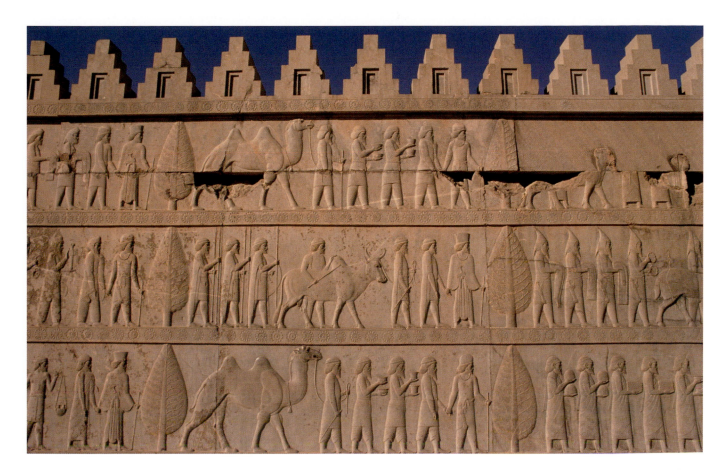

Various materials were used for the construction of Persepolis. All the sculpture and columns were limestone, while the roofing was made of wood. In between doorframes and columns, glazed decorative brickwork was used for the walls. The columns of the largest buildings are massive in scale, made of fluted drums similar to those in Greek architecture [13.17]. In the Apadana (see p. 312) they stood 57 ft. (17 m) tall, topped by palm leaves, floral patterns, and volutes, and bull-men, lions, and griffins, each of which was another 6 ft. (2 m) high. The bases were carved in the form of inverted bell-shaped flowers so that the columns appeared to rest on the rings of petals.

It is at Persepolis that Classical royal Achaemenid art can be seen at its best. The architectural techniques and sculptural program represent a mixture of elements from Mesopotamia, Egypt, Ionia, and Iran. Egyptian forms appear in the architectural details. Floral shapes on the capitals and the Egyptian-style cavetto cornices (the projecting member of the entablature) are juxtaposed to the winged bulls and lion-demons of Assyrian origin. Greek-style stone carving can be seen in the sculptural program [13.18]. The soaring columns are a synthesis of Egyptian, Assyrian, and Greek elements transformed into a new imperial Persian architecture, embodying the diversity of nations and traditions in the empire.

After passing through the Gate of All Lands, dignitaries and nobles approached the Apadana. This was the largest of the buildings, raised on its own platform, a reception hall measuring 1173 sq. ft. (109 sq. m) with columns about 65 ft. (20 m) high with bull and lion capitals; here Darius had deposited gold and silver foundation texts in stone boxes, written as trilingual cuneiform inscriptions in Babylonian, Elamite, and Old Persian. Foundation texts are an ancient tradition in the region, first used in the third millennium BCE in the Sumerian city states, but in Persepolis the choice of gold and silver for these objects fits well with the imperial lavishness and

13.18 Reliefs on the Apadana depicted peoples of the empire: Scythians with pointed hats, Bactrians with camels, and Ionian Greeks in front of them.

luxury of the city. The Apadana's monumental staircases were covered with reliefs on the facade showing imperial guards in profile facing a royal inscription, overseen by a winged disc. At each corner was a lion attacking a bull, yet another ancient iconographic means of conveying the order of kingship and correct rule.

The sculpture at Persepolis interacts with the visitor in a direct way. Often the figures of the dignitaries and guards are carved in relief on the sides of the stairway with their feet resting on the steps as they climb upward alongside the visitor [13.19]. Thus they are not a narrative of one specific event or procession but an interactive narration of the place of the visitor in the order of imperial ceremony. At the end of the procession, visitors reached the Tripylon, a small building with three doors, where they saw the image of the king walking in profile on the sides of the door, his attendants holding a parasol over his head, while the winged emblem of Ahuramazda hovers above [13.20]; they raise their heads looking upward while their feet rest on the base of the doorframe. The sides of the Tripylon staircase, the Apadana stairs [13.21, see p. 312], and the other palace buildings thus convey direction and movement, leading the visitor while at the same time underscoring the sense of Persepolis as a space of ceremony continuously recurring through time.

13.19 Dignitaries climbing the stairway of the Tripylon are carved in high relief with their feet placed on the steps, Persepolis, Iran

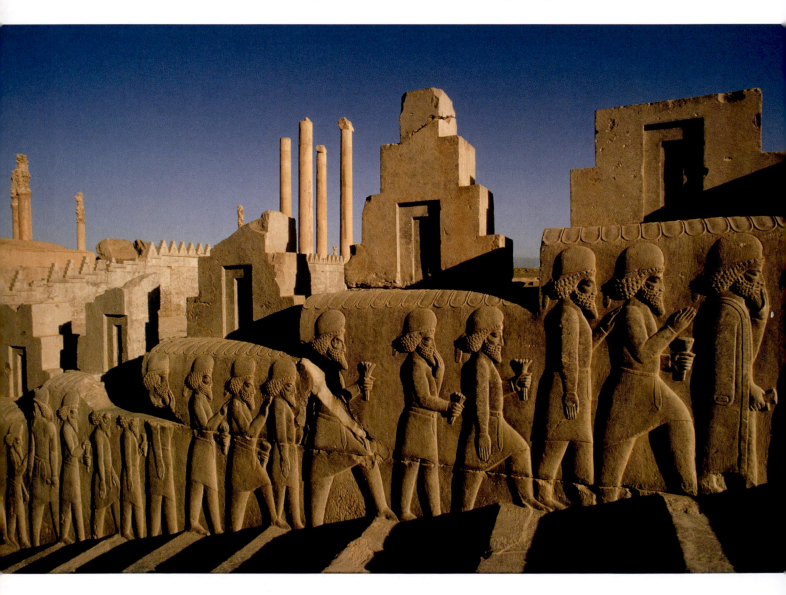

Peoples of this remarkably diverse and vast empire are depicted in the procession of tribute bearers on the east stairway of the Apadana: Armenians with vases of precious metals and horses, Babylonians with textiles and bowls, Syrians and Lydians with gold work, Gandaran Indians with oxen, and Greeks with skeins of wool. On the sides of the Apadana walls, rows of repeating guards give a sense of the incessant force of Achaemenid military might. They may have been meant to represent the elite regiment of the Ten Thousand Immortals. Heroes in doorways fight in dual combat scenes with lions, further emphasizing the order over chaos that empire has brought. These compositions of dual combats are also known in Late Archaic and Early Classical Greek art, contemporaneous with Achaemenid art, where they are described using the Greek word *agon*, implying a competition between two equally powerful forces. Images of the king seated upon a throne carried by the people of all lands are a visual metaphor, conveying the diverse nature of the empire as the foundational throne for Achaemenid kingship [13.22, p. 313]. The throne bearers are similar to those who carry Sennacherib's throne in the image of the battle of Lachish at Nineveh (see p. 242); however, Sennacherib's throne is held up by supernatural apotropaic beings. At Persepolis, subject peoples stand in the "Atlas pose" (Atlas was the Titan in Greek mythology who held up the universe), carrying the royal dais with ease on the tips of their upraised fingers. The empire is thus orderly and harmonious.

This visual rhetoric of diversity within empire is unequivocally recorded in the royal inscriptions as well. At Susa, the ancient Elamite capital, a foundation charter was found in the debris of an Achaemenid palace built by Darius. This charter was a trilingual text in cuneiform that described

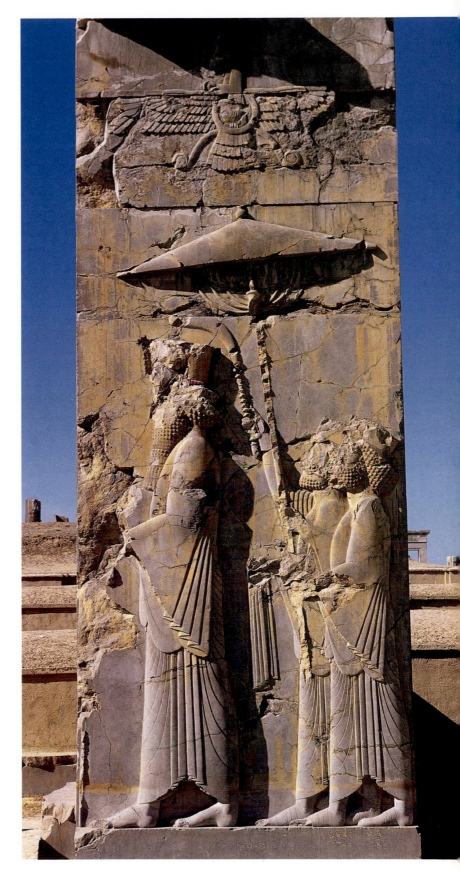

13.20 Darius beneath sunshade from the Tripylon doorway, Persepolis, Iran

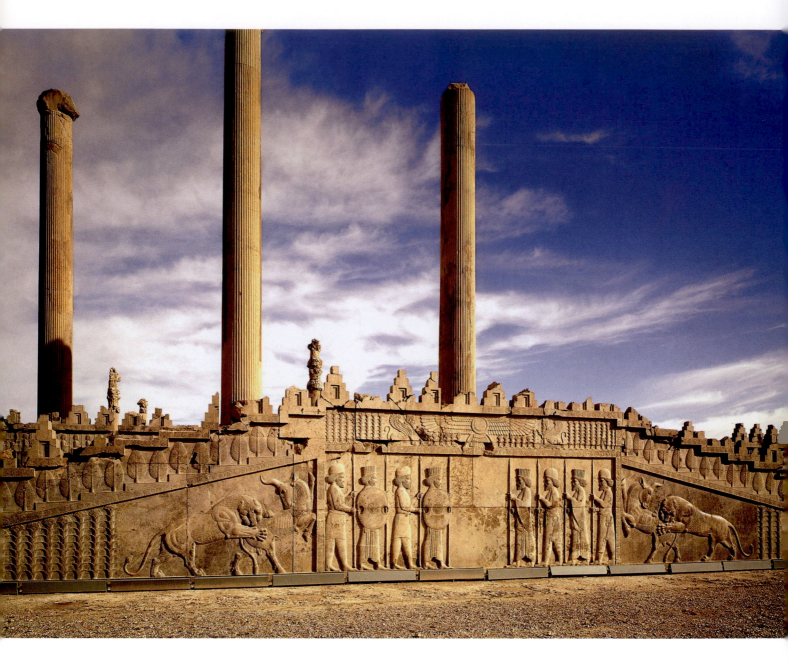

13.21 A symmetrical composition of royal guards flanked by bull and lion contests appears at the southern end of the Apadana stairway, Persepolis, Iran

the construction of the palace, the laying of the foundations, and how the construction materials and craftsmen who built it were from many different nationalities:

The silver and the ebony were brought from Egypt. The ornamentation with which the wall was adorned, that from Ionia was brought. The ivory which was wrought here, was brought from Ethiopia and from Sind and from Arachosia. The stone columns were here wrought, a village by the name Abiradu, in

Elam—from there were wrought. The stonecutters who wrought the stone, those were Ionians and Sardians. The goldsmiths who wrought the wood, those were Sardians and Egyptians. The men who wrought the baked bricks, those were Babylonians. The men who adorned the wall, those were Medes and Egyptians.

Artists from across the empire were employed in the construction of Achaemenid architecture and monuments. Graffiti inscriptions in Greek

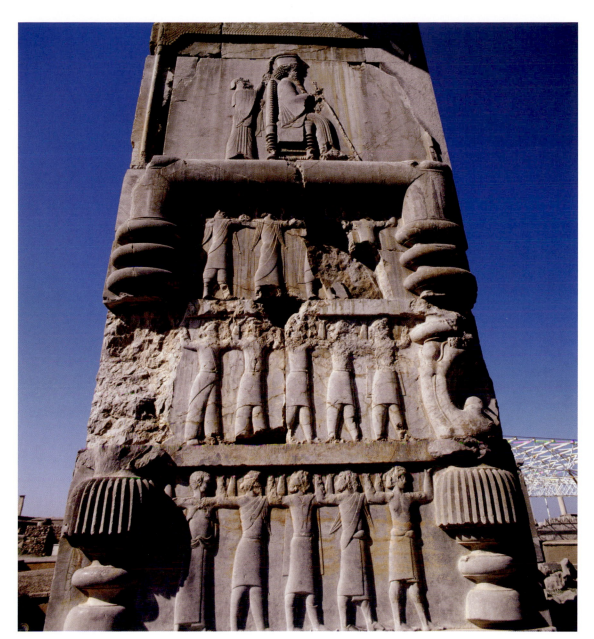

13.22 Artaxerxes I is seated in an enormous throne, elevated by the people of the empire who carry the seat of kingship upon their fingertips, at Hall of Hundred Columns, Persepolis, Iran, 464–424 BCE

on the rock face in the quarry at Persepolis are interesting in this respect. One says "I belong to Pytharchos," most likely made by a Greek contractor or quarryman of that name who wanted to reserve that section of the cliff face for his own work. Achaemenid kings commanded labor forces from all over the realm, including Greek workers who excelled in stone masonry and sculptural techniques.

The art of the Achaemenid dynasty was an intentional visual language of empire, not only in its grandiose forms but also in the means and methods that were utilized and the deliberately international creations made to represent empire. The kings mobilized work forces of artists, sculptors, and architects as well as materials at a scale previously unknown in the ancient world. The expense and logistical feats required were without parallel. Achaemenid art is therefore not so much an art of kingship, focusing on the person of the king as a specific individual; instead, the new visual language was one of empire as an integral whole, an order created from diversity.

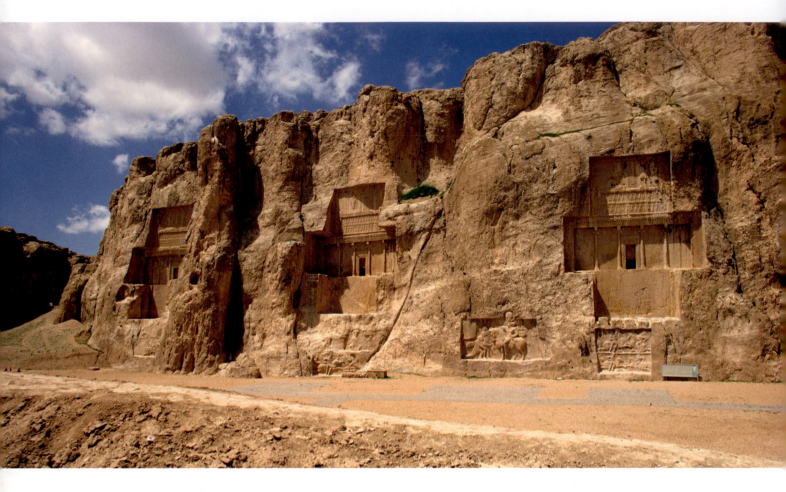

Above

13.23 Rock-cut tombs at Naqsh-i-Rustam, near Persepolis, Iran, 4th–5th centuries BCE

Naqsh-i-Rustam

The monumental tombs of the Achaemenid kings were carved into the rocky cliffs, in the rugged and imposing landscape around 3.5 miles (6 km) north of Persepolis [**13.23**]. There had already been a number Elamite rock reliefs near Persepolis that were still visible to the Achaemenids, indicating that the site was already sacred in previous eras and thus allowing them to form a link with their predecessors. A series of tombs were carved into the living rock. The first of these monuments was made for Darius I, and it set a precedent for three of his successors, who selected the same site and the same form of monument for their own places of burial. A stone tower in the plan of a square stands in front. The tower has three rows of windows on three sides, the largest windows on the lowest level.

Each of the tombs, beginning with the first one of Darius I [**13.24**], has a facade in a cruciform (cross-shaped) plan 75 ft. (23 m) high with its bottom edge 50 ft. (15 m) wide. The tombs all have the same sculptural program, with minor variations. The king stands on a three-stepped podium placed upon an elaborately carved dais or throne with griffin heads surmounting each corner, carried by men who are personifications of the thirty lands of the empire, each labeled by an inscription saying where they are from, for example: "This is an Armenian." To the left and the right of the dais are sculpted registers with courtiers and guards whose names are also recorded on their images. The king stands before a fire altar holding a bow set upon his foot, similar to the figures on the Qyzqapan relief. This is a sign of his masculine prowess, which is also emphasized in the inscription at the top left side, where he tells the world that he was a good horseman, bowman, and spearman both on foot and on horseback. Above is a winged disc bearing the figure of crowned man, usually identified as Ahuramazda [**13.25**]. To the right of Ahuramazda

is a disc with an inscribed crescent. This scene is placed over a middle zone consisting of an architectural facade carved into the rock face with a portico of applied columns with impost blocks (projecting blocks that rest on top of the columns and below the capitals) and capitals of double-bull protomes carrying a sculpted frieze. This facade resembles the architecture of the palaces at Persepolis. One main entrance leads to the interior of the tomb, a vestibule space hollowed into the rock of 61 ft. (18.72 m) running parallel to the facade. Three chambers emerge off it with three crypts in each. Here the burials (with massive stone covers) were placed. The tomb of Darius I is identified by an inscription, which calls on the viewer to contemplate the sculpture: "If now thou shalt think that 'How many are the countries which King Darius held?' look at the sculptures of those who bear the throne, then thou shalt know."

The tomb of Darius I was a new type of royal funerary monument in Iran in that it was a monumental rock-carved burial site. Although its location was selected for the antiquity of the site, already carved with Elamite relief sculpture, these early rock reliefs were not funerary sites but monuments commemorating places and events. It is also similar to the rock-cut tomb of Qyzqapan—although it is not clear which is older in date—as the latter also imitates architectural elements, such as columns with capitals, in the rock facade, and depicts a scene of men before a fire altar in Medean attire. The Achaemenid kings that came after Darius I followed this tradition of the king before the fire altar, carried on a throne by peoples of the empire. Traces of paint have been discovered indicating that at least some parts of the facades of the tombs were painted.

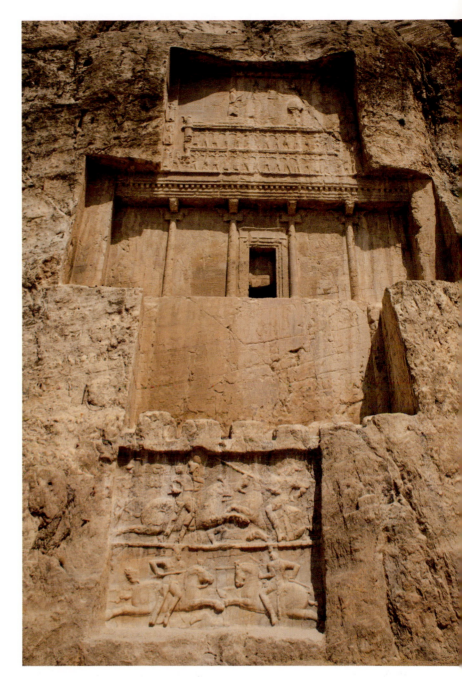

Top right **13.24** Detail of the Tomb of Darius I at Naqsh-i-Rustam

Right **13.25** Ahuramazda disc detail, from Darius Palace at Persepolis, Iran, *c.* 500 BCE

This winged disc emblem is usually identified as Ahuramazda. The Parsee scholarly community diverges from this opinion and has pointed out that in Zoroastrianism, the religion they practice today, images of gods are banned. They therefore prefer an interpretation of the disc as the *fravashi* or the spirit of the king. Some of these ancient traditions have survived in modern forms and versions in this region of the world.

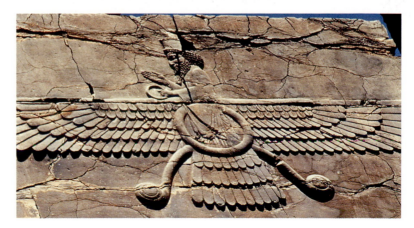

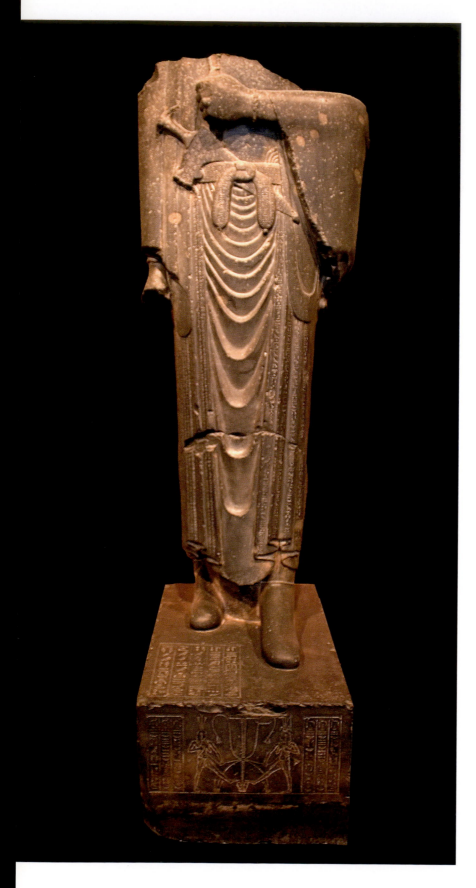

Sculpture

Most of the works that have survived from this era are architectural sculpture. Sculpture in the round is known from elsewhere in the empire beyond Iran. A headless, larger-than-life-size statue of Darius I, for example, was found at a monumental gatehouse in Susa [13.26]. It was probably one of a pair of images placed on either side of the entrance. The king is shown in Persian court dress and boots, with a dagger tucked into his belt; otherwise the statue has strong Egyptian features. The figure is attached to a back pillar and stands with left leg striding forward, as in Egyptian statuary. His left hand is raised and placed upon his chest in a gesture that resembles statues of pharaohs. The style and iconography, as well as the stone—greywacke—are all Egyptian. A trilingual inscription in cuneiform is accompanied by an Egyptian **hieroglyph** text. The ends of the king's belt are also decorated with a royal cartouche bearing his name in Egyptian hieroglyphs. Upon the base are further hieroglyphic inscriptions and the images of conquered lands, in accordance with Egyptian forms of iconography. Twenty-four fortress-shaped cartouches appear on the base, upon which kneel personifications of the place names within, including Babylon and Assyria. The kneeling figures are shown as foreigners with distinctive hair and costume, and they raise their hands in adoration and support, a visual theme that can be seen in the throne images at Persepolis as well. At the front of the base is the traditional double image of the Egyptian god Hapi with the entwined lotus and papyrus plants, a symbol of the unification of upper and lower Egypt.

The Darius I statue is a rare example of a large statue in the round from this dynasty. It was no doubt made in Egypt under Achaemenid rule and then brought back to Susa at a later time. This transportation was an extraordinary act in itself. The Persians had built a massive canal from the eastern Nile Delta to the Red Sea and the statue of Darius I was most likely shipped by canal to the Red Sea and, from there, around the south of Arabia and up to the Persian Gulf, covering a distance of well over 1200 miles (2000 km). The desire for monuments and

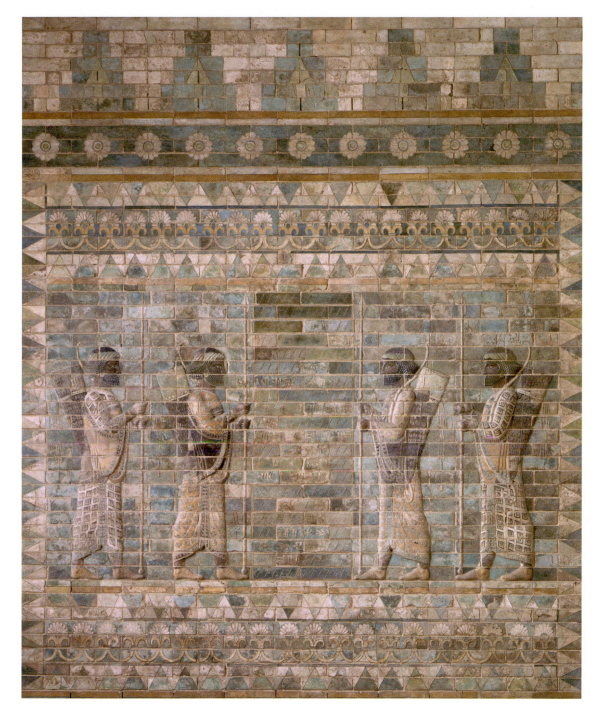

Opposite
13.26 King Darius I, from Susa, Iran, 521–486 BCE. Greywacke, h. 9 ft. 10⅛ in. (3 m)

Left
13.27 Facade of the royal guards, called the "Immortals," Susa, Iran, 510 BCE. Brick and colored glaze, h. 15 ft. 7 in. (4.75 m)

precious materials led to the transportation of goods across the empire. This distribution worked both ways, however, as the Achaemenid imperial style was mostly disseminated by means of the applied arts and smaller-scale luxury objects, which could travel easily to conquered lands.

For the ideological images of kingship in Achaemenid art, Assyria was also a main source of iconography and monumental forms. Babylonian traditions were adopted by the Achaemenids for glazed brick techniques [**13.27**], transformed into the spectacular royal designs of Susa, but the Assyrian colossal mythical guardians of the palace portals, and Assyrian sculpture, influenced the new visual rhetoric of the Persian empire perhaps more than any other art form.

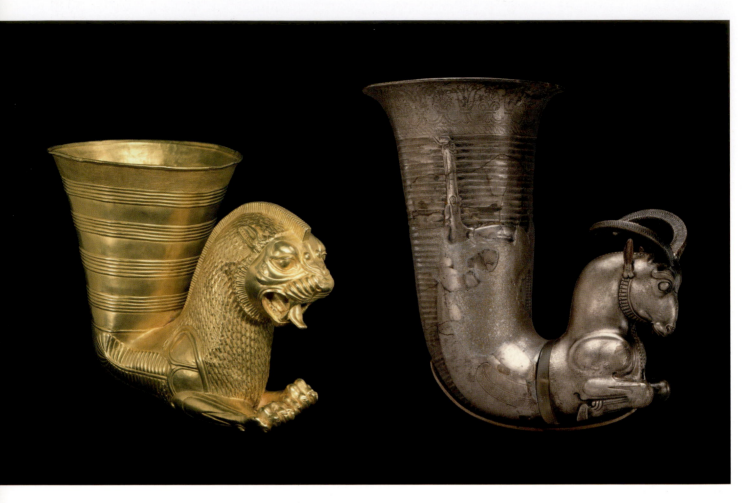

Above left
13.28 Winged-lion griffin rhyton, 5th century BCE. Gold, h. 6¾ in. (17 cm)

Above right
13.29 Leaping ibex/ram rhyton, 5th century BCE. Silver, h. 7⅞ in. (20 cm)

Applied Arts and Luxury Objects

The Greek historian Plutarch's *Life of Alexander* recounts that it took 10,000 mules and 5,000 camels for Alexander and his troops to carry away the war booty from Persepolis. All the gifts brought by the gift-bearing delegations represented on the Apadana reliefs were long gone, but other precious objects give us a sense of Achaemenid royal vessels. The **rhyton**, a horn-shaped vessel terminating in protomes with winged animals, was a popular form used for drinking and for pouring libations [**13.28, 13.29**]. These animal-headed vessels were highly valued throughout the empire and beyond, as they were acquired as exotic objects in such places as Greece. The Persians conducted diplomatic gift-giving through gifts of gold and silver vessels, a practice that disseminated such works [**13.30–13.32**]. Vessels both of stone and of precious metals inscribed with the king's name have

been found all over the empire, and were often placed in burials, suggesting that they had great meaning for the recipient's family well beyond the costliness of the gold or silver.

Opposite, above
13.30 Lobed bowl with a royal inscription, unknown provenance, probably Iran, *c.* 465–424 BCE. Silver, h. 1⅞ in. (4.6 cm)

Opposite, below right
13.31 Fluted bowl, unknown provenance, probably Iran, 6th–5th century BCE. Gold, h. 4⅜ in. (11.1 cm)

Opposite, below left
13.32 Bull handle, from Babylon, Iraq, *c.* 400 BCE. Silver, h. 5⅛ in. (13.1 cm)

A tubular amphora handle made of silver and showing a winged bull with its head turned back. The base flares out and has three rivet holes for attachment to the vessel while the forelegs were attached to the rim. Found in a hoard at Babylon, it is from a vessel of the kind depicted on the Persepolis reliefs.

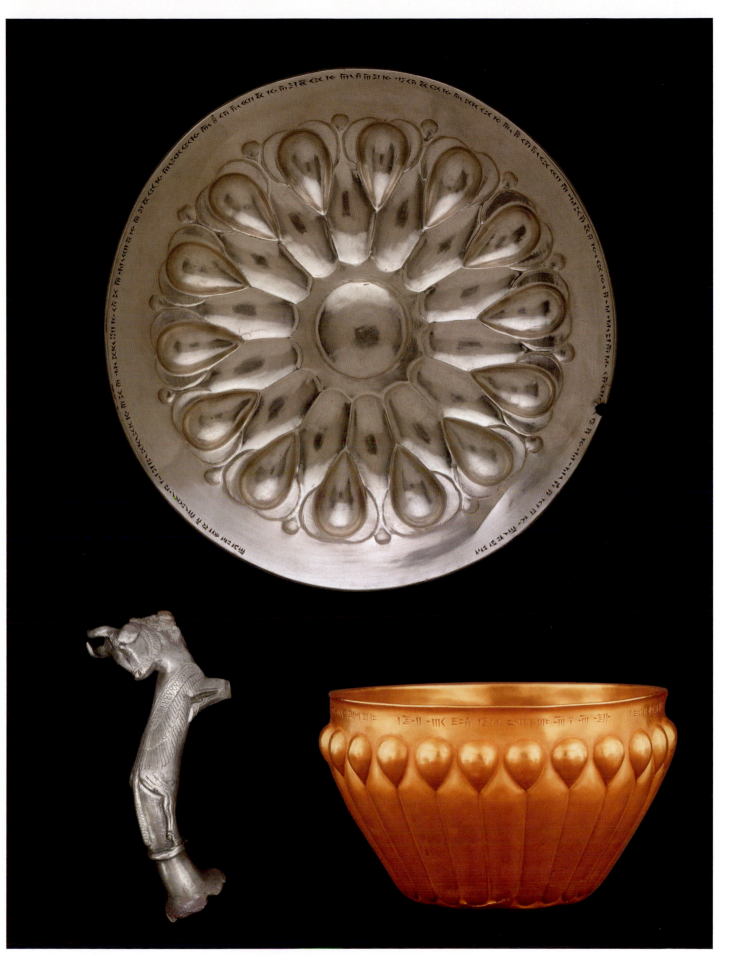

Cylinder Seals

According to Herodotus in his *Histories*, each Babylonian had his own seal. By this time, they were probably stamp seals or rings with circular or square engraved stones. Cylinder seals had fallen out of favor for a time but were revived by the Achaemenid Persians, alongside the use of stamp seals and signet rings. The seal designs drew on ancient Near Eastern artistic legacies and traditional iconographies. The most popular scene was the hero and animal combat [**13.33**, **13.34**]. A typical composition of this type presents a hero or a king in the centre of a symmetrical composition grasping rearing rampant lions or winged bulls. Other scenes continued to be used as well, such as the worship scenes of Babylonian glyptic arts, along with new court styles with hunting and battle scenes. The seal of Darius I from Thebes in Egypt is typical of this court style [**13.35**]. The seal stone of green chalcedony is carved with a scene of a hunt, closely following the hunt theme of the royal Assyrian reliefs of Ashurbanipal in the North Palace at Nineveh. The king wields a bow and arrow from the back of a chariot, while a charioteer holds the reigns of a pair of horses. Wearing a dentate (serrated) crown and formal robes, Darius I faces to the right with his torso presented frontally as he confronts a rearing upright lion of enormous proportions. His bow is carved in minute and careful detail with bird-headed ends. The symmetrical scene is placed between two date palm trees and bands

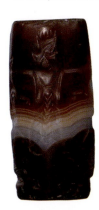
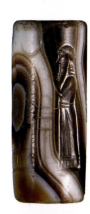
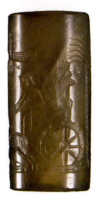

13.33 Seal with king standing on two crouching sphinxes and holding in each hand a lion, unknown provenance, 550–530 BCE. Agate, h. 1¼ in. (3.2 cm)

13.34 Seal with a double scene of ritual and combat, from the Southeast Palace, Nimrud, Iraq, Late Babylonian/ Achaemenid. Sardonyx, h. 1½ in. (3.7 cm)

13.35 Darius seal from Thebes, Egypt, 521–486 BCE. Chalcedony/parse, h. 1½ in. (3.7 cm)

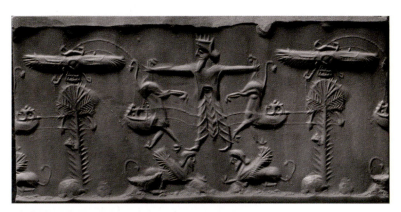
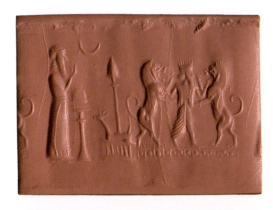
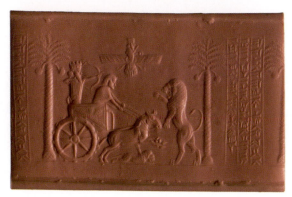

This is a reused late Babylonian seal that originally represented a ritual with a praying figure before an altar with emblems of the Babylonian god Marduk, recarved with an additional scene depicting a heroic kingly figure wearing a crenellated crown and Persian clothing, overpowering two upright lions. It was found in the Assyrian city of Nimrud in the north of Mesopotamia.

of inscription. A deity in a winged disc, probably representing Ahuramazda, floats over the center of the scene. The seal is exquisitely carved with details of chariot parts, clothing, animal sinews, fur, and drill holes for the eyes. The inscription panel states "I am Darius the King" in Old Persian, Elamite, and Babylonian, the three languages used for imperial Achaemenid representations. The Darius seal is an excellent example of the naturalistically modeled yet formal compositions favored by the Persian courtly elite.

The End of the Persian Empire

Persian rule in Mesopotamia lasted more than two centuries. The Achaemenids maintained the city plan of Babylon, and its temples and cults, restoring and preserving the monuments under their charge. Babylonia was made the ninth **satrapy** of the Persian Empire and Aramaic, a local Mesopotamian language, was taken up as the lingua franca of the empire, although cuneiform Babylonian continued to be used as well. Thus Babylonia remained at the heart of the Persian Empire and its identity.

There were short-lived rebellions in 522 BCE and 521 BCE at the death of Cambyses II, the son of Cyrus, and in 479 BCE during the reign of Xerxes. Herodotus wrote that the Temple of Zeus, that is Marduk, was destroyed and that Xerxes ordered the melting down of the golden statue of the god. The cult of Marduk continued, however, as cuneiform texts indicate that it was still in existence at the end of the Achaemenid era. Herodotus was full of admiration for the grandeur, beauty, and splendor of Babylon. The memory of Mesopotamian history and mythology continued into the following centuries in stories that merged and drew parallels with those of Greek and Roman mythology, keeping the ancient names of such heroes as Gilgamesh alive.

As late as the third century CE an account of the Roman scholar Aelian indicates clearly that the ancient Sumerian epic tale of Gilgamesh was still read and known even in the western Mediterranean world. In his work *On the Nature of Animals* he wrote:

When Eucheros [probably Enmerkar] was king of the Babylonians, the Chaladaeans prophesied that his daughter's son would take away the kingdom from his grandfather (what was said by the Chaladaeans had the status of a prophecy). This frightened him, and (if you will allow the jest) he played Acrisius to his daughter, guarding her closely. However, the girl became pregnant by someone obscure and gave birth in secret, for need was wiser than that Babylonian. The guards were afraid of the king and threw the child from the citadel, where the girl was imprisoned. But an eagle, spotting the child fall with its sharp eyes flew down and put its back under it before it fell to the ground. The eagle brought the child to a garden and put it down carefully. When the man in charge of the garden saw the beloved child, he loved it and brought it up. It was called Gilgamos and became king of the Babylonians. If anyone thinks that this is just a story, I do not agree having investigated it as much as I could. Indeed, I hear that Achaemenes, the Persian, from whom the Persian nobility is descended, was nursed by an eagle.

The Achaemenid empire was a time of splendor and prosperity, but it came to a quick end. In 331 BCE Alexander of Macedon defeated Darius III and his Persian army at the battle of Gaugamela, near Khinnis in the north of Mesopotamia, and became the heir to the entire Achaemenid empire. Darius III escaped to the east, but upon his arrival in Bactria he was murdered instead of being protected, as even his eastern satrapies could see that this was the start of a new political order that they wished to appease. The period of the Achaemenid dynasty, which had united an immense expanse of lands and diversity of peoples, came to an end, but the innovations of this empire and its methods of rule—including the use of common monetary systems and administrative languages—became the basic elements of future empires. Alexander regarded himself as the heir to the empire and the ruler of Babylon, while instigating a new era of Hellenistic rule in the east.

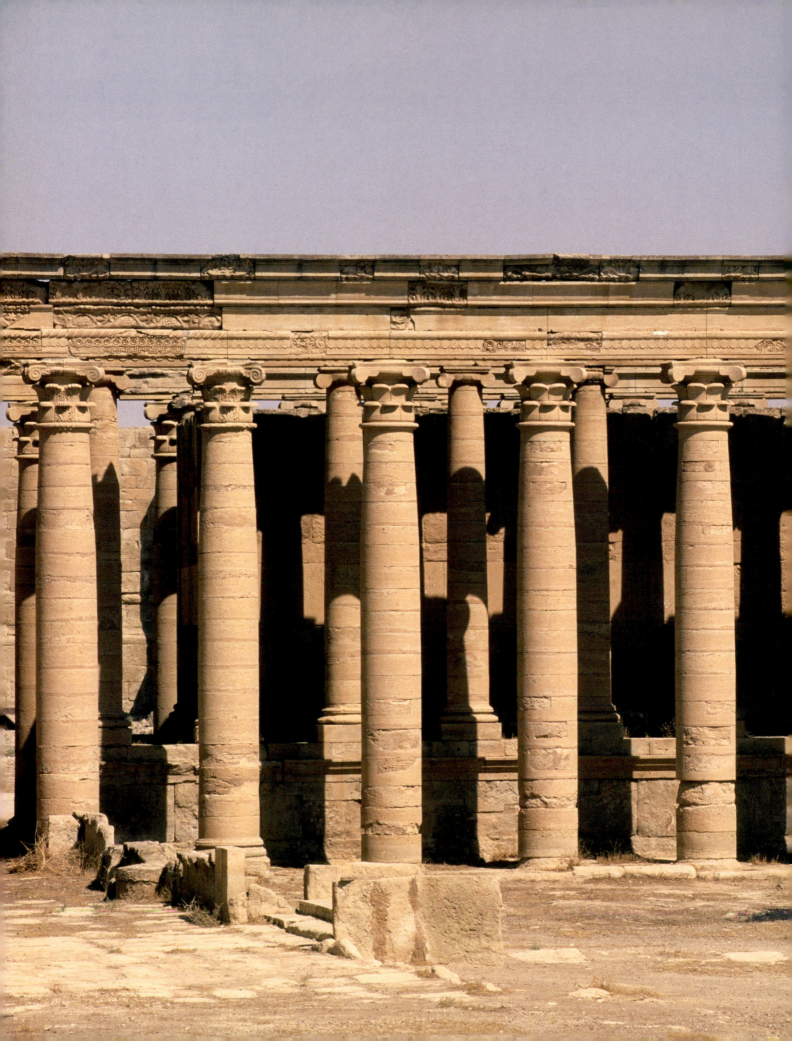

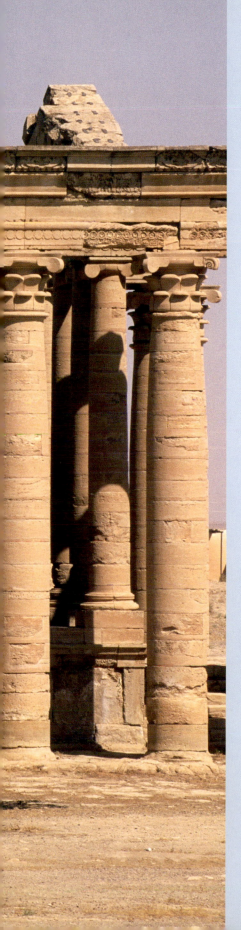

CHAPTER FOURTEEN

Alexander in Babylon and Hellenism in Mesopotamia: Seleucid and Parthian Art

Temple of Marn, Hatra, Iraq,
1st century BCE to 2nd century CE

14 Alexander in Babylon and Hellenism in Mesopotamia: Seleucid and Parthian Art 331 BCE–241 CE

Periods	Hellenistic, Seleucid, and Parthian (also called Arsacid)
Rulers	Alexander of Macedon r. 331–323 BCE
	Seleucus I Nikator r. 311–281 BCE
	Antiochus I Soter r. 281–261 BCE
	Mithridates I r. 178–138 BCE
	Sanatruq I r. 140–180 CE
	King Sanatruq II r. 200–241 CE
Major cities	Seleucia on the Tigris, Hatra, Ctesiphon, Uruk, Assur, Nippur, Messene (modern Maysan)
Notable facts and events	Death of Alexander in Babylon 323 BCE
	Trajan attacks Hatra 117 CE; Septimius Severus attacks Hatra 198 CE
	Ardashir crowned in Ctesiphon, start of Sassanian rule 226 CE
	Hatra captured by Shapur I 241 CE
Important artworks	Bronze Herakles with bilingual inscription
	Hatra statues
Technical and stylistic developments in art and architecture	Graeco-Babylonian style
	New terra-cotta-making techniques

14 Alexander in Babylon and Hellenism in Mesopotamia: Seleucid and Parthian Art

The Babylonian astronomical diary records the arrival of Alexander of Macedon in the great city of Babylon on the twelfth day of Tashritu (October) 331 BCE [**14.1**, see p. 326]. This grand entry into the city followed a total lunar eclipse on September 20, an ancient omen that predicted the end of one reign and the start of a new one. According to the first-century CE Roman historian Quintus Curtius Rufus, the people of Babylon stood on the walls of the city to greet their new ruler and the road was decorated with scattered flowers. Silver altars for incense, perfume, and offerings were placed on either side of the broad processional way through which Alexander entered the city in triumph as its new king. Horses, cattle, leopards, musicians, and priests, and the Babylonian cavalry were all part of the processional festivities that welcomed him as he appeared in his war chariot and made his way to the palace [**14.2**, see p. 326].

The astronomical diary gives Alexander the traditional Mesopotamian title of "king of the world" in the Akkadian language. This new ruler, a young man from Macedonia in the north of Greece, identified himself as the legitimate heir to the Persian kings. From the outset, Alexander had his sights set on Babylon. After the battle of Gaugamela (near the Gomel river), where he had routed the last Achaemenid king Darius III, he immediately moved south to Babylon, rather than pursuing a path eastwards to Iran. In Babylon, he took up residence in the palace of Nebuchadnezzar II, setting up his new imperial court there.

Alexander's conquests and his practice of establishing settlements and populating them with Greek residents began the cultural changes in the Near Eastern world known by scholars as Hellenization (from Hellenic, meaning "Greek"). In Mesopotamia, during the reign of Alexander himself and the Greek Seleucid rule that followed, the arts and architecture entered a new and distinctive phase of great creativity. We can recognize three workshops that are distinctive of Hellenism in Mesopotamia. Traditional Babylonian genres of art and iconographies flourished under Macedonian and Seleucid rule. Yet this continuity of traditional forms occurred alongside new hybrid styles that appear to mix the local preference for mixed media and decorative patterning with the idealizing naturalism and smooth surfaces of Greek sculptural styles and techniques. At the same time, a third and far less abundant group of imported artworks made in the Greek west began to appear soon after the arrival of Alexander in Babylon. The imported Greek works are recognizably different from two types of local production: artworks made in the Mesopotamian tradition, and the group of hybrid images that mixed elements of Mesopotamian and western arts.

The local artistic workshops created these new combinations of forms, techniques, and traditions, merging the Greek and Babylonian in a way that became distinctive of the Seleucid arts. We can call this the Graeco-Babylonian image. These Graeco-Babylonian works went on to influence the art

14.1 Alexander the Great portrait, from Pergamon, Turkey, 2nd century BCE. Marble, h. 16½ in. (42 cm)

and architecture of the **Parthian** era that was to follow in the succeeding centuries, and some of the iconography and decorative details appear well into the medieval era in the arts and architecture of both East and West. In this chapter, the arts of the age of Alexander and the final eras of ancient Mesopotamia—Hellenistic, Seleucid, and Parthian (also called **Arsacid**)—will be considered, with a focus on the arts and architecture of the great cities of Seleucia on the Tigris and Hatra, taking us to the era of the **Sassanian** Empire and the advent of Islam.

14.2 Charles Le Brun, *Alexander the Great Enters Babylon*, 1665. Oil on canvas, 14 ft. 9⅛ in. × 23 ft. 2⅜ in. (4.5 × 7.07 m)

The story of Alexander's victory in Babylon became a theme in later Western art. In this seventeenth-century painting, made for Louis XIV of France, a parallel is drawn between Alexander's triumph and the glories of the reign of Louis XIV.

Hellenism in the Art of Mesopotamia

The era of Alexander and the Seleucid Greeks in Mesopotamia (331–141 BCE) was a turning point for the arts and architecture, not only in Babylonia, but also for many parts of the ancient eastern Mediterranean and Near Eastern world, all of which was now under a Macedonian imperial rule. Alexander, who specifically chose Babylon for his grand entry into Mesopotamia, wanted to develop that city as one of the key urban centers of the empire. He therefore initiated renovations of Esagila, the sanctuary of the great god Marduk, as well as major building works detailed in the Babylonian chronicles.

The city of Babylon and its palaces were utilized by the ruling elite, and at the same time, a Greek theater was built [14.3]. This was an entirely new type of building for the region, dedicated to theatrical performances. It was erected in the city very early in the Seleucid period, possibly even in the lifetime of Alexander. This theater seems to have been called the *bit tamartu* in Babylonian ("the house or place of viewing"). Although Greek plays had been performed in the Achaemenid Persian era in other settings, for example within palaces, there had been no edifice dedicated to these activities before it was introduced in the Seleucid era from Greek prototypes. The Babylonian theater, built in part out of bricks taken from the earlier constructions of Babylon, consisted of a horizontal stage building called a *skene* in Greek, an *orchestra* (the space where the chorus danced and sang), and *paraskenia* (side wings). The theater must have been in use for an extended period of time, as it was renovated and reconstructed in antiquity at least twice. The large open arena with its semicircular area for seating was also used for social gatherings and assemblies of the people. There was also a Greek-style gymnasium in Babylon next to the theater, and an *agora* ("marketplace") nearby.

Greek influences on the visual arts in Mesopotamia were rapid and extensive. Graeco-Macedonian craftsmen and artists traveled east into the Hellenistic empire and brought new styles of stone carving with them. They also set up workshops in the east where they interacted with the local traditions and artists. Although Greeks had lived in Assyria and Babylonia as early as the ninth and eighth centuries BCE, and the era of extensive international contacts had existed long before that time, the new influx of Greek culture was on a different and far more extensive scale. The influence from west to east, which had begun to change direction in the Achaemenid era, now increased significantly as the Greek colonies in Asia Minor and the large Greek presence in Mesopotamia and Iran impacted on local practice. Objects imported from Greece influenced both the technologies and the iconographies of Mesopotamia. The extensive cultural interaction

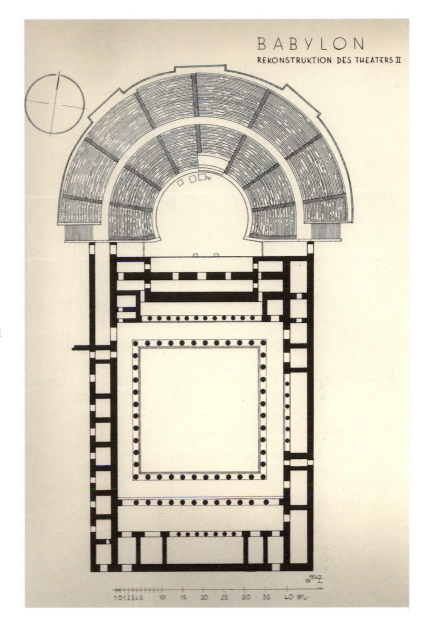

14.3 Theater with semi-circular orchestra and adjacent Palestra (gymnasium), with colonnades, Babylon, Iraq, c. 330–323 BCE, with 2nd century BCE additions.

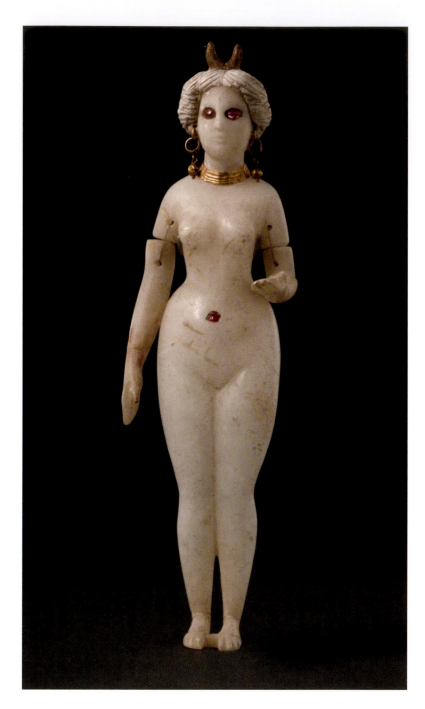

14.4 The goddess Ishtar, from Babylon, Iraq, 3rd–2nd century BCE. Alabaster, rubies, and gold. h. 9¾ in. (24.8 cm)

of the Hellenistic empire resulted in a delightfully creative mix, which can be seen in written works as well as in the visual arts of Mesopotamia. Graeco-Babylonian artworks employ a fascinating visual **syncretism** (a fusion in the visual arts) that echoes, in its forms and iconographies, the syncretism of Greek and Mesopotamian religions and ritual practices. One exquisite example can be seen in the statue of the goddess Ishtar

from Babylon, now in the Louvre Museum [**14.4**]. Found in a tomb in 1862 CE, the Ishtar statue is one of a number of alabaster figures that combine Greek modeling and bodily ideals with Babylonian features and decorative applied attachments. This small figure is carved from alabaster, with the naturalistic modeling of Greek sculpture. The emphasis on the rounded hips and thighs and the nipped-in waist adhere to the Greek idealized forms of the female body. Yet certain features of the statue are specifically Babylonian. The eyes and navel that are inlaid with red gems and the addition of a golden headdress upon her head follow the Mesopotamian preference of mixing materials to which they attributed essential values. The golden crown has a dual role of being a traditional horned crown and a crescent moon, thus referencing her nature as the horned goddess while perhaps also associating her with the moon.

The arms of the Ishtar statuette are articulated. Her forearms are carved separately and attached to the upper arms with a thin gold cord in order to allow some movement. The left arm is bent, with the palm held open as if to receive or to give something. Traces of dark paint survive on the hair, which is surmounted by the gold horned crown. The goddess wears large gold crescent-shaped earrings with pendant spheres of gold and a thick gold collar necklace, made in one piece. An analysis of the stone inlay of the eyes and belly by conservators revealed that the source of the red rubies was Burma (Mynamar) in Southeast Asia or possibly Sri Lanka, indicating that long-distance eastward trade for precious materials flourished at this time.

Nude female figures carved out of alabaster or marble with moveable arms are known from several examples discovered at Babylon and elsewhere [**14.5**]. A less well preserved example now in Berlin has the eyes and navel hollowed out to receive inlays, perhaps rubies or other precious stones, which are now missing [**14.6**]. The full female figure is carved with rounded Hellenistic modeling, the right leg slightly bent to give a sense of movement. The left arm is bent with the palm held open, while the right hangs to the side.

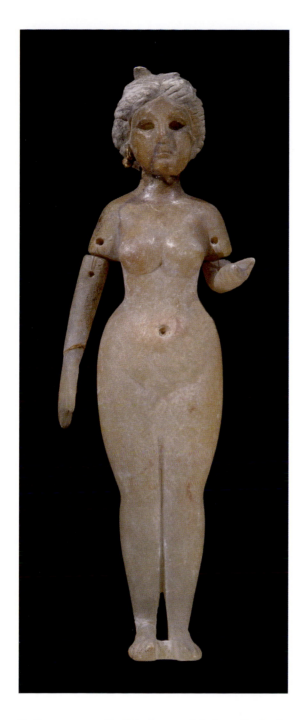

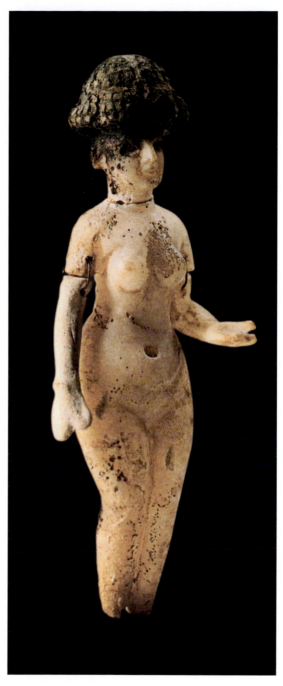

Far left
14.5 Nude female, standing, from Babylon, Iraq, 3rd century BCE– 2rd century CE. Alabaster, gold, glass, and terra-cotta, h. 8½ in. (21.5 cm)

Left
14.6 Female with moveable arms and headdress, unknown provenance, probably from Babylon, Iraq, 3rd century BCE– 2rd century CE. Alabaster and bitumen, h. 7½ in. (19 cm)

The representation of the female body changed in the 4th–3rd centuries BCE, when Greek styles were introduced. Greek artists did not always represent the details of the female anatomy, while Mesopotamian tradition had done so explicitly. Babylonian sculptors used inlays and paint to indicate these features, combined with Greek naturalistic modeling.

Both arms are articulated separately from the body and attached with golden pins. The voluminous hairstyle is made of black bituminous stone and attached to the alabaster head. This figure may represent an acolyte or a priestess of the goddess Ishtar, whose cult continued to be of central importance in Babylon, as she came to be associated with such goddesses as the Greek Aphrodite and the Parthian Anahida.

A second type of Graeco-Babylonian nude female is the reclining figure. Images of reclining women, completely nude or with their lower body draped in cloth, are found in abundance in Seleucid and Parthian contexts. One figure from Seleucia on the Tigris is a good example of the type. It represents a woman reclining on her left side while raising her upper body with her left bent arm [**14.7**]. The right arm lies draped along

her upper leg and hip. The squared fingers have pink-colored grooves. Her full rounded form is completely nude, an idea that would be unusual in Greek art, but it is also decorated with paint to emphasize parts of the body. She is adorned with a necklace of red and black paint, and she wears reddish strap sandals on her feet. The lines of the folds at her belly and her navel are all painted with a dark pink pigment. While her reclining attitude and her rounded naturalistic modeling follow Greek sculptural traditions, the addition of other materials is more in keeping with Babylonian preferences in the representational arts. Both the reclining female figures, nude or partially clothed, and the standing figures were made in terra-cotta versions as well [14.8]. They were statuettes that

could be acquired in different materials for votive offerings and for burial gifts. They continue in popularity from the Seleucid through the Parthian era without interruption: political changes seem to have had little impact on the visual culture of the people of Babylonia at this time.

Seleucia on the Tigris

The death of Alexander on June 10/11, 323 BCE in Babylon is known so precisely because it was recorded in the Babylonian astronomical diaries. (Babylonian documents are of central importance for the study of the Hellenistic empire and its history.) Alexander's untimely death created a power vacuum that led to the splitting of the

Right
14.7 Reclining nude female, from Seleucia on the Tigris, Iraq, Parthian, 2nd century BCE– 1st century CE. Marble with inlaid eyes, plaster and pigment, 12¼ × 5⅞ in. (31 × 15 cm)

Below right
14.8 Reclining nude female, from Seleucia on the Tigris, Iraq, 2nd century BCE– 1st century CE. Terra-cotta, 3⅜ × 4½ in. (8.6 × 11.4 cm)

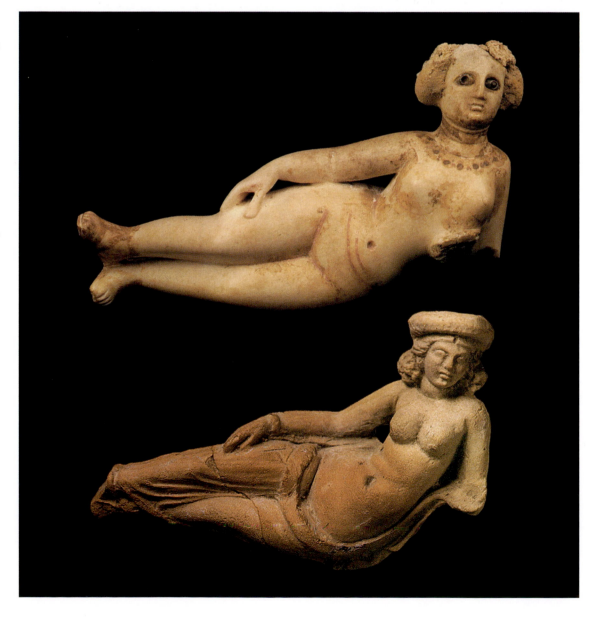

empire; each section came to be ruled by one of his generals, the *diadochi*. Alexander is said to have become increasingly orientalized, seeing himself as an eastern ruler. Like the Achaemenid kings before him he received delegations in Babylon from many lands, including Africa, Spain, Sicily, Gaul, Italy, and Greece. A local Persian man named Mazaeus was given the important title of **satrap**, or governor, while the military and financial functions of Babylonia were given to Macedonians loyal to Alexander. Apollodorus of Amphipolis, Menes of Pella, and Agathon of Pydna are recorded as commanders of the military forces; while Asklepiodorus, son of Philon, and Antimenes of Rhodes had the financial authority. Together, these men became the new Hellenistic ruling elite. After the death of Alexander and the division of the empire, **Seleucus I** Nikator ("the Victorious") (r. 311–281 BCE) who had been a military commander under Alexander, became king in this region of Mesopotamia, initiating the Seleucid Empire [14.9]. It was the largest part of the former Hellenistic empire of Alexander after the division.

Soon after taking control of Mesopotamia, Seleucus I founded his new city of Seleucia on the Tigris, where he was eventually buried after his assassination in 281 BCE. Along with Babylon and Uruk it is the best known of the Seleucid cities, because excavations in the twentieth century have revealed much of its layout. Here the impact of Greek influence can be studied in detail as it was a newly founded city, not one based in such ancient urban centers as Babylon or Uruk. It was thus the ideal Hellenistic city, which deliberately combined aspects of both east and west. It is interesting to observe that even at the newly established Seleucia, there is still a great deal of visual culture that is distinctively Babylonian. It was not a city that ever became entirely Greek. In 292 BCE Seleucus appointed his son Antiochus I Soter ("the Saviour") as co-regent. Antiochus I later moved to his new city, Antioch, after his father's death in 281 BCE, where he reigned until 261 BCE. But Seleucia was still at the center of the Hellenistic east, rivaling Antioch, Alexandria, and even Rome for its wealth and urban expanse.

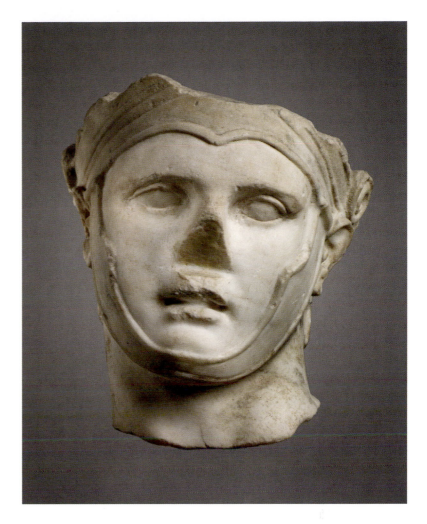

In terms of sheer size and scale, Seleucia on the Tigris was huge compared to other new Seleucid cities. The Roman scholar Pliny the Elder (23–79 CE) records that the population was 600,000.

The early twentieth-century excavations uncovered the ruins of an urban settlement in an area covering *c.* 40 sq. miles (100 sq. km) over both banks of the Tigris, *c.* 22 miles (35 km) south of modern-day Baghdad and 37 miles (60 km) northeast of Babylon. This archaeological area, where Seleucia stood in antiquity, includes the ruins of more than one city, dating from the Seleucid through to the end of the Sassanian age in the seventh century CE, a vast metropolitan mass that led medieval Arab writers after the Muslim conquest to refer to it as al-Mada'in ("the cities"). Here, the Greek city of Seleucia on the Tigris was built at the outset on the right bank of the Tigris river, at the main mound of Tell Umar.

14.9 Head of Seleucus I, Roman copy, made in Syria, 1st century BCE–2nd century CE. Marble, h. 9½ in. (24 cm)

The important urban innovation at Seleucia was the division of the city into a grid of streets crossing at right angles following the Hippodamean method, a Greek urban design based in a rectilinear grid. Seleucia's city blocks were the biggest in the Hellenistic world, each measuring 500 × 250 ft. (144.7 × 72.35 m), and there were two main roads that crossed the city longitudinally. The rectilinear grid was broken here and there by rectangular spaces reserved for public, civic, and religious buildings. There was also a square where the city archives stood. More than 30,000 clay *bullae*, or seals, were found in these archives. The documents that they had sealed were burnt in a fire in 154 BCE, leaving only papyrus fibers on the backs of the seals. The clay

was applied on top of the string that had been used to tie the papyrus documents, forming a rolled up tube. Each piece of sealing clay was imprinted with the marks of a stamp seal bearing a Greek epigraph of about three lines, and often with an image. Seals of the city administration bore the symbol of an anchor or tripod, and seals of civil officials had male portrait heads in profile in a naturalistic Greek style accompanied by a short inscription. Some seals bore images that accord with the Greek repertoire and other seals echo instead the iconographies of ancient Mesopotamian arts, such as the mushhusshu dragon of Marduk and the bull of Adad.

While few monumental works of marble, limestone, or bronze were found at Seleucia on the Tigris, a considerable amount of small terra-cotta figurines survive [**14.10**, **14.11**]. They are strong evidence for the contemporaneous existence of different sets of iconographies and methods of creating images in a major Hellenistic capital. These small works perhaps best represent the Mesopotamian Seleucid culture with its mixture of Greek and Mesopotamian arts. They are even more important because they represent works of art that were accessible to the people of the city, and were not limited to the ruling elite. They were an art for the people. The production of terra-cotta figurines and plaques has a long lineage in southern Mesopotamia, where good clay is abundant and where molds for mass production had been in use since the third millennium BCE. There must have been a large demand for them, as they are far more abundant than the small bronzes. Practically every house in the city of Seleucia on the Tigris contained works of art in the form of terra-cotta figurines. Indeed, there were as many figurines as pottery fragments, an astounding observation made by the excavators of Seleucia on the Tigris.

Three workshops for the production of terra-cottas were also identified by the excavators. They continued to use the ancient techniques of Babylonia, but they also imported a new Greek technique of using two molds to produce a rounded hollow statuette. Often the back of such figures was less well worked, giving the

Seleucid terra-cottas, 3rd century BCE–1st century CE

Left **14.10** Young girl, h. 4⅞ in. (12.4 cm);

Right **14.11** Female figure with mantle, h. 6⅛ in. (15.7 cm)

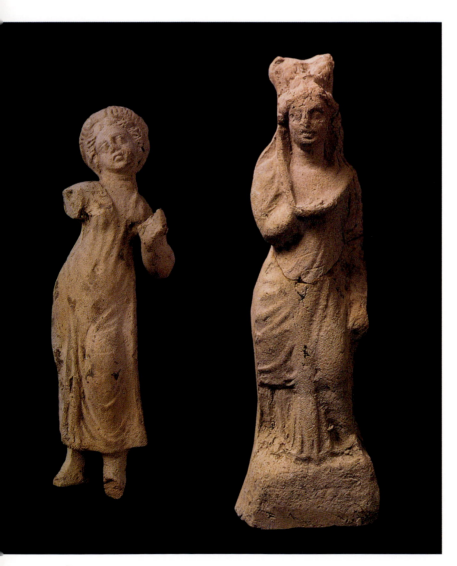

impression that it was the frontal view that was most important for their display or devotional use. Small figurines could also be made out of bone or ivory, and small mass-produced votive bronzes were also made for the citizens of Seleucia on the Tigris. Three iconographic or stylistic types can be recognized: Greek style, Graeco-Babylonian style, and Babylonian style. Greek types of relief *pinakes* (figures in the round or in full relief made out of molds) include children playing with animals, erotic scenes, and other standardized and repeated images. A clothed and cloaked female figure was one of the most widespread types directly adopted from Mediterranean works. These figures were made in a range of closely related examples across the south of Mesopotamia. Reclining female figures, partially covered in a cloth from the waist down or completely nude, were made in abundance. The reclining nudes are often found as grave gifts and may have been connected with funerary rites, perhaps with funeral banquets. The style of the figures looks essentially Greek in origin, but they are rare there, while common in Hellenized Mesopotamia. The depiction of females completely nude was never accepted in Greece in the way that it was in Mesopotamia. These nudes belong to the Graeco-Babylonian style. At the same time, traditional Babylonian terra-cottas, such as the standing frontal nudes, continued to be produced.

One seated nude male torso from the Parthian period was made in a double mold and is hollow [**14.12**]. The arms seem to have been made separately. The torso is very well modeled in a naturalistic portrayal of the male body, which turns in a three-quarters view with the right arm raised. The musculature is well defined with a pronounced emphasis on the abdominal area. The small figure echoes the well known Belvedere Torso in the Vatican Museums, a Roman copy of a work by the Greek sculptor Apollonios that had a great influence on artists of the Renaissance and Baroque eras in Europe.

Among the small terra-cottas, there were many Greek themes and iconographic types. The divine hero **Herakles** was also commonly portrayed in Greek-style terra-cottas and small bronzes.

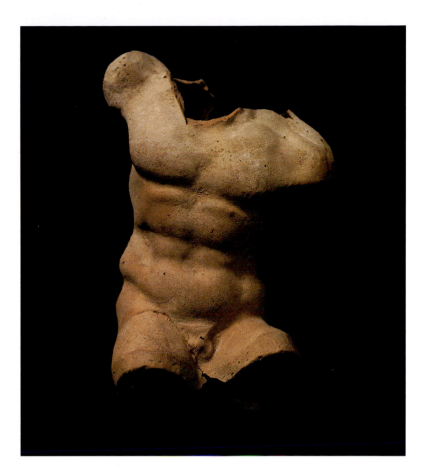

His cult was popular in the East as he became associated with the god Nergal. Other subjects, such as Harpokrates (the Hellenized version of the child god Horus), or a child holding a pomegranate, as well as figures seated supporting a vessel on their head or shoulders, were all popular. Greek-type masks were also characteristic of Hellenistic Mesopotamia. Many of these were found in the workshops of Seleucia on the Tigris. They are often made in the form of Silenus and other satyrs of Greek mythology, as well as some female faces. Holes were made in them at the sides or top so that they could be hung on the wall. Traditional Mesopotamian types continued to be made in large numbers alongside the Greek images. They include the nude frontal female figure standing with legs together, arms at her sides or with one raised to her breast, or both arms at the breasts or waist. Another is the nursing mother image, which is not a Greek pictorial subject but a purely Mesopotamian subject, represented commonly from the late

14.12 Nude male torso, from Seleucia on the Tigris, Iraq, 3rd century BCE–2nd century CE. Terra-cotta, h. 4¾ in. (12.1 cm)

Burials

The inhabitants of Seleucia on the Tigris and other Hellenistic Mesopotamian cities were mostly of Mesopotamian descent. They followed their own local funerary traditions, which included the interment of figurines, pottery and glass vessels, lamps, and often reclining female statuettes with the body of the deceased. The middle classes were buried in *cappuccina* graves, a type in which the grave was lined with baked bricks to form a coffin and covered with two rows of bricks on top to form a sloping roof. They also used sarcophagi, which were in the form of rectangular ceramic containers with curved ends. In the Parthian era, these were often decorated with architectural motifs and nude female figures. The slipper coffin shape—ceramic with applied decorations—was also typical for the Parthian era. Family **hypogea** graves consisted of rectangular underground chambers with barrel-vaulted ceilings in baked brick accessed through a shaft or stairs leading downward. Sarcophagi were placed inside the hypogea and lamps were set inside niches within that space. The burials of Greek residents may be recognized by the inclusion of a coin—an offering to Charon, the boatman of Hades who was believed to carry the dead across the River Styx, the body of water that divided the worlds of the dead and the living in ancient Greek religious beliefs.

third millennium BCE onward. These are age-old Babylonian types, although the modeling of the body now takes on some Greek naturalistic features. They represent the survival of very ancient religious beliefs.

Continuity and Change

During the Seleucid era, the governor of Uruk was a Babylonian, but he had a Greek name in addition to his Babylonian one, and used both in his inscriptions: Anu-Uballit-Nikarchos. These kinds of bilingual names are of importance for understanding the extent to which the two cultures became fused and hybridized into a Graeco-Mesopotamian form. The buildings and cults of Uruk and other ancient cities were maintained, and old cultic texts were copied, but new complexes were also built in the tradition of local Babylonian architecture. In Uruk, the Bit Resh (or "main temple") was built by Anu-uballit-Nikarchos in 244 BCE [14.13]. Further construction on the Bit Resh took place when it was enlarged by another city official, Anu-uballit-Kephalon (who also used dual names),

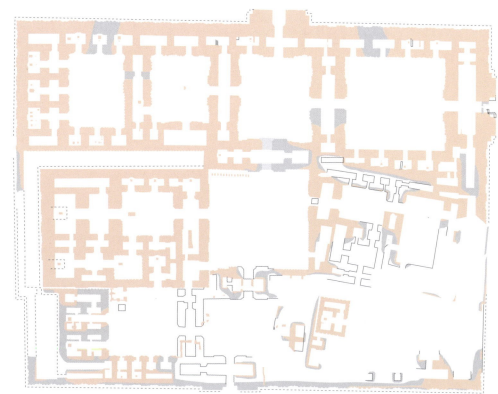

14.13 Bit Resh, Main Temple, Uruk, Iraq, 244 BCE

N

0 130 ft.

0 40 m

in 202 BCE. This temple was constructed in Babylonian style and method and dedicated to the Mesopotamian god of heaven Anu and his wife Antum. Here numerous cuneiform tablets were found written in ancient Sumerian and translated into Babylonian in sentences placed in between the lines. These documents are copies of old Mesopotamian texts made in the Seleucid era. They reveal that the Seleucid elite was interested in preserving and studying the scholarship of the past. Another archive was found in the house of a priest in the city, and other tablets were found in private homes. There were also texts that belonged to a temple library that was maintained in the Seleucid era. The Irigal (a temple of the goddess Nanaya, south of Bit Resh) and the Eanna sanctuary of Ishtar were repaired, and a New Year Akitu festival house was built at Uruk.

At Babylon, the great temple of Marduk continued to be used, and some renovations were made in the Seleucid era. A New Year Akitu festival house was constructed north of the palace area, showing that the ancient Akitu festival continued (see pp. 278–79). Indeed, the Babylonian cults were always supported by the Seleucid rulers. Members of the royal family were actively involved in the numerous ancient cults and temples according to chronicles of the time, and texts reveal that they

supported many restoration projects. Antiochus III (r. 242–187 BCE), for example, took active part in the Akitu festival on 8 Nissanu, year 107 Seleucid Era; that is, April 7, 205 BCE. A text describes how he went from the palace to Kasikilla, the main gate of Esagila, and then to the New Year house (referred to as the Temple of Day One in the cuneiform documents of the Hellenistic period) situated just outside the inner wall of the city, to the north of the Ishtar Gate. There the king offered sacrifices to Ishtar of Babylon, reaffirming the thread of continuity to the distant past.

The last foundation deposit text made according to the ancient Sumerian tradition dates to the Seleucid era [**14.14**].a It was a dedication by Antiochus I Soter, the eldest son of Seleucus I. The clay cylinder inscribed in cuneiform writing is in the form of numerous earlier clay cylindrical or prism foundation texts. It describes the renovation and rebuilding by Antiochus, at the Ezida Temple of Nabu (the god of writing and the son of Marduk) in Borsippa. Antiochus, who had become co-ruler with his father in 292 BCE, was thus participating in the ritual of the builder-kings of antiquity. He stands at the end of a long line of Mesopotamian kings who created foundation texts, following Sumerian architectural rites going back to the third millennium BCE.

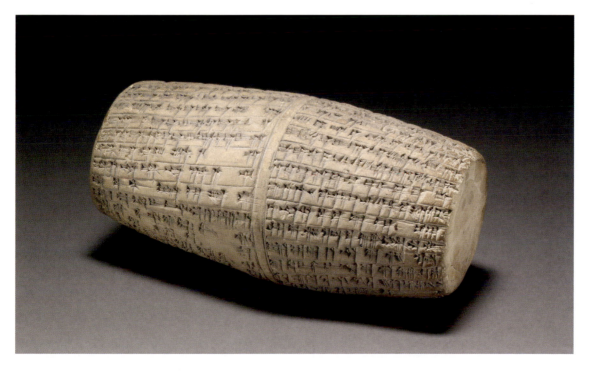

14.14 Antiochus I Soter cylinder, from the Ezida Temple, Borsippa, Iraq, 324–261 BCE. Clay

Mesopotamian Arts under the Parthian-Arsacid Rule

In 141 BCE, Seleucid Mesopotamia fell to the Parthian king Mithridates I (178–138 BCE). The Parthian dynasty had started to the east in the Seleucid province of Parthia in the mid-third century BCE, where Arsaces was the first king and founder of the dynasty. The Parthian arts in Mesopotamia are therefore at times referred to as Arsacid. The Seleucid rulers were driven to western Syria where they would soon face pressure from the Roman expansion to the east. Yet the political changes in Mesopotamia did little to disrupt the Graeco-Babylonian styles and techniques that had flourished in the Seleucid era. Links with Hellenistic culture did not cease. Sculptures continued to be made in a similar fashion to those produced during the Seleucid dynasty and architectural forms and details continued, even in the way in which private houses were constructed. Domestic buildings followed the Greek tradition, with a portico in front, but gradually evolved into courtyard houses. Seleucia on the Tigris continued to be the preeminent cultural and economic center of Mesopotamia, even under the Arsacid kings, and its hybrid Graeco-Babylonian visual culture flourished throughout the south of Mesopotamia.

At the same time as the continued appearance of Graeco-Babylonian styles and iconographies, some innovations nevertheless did take place. The extensive Parthian relations eastward—as far as Han China—and the rise of the Silk Road trade, brought new materials and iconographies to their Mesopotamian domains. These new forms introduced some innovations in the visual arts but did not replace the predominant

14.15a, 14.15b
Gareus Temple, Uruk, Iraq, Parthian, 111 CE

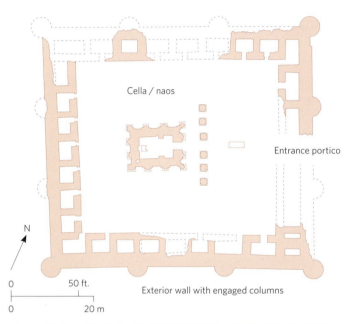

Cella / naos

Entrance portico

N

0 50 ft.

0 20 m

Exterior wall with engaged columns

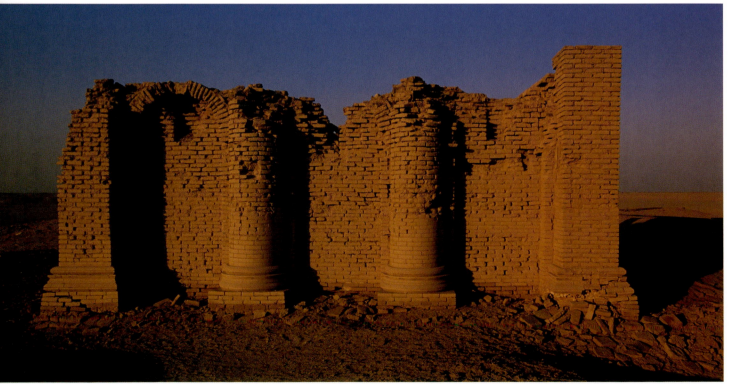

Graeco-Babylonian styles of the preceding era, or the older traditions of Mesopotamia. The Temple of Gareus in Uruk is a good example of this continuity [**14.15a, b**]. This brickwork temple, dated by means of a Greek inscription, was built in the Parthian era but exhibits a typical Seleucid fusion of east and west. It is in the form of a Babylonian plan with a naos or cella terminating in niches where statues were placed. Greek-style applied semi-columns frame arched niches on the exterior walls. It also had a sculptured frieze of mythical creatures.

In the arts and architecture of the main trade cities of the time, such as at Hatra in northern Mesopotamia, or at Assur and Nineveh where Parthian settlements reinvigorated the ancient cities, major sculptures began to be made in a distinctive style, representing local kings or governors or syncretized gods of East and West, within new large-scale temple and palace architecture. Parthian art per se is poorly represented in Mesopotamia, perhaps because the main Parthian cities have not yet been excavated. We know Parthian art and architecture mostly from the peripheral cities rather than from Parthian imperial centers.

One of the most impressive works discovered in Seleucia on the Tigris is a large hollow-cast bronze statue of Herakles made in the lost-wax method with inlaid eyes [**14.16**]. The nude hero stands in a contrapposto position, in which the body is presented in a rhythmic balance with one hip jutting out, creating a swaying curve in the torso. His right hand rests upon his hip. The left arm is now missing but must originally have rested upon a club covered by the lion skin that the hero often wears. The statue is a variant of a Hellenistic type known as the Herakles Farnese, a type attributed to the Greek sculptor Lysippos who lived in the late fourth century BCE. The contrapposto position, a method of representing the body at rest that came into use in the early Classical era in Greece (fifth century BCE), is not known in the arts of Mesopotamia before the Hellenistic era. The details of the body, such as the hard line of the clavicle and the asymmetrical musculature of the stomach and pectorals, are modeled to follow the natural contractions that result from the twisting of the torso, and emphasize the great strength of the hero. His calves and legs are also emphasized for strength. The thick tousled hair and heavily curling beard are typical for depictions of Herakles, who became a very important divinity in Seleucid and Parthian Mesopotamia. Identified with the god Nergal, he came to be worshiped in that guise as a new syncretized manifestation of the ancient god.

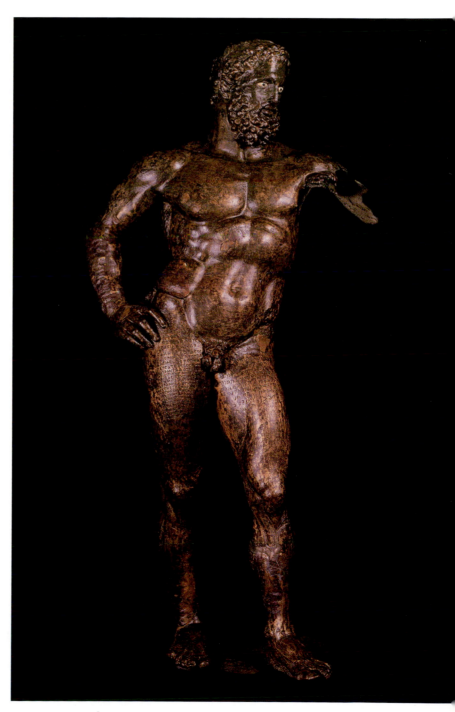

14.16 Herakles, from Seleucia on the Tigris, Iraq, 3rd century BCE– 2nd century CE (inscription of 150–51 CE). Bronze, h. 33⅝ in. (85.5 cm)

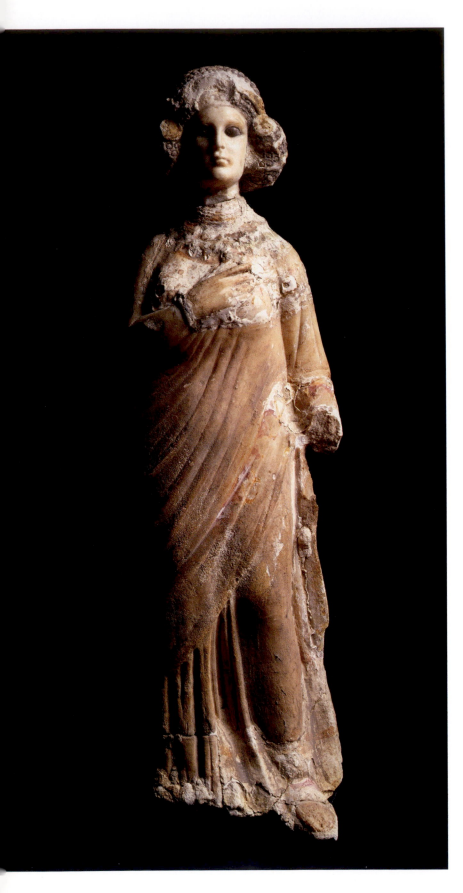

A bilingual inscription placed onto the thighs of the statue—the right thigh in Greek and the left in the Aramaic characters used to write the Parthian language—informs us that Arsaces Vologases led a military expedition into Messene (modern-day Maysan in southern Iraq) and that Vologases, King of Kings, had fought Mithridates, son of Pacoros across Mesopotamia, and had conquered Messene. He placed the statue of the god Verethragna (associated with Herakles), which he had brought out of Mesene, in the sanctuary of Apollo before the bronze gate in year 462 of the Seleucid era (150–151 CE). While the modeling and the technique used to cast the statue of Herakles is purely Hellenistic, the addition of inscriptions onto the body of the statue is a Mesopotamian practice. The inscription was perhaps added to the bronze surface of the statue when Messene was conquered. The date of the inscription and the date of the original casting of the statue may therefore be centuries apart. We know that bronzes were produced in Mesopotamia and exported west to Palmyra in Syria and elsewhere. Such bronzes also inspired small-scale terra-cotta and small bronze figures of Herakles and other Hellenistic and Classical themes.

A portrait of an elegant upper-class woman standing in a contrapposto position with the left knee bent and leg advanced forward is a remarkable example of the mixture of Mesopotamian and Greek styles and traditions of representation [14.17]. The elite woman wears Greek-style clothing consisting of a long gown wrapped diagonally with a thin cloak. The textiles are carved in a series of thick, rippling folds that emphasize the movement of the body beneath, even though it is completely covered. This method of suggesting the form of the body by means of the articulation of the clothing is a well known Greek sculpting technique. The body is made

14.17 Elite woman, from Seleucia on the Tigris, Iraq, 2nd–3rd century BCE. Limestone, marble, and stucco, h. 22 in. (56 cm)

14.18 Priestess, from Borsippa, Iraq, 3rd century BCE–2nd century CE. Alabaster, h. 18⅛ in. (46 cm)

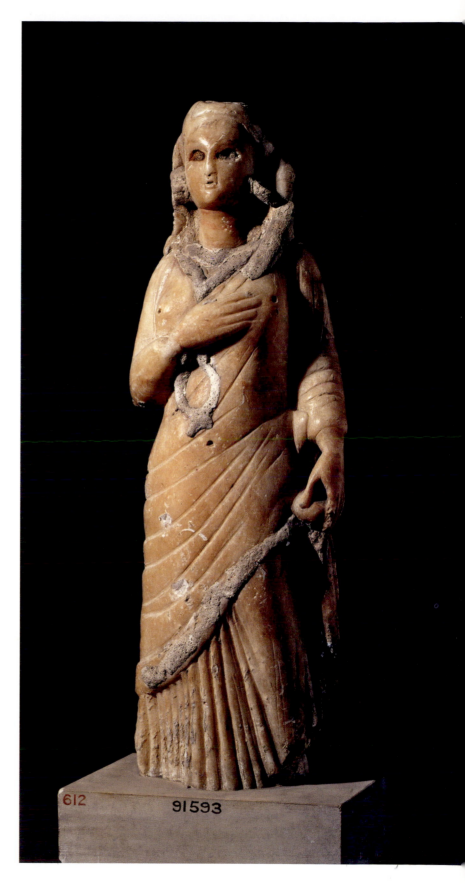

out of limestone but it is further decorated with a **stucco** overlay to indicate the upper part of the gown, a necklace, and a bracelet. The surfaces of the stone statue were thus heavily worked with painted and gilded stucco. The head of the woman was carved separately of marble and the eyes were inlaid and painted. Her elaborate thick hairstyle is of bituminous stone covered with stucco. Traces of a gilded diadem are still visible at the nape of the neck, and would also have been visible at the front of her forehead. The statue combines the Greek-style stance and drapery with the mixed-media articulation of stone surfaces with other materials characteristic of Mesopotamian art.

The technique of mixing materials and combining Greek and Mesopotamian traditions of representation can also be seen in a figure found in Borsippa, now in the British Museum [**14.18**]. The woman, who is dressed in a pleated garment and shawl, holds her right hand at her breast and with her left she pulls at the shawl. The sculpture is made out of alabaster but the eyes were inlaid and dark pigment emphasizes the rims of the eyes. The use of pigment and inlay is an ancient tradition, as is the preference for an idealized female with full cheeks, large eyes, and a small mouth. There are traces of pigment elsewhere on the statue and the rim of the cloak; the crescent-shaped ornament she wears around her neck is added in plaster. The figure is very much in the tradition of Hellenistic Greek portrait sculpture of the third to second century BCE. The garments she wears are identifiable as the Greek *chiton* and *himation*. Her head is covered and she wears a diagonally placed shawl over a long gown with thick folds. The rolled border of the shawl is enhanced with painted plaster. The manner in which she wears the garments and holds the cloak out to the side is also known from Greek sculpture of the west. The nipples and navel are perforated through the dress, however,

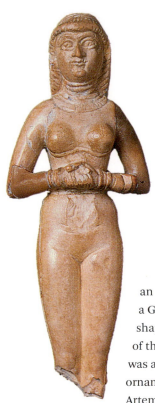

14.19 Nude female figure, from the Inanna Temple at Nippur, Iraq, Parthian. Ivory, h. 4½ in. (11.4 cm)

This nude female figure with hands joined at the waist, wearing bracelets at her wrist and a large collar necklace, dates to the Parthian era. Her small face and dimpled chin, full cheeks, and thick eyelids and brows are in the tradition of the ancient votives of Mesopotamia, and she continues that type almost unchanged.

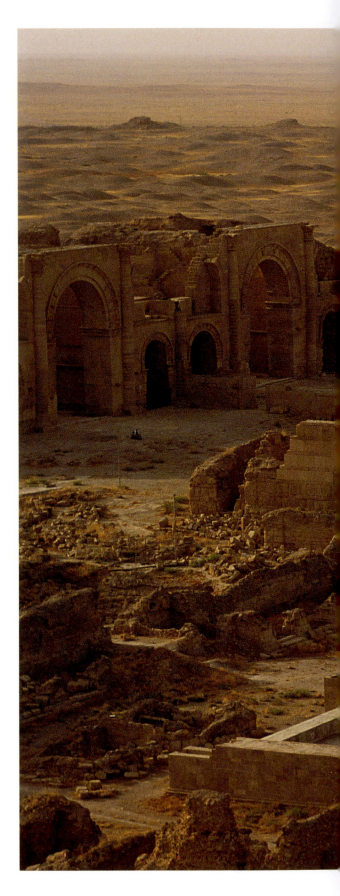

an aspect that would have been unacceptable in a Greek counterpart in the west. The crescent-shaped ornament around her neck is an emblem of the moon god Sin and may indicate that this was a priestess. At this time, however, the crescent ornament is also the emblem of the Greek goddess Artemis. The details, as well as the treatment of the eyes and the use of pigment and plaster, are all local translations of a portrait type that is typically Hellenistic, indicating that Greek styles and techniques were readily mixed with the local traditions. These Graeco-Babylonian-style images existed alongside the traditional Mesopotamian forms of representation [**14.19**].

Hatra and the Mesopotamian Legacy

Hatra, a city on the trade route in Parthian times, lies about 70 miles (110 km) southwest of modern Mosul in Iraq [**14.20**]. It was called the City of the Sun in the ancient Aramaic inscriptions carved there. First built in the third to second century BCE during the Seleucid era, it then became a religious and trade center in the following centuries under Parthian domination. Its rulers were referred to as "lord" (Aramaic *marya*) until Sanatruq I took on the title of king in 167 CE. Hatra was attacked by the Roman emperor Trajan in 117 CE and by Septimius Severus in 198 CE before it was conquered by the Sassanian king Shapur I in 241. Hatra was a bustling trade city connected with a trade route used by major cities including

14.20 Aerial view of Hatra, sanctuary of the Sun, photograph taken in 2003

Below
14.21 Gorgon's head and Aramaic inscription, on Iwan 4, Temple of the Sun God, Hatra, Iraq, 2nd century BCE–2nd century CE

Palmyra, Petra, and Baalbek. It had a circular enclosure wall 2.5 miles (4 km) in diameter and more than 160 towers. The magnificent limestone architecture at the site, which mixes classical columns, moldings, **architraves**, and decorative patterns with large vaulted spaces, dates mostly to the first and second centuries CE [**14.21, 14.22**].

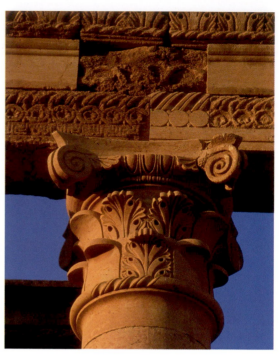

The gorgon face with a beard of acanthus flowers and a serpent crown is described in the inscription as the *jinn* Abshafa. The inscription mentions Zubaydu and Yahbashi, sons of Barneni the architect, son of Yahbashi the architect, whom the gods instructed in a dream; a remarkable echo of Sumerian building inscriptions, such as those of Gudea.

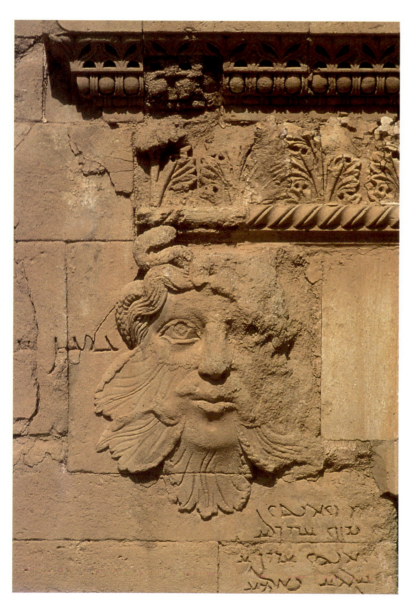

Above **14.22** Capital in Roman style with volutes and acanthus leaves, Marn Temple, Hatra, Iraq

The majestic Great Iwan complex [**14.23, 14.24**] at Hatra was built of ashlar cut-stone masonry at the start of the second century CE. Its facade, 377 ft. (115 m) long, is pierced by eight massive vaulted entrances, the **iwans**. As the vaults are of different dimensions they create a rhythm of arches flanked by Corinthian-style engaged columns. The arches and their bands of molding were sculpted with a series of figures, heads, and busts, carved in high relief, while mythical creatures were sculpted on the piers that carried the arches. The temples of the goddess Allat and of Dionysos Mithra also consisted of a series of massive iwans framed by engaged columns. Iwans are typical of architecture in the Parthian era. They were used not only in Hatra and Assur but also in monumental architecture in the south, at Nippur—in the area of the old ziggurat and temple of Enlil—and at Seleucia on the Tigris. Iwans were to influence later Islamic architecture, especially in this region.

The central temenos was not the only area of Hatra with monumental architecture. Smaller

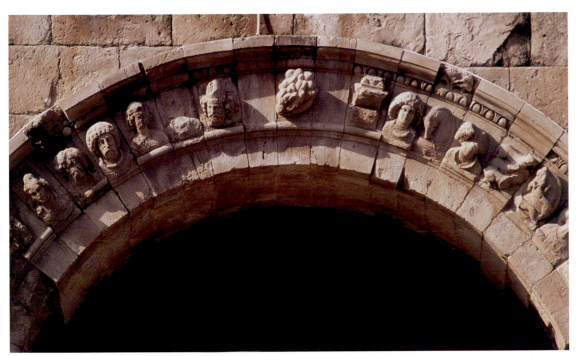

Left
14.23 Voussoir with heads carved in high relief, tilting down toward the viewer, Great Iwan Bulding, Hatra, Iraq

Below
14.24 Great Iwan Building and colonnade, Temple of the Sun God, Hatra, Iraq. 2nd century BCE– 2nd century CE

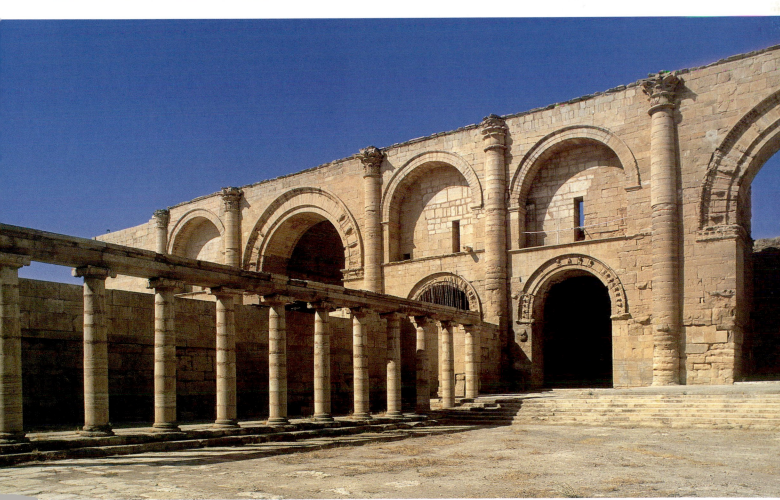

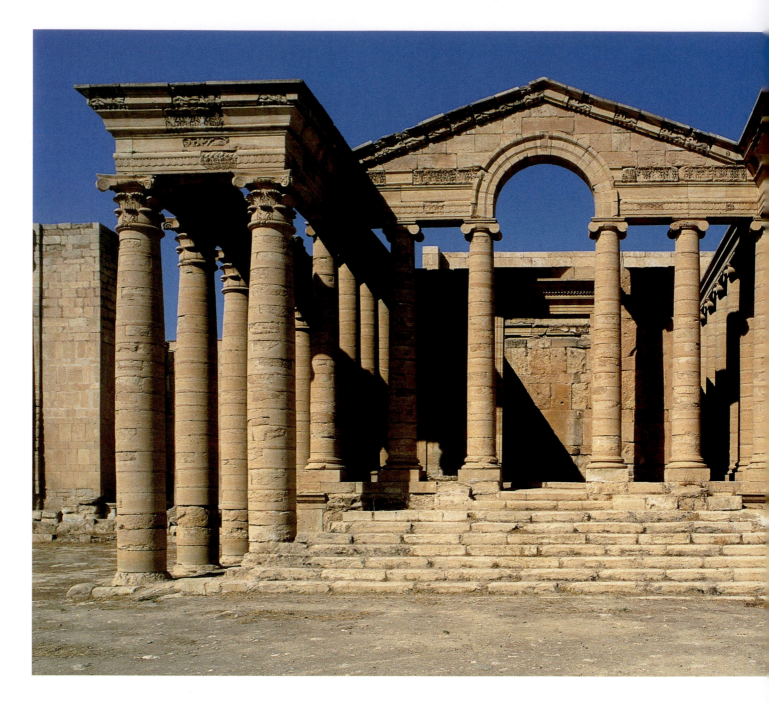

temples stood in the area where people lived. Fourteen of these have been uncovered thus far, which exhibit an admixture of Assyro-Babylonian traditions. Here the old gods of Mesopotamia were worshiped—Nabu, Nergal, and Nanaya—as well as the syncretized gods of the Parthian era.

The main sanctuary or temenos was in the center of the city within a rectangular enclosure wall that divided the sacred space from the day-to-day market activities. The temenos had massive vaulted buildings and great stretches of porticoes dedicated to the syncretized gods of Hatra [**14.25**]. Images of the Hatrian elite were also placed throughout the temenos [**14.26**]. A **peristyle** temple (i.e., surrounded by a row of columns) with a western-style entablature, which rather than being a straight horizontal element, has an arched pitched center, distinctive of the Mesopotamian translation of Graeco-Roman architectural traditions. The entablature is decorated with

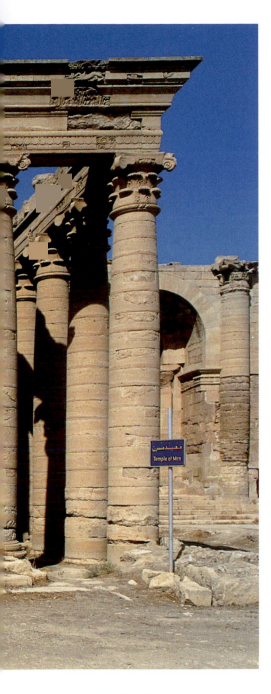

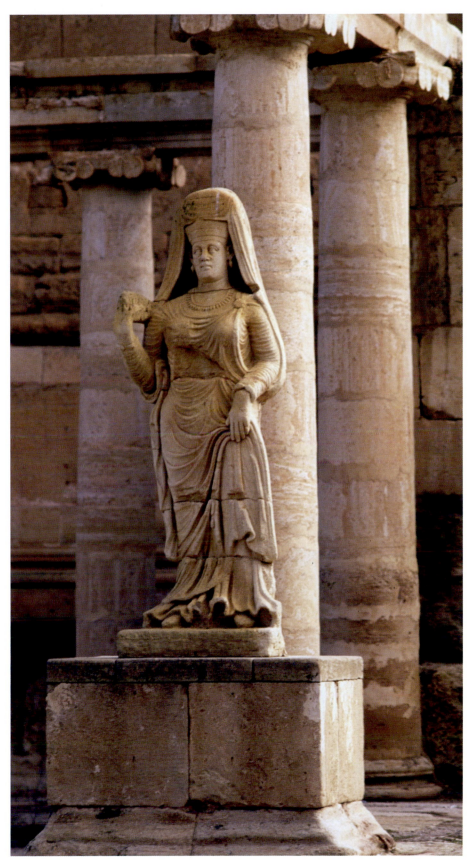

Above **14.25** Temple of Marn, a classical peristyle temple on a raised platform, Hatra, Iraq, 2nd century BCE–2nd century CE

Right **14.26** Statue of the Lady, Abu Bint Damyune, Hatra, Iraq, 1st century BCE–2nd century CE. Limestone, h. 6 ft. 10⅝ in. (2.1 m)

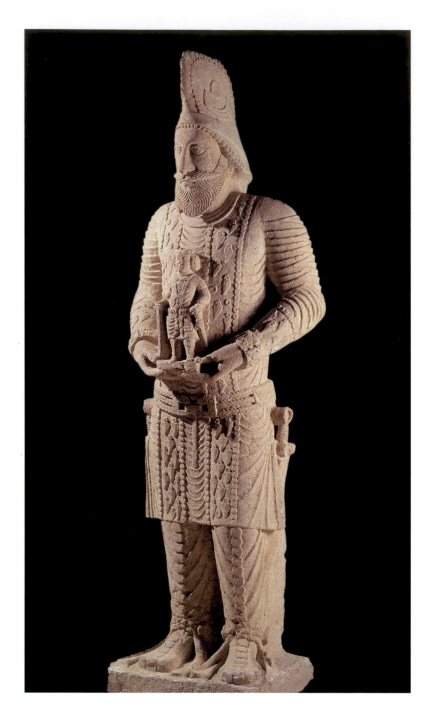

14.27 Atlu, from the center of the entrance of the North gate, Hatra, Iraq, Parthian, 3rd century CE. Limestone, h. 6 ft. 4¾ in. (1.95 m)

Hatrian statues represented noblemen and women, kings and princesses, scribes and officials. They were set up in temples to pray for the donor, thus continuing the ancient Mesopotamian tradition. Here Atlu's statue represents him in the act presenting a votive image to the gods.

deeply carved acanthus leaves, friezes of rosettes, and a molding with griffins. Inside were colored mosaics, painted stucco decoration, and statues of marble and limestone. This was the temple of the great sun god Shamash, who was associated with Maran–Apollo, perhaps the oldest of the temples in the complex. The Shahiru Temple was another peristyle temple, raised on a stepped platform, as in Hellenistic or Roman examples, and using the Classical orders for columns and capitals. Although western moldings are used, they do not follow the usual sequence that one expects in Greek architecture.

Statues of the royal family, priests, and the elite of Hatra were made out of marble or limestone at a large scale and placed inside the temple to pray in perpetuity before the gods [**14.27**]. They are thus devotional statues in the tradition of the earlier Mesopotamian votive statues. The large statue of Dushefri, daughter of King Sanatruq II, represents the princess standing with her right hand upraised and the left grasping her garment [**14.28**]. She is sumptuously dressed in elegant clothing with beaded sleeves and jewelry. She wears bracelets and earrings as well as a thumb ring. Her tall cylindrical crown is encrusted with gems. A round emblem at the center of the crown has an image of the sun god, the supreme god of Hatra. The base bears an inscription that identifies her and her lineage and dedicates the statue as a votive image.

The standing portrait of King Sanatruq I represents him in the richly ornamented attire of a beaded and embroidered tunic and trousers [**14.29**]. He wears a jeweled belt and a royal headdress with an eagle with outspread wings. His right hand is raised in reverence to the gods, while he holds a palm leaf in his left hand. The name of the king is inscribed on the base in Aramaic. The large figure of the king is elongated in proportions and has a tall forehead in keeping with many of the royal statues that stood in the temples of Hatra.

Some devotional statues were made in a smaller scale out of alabaster or marble and then painted [**14.30, 14.31**, see pp. 348–49]. The statue of Smy, the daughter of Aga, dating to the second or third century CE is one such image [**14.32**, see p. 350].

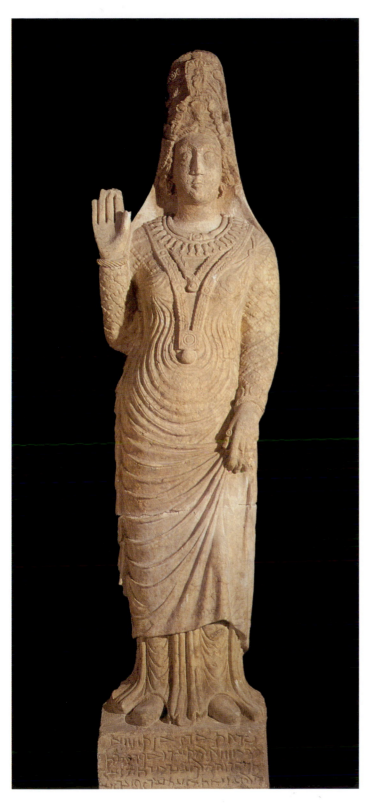

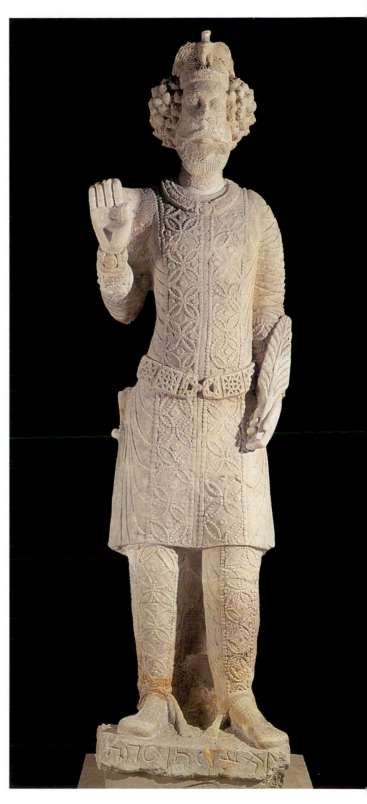

14.28 Princess Dushefri, daughter of Sanatruq II, from the fifth shrine at Hatra, Iraq, Parthian, 238 CE. Gray marble, h. 7 ft. 3¾ in. (2.23 m)

14.29 Sanatruq I, from the tenth shrine at Hatra, Iraq, Parthian, 168–190 CE. White marble with gray veining, h. 7 ft. 6½ in. (2.3 m)

14.30 Female figure, probably Aphrodite, from a well south of the Great Temple, Hatra, Iraq, Parthian, 2nd century BCE. White marble, h. 13⅛ in. (33.4 cm)

Greek gods and goddesses, such as Aphrodite, were incorporated into the Mesopotamian pantheon, and identified with local gods. This Aphrodite was carved in a Classical *contrapposto* stance, probably by a local sculptor who chose to represent her as Mesopotamian nude goddess.

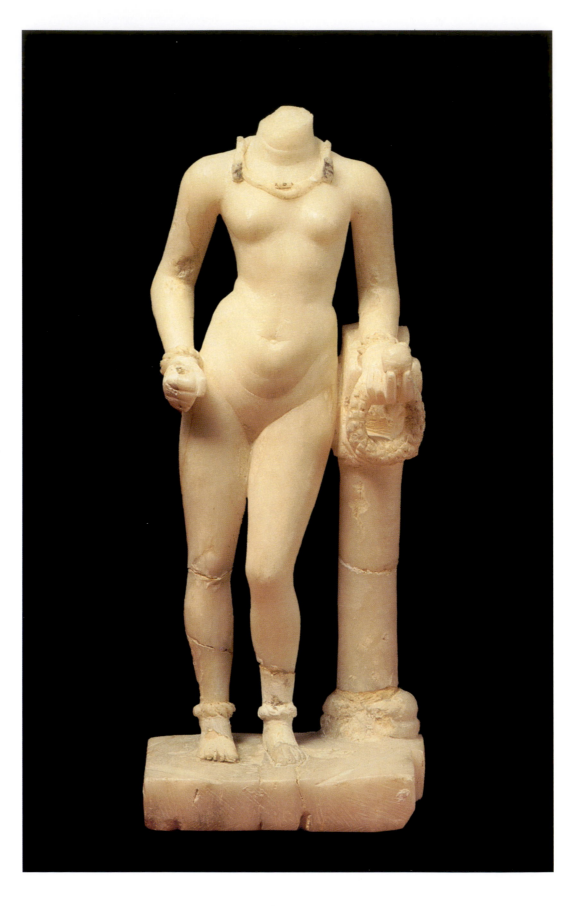

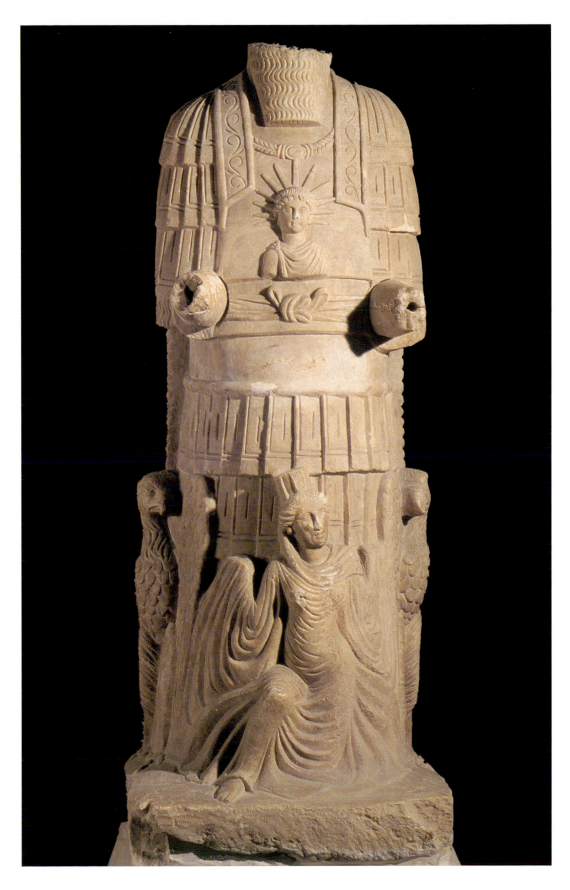

14.31 Baalshamin, Lord of Skies, from the fifth shrine at Hatra, Iraq, Parthian, 2nd century BCE. Grey marble, h. 3 ft. 5⅛ in. (1.05 m)

Baalshamin is depicted as a bearded military general wearing a cuirass with an image of the sun god Shams-Shamash (the Hatrian name for the god Shamash) on his chest, with a halo of sun rays. Below him, Tyche, the Greek goddess of fortune who protects the city, is seated, wearing a citadel crown. Sacred eagles flank the god of the sky. His name, "Lord of the Sky," is the same as the name of the ancient god Anu.

14.32 Portrait of Smy, from the first shrine at Hatra, Iraq, Parthian, 2nd century CE. Light gray marble, h. 25⅛ in. (63.7 cm)

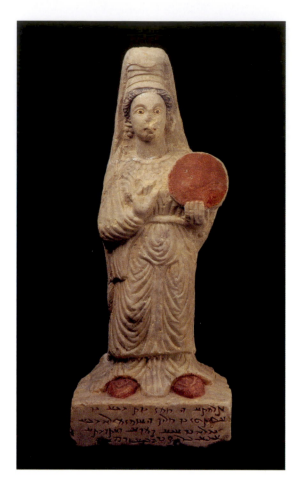

who governed under the Hellenistic Seleucid kings in the second century BCE [**14.33**]. Gudea's statues date to 2150 BCE but the archaeological level where they were found postdates them by two thousand years. They were already collected as antiquities within the palace of Adad Nadin Ahhe at Girsu.

During the construction of his new palace, Adad Nadin Ahhe's workmen found ancient walls, texts, and numerous statues. The scholars who worked for him read the inscriptions on the statues and identified the ruins as those of Gudea of Lagash, who they took to be an ancestral king. The governor then decided to build his palace as a new construction but following along the lines of the ancient palace. It thus became partly

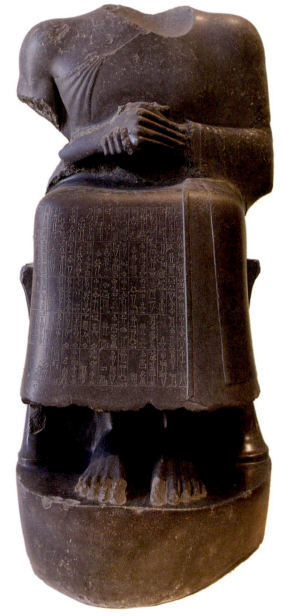

She stands in a long gown, wearing a pendant necklace and a tall headdress, and carries a tambourine painted in red; her right hand is about to touch it. Her hair is painted black while the eyes are inlaid with shell and black stone. Her shoes are red. The inscription on the base reads "Statue of Smy daughter of Aga, who is the son of Ashtati, erected for her in the First Shrine by her husband who is the son of Abba, the priest of the Goddess Atra'ta"

Interacting with the Past

Some of the works of art in the previous chapters were in fact discovered in a Seleucid- or Parthian-era archaeological context. The most significant of these finds was the collection of statues of the Sumerian ruler Gudea of Lagash that was found not in a third-millennium BCE level at the archaeological site of Lagash (see chapter 6), but in the palace of Adad Nadin Ahhe, a local ruler

Right
14.33 Colossal Gudea, from Girsu, Iraq, Neo-Sumerian, 2150 BCE. Diorite, h. 5 ft. 2¼ in. (1.58 m)

a restoration project that consciously linked the Seleucid ruler with the third millennium BCE. He restored the ancient walls and followed the outlines of the earlier building with its buttresses and recessed walls wherever possible, using the layout of the earlier foundations. He used new bricks, which carefully copied the older brick type, but instead of the original Sumerian inscription he had a bilingual inscription written in Aramaic and Greek. [**14.34**]. Adad Nadin Ahhe also followed the ancient Sumerian tradition of burying foundation deposits, a practice that was distinctive of Mesopotamian historical consciousness. The interred images and texts that were discovered in the Seleucid era thus became catalysts for rebuilding and continuing architectural rituals; they also formed parts of collections of antiquities that were proudly displayed in the palace. Some of the ancient statues were polished and repaired by Adad Nadin Ahhe's sculptors before they were placed on display in the paved courts of the Hellenistic-era palace.

In the Parthian era that followed Seleucid rule, such preservation of and interaction with the past and its monuments and works of art continued. A colossal statue of the Neo-Assyrian king Shalmaneser III (r. 859–824 BCE), now at the Istanbul Archaeological Museum, was found in the northern Mesopotamian city of Assur, an Assyrian city that enjoyed a period of revitalization in the Parthian era, with the construction of a palace and temples that combine Parthian and western Seleucid influences. The Shalmaneser statue was uncovered in a Parthian level of the city [**14.35**].

Made of basalt, it is sculpted in the Neo-Assyrian form of a standing full-figure portrait of the king. Such statues were used as devotional images, which permitted the kings to stand in prayer before the gods. The king's body is a solid slab-like stone carved with surface details that represent the diagonal lines of the wrapped fringed garment across his lower body. Weapons are inserted into the belt at his waist. He carries a sickle sword in his right hand and a scepter in his left, emblems of his royal office. His hair is thick and organized in neatly distributed rows of tight curls for the beard and in a thick wedge of hair at his back. The statue is inscribed with a cuneiform text on the clothing of the king, identifying it as the image of Shalmaneser. It was eight hundred years old when it was preserved by the Parthian inhabitants of Assur as an antiquity and placed on public display—yet more evidence of the collecting and conservation practices of the age.

Left
14.34 Bilingual inscription on Adad Nadin Ahhe's palace, Girsu, Iraq, 2nd century BCE. Baked brick

14.35 Colossal statue of Shalmaneser III, from Assur, Iraq, 859–824 BCE. Basalt

The End of an Era: Sassanian Empire and the Rise of Islam

The Sassanian Ardashir, a minor king, defeated his Parthian overlord Artabanus IV in 224 CE, and a new empire arose that would last for four centuries until the Islamic conquest. Ardashir was said to be a descendant of the Zoroastrian priesthood of Persis/Fars in Iran, and the name of the dynasty derives from Sassan, an ancestral priest. He had a coronation ceremony at the great palace of Ctesiphon (**0.3**, see p. 11), and assumed the title "king of kings." The late antique era of the Sassanian empire and its connections westward to Europe and eastward to Asia is a vast and complex history of art, international interaction, and trade networks beyond the scope of this book. Nevertheless we can note that Sassanian kings engaged with the ancient landscape where they had risen to power. For a new yet recognizable visual language of kingship and empire, they looked to the history of Mesopotamia and Iran, but transformed it into their own. For example, the distinctive art of rock reliefs known in earlier millennia as well as in the Parthian era underwent a great revival under the Sassanian dynasty. This remarkable ancient idea of carving sculpture in the living rock reached new levels of expertise and greatness in composition and skill of carving, and outstanding examples of relief scenes were placed in numerous locations in the landscape. A major factor in the revival of this genre of sculpture, and in the siting of many of the Sassanian-era reliefs, seems to have been the location of earlier sculptures. This is the case at Naqsh-i-Rustam near Persepolis, for example [**14.36**], where the rock-carved tombs of the Achaemenid kings were cut into the cliffs (see pp. 314–15). Below these tombs, a series of relief scenes were carved in high relief, an interplay between the past and the present of the Sassanian era.

14.36 Relief of Investiture of Ardashir I at Naqsh-i-Rustam, near Persepolis, Iran, 3rd century CE. The relief is carved at the site of the Achaemenid royal tombs.

Two horsemen exchange a diadem, the symbol of rule and authority. Their crowns and inscriptions tell us that they are Ardashir I and Shapur I (r. 240–272 CE). Below the horses are the defeated Parthian king and Ahriman, the spirit of evil.

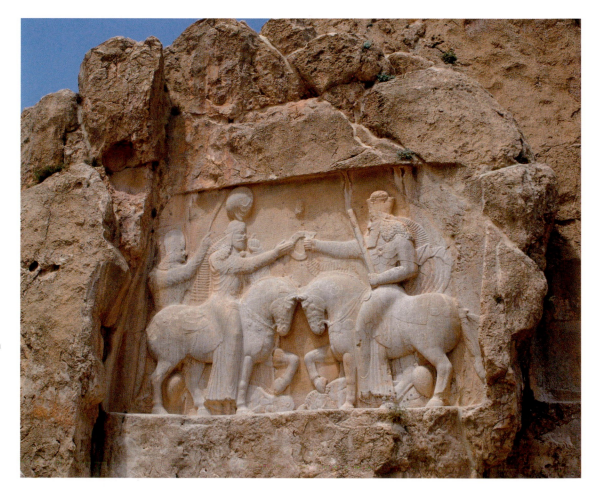

The ancient world changed with the arrival of Islam in Mesopotamia and Iran in 636 CE, an era that saw the beginnings of a new Islamic art. But Islamic art was not an imported style, as the Hellenistic style of Classical art was, for example. Instead it grew and developed in these lands, engaging with their ancient artistic traditions and impressive architecture that the Muslims encountered upon their arrival. Although Arabic became the official language and Islam the dominant religion, during the first Islamic dynasty—the Ummayad caliphate (661–750 CE)—the early caliphs (rulers) supported the indigenous local artists and architects, who continued to work in their own established traditions. Local artists and workshops were asked to create works for the new ruling elite and to take into account their new religious needs for different uses of space in architecture, including the new requirements for religious devotion. The Ummayad dynasty had its seat in Damascus, Syria, where skilled architects transformed the ancient Temple of Jupiter into the space of the magnificent Great Mosque of Damascus in 706 CE

[14.37]. This building still stands today as one of the most beautiful mosques of the Islamic tradition. Here, a church to St. John the Baptist had already been erected in the fourth century CE, and even today both Muslims and Christians attend this sanctuary and consider the site to be sacred. The earliest works of Islamic art and architecture, and the formation of new visual forms, were thus all deeply grounded in the late antique arts of Mesopotamia, western Syria, and Iran. In architecture especially—the artistic arena in which Islam would excel in the following centuries—the late antique methods of building with the use of iwans, peristyles, and hypostyle halls were adapted as standard forms for mosques and for palace architecture. Glazed brick facades and sculpted stucco decoration, as well as monumental calligraphy, were all ancient Mesopotamian traditions that were adapted for use by the new faith. These forms became the foundation, the basic vocabulary, for the creation of Islamic art and architecture through the following centuries across the Middle East and the Mediterranean world.

14.37 The Great Mosque, Damascus, Syria

One of the oldest mosques in Islam stands on the site of an earlier church and the Roman Temple of Jupiter, which in turn stood upon a sacred site of the 2nd millennium BCE. It takes its location, architectural elements, and decoration from pre-Islamic architecture and demonstrates millennia of continuity at one site.

EPILOGUE

The Past in the Present

When the wall of a temple falls into ruin, in order to demolish and re-found
that temple, the diviner shall investigate the site [for ancient remains].
The builder of the temple shall put on clean clothes and put a tin bracelet
on his arm; he shall take an ax of lead, remove the first brick, and put it in
a restricted place. You set up an offering table in front of that brick god of
the foundations, and you offer sacrifices.

These instructions for a building and restoration ritual date to the Hellenistic Seleucid era of Babylonia (fourth to third century BCE) and show that architectural rituals and preservation rites that had begun in Sumer in the early third millennium BCE still existed in some form thousands of years later. The text orders the *kalu* priest to remove the first brick and place it on an altar. The kalu priest was then to sing the lamentations according to an age-old Mesopotamian tradition. These laments had been sung for the destruction of cities and their architecture, for the terrible loss of temples and their magnificent sculptures during warfare, as early as the late third millennium BCE.

In the Seleucid ritual quoted here, there was some sense that the original brick set up on the altar had to be appeased, because it was the representative of the brick god, Kulla. Its removal from the original context of the building was played out as a temporary dislocation, while the repairs were being made as carefully as possible, following the original ground plans of the temple. When an ancient wall had to be pulled down and rebuilt, a process of mourning thus had to take place in order to bridge the gap between the existence of the old wall and the rebuilding of the new one. The text also makes clear that the building site had to be surveyed by the *baru* (the seer priest), so that nothing would be inadvertently missed or damaged in the processes of reconstruction.

The ancient Mesopotamians were constantly concerned with the reverence and respect for the remains of the past, and Mesopotamia is the earliest place where we can study such deep historical consciousness through textual and archaeological evidence. We can even say that the reverence for the past and the concern with preservation of their ancient temples and cities was distinctive of Mesopotamian cultures, and these concerns are at times somewhat similar to our own. A lengthy compendium of omens—known as *Shumma alu* ("If a City"), after its opening line—shows this well. The compendium, which dates as early as the Old Babylonian period and continues into the Seleucid era, provides a long list of omens that have to do with conservation and preservation practices, and makes it clear that they are intended not only for the king and those in power but also for common people:

If a man repairs a sanctuary: he will have
good luck

If a man tears down a sanctuary: the river
will swallow him

If someone relocates a chapel: that man will
go to ruin

If a man repairs something old: that man's
god will come to him.

These are but a few lines from a long list
of forms of restoration and preservation of
things, from images of gods and heroes to entire
buildings and more limited architectural repairs.
The text even includes a section of practices that
surveyors should follow when planning to build
at a particular location: so that if a man plans to
build a house and, while digging the foundations,
finds something in the ground, he must follow
particular procedures for preservation. All ancient
objects found in the ground, or that remained
standing in temples or public places, were
considered to belong to the terrain and its history;
they were propitious for the people of the land
and their future.

Despite millennia of wars and devastation,
the antiquities of the land survived in some form.
When in the second century BCE Adad Nadin
Ahhe's builders found the statues of Gudea that
had been set up two thousand years earlier,
the later ruler had them placed in his newly

constructed palace at Girsu (see p. 350). Not only
did he collect them and set them up carefully
for display, but he also ordered his scholars and
scribes (who were able to read ancient languages
and scripts) to imitate the Sumerian methods of
building and of writing inscriptions to be used in
his own palace. They made inscriptions written in
Aramaic and Greek in such a way that they looked
like the bricks inscribed with Gudea's name
written in ancient Sumerian. This was one of the
earliest forms of antiquarian collecting and study
of the past that we have; it prefigures the interests
and activities of the Italian Renaissance collectors
whose antiquarianism was to come a millennium
and a half later. These were ancient forms of
preserving the past as a way to form ideological
links to the antiquity of the land, but also as a
pious act, and for the pursuit and preservation
of historical knowledge.

Today, the disciplines of art history and
archaeology are not esoteric subjects and practices
that have to do only with the past. They are part
of the present, as the past remains constantly
present in our world today in historical narratives
that we relate, and in the monuments that we
admire and that have survived from antiquity.
These things form the basis of our own histories
and identities. The way that we apprehend the past
in our present context, the way that we formulate
our ideas of history and where we fit within that

The Uruk Vase is an early monumental ritual vessel
(c. 3300 BCE) that represents one of the world's oldest
examples of a complex narrative, to which we have
given the name "performative narrative." It was
smashed in 2003 during the looting of the Iraq
Museum, Baghdad, at the beginning of the Iraq war.
Already in the late fourth millennium BCE, that vase had
been repaired at the top. A triangular piece that had
been broken off was re-attached with a copper wire that
was used to tie the fragment back into its original place.
This is one of the earliest examples of object
conservation that we have from anywhere in the world.
It reveals that the concern with preserving objects is
indeed an ancient one.

history, is therefore structured by a landscape (both actual and discursive) of monuments and artifacts.

These are ways of relating to the built environment and to artifacts that now fall under what we refer to as the arena of cultural heritage or cultural patrimony. Rather than through architectural rites and conservation omens,

the protection of these aspects of human creativity and production is now covered by international laws under the auspices of the United Nations. Today's laws make the destruction of heritage sites a war crime and see such acts as related to human rights violations. The 1954 Hague Convention for the Protection of Cultural Property in the Event of Armed Conflict and the Geneva Conventions of 1949 and 1977 make the targeting of historical monuments and ancient sites crimes and forms of violence that are unacceptable even within warfare or armed conflict. These are the laws that exist in our world today. Some of these concerns were already in existence in antiquity, as we have seen, as the protection and conservation of artifacts and monuments is recorded both in the archaeological record in practices of preservation, and in written texts.

Objects in museums and museum collections are protected by international laws that also cover the trafficking of stolen antiquities, such as the

The statue of a nude Apollo from Hatra, Iraq, carved in a naturalistic classical style and dating to 2nd century BCE–2nd century CE, was smashed to fragments during the Iraq Museum looting of 2003.

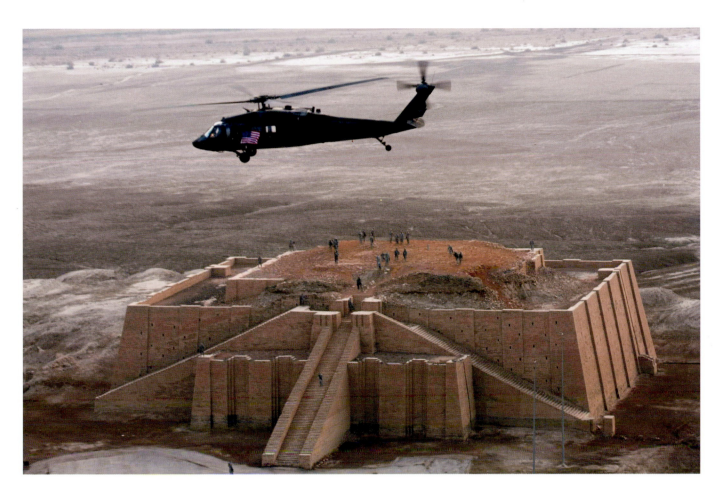

Helicopter flying over ziggurat at Ur, Iraq

The ancient city of Ur was used as US military base from 2003 until 2009. Military installations and heavy trucks caused damage, and bullets and shells damaged the south face of the ziggurat.

UNESCO Convention on the Means of Prohibiting and Preventing the Illicit Import, Export and Transfer of Ownership of Cultural Property (1970). Perhaps even more important now, however, are the concerns regarding archaeological sites and in situ monuments. In the last twenty-five years, there has been a tremendous increase in the destruction of heritage in the region. The erasure of history, both deliberate and accidental, has had a devastating impact on the historical landscape of Mesopotamia. There is now a crisis situation: some of the ancient cities and works

Babylon was utilized as a large US and coalition military base in 2003–4. A helicopter landing zone was bulldozed into the heart of the ancient city, very close to the palace of Nebuchadnezzar II. After lengthy discussions and negotiations with archaeologists, the military forces agreed to dismantle the base in 2004.

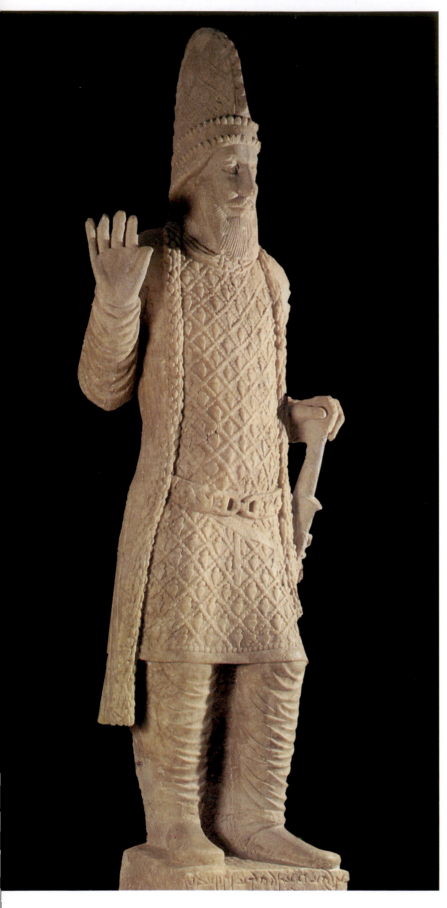

of art that we have covered in this book were destroyed even while the book was being written. Ancient cities and temples have been used, and continue to be used, as military installations, causing great amounts of damage to ancient sites and archaeological ground. Even worse, entire cities have been deliberately destroyed in an attempt to erase parts of history. Scholars everywhere have decried these acts as forms of cultural cleansing that are human rights violations for the local people and their indigenous history, as well as a tremendous loss for all the world and its cultural heritage. Thus it is more important now than ever before not only to study and preserve the Mesopotamian past through the conservation of artifacts, monuments, and archaeological sites, but also to sustain in books and in our scholarship the historical knowledge of this fascinating past, so that future generations may not forget it, or imagine that there never was such an ancient world.

King Atlu, from shrine III at Hatra, Iraq, Parthian, 2nd century BCE–3rd century CE. Grey marble, h. 7 ft. 4⅝ in. (2.25 m)

The portrait of King Atlu depicted him in a splendid tall crown and an elaborately beaded coat. His right hand was raised in reverence. This statue was destroyed in the attack on the Mosul Museum in 2015.

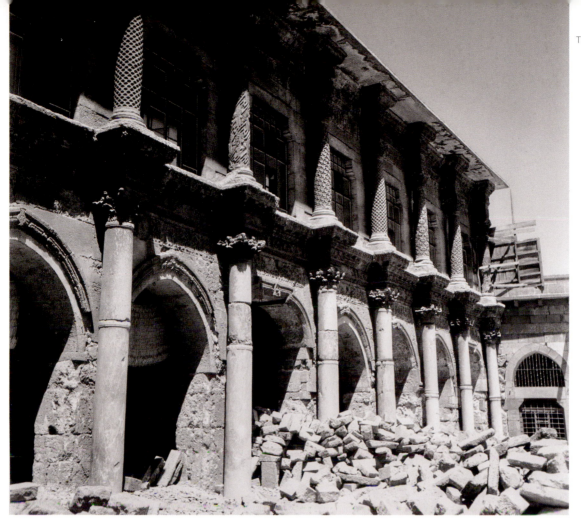

Mosque at Diyarbakir, Turkey; photographs taken in c. 1970s and 2015

The mosque of Diyarbakir is one of the oldest mosques in Islam, established in the late 7th century CE and restored in 1091 CE. It utilizes Roman columns and capitals and is influenced by ancient architectural and decorative forms. The mosque has been damaged by modern conflicts.

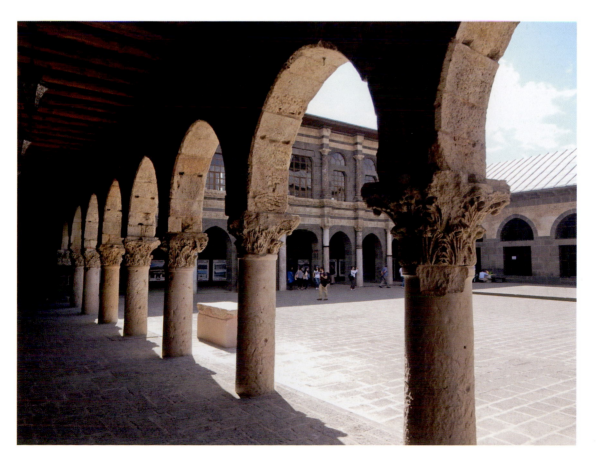

GLOSSARY

This glossary comprises, firstly, the names of significant people in Mesopotamian art history, and the names of key gods and goddesses; secondly, important terminology (pp. 361–64).

SIGNIFICANT PEOPLE AND DEITIES

Adad Storm god (**Ishkur** in Sumerian), associated with bulls and thunderbolts.

Adad Nadin Ahhe Governor of Lagash in the second century BCE.

Ahuramazda Zoroastrian god, represented as a bearded man in a winged disc.

Alexander the Great/Alexander of Macedon (356–323 BCE) King of Macedon from 336 BCE; conquered the Persian Empire in 331 BCE.

Anu *also* **An** God of heaven, a sky god. His name is the **Sumerian** word for heaven and he is married to the earth goddess, Ki. Sometimes represented as horned crowns on an altar.

Artaxerxes I King of the Persian Empire, r. 464–423 BCE.

Artaxerxes II King of the Persian Empire, r. 404–359 BCE.

Ashurbanipal King of Assyria, r. 668–627 BCE.

Ashurnasirpal II King of Assyria, r. 883–859 BCE.

Assur Name of both a god and a city in Assyria. The god Assur is a personification of the city. He is sometimes shown as a man in a winged disc.

Bey, Osman Hamdi (1842–1910) Ottoman archaeologist and curator, excavated Nemrud Dagh in Turkey, among other places.

Burnaburiash II Kassite king, r. 1359–33 BCE.

Cyrus the Great Ruled the Persian Empire from 559 to 530 BCE; conquered Babylon in 539 BCE.

Darius I King of the Persian Empire (r. 521–486 BCE), established Persepolis in Iran.

Darius III King of the Persian Empire, r. 335–331 BCE; defeated by **Alexander of Macedon**.

Ea God of freshwater, wisdom, magic, arts, architecture, and crafts (**Enki** in **Sumerian**). He is represented surrounded by streams of water.

Enki *see* **Ea**.

Enlil A **Sumerian** god of the sky, associated with mountains and with the city of Nippur, Iraq. His great temple was the E-Kur, the Mountain House, and his wife is the goddess **Ninlil**.

Enmerkar A mythical king who features in a **Sumerian** legend of the third millennium BCE that describes the invention of writing.

Enmetena Ruler of Lagash, *c.* 2400–2350 BCE.

Ereshkigal "Queen of the Night." A goddess of the underworld, also known in **Akkadian** as Allatu. She is sometimes represented with the talons of a bird of prey.

Gudea Ruler of Lagash, *c.* 2150–2125 BCE.

Hammurabi Babylonian king, r. 1792–1750 BCE, installed a public law **stele** in Babylon in *c.* 1760 BCE.

Herakles A Greek semi-divine hero.

Herodotus of Halikarnassos Greek historian, *c.* 484–425 BCE. He wrote *The Histories*.

Imdugud A lion-headed eagle, the supernatural creature associated with the god **Ningirsu**.

Inanna A goddess of love and war (**Ishtar** in **Akkadian**). She is often shown in association with lions.

Ishkur *see* **Adad**.

Ishtar *see* **Inanna**.

Koldewey, Robert (1855–1925) German archaeologist who excavated Babylon.

Kurigalzu II Kassite king, r. 1332–1308 BCE.

Layard, Austen Henry (1817–1894) British explorer, excavated Assyrian cities.

Manishtushu King of the Akkad Dynasty, r. 2269–2255 BCE.

Meskalamdug King buried at the Royal Cemetery of Ur, *c.* 2500 BCE.

Nabonidus King of Babylon, r. 555–539 BCE.

Nabopolassar King of Babylon, r. 626–605 BCE. Began the **Neo-Babylonian** dynasty.

Nabu God of writing and scholarship. He is often shown holding a wedge; his emblems are a tablet and stylus for writing.

Nanna Moon god (**Sin**, in **Akkadian**). He is shown as a crescent moon.

Naramsin King of the Akkad dynasty, r. 2254–2218 BCE. Became the first deified king.

Nebuchadnezzar I King of Babylon, r. 1125–1104 BCE.

Nebuchadnezzar II King of Babylon, r. 604–562 BCE.

Nergal A god associated with **Akkadian** Erra, god of underworld, consort of **Ereshkigal**, also a god of war. Nergal is shown as a warrior, holding a scimitar and double-headed lion mace.

Ningal Consort of the moon god **Nanna**, mother of the sun god Utu (**Shamash** in **Akkadian**).

Ningirsu God of Girsu and Lagash, associated with the god Ninurta and with the plough.

Ningiszhida An underworld god.

Ninhursag A mother goddess, "Lady of the Mountain," also called Ninmah. Her symbol is a horned snake.

Ninhursanga **Sumerian** goddess, associated with motherhood and birth, also known as the mother of the gods.

Ninlil A mother goddess and consort of **Enlil** (Mulissu in Assyrian). She is sometimes shown upon a lion throne.

Puabi Queen buried in the Royal Cemetery of Ur, *c.* 2500 BCE.

Rassam, Hormuzd (1826–1910) Archaeologist from Mosul, Iraq; one of the first to excavate Assyrian and Babylonian cities.

Rich, Claudius James (1786–1821) British representative of the East India Company in Baghdad, Iraq, in the nineteenth century; explored Babylon.

Sargon of Akkad King and founder of the dynasty of Akkad, *c.* 2334–2279 BCE.

Sargon II King of Assyria, r. 721–705 BCE, founded Dur Sharrukin.

Sennacherib King of Assyria, r. 705–681 BCE.

Shalmaneser III King of Assyria, r. 858–824 BCE.

Shamash Sun god, god of justice (**Utu** in **Sumerian**). His emblem is a sunburst.

Sharkalisharri King of the Akkad dynasty, r. 2217–2193 BCE.

Shulgi King of the **Third Dynasty of Ur**, r. 2094–2047 BCE.

Shutruk-Nahunte Elamite king, c. 1165–1155 BCE; raided Babylonia 1158 BCE.

Sin God of the moon (**Nanna** in **Sumerian**). His emblem is a crescent moon.

Tiglath-Pileser I King of Assyria, r. 1114–1076 BCE.

Tukulti-Ninurta I King of Assyria, r. 1243–1207 BCE.

Ur-Namma King of the Ur III dynasty, r. 2112–2095 BCE.

Urningirsu Ruler of Lagash, c. 2150–2125 BCE.

Utu *see* **Shamash**.

Woolley, Leonard (1880–1960) British archaeologist who discovered the Royal Cemetery at Ur.

TERMINOLOGY

absolute chronology/absolute dating The determination of historical dates and the order in which they occur in relation to a fixed time scale.

abstract In art, a non-representational work that emphasizes an essential aspect of the subject as a way of referencing it in a symbolic or **stylized** way.

Aceramic Historical era also called the **Pre-Pottery Neolithic**, c. 9600–7000 BCE.

Achaemenid dynasty 559–331 BCE. Based in Iran, the dynasty included Syria, Egypt, Asia Minor and its Greek cities, as well as parts of northern India.

Akitu The New Year festival, which took place at the start of spring. The festival was primarily associated with Babylon but occured elsewhere in Mesopotamia also.

Akkadian Language used throughout the ancient Near East for several millennia in antiquity; Akkadian I, II, and III refer to **seal**-style categories used by modern scholars.

amulet An object that has talismanic power.

anthropomorphic Resembling the human form.

apkallu Sages, or protective genies, who appear on palace walls or are buried underneath the foundations of buildings for **apotropaic** purposes. They are usually winged **anthropomorphic** beings.

apotropaic Averting evil or misfortune.

Aramaic A language used in ancient Mesopotamia from the early first millennium BCE. It is still spoken in Iraq today as Neo-Aramaic.

archaizing In visual arts or writing, made to appear ancient.

architrave In architecture, the lowest part of the **entablature** of a building.

Arsacid Also called the **Parthian dynasty**; it is sometimes referred to as Arsacid after the name of its founder, Arsakes. The Parthian-Arsacid dynasty began in 247 BCE, and ruled Mesopotamia from 141 BCE to 226 CE.

articulated In architecture, refers to a method of emphasizing and styling joints and segments into the design or formal aspect of the work.

atrium In architecture, an entrance hall or space.

attribution Assignment of a work of art to a maker or makers, specific dates or places of manufacture, based on technological, stylistic, or iconographic features.

avant-garde In art, early twentieth-century emphasis on innovation, which challenged accepted values, traditions, and techniques.

barrel-vaulted In architecture, a roof constructed on the principle of an arch; semi-cylindrical in cross-section.

basilica In Roman architecture, a large, rectangular public building, entered through one of the short sides. The same plan is followed by later Western Christian churches.

Bronze Age Early historical period in Mesopotamia, roughly 3500–1100 BCE (Bronze Age dates will differ in other regions).

buttress In architecture, an exterior brick or masonry structure that opposes the lateral thrust of a wall or arch, thus strengthening and supporting the building.

cache A collection or hoard of objects.

calligraphy Writing as a form of art.

capital In architecture, the top section of a column between the column shaft and the roofing or **entablature** of the building.

cartouche A French term used in Egyptology to refer to the placing of Pharaonic names in an oval enclosure.

caryatid In architecture, a column that takes the form of a person.

cella In Greek, *naos*: the main room of a temple.

Chaladaean A name used for southern Babylonians in the later first millennium BCE.

chased In metalwork, this refers to the incising of surface details after casting or hammering.

cipher A code or symbol.

city state An independent city.

cloisonné A jewelry-making technique that uses inlays of precious stones or vitreous paste.

composite statue(tte) A statue made from various different materials.

conceptual art An art form that conveys an idea or a concept; opposite of imitative or representative works.

connoisseurship A method of art criticism or analysis that studies fine details of making and style.

contrapposto In sculpture, the stance of a human figure in which the weight of the body is shifted to one side, with one knee bent and one knee engaged, resulting in a swing in the torso.

corbeled In architecture, a progressive stacking of cut stones or bricks to create an arch or dome, with each course projecting beyond the one beneath it.

crenellated In architecture, the indented tops of walls, as in battlements.

cult statue A statue of a god or goddess, placed in the main temples in cities, which are described as the houses of the gods. Cult statues are considered to be manifestations of the god or goddess, rather than their representation.

cuneiform Wedge-shaped script used in the ancient Near East. Invented in 3400 BCE in southern Iraq, the last cuneiform tablets date to the first century CE.

cylinder seal A cylindrical-shaped stone, carved in *intaglio* with various designs that change through the ages. Cylinder seals are first used around 3300 BCE. They are used for administrative purposes, but also as personal signatures for documents.

Dark Age A term used by modern archaeologists and historians to describe a period that followed the end of the Late Bronze Age, c. 1100–900 BCE, in which many main centers were abandoned in the eastern Mediterranean world.

demiurgic Emerging from divine spirits of creation (from the ancient Greek, artisan-god).

divination The reading of the future. Mesopotamia had more forms of divination than other societies, e.g. reading the stars and planets, smoke, water and oil, the flight of birds, the shape of their feathers, the entrails of sacrificial animals, signs in human and animal anatomy, signs in the landscape, and more.

divine determinative A sign in **cuneiform** writing that is placed before the name of a god or goddess to signify that what follows is a name of a deity.

dromos A long passage leading to a tomb.

Early Dynastic In Mesopotamian history, the era of the independent city states, 2900–2300 BCE. In the early twentieth century, archaeologists divided this long era into three phases, with the final phase subdivided into A and B. The three phases are: ED I (2900–2750 BCE); EDII (2750–2600 BCE); EDIIIa (2600–2400 BCE), EDIIIb (2400–2334 BCE).

ekphrasis From the Greek, a literary description of a work of art.

Elamite Refers to Elam, ancient Iran. The Elamite civilization flourished from the early third millennium BCE until the sixth century BCE.

EN **Sumerian** title for a ruler.

ensi A **Sumerian** title for governor.

entablature In architecture, a structure above the columns and below the roof.

entasis In architecture, a deliberate distortion or tapering of columns to create visual effect.

entu A priestess, known from the third millennium BCE and later; usually a royal princess. The best-known entu priestess was the **Akkadian** princess Enheduanna.

epigraphy The study of inscriptions.

epiphany A miraculous appearance of a god or goddess on earth. The ancient Mesopotamians considered this to take place in an image, by means of an image.

ex voto *see* **votive**

eye-stone A banded agate stone cut to show concentric circles, resembling an eye.

faience Man-made glass, a highly lustrous non-clay ceramic material.

filigree A goldsmithing technique that uses fine wires of gold or silver to create **openwork**, ornamental designs.

foundation figure A statuette buried in the foundations of a building to protect and to record the ritual offering.

fresco Wall painting on plaster.

frieze In architecture, a horizontal sculpted band that is part of the **entablature**.

frit A ceramic-like material that is colored but not glazed in the same way as **faience**.

genie A supernatural mythical creature or spirit.

genre A category of artistic subject matter.

glyptic An engraving method used on small stones, gems, and **seals**.

Graeco-Babylonian A mixture of Greek and Babylonian styles that emerges in Babylonia in the third century BCE.

granulation A goldsmithing technique that creates granules, or small spheres, of gold for decoration.

griffin A creature with the body of a lion and the head and wings of an eagle.

ground plan An architect's plan or design for a structure, depicted as an outline at foundation level.

guardian figure Usually a winged anthropomorphic figure that guards doorways and other parts of buildings.

guilloche A pattern of interlaced spirals.

hammered A metalsmithing technique for creating a work by hammering or beating the metal from the back to impress a three-dimensional design that projects outward from the front of the object.

Hellenistic, Hellenize Greek era, Greek rule in Mesopotamia, 331–141 BCE; to make Greek in style.

herringbone A decorative, v-shaped pattern that resembles fish bones.

hieroglyph "Sacred writing": a system of writing in ancient Egypt.

Hittite Refers to the land of Hatti in Anatolia, modern-day Turkey, the location of the Hittite kingdom of the late Bronze Age; also its language.

hüyük Turkish word for a **tell** or archaeological hillock.

hypericon An image that references itself, a self-aware representation. For example, the Lu-Nanna votive statue, p. 183.

hypogea Underground tombs.

hypostyle hall In architecture, a multi-columned space.

iconoclasm The destruction of images.

iconography The symbolic meaning of images and their study.

idealized Representation according to a preconceived form, usually one that is more "perfect" than in reality.

image–text dialectic The interdependence of image and text.

Indo-European A linguistic category that refers to a grouping of languages that share a grammatical structure and similarities in vocabulary: comprised of some European and Asian languages.

inlay In art, a piece that is set into a larger work.

in situ Latin term used to refer to monuments and works that are still in their original place at an archaeological site.

intaglio From the Italian for "cut into," a carving technique used especially for seals and gems in which designs are incised in reverse; these can then be impressed onto wax or clay.

Isin-Larsa period An era at the start of the early second millennium BCE in Mesopotamia.

iwan In architecture, a large vaulted space.

Jemdet Nasr An archaeological period, *c.* 3150–2900 BCE in Mesopotamia.

Kassite A Middle Babylonian dynasty, *c.* 1595–1155 BCE.

king list *see* **Sumerian King List**

Kleinfunde German word meaning "small find." Often used to refer to a group of objects found in **Uruk**, dating to the end of the fourth millennium BCE.

kudurru A stone monument, sometimes a boundary stone. Although associated with the **Kassite** dynasty, these monuments were known both before and after this dynasty.

lama Interceding goddess; usually appears in **presentation scenes**, for example on **cylinder seals**, where the worshiper stands before an enthroned deity.

lamassu A supernatural mythical creature that takes the form of a winged, human-headed bull or lion. These creatures were carved in stone as the guardians of the Assyrian palace gates.

libation A liquid offering for a deity.

liminal In anthropology, a threshold or transitional zone.

lost-wax method A technique for metal-casting that involves creating a wax model (or a wax layer around a clay model), and encasing it in a clay mold. The mold is heated and the wax melts, leaving a cavity into which molten metal is poured. Once it has cooled, the mold is removed and the metal sculpture is revealed.

Lullubi A mountain people in the northeast of Mesopotamia, depicted in the **stele** of Naramsim.

Marduk The supreme god of Babylon. His sacred animal is the *mushhusshu* dragon.

ME In **Sumerian** thought, this means the arts or aspects of civilization.

Middle Assyrian A historical era, 1363–1000 BCE.

Middle Babylonian *see* **Kassite**.

Modeled Babylonian style A modern definition used by scholars to identify a Babylonian style of **seal** carving in the first millennium BCE.

Modernism In art history, a style of early twentieth-century art and architecture.

mother goddess figures A term used in the nineteenth and twentieth centuries to refer to prehistoric nude female statuettes.

mouth-opening ceremony Ritual used to consecrate statues.

mushhusshu Dragon associated with the god **Marduk**.

naos *see* **cella**.

naru **Akkadian** word for **stele**.

nave In architecture, the central section of a **basilica**.

Neo-Assyrian A historical era, *c.* 900-612 BCE.

Neo-Babylonian A historical era and dynasty, *c.* 626–539 BCE.

Neo-Sumerian A historical era, 2112–2004 BCE.

Neo-Sumerian renaissance The revival of older traditions from the **Early Dynastic** period in the **Ur III dynasty** (beginning in 2112 BCE).

obelisk A stone monument, usually with a square cross-section.

Old Assyrian style A style of **seal** carving from the early second millennium BCE.

Old Babylonian A historical era, 1894–1595 BCE.

Old Elamite A historical era and language used in Iran, 2400–1600 BCE.

Old Persian Language used in **Achaemenid** inscriptions.

Old Syrian style A style of **cylinder seal** carving used in Syria in the second millennium BCE.

openwork In art and architecture, a work designed with perforations.

orthogonal In perspective systems, imaginary lines that extend from the form to the vanishing point.

Ottoman Empire An empire with its center in Istanbul, it flourished from 1453 CE (capture of Constantinople) until 1922, and included in its domains Mesopotamia, Syria, Greece, and parts of eastern Europe.

palette In ancient Egypt, a stone slab used for grinding pigment, often carved in **relief**.

palmette A decorative ornament resembling palms.

pantheon Collective of the gods.

Parthian dynasty *see* **Arsacid**.

perceptual art In art criticism, an artform that relies on perception or resemblance.

performative An image that represents an event or action and also affects its expected result, by means of its representation. For example, the Uruk Vase, p. 47.

peristyle In architecture, a colonnade around a building.

philology The study of language in original historical sources.

physiognomy Physical appearance.

pictographic Word signs. Pictographic script was used in ancient Mesopotamia for the **Sumerian** language *c.* 3400 BCE.

pier In architecture, a vertical support.

pilaster In architecture, a small, thin pier, attached to the wall.

plano-convex A type of brick used in the **Early Dynastic** era, its name refers to its particular shape. It can be used to identify when a building was constructed.

polis In Greek, "city."

polychrome In several colors.

polytheism The belief in many gods and goddesses.

portico In architecture, a porch with columns.

presentation scene A portrayal of a person who is being presented to a god or king.

Pre-Pottery Neolithic An archaeological era also called the **Aceramic**, *c.* 9600–7000 BCE.

propylon In architecture, a monumental gate building.

protome In art and in architectural details, a decorative object ending in an animal head.

reception In art history and criticism, the way in which a work is received and responded to by viewers.

rectilinear Straight.

redans In architecture, an arrow- or V-shaped **buttress** that forms part of fortifications, used for protection against attack.

relief In sculpture, a carved design that projects from a solid background.

Renaissance Meaning "rebirth," an art historical era in Europe in the fourteenth to sixteenth centuries CE.

repoussé A metalsmithing technique that involves beating metal from the back to form a design that projects outward from the front.

revetment In architecture, a facing or retaining wall.

rhyton A type of ceremonial vessel for liquids.

ring-post standard A ring post, usually with streamers, that appears in art of the **Uruk** era. It represents the doorpost of the Temple of **Inanna**.

salmu **Akkadian** word meaning image.

sanctuary In architectural history and archaeology, a sacred precinct (*see temenos*).

sarcophagus A coffin.

Sassanian An Iranian dynasty and empire, 224–651 CE.

satrap, satrapy Governor and district in the Persian empire.

seal, seal stone A small, carved stone (*see* **stamp seal** and **cylinder seal**).

Seleucid Era of Greek rule in Mesopotamia (311–141 BCE) and the dynasty founded by Seleucus I Nikator (311–281 BCE).

Semitic A linguistic category used to designate a group of languages with shared grammatical structures and similarities in vocabulary, comprised of Arabic, Hebrew, Aramaic, and other ancient languages.

shaft-hole A type of ax with the handle placed within the metal blade, used in the ancient Near East.

shedu A winged, human-headed lion or bull.

socle A base or pedestal.

sphinx A mythical supernatural creature with the body of a lion and a human head.

stamp seal A small round or pyramidal stone, or ring, with a design carved into one end. It is used to make impressions into clay.

stele A carved stone monument.

stucco In architecture, plaster ornament.

stylized Art that represents its subject, or certain features, in an exaggerated way in order to create emphasis.

Sumerian A language used in ancient Mesopotamia, also a culture beginning in the fourth millennium BCE.

Sumerian King List A text known from the beginning of the second millennium BCE, it describes how kingship "descended from heaven" and went from city to city. It lists city-states, their rulers, and the length of their reigns, from mythical historical times until *c.* 1900 BCE. The text is known today from sixteen ancient manuscripts; one example is the Weld-Blundell Prism in the Ashmolean Museum, Oxford.

surviving height The height of an ancient work as it stands intact today (as opposed to its complete original height).

Sushgal net A net used by the ancient Mesopotamian gods in battle.

syncretism Fusion or amalgamation.

tell **Akkadian** and Arabic word for a mound or archaeological hillock.

temenos A sacred precinct.

temple tower In archaeology and architectural history, the stepped **ziggurats** of Mesopotamia.

tepe Persian word for a mound or archaeological hillock.

terra-cotta Baked clay that may be glazed or painted. Terra-cotta was used in the fourth millennium BCE in Mesopotamia.

Third Dynasty of Ur A dynasty and historical era, 2112–2004 BCE.

throne name A name assumed by a monarch. Throne names are not always used by rulers, but when they are, they are different from their first names. **Sargon of Akkad** used a throne name in the third millennium BCE, but throne names are known earlier in Egypt.

transept In architecture, the section in a cruciform building that crosses the main axis at right angles.

true arch Sometimes referred to as a Roman arch, a semi-circular arch that depends on compression, first used in Mesopotamia in *c.* 2500 BCE.

true fresco A **fresco** technique in which the artist paints onto wet plaster.

Ubaid A site in Mesopotamia, also an archaeological era, 5000–3800 BCE.

Ur III *see* **Third Dynasty of Ur**

Uruk A city in the south of Mesopotamia, also refers to an era (600–3800 BCE).

volumetric Relating to a measurement of volume.

volute In architecture, a spiral form used in column **capitals**.

votive A dedication or gift to a god or goddess.

ziggurat A stepped temple tower of Mesopotamia.

Zoroastrian A religion that comes from ancient Iran, founded by Zoroaster in the sixth century BCE, and still practiced there today.

FURTHER READING

GENERAL

Bahrani, Zainab, *The Graven Image: Representation in Babylonia and Assyria* (Philadelphia: University of Pennsylvania Press), 2003

Bottéro, Jean (trans. Z. Bahrani and M. Van De Mieroop), *Mesopotamia: Writing, Reasoning and the Gods* (Chicago: The University of Chicago Press), 1992

Brown, Brian A. and Marian Feldman (eds.), *Critical Approaches to Ancient Near Eastern Art* (Boston: De Gruyter), 2014

Collon, Dominique, *Ancient Near Eastern Art* (London: British Museum), 1995

Frankfort, H., *Art and Architecture of the Ancient Orient* (London: Penguin Books), 1954

Dalley, Stephanie, *Myths from Mesopotamia* (Oxford: Oxford University Press), 1989

Oppenheim, A. L., *Mesopotamia* (Chicago: The University of Chicago Press), 1964

Postgate, Nicholas, *Early Mesopotamia: Society and Economy at the Dawn of History* (London: Routledge), 1992

Roaf, Michael, *The Cultural Atlas of Mesopotamia and the Ancient Near East* (Oxford and New York: Facts on File Inc.), 1990

Van De Mieroop, Marc, *A History of the Ancient Near East, 3000–323 BC* (Oxford: Oxford University Press), third edition: 2016

Winter, Irene, *On Art in the Ancient Near East* (Leiden: Brill), 2010

CHAPTERS 1 TO 7

Aruz, Joan, with R. Wallenfels (eds.), *Art of the First Cities* (New York: The Metropolitan Museum of Art), 2003

Bahrani, Zainab, Zeynep Çelik, and Edhem Eldem (eds.), *Scramble for the Past. A Story of Archaeology in the Ottoman Empire 1753–1914* (Istanbul: SALT), 2011

Bohrer, F. N., *Orientalism and Visual Culture: Imagining Mesopotamia in Nineteenth Century Europe* (Cambridge: Cambridge University Press), 2003

Collon, Dominique, *First Impressions: Cylinder Seals in the Ancient Near East*, (London: British Museum Press), 2006

Evans, Jean M., *The Lives of Sumerian Sculpture: An Archaeology of the Early Dynastic Temple* (Cambridge: Cambridge University Press), 2012

Zettler, R. L and L. Horne, *Treasures from the Royal Tombs of Ur* (Philadelphia: University of Pennsylvania Press), 1998

CHAPTERS 8 TO 9

Aruz, Joan, Kim Benzel, and Jean M. Evans, *Beyond Babylon: Art, Trade and Diplomacy in the Second Millennium B.C.* (New York: The Metropolitan Museum of Art), 2009

Feldman, Marian, *Diplomacy by Design: Luxury Arts and an "International Style" in the Ancient Near East 1400–1200 BCE* (Chicago: University of Chicago Press), 2006

Van De Mieroop, Marc, *King Hammurabi of Babylon: A Biography* (Oxford: Oxford University Press), 2005

CHAPTERS 10 TO 11

Albenda, Pauline, *The Palace of Sargon, King of Assyria* (Paris: Erc), 1968

Aruz, Joan, Sarah B. Graff, and Yelena Rakic, *Assyria to Iberia* (New York: The Metropolitan Museum of Art), 2014

Barnett, R. D., E. Bleibtreu, and G. Turner, *Sculptures from the Southwest Palace of Sennacherib at Nineveh* (London: British Museum Press), 1998

Collins, Paul, *Assyrian Sculptures* (London: British Museum), 2008

Curtis, J. E. and J. E. Reade (eds.), *Art and Empire: Treasures from Assyria in the British Museum* (London: British Museum Press), 1995

Gunter, Ann, *Greek Art and the Orient* (Cambridge: Cambridge University Press), 2009

Oates, Joan and David, *Nimrud: An Assyrian Imperial City Revealed* (British School of Archaeology in Iraq), 2001

Reade, J. E., *Assyrian Sculpture* (London: British Museum Press), 1998

Russell, J. M., *Sennacherib's Palace without Rival at Nineveh* (Chicago: University of Chicago Press), 1991

CHAPTER 12

Finkel I. and M. Seymour (eds.), *Babylon* (London: British Museum Press), 2009

Seymour, M., *Babylon: Legend, History and the Ancient City* (London: I. B. Tauris), 2015

CHAPTER 13

Briant, Pierre, *From Cyrus to Alexander: A History of the Persian Empire* (Winona Lake: Eisenbrauns), 2002

Cool Root, Margaret, *The King and Kingship in Achaemenid Art* (Leiden: Brill), 1979

Porada, Edith, *The Art of Ancient Iran* (New York: Crown), 1962

CHAPTER 14

Colledge, Malcolm, *Parthian Art* (Ithaca: Cornell University Press), 1977

Curtis, John, ed., *Mesopotamia and Iran in the Parthian and Sasanian Periods* (London: British Museum Press), 2000

Downey, Susan B., *Mesopotamian Religious Architecture: Alexander through the Parthians* (Princeton: Princeton University Press), 1988

SOURCES OF QUOTATIONS

p. 20 G. W. F. Hegel (trans. T. M. Knox), *Aesthetics: Lectures on Fine Art* (Oxford: Clarendon Press), 1975, p. 303

p. 36 Alexander Heidel, *The Babylonian Genesis: The Story of Creation* (Chicago: University of Chicago Press), 1951, p. 62

p. 68 J. S. Cooper, *Sumerian and Akkadian Royal Inscriptions* (New Haven: American Oriental Society), 1986, p. 54

p. 72 (**box**) Cooper, p. 63

p. 72 Cooper, pp. 52–53

p. 123 J. B. Pritchard, *Ancient Near Eastern Texts Relating to the Old Testament* (Princeton: Princeton University Press), 1969, p. 340

p. 143 Translation after D. O. Edzard, *Royal Inscriptions of Mesopotamia–Early Periods*, volume 3/1, (Toronto: University of Toronto Press), 1997

p. 149 D. O. Edzard, *Gudea and His Dynasty* (Toronto: University of Toronto Press), 1997, pp. 69–88

p. 151 D. R. Frayne, *Royal Inscriptions of Mesopotamia–Early Periods*, volume 3/2: Ur III period (Toronto: University of Toronto Press), 1997, pp. 445–46

p. 153 Frayne, p. 441

p. 166 Frayne, pp. 158–59

p. 168 Frayne, p. 154

p. 173 P. Michalowski, *The Lamentation over the Destruction of Sumer and Ur* (Winona Lake: Eisenbrauns), 1989, pp. 63–64

p. 179 M. T. Roth, *Law Collections from Mesopotamia and Asia Minor* (Atlanta: Scholars Press) 1995, pp. 71–142

p. 180 Roth, pp. 71–142

p. 193 (excerpts from the Dadusha Stele) Translation after B. Khalil Ismail and Antoine Cavigneaux, "Dadusas Siegesstele aus Esnunna: Die Inschrift," *Baghdader Mitteilungen* 34 (2003), pp. 129–57

p. 193 (excerpts from the Nippur scribes' catalogue) I. J. Gelb and B. Kienast, *Die altakkadischen Königsinschriften des dritten Jahrtausends* v. Chr., Freiburger Altorientalistische Studien 7 (Stuttgart: Franz Steiner Verlag), 1990, pp. 136, 139. D. R. Frayne, *Royal Inscriptions of Mesopotamia–Early Periods*, volume 2: Sargonic and Gutian Periods, (Toronto: University of Toronto Press), 1993, pp. 135, 155

p. 218 Translation after G. Buccellati, "Through the Past Darkly," in M. Cohen (ed.), *The Tablet and the Scroll* (Bethesda: CDL), 1993, p. 70

p. 227 A. Kirk Grayson, *The Royal Inscriptions of Mesopotamia—Assyrian Periods*, volume 2: Assyrian Rulers of the Early First Millennium BC I (1114–859 BC) (Toronto: University of Toronto Press), 1991, p. 227

p. 259 A. Kirk Grayson, *The Royal Inscriptions of Mesopotamia—Assyrian Periods*, volume 3: Assyrian Rulers of the Early First Millennium BC II (858–745 BC), (Toronto: University of Toronto Press), 1996, pp. 62–71

p. 263 A. Kirk Grayson, *The Royal Inscriptions of Mesopotamia—Assyrian Periods*, vol. 3, p. 61

p. 312 R. G. Kent, *Old Persian: Grammar, Texts, Lexicon*, AOS XXXIII (New Haven: American Oriental Society), 1953, pp. 142–144

p. 315 Kent, p. 138

p. 321 Translation after Amelie Kuhrt, *Persian Empire: A Corpus of Sources* (London: Routledge), 2007

p. 354 R. Ellis, *Foundation Deposits in Ancient Mesopotamia*, (New Haven: Yale University Press), 1968, p. 184

p. 355 Sally Freedman, *If A City Is Set On A Height: The Akkadian Omen Series Summa Alu Ina Mele Sakin* (Philadelphia: University of Pennsylvania Press), 1998, pp. 19, 69, 81, 161

ACKNOWLEDGMENTS

I offer my sincere thanks to the following colleagues for their suggestions and their assistance with images: Sidney Babcock, The Morgan Library & Museum, New York; Lorans Tanatar Baruh, SALT, Istanbul; Joan Aruz, Kim Benzel, Sarah Graff, and Yelena Rakic, The Metropolitan Museum of Art, New York; Edhem Eldem, Bogaziçi University, Istanbul; Zeynep Kiziltan, Istanbul Archaeological Museum; Haider al Mamori, State Board of Antiquities, Iraq; Elizabeth Stone, SUNY: Stony Brook University, New York; Giorgio Buccellati, University of California; Frederick Bohrer, Hood College, Frederick, MD; and Helen Malko, Gabriel Rodriguez, and Serdar Yalcin, Columbia University, New York. I am most grateful to the anonymous reader for taking the time to read and comment on the manuscript and for many helpful points that improved the text, and many thanks also to Jean-François de Lapérouse, Conservator at The Metropolitan Museum of Art, for answering my incessant questions on ancient technologies of making artworks. I would like to take this opportunity to thank Ian Jacobs of Thames & Hudson for steering this book through the writing process and for all his thoughtful suggestions, and to the outstanding team at Thames & Hudson who saw it through to completion. I offer a special and sincere thank-you to Leopold Swergold for his kind generosity in providing the grant that supported the production, and for understanding the need for such a publication today. This book is dedicated to Ayten and Mustafa with love and thanks.

SOURCES OF ILLUSTRATIONS

The artwork captions in this book provide information about the locations at which these ancient objects were excavated. Artworks for which the original context has not been verified are given as "unknown provenance." Please see below for details of the current collections or institutions at which the artworks in this book are held.

Numbers refer to pages in the book, and letters refer to:
a = above; b = below; c = center; l = left; r = right

2–3, 245 British Museum, London (124876); 7, 270–71 Vorderasiatisches Museum, Staatliche Museen zu Berlin. Photo Olaf M. Tessmer/Scala, Florence/bpk, Bildagentur für Kunst, Kultur und Geschichte, Berlin; 9 British Council Collection, London. Photo akg-images/De Agostini Picture Library/G. Dagli Orti. Reproduced by permission of The Henry Moore Foundation; 10 Museum of Modern Art, New York/Scala, Florence; 11a Photo Fotosearch/Getty Images; 11b Photo Mimmo Capone. Courtesy Fondazione Nicola Del Roscio. © Cy Twombly Foundation; 12 © Hanaa Malallah; 14–15 Archeological Museums, Istanbul; 16, 40, 64, 86, 112, 136, 156, 176, 202, 224, 252, 272, 29, 324 ML Design, © Thames & Hudson Ltd, London; 9a Kunsthistorisches Museum, Vienna (GG_1026); 19b © 2004 Topfoto/Josef Polleross/ImageWorks; 20 Musée du Louvre, Paris (RF2346); 21a British Embassy, Athens. Government Art Collection, UK; 21b Bibliothèque nationale de France, Paris; 22a Norman B. Leventhal Map Center, Boston Public Library, MA; 22b British Museum, London (926870); 23a C. J. Rich, *Second Memoir on Babylon*, 1818. Columbia University Library; 23b Istanbul University Library; 24a British Museum, London (1976,0925.9); 24b City & County of Swansea, Swansea Museums Collection (SWASM:SM1987.845.79); 25 Mary Evans Picture Library/Alamy Stock Photo; 26l Robert Koldewey and Friedrich Wetzel (eds.), *Königsburgen von Babylon, part 2: Die Hauptburg und der Sommerpalast Nebukadnezars im Hügel Babil* (Leipzig), 1932; 26r British Library, London. Talbot Photo 22 (86); 27a Myron Bement Smith Collection: Antoin Sevruguin Photographs. Freer Gallery of Art and Arthur M. Sackler Gallery Archives, Smithsonian Institution, Washington, D. C. Gift of Katherine Dennis Smith, 1973–1985 (FSA A.4 2.12.Sm.19); 27b Gertrude Bell Archive, Newcastle University (M_074); 29a Photo Vincent J. Musi/Getty Images; 29b Photo De Agostini/Getty Images; 30 © Sebastian Meyer/Corbis; 31a Photo Arlette and James Mellaart; 31b Anadolu Medeniyetler Muzesi, Archaeological Museum, Ankara. Photo De Agostini/Getty Images; 32a Metropolitan Museum of Art, New York. Bequest of Lester Wolfe, 1983 (1984.175.15); 32b British Museum, London (127414); 33l Archaeological Museum, Amman, Jordan; 33r British Museum, London (125381); 34a, 34bl National Museum of Iraq (Archaeological Museum), Baghdad. Photo akg-images/De Agostini Picture Library/A. De Gregorio; 34br British Museum, London (127717); 35 British Museum, London (1928.1010.816); 36 Pitt Rivers Museum, Oxford/Bridgeman Images; 37 F. Safar, M. A. Mustafa and S. Lloyd, *Eridu* (Baghdad: Ministry of Culture), 1981; 38–39 Photo Essam Al-Sudani/AFP/Getty Images; 42 © robertharding/Alamy Stock Photo; 43 Peter Bull, © Thames & Hudson Ltd, London; 44 Drazen Tomic, © Thames & Hudson Ltd, London. After E. Heinrich, *Uruk vorläufige Berichte* VIII (Deutsches Archaologisches Institut), 1937; 45 Plan originally reproduced in Michael Imhof Verlag, *URUK 5000 Jahre Megacity* (Berlin), 2014, p. 110 fig. 14.5. © DAI, Orient-Abteilung; 47 National Museum of Iraq (Archaeological Museum), Baghdad (IM19606). Photo akg-images/Erich Lessing; 49 National Museum of Iraq (Archaeological Museum), Baghdad (IM45434). Photo akg-images/Bildarchiv Steffens; 50l National Museum of Iraq (Archaeological Museum), Baghdad. Photo Donald P. Hansen; 50r British Museum, London (116686); 51l Vorderasiatisches Museum, Staatliche Museen zu Berlin (VA 11025); 51r National Museum of Iraq (Archaeological Museum), Baghdad; 52 National Museum of Iraq (Archaeological Museum), Baghdad (IM69185). Photo akg-images/De Agostini Picture Library/A. De Gregorio; 53al Museum of Egyptian Antiquities, Cairo; 53ar, 53b Musée du Louvre, Paris (MNB1167). Photo RMN-Grand Palais (musée du Louvre)/Franck Raux; 54bl Vorderasiatisches Museum, Staatliche Museen zu Berlin (VA 7736); 54ca Pierpont Morgan Library, New York (Morgan seal 608); 54cb Pierpont Morgan Library, New York

(Morgan seal 781); **54ra** Pierpont Morgan Library, New York (Morgan seal 773); **54rc** Metropolitan Museum of Art, New York. Gift of Martin and Sarah Cherkasky, 1989 (1989.361.1); **54rb** Metropolitan Museum of Art, New York. Gift of Nanette B. Kelekian, in memory of Charles Dikran and Beatrice Kelekian, 1999 (1999.325.4); **55la** Pierpont Morgan Library, New York (Morgan seal 609); **55lc** Metropolitan Museum of Art, New York. Gift of Martin and Sarah Cherkasky, 1988 (1988.380.2); **55lb** Pierpont Morgan Library, New York (Morgan seal 833); **55cla** Pierpont Morgan Library, New York (Morgan seal 190); **55cl** Metropolitan Museum of Art, New York. Rogers Fund, 1962 (62.70.74); **55clb** Metropolitan Museum of Art, New York. Bequest of W. Gedney Beatty, 1941 (41.160.192); **55bl** Pierpont Morgan Library, New York (Morgan seal 824); **55cra** Pierpont Morgan Library, New York (Morgan seal 757); **55cr** Pierpont Morgan Library, New York (Morgan seal 85); **55br** Pierpont Morgan Library, New York (Morgan seal 149). Acquired by Pierpont Morgan sometime between 1885 and 1908; **55ra** Pierpont Morgan Library, New York (Morgan seal 607); **55rb** Pierpont Morgan Library, New York (Morgan seal 749); **56** Vorderasiatisches Museum, Staatliche Museen zu Berlin (VA 8255). Photo Scala, Florence/bpk, Bildagentur für Kunst, Kultur und Geschichte, Berlin; **57** Vorderasiatisches Museum, Staatliche Museen zu Berlin (VAT 14942). Photo Scala, Florence/bpk, Bildagentur für Kunst, Kultur und Geschichte, Berlin; **59** Musée du Louvre, Paris (AO5718; AO5719). Photo RMN-Grand Palais (musée du Louvre)/ Hervé Lewandowski; **62–63** Courtesy the Oriental Institute of the University of Chicago; **66** Ashmolean Museum of Art and Archeology, Oxford (AN 1923.444); **67** Vorderasiatisches Museum, Staatliche Museen zu Berlin (VA 14536); **68l, 68r** British Museum, London (23287); **69** Musée du Louvre, Paris (AO2674). Photo RMN-Grand Palais (musée du Louvre)/Hervé Lewandowski; **71l** Metropolitan Museum of Art, New York. Fletcher Fund, 1940 (40.156); **71c** Archives of the University of Pennsylvania Museum of Archaeology and Anthropology. Courtesy Penn Museum, Philadelphia, PA (image no. 152346); **71r** Worcester Art Museum, MA (1937.91); **72** National Museum of Iraq (Archaeological Museum), Baghdad (IM5); **73** National Museum of Iraq (Archaeological Museum), Baghdad (IM96190); **74l** Musée du Louvre, Paris (AO3279-3280,4494). Photo RMN-Grand Palais (musée du Louvre)/Franck Raux; **74r** National Museum of Iraq (Archaeological Museum), Baghdad (IM66190); **75al, 75ar** National Museum, Aleppo, Syria (10406). Photo Philippe Maillard/akg-images; **75bl, 75bc** Musée du Louvre, Paris (AO17551). Photo Musée du Louvre, Dist. RMN-Grand Palais/Raphael Chipault; **75br** National Museum, Damascus, Syria (2071); **76l** Courtesy the Oriental Institute of the University of Chicago; **76r** National Museum of Iraq (Archaeological Museum), Baghdad (IM31389); **77** National Museum of Iraq (Archaeological Museum), Baghdad (IM41085); **78** Drazen Tomic, © Thames & Hudson Ltd, London. After Donald P. Hansen, "Al Hiba, 1968–1969," *Artibus Asiae*, vol. 32, no. 4, (1970), p. 251; **79a, 79b** National Museum of Iraq (Archaeological Museum), Baghdad; **80a, 80bl, 80br** Courtesy Haider Almamori; **81** British Museum, London (114308). Photo akg-images/ Erich Lessing; **82l** Eski Şark Eserleri Müzesi, Archeological Museums, Istanbul (1521); **82r** Eski Şark Eserleri Müzesi, Archeological Museums, Istanbul (1531); **83** Musée du Louvre, Paris (AO2344). Photo RMN-Grand Palais (musée du Louvre)/Philipp Bernard; **84–85** British Museum, London (121201); **88a** Archives of the University of Pennsylvania Museum of Archaeology and Anthropology. Courtesy Penn Museum, Philadelphia, PA (image no. 139556); **88b** *Illustrated London News*, 23 June 1928; **89** Archives of the University of Pennsylvania Museum of Archaeology and Anthropology. Courtesy Penn Museum, Philadelphia, PA (image no. 142731); **90l** C. L. Woolley, *Ur Excavations*, vol. 2, 1934, p. 73; **90r** Archives of the University of Pennsylvania Museum of Archaeology and Anthropology. Courtesy Penn Museum, Philadelphia, PA (image no. 152100); **91** Archives of the University of Pennsylvania Museum of Archaeology and Anthropology. Courtesy Penn Museum, Philadelphia, PA (image

no. 152099); **92a** National Museum of Iraq (Archaeological Museum), Baghdad (IM8269); **92b** British Museum, London (image Ur_GN_0959); **93** National Museum of Iraq (Archaeological Museum), Baghdad (IM4307). Photo Scala, Florence; **94l** Archives of the University of Pennsylvania Museum of Archaeology and Anthropology. Courtesy Penn Museum, Philadelphia, PA (image no. 151000); **94r, 95** British Museum, London (122200); **96a, 96b** British Museum, London (121201); **97** Archives of the University of Pennsylvania Museum of Archaeology and Anthropology. Courtesy Penn Museum, Philadelphia, PA (image no. 150480); **98** After C. L. Woolley, *Ur Excavations*, vol. 2, 1934, pl. 29; **99** National Museum, Damascus, Syria (2409); **100** National Museum, Damascus, Syria (2399); **101l** National Museum, Damascus, Syria (2366); **101r** National Museum, Damascus, Syria (2424); **103l, 103r** Musée du Louvre, Paris (AO 50). Photo RMN-Grand Palais (musée du Louvre)/ Hervé Lewandowski; **104l, 104r** Metropolitan Museum of Art, New York. Funds from various donors, 1958 (58.29); **105** Musée du Louvre, Paris (AO22299). Photo RMN-Grand Palais (musée du Louvre)/ Christian Larrieu; **106** After E. Klengel-Brandt, *Mit Sieben Segeln versehen* (Berlin: Vorderasiatisches Museum), 1997; **107a** Courtesy Donald P. Hansen; **107b** After Henri Frankfort, *Cylinder Seals*, (New York: Macmillan & Co.), 1939; **109** British Museum, London (121544); **110–111** National Museum of Iraq (Archaeological Museum), Baghdad (IM11331). Photo DEA/M. Carrieri/De Agostini/Getty Images; **114** After Marc Van de Mieroop, *A History of the Ancient Near East* (New York: Wiley Blackwell), p. 348; **115** Musée du Louvre, Paris (SB1); **116l, 116c, 116r** Musée du Louvre, Paris (AO2111). Photo RMN-Grand Palais (musée du Louvre)/Franck Raux; **117** National Museum of Iraq (Archaeological Museum), Baghdad (IM11331); **118** National Museum of Iraq (Archaeological Museum), Baghdad (IM77823); **119** David Bezzina, © Thames & Hudson Ltd, London; **120** Musée du Louvre, Paris (SB47); **121** Musée du Louvre, Paris (SB20), Photo RMN-Grand Palais (musée du Louvre)/Franck Raux; **123** Musée du Louvre, Paris (SB52); **124** Musée du Louvre, Paris (SB4). Photo RMN-Grand Palais (musée du Louvre)/Franck Raux; **125** Archives of the University of Pennsylvania Museum of Archaeology and Anthropology. Courtesy Penn Museum, Philadelphia, PA (image no. 162399); **126** Courtesy Giorgio Buccelati; **127** Musée du Louvre, Paris (AO4799). Photo RMN-Grand Palais (musée du Louvre)/Mathieu Rabeau; **128** Drazen Tomic, © Thames & Hudson Ltd, London. After Max Mallowan, *Excavations at Tell Brak and Chagar Bazar, Iraq*, vol. 9, 1947, pl. LX; **129** Drazen Tomic, © Thames & Hudson Ltd, London. After S. Lloyd 1933, from Seton Lloyd, *The Archaeology of Mesopotamia* (London: Thames & Hudson Ltd), 1980, p. 140, fig. 94; **130** British Museum, London (89137); **131** British Museum, London (89115); **132l, 132r** Metropolitan Museum of Art, New York. Anonymous loan (L.1992.23.5); **133** Musée du Louvre, Paris (AO 22303). Photo RMN-Grand Palais (musée du Louvre)/Franck Raux; **134–135** Vorderasiatisches Museum, Staatliche Museen zu Berlin (VA 2796). Photo 2016 Scala, Florence/bpk, Bildagentur für Kunst, Kultur und Geschichte, Berlin; **139** Musée du Louvre, Paris (AO6). Photo RMN-Grand Palais (musée du Louvre)/Hervé Lewandowski; **140l** Musée du Louvre, Paris (AO20164). Photo RMN-Grand Palais (musée du Louvre)/René-Gabriel Ojéda; **140r** British Museum, London (122910); **141l, 141r** Musée du Louvre, Paris (AO9). Photo RMN-Grand Palais (musée du Louvre)/Franck Raux; **142** Musée du Louvre, Paris (AO8); **143** Metropolitan Museum of Art, New York. Purchased 1959 (59.2); **144l, 144r** Musée du Louvre, Paris (AO2); **145l** Musée du Louvre, Paris (AO3); **145r** Musée du Louvre, Paris (AO3). Photo RMN-Grand Palais (musée du Louvre)/Hervé Lewandowski; **146** Detroit Institute of Arts, Founders Society Purchase, Robert H. Tannahil Foundation F82.5 (82.64); **147** Metropolitan Museum of Art, New York. Rogers Fund, 1947 and lent by Musée du Louvre (47.100.86)/Musée du Louvre, Paris (AO9504); **148** Musée du Louvre, Paris (AO295). Photo RMN-Grand Palais (musée du Louvre)/Hervé Lewandowski; **149** Musée du

Louvre, Paris (MNB1512). Photo RMN-Grand Palais (musée du Louvre)/Franck Raux; **150** Pierpont Morgan Library, New York (AZ145); **152** Eski Şark Eserleri Müzesi, Archeological Museums, Istanbul; **153** Musée du Louvre, Paris (AO19486); **154–155** © Janzig/MiddleEast/Alamy Stock Photo; **158** Courtesy Marc Van de Mieroop; **159a** C. L. Woolley, *Ur Excavations UE5,* 1939, pl. 86; **159b** © Georg Gerster/panos pictures; **161** C. L. Woolley, *Ur Excavations VI,* 1939, pl. 53; **162a** C. L. Woolley, *Ur Excavations VI,* 1939, pl.12b; **162b** Archives of the University of Pennsylvania Museum of Archaeology and Anthropology. Courtesy Penn Museum, Philadelphia, PA (image no. 291639); **163l** Courtesy Donald P. Hansen; **163r** Courtesy the Oriental Institute of the University of Chicago; **164** Archives of the University of Pennsylvania Museum of Archaeology and Anthropology. Courtesy Penn Museum, Philadelphia, PA (image no. 141417); **165l, 165r** Archives of the University of Pennsylvania Museum of Archaeology and Anthropology. Courtesy Penn Museum, Philadelphia, PA (image no. 149986 and 149987); **166** Metropolitan Museum of Art, New York. On loan from the New York Public Library (L. 1983.95 a,b); **167a** National Museum of Iraq (Archaeological Museum), Baghdad (IM41014). Photo 2016 De Agostini Picture Library/Scala, Florence; **167c** Musée du Louvre, Paris (AO20216); **167b** Archives of the University of Pennsylvania Museum of Archaeology and Anthropology. Courtesy Penn Museum, Philadelphia, PA (image no. 225830); **168a** Musée du Louvre, Paris (AO3146); **168b** National Museum of Iraq (Archaeological Museum), Baghdad. Photo 2016 Scala, Florence; **169l** Musée du Louvre, Paris (AO2761). Photo RMN-Grand Palais (musée du Louvre)/Franck Raux; **169r** Musée du Louvre, Paris (SB6). Photo RMN-Grand Palais (musée du Louvre/Droits reserves; **170** Musée du Louvre, Paris (SB5634). Photo RMN-Grand Palais (musée du Louvre)/Franck Raux; **171** Photo Osama Shukir Muhammed Amin FRCP (Glasgow); **172l, 172r** British Museum, London (89126); **173** After J. Aruz, *Art of the First Cities* (New York: Metropolitan Museum of Art), 2003, fig. 107; **174–175** Musée du Louvre, Paris (AO19825). Photo Musée du Louvre, Dist. RMN-Grand Palais/Thierry Ollivier; **178** Musée du Louvre, Paris (SB8); **180** Musée du Louvre, Paris (SB95). Photo Musée du Louvre, Dist. RMN-Grand Palais/Raphaël Chipault; **181** Musée du Louvre, Paris (SB61); **182l** Metropolitan Museum of Art, New York. Gift of Mr. and Mrs. J. J. Klejman, 1966 (66.245.5a); **182r** Metropolitan Museum of Art, New York. Gift of Mr. and Mrs. J. J. Klejman, 1966 (66.245.5b); **183l** Musée du Louvre, Paris (AO15704); **183r** Archives of the University of Pennsylvania Museum of Archaeology and Anthropology. Courtesy Penn Museum, Philadelphia, PA (image no. 291638); **184l** C. L. Woolley, *Ur Excavations,* Vol. VII, pl. 52a and 53a; **184r** C. L. Woolley, *Ur Excavations,* Vol. VII, pl. 55b; **185l** British Museum, London (123040); **185r** British Museum, London (91145); **186** Drazen Tomic, © Thames & Hudson Ltd, London. After A. Parrot, *Mari* (Paris: P. Geuthner), 1937; **187a** Photo André Bianquis, from A. Parrot, *Sumer* (London: Thames & Hudson Ltd), 1960. Ill. 323; **187b**; Photo André Bianquis, from A. Parrot, *Sumer* (London: Thames & Hudson Ltd), 1960, Ill. 320; **188** Musée du Louvre, Paris (AO19825). Photo Musée du Louvre, Dist. RMN-Grand Palais/Thierry Ollivier; **189** Musée du Louvre, Paris (AO19826). Photo RMN-Grand Palais (musée du Louvre)/Franck Raux; **190** National Museum, Aleppo, Syria (1659); **191** National Museum, Aleppo, Syria. Photo akg-images/Erich Lessing; **192** Musée du Louvre, Paris (AO19830; AO19833; AO19832). Photo RMN-Grand Palais (musée du Louvre)/Christian Jean; **193** National Museum of Iraq (Archaeological Museum), Baghdad; **195al** Musée du Louvre, Paris (AO12466). Photo RMN-Grand Palais (musée du Louvre)/Franck Raux; **195ar** Metropolitan Museum of Art, New York. Rogers Fund and Gifts of Lucy W. Drexel, Theodore M. Davis, Helen Miller Gould, Albert Gallatin, Egypt Exploration Fund and Egyptian Research Account, by exchange, 1950 (51.25.12); **195bl** Metropolitan Museum of Art, New York. Rogers Fund, 1932 (32.39.1); **195br** Archives of the University of Pennsylvania Museum of Archaeology and Anthropology. Courtesy

Penn Museum, Philadelphia, PA (image no. 198441); **196** British Museum, London (2003,0718.1); **197** National Museum of Iraq (Archaeological Museum), Baghdad (IM20631). Photo Scala, Florence; **198** British Museum, London (122934); **199** British Museum, London (135680); **200–201** Vorderasiatisches Museum, Staatliche Museen zu Berlin (VA 8146). Photo Scala, Florence/bpk, Bildagentur für Kunst, Kultur und Geschichte, Berlin; **205a** Michael Roaf; **205c, 205b** Taha Baqir, "Iraq Government Excavations at 'Aqar qūf Third Interim Report," 1944–45, in *Iraq*, vol. 8, British Institute for the Study of Iraq, 1946, pp. 73–93; **206l** National Museum of Iraq (Archaeological Museum), Baghdad (IM5022). Photo Scala, Florence; **206r** National Museum of Iraq (Archaeological Museum), Baghdad (IM50920); **207a** Drazen Tomic, © Thames & Hudson Ltd, London; **207b** Vorderasiatisches Museum, Staatliche Museen zu Berlin (VA 10 983); **209** Musée du Louvre, Paris (SB23). Photo RMN-Grand Palais (musée du Louvre)/René-Gabriel Ojéda; **210** British Museum, London (90858); **211** Musée du Louvre, Paris (SB25). Photo RMN-Grand Palais (musée du Louvre)/Droits reserves; **213** British Museum, London (124963); **214** Archaeological Museum of Thebes, Greece (seal 198); **215a** Metropolitan Museum of Art, New York. Gift of Nanette B. Kelekian, in memory of Charles Dikran and Beatrice Kelekian, 1999 (1999.325.89); **215c** Pierpont Morgan Library, New York (Morgan seal 601); **215b** Vorderasiatisches Museum, Staatliche Museen zu Berlin (VAT9009); **216** British Museum, London (118931); **217** National Museum of Iraq (Archaeological Museum), Baghdad; **219** Musée du Louvre, Paris (SB2731). Photo RMN-Grand Palais (musée du Louvre)/Franck Raux; **221** Drawing by W. Andrae in E. Mallwitz, *Das Babylon de Spätzeit* (Berlin), 1957; **222–223** British Museum, London (124565). Photo akg-images/Album/Prisma; **227a** Drazen Tomic, © Thames & Hudson Ltd, London. After "Plan 2" from Samuel M. Paley and Richard P. Sobolweski, *The Reconstruction of the Relief Representations and their Positions in the Northwest-Palace at Kalhu (Nimrud) II* (Mainz: Verlag Philipp von Zabern), 1987; **227b** Mosul Museum, Iraq (ND1104); **228a** © Barry Iverson/Alamy Stock Photo; **228b** Photo David Lees/Corbis/VCG via Getty Images; **229a** © Barry Iverson/Alamy Stock Photo; **229b** Photo Spectrum/Heritage Images/Scala, Florence; **230** British Museum, London (124562); **231** Metropolitan Museum of Art, New York. Gift of John D. Rockefeller Jr., 1932 (32.143.1-.2); **233** British Museum, London (1849,0502.15); **234** Metropolitan Museum of Art, New York. Gift of John D. Rockefeller Jr., 1932 (32.143.3); **235a** Hood Museum of Art, Dartmouth College, Hanover, NH. Gift of Sir Henry Rawlinson through Austin H. Wright, Class of 1830 (s.856.3.2); **235b** British Museum, London (91839, 90992, 90989); **236** Drazen Tomic, © Thames & Hudson Ltd, London. After G. Loud and Ch. B. Altman, *Khorsabad II* (Chicago: Oriental Institute Publications), vol. XL, 1938; **237** Musée du Louvre, Paris (AO19861). Photo Musée du Louvre, Dist. RMN-Grand Palais; **238** Musée du Louvre, Paris (AO19889). Photo RMN-Grand Palais (musée du Louvre)/Hervé Lewandowski; **239** Musée du Louvre, Paris (AO19873). Photo RMN-Grand Palais (musée du Louvre); **240** British Museum, London (Or.Dr.I.57); **242a** British Museum, London (124911); **242b** British Museum, London (124906); **243a** British Museum, London (Or.Dr.I.62); **243b** British Museum, London (124910); **244** British Museum, London (124867-8); **246–247** British Museum, London (124801a-c); **248** British Museum, London (124920); **249a** British Museum, London (124774,a); **249b** British Museum, London (124954); **250–251** Courtesy Mapping Mesopotamian Monuments, Columbia University. Photo Zainab Bahrani; **254a** National Museum of Iraq (Archaeological Museum), Baghdad (IM115619); **254cl** National Museum of Iraq (Archaeological Museum), Baghdad (IM105813, IM105814); **254cr** National Museum of Iraq (Archaeological Museum), Baghdad (IM105702, IM105703); **254b** National Museum of Iraq (Archaeological Museum), Baghdad. Photo Marc Deville/Gamma-Rapho via Getty Images; **255** National Museum of Iraq (Archaeological Museum), Baghdad (IM105697);

257al Metropolitan Museum of Art, New York. Rogers Fund, 1954 (54.117.11a–c); 257ac National Museum of Iraq (Archaeological Museum), Baghdad (IM79525); 257ar National Museum of Iraq (Archaeological Museum), Baghdad (IM56642). Photo Heritage Image Partnership Ltd/Alamy Stock Photo; 257b Metropolitan Museum of Art, New York. Rogers Fund, 1961 (61.197.5); 258l, 258r, 259l, 259r British Museum, London (118885); 260 British Museum, London (118805); 261 Vorderasiatisches Museum, Staatliche Museen zu Berlin (VA 968); 262 British Museum, London (118871); 263 National Museum of Iraq (Archaeological Museum), Baghdad (IM60497); 264l Archaeological Museums, Istanbul; 264r, 265l, 265r; Courtesy Mapping Mesopotamian Monuments, Columbia University. Photo Helen Malko; 266a Courtesy Mapping Mesopotamian Monuments, Columbia University. Photo Serdar Yalcin; 266b Courtesy Mapping Mesopotamian Monuments, Columbia University. Photo Haider Almamori; 267l Courtesy Mapping Mesopotamian Monuments, Columbia University. Photo Gabriel Rodriguez; 267r Photo Chronicle/Alamy Stock Photo; 268a Pierpont Morgan Library, New York (Morgan Seal 773); 268b Pierpont Morgan Library, New York (Morgan Seal 691); 269a Antikensammlung, Staatliche Museen zu Berlin (SA207); 269c Antikensammlung, Staatliche Museen zu Berlin (SA206); 269b British Museum, London (89769); 274 British Museum, London (91000); 275a, 275c British Museum, London (91001, 91002); 275b British Museum, London (91004); 276 Vorderasiatisches Museum, Staatliche Museen zu Berlin (VA 2663). Photo Juergen Liepe/Scala, Florence/bpk, Bildagentur für Kunst, Kultur und Geschichte, Berlin; 277l British Museum, London (90864); 277r British Museum, London (90837); 278 Sanli Urfa Museum Turkey. Photo © 2015 Ronnie Jones III; 279a After Marc Van de Mieroop, A History of the Ancient Near East (New York: Wiley-Blackwell), 2007, p. 278; 279b Deutsche Orient-Gesellschaft, Berlin; 280–281 Vorderasiatisches Museum, Staatliche Museen zu Berlin. Photo Scala, Florence/bpk, Bildagentur fuer Kunst, Kultur und Geschichte, Berlin; 282a Photo akg-images/De Agostini Picture Library/C. Sappa; 282b Photo Zainab Bahrani; 283 Vorderasiatisches Museum, Staatliche Museen zu Berlin (VA Bab 1385, VA Bab 1386). Photo Olaf M. Tessmer/Scala, Florence/bpk, Bildagentur für Kunst, Kultur und Geschichte, Berlin; 284a Photo Zainab Bahrani; 284bl Drazen Tomic, © Thames & Hudson Ltd, London. After I. Finkel and M. Seymour, Babylon (London: British Museum Press), 2008; 284br Vorderasiatisches Museum, Staatliche Museen zu Berlin (VA Bab 3135); 285 Deutschen Orient-Gesellschaft, Berlin; 286 Vorderasiatisches Museum, Staatliche Museen zu Berlin; 287a British Museum, London (90136); 287b British Museum, London (129397); 288a Pierpont Morgan Library, New York (Morgan seal 747); 288b Vorderasiatisches Museum, Staatliche Museen zu Berlin (Bab 647); 289 Musée du Louvre, Paris (AO4366); 290–291 Photo akg-images/Jürgen Sorges; 294 British Museum, London (90920); 295 After E. Haerinck, "Babylonia Under Achaemenid Rule," in J. Curtis, Mesopotamia and Iran in the Persian Period (London: British Museum Press), 1997, pp. 26–34, figs. 8, 9; 296a Vorderasiatisches Museum, Staatliche Museen zu Berlin (VA 5954); 296b Vorderasiatisches Museum, Staatliche Museen zu Berlin (VA 08452). Photo Olaf M.Tessmer/Scala, Florence/bpk, Bildagentur für Kunst, Kultur und Geschichte, Berlin; 297 Courtesy Kim Bezel; 298 Photo The Art Archive/Gianni Dagli Orti; 299a © Borna/Dreamstime.com; 299b Drazen Tomic, © Thames & Hudson Ltd, London. After David Stronach, Pasargadae (Oxford: Clarendon Press), 1978, p. 27, fig. 9; 300 Courtesy Mapping Mesopotamian Monuments, Columbia University. Photo Zainab Bahrani; 301a, 301c, 301b Courtesy Mapping Mesopotamian Monuments, Columbia University. Photo Helen Malko; 302 Photo De Agostini/Getty Images; 303 © Wojtek Buss/age fotostock; 304 New York Public Library; 305 Drawing by Tessa Rickards, previously published in Amelie Kuhrt, The Persian Empire (New York: Routledge), 2007, vol. I, p. 158, fig. 5.4; 307a © Heritage Image Partnership Ltd/Alamy Stock Photo; 307b Drazen Tomic,

© Thames & Hudson Ltd, London. After H. Frankfort, Art and Architecture of the Ancient Orient (Penguin books), 1955, p. 219, fig. 110; 308a Photo Marka/UIG via Getty Images; 308b After Roman Ghirshman, The Art of Ancient Iran, 1964, p. 125, fig. 263; 309 Photo akg-images/Suzanne Held; 310 Photo James P. Blair/National Geographic Creative; 311 Photo The Art Archive/DeA Picture Library/W. Buss; 312 © INTERFOTO/Alamy Stock Photo; 313 Photo akg-images/De Agostini/Archivio J. Lange; 314 © robertharding/Alamy Stock Photo; 315a © Marco Kesseler/Alamy Stock Photo; 315b Photo Ann Ronan/Heritage Images/Scala, Florence; 316 National Museum of Iran, Tehran. Photo akg-images/Jürgen Sorges; 317 Musée du Louvre, Paris (AOD488). Photo RMN-Grand Palais (musée du Louvre)/Hervé Lewandowski; 318l Metropolitan Museum of Art, New York. Fletcher Fund, 1954 (54.3.3); 318r Metropolitan Museum of Art, New York. Gift of Norbert Schimmel Trust, 1989 (1989.281.30); 319a Metropolitan Museum of Art, New York. Rogers Fund, 1947 (47.100.84); 319bl British Museum, London (120450); 319br Metropolitan Museum of Art, New York. Harris Brisbane Dick Fund, 1954 (54.3.1); 320a Pierpont Morgan Library, New York (Morgan Seal 824); 320c British Museum, London (89324); 320b British Museum, London (89132); 322–323 Photo De Agostini/C. Sappa/Getty images; 326a Archaeological Museums, Istanbul; 326b Musée du Louvre, Paris (2898). Photo RMN-Grand Palais (musée du Louvre)/Daniel Arnaudet/Gérard Blot; 327 After E. Mallwitz, Das Babylon de Spätzeit, Berlin, 1957; 328 Musée du Louvre, Paris (AO 20127). Photo RMN-Grand Palais (musée du Louvre)/Franck Raux; 329l Musée du Louvre, Paris (AO20132). Photo Musée du Louvre, Dist. RMN-Grand Palais/Christian Larrieu; 329r Vorderasiatisches Museum, Staatliche Museen zu Berlin (VA 281); 330a National Museum of Iraq (Archaeological Museum), Baghdad (IM17805); 330b National Museum of Iraq (Archaeological Museum), Baghdad (IM75467); 331 Musée du Louvre, Paris (MND2272). Photo Musée du Louvre, Dist. RMN-Grand Palais/Thierry Ollivier; 332l National Museum of Iraq (Archaeological Museum), Baghdad (IM79082); 332r National Museum of Iraq (Archaeological Museum), Baghdad (IM79180); 333 National Museum of Iraq (Archaeological Museum), Baghdad (IM75116); 334 Drazen Tomic, © Thames & Hudson Ltd, London. After Susan Downey, Mesopotamian Religious Architecture (Princeton: Princeton University Press), 1988; 335 British Museum, London (36277); 336a Drazen Tomic, © Thames & Hudson Ltd, London. After Susan Downey, Mesopotamian Religious Architecture (Princeton: Princeton University Press), 1988; 336b Photo akg-images/François Guénet; 337 National Museum of Iraq (Archaeological Museum), Baghdad (IM100178); 338 National Museum of Iraq (Archaeological Museum), Baghdad (IM17885); 339 British Museum, London (91593); 340 National Museum of Iraq (Archaeological Museum), Baghdad (IM61399); 340–341 Photo akg-images/François Guénet; 342l, 342r Photo akg-images/Gerard Degeorge; 343a Photo akg-images/De Agostini/Archivio J. Lange; 343b Photo De Agostini Picture Library/Scala, Florence; 344–345 Photo De Agostini Picture Library/Scala, Florence; 345 Photo akg-images/De Agostini/Archivio J. Lange; 346 National Museum of Iraq (Archaeological Museum), Baghdad (IM17HT608); 347l National Museum of Iraq (Archaeological Museum), Baghdad (IM56752); 347r National Museum of Iraq (Archaeological Museum), Baghdad (IM57819); 348 National Museum of Iraq (Archaeological Museum), Baghdad (IM73015); 349 National Museum of Iraq (Archaeological Museum), Baghdad (IM56766); 350l Mosul Museum, Iraq (MM21) (IM110589); 350r Musée du Louvre, Paris (AO1); 351l Musée du Louvre, Paris; 351r Archaeological Museums, Istanbul; 352 © Alberto Paredes/Alamy Stock Photo; 353 Photo Zainab Bahrani, 2008; 355 Photo Zainab Bahrani, 2003; 356l National Museum of Iraq (Archaeological Museum), Baghdad; 356r Photo Zainab Bahrani, 2003; 357a Photo Essam Al-Sudani/AFP/Getty Images; 357b Photo Zainab Bahrani, 2004; 358 Mosul Museum, Baghdad (IM110662, MM8); 359a Photo 2006 Alinari/Topfoto; 359b Photo Zainab Bahrani, 2015

INDEX